PARADISE NOW

ALSO BY WILLIAM MIDDLETON

Double Vision: The Unerring Eye of Art World Avatars
Dominique and John de Menil

PARADISE NOW

THE EXTRAORDINARY LIFE OF
KARL LAGERFELD

WILLIAM MIDDLETON

HARPER
An Imprint of HarperCollinsPublishers

HarperCollins books may be purchased for educational, business, or sales promotional use. For information, please email the Special Markets Department at SPsales@harpercollins.com.

FIRST EDITION

Designed by Bonni Leon-Berman

Library of Congress Cataloging-in-Publication Data has been applied for.

ISBN 978-0-06-296903-3

23 24 25 26 27 LBC 5 4 3 2 1

Je m'en fous de la postérité. Je m'en fous ! Je ne profiterai pas. C'est aujourd'hui: paradise now !

I don't care about posterity. Just don't care! It won't do anything for me. It's today that counts: paradise now!

—KARL LAGERFELD
(September 10, 1933—February 19, 2019)[1]

CONTENTS

PARADISE NOW

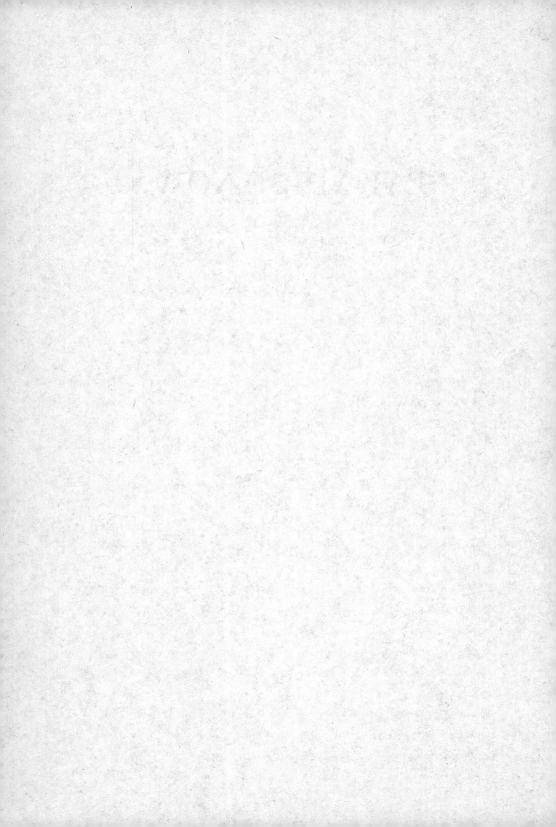

Prologue

SUPERSTAR!

It's Never Too Late for a New Life.[1]

IT WAS THE FALL of 2004 and Karl Lagerfeld was throwing everything into high gear. Karl, as most everyone called him, was just turning seventy-one, an age when his many fellow fashion designers were looking for an exit. Yves Saint Laurent, long perceived as his great rival, had retired two years before (and would die in 2008, when he, in turn, was seventy-one). Karl, however, was engineering a series of significant events, the first indication that he would be turbocharging the last fifteen years of his life.

By that time, he had already been in the public eye for fifty years. Karl was born and raised in and around Hamburg, the second-largest city in Germany, on the Elbe River just off the North Sea, an atmospheric port that was turned to face the world. As a teenager, he was given his parents' blessing to move to Paris, his emotional, intellectual, and spiritual home. Karl's slice of the French capital was quite concentrated, no more than a couple of square miles, on both sides of the Seine. His Paris extended from the Luxembourg Gardens and the Place Saint-Sulpice, where he had his first apartments, to the Faubourg Saint-Germain, the aristocratic neighborhood where he lived for decades in a sequence of increasingly dramatic apartments, to the gilded streets around the Avenue Montaigne, where he began his career, to the top of the Champs-Élysées, where, with a view out onto the Arc de Triomphe, he launched his own fashion house, to the rue Cambon, the narrow street just behind

the Hôtel Ritz, the headquarters of Chanel, the historic house that he revolutionized, beginning in 1983, turning it into an international colossus that produced over $11 billion in annual sales.[2] Within that enchanted slice of Paris, Karl ascended to the very top of the city's social, financial, and intellectual worlds, managing to make himself into one of the most remarkable cultural figures of recent decades.

The designer had first started revving up around the new millennium. He had settled a thorny case with the French tax authorities establishing that he had, in fact, been an official resident of Monaco but agreeing to pay taxes on his French income.[3] For much of the '90s, he had been overweight, cloaking his gains in oversized black suits by avant-garde Japanese designers and concealing himself behind one of his longtime signatures, a large fan. Then, in the year 2000, he began a radical weight loss. He told everyone that he wanted to diet so that he would be able to wear the form-fitting designs of the hottest menswear designer around, Hedi Slimane for Christian Dior, who also happened to be a younger man whom Karl found quite attractive. He ended up dropping ninety pounds in thirteen months. "Like letting go of a parka of fat," Karl said.[4]

In those years, Karl would begin every day at 5:00 or 6:00 a.m., waking up in his eighteenth-century apartment and putting on a robe in white, starched cotton piqué. As rigorous as he was about his work, he could be equally exacting about his appearance, often spending two hours every morning getting ready.[5] His first task was to tie his shoulder-length hair back into a ponytail, which he had been doing since the late 1970s. "My hair is too wavy, undisciplined, and it does not stay in place even when short," he explained. "The only way for me to be correct is to pull my hair back."[6] Only later, in the 1990s, did he turn his signature flourish white with a dusting of dry shampoo. After several hours of sketching every morning, in his office adjacent to his bedroom, Karl would go to his perfectly arranged closets to dress for the day. Newly trim, he began wearing his tailored suits, or jackets and skinny jeans, with white shirts with high collars that he had custom-made at Hilditch & Key. In September 2003, just after he turned seventy, Karl made one

of his many appearances on French television with his sleek new look. The host suggested that, with his powdered hair and grand lifestyle, it was as though he were living in another century. "I am both more simple and more modern than that," he explained. "I prefer living in the 3rd millennium, rather than the 18th century, or the 19th century, which I hate, or the 20th century, which was fine. I prefer today."[7]

Karl's birthday, September 10, happened to fall on a Friday. He rarely wanted to celebrate his own birthday, bristling at anything that focused too much on his past. Still, two of his close friends, Françoise Dumas, a beautifully connected publicist and event planner, and Bethy Lagardère, a former model from Brazil and the widow of French industrialist Jean-Luc Lagardère, asked if he would let them organize a birthday dinner. Karl agreed. It would be one of the first times he had done such a thing, and they had twenty-four hours to make it happen.[8] The party took place in the spectacular eighteenth-century town house of Lagardère (one of the grandest private houses in Paris, on the rue Barbet de Jouy, it is now owned by another of Karl's close friends, Bernard Arnault). "It was such a splendid day, with an incredible light," Lagardère remembered. "We had a salon cleared out and placed a long table, for 14 or 16, at a diagonal. We wanted to make the décor very special, so we filled the room with white orchids. And we started inviting Karl's friends."[9]

The evening, though hastily organized, had no problem attracting guests. More than a dozen dropped what they were doing to attend: Princess Caroline of Monaco and Ernst of Hanover, actresses Jeanne Moreau and Isabelle Huppert, designer Hedi Slimane, politician Roselyne Bachelot, and decorator Jacques Grange and his partner, gallerist Pierre Passebon. It was a *dîner placé*, so Dumas and Lagardère had the seating impeccably organized. When Karl arrived, though, he had a surprise guest. "He hadn't told us that he was bringing someone like Amanda

Harlech or another good friend, and then he suddenly appeared with Yoko Ono," Lagardère remembered with a laugh. "Karl seemed to be quite pleased with himself."[10]

The room had dark wood paneling and doors, eighteenth-century drawings in gold frames, and French windows looking out onto the garden. The long table was lit with massive, gilded candlesticks and covered with white orchids in oversized crystal bowls filled with fresh green grapes, by Karl's favorite Paris florist, Lachaume. Guests were served by a half dozen waiters, wearing their white double-breasted jackets with white shirts and black ties. After his extreme loss of weight, Karl was quite particular about what he ate. To prepare the birthday dinner, Dumas and Lagardère went straight to the top, turning to Guy Savoy, widely recognized as one of the best chefs in the world. Savoy came up with an exquisite menu for Karl and his friends: lobster from Brittany with an eggplant and sea crab salad, artichoke soup with black truffles, candied lamb shank with truffled potatoes, and a warm chocolate cake, layered with praline and chicory crème. Although Karl rarely drank, France will always be France, so Savoy paired the meal with well-chosen wines: a white Burgundy, Meursault, 2001, and a red Bordeaux, Château La Lagune, 1995.[11]

That night, Karl wore a dark suit, a white dress shirt with a vertiginous officer's collar, a narrow black tie, and a pair of jet-black sunglasses. As usual, his hair was pulled into a ponytail and powdered white. He was, as he tended to be in private, warm, engaging, interested in others. Around the table, it was obvious to all that he was in great spirits and the evening became particularly festive. "The dinner went on and on," said Lagardère. "Everyone was in such a great mood. The light was exceptional, the meal was perfect, there was a real sense of harmony. We could have planned it out for a month, and it would not have been as much of a success."[12]

As the party eventually wound down and guests made their way back to the entrance of the house, they found one final treat. In the center of the courtyard, the *cour d'honneur*, Dumas and Lagardère had arranged

to have dozens of votive candles positioned on the old cobblestones, lighting up the Paris night, forming a giant K.[13]

The following Friday, at a much more public event on the top floor of the Pompidou Center, was the moment that Karl turned from being an important designer into an international superstar. "Fashion designers think they are famous," Dior Homme designer Hedi Slimane said at the time. "In fact, they are not, not even Calvin Klein. There's only one famous fashion designer, and that's Karl."[14]

The catalyst for his new level of renown: a capsule collection Karl had designed for H&M, the Swedish colossus, with $6.2 billion in annual sales, and one thousand stores in nineteen countries (now over $25 billion in sales every year). The man responsible for turning Chanel into one of the most exclusive fashion brands in the world was going mainstream. He intended to do what no one else had ever successfully achieved: fuse the elegance of high fashion with the power of the mass market (two decades before, in 1983, when Halston attempted it with JCPenney, it ruined his career, with Bergdorf Goodman dropping him overnight).[15]

Karl's collaboration with H&M illustrated a host of qualities that set him apart from other designers. He was always completely focused on the moment. Although he had a great grasp on history, he found nostalgia horrifying. He also had a fascination about, and knowledge of, everything that was happening in the world of style. It was rare that any fashion trend, a new piece of music, or any artistic movement escaped his attention. And, unlike many designers, certainly those who were septuagenarians, Karl was always eager to take risks.

He was first approached about the H&M project by Donald Schneider, the former art director of French *Vogue*, who had been doing advertising campaigns for the firm. Schneider called Karl to propose his idea. "I asked him if he knew this Swedish company, and he said, 'Of course: all of the assistants are wearing it.'" One of the first times Karl

had clocked the brand was in the elevator at Chanel, going up to the studio. There was an attractive young woman with him, wearing jeans and a tweed coat, and carrying a quilted leather bag. When he complimented her, she said, "The bag is Chanel but the coat is H&M—I can't afford a Chanel coat."[16] Karl had noticed that this brand was in his world, sensing its relevance and its potential. "He immediately got it," Schneider said of their phone call. "I think it was maybe a two-minute conversation. I said, 'Oh, great, I'll organize the first meeting.'"

Schneider was starting to hang up when he heard Karl say, "No, I have a question."

"And I thought, 'Oh no, here we go, he is going to want €10 million or something.'"

Instead, Karl asked, "Donald, have you asked anybody else, have you asked another designer?"

"No, you're the first."

Karl's response: "OK, then let's do it."

"I have thought about that a lot over the years," Schneider explained. "I am sure that other designers I could have called at the time, like Tom Ford, would have wanted to know who had done it before. 'No, first you try it with a couple others and then if it's really successful we can talk about it.' And that was the big difference with Karl. He sensed what it could mean, he wanted to do it, and he wanted to do it first."[17]

Karl may have been eager to make such a bold move, but even some members of his team were dubious. Caroline Lebar, who had worked with Karl since 1985 at his eponymous label, asked him: "But have you actually seen the clothes at H&M?" Lebar mentioned the poor quality of the fabrics, the fit, the ugly interiors of the stores. She was horrified. Karl's reaction: "Oh, you're really bourgeois, aren't you?"[18]

Karl decided to unveil the project for H&M, which he had kept secret for the better part of a year, on Friday, September 17, at the restaurant Georges on the sixth floor of the Pompidou Center. The slick, futurist space had floor-to-ceiling windows, a rooftop terrace, and a spectacular view out over the city of Paris. A sound system blared the latest in

dance music and Europop, while a disco ball spun and colored lights bounced off the glass walls. Along the interior walls, glass display cases had mannequins with highlights of the thirty-piece collection, primarily in black or white, priced from $19.90 for a T-shirt to $149 for a wool and cashmere coat.[19] The range included women's wear, menswear, and such accessories as leather bags, lingerie, and a fragrance dubbed Liquid Karl. The clothes—jersey skirts, turtleneck sweaters, tuxedo shirts, and sequin jackets—were graphic, modern, and undeniably Parisian.

The party attracted a thousand guests—international fashion editors, models, friends of Karl. The designer, notoriously late, arrived only slightly behind schedule, with the model Erin Wasson, whom he had selected to star, along with himself, in the H&M campaign. With a small group, they made their way up the Pompidou Center escalators and into the party. "It was a beautiful summer evening, and everyone was out on the terrace under the open sky, drinking champagne and having little bites to eat," Schneider recalled. "There were sofas and chairs everywhere, it felt a little like a beach club. Karl came up the escalators with his entourage and it was like Michael Jackson entering. People started screaming, and clapping, and jumping on one another to get a view of him."[20]

He was surrounded by a ring of photographers, cameramen, and journalists. One Spanish reporter, upset at not being granted an interview earlier in the day, tried to jump into the center of the circle and had to be removed by security. Sébastien Jondeau, the designer's chauffeur, bodyguard, and private secretary, kept an eye on the scrum. Karl, at the center of it all, and seemingly delighted at the commotion, made his way into the crowd.

"He loved being in the limelight," explained Anna Wintour, the editor in chief of *Vogue* and a close friend of Karl's for decades. "He was the first to understand the power of celebrity and he used it and he amplified it. Some designers are very elitist, and, though Karl was a snob in some ways, he was also very democratic. He wanted to appeal to the world—I mean, he wanted everyone to come to his party."[21]

Exactly three weeks later, on Friday, October 8, Karl pulled off another coup. By that point, he had been creative director of Chanel for just over two decades. He was the first to show how the DNA of a great designer could be tweaked, teased, and even tossed aside in order to create work that was completely new and relevant. "Karl was the first of us to take an old house and renovate it and make it new, as he did beginning in the eighties," said Tom Ford in 2005. "When I was at Gucci in the nineties, I very much had in mind what Karl had done at Chanel. I think he has done an amazing job of not only continuing what Coco Chanel did and would have done but also renovating and reinvigorating the brand, so that it is something that constantly speaks to contemporary life."[22]

Karl was presenting the Chanel 2005 Spring/Summer Ready-to-Wear Collection in the Carrousel du Louvre, an auditorium complex under the museum. Chanel combined two of the halls, to accommodate a large audience and bigger sets. In recent years, runways had been brought down to floor level, placing the audience closer to the models and the clothes. For that season, Karl decided to raise the runway like it had been in the past.[23] He had the long stage covered with red carpet and he booked ninety-five models for the show.[24] As the fashion professionals were taking their seats, just outside, in the parking garage, a black Mercedes pulled to a stop. Out stepped the film director Baz Luhrmann with Nicole Kidman.

The actress was at the first height of her fame, after such award-winning films as *Moulin Rouge*, *Cold Mountain*, and *The Hours*, and Karl had the idea of offering her a new role, the star of an advertising campaign for Chanel N°5.[25] Kidman appeared in a black Chanel pantsuit, a white silk scarf tied around her neck, her blond hair pulled up in back and falling down around her face in ringlets. Kidman and Luhrmann, along with his wife, the costume designer Catherine Martin, and a half dozen bodyguards, moved slowly through the garage. The group reached a small room, with beige curtains for walls, where they were greeted by

Karl. His great friend Ingrid Sischy, the editor in chief of *Interview*, was standing with the designer. There were kisses all around and they posed together for photos, with flashes lighting up the little room.

The conversation was about the show that was about to begin.

"We're in your hands," Luhrmann said to Karl.

"I know how to do this," the designer reassured them. "You're good on films—I'm good at this."[26]

Over the years, Karl had very carefully created his public image: tight ponytail, dark glasses, severe tailoring, expansive knowledge of history and culture, amusing, if bitchy, comments. The codes were as rigorous as those he had established for Chanel, and no less effective. He had crafted such a vivid public persona, very different from how he was in private, and he loved to make it clear that he was in on the joke.

"It's your show," Luhrmann said to the designer, suggesting that he should stage-manage their appearance. "You're directing us."

"It's not my show," Karl replied. "It's *our* show. We're all performers."[27]

Inside the Carrousel du Louvre everyone was already in their seats, a wall of photographers massed at the end of the runway, growing impatient, when, from the far corner of the room, the actress suddenly appeared, the lights catching her blond hair and strict Chanel jacket. Pandemonium. As Kidman made her way to her front-row seat, she was surrounded by a crush of photographers and journalists. "*Nicole!*" "*Baz!*" The bodyguards formed a protective barrier around them as they made their way to their places. Some suggested there were as many as one hundred photographers and cameramen barraging Kidman.[28] One fashion editor who was positioned in the row just behind her, Hamish Bowles of *Vogue*, said it reminded him of the crowd scenes from *The Day of the Locust*.[29] As the commotion continued, the show was running almost an hour late. "He wanted a spectacle, he got a spectacle," one of the photographers grumbled after the show. "There has never even been a crush like that at Cannes."[30]

Karl was compelled to make a public announcement, asking everyone

to go back to their places so they could start.[31] "He wanted to create a buzz," recalled Stefan Lubrina, the set designer who worked with Karl on that show and all of his major productions for three decades. "But that got out of control—he didn't want that much of a buzz!"[32]

As the presentation finally began, the set was lit by the brightest of lights, and the room was filled with a remix of Whitney Houston's "I Wanna Dance with Somebody." At the end of the runway, in front of the photographers, separated by the same kind of barricades used for the Cannes Film Festival, appeared a slew of supermodels: Linda Evangelista, Naomi Campbell, Amber Valletta, Shalom Harlow, Kristen McMenamy, Eva Herzigová, Erin Wasson, and Nadja Auermann. They wore Chanel evening ensembles in black satin, posing as a group. As they walked, they were followed in the aisles by male models in tight black sweaters, holding cameras with old-fashioned flashes. At the end of the show, Karl came down the runway to give the actress a kiss.

That night, at his eighteenth-century apartment at 51, rue de l'Université, known as the Hôtel Pozzo di Borgo, Karl hosted a high-voltage dinner in honor of Kidman. The invitation showed a drawing by Karl of the actress wearing a Chanel haute couture ball gown he had designed in pale pink ostrich feathers and silver crystals with a train that was over thirteen feet long.[33] Guests entered through the courtyard of the designer's house, into the main entrance, with its double-height ceiling and dramatic marble staircase. Karl had turned the ground-floor dining room into a photo studio, doing portraits of many as they arrived. "He always enjoyed being with his friends and talking," said Amanda, Lady Harlech, who was one of Karl's closest collaborators at Chanel and Fendi since 1996. "But he was not really good at what I would call social small talk in a room with lots of people. So, instead of staying seated, he loved taking pictures."[34]

Kidman arrived for the dinner wearing a strapless Chanel evening gown with silver beaded embroidery. From the entrance of the house, guests were directed out the back doors to a massive structure that had been built for the evening on the lawn of the garden. It was more like

a medium-sized auditorium than anything that could be called a tent. The interior re-created an eighteenth-century space in a way that felt seamless—many thought they were still in the house—but on a scale that allowed for oversized video screens.

"I think that was one of the most beautiful Chanel dinners that has ever been given," recalled Virginie Viard, who began as an intern with Karl in 1987 and became his successor as the creative director of Chanel in 2019, after he died. "The rue de l'Université was magnificent that night. I was super happy for him."[35]

The main event of the dinner was the debut of the Chanel N°5 commercial, directed by Luhrmann and starring Kidman. The two-minute-long film was set in a fictionalized version of Manhattan, with the actress running through traffic-clogged streets in the pink Chanel ostrich haute couture gown, her train sweeping behind her. Hounded by the paparazzi and the subject of spinning, intrusive headlines, she was a prisoner of her own celebrity. She escaped into a Yellow Cab, only to discover that she was sharing the back seat with smoldering Brazilian actor Rodrigo Santoro. "I must have been the only person in the world who didn't know who she was," the actor said. As the music swelled, they had an immediate romance, followed by the realization that it would be an impossible love. Instead of running off together, there was a tearful goodbye. She chose duty over passion, attending a film premiere alone. "She takes the stairway to glory," was Karl's description of the scene.[36] Kidman ascended a steep set of red carpeted stairs, now wearing a black Chanel evening gown Karl had designed in silk velvet, with a plunging neckline in back, and a three-foot-long diamond chain with a pendant that spelled out N°5.

That night, the French national news covered much of the day's action. "It's not the Festival de Cannes, it's the Festival de Karl," one journalist announced. The coverage led with the mayhem as Kidman appeared at Chanel, showing the scenes in the audience and shouting of the photographers. Reports detailed the fashion highlights of the collection and broke the news of the commercial by Luhrmann, announcing that it would be screened on French television the following week.

One report showed the designer standing on the runway immediately following the show, just after he had given the actress a kiss. A television reporter rushed up to him, asking if it was true that she had been paid $7 million for her participation.

"No idea," Karl said quickly. "I don't work in accounting!"[37]

1

BLURRED ORIGINS

My mother had a cousin in Münster who was an archbishop.
The only time I met him, I said that when I grew up that I wanted
to be dressed just like him. My mother was horrified! She said,
"Do whatever you want to do in life but it is out of the question
that you become either a priest or a professional dancer."[1]

KARL OTTO LAGERFELD WAS born in Hamburg on Sunday, September 10, 1933. That should not be a contentious statement but, throughout his life, Karl tended to shave five years off of his age. Decades of obscuring his date of birth has meant that any anecdote that becomes too specific requires arithmetic. When he moved to Paris, in 1952, he was not fourteen years old, as he had long claimed, but nineteen. When he won his first big fashion prize, in 1954, he was not sixteen but twenty-one. And when he took over the responsibilities of Chanel, in 1983, he was not forty-five years old, as he suggested, but fifty.

Karl would not be the first fashion designer to blur the outlines of an origin story. Gabrielle "Coco" Chanel, for example, led an astonishing life. Born into poverty in the center of France, and abandoned to an orphanage for six years of her youth, she revolutionized the world of style, bringing women's wardrobes from the nineteenth century into the twentieth, and turning a small hat shop in Deauville into an international fashion and beauty empire. Her modest beginnings, which made her success even more impressive, were not something that she was interested in discussing. In 1947, Chanel asked elegant French writer Louise

de Vilmorin to pen her life story. And they sat down for a series of interviews about her childhood. "But Louise de Vilmorin was distraught," noted Chanel biographer Edmonde Charles-Roux. "She was unable to get her to say as much as one word that was true."[2]

In February 1948, in order to sell the project to an American publisher, Chanel flew to New York with the pages de Vilmorin had written. There was little interest. Chanel, very much in character, blamed the author. Five decades later, French writer Patrick Mauriès published the text for the first time, with a backhanded title: *Coco's Memories*. "This is not a memoir," he pointed out, "it's Chanel's imaginary life."[3]

There is nothing so false in Karl's own past. He certainly embellished parts of his story and consistently lied about his age, but the general outlines of his youth are widely accepted. His beginnings have something of the sense of a fairy tale, an account that, like all good folklore, includes plenty of darkness.

Karl was born in one of the most elegant sections of Hamburg, Blankenese, a leafy neighborhood of two- and three-story houses built on a verdant hillside that slopes down to the Elbe River. His family lived at Baurs Park 3, on a landmark, early nineteenth-century park with sloping lawns, mature trees, and unobstructed views of the river. His father, Christian Ludwig Otto Lagerfeld (1881–1967), having traveled around the world in his youth, made his fortune as the first German manufacturer of evaporated milk. Karl's mother, Elisabeth Bahlmann Lagerfeld (1897–1978), was a formidable woman who doted on Karl, her only son. She could also be incredibly harsh.

Otto Lagerfeld was born and raised in Hamburg, the son of a prosperous import-exporter, primarily of wine and coffee, with offices in Venezuela, New York, and San Francisco.[4] By the time he was twenty-one, Karl's father began his apprenticeship with a Hamburg coffee importer and, to learn the business, shipped out to Maracaibo, Venezuela. After a few years in South America, he traveled to the United States, where two of his brothers were already living. He arrived in San Francisco just a couple of days before the great earthquake of 1906, escaping the most

serious damage because he was across the bay in Sausalito.[5] By the end
of that year, he traveled to Kent, in King County, Washington, south of
Seattle, and the headquarters of a new kind of dairy producer, the Pa-
cific Coast Condensed Milk Company, later known as Carnation Milk.
The firm had begun producing its dehydrated product only seven years
before. The company slogan was "The Modern Milkman," with adver-
tisements showing black-and-white Holsteins grazing in pastures with
the snow-covered Mount Rainier in the background. "From contented
cows," the ad promised, "Green grass the year round on the North Pa-
cific Coast."[6] Otto Lagerfeld began a working relationship with the firm
that lasted for over fifty years.

Dairy cattle, which were, after all, the source of the family's fortune,
took on a significant place in their lives. "I'm the son of a dairy farmer,"
Karl once said. "We had 120 cows. My father gave a name to each one,
and ever since, I have loved this animal."[7] Karl even said that his mother
used the family business to justify not wanting to nurse her children.
"She was amusing," Karl said of his mother. "She liked to say, 'I don't
breastfeed my children—why else did I marry a milk canner?'"[8]

Otto Lagerfeld was sent to spread the gospel of this new product in
Russia, where he spoke the language, installing himself in the Eastern
Pacific port city of Vladivostok. There, he sold Carnation Milk along
with other American- and German-produced staples. In 1914, when
Germany declared war on Russia, Otto, who had been in the country
for seven years by that point, applied for citizenship. Instead, he was ar-
rested, under suspicion of espionage, and sent off to exile in Siberia for
the remainder of the war. In the turmoil of the Russian Revolution, in
1917, he was able to flee Siberia, travel to Saint Petersburg, and then
return to Hamburg.[9]

In 1919, he founded his own company, first importing Carnation. In
1923, he began producing a German version, "Glücksklee," or "Lucky
Clover," with a distinctive red-and-white label with a green four-leaf
clover (a brand that still exists). As Karl later summarized, "After
World War I, my father started importing concentrated milk to Germany

and to France. Then, working with Americans, he built factories in both countries."[10]

In 1922, at the rather advanced age of forty-one, Otto Lagerfeld married Theresia Feigl, who, that same year, died giving birth to their first child, Karl's half sister, Theodora, or Thea. On March 8, 1929, Otto Lagerfeld announced his second engagement, to Elisabeth Bahlmann. The following year, on April 11, 1930, they were married in her family's hometown of Münster.[11] The groom was forty-eight years old; the bride was thirty-two.

Elisabeth's father, Karl Bahlmann, Karl's namesake, was an accomplished politician and administrator in the province of Westphalia. He died young, in 1922, at the age of sixty-three, when Karl's mother was twenty-four. Elisabeth, by all accounts, was an independent young woman: she cut her long hair into a bob, which she wore for the rest of her life, and was an avid reader. "My mother was interested in the history of feminism," Karl later explained. "And in my childhood, I heard about Hedwig Dohm, a German-Jewish feminist who was a writer in Berlin. The rights of women in Germany in the 1870s were limited to the Three Ks—*Küche*, *Kirche* and *Kinder*—the kitchen, the church and the children. But nobody remembers her—people remember the English suffragettes but the first to care about women's rights was Hedwig Dohm."[12]

Elisabeth left the provinces for Dresden when she was eighteen years old, and for Berlin during the 1920s, where she may have worked for a department store or as a director of a fashion house.[13] "I was lucky to have parents who were very open-minded," Karl later explained. "Although I am not sure that they were completely innocent in their youths. My mother always said, 'You can ask me about my childhood and about the time since I have known your father. But everything in between is none of your business.'"[14]

Elisabeth Bahlmann also lived in Cologne and Munich before meeting Otto Lagerfeld, the widower, apparently when both were on holiday on the Baltic coast. He was distinguished-looking, still handsome, with dark hair and a mustache, and favoring gray suits. She was an attractive

woman with fine features, short dark hair, and piercing somber eyes. The year after their wedding, 1931, Otto and Elisabeth had their first daughter, Christiane, or Christel. The birth of their son, Karl, came two years later.

The year 1933 in Germany may have been one of the more eventful, and ultimately tragic, in history. In the presidential elections the year before, Adolf Hitler had come in second, winning no more than 35 percent of the national vote. By the end of January 1933, to appease his party, he was named chancellor. In February, the Reichstag, seat of the German parliament, burned to the ground. Hitler issued the Reichstag Fire Decree, suspending most civil liberties throughout Germany, including the freedom of expression, freedom of the press, and habeas corpus. The country's political and social leadership was fractured, seemingly frozen. There was a sense of anarchy, a fear of communism, and a political void that Hitler was able to exploit. Throughout March, the Nazi Party began to seize control of state governments.[15] By the end of the month, in a series of legislative moves, Hitler forced votes that gave him and his party full dictatorial power. "The one-party totalitarian State had been achieved with scarcely a ripple of opposition or defiance," wrote William Shirer, the American journalist who was a firsthand witness to the events of those years.[16] By May, all trade unions were dissolved. From June 30 to July 2 was the "Night of Long Knives," when Hitler had hundreds of his former allies and political opponents murdered.[17]

The Weimar Republic, which had begun in 1919, was over. It had been a time of rampant inflation, political unrest, and class conflict, but it had also been an era of tremendous personal freedom and artistic excitement, much of the creativity that inspired Karl. Think of the vigorous paintings of Berlin bohemians by Otto Dix; great German expressionist films such as *The Cabinet of Dr. Caligari* (1920) and Marlene Dietrich's star turn in *The Blue Angel* (1930); *The Threepenny Opera* (1929), the

modernist musical by Bertolt Brecht and Kurt Weill; or Christopher Isherwood's 1935 novel of his time in the German capital, *Goodbye to Berlin*, and the 1972 film it inspired, *Cabaret*. The family of a successful businessman like Otto Lagerfeld enjoyed the cultural excitement of those years while being insulated from much of the hardship. "My parents lived in a protected world in the late '20s and early '30s," Karl once explained. "They always talked about how marvelous life was then: how pleasant, how luxurious, how divine."[18] That insouciance was coming to an end.

Karl's altering of the date of his birth, from 1933 to 1938, was not accidental. Yes, it reduced his age by five years, but it also shifted his childhood away from the Nazis. If he had been born in 1938, he would have been too young to have seen what happened in the late '30s and during much of World War II. Although his childhood was more sheltered than many, he was very present for the horrors of Nazi Germany.

The German book publisher Gerhard Steidl, founder of Steidl Verlag, worked closely with Karl for three decades. He believed that Karl had gone so far as to falsify his birth certificate and passport, physically altering the year of his birth, turning the "3" into an "8."

Early in their relationship, in the mid-1990s, the publisher asked Karl about it. "I was young and naïve," Gerhard Steidl said of his decision to broach such a sensitive subject. "So, I asked him, 'Why do you say you were born in '38 when you were obviously born in '33?'"[19]

Karl's answer was revelatory. "I was ashamed," he told Steidl. "I was ashamed that I was born in the year when Hitler started his project of killing the Jewish population of Germany. And I did not want to be connected to that year."[20]

Put that directly, his desire to distance himself from his true date of birth is understandable. "You know, 1933, even today, means the far right," Steidl continued. "It is a terrible date in Germany and in world history. So, he said that he changed it because he did not want his birth date connected with such an infamous year."[21]

The fact of the matter, however, is that Karl came into the world at the same time as the Third Reich.

2

THE WEIGHT OF
GERMAN HISTORY

There was one thing I hated and that was being a child. I thought
it was humiliating. I wanted to be a grown-up person as soon as
possible.[1]

KARL'S EARLIEST YEARS WERE spent in the splendor of the family
home in the Hamburg district of Blankenese. "I've always had a nostal-
gia for that part of Hamburg with the river, the boats, and that poetic
atmosphere," he said. "The first sounds I remember were the ships on
the river, and my first memory in life was sheer tulle curtains at the
windows, blowing in the wind."[2]

By 1935, Otto Lagerfeld moved his family into a more protected part
of the country, twenty-five miles north of Hamburg. Karl later suggested,
improbably, that the move took place because they felt that being so close
to the river was too humid.[3] Nevertheless, his father, who had already
lived through a surprising amount of historical upheaval, bought a prop-
erty in the state of Schleswig-Holstein, on the outskirts of the town of
Bad Bramstedt. As Karl described their move, "I spent my childhood in
the country, near the Danish border, in an isolated house in the middle
of a forest."[4] The estate, known as Bissenmoor, included a large white
country house that had been built around 1900. The drive ended in a
cobblestone circle in front of the house, set off by flower beds, mani-
cured shrubs, and tall pine trees.[5] It was a three-story structure with a

large veranda on the ground floor, the family's bedrooms on the second floor, and a steep pitched roof in red tile surmounted by a central cupola. Karl's room was in the center, with two large French doors that opened onto a terrace.[6] Bissenmoor sat on over twelve hundred acres of pasture and wooded land.[7]

Otto Lagerfeld, who was fifty-two when Karl was born, was a distant presence, focused on the running of his company, Glücksklee. He always wore a hat and carried a cane, preferring his suits in light gray *fil à fil*, a woven fabric that Karl never really liked.[8] "At that time, those kind of people did not really spend a lot of time talking with their children," Karl said of his father in 2008. "It wasn't necessary. He was always nice. In fact, my mother said: 'Ask your father—he's nicer than I am.' And he would say, 'Do what you want but not in front of your mother, because she will make fun of me.'"[9]

Both of his parents were polyglot, with his father said to have spoken nine languages. He encouraged Karl, when he was young, to learn Russian. His parents often spoke French together. "When I was five, I asked for a French tutor," Karl recalled. "I hated not being able to understand what they were saying, which is why they were speaking French."[10] His mother, trilingual, had assembled quite a library of German, French, and English literature. "Her great passion was reading," he remembered. "She would shut herself in her room to read."[11]

The first tome in his parents' library that attracted Karl's attention was *Das Nibelungenlied*, an epic poem from the German Middle Ages.[12] The story was one of Richard Wagner's inspirations for the four operas in his Ring Cycle (*Der Ring des Nibelungen*, 1853–1874). The Lagerfelds' copy featured illustrations by a nineteenth-century German artist, Julius Schnorr von Carolsfeld. "It was a thick book, with images that were pretty terrifying," Karl recalled. "It was not a book for children. But my mother said, 'If you want to read it, learn how to read.' And that is how I learned."[13]

His mother went on to encourage young Karl to read Johann Wolfgang von Goethe, the great eighteenth- and nineteenth-century literary

figure. "My mother was fascinated by Goethe and literally forced me to read his entire works," Karl explained. She focused Karl on the complete edition of his works, forty volumes published by Johann Friedrich Cotta in 1832. There were some elements of Goethe that Karl found tedious. His poetry, for example, was less than inspiring. But Goethe's *Elective Affinities* was, throughout his life, Karl's favorite German novel.[14] Goethe had a vast range of interests, moving between the disciplines of literature, theater, philosophy, science, aesthetic criticism, politics, and religion. There was an expansiveness about Goethe's intellectual life, an ambition that inspired Karl from an early age.

There were other significant literary discoveries. His mother introduced him to such figures as Gustav Stresemann, the German statesman, and Walther Rathenau, an industrialist and author who was assassinated in 1922 by the Organisation Consul, a forerunner of the Nazis.[15] He also learned of Eduard von Keyserling, a nineteenth-century author of stylized novels. "He writes about the passions of the Baltic aristocracies in the 1880s," Karl noted. "Ravishing!"[16] He was struck by the spareness of the prose. "Keyserling is Impressionism. With three words, you see the place, the area, you smell the air. His descriptions, which still strike me today, are so evocative with such few words."[17]

But Karl was particularly taken by another historical German figure that he was encouraged to read: Count Harry Graf Kessler (1868–1937). "I have been a huge fan of Harry Kessler since my early youth because of my mother," Karl later explained.[18] Kessler was intellectually rigorous, international, and urbane. Kessler never missed the opening of a major cultural event, whether it was the premiere of Sergei Eisenstein's *Battleship Potemkin* or Brecht and Weill's *Threepenny Opera*. One week, at his apartment in Berlin, he had Albert Einstein over for dinner, followed, the next week, by Josephine Baker, who improvised a dance around his sculpture of a crouching nude woman by Aristide Maillol.[19] W. H. Auden considered Kessler "probably the most cosmopolitan man who ever lived."[20] Karl was fascinated. As he once said, "If I identify with anyone, it would be Harry Kessler."[21]

The son of Hamburg bankers, Kessler was born in Paris and grew up in France, England, and Germany. He studied law and art history and was an army officer and a diplomat. In the decades before and after World War I, he was at the center of European intellectual and artistic life. Gerhard Steidl often discussed him with Karl. "His mother idolized Harry Graf Kessler," Steidl explained. "He was left wing, referred to by some as the Red Count, he was a minister in a new German government prior to Hitler, and he was interested in Jewish culture."[22] Intellectually and politically, Kessler was progressive. "Karl cared about Kessler because of the connection between politics, social engagement, and art," Steidl continued. "Karl said very often that before the war, before Hitler, that that was Germany: looking to the future, building a better future for workers, for women, for children. And that, in turn, led to great cinema, to theater, to literature, to music and so on. And Karl found all of this in the person of Harry Graf Kessler."[23]

Settling in Berlin in the late nineteenth century, and then also in Weimar, Kessler was an editor for a literary journal, a museum curator, and an author. In 1909, he conceived and wrote the libretto for *Der Rosenkavalier*, the very successful comic opera with music by Richard Strauss. More than his other works, Kessler has been best remembered for his journals. The English translation of his diaries leading up to the First World War, *Journey to the Abyss: The Diaries of Count Harry Kessler, 1880–1918*, characterized them as "his greatest work, fifty-six years of journals, chronicling his life led at the center of European art, literature, and politics during the greatest cultural and political transformations in modern history."[24]

The author Ian Buruma, in the introduction to Kessler's interwar diaries, *Berlin in Lights: The Diaries of Count Harry Kessler (1918–1937)*, underscored the poignancy of his observations. "The Europe of Kessler's diary is a lost world encrusted with glittering layers of myth, spun by Isherwood, Grosz, Brecht, and Weill, among others," Buruma wrote. "What infuses Kessler's descriptions of 1920s Berlin, Weimar, Paris, and London with such melancholy beauty is the author's own awareness

that, even as he was writing, that world was doomed to almost total destruction. It was decadent in the most literal sense."[25]

Kessler, just like Karl, was not a mild-mannered observer. In March 1911, he went to the house of Walther Rathenau, whom he very much admired, in the Berlin suburb of Grunewald. "He had the room painted in a Biedermeier style, cold, formal tones: cornflower blue, sepia brown, ochre yellow," Kessler wrote. "It is as if everything that is hidden under the stiff bourgeois façade of dead 'culture,' of petty sentimentality, and of stunted eroticism, comes to the fore like a skin rash. The whole thing a mixture of stiff dignity and schoolboy fantasy, as if thought up together by a banker and a masturbating boy."[26]

Harry Kessler was also a book publisher. In 1913 in Weimar, he started the Cranach-Presse, which became legendary in the history of book publishing. Inspired by the turn-of-the century Arts & Crafts movement, Kessler paid tremendous attention to every detail of the fifty-three books that he published between 1928 and 1932. Karl had a collection of practically every publication of the Cranach-Presse.

Through the Paris sculptor Auguste Rodin, Kessler met the sculptor Maillol, whom Kessler hired to produce engravings for a publication of Virgil's *Eclogues*, and the poet Rainer Maria Rilke, who became Kessler's secretary. The high point of Kessler's work as a publisher was a version of Shakespeare's *Hamlet*, published first in German and then in English. "This 1930 version of *Hamlet*, illustrated by Edward Gordon Craig, is often regarded as the most bold and ambitious example of 20th century book art," noted the British Library. "Elegantly put together, with obsessive attention to detail, it uses hand-made paper and decorated binding, fine images, and beautiful typefaces to enhance the dramatic effect of Shakespeare's play."[27]

Having been fascinated by books from the earliest age, Karl, by the 1990s, became a book publisher. He worked with Gerhard Steidl, conceiving and publishing dozens of books on fashion, art, photography, and translations of German literature. "And Harry Graf Kessler was a role model as a publisher," Steidl pointed out.[28]

Another aspect of his character that was meaningful for Karl: Harry Graf Kessler was homosexual. He was a strong gay man, a Prussian officer, who achieved tremendous success in a variety of creative fields. Particularly at that time, he was a rare positive role model. It also has to be said that Count Kessler was quite the dandy. "Even the way I dress is, in a way, inspired by him," Karl once explained.[29] Kessler wore thin dark suits, with narrow ties, overcoats with extravagant fur lapels, and high-collared white dress shirts. He was always impeccably groomed, even when he joined his workers on the loud, dirty printing press.[30] Kessler had the same sense of formality, and flair, that Karl favored in the last decades of his life.

For all of those reasons, Karl made sure that he was never far from his writings. He bought multiple copies of the complete German editions of the journals. "The nine volumes of his diaries are always near my bedside in all of my houses," Karl explained. "Kessler represents for me Germany at its best, a Germany now gone forever."[31]

The 2009 film by the Austrian director Michael Haneke, *The White Ribbon*, though not a film that everyone has seen, is not easily forgotten. It explores a series of mysteries and tragic acts in a northern German village just before World War I. It was the winner of the Palme d'Or at the Cannes Film Festival, nominated for two Academy Awards, and winner of the Golden Globe Award for Best Foreign Language Film. Although shot in color, the director, in postproduction, had all of the color drained out in order to produce a lustrous, but menacing, black and white. "I was shocked by *The White Ribbon*," said Karl. "It is so beautifully observed and gorgeously filmed—it is a masterpiece. But I was sick for three days after seeing it because I practically lived what is shown in the film."[32]

It is set in a village called Eichwald, a small, northern German town that is not unlike Bad Bramstedt. The rural landscape, the modest scale

of the architecture, are very familiar. As Karl pointed out, "The place where Haneke filmed was not even 20 miles from where I spent my youth."[33] In the opening moments of *The White Ribbon*, an unseen narrator sets the scene. "I don't know if the story I want to tell you is entirely true," he intones. "Some of it I only know from hearsay. After so many years, a lot of it is still obscure, and many questions remain unanswered. But I think I must tell of the strange events that occurred in our village. They could perhaps clarify some things that happened in this country."

Although calm on the surface, Eichwald is the scene of a host of malicious acts: a trip wire is strung between two trees to fell, violently, a horse and rider; the infant son of the local baron is abducted and beaten with a cane; a doctor mistreats his midwife girlfriend while abusing her daughter; a pastor insists on complete purity from his children and punishes any infraction by making them wear a white ribbon around their arm, symbolizing their loss of purity. It depicts a repressed and repressive society, with violent acts that erupt without warning and senseless reprisals.

Haneke encourages viewers to see the story as an exploration of the rise of Nazism. The children in the film, most of whom are quite frightening, would have become young adults by the time Hitler swept to power. The name of the village seemed to be a combination of "Eichmann" and "Buchenwald." *The White Ribbon* provoked a great amount of academic analysis. As one scholar noted: "It depicts the fictional community of Eichwald as a template for a nation's biopolitical destiny, its future set on a course toward violence, fanaticism, and genocide."[34]

Karl also reacted strongly to the religious elements of the story. As he said, "The film reminds me of the depraved pastor when I was young who insisted, 'You have to go to catechism class or you will go to hell.' I told him that my mother said that hell doesn't exist."[35] Both of his parents were Catholic but they were living in a part of the country that was mostly Protestant. Otto Lagerfeld's parents, however, had been Protestant. "I know that his mother was very mean," Karl said of his paternal grandmother. "They were strange people. They were Protestants who

had become Catholic, and those are the worst: they are hysterical and they overreact."[36]

There may have been some familial reasons for Karl to be suspicious of the Protestant severity that he saw in Bad Bramstedt. But he was also sensitive to what he saw as religious hypocrisy, in *The White Ribbon* and in the rural environment of his youth. "I remember the pastor, at a party in the village, being completely drunk," Karl later explained. "The dance floor was empty and he was dancing all alone, holding his mug of beer. He passed in front of his wife and shouted, '*Emma, try not to fall down!*' I said to myself, 'If this is the Protestant Church, no thanks.'"[37]

Karl always gave the impression that he had not been particularly worried about fitting in with the other children in Bad Bramstedt. At a time when other boys had short buzz cuts—it was, after all, the time of the Hitler Youth—Karl kept his dark hair glossy and long. While his classmates wore rough shorts and home-knit sweaters, he wore Tyrolian suits with big bow ties. He even had one for Sunday in black suede embroidered with gold.[38] In one class photo, Karl sat in the front row, his legs crossed, wearing a signet ring and a dark double-breasted jacket with peak lapels.[39] "Someone sent me a photo from when I was a child," he later explained in an interview on CNN. "They are all in little knit things and little shirts. And there is one person in a black jacket, tie, white shirt, tons of hair—it's me. I always like the idea of being different from other people. I don't know why—I was born this way."[40]

When he was four, he asked his mother for a valet for his birthday. "I wanted my clothes prepared so I could wear anything I wanted at any time of the day. I was mad for dressing differently, at least four times a day."[41] Whether or not he was that much of a child prodigy, he was clearly sensitive to style from a very early age. "I was always interested in fashion and I think in my heart that I more or less knew that I would one day design clothes," Karl explained four decades later. "As a child, I

loved clothes. I used to criticize the way people dressed and I was fascinated by the pictures in my history books. The costumes interested me far more than the battles."[42]

By the time he was six, he had gained some proficiency in English and French, and he was not shy about showing it off.[43] The French teacher at his school at Bad Bramstedt had horrible pronunciation. Karl corrected him in front of the class. And he engaged in plenty of activities that set him apart from the other boys. "We could choose between gym classes and dance classes, and I chose dance because it seemed more amusing to me," Karl later explained. "I rode my bike several miles to school, so that was enough for exercise. And I was always afraid with other sports that I was going to damage my hands. I didn't want to do anything that might endanger my drawing."[44]

From the youngest age, Karl was passionate about sketching and drawing. "I was born with a pencil in my hand," as he put it. "I drew all the time."[45] His mother's library was an excellent source of artistic inspiration. "My gods were Aubrey Beardsley, Toulouse-Lautrec, and the great caricaturists of the satiric review *Simplicissimus*, with such incredible artists as the Norwegian Gulbrandsen, Bruno Paul, Thomas Theodor Heine," Karl explained. In his parents' attic, he discovered large bound volumes of *Simplicissimus*, covering the best years of the magazine, from 1900 to 1918.[46] The review, based in Munich, published scathing cartoons on a host of targets, including the church, society, and politicians, both right and left. The publication's illustrators, many of whom also worked in advertising, produced work that was stripped down but very bold. Karl, who later built an important collection of posters and lithographs from these illustrators, felt that their work represented the birth of modern art. By integrating typography in their graphics, they were like Pop Artists, Karl believed, fifty years before that movement began.[47]

An art instructor at Bad Bramstedt, Heinz-Helmut Schulz, recognized Karl's skill at drawing and encouraged him. He drew caricatures of teachers, at least one of which was given pride of place on the wall of

the school's auditorium. For the girls in his class, at their request, he would sketch dresses.[48]

Although he was clearly interested in style, his earliest thoughts about his future involved art. "I wanted to become an illustrator or caricaturist," he later explained.[49] "I was always interested in paper and pencil, reading and learning languages—I did not care about the rest."[50]

From the time he was quite young, Karl had an active imagination. "Much of my youth was spent in the country, so I had to try to imagine the world," he once explained. "Without television, and practically without radio, with only a huge library, I had to dream about how life could be."[51] In 1980, when he was forty-six, Karl sat for an interview with *Le Monde*. "You want to shout 'bravo' as though you're at the theater or cry out in frustration," the newspaper noted. "Karl Lagerfeld pushes his personality to the limit of the most sophisticated kind of dandy. But he does it all with such art!" The journalist suggested that Karl's distinctive personality had not happened overnight and asked where he really came from. His answer: "From the idea that I made of myself when I was a child."[52]

Karl insisted that he was unconcerned about how other children reacted to him but there was another source of hostility in his youth: his mother. Elisabeth Lagerfeld was not particularly happy living in Bad Bramstedt. "His mother wanted to make it an intellectual household," Gerhard Steidl said. "She was dreaming of having literary salons like those in Weimar by Nietzsche, Harry Graf Kessler, Henry van de Velde, and so on. But it was, of course, impossible, because people in the country were not interested in that kind of high culture."[53]

Regardless, when it came to her children, his mother could be almost shockingly severe. "I had to fight to speak with her," Karl remembered. "She said, 'Look, you are six years old and I'm not. Make an effort or shut up.'"[54] He traced his rapid-fire delivery, which he had throughout his

life, to his mother. "She was not a fan of children talking a lot. I learned to be able to finish a story between where I was standing and the door. She said, 'We can't spend much time on all of the foolishness that you have to say—speak faster.'"[55]

His mother certainly had a strong personality and ran the household with a firm hand. As Karl said simply, "My mother told other people what to do."[56] She had long played the violin, and when Karl was a child, she practiced for several hours every morning.[57] She played on a nineteenth-century French violin by Jean-Baptiste Vuillaume, and she filled the house with the demanding compositions of Niccolò Paganini. "It was horrible, not to listen to her, but during her endless practice sessions, my sisters and I barely had the right to breathe," Karl later explained.[58] She did, though, encourage her children to follow her lead and take up an instrument. Once, when Karl was practicing the piano, she slammed the cover shut and said, "Stop playing—it makes too much noise. Why don't you draw—at least that will be quieter."[59]

Elisabeth Lagerfeld was dismissive of her son in a seemingly unlimited number of ways, and Karl was fond of recounting her observations. "My mother used to say to me, 'Your nose is like a potato,'" he recalled. "And, 'I think I should order curtains for those nostrils!' She would also say, 'You look like me, but not as good.' I heard that all of my life."[60] Karl described his mother's hair as raven colored and admitted that she was disappointed with his lighter shade. "My mother hated my mahogany-colored hair and used to call me an 'old chest of drawers.' She was right, plus it was said with a smile. All of that was traumatic, however, for my sister and my stepsister, from my father's first marriage, though I barely knew them—they were in boarding school and were married as soon as they graduated."[61]

Her son was not the only target of her scorn. "My mother was fun, witty—perhaps, even a little mean—but amusing," Karl said decades later. "She was a little offhand with my father, making funny remarks about him. We laughed at him when we shouldn't have. Sometimes, I have a bad feeling that I wasn't nice enough to him."[62]

Elisabeth Lagerfeld's harshness could also become corporal. Once, Karl tried to get out of going to school by pretending to have polio. He said that he hurt all over and couldn't move. To prove that he was faking it, his mother slapped him in the face.[63] "She wasn't exactly namby-pamby/wishy-washy," Karl said, in quite the understatement. "One day, an orthopedist said that my feet had a tendency to widen. She bought this fairly frightening piece of equipment on which I had to walk for a long time in order to have feet that were well muscled and narrow."[64]

There has been the sense that some of his mother's takes were a little too much like Karl's, that they were too good to be true. His stories about her seemed designed to grab the attention. Her severity, whether this was intended or not, also suggested adversity that Karl had to overcome. These tales also livened up his family story. But his accounts of maternal harshness were consistent over the decades and were confirmed by other witnesses.

It was later discovered that Elisabeth Lagerfeld had been a member of the Nazi Party. The German journalist Alfons Kaiser, author of the biography *Karl Lagerfeld: A German in Paris*, has done more research than anyone on Karl's youth. He uncovered a family photo from March 1938, of a twenty-foot-tall pole in front of Bissenmoor, with the red-and-black swastika flying in the wind. A four-year-old Karl stood in the foreground facing the flag, while his six-year-old sister, Christel, stood behind the pole, looking up. The occasion was the Anschluss, when Germany annexed Austria. She noted the date on the back of the photo.[65]

Otto Lagerfeld, like most German professionals, gave the impression that he adhered to Nazi thinking. He was an official member of the party from May 1933 until May 1945, as his postwar de-Nazification file showed. As a representative of American interests, he was viewed with suspicion by party loyalists, and during the war he had to fight to make sure that his business was not overtaken by Nazi opportunists. After the war, it was determined that his party membership was not out of ideological support but rather commercial necessity.[66] Elisabeth made the choice to join. After the war, she wrote a five-page text, Kaiser discovered, that

did not gloss over the subject. It was entitled, "Why Did I Decide to Become a Member of the National Socialist German Workers Party?" She stressed her patriotic background, as "the daughter of a royal Prussian administrator," and her sensitivity to the exploitation of working people that she had seen in Berlin and Hamburg. She saw Hitler as a way to restore a sense of discipline to a country that was out of control and to hold off the communist menace from the Soviet Union. The 1936 Berlin Olympics and the 1938 annexation of Austria were, to her, examples of Hitler's vigor. But by the fall of 1938, and Kristallnacht, and 1941, when she saw that the Jewish population of Hamburg was being systematically rounded up, she was shocked by what the Nazis had shown themselves to be.[67] "What is striking about her written declaration," Alfons Kaiser wrote, "is how Elisabeth Lagerfeld is trying to make excuses while simultaneously asking herself some rather probing questions. In fact, she is probably more critical and scrutinizing than most other Germans who played their part in National Socialism."[68]

After Otto Lagerfeld retired in 1956, he and Karl's mother retired to the spa town of Baden-Baden. After he died, in 1967, Elisabeth Lagerfeld, rather incredibly, moved in with her son in his apartments in Paris. She first lived with him in his three-room flat at 35, rue de l'Université. Then, when he took over a floor of a grand apartment on the Place Saint-Sulpice, he made a room for her that was decorated with Biedermeier furniture, the classical, early nineteenth-century style that she preferred.

One of Karl's closest German friends, Florentine Pabst, who wrote stories about Karl for *Stern* beginning in the early '70s, knew his mother quite well. "Whenever I was in Paris for work and met Karl at his apartment on the Place Saint Sulpice, he always wanted to make sure that I kept an afternoon to have tea with his mother," Pabst remembered. "I spent time with her in her Biedermeier room at the end of the apartment. She may have been fond of me because I lived and worked in Hamburg, which gave her the chance to reminisce. She was an extraordinary woman . . . looking at her face was like looking into Karl's. She had the same mind and a similar wit."[69]

Silvia Venturini Fendi knew Karl since she was four years old, when he began working with her mother and her four aunts at Fendi. Over the years, she had heard Karl tell so many stories of his mother's harshness. "Oh my God, she was such a bitch," Venturini Fendi recalled. "That is the way that she showed her love to him. And I think that stayed with him."[70]

The Princess Diane de Beauvau-Craon was a close friend of Karl's beginning in the late 1970s. She first met his mother at Grand Champ, the eighteenth-century château in Brittany that he restored. Beauvau-Craon, who hails from one of the oldest families in France, always had a very strong personality and had certainly met her share of formidable people over the years. "Karl had a love for his mother that was absolute," she explained. "But I have to admit that when I met her, she reminded me of an ice pick! She was someone who was terribly cold. An ice pick is for breaking ice, of course, but also, unfortunately, for killing—that's the impression she gave me. I was terrified."[71]

Karl always implied that he appreciated his mother's stern lessons. "At the same time, she was very protective," he pointed out. "No one could touch me."[72] Once, a teacher from Bad Bramstedt told Elisabeth Lagerfeld that she should make Karl cut his hair. She grabbed him by the tie and said, "What, are you still a Nazi?" It was a startling story that Karl reenacted on German television in 2012, grabbing the presenter's tie and flinging it in his face.[73]

Her observations could be amusing. "When I wore a Tyrolian badger hat with a feather on top, my mother said, 'Don't wear that, you look like an old lesbian!' Is that something that should be said to a child?"[74] And there were other times when her input was reassuring. "When I was a child, I asked my mother what homosexuality was and she said, 'It's like hair color—it's nothing. There are people with blond hair and people with dark hair—it's not an issue.' I was lucky to have parents who were so open."[75]

Karl was always extremely sensitive, a quality that was essential to his success as a designer, and an aspect of his personality that he hid behind

his bravado and his ever-present pair of dark sunglasses. So, her words, even if they were said in jest, had to have stung. But Karl discounted any damage that may have come from his mother's behavior, refusing to do any self-analysis about the subject. "Today, we like to give the impression that those kinds of things hurt but they didn't," he explained. "I was very comfortable with that—I was very comfortable with myself. And I think that this attitude gave me a kind of armor that still serves me today. It has not contributed to any kind of suffering or anything."[76]

That may be, but Karl was very eager to leave his early years behind. "My childhood desire was to no longer be a child," he quipped seven decades later. "Now, there is all of this talk about the paradise of childhood—I felt that it was humiliating. Horrible. It was being a second-class citizen."[77] He was eager to grow up and to be somewhere more compelling than Bad Bramstedt. "I didn't dislike being a child because I was unhappy, that was not at all the case, but because I found it boring. I wanted to be in big cities, ideally in another country, where I thought that everything was impeccable."[78]

And he always gave his mother credit for one comment that would be essential to the direction of his life. She encouraged his desire to leave Germany. "Hamburg is supposed to be the gate to the world," Karl was fond of quoting his mother.[79] "But it's only a gate, so get out!"[80]

3

THE AGE OF
ENLIGHTENMENT

I had an image, grandiose and idealized, of France. It had
dimensions that my childhood did not have, and I felt that,
ideally, life should be something like this.[1]

IN THE FINAL YEARS of World War II, much of Hamburg was obliter-
ated by Allied bombing. Beginning on July 24, 1943, a series of joint
missions by English and American forces, called Operation Gomorrah,
was a fierce firebombing campaign, the most severe of the war, at that
point. As the largest German port, Hamburg was an obvious military
target. But the intensity of the effort was thought to be retaliation for the
ferocious aerial attacks by the Nazis on London, Warsaw, and Rotterdam.
An official Allied document, "Bomber Command Operation Order No.
173," was clear about the objective, "Intention: to destroy Hamburg."[2]
The campaign, which lasted for eight days and seven nights, leveled over
60 percent of the city's housing. It created a tornado of fire estimated to
be over fifteen hundred feet tall. More than thirty-five thousand residents
were killed, and hundreds of thousands were injured.

"Biggest RAF-U.S. Raids on Reich Blast Hamburg, Hit Baltic Cities,"
was the front-page headline of the *New York Times*. "United States heavy
bombers struck deep and hard into Germany by daylight yesterday,
hammering aircraft factories at the Baltic port of Warnemuende and
showering hundreds of high explosives into the smoking ruins of Ham-

burg, gutted by the British Royal Air Force's night bombers twelve hours earlier in the greatest bombing assault of the war," wrote the *Times*. The Allied raids began at night, with the Royal Air Force dropping twenty-three hundred tons of explosives and incendiary bombs on the city, far more than had ever been deployed in a single operation. Then came the American planes. "Large formations of American Flying Fortresses staged the follow-up daylight raid on Hamburg, raining hundreds of 500-pound bombs in mid-afternoon through great clouds of smoke rising thousands of feet from the fires started by the RAF armada."[3]

In the first week after the bombings, it was estimated that around one million people evacuated the city. Of course, Karl, who was just about to turn ten years old, would have seen the destruction only twenty-five miles away. But he preferred not to speak of what he had witnessed. He always insisted, in dozens of interviews over the decades, that he had seen nothing of the war. But in the summer of 2018, the year before he died, he discussed the bombing of Hamburg with a journalist from *Le Monde*. "We saw the red sky and the planes," Karl admitted. "We went to a high point in a field to watch the fire from far away."[4] By the time the war was over, in 1945, Karl was turning twelve. He experienced not only the war but much of its aftermath.

Beginning in 1943, refugees had begun pouring into Bad Bramstedt, which was also the site of bombings, gunfire, and blackouts. In the spring of 1945, the school was closed, in order to house refugees. By July, Bissenmoor was requisitioned by British forces, with dozens of soldiers living in the house. The Lagerfelds were confined to the barn and cooked their meals over an open fire in the courtyard.[5]

Much of Hamburg, for many years after, was in ruins. Paris writer Julien Green visited Germany in the summer of 1952 and, even then, was shocked by the destruction. "This city, filled with marvelous memories for me, is sown with ruins," Green wrote about Munich. "It reminds

me of the fading memory of a man who is getting old. Here there was a palace, there was a church, now it is nothing but rubble. I turn my head to find what remained of the Residenz Theatre and see nothing but a few columns from the portico." Green remembered that Cocteau had once suggested that Paris would make beautiful ruins, but he felt that this kind of destruction had nothing to do with the poetic remains of ancient Greek or Roman civilizations. "Cities that are instantly transformed into ruins are simply hideous: Hamburg, Bremen, Le Havre. Old stones need to fall one by one over time, with grasses growing over them, while the sun gilds all of that. There is nothing beautiful in this great black rubble that now covers Europe."[6]

Karl and his family were fortunate, of course. Unlike millions of victims of the Nazi regime, they survived the war. And, postwar, Otto Lagerfeld was able to continue to build the family fortune. But they were also surrounded by tremendous destruction and hardship. It is not surprising, then, that distant lands, other cultures would become attractive.

In the fall of 1945, Karl was in Hamburg, passing by one of the city's art galleries, and saw a painting of a historical scene that fired his imagination. "It was love at first sight," he later recalled.[7] The canvas was a copy of a work by nineteenth-century German artist Adolph Menzel, *König Friedrichs II. Tafelrunde in Sanssouci 1750* (1850). It depicted the eighteenth-century Prussian king Frederick the Great, at a round table, a *tafelrunde*, in the palace that he had built, the Sanssouci in Potsdam, known as the Prussian Versailles. King Frederick was depicted with a host of European intellectuals and artists, including the great French philosopher Voltaire.

The original was a massive canvas, over six and a half feet in width and just under six feet in height. Since 1873, it had belonged to the German National Museum in Berlin. At the start of World War II, the Menzel painting had been stored with a priceless collection of the museum's holdings—Botticelli, Caravaggio, Goya, Rubens, Tintoretto, Titian, Van Dyck—in massive "Flak Towers" at Berlin's Flakturm Zoo. The bunkers had been bombed by the Allies but never sustained serious

damage. Earlier that year, however, in May 1945, once Berlin had fallen, fires broke out in the massive structures. Along with over four hundred important paintings, *Tafelrunde in Sanssouci 1750* was destroyed.[8]

The modestly scaled copy that Karl saw, likely late nineteenth century, was painted when *Tafelrunde* was hanging in the museum. The scene showed the Prussian king and his guests, most with white wigs, wearing dark waistcoats and engaged in spirited conversation. The setting was the *Marmorsaal,* or Marble Hall, a high-ceilinged oval reception hall, with marble floors, gilded Corinthian columns along the walls, and a tall Palladian window over French doors that opened outside onto a garden. "The beautiful table, sumptuously set, suggested a world that was so different from the strict, 19th century, neoclassical, style that I was surrounded by," Karl later explained.[9] "I immediately decided that this refined scene represented life as it deserved to be lived. I saw it as a sort of ideal that, ever since, I have always tried to attain."[10]

This aristocratic, intellectual scene offered Karl his first glimpse of a world, the eighteenth century, which would fascinate him for the rest of his life. "I didn't even know if this was French or not," he said of the painting. "But Sans Souci was inspired by Versailles, as were all of the German princes of the 18th century."[11] After seeing the painting, he asked his parents for books on the artist, Menzel, on the life of Frederick II, and on Voltaire. He shut himself up in the family library and went upstairs into the attic to do more research. "My mother's side of the family was made up of functionaries and *geheimräte,* government advisors, for generations," Karl explained. "It was because of this that I found in our attic, a 12-volume edition illustrated by Menzel on the life and work of Frederick II offered by the emperor to my great grandfather."[12]

The English writer Lytton Strachey took an ironic view of the evenings at Sanssouci, when Frederick would entertain his guests with a concert where he played the flute, followed by dinner in the oval hall. "The royal master poured out his skill in some long and elaborate cadenzas and the adagio came, the marvelous adagio, and the conqueror of

Rossbach drew tears from the author of Candide," wrote Strachey. "But a moment later it was suppertime, and the night ended in the oval dining room amid laughter and champagnes, the ejaculations of La Mettrie, the epigrams of Maupertuis, the sarcasms of Frederick, and the devastating coruscations of Voltaire."[13] It was precisely that energy that enchanted the young Karl. "Elegant frivolity" was how he characterized the mood in the painting.

He expanded his research into the intellectual life of the French seventeenth and eighteenth centuries. One of his first discoveries was Jacques-Bénigne Bossuet, the bishop and theologian renowned for his sermons. Bossuet became one of Karl's favorite authors, particularly for the style of his oratory.[14] He also revered the Duc de Saint-Simon, author of vibrant memoirs of life at the court of Louis XIV. "I love his voice, so singular," Karl explained.[15] "He would have been an honest man," Saint-Simon wrote of one priest in 1717, "if only he had had any morals."[16] Saint-Simon had a clarity, and harshness, that was impressive. "It would be impossible to be more amusing, more enthralling, more charming, have a more agile mind and a more sophisticated, if salty, sense of humor," he observed of one aristocratic lady. "Yet, at the same time, she was someone whose entire essence was the meanest, the darkest, the most dangerous, the most contrived, just perfectly false."[17]

But the writer Karl discovered who meant the most to him was originally a German, Elisabeth-Charlotte of Bavaria, known as the Princess Palatine. She was a major figure at the court of Louis XIV, who, when she died in 1722, had authored some ninety thousand letters, a correspondence that the French literary critic Sainte-Beuve called "spiritual, alive, brutal."[18] Her letters were written primarily to her family back in Germany, or, as Karl put it, "to her aunt, the Electress of Hanover, and her 13 half-sisters and half-brothers, all bastards."[19] In his parents' attic, Karl found an 1865 edition of her writings, six volumes that he devoured.[20] "It is pretentious to say but I discovered French culture through the letters of Princess Palatine," he explained.[21] "And I was

fascinated by this strange seventeenth-century German that she used, and started imitating her, to the great furor of my parents and teachers."[22]

The Princess Palatine had been plucked from aristocratic obscurity in the German province of Hanover, at the age of nineteen, and brought to France to marry the widowed Monsieur, the brother of Louis XIV, who preferred the company of his legions of young men (and whose first wife may have been poisoned by some of his "favorites"). Although she was not bothered by his boyfriends, she did clash with her husband over the extravagances he showed them. The Princess Palatine was known to be quite unforgiving. She once warned an impertinent young aristocrat that if he continued to misbehave, she "would cover him with such ridicule that he would never recover."[23] Although she loved Louis XIV, she called Madame de Maintenon, his mistress and secret wife, "the old, shriveled one," "that old bag of trash," or "the King's whore." Not one to let go of a grudge, she wrote of Madame de Maintenon's death in 1719, "This morning, I found out that old Maintenon died, yesterday evening, between 4 and 5 o'clock. It would have been fortunate if it had happened 30 years ago."

The Princess Palatine was quite fat, not particularly attractive, and considered very rustic. But her biting observations were thrilling to Karl. And she had a certain vulgarity that he relished and often deployed himself. Throughout his life, Karl read and reread her correspondence, even suggesting, in the 1970s, that he wanted to write her biography.[24]

It was this entire world that opened up for the young Karl. "For me, the French eighteenth century is like a spine," Karl once explained, fifty years after he began to learn about the period. "It allows me a complete openness for experiencing everything in terms of taste. I know that I will always land on my feet, on my paws. It was not mine to begin with but I have appropriated this spiritual heritage, allowing me to escape any unpleasant elements of reality."[25]

The twelve-year-old Karl told his parents, over and over, that he wanted the canvas for Christmas. "It was 3000 marks, which was a very

high price at the end of the war and a sumptuous gift for a child of my age," he recalled.[26] On Christmas morning 1945, however, he was very disappointed. "I found out that they had bought me a lithograph by the same artist, with a similar subject, also showing King Frederick but with sister and playing a *traversière* flute," he said in an interview on French television in 2015, seventy years later.[27] "I sulked so much that they had the gallery opened on Christmas day and bought me my painting."[28]

Karl kept his version of *Tafelrunde in Sanssouci 1750* close to him throughout his life. It was a modest canvas, after all, it was only a copy, yet it galvanized Karl's intellectual and cultural development. By pointing him in a new direction, toward French history and *l'art de vivre*, it had a tremendous impact on his character. It was seen in his impeccable collection of eighteenth-century paintings, furniture, and objects that he gathered over the decades, and the French literature that continued to inspire him.

Through his friend Liliane de Rothschild, a doyenne of the great family and a noted expert on Marie-Antoinette and the eighteenth century, Karl met Marc Fumaroli, the historian, author, and advocate of the French language. Fumaroli was an important public intellectual, on the faculty of the Collège de France and a member of the Académie française. He was the author of *When the World Spoke French*, a classic text about the French Enlightenment and the importance of the language. And he was deeply impressed by the designer. As Fumaroli said, "I have never met any man as cultured as Karl."[29]

In 2008, he walked around the grounds of the Palace of Versailles, along those perfectly manicured garden pathways by Le Nôtre, with, in the distance, the serene facade of the palace designed by Mansart. Karl took photographs and mused about the attraction he had long had, about how the reality was even more powerful than what he had expected. "How could I ever have imagined this kind of splendor, deep in the Nordic countryside where I grew up?" Karl stated. "Seeing a painting doesn't give a full sense of the proportions, the scale. For me, France was *les grands siècles*, the 17th and 18th centuries."[30]

Karl developed an artistic, almost conceptual, vision of the country and its history. His "spine," as he put it, came primarily from his knowledge of the subject and the power of his imagination. Being an immigrant, he felt, only enhanced the experience. "To be more French than the French, you have to be a foreigner," he once explained. "And I love being a foreigner because it means that I have a different approach. It is not about chauvinism or patriotism—it is purely aesthetic. It's the idea of the *Mémoires* of Saint-Simon and the royal court, rather than the reality. It is like Greek mythology for me: Troy and Versailles are the same thing."[31]

4

FRENCH LESSONS

I love everything that is mysterious. Reality is not very amusing.[1]

IN 1949, KARL AND his parents moved back to Hamburg. "My mother was bored to death in the provinces," he explained, "and I also dreamed of getting out of there as quickly as possible."[2] In Hamburg, Karl attended the Bismarck School, in an imposing redbrick building with a steep, black gable roof, just off the Elbe River. He was a student there for two years, a period that would be his last formal education.[3]

Otto Lagerfeld decided to buy and renovate a house in Hamburg for the family. Because it was under construction, they moved into the Hotel Esplanade, a grand six-story hotel on the Esplanade, a wide boulevard in central Hamburg, near the port and across from the Planten un Blomen, a large public park and botanical garden. The Esplanade had long been the favored hotel of Hamburg's high society and diplomatic corps (since 2006, the landmark building has been the Casino Esplanade). While living in the hotel, Karl had two revelations.

By the time he was a teenager, Karl's childhood thoughts about his future had become more specific. He dreamed of being a portrait artist because of his ease of making caricatures, or of becoming a film director. "I'd never actually been to the movies," Karl later recalled. "I'd only seen pictures in newspapers and posters outside cinemas." In 1948, the year before they moved into the hotel, the Esplanade had one of its ballrooms converted into a cinema. So, living there presented Karl with his first opportunity to go to the cinema. "When I finally got inside to watch a

film, I was horribly disappointed," he noted. "It was so slow and boring and there was so much talking. I soon worked out that I much preferred silent cinema, which depends on a language of images. Images are reality idealized. They do away with dialogue and offer magic instead. They can reflect things that I want to keep intact, unharmed."[4]

He would always be fascinated by silent movies, but his disappointment about the first talking films, and his thought about the importance of images, led him to photography, an art that he would practice seriously for over three decades. "There is always something melancholy and ephemeral about a photograph," Karl once pointed out. "The unstated but inescapable feeling of 'Never again.' Reality never repeats itself. You can never take the same photograph twice. Each photo belongs to a unique moment. Thus, its beauty is immediately imbued with nostalgia."[5]

Photography appealed to the broader approach to culture that Karl had had since he had begun reading. One of his favorite phrases from Goethe, which he quoted all of his life, was, "Make a better future with expanded elements of the past." Photography was a way to build on history, to make it modern.[6]

In December 1949, another formative moment in Karl's life took place at the Hotel Esplanade. The house of Christian Dior traveled from Paris to the still-destroyed city of Hamburg to stage a series of fashion shows. They were held in a sequence of grand rooms on the ground floor of the hotel. "And all I had to do was go downstairs," Karl said.[7]

Just two years before, on February 12, 1947, Christian Dior had created an international sensation in Paris with his first show, a sumptuous collection that was dubbed "The New Look." After years of wartime privations, Dior introduced an extravagant, feminine aesthetic, a romantic vision of fashion that revived French haute couture.[8] Karl considered the New Look to be one of the most significant design developments of

the twentieth century (along with the 1925 Art Deco exhibition, the Bauhaus, and Chanel's little black dress).[9] The New Look meant jackets with rounded shoulders, cinched waists, and long skirts, all in opulent fabrics and rich colors.

Christian Dior held three shows at the Hotel Esplanade in Hamburg, the first time it had done events in Germany that were open to the public. Each was sold out, attracting a total of three thousand spectators. The shows were facilitated by a German women's magazine, *Constanze*, for one of its two annual fashion issues. They were also gala events that benefited the Deutsche Hilfsgemeinschaft, a charity founded in 1945 by the mayor of Hamburg to help alleviate the misery of city residents after the war.

The production required a team of fourteen men and women from Dior and the transportation of four large trunks containing eighty dresses, furs, and accessories.[10] Monsieur Dior did not make the trip from Paris, though he was represented by Suzanne Luling, his childhood friend and right-hand man at the house, other senior executives at Dior, and six of the designer's favorite models (even decades later, Karl still recalled their names).[11] After stepping off the overnight train, holding bouquets of red roses, the Parisian models were received in a ceremony at the Hamburg station. They were photographed wearing Dior in front of the city's ruins.[12]

The shows were held in the elegant salons of the Hotel Esplanade, for standing-room-only crowds. The audience, which included many foreign diplomats, consisted of men in dark suits and ties and women in day dresses and suits. The backstage was separated from the public by a thick velvet curtain. An orchestra played such well-known French songs as the prewar "Parlez-moi d'amour," or "Tell Me About Love." German press magnate Axel Springer, publisher of the magazine *Constanze*, spoke about fashion as art.[13]

As the show began, an emcee whispered the titles of each ensemble: "Matisse," "Poudre et Sucre," "Christian Bérard." And out came the Dior models, in long dresses, full coats, hats, and jewels. They walked

around the rooms, gracefully navigating the plush carpeting, with a sense of grandeur and drama. One model took off her white trapeze-cut fur coat to reveal a slinky black, sleeveless evening gown, "Cygne Noir," or "Black Swan," that was intended for Marlene Dietrich.[14] One dark evening ensemble had a taffeta overskirt that was removed dramatically and turned into a cape. The models took spins in the center of the rooms, while the audience broke into applause.

The sixteen-year-old Karl Lagerfeld attended the Christian Dior show with his mother. And the experience could not have been more stimulating. "I still remember the Dior show very clearly," he said in 2017, almost seventy years later.[15] "I thought it was the height of chic."[16]

And there was a powerful sense of fantasy. "It was the adorable girls from Paris who, with their sensational dresses, sinful clouds of scent, and sparkling jewelry, brought to life the flair of this enchanting city," wrote the national weekly newspaper *Die Zeit*. "They were messages from a world that still exists somewhere, a place where, instead of rubble and work, there were only parties, air travel, and grand balls."[17] There was also an unmistakable sensuality to the clothes and to the presentations. "The ladies devoured the clothes with their eyes, the gentlemen not only the clothes," suggested *Constanze*.

The German press, which covered all aspects of the productions, was enthusiastic about the result. "Edifying and Instructive Clothing Show," was the headline in the local newspaper, the *Hamburger Abendblatt*. "First, the material—how rich that country is in costly fabrics! A great deal of rep, a lot of ottoman, duchesse, velvet, taffeta. And how the style grows out of the fabric! M. Dior also has such first-rate personnel at his fingertips. His seamstresses must be outstanding. All that has grown over the years—we are disadvantaged in this respect."[18]

The shows were a great success on many levels. They added to the international reputation of Dior, of course, and helped the house access the German market, which would soon be exploding. But it was also a diplomatic triumph for France. The French consul general in Hamburg wrote a member of the Dior board of directors to say that the house had

done more for the prestige of France in Germany than he himself had achieved in six months.[19]

And the Dior shows helped decide the direction of Karl's life. "It was the image of Paris, and I said to myself, 'That is where I want to live.'"[20]

In 1950, shortly after the Dior presentations, Karl and his parents moved to their new house in Hamburg. It was a grand, five-story town house, built in the nineteenth century, at Harvestehuder Weg 65. It was positioned on a wide boulevard, across from Eichenpark, a beautiful public park with green lawns and tall oak trees that opened onto an urban lake, the Außenalster. Karl's interest in school, never strong, waned as he approached eighteen, the age when he could sit for his diploma. His parents allowed him a lot of leeway. "The best inheritance from my parents is not the money they left me but the freedom to do things that I wanted to do when I was very young," Karl later explained. "People are normally not supposed to do what they want other than go to school. I could do what I wanted, when I wanted, and there is nothing better in the world than that."[21]

One important activity that Karl pursued in those years was drawing. In 1949, he did a splendid scene, in ink and watercolor, of a woman standing at her window. Viewed from behind, advancing toward a balcony with a crescent-shaped moon in the sky, she wore a floor-length, three-tiered dress, with a big bow at the waist and ruffles at the sleeves, holding back the equally frilly curtains. He signed it "K.O.L.," for Karl Otto Lagerfeld, before he would simplify his monogram down to the famous K.L.[22] Also that year, he drew a stylishly simple ink drawing of Salomé, holding up a platter containing the severed head of John the Baptist. Standing in profile, with the lines of her dress disappearing down to the floor, a snake wrapped around her bicep, she stared at the head with disdain. Interestingly, the crosshatchings that surround the top half of the image were in the form of a heart. Another of Karl's ink drawings, in 1950, captured

a Belle Époque woman in a long, corseted dress holding up a bouquet of flowers. He also added an eighteenth-century armchair, a table with a vase, and a sweep of curtains that defined the room. He was careful about the details of the dress, showing the embroidery on the skirt and bodice, the cap shoulder sleeves, and a high collar. Even at seventeen years old, he was documenting the subject's style but also her environment, the world that went with it all.[23]

His illustrations at that time also made clear his continued fascination with the French eighteenth century. While living in the midst of bombed-out Hamburg, he used his imagination to conjure up scenes from the ancien régime. One series of ink drawings included three distinct historic images. One included an elegant woman sitting alone at a table in a drawing room, with an eighteenth-century settee, a gilded mirror, and her elaborate gown spilling onto the floor. Another included a group of four troubadours, with Elizabethan collars and plumed hats, sitting at a banquet table waiting for their chance to perform. And one drawing featured a group portrait of dozens of members of a royal court, inside a room with wall paneling and French doors, with one male aristocrat, seen from behind, on his knee to propose to his lady. All were signed K.O.L. and dated 1950.[24] Also that year, Karl did a pair of pastels, of an eighteenth-century woman in conversation with her suitor and of another lady in her historical gown visiting a patient's bedside.[25]

His parents certainly noticed Karl's talent. Thinking that she could encourage his career as an artist, Elisabeth Lagerfeld showed Karl's drawings to the director of the University of Fine Arts in Hamburg. He wanted to orient the young man, however, in another direction. "Your son is not interested in art but in fashion," she was told. "Look carefully at what he's drawing: lots of clothes. He could become a costume designer."[26]

Karl did not particularly need the guidance. "I had already passed my first high school degree and would need to wait two years in order to sit for my second," he later recalled. "That would have meant two years of not working in order to allow the poor kids who had been enrolled in the

Wehrmacht to catch up. Really? Staying nice and cozy at home in order to end up selling condensed milk? I couldn't quite imagine myself in that picture!"[27]

Karl continued to see his future on the other side of the Rhine. During the three years that he spent in Hamburg, he took French lessons in the evenings, making himself fully fluent. He bought French fashion magazines and studied the work of the leading Paris designers. "I saw magic in the pictures of the clothes by Jacques Fath," he later recalled.[28] One film that made an impression on Karl, from 1949, *Scandale aux Champs-Élysées*, featured evening gowns by Jacques Fath and even had him playing a design assistant. It tells a story of murder and betrayal set in the salon of an unscrupulous couturier.[29]

Karl, still a student, also went to see *Caroline Chérie*, a very popular film about the turbulent loves of a young aristocrat, played by Martine Carol, in the wake of the French Revolution. For the time, *Caroline Chérie*, which premiered in 1950, was something of a bodice-ripper. "The film was forbidden to minors," Karl once said, "which made it even more attractive." Although he never saw the film again, five decades later, in 1989, he would re-create it in a photo with lingerie-clad Claudia Schiffer lying in bed with a shirtless male model. Published at the time of the anniversary of the French Revolution, the story was entitled, "The Bicentennial of Frou-Frou."[30]

When he was still only a teenager, Karl had begun to have a clear sense of his future. And he announced his decision to his parents: "I am leaving to become a fashion designer in Paris."[31]

5

UNDER THE PARIS SKY

My father had left Germany at sixteen to go to Venezuela and it was more dangerous than me going to Paris. Even if everybody said to my mother, "This boy will get lost." She knew that I was not the kind to get lost.[1]

AT THE END OF August 1952, just days before his nineteenth birthday, Karl arrived in the French capital.[2] The move had been fully sanctioned by his parents, who had declined to pressure him to stay in Germany to finish his secondary education and go to college. They did set some expectations, however. "They always said, 'If it doesn't work out, you can come back to school,'" Karl recalled. "'Do what you want but it has to be a success.'"[3] As Karl explained it, he was going to try Paris for a couple of years. If he was not able to find his way, he could always return to Germany and resume his education. The move was not always easy. In a letter to his mother back in Hamburg, he wrote about being so sad several months after he arrived in Paris that he cried himself to sleep.[4] As difficult as it could be to be a teenager away from home for the first time, and in a foreign country, the idea of not returning to Germany was motivating. As he later explained, "I did not want to go back to school and sit with all the other idiots."[5]

The move was not Karl's first time abroad. In the summer of 1950, he and his parents made a trip to the United States. They needed to be cleared for travel by a state commissioner of denazification in Hamburg. Clearance was granted on March 23, 1950, the German biographer

Alfons Kaiser uncovered, with the committee determining, erroneously, that neither of his parents had been a member of the Nazi Party or its branches.[6] Once their vacation was approved, Karl and his parents flew to New York and Los Angeles.[7] He later suggested that they had stayed at the Beverly Hills Hotel.[8]

A youthful trip to America was one thing but moving to France, a country that he had been fascinated by for years, was a much more serious affair. He was well prepared, having dreamed of the country for so long and having spent his early years researching the subject. "I already knew the city by heart, without ever having set foot here," he recalled.[9] His father had an office in Paris, which helped with such details as providing occasional spending money and suggesting a place to stay. "His secretary, a horrible woman with bulging eyes, found me a hotel for minors."[10]

Karl moved into the Hôtel Gerson, at 14, rue de la Sorbonne, in the 5th arrondissement, the academic neighborhood on the Left Bank, known as the Latin Quarter. The Gerson was a seven-story residential hotel, primarily for students, that he felt was run "with empathy, warmheartedness, and a great understanding of budding freedom."[11] Karl was on the top floor, in a one-bedroom apartment with French doors and a balcony that ran the length of the room.[12] The Gerson was managed by a Madame Zapusec.[13] "She was a French woman, married to a man who was Czech, which explains her last name," Karl recalled.[14] The establishment was certainly not lacking in color. Monsieur Zapusec seemed to spend every afternoon gambling at the racetracks, so it was left to Madame Zapusec to oversee her wards. She was quite lenient, Karl suggested, and could be attentive to her guests in particular ways. "Every once in a while, she would send the maids into rooms to help clients lose their virginity," he said. "Madame Zapusec was adorable."[15]

Karl felt that the ambience in the hotel was much like *Sous le ciel de Paris* (*Under the Paris Sky*), a 1951 film that documents a day in the life of Paris in the years when he arrived.[16] It begins with a view of the city as it wakes up, an eclectic cross section of Parisians: an old woman in

her walkup apartment in the 6th arrondissement who takes care of the neighborhood's stray cats, a man who had served in both world wars now on strike in a factory, a man in overalls in Belleville walking with his dog down to the Seine for a day of fishing, college students from around the world at the Cité Universitaire, and a twenty-year-old blond ingenue arriving at the Gare de Lyon from the provinces. The film shows how lively city life could be at that time. Crowds bicker over the prices of vegetables at the market on the rue Mouffetard, just a short walk from Karl's hotel. A sculptor in his atelier in Montmartre struggles with inspiration, while painters gather in cafés to argue over the merits of their work.

Sous le ciel de Paris also provides examples of how daily life, still in the 1950s, was not so different from the nineteenth century. Horse-drawn carriages were seen on the city streets. Before a restaurant opened, women in floral dresses sat around tin buckets placed on the floor, peeling potatoes. Fortune-tellers, whom Karl would patronize, sat in their offices reading tarot cards, palms, and crystal balls. Organ-grinders played on narrow streets, where the facades of buildings were still dark with soot. "At that time, because of coal heating, Paris was a dark city, almost sinister," Karl later recalled. "And the most beautiful city in the world was not very clean. Trash cans were made of zinc and, because there was not any refrigeration, when people threw out their food, there were some pretty gamy scents. There was a transportation and trash strike one August that has forever haunted my memory."[17]

Thankfully, sure to have grabbed Karl's attention, there is also a fashion element to *Sous le ciel de Paris*. The roommate of the blond ingenue works as a model. A photographer swings by their apartment on the Quai de la Tournelle, across from Notre Dame and just steps away from Karl's hotel. After she hops into his convertible, he shows her the latest issue of *Harper's Bazaar*, with her photo on the cover, one that they had taken at Versailles. And in one of the film's most memorable set pieces, she stars in a fashion shoot on the esplanade of the Palais de Chaillot, the Moderne structure overlooking the Eiffel Tower. Flanked by fountains

and rows of sculptures, the photographer and his team work with a half dozen models, all wearing costumes by Christian Dior.

There is plenty of darkness to the film, as there was in postwar Paris, including poverty, brutal social conditions, and a serial killer who is slitting young women's throats and tossing their bodies into the Seine. But Karl's takeaway from *Sous le ciel de Paris* was more buoyant. Like many of the characters, he was living a dream of Parisian success. "I felt that the world was mine," he later wrote, "or would be soon."[18]

The location of the hotel could not have been more perfect for Karl. It was directly across the street from a main building of the Sorbonne, the University of Paris, an imposing structure in beige limestone with soaring windows, ornate pilasters, and elaborate sculptures. The university building housed the library and what is now called the Faculty of Arts and Humanities, an institution that was founded in the thirteenth century.[19] He found himself right in the heart of the greatest center of French knowledge and education. Although he was not enrolled in the Sorbonne, he did attend some high school classes not far away, at the Lycée Montaigne, an esteemed, and historic, public school just on the other side of the Luxembourg Gardens.[20] He also continued his drawing. But his main objective seemed to be exploring the new city. "I spent my time walking around," he later recalled. "I could have been a tourist guide."[21]

Of course, there is a long history of the *flâneur*, one who saunters the streets of Paris, intent on fully absorbing the surroundings. Perceptive residents from Baudelaire to Walter Benjamin, those who were born in Paris and those who were new to the city, have elevated the meaning of the leisurely stroll. "To really wander in Paris is an adorable, delicious way to live," wrote Honoré de Balzac. "To be a true flaneur is a science— the gastronomy of the eye. To walk is to vegetate; to stroll is to live."[22]

Stepping out of his hotel and turning to the right led immediately to the Place de la Sorbonne, a tree-lined square between the university entrance and the Boulevard Saint-Michel, filled with bookstores and cafés. Farther along the rue de la Sorbonne was the rue Soufflot. To the left was the majestic Panthéon, the eighteenth-century colonnaded mausoleum, resting place of the greats of French history. To the right, the rue Soufflot led to the Luxembourg Gardens, one of the most beautiful parks in Paris. Between his hotel and the Luxembourg Gardens was the Place de l'Odéon, site of the great neoclassical Théâtre de l'Odéon, the streets surrounding it filled with one the city's greatest concentrations of bookstores.

Turning left out of the Hôtel Gerson, at the corner of the rue de la Sorbonne and the rue des Écoles, was the Brasserie Balzar, a beloved historic restaurant with paneled walls, starched white linen tablecloths, and simple meals served by bemused waiters, many of whom spent their entire careers at the establishment. Founded in 1894, the Balzar was a favorite with Sorbonne professors, book editors, university students, and Left Bank intellectuals. Over the decades, it built such a loyal following that in 1998, when Balzar was taken over by a commercial French chain, a group of customers organized themselves and took over the restaurant to protest any changes.[23]

Just a few steps along from the Balzar, at the corner of the rue des Écoles and the rue Champollion, was Le Champo, a mythical cinema that was important for Karl. Founded in 1938, Le Champo was one of the best places in Paris for major French and international films. Throughout the 1950s, leading directors of the French Nouvelle Vague, including François Truffaut and Claude Chabrol, considered Le Champo their unofficial headquarters and their "second university."[24] There were many other cinemas within walking distance of Karl's hotel, including L'Espace Saint-Michel, Le Cinéma du Panthéon, the Studio des Ursulines, L'Arlequin, and La Pagode. And he took full advantage of the offerings. "I went to the cinema, from the first screening to the last, to work on

my French accent," Karl later explained.[25] He cut classes at the Lycée Montaigne to go to the cinema in the early afternoon, often staying until midnight.

One film that was very important to Karl in those years was *Les enfants terribles*, written by Jean Cocteau and directed by Jean-Pierre Melville. Released in 1950, and telling a stylized story of the claustrophobic, almost-incestuous world of a brother and sister, it fascinated Karl. In those first years in Paris, he saw it seven times. "But that's not my record," he pointed out to a journalist in 1958. "My record is *Les Dames du Bois de Boulogne*—that I saw eight times."[26] Shot during the Occupation, and released in 1945, *Les Dames du bois de Boulogne* was directed by Robert Bresson. It tells the story of a woman, played by Maria Casarès, spurned by her lover, who then tricks him into marrying a former prostitute so that she can ruin his life. When she reveals her rival's background, the new couple's passionate love story shifts into tragedy. "It's my favorite film," Karl said, decades later.[27] "This story of revenge by Maria Casarès, who gets her guy to marry a whore—amazing!"[28]

All of the time that he spent seeing films helped Karl with another quality that served him well: sharpening his wit. For someone who was so fascinated by the eighteenth century, Karl knew that quick thinking was a tool of survival. The French term "esprit" suggests quickness of mind, which Karl had, but the true meaning is more expansive. "It really means the quality of the soul," suggested Voltaire, in his 1755 essay on esprit. "It encompasses judgment, genius, taste, talent, penetrating thought, expansiveness, grace, finesse. And it should encompass all of these traits—it can be defined as ingenious reason."[29] The flip side of the concept, *"L'esprit de l'escalier,"* underscored its importance. It meant the tendency to think of a comeback only belatedly, on the stairway (the *escalier*), or on the way home.

In perfecting his French, Karl mastered the ability to be clever, to think on his toes, to engage in witty repartee. Thanks to the work Karl did on his language in those years, he would not be leaving his cleverness on the stairway, or anywhere else.

Not far from his hotel, about half a mile along the Boulevard Saint-Germain, or a ten- or fifteen-minute walk, was the center of one of the most exciting neighborhoods in the world at that time, Saint-Germain-des-Prés. It was a village-like area, centered around the medieval abbey and church, that was best known for its cafés—Les Deux Magots, Café de Flore, and Brasserie Lipp—the philosophical ideals of existentialism, and smoky basement clubs filled with the sounds of jazz. "In the afternoon, Jean-Paul Sartre, the existentialist oracle, garbed in a frayed jacket, woolen sweater, and beret, a cigarette tucked in his mouth, and his pockets stuffed with papers, descended from his apartment on the rue Bonaparte to join Simone de Beauvoir and their disciples for aperitifs and chitchat at their habitual haunts, the Flore or the cameo cellar bar at the Pont Royal hotel," wrote Stanley Karnow, the 1950s Paris correspondent for *Time*. "The preceptive political analyst Raymond Aron held forth at the Deux Magots, while Albert Camus preferred the solitude of a rear table in the drab Café de la Mairie du Sixième Arrondissement, in the nearby Place Saint-Sulpice. Now and again, attired in his signature turtleneck, Samuel Beckett would emerge from his secluded studio to nurse a beer at the Montana."[30] The neighborhood was home to American expatriates, led by Richard Wright and James Baldwin, leading French writers, and packed cabarets like Tabou, where Juliette Gréco, dubbed "the existentialist pinup," became a major star.[31]

There was a real sense of youthful exuberance in Saint-Germain. As one French observer wrote, "In about a decade, between 1945 and 1956, Saint-Germain-des-Prés became something of a satanic parish, where scandal was raised to the level of the sacred: Zazous, Existentialism, Nihilism, Boris Vian, and in 1954, *Goodnight Sagan!*"[32] For it was in 1954 that nineteen-year-old Françoise Sagan published her first novel, *Bonjour Tristesse*, which painted a shocking, amoral portrait of 1950s youth in France.

Of course, the scene in the years after the war also became overheated. Tour buses trawled the boulevards while the basement clubs

were crowded with tourists trying to be cool for one night. "At the Flore, people stared at us and whispered," Simone de Beauvoir noted in her postwar journals. "When Sartre gave a lecture, there was such a crowd that the hall could not contain it, which led to pushing and shoving and women fainting. One explanation was that France, having become a second-rate power, burnished its image by exporting its two homegrown products: haute couture and literature."[33]

Karl's attraction to Saint-Germain-des-Prés began in the years when he first arrived. Café de Flore, the mythical spot at the corner of the Boulevard Saint-Germain and the rue Saint-Benoît, became his unofficial headquarters and would remain that way for the rest of his life. The Flore, founded in 1887, also happened to be across the street from La Hune, begun in 1949, the legendary bookstore and gallery that was one of Karl's favorite places in the world (until 2015, when it became a Louis Vuitton boutique). During World War II and in the years when Karl first arrived in Paris, the Flore had a loyal clientele of artists, writers, filmmakers, thinkers, and film stars. The mood managed to be intellectual, stylish, and unrestrained. "As Sartre wrote," noted a historian of Paris restaurants, "'The path to freedom begins at the Flore.'"[34]

Later in life, Karl did a beautiful drawing of the Café de Flore. It was a collage of elements important to him: the white terrace awnings bordered in green, the beige menu with red and black type—a design inspired by the famous book covers of the nearby publisher Gallimard—a napkin with the name of the restaurant in its expressive green script, and a fragment of himself in profile, with his white ponytail, high-collared shirt, and black jacket. "This is Paris for me," Karl wrote for the caption, "Saint-Germain-des-Prés and the Café de Flore."[35]

Another element of the neighborhood in the 1950s was that it also happened to be Paris's gay center. Jean Genet would hang out at the Flore, André Gide was a regular at Brasserie Lipp, and there were such underground bars as Le Fiacre, at 4, rue du Cherche-Midi, where Karl would go. "The homos, from every class, went to the Cherry Lane, to

the Flore, and especially to the Fiacre," remembered Gerald Nanty, who would go on to start some of the hottest Paris clubs in the '60s and '70s, and who happened to be, in the 1950s, the lover of the young Italian-born designer Valentino. "It was a marvel of sophistication and decadence, the first restaurant and club for boys in Paris."[36]

Surprisingly, particularly considering how luxurious the neighborhood has become in recent decades, Saint-Germain-des-Prés was also the setting for street hustlers. Beginning in the evening, the Boulevard Saint-Germain and the side streets teemed with rent boys. Karl cut a striking figure and wondered if he wasn't occasionally mistaken for one of the local sex workers. "When I was younger, they thought that I was a gigolo," he later explained. "And, of course, in those kinds of professions, Germans did have a lot of success."[37]

Karl was a good-looking young man who also appeared exotic, more Latin than German.[38] He cut an elegant figure around Paris, with custom-made suits from his father's tailor on the Avenue Montaigne and shirts from Hilditch & Key, the English shirtmaker on the rue de Rivoli, where his father had his shirts made. "It was often assumed that I was Jewish," Karl once said of his appearance in his first years in Paris. "And I would have liked being Jewish. I really feel at home in that kind of cosmopolitan culture."[39]

To be a German in Paris shortly after the war was not easy. French memories of the Nazi occupation were still very sharp. In November 1952, shortly after Karl arrived, a massive trial began of fourteen defendants, German and French, charged with committing hundreds of acts of torture and murder at the Gestapo headquarters on the rue de la Pompe in the 16th arrondissement.[40] It was not until 1955, felt Janet Flanner, the legendary Paris correspondent for the *New Yorker*, that the French Bastille Day parade felt like a proper celebration rather than a painful reminder of the June 1940 military collapse to the Germans. "Maybe a decade and a half is a span of time that agonizing history can fade," Flanner wrote of the occasion.[41] Simone de Beauvoir remained very focused on the years during and just after World War II. When Karl was settling

in Paris, she was writing her novel *The Mandarins*, which won France's most prestigious literary prize, the Prix Goncourt, in 1954. It was set on the Left Bank during the war. "We were not very attentive to our own lives—all that mattered was what was happening," de Beauvoir wrote of life under the Occupation. "The exodus from Paris, the return, the sirens, the bombs, the lines . . . Outside, there were pools of blood, sounds of gunfire, the groaning of cannons and tanks. Every morning, we woke with the same question: was the Nazi flag still flying over the Senate?"[42] De Beauvoir's evocative image of the swastika flag in the Paris sky was at the Palais du Luxembourg, the historic building housing the French Senate, just around the corner from Karl's hotel.

There was also, though, a certain amount of French-German cooperation in the air. Two years before Karl arrived, French foreign minister Robert Schuman had proposed a plan to pool the French and German production of coal and steel. The Schuman plan was the first step toward economic cooperation that would lead, decades later, to the European Union. The idea was immediately popular in postwar France. "Psychologically, the Schuman project has given local spirits a lift," wrote the *New Yorker*'s Flanner. "It has been inspiring for Frenchmen to see their defeated France, once mistress of Europe, actually taking a positive, unwobbling step forward on her worn, old high heels."[43]

Flanner was lucid, as well, about the stakes that were involved. The idea of the two nations working together may have been novel, but it was better than what had come before. "In the past hundred and fifty years, France has tried everything with the Germans except helping them," Flanner wrote. "She has conquered them and been conquered by them, has paid them and attempted to get paid by them, has been occupied by them and has occupied them, has been overharsh with them and contemptuously loose with them. Schuman's shrewd plan is regarded by some as the first intelligent French effort to control modern Germany's vigorous industrial genius, which is always working on what look like baby carriages but turn out, when put together, to be cannons."[44]

It just so happened that Karl arrived in Paris at a key moment in the history of French fashion. "Haute couture was at its apogee," suggested the Pompidou Center in *Les années 50*, its massive 1988 exhibition on the decade. "The refined rules that the couturiers hand down have the weight of diktats. Women appear with gloves and hats, extremely attentive to the harmony of the clothing and of the accessories. It is a very elaborate style, very designed, with a consistency of line from one couturier to another."[45]

When Christian Dior was asked to explain why fashion was so important in France, he pointed to the country's long history. "We inherited a tradition of craftsmanship rooted in the anonymous artisans who constructed the cathedrals and expressed their genius in chiseled stone gargoyles and cherubs," Dior told *Time* for a 1957 cover story. "Their descendants—skilled automobile mechanics, cabinetmakers, masons, plumbers, handymen—are proud of their métiers. Similarly, my tailors, seamstresses, even novice *midinettes*, constantly strive for perfection. We also benefit, paradoxically, from having a singularly difficult consumer: the Parisienne."[46]

When Karl arrived, Dior was at the height of his power. The house, having been founded in October 1946 with a team of eighty-five, had, by December 1951, increased to almost one thousand employees, including 572 tailors and seamstresses, 18 *premières d'ateliers*, and 21 *premières vendeuses* (sales directors).[47]

There were other important designers in Paris, as well. The elegant Jacques Fath was "as beautiful as a mythological warrior and, like them, would die early," according to one historian.[48] Fath, whom Karl had long appreciated, regularly disseminated his own portraits and became "as fashionable as his designs."[49] Pierre Balmain, considered the third great figure of postwar French fashion, was a former architecture student known for a pure approach to suits, cocktail dresses, and evening wear (his friends Gertrude Stein and Alice Toklas dubbed his work "Le Nouveau Style Français").[50] The Spanish-born Balenciaga was an

acknowledged master of sculptural design—one of the great purists of fashion history—while the Italian-born avant-garde designer Elsa Schiaparelli was considered the Surrealist of haute couture. The year Karl arrived, French aristocrat Hubert de Givenchy launched his own house, when he was just twenty-five years old. And Coco Chanel was busy planning her remarkable comeback, which took place on February 5, 1954, when she was seventy-one.

It was, in short, a heady time for haute couture. And it was into this exciting world that the eighteen-year-old Karl happened on his first day in Paris, in August 1952. It was the end of the month and most Parisians were still on vacation. "The city was empty and magical," he later recalled. He walked over to the Pont Alexandre III, that Belle Époque fantasy of a bridge that spans the Seine. Completed in 1900, it is the most extravagantly beautiful bridge in Paris. On the Right Bank side is the Grand Palais, built at the same time, with its massive stone facade and soaring steel-and-glass roof. The Left Bank perspective leads to the Esplanade des Invalides, the gold dome of the Hôtel des Invalides, and, just down the river, the Eiffel Tower rising majestically.

As Karl approached the Pont Alexandre III, he noticed another striking sight. A model was being photographed wearing haute couture. The bridge, and the remarkable view of Paris, became the backdrop for the shoot. He would later see the images published in French *Vogue*. "It was a scene that really struck me at the time," Karl explained. "Sitting on the benches in school, I dreamed that one day dresses I had designed would be photographed on the bridges of Paris."[51]

6

CENTER STAGE

My Dear Mummy,
So, that was the big day! I was so happy I could have cried.
–*Karl Lagerfeld to Elisabeth Lagerfeld, December 10, 1954*[1]

IN THE CLASSROOM, WHETHER he was living in Germany or in Paris, Karl was something of a slacker. Whenever he talked about his past, he always suggested that he was self-taught. In a general sense, that was true—his immense grasp of history and culture came from his own extensive research and reading. That changed, however, in 1953, in a previously unknown part of Karl's story.

The year after he arrived in Paris, he enrolled in classes of fashion illustration and design given by Andrée Norero Petitjean at her school, known as the Cours Norero, on the Place Pereire, now known as the Place du Maréchal-Juin, in the 17th arrondissement. Karl had natural ability as an illustrator and a sensitivity to style. But the year he spent studying with Madame Norero helped him learn how to apply his talent to fashion. And he was forever appreciative. He invited Norero to his fashion shows over the years, often asking for her input, and when she died, in 2001, Karl went to her funeral service and burial.[2]

Madame Norero was the daughter of two accomplished artists, Edmond Marie Petitjean, who painted primarily Impressionist landscapes, and Jeanne Lauvernay (1875–1955), best-known for still lifes, interiors, and portraits. Having been taught drawing by her parents, she had been a student at the École Duperré, a leading municipal arts college. In 1944

and 1950, she published two children's books of her illustrations. An-
drée Norero also worked as an illustrator for Nicole Groult, a fashion and
costume designer and the younger sister of the legendary couturier Paul
Poiret.[3] She was quite knowledgeable about design, therefore, and was a
significant collector, donating dozens of historical garments to the lead-
ing museums in Paris, including eighteen objects from the nineteenth
and twentieth centuries to the Musée des Arts Décoratifs[4] and eighty-
three pieces from the eighteenth century to 1950 to the Palais Galliera.[5]
Her familiarity with Paris fashion encouraged her to become an educator.
"She was asked by a few designers, including Hubert de Givenchy, to
open her own school of fashion illustration," explained her grandson,
Éric Guillot. "These couturiers needed illustrators who could design."[6]

In order to go to Madame Norero's classes from the Hôtel Gerson to
the far end of the 17th arrondissement, Karl took public transportation.
"I always loved the Métro," he said, years later. "When I was young, I
took it every day. To go to the 17th, I took the bus from the Place Saint-
Michel to the Opéra. From there, I took the Métro to the Porte de Cham-
perret. Coming back, I took the 83 bus to the rue du Bac, then I walked
to the rue de la Sorbonne, where I was staying."[7]

In the studio of Madame Norero, he joined some forty students, many
international, drawing from life models and creating designs on manne-
quins. "Very quickly she realized that she had a brilliant student," her
grandson continued. "She taught him drawing and took him to some
of the haute couture shows that she attended."[8] Soon, Karl was collect-
ing thoughtful fashion journalism, such as a piece by writer Blaise Cen-
drars, "The Mystery of Design," published in the October 1952 issue
of Le Jardin des Modes, studying the cultural inspirations for the fall
designs by Schiaparelli (grasshoppers), Givenchy (antique jewelry), and
Dior (streamlined automobile design).[9] And he was experiencing Paris
fashion shows for the first time, seeing Alwynn, a now-forgotten house
founded by an English designer, Alwyne Camble.[10]

Through a friend of his mother, Karl also was able to see Chanel's
famous comeback collection, in February 1954, a show that was received

coolly by many but was the beginning of her remarkable second act. "She thought it was horrible," Karl recalled of his mother's friend. "Like everyone—except for me."[11] Karl collected a Chanel calling card, with the handwritten name of a representative.[12] "I loved that collection because I felt like I was seeing the atmosphere and the climate of elegance from the '20s and '30s that I so regret not having known," he later explained.[13]

By 1954, the quality and style of Karl's drawings reflected his exposure to the fashion world and his education. Clothes had always been important to his sketches but the new work, some of which were class assignments, began to emphasize the design. One spare drawing of a woman in a long dress in profile, studying herself in a handheld mirror, was done from a live model, posing for only five minutes.[14] *Two Bathers* was a color pencil drawing and gouache of a pair of women in bathing attire, one in yellow shorts with a black halter top, the other in a red one-piece swimsuit, reclining on a diving board. Their faces are left unfinished, underscoring the fact that it is the fashion that matters.[15] Karl gave one pencil drawing and gouache, dated 1954, the title of *The Art of Accommodating Leftover Fur*. It depicts a half dozen women in an elegant restaurant using bits of fur that had been fashioned into a stole, a collar, a pillbox hat, a muff, and the cuff on a short sleeve. Men, though present in the room, are merely suggested. In the center, hanging on the wall of the dining room, is a clever image within an image: it is a framed work showing two women, one with a wide fur belt, the other with a fur cape, and, below, his signature, "Karl '54."[16]

Another pencil and gouache from that time, entitled *Spring Hats*, shows seven women in profile, lined up in front of a large gilded frame—it could be a painting or a mirror—each modeling the hats of the season. The image is meant to be a spread in a fashion magazine. In the top left corner is the headline, in graphic block letters, "Les Chapeaux de Printemps," with lines below indicating a paragraph of copy. One beautifully composed ensemble illustration from 1954, also in pencil and gouache, *Élégantes*, shows nine models from head to toe with a variety of chic

ensembles with nipped waists, full midcalf skirts, wide-brimmed hats, and long gloves. The dresses or suits are in black or in light blue, while, in the right margin, is a pale blue column with silhouetted drawings of accessories: a hat, a pair of gloves, a bag, and a pair of shoes. It is also intended to be a magazine spread, with a block of copy on the lower left.[17]

The sophistication of his work from those years was dramatically different from what had come before. There was a confidence and a simplicity to Karl's new style. He was evolving from someone who was naturally adept at drawing into a capable fashion illustrator. It was a skill that would serve him for the rest of his career.

The work that Karl did at the Cours Norero was not limited to sketching. In the spring of 1954, Madame Norero had an assignment for the students: design the gown for the upcoming wedding of her daughter, Christiane. The young woman met with the students, explaining what she would like out of her wedding gown. She was marrying someone who was a politician, so it was important for her to be able to reuse the gown for receptions. Karl asked a lot of questions and came up with a design that he felt met her needs. Madame Norero was impressed with Karl's attentiveness to the client and the design that he proposed. And she selected Karl, who was twenty at the time, to produce her daughter's wedding dress. Karl then worked with seamstresses, and the client, to turn his design into a reality.[18]

The ceremony took place on October 7, 1954, just after Karl had turned twenty-one. It was held in the Église Saint-François de Sales in the 17th arrondissement.[19] The wedding gown, in white frosted silk, consisted of a top with three-quarter-length sleeves that was open in front and tucked into a long skirt. At the waist was a corselet with, in back, a half belt, which secured a dramatic, voluminous train that swept the floor. After the ceremony, the corselet and the train were removable, leaving a simple long white skirt and top.[20]

For the wedding, the bride walked down the aisle in her floor-sweeping gown with an equally long veil and a tall tiara, and holding a bouquet of white flowers. The effect was elegant, but it also managed to be simple and modern. This wedding gown, known only within the family, was Karl's first produced design.

"This is incredible," said Amanda Harlech when shown images of the 1954 wedding. "It shows that Karl, even then, understood evening wear as well as tailoring. The dress, with its removable corselet, is very pure and constructivist."[21]

In the spring of 1954, while Karl was hard at work at the Cours Norero, a series of beautiful posters and newspaper advertisements began appearing around Paris. They were designed by René Gruau, the legendary fashion illustrator, contributor to *Vogue* and *Harper's Bazaar*, and artistic director for Christian Dior. They were part of a campaign for a design competition held by the International Wool Secretariat, or IWS, a trade organization promoting wool produced in Australia, New Zealand, and South Africa.[22] Gruau had made a gorgeous image of a woman seen from behind, her face turned in profile, wearing a black evening gown and carrying a matching shawl. Her long slash of a dress ended at the base with the source of the image: a hand holding a pencil. "Pierre Balmain, Jacques Fath, or Hubert de Givenchy will execute the coat, the suit, or the dress that you design," the copy suggested, announcing the call for entries for the competition. The images caught Karl's attention. As he remembered, "Those posters said, 'If you are an amateur, not a professional fashion designer, send a sketch of a coat or a dress or a suit'—it had to be in wool."[23]

The competition, which became known as the Woolmark Prize, was open to any French resident interested in design, who did not work for a fashion magazine or a couture house. This was the second annual event, which some French journalists had taken to calling the Prix Goncourt

of fashion. The drawing had to be an original, not a copy, in black ink, on paper that measured 30 x 40 cm, and include a fabric swatch. Participants could enter multiple drawings, but each entry had to be sent separately, and, unlike the Goncourt, all would be judged anonymously. The winner of each category would have their design produced by one of the three participating houses—Balmain, Fath, and Givenchy—chosen at random.

A technical jury would make a first selection, then all of those would be evaluated by an artistic jury including the three couturiers, the illustrator Gruau, actress Jacqueline Delubac, painter Jean Oberlé, and six members of the French press, led by Michel de Brunhoff, the director of *Vogue*. Karl sent in some sketches and then, he later said, forgot all about the competition.[24] That is unlikely, for, the year before, he had cut out and kept newspaper stories about the winners.[25]

Nevertheless, six months later, on November 25, 1954, Karl received a pneumatique, the Paris postal service that used underground vacuum tubes to deliver messages instantaneously across the city. It was a letter from Thelma Sweetinburgh, the head of fashion for the IWS, addressed to Karl at 14, rue de la Sorbonne. The day before, the members of the jury had met over lunch at Maxim's on the rue Royale to determine the winners of the competition.[26] The jury also held a drawing to assign the victor of each category a house to produce their design.[27] As Sweetinburgh informed Karl, "We are happy to inform you that after deliberations by the jury on Wednesday, November 24, you have been awarded the first prize for the coat category in our Fashion Illustration Competition."[28]

Karl immediately fired off a telegram to his mother in Hamburg: "I just won first prize. Call Me. Karl." His lack of explanation to his mother was another indication that the competition had not slipped his mind. At the bottom of the telegram an operator added, amusingly considering how well known the name would become, "Lagefeld or Lagerfelo—it's poorly written."[29]

Karl was summoned by Sweetinburgh to an appointment the next day at 11:00 a.m. at the IWS offices on the Place de la Madeleine, so that his

entry could be verified. "We had to redo the drawing in front of a bailiff," he remembered. "In order to prove that we had done the drawing, to make sure that someone had not just hired a professional."[30]

The news of the Woolmark Prize broke that day. "The International Wool Secretariat has chosen three winners from 6,000 entrants," announced the French daily *Le Figaro*. "The three winners are Monsieur Yves Saint-Laurent for the dress; Mademoiselle Colette Bracchi for the suit; and Monsieur Karl Lagerfeld for the coat."[31]

Karl's entry, which he termed a "cocktail coat," depicted the front and back of a coatdress that hit just below the knees. He gave it a title, in the haute couture tradition of the day, *Longchamp*, after the hippo-drome in the Bois de Boulogne.[32] It had three-quarter-length sleeves, buttoned in front with large patch pockets at the hips, and, in back, a plunging neckline. The design also included a wide-brimmed flat hat and a veil. "With the décolleté in back, it was pretty unconventional for the time," he later explained. "So, it must have been more original than others."[33]

After successfully re-creating his design at the IWS offices, Karl received, several days later, another pneumatique from Thelma Sweetinburgh, instructing him to go that evening to the Comédie Française at the Palais-Royal, in order to meet with the actor Jacques Charon. A member of the Comédie Française, Charon would be the master of ceremonies for the presentation and wanted to meet with the winners. "Use the artists' entrance," Karl was instructed, "and, tomorrow morning, call the office to confirm that you were able to meet with Monsieur Charon."[34]

The awards ceremony was to take place the following week. It would also include a fashion show to present the winning designs. Each of the drawings would be produced by one of the three participating houses, chosen by the IWS.[35] First-prize winners would be awarded 300,000 francs, a significant amount of money in postwar France (the model in *Sous le ciel de Paris* made 3,000 francs per day, while the starting annual salary for most office workers was 293,000 francs).[36]

The ceremony for the Woolmark Prize, which jump-started Karl's career, was held on Friday, December 10, 1954. The reception attracted over one thousand guests: Paris designers, international journalists, the team from the IWS, actors, and socialites. After the ceremony, Karl went back to the Hôtel Gerson. He had dinner by 8:30 p.m., alone, and then sat down, by 10:30 p.m., to write an eight-page letter to his mother telling her every detail about the evening.

Karl often said that she had been dismissive of his career as a designer. "Oh, it is good," his mother was said to have told him when he began working, "it shows that you are not a snob because otherwise you would never do a job like that."[37] It is true that being a fashion designer did not have the social standing then that it would have in later decades. But Elisabeth Lagerfeld was more interested in her son's work than he suggested.

In addition to the letter, Karl sent her everything about the ceremony—his correspondence with the IWS, photographs from the event, press releases, and French and international newspaper clippings. In Hamburg, Elisabeth Lagerfeld took all of this material and placed it in a large blue binder. She organized the notebook into five sections, labeling each carefully, and added a table of contents. On the cover, she affixed a copy of Karl's winning sketch. Also included were some of his other drawings from the 1950s, a host of material from his first job, at Pierre Balmain, and other memorabilia from his first years in Paris. Later, she organized another large blue binder, just as stuffed with information, on his second job, at Jean Patou.

Elisabeth Lagerfeld may have destroyed, as Karl suggested, her son's youthful journals. But she kept these two binders with her throughout her life. Two years later, she took them when she and Otto Lagerfeld retired to Baden-Baden. In the '60s, she transported them from Germany when she moved in with Karl to his apartment in Paris. In the '70s, she kept the scrapbooks with her when she moved to his château in Brittany. After her death, they found their way to Karl's house in Biarritz. Then, along with many of his possessions, they were put into storage.

In December 2021, in Monaco, when the first of three auctions of

Karl's estate was conducted by Sotheby's, the two binders surfaced for the first time in decades. Although they were credited as being the work of Karl, it would have been more accurate to name Elisabeth Lagerfeld as the creator. Estimated to sell for between €2,000 and €3,000, the pair went for €189,000, or roughly $200,000.

On the night before the Sotheby's sale, a dinner was hosted in Monaco by Karl's friend Princess Caroline of Monaco. It took place at One Monte Carlo, a glitzy convention center where the exhibition and auction were being held. There were seventy-five guests, including collectors, friends of Karl, and those who had worked closely with him. The evening was organized, like all of his large dinners for decades, by Françoise Dumas. The tables were dressed with the white embroidered linens he had long collected, pieces of his antique silver flatware, and one of his striking silver candelabra by Georg Jensen. After dinner, there was a virtuoso performance of Niccolò Paganini by Charlie Siem, an English violinist and model whom the designer really liked, while the room was presided over by a large portrait of Karl by Japanese pop artist Takashi Murakami.

The next day, prior to the auction, Sotheby's allowed me to study the two binders. They had been displayed in glass cases in an exhibition of furniture, art, and objects from the sale. The house had photographed material from the scrapbooks but had not closely analyzed the contents (there were, after all, some three thousand lots in the combined auctions). As I reviewed the books, realizing the wealth of information they contained, I was astounded. They had brand-new detail about his early career, material that he had never documented. Coming across so much about a subject as well-known as Karl was heady stuff—the kind of discovery that throws the story of someone's life into a new focus.

Both of the scrapbooks were in pristine condition. Although the newspaper stories had yellowed, the press photographs were glossy and unfaded, while Karl's illustrations, some that were seventy years old, looked like they could have just been drawn. There was one somewhat alarming reminder of their decades of obscurity: as I turned the pages of the 1954 binder, out crawled a little brown spider.

In addition to providing context on Karl's early life, the scrapbooks shed light on another issue. They give a better sense of the character of Elisabeth Lagerfeld. So lovingly assembled by her, and kept in her possession throughout her life, they made it clear that this was a mother who was deeply proud of what her son had accomplished.

That morning of the Woolmark Prize ceremony, the IWS sent an official press statement to journalists around the world. "If this year's winners prove that creative gifts can flourish in any environment, they also make it clear that fashion illustration really blossoms in Paris," noted the communiqué. "The winners are from completely different worlds but all three have studied under the direction of Paris instructors."[38]

The IWS introduced the three winners. Colette Bracchi was a twenty-two-year-old Franco-Italian student at the Chambre Syndicale de la Haute Couture. She had first entered the competition the year before, when her design for a dress had come in fourth. This year's winning suit, a black and white jacket and skirt, was produced in the studios of Jacques Fath.[39]

The eighteen-year-old Yves Mathieu Saint Laurent, from Oran, Algeria, was also a student at the Chambre Syndicale de la Haute Couture. Saint Laurent, too, had entered the contest the year before, placing third in the dress category. In fact, according to the IWS, his previous victory had encouraged him to move to Paris to focus on his career. In 1954, in addition to his winning dress design, he also had another drawing that placed third in the same category. His first-prize effort was an off-the-shoulder cocktail dress, in black wool, made by the studio of Hubert de Givenchy.[40]

"Monsieur Karl O. Lagerfeld was born in Hamburg 21 years ago," the IWS announced, using his accurate age. "For the past year, he has been studying fashion illustration with Madame Norero, the daughter of the artist Petitjean, whom he had heard about from Jacques Fath. He

has been in France since 1952 and hopes to join a couture house as a designer. With that goal in mind, he has also been taking dressmaking classes for the past six months."[41] Karl's winning design was produced by the house of Pierre Balmain.

The evening took place at the Théâtre des Ambassadeurs, in the Jardins des Champs-Élysées, just off the Place de la Concorde (since 1970, the theater has been known as the Espace Cardin). Karl left the Hôtel Gerson by taxi shortly after 4:00 p.m., getting to the Ambassadeurs well before the 6:00 p.m. start time. The stage held several massive candelabra and large bouquets of flowers. The back of the stage had red velvet curtains that held all three winning designs blown up to a scale that was larger than life size. A runway extended into the hall.

Standing on the stage, Karl was handsome, with high cheekbones and full lips. He wore a dark gray three-button flannel suit, a white shirt with French cuffs, and a narrow tie. His glossy black hair was styled into something of a pompadour. "I had hair that was fairly long but covered in brilliantine so that it held," he later recounted. "I wore a tie that was aubergine, which was very unusual at the time, that I had bought at the first Pierre Cardin boutique."[42]

Karl was paired with Marie-Thérèse, a star model who was closely connected with the house of Balmain (just after the ceremony, she left for a tour of South America with the designer). She wore Karl's coat, with its revealing neckline in back, with suede gloves, a short triple strand of pearls, and the wide-brimmed hat with a veil. Karl stood next to her, in front of the scaled-up version of his drawing, before a phalanx of photographers in dark suits with bulky cameras and oversized flashbulbs. The winners were bombarded by flashes, while newsreel cameras recorded the scene.

The second- and third-place drawings, Karl noticed, were smaller and shunted over to the side of the stage. He was not magnanimous about the runners-up. "They were almost invisible," he wrote his mother, "and the second prize in the coat category was particularly complicated and ugly."[43]

He was equally unforgiving about his fellow victors. Karl felt that Bracchi and Saint Laurent were incredibly nervous onstage but that he was entirely at ease in the spotlight, standing with Marie-Thérèse, making adjustments on the coat, posing along with her. And he thought that his model received the biggest ovation from the crowd. "Madame Norero told me that the people around her were very enthusiastic, feeling that the coat was new and daring," Karl told his mother. "The others, in comparison, did not seem so significant."[44]

He critiqued the other designs. He felt that Colette Bracchi's suit was badly made, that the fabric was heavy, and that the hat, which he suggested was probably part of the Fath collection, did not go. He was also negative about Saint Laurent's winning design. "The dress was OK, though I find it very banal," Karl wrote his mother. "Isn't that terrible? The design is chic but not very exciting. And it is so much like other dresses that Givenchy has been doing for two years now."[45]

Karl felt that there were practical reasons why his was better. He was the only candidate with a drawing that illustrated the front and the back, which he felt could have made a difference on the quality of the production. And the other candidates seemed not to have participated in fittings for their designs. Karl had.[46]

The ceremony began with a sketch by French actress Odette Joyeux. Each model then walked down the runway and the victors stood at a microphone and were asked questions. "Some said afterwards that it was as though I was used to being in the spotlight," Karl wrote. "Many people that I had just met congratulated me for being so direct."[47]

The prize was awarded by the IWS's Thelma Sweetinburgh, who would go on to become a fashion editor (helping put *Women's Wear Daily*, or *WWD*, on the map during the 1960s). In 2007, when Sweetinburgh died at the age of ninety-seven, Karl sketched from memory the outfit she wore on that day: a gray flannel ensemble by Jacques Fath. "She was so chic," he recalled. "I went to Lachaume and ordered her flowers."[48]

After the ceremony, there were cocktails and hors d'oeuvres, though Karl concentrated on networking. "I didn't come to drink, let alone eat."

For a long time, Karl was in conversation with Sweetinburgh and Pierre Balmain. The designer congratulated Karl on his design, and teased him some, suggesting that someone so young would have to get used to the coarse world behind the scenes of haute couture. Balmain also complimented Karl on his Cardin tie. "The velvet tie worked," Karl wrote his mother. "Was it tasteful, I don't know. But it was noticed and that is the only thing that matters to me. I don't care what people say as long as they say something."[49]

Even at twenty-one years old, in a letter to his mother, Karl gave the impression that he was impervious to criticism. It was the public stance that he had for much of his life. "He ended as he began," pointed out Amanda Harlech, when told about the comment. "Pretending he didn't care what people thought of him when, in fact, he cared immensely."[50]

As the crowd thinned out, Pierre Balmain took Karl aside for a private conversation. "He suggested that I come see him in the new year about joining his team. He wants me to design his collection for the boutique. It would be what he called the 'petite collection,' better than what is in the boutiques, because it would involve two fittings. I would have to start working right away. He wants me to come into the office on Monday, before he flies to Venezuela, where he will be for the holidays."[51]

Karl suggested that he would not be surprised if other offers were to be made. Jacques Fath had died of leukemia, only forty-two years old, just a few weeks before (Karl kept several stories on his funeral). Charles Simoni, who represented the house, seemed to be interested in Karl. "Monsieur Simoni never let me out of his sight," Karl told his mother. "To go to work there would feel triumphant but also sad." He was less optimistic about the possibility of an offer from Chanel. "Because the old lady is too stupid," he announced to his mother.[52]

He also had another conversation with Sweetinburgh and Madame Norero. The IWS fashion director congratulated the instructor on having such a gifted student. "They talked about her during the presentation and even mentioned her father, so it was as good for her as it was for me," Karl told his mother. "At the Place Pereire, I will always be cited

as an example. Even if she loses me as a pupil, there will be tremendous publicity that comes from this."[53]

Karl's first fashion triumph was inseparable from his first taste of press coverage. "*L'Officiel* appeared here today," he wrote of one of the advance articles. "It's very pretty."[54] All of the French press was enthusiastic. "Three Hopes for Haute Couture," was the headline in *L'Aurore*. "These young laureates can immediately imagine the hopes of brilliant careers in the haute couture," wrote *France-Soir*.

The German press, which had been sent a communiqué in German, focused, of course, on Karl. "Sensation in Paris: A Hamburger Wins," was the headline in the *Berliner Morgenpost*. The newspaper noted that Karl was studying with Madame Norero, made the connection with Jacques Fath, and concluded with a question: "*Karriere in Paris?*"[55]

When he went home for Christmas to his parents' elegant town house at 65 Harvestehuder Weg, Karl was the subject of his first feature story. "'That was the happiest moment of my life,' said Karl to *Bild*, when we visited the young man from Hamburg, whose father is the director of the Glücksklee dairy company." Karl explained how he had always been fascinated by fashion, suggesting that when he was two years old, to the great embarrassment of his mother, he criticized the wardrobes of women who visited their house. The story announced that he would be starting at Pierre Balmain on January 3, concluding, "This 21-year-old is going to have a great career in fashion."[56]

The care that Karl took in assembling all of the clippings, the importance he placed on the photographers and newsreels documenting the reception, was proof of how significant the press reaction was for him. Overnight, he became a figure in the world of Paris couture. And success in fashion would forever be fused with media attention.

As it was happening, Karl knew that winning the Woolmark Prize was incredibly significant. He sat in his room at the Hôtel Gerson, not finishing the letter back to Hamburg until after midnight. "Basically, I am

happier than I even dared hope," he explained to his mother. "While I'm writing this, the whole thing comes back like in a film."[57]

Karl also knew that he needed to capitalize on his victory. "The I.W.S. held the same competition the year before and for two years running afterwards," he later pointed out. "But nobody knows what happened to the winners in those years."[58]

7

PUBLIC RELATIONS

I'm like Scheherazade. I know what to do to make sure that the sultan never falls asleep.[1]

IT WAS JANUARY 1995, four decades after he had won the Woolmark competition, when I first met Karl Lagerfeld. He would be turning sixty-two that year; I was thirty-three. At that point, I was the newly named Paris bureau chief for Fairchild Publications, overseeing *Women's Wear Daily* and *W* magazine, which had been, for decades, two of the most formidable and feared fashion publications in the world. The group was run by John Fairchild, always referred to as Mr. Fairchild, who had turned a sleepy, family-run firm into a media powerhouse. One of my responsibilities was going to the major houses to do a preview of the 1995 Spring/Summer Haute Couture Collections that would be presented later that month.

It was only a few minutes' walk from our offices at 9, rue Royale to the famous headquarters of Chanel at 31, rue Cambon. Once past a security guard who placed a call upstairs—the house was so much smaller in those years, simpler—our photographer and I took a tiny elevator up to the top floor. The door to the atelier was beige, with black block letters spelling out the word "Mademoiselle," the preferred title of the founder, and, below, only one word, a warning, really, *"Privé."* The door led directly into a large room with a wall of windows on the far side and floor-to-ceiling mirrors on each end. It was a matter of days before the couture collections and the Chanel studio was buzzing. Karl was sitting at his

semicircular, oversized desk, his back to the windows, wearing a black suit by Yohji Yamamoto. "I wear only black jackets, black pants, black ties, and white shirts," he explained in those years.[2] He had just started, however, powdering his hair white. Karl was a master at media relations, so, of course, he was charming from the moment we were introduced. He lowered his sunglasses, offered a warm smile and the brisk handshake favored by the French, one pump, up and down. Karl had that skill, incredibly rare, of being able to concentrate completely on the act of greeting someone, completely blocking out everything else that was around.

The room was filled with more than a dozen members of the Chanel team and those brought in for the preview: the directors of the couture ateliers, seamstresses, models, hair and makeup stylists. Introductions were made to the team. His assistant was Gilles Dufour, the designer who had been a friend of Karl's since the 1970s; tan, also wearing sunglasses, in an impeccable dark suit with a tie and pocket scarf. Victoire de Castellane, Dufour's niece, responsible for Chanel jewelry, had a sparkling personality and an irreverent style—including fetish gear that she picked up at sex shops in Pigalle—that was a great inspiration for Karl. There was music playing and the mood in the room was lively and much friendlier than might be expected—the studio did not feel like an ivory tower or a super serious laboratory of haute couture. There was some tension in the air, of course—it was the first time the new collection had been shown—but everyone seemed to be enjoying themselves. At the same time, there was a brisk efficiency about it all. And Karl, at sixty-one years old, was very much running the show.

A model walked out from behind a screen in the corner of the room, wearing one of those perfect Chanel suits. This one was black wool, with a nipped waist, strong shoulders, and skirt length just above the knee. Karl opened up the sketchpad that was always on the top of his desk and drew a quick outline of the silhouette. With just a few strokes, he was able to convey the newest line. He tore off the page and gave it to me. That season, he explained, would be practically all black. "It is not black in the sense of black," he explained. "It's black in the sense of *chic*!"

It was an absurd comment, of course. It meant nothing. And, yet, it said everything. And Karl's line flowed right onto the front page of *Women's Wear Daily*. "'It's not black in the sense of black—it's black in the sense of chic,' says Karl Lagerfeld of the spring Chanel couture collection he will unveil Jan. 24," read the cover. "That may be the leading shade at Chanel but Karl's hair has gone positively white. 'I've taken to powdering it,' he admits. It's all the better to get into his retro mood, with a new silhouette that features a longer corset, squared shoulders and a raised waist." The newspaper headline was "Taking a Powder," suggesting that, by that point, information about Karl's life could be as newsworthy as the fashion.[3]

It was the first of many occasions we had to work together. For several years, just before the couture and the ready-to-wear shows, I was the first to talk with him about what he was going to present—at Chanel, at Chloé, and at Lagerfeld—and then to explain it to the world. The first magazine story we did together, in July 1995, which he photographed, was his just-renovated apartment in Monaco (the title: "Monte Karl"). He had filled the interiors with the best French neoclassical designs from the 1940s, including lacquered daybeds by André Arbus, forged iron and marble tables by Gilbert Poillerat, a corner canapé, in a dusty rose, by Christian Bérard for Jean-Michel Frank. "I'm a frustrated interior designer," Karl said about his work on the apartment. "It's fun to play with different styles, different periods, different atmospheres. It's a very luxurious, very expensive way to play, but it's fun, *non*?"[4]

In the spring of 1996, I flew with him in his Falcon 50 jet to Hamburg to do a story on a neoclassical house he had bought, like a modernist Greek temple, in the same neighborhood where he was born. Karl photographed that story, as well. For the trip to Hamburg, we were to meet at the private airport of Le Bourget, north of Paris. I joined a group waiting for him: members of his teams at Chanel and Lagerfeld, his financial manager, his antiques consultant, and his picture framer—his team of movers, who shuffled between his various properties, were already in Hamburg at the house. Karl was notoriously tardy, so we

waited. And waited. "It's not that Karl is ever late," quipped one member of his team. "Whenever he arrives is the right time. It's the rest of us who are early."[5]

Of course, our relationship was also mutually beneficial. I represented two publications that were extremely important in his world, so it was in his interest to cultivate me. And he was the leading figure in the Paris that I covered, so it was essential that I establish a rapport with him. Nevertheless, quite quickly, Karl and I began to have a good working relationship, even a friendship. He had handwritten notes messengered over to the office, in thanks for a story or a review, with comments on the latest fashion news, or with his most recent photographs of beautiful young men. The cards were extravagant, with designs drawn by Karl and, I later learned, printed in Germany by Steidl. They arrived in large portfolio envelopes, with an oversized card inside and matching paper. He also sent enormous bouquets of flowers from Lachaume, still his favorite florist, with a thoughtful, handwritten note. It was usually clear when a bouquet from Karl arrived—the lavishness of the arrangement gave it away from across the office.

I was not, in any way, one of Karl's best friends. But I respected him, as a designer, of course, particularly for what he had accomplished at Chanel, but also as someone who was fully committed to the culture of his time. He knew everything that was going on in the worlds of art, cinema, music, photography, and design. And he had a firm grasp of history. He was also eager to share his knowledge, but, at least with a journalist, in a gentle way.

In September 1996, I worked with English photographer Miles Aldridge to do a series of previews of the upcoming ready-to-wear collections for *W*. We photographed Vivienne Westwood at work at her atelier in London, John Galliano in a café across from his apartment, and Gianfranco Ferré with a model sitting on his desk at Dior. Yves Saint Laurent was captured alone in his private office on the Avenue Marceau. He was wearing a dark pinstripe suit and his signature tortoiseshell glasses, and was looking directly at the camera. To explain the season, Saint Laurent

sighed and told me, "I've seen so many dresses in my life." He seemed to be exhausted by it all.

For Karl, we photographed him in the courtyard of Chanel on the rue Cambon, in the back seat of his Volvo, with the model-of-the-moment Kristen McMenamy. He was wearing a black corduroy suit by Yohji Yamamoto, a dress shirt, a dark tie, and sunglasses, while McMenamy was modeling next season's velvet dress for Chanel in vivid lavender. Of course, Karl came up with a sharp quote: "I should walk, but, on the streets, people always ask me for jobs."[6]

During the shoot, it was clear that Miles Aldridge, an attractive young man from London, was taken with Kristen McMenamy. Who wouldn't be: she was one of the most beautiful models in the world, with an electric personality. After we got the picture, she said goodbye to the team and started walking back into Chanel. I told Miles that he should go in and invite her to come to our last photo shoot that day, which was happening at Anahi, a South American restaurant near the Marais that was a fashion canteen. He did. She came to the restaurant. We shot a lovely portrait of the designer Martine Sitbon and her art director husband, Marc Ascoli, before all having dinner together.

That night, Miles Aldridge and Kristen McMenamy began a romance. She often said that they were a couple that began in the back seat of Karl's car. It was a racy-sounding comment that delighted the designer.

A year later, at a ceremony in London, Aldridge and McMenamy were married. Six months pregnant by that point, she wore a gorgeous Empire-waisted gown in peach chiffon designed by Karl for Chanel. He also made the trip to London, to walk her down the aisle. "It's not easy being the father of the bride," Karl said to me that day.

I began to spend enough time with him that I had a good sense of how he was when he was offstage. His public image, particularly at that time, was harsh: the somber suits, the oversized fans, the dark glasses, the bitchy bon mots. But that was not the person I saw behind the scene, and I was struck by the difference. One day, having lunch at his apartment on the rue de l'Université, I raised the subject. I told him that I had never

seen anyone who had a public persona that could be so harsh, intimidating, even unpleasant, but that once you got to know him, you discovered that he could actually be quite warm, even touching. He shot back: "Better that than the opposite, *non*?"

Karl loved to provoke. For the press, it was a role he played, meant to ensure that he was never far from the spotlight. And it worked: his constant presence in the press, his sheer quotability, helped fuel his reputation. In private, his provocations were different. They were warmer, less mean-spirited, tending to involve a little gossip, a clever turn of phrase, or were just to have a laugh. They could still, however, pack a punch.

For many years after the Woolmark Prize, Karl and Saint Laurent had been the best of friends. Yet by the time I knew them, they had not been close for years. A rupture had taken place in the 1970s, when Saint Laurent pursued, and then slept with, Jacques de Bascher, a seductive aristocrat who was the great love of Karl's life. Their affair did not make Karl jealous. His relationship with de Bascher was an emotional and sentimental one, a passionate friendship, rather than something sexual. But Pierre Bergé, the business partner and longtime lover of Saint Laurent, felt that de Bascher was a threat to his relationship and to the house that they had built. So, Bergé forced a falling-out: between Saint Laurent and de Bascher and between the two designers. It created something of a schism: two of the biggest names in Paris fashion were estranged and most felt the need to choose one side or the other. There were exceptions, but for many years, you were either on Team Lagerfeld or Team Saint Laurent.

By the mid-'90s, the great fashion triumphs of Yves Saint Laurent were behind him. The house was successful—perfect, really, in many ways—but it existed mostly on inertia and the sales of fragrances and cosmetics. One day, we were doing an haute couture preview for *WWD*

on the streets near the YSL offices on the Avenue Marceau. The model was wearing thigh-high Saint Laurent boots in crocodile and an incredibly formal checked suit. It was very elegant but overwrought. Tom Ford, who was in the midst of his rejuvenation of Gucci, the most successful repositioning of a historic house since Karl had done the same at Chanel, happened to drive by our shoot. A few nights later, I met Tom Ford and his partner, Richard Buckley, for dinner and he raised the subject. "I saw your Saint Laurent preview," he said with an arched eyebrow. "I wouldn't say that it looked particularly modern!"

Saint Laurent was barely sixty by that time but his years of alcoholism and drug abuse had caught up with him. He appeared much older than his age, moving slowly and speaking hesitatingly. His image was propped up by a circle of enablers of his various addictions, by sycophants who treated his every move as an act of genius, and especially by the pugnacious Bergé, who controlled every aspect of the designer's public persona and shot down any inquiry that might have come too close to the truth. Bergé's combativeness allowed Saint Laurent to play the suffering genius. And play it he did.

Karl, in those years, was fully engaged, and, when it came to his former friend, ready to stir things up. One afternoon, in his apartment on the rue de l'Université, Karl was holding court around a massive round dining table in blond wood. Designed by Andrée Putman, it was his version of Frederick II's round table at Sanssouci in the painting he had owned since childhood, which was hanging in his bedroom. Karl reached across the table, his own *tafelrunde*, and gave me a glossy print of an old black-and-white photo.

Taken in the '50s, it showed him at the beach in Deauville, at the height of his bodybuilding phase, with the model Victoire Doutreleau, who had been hired personally by Christian Dior and was considered, by many, to be one of the first supermodels. I later learned that the photo was taken in the summer of 1956, meaning Karl was twenty-three years old at the time and working at Pierre Balmain.[7] He was standing on the right of the frame in profile, wearing a skimpy dark swimsuit. Victoire,

who was twenty-three, was in the center, wearing a polka-dot bikini, her hands behind her back, smiling, with her eyes fixed on the camera. The beach extended all around them and behind were the half-timbered buildings of Normandy. It was a striking image, one that I had never seen. When I told Karl how much I liked it, he suggested I go into the next room to see the original on the computer.

The photo had been taken on a weekend getaway to Deauville with Karl, Victoire, Yves Saint Laurent, and Anne-Marie Muñoz, who managed the studio for Saint Laurent throughout their long careers. In the '50s, '60s, and into the '70s, the four were the best of friends. They went to the same restaurants, the same clubs, were members of the same social set. In 1963, when Muñoz had her son, Carlos, she asked Karl to be the godfather.

After he handed me the photo from Deauville, I went into the next room in Karl's apartment, a massive salon that had been converted into a photography studio. The floors were wood parquet, while the ceiling, very high, was covered with ornate swirls of white plaster moldings. I relayed what Karl had said to his assistant. Working on one of those unwieldy computers of the time, he located the scan of the old photo. It turned out that there had been one major alteration to the lovely scene in Deauville. Karl had asked that it be retouched. In those days, Photoshop was far from ubiquitous, so reworking the photo required effort.

On that sunny day at the coast, there had actually been three people in the frame. In the original, just to the left of Victoire, sitting on the beach, was Yves Saint Laurent. On the print that Karl had given me, where Saint Laurent had been, was nothing but a mound of sand.

8

HIGH FASHION, ENTRY LEVEL

Two collections a year is not enough for a young man of 20. However, as my contract did not allow me to do anything else, I decided to enjoy life. I travelled, I drove around in flashy, drop-dead cars, I was tanned all year round, I nightclubbed non-stop. In fact, I did all the stupid things you can do at that age and I am now very glad I did—it is better to be silly at 20 than after 40.[1]

THE HOUSE OF PIERRE Balmain was located at 44, rue François Premier, in the Right Bank neighborhood known as the *Triangle d'or*, or the Golden Triangle. Bordered by the Champs-Élysées, the Avenue George V, and the Avenue Montaigne, the district had been a destination for fashion and luxury since the turn of the twentieth century. The headquarters of Christian Dior was just down the rue François Premier, at the corner of the Avenue Montaigne. Balmain was a significant couturier but Karl felt that there was certainly a gap between the two. "But I told myself that I was at Balmain to learn a job and not to criticize. I felt that I had better stay there and learn, which I did."[2]

Pierre Balmain began his career with Lucien Lelong, where he also met Christian Dior (in fact, it was Balmain's talk of launching his own house during the war that inspired Dior).[3] He opened in 1945, with the help of a team of seamstresses from Balenciaga who shared his architectural view of design. Like many French couturiers, Balmain sought to

elevate high fashion. "There is a great connection between the role of architect and that of couturier," Balmain explained in 1950. "That one builds in stone and the other in mousseline, that one tries to span centuries while the other is concentrated only on a season are not essential differences."[4]

Karl's time at Balmain did not begin in the most promising way. On his first day, at the beginning of January 1955, it was pouring rain and difficult to get a taxi from the Hôtel Gerson. Once he made it to the rue François Premier, he found the mood to be as dismal as the weather. "If that is fashion, I thought, I better go back and finish high school," Karl later explained of his introduction to Balmain. "Today, nobody would accept the work conditions and the money we had to accept at that time. It would be illegal today."[5]

Karl was shown to his office with four other people, who were drawing away. His first task was to create portfolios for the Balmain clients, laborious work that turned out to be important for his development as a designer. "At that time, you had to draw every design for the clients—all of the forms, the embroidery, the flowers, etc. That is why I know how to draw clothing so well. To be able to show every detail, every stitch, required real discipline. Today, with computers, many young people have not learned that, but making all of those albums was such a pain."[6]

Karl was not particularly thrilled with the couturier, either, who, though he was only forty-one years old, seemed, to the twenty-one-year-old, a thing of the past. "Monsieur Balmain was young at that point, but he seemed ancient to me," recalled Karl. "He dressed very conservatively, he was pretty plump, and he was very much a snob. He was a couturier but he looked more looked like a French businessman."[7]

Balmain may have been able to pass for an elegant banker but he also had a wild side. At his villa on the banks of the Seine northwest of Paris, at 32, quai de l'Ecluse in Croissy-sur-Seine, he had parties that were filled with young men. "It was a marvelous villa and he collected Art Nouveau," recalled Peter Bermbach, a German journalist in Paris who knew Karl beginning at the time when he was working at Balmain.

"Mr. Balmain liked young, beautiful boys, and I was not so unattractive, so he invited me to his dinner parties," Bermbach recalled. "There were about 20 young men and there was always one that he disappeared with at the end. He would make an outfit for him out of paper, then he would come back to the table, dance, and remove everything until he was naked and everyone would scream—it was very degenerate and very fun!"[8]

Karl was not included in these wild gatherings. "He was never invited because he worked for the house and Monsieur Balmain made sure there was a schism between his work and personal life," Bermbach said.[9] It was no secret that the couturier was gay, although there were some around the house who preferred to not see the reality. "He had a mother who was pretty frightening," Karl remembered. "One day, she was talking to the sales staff and said, 'If ever I hear that my son is a homosexual, I'll kill him.' And there was this *vendeuse*, an old Russian princess, who said, '*Ready, aim, fire!*'"[10]

As Karl began working at Balmain, he finally, after two and a half years, moved out of the Hôtel Gerson. His new apartment was at 32, rue de Varenne. In the heart of the aristocratic Faubourg Saint-Germain, he was just down the street from the Hôtel de Matignon, the eighteenth-century mansion that is the home of the prime minister of France. Positioned at the corner of the rue de Varenne and the rue du Bac, a chic commercial street, it was one of a pair of eight-story modern structures that had been built in 1935. Karl was disappointed not to be in an eighteenth-century apartment, but he was fortunate to have found a penthouse duplex in a building that had an uninterrupted perspective of the city. "It had a marvelous view of Paris, with the Eiffel Tower, Sacré Coeur, and the Arc de Triomphe," Karl recalled. Even at home, he had a fashion connection. "The landlady, a former haute couture saleswoman, kept a closer watch on me than Madame Zapusec in the rue de la Sorbonne."[11]

The team of four that Karl was a part of at Balmain worked on a boutique collection called Florilège. "For a kid who has just landed, it was not bad," he once explained. "It was clothing that was a little '*jolie madame*' [pretty lady]. Somewhat less expensive, it was the fashion of the

times with tight waist, spencer jackets, and skirts."[12] His first job also presented his first opportunity to advance. In order to make that happen, Karl suggested that he could be somewhat Machiavellian. "I did everyone's work so that they could leave when they wanted. Then, it was clear that I was the only one who was working and that they did absolutely nothing. Six months later, all of the others were pushed out and I was in charge."[13]

Karl also made friends in the house, including English model Bronwen Pugh. Known for her somewhat haughty presence on the runway, Pugh was a muse to Balmain, who considered her, along with Vivien Leigh, Greta Garbo, and Marlene Dietrich, one of the most beautiful women in the world. In 1960, she married Viscount Bill Astor, becoming Bronwen, Lady Astor, and moved into the family's famous Cliveden estate (where, within a few years, she and Lord Astor would be swept into the Profumo affair).[14]

Pugh got on famously with Karl, seeing him often socially and even inviting him to the apartment she shared with other models. "Karl was the principal assistant to Pierre Balmain, which meant that one of his dresses might be included in the collection but most of the time, he was feeding him with ideas," Bronwen Pugh later explained. "I remember so well that he said one day that he would be rich and famous. We just laughed."[15]

Quite quickly, though, Karl's profile within the house increased. In July 1955, the Hungarian-born actress Zsa Zsa Gabor breezed through Paris and made a stop at Balmain. She had recently starred in John Huston's *Moulin Rouge*, set in the famous dance hall in nineteenth-century Paris. Gabor traveled with her fluffy dog, Suzy Smith, whose handler and personal chef, Victor, had been passed along to her by the notorious Dominican playboy Porfirio Rubirosa. Gabor was known for her flair with hats, and, at Balmain, she tried on a dozen different styles before choosing one that had been designed by Karl. It was made of an elegant gray fabric, trimmed in black, with, under the brim, natural straw. She was then photographed on a bridge that was meaningful for designer and

client. "A pilgrimage to this beautiful Pont Alexandre III, which holds so many memories for me, including the filming of *Moulin Rouge*," Gabor told a French film magazine, wearing a dark suit and white gloves, and modeling her straw hat by Karl.[16]

Karl was in his second year working at Balmain, while Yves Saint Laurent, who had finished his school at the Chambre Syndicale, was trying to find his way into Paris fashion. His father, Charles Mathieu Saint Laurent, back in Algeria, was in contact with *Vogue*'s Michel de Brunhoff, telling him of his son's talent and imploring him to help with his career.[17] In March 1955, thanks to the introduction by the *Vogue* director, Yves Saint Laurent was hired by Christian Dior.

Another important figure on the Avenue Montaigne was the model Victoire Doutreleau, née Jeanne Devis. She, too, had a letter of introduction to Christian Dior from Michel de Brunhoff, hers in the summer of 1953 when she was just nineteen years old. She was petite, busty, and extremely beautiful, with short, dark hair and fine features. Not only was she more voluptuous than most couture models, she was also very irreverent. Staff at Dior, on her first visit, seemed doubtful that she could be a model. Introduced to Monsieur Dior, however, before she could even show her letter of introduction from *Vogue*'s Brunhoff, she was immediately hired.

"And what is your name?" Dior asked.

"Jeanne," she replied.

"From now on you will be Victoire," he announced.

"I was taken aback," she wrote in her memoirs. "I thought that I saw a twinkle in his eye but it was also a challenge."[18]

And she rose to the occasion. Almost immediately, even though she was often the subject of sniping from fellow models and the fashion press, Victoire became the star model at Dior. She entitled her memoirs *And Dior Created Victoire*. By the time Saint Laurent began there, she was

one of the best-known models in Paris. Noticing which designs were by Saint Laurent, she struck up a friendship with the shy newcomer. Even though, as Victoire recalled, "models rarely had dinner with designers," she drove him in her snappy Renault Dauphine out for a supper in Saint-Germain-des-Prés.[19]

In the summer of 1956, Victoire was having lunch at the Bar des Théâtres, a legendary restaurant with a terrace on the Avenue Montaigne, across from the Théâtre des Champs-Élysées. That day, Karl was lunching with Bronwen Pugh, who introduced him to Victoire. "Karl exclaimed, very loudly, forgetting about everyone who was lunching at nearby tables, 'But of course I know of Victoire—who doesn't?'" she recalled. "Then he sat close to me and, lowering his voice, said, 'We don't care what people think, do we?'"[20]

When he was not working at Balmain, Karl already had an active social life. "When we went out, it was to nightclubs," he recalled of those years. "L'Éléphant Blanc had a band that rotated. They would play jazz for 30 minutes, then South American music—because I specialized in South American dance."[21] Having studied when he was a child, Karl loved dance and was quite skilled. He took lessons at Georges & Rosy, a school near his apartment on the rue de Varenne.[22] "At the time, I was really into the Cha Cha, merengue, and the waltz," Karl once said. "I spent my nights dancing: at Macumba, the White Elephant, and then, later, in a club that was somewhat gay, on the rue du Cherche-Midi, Le Fiacre. It was all so fun."[23]

Very quickly, Karl brought Victoire and Saint Laurent along. The Dior designer also introduced Anne-Marie Muñoz into the circle, making for quite a fashionable foursome. "Both Yves and Karl had such strong personalities that I forgot that they were not really known," Victoire recalled of those early days.[24]

One evening, as everyone clocked out at Dior, Karl met them at the entrance to the house.[25] He was driving a convertible Volkswagen, a Christmas gift from his father, which Karl had painted a dark blue.[26] After the four had dinner in Saint-Germain, they went to Le Fiacre. As

the four friends entered, they were immediately spotted by the owner of the club, Louis Baruc, also known as "Loulou," or even "Louise." *"Ah, Divine—here's La Divine,"* Baruc exclaimed about Victoire.

"It was not easy going upstairs," she recalled of their first trip to Le Fiacre. "You had to keep your elbows in and try to make your way between men in leather jackets. Luckily, Louis, very attentive and good at his business, was quick to take care of new arrivals. As he shouted *'Divine,'* the crowd parted and he saw me flanked by Yves, Karl, and Anne-Marie. *'Victoire, La Divine,'* he continued. 'Quick: find a table for the *Divine Victoire!'"*

The upstairs area at Le Fiacre, which attracted a more mixed crowd, had banquettes along the walls, tables and chairs, and a small dance floor. It was lit by old carriage lamps and had drawings by the Belle Époque caricaturist Sem. The four squeezed into a booth. Karl sat with his friends, watching the scene and drinking his favorite, Coca-Cola. Saint Laurent seemed a little restless, so Karl suggested that they go to L'Arlequin, a gay disco in Pigalle. "I had never been there and wondered how Karl knew it and with whom he had gone," suggested Victoire. They made a final stop at L'Epi Club, a tiny disco on the Boulevard du Montparnasse, owned by nightlife impresario Jean Castel, where, in September 1960, the director Roger Vadim would discover a seventeen-year-old Catherine Deneuve (and her equally stunning sister, Françoise Dorléac, who became a friend of Karl's).[27] They finished the night at 4:00 a.m.[28]

By 1957, Karl had moved from his modern duplex on the rue de Varenne to 31, rue de Tournon, a historic building right at the entrance to the Palais du Luxembourg and the park. "My own apartment and, at last, an 18th century building," Karl recalled. "Nobody keeping an eye on me anymore—I could finally do what I wanted."[29]

That year for Mardi Gras, Karl, Victoire, Saint Laurent, and Madame Muñoz were back for a night at Le Fiacre. Though they were not in costume, many clients that night were in drag. As the piano played, some danced the Charleston and the Boston.

Just before 4:00 a.m., the four piled into Karl's Volkswagen. He drove slowly back to his place on the rue de Tournon, where Victoire had left her car. Thinking that it would be best if no one else drove, they decided to have a sleepover at Karl's. "I loved his apartment," Victoire wrote. "The salon was huge, with high ceilings, piles of books on small tables that cluttered up the room, and an old Turkish rug. We each chose our places, taking seat cushions to use as pillows. Heavy double-lined curtains let in a mauve light, enough to make it clear that it was no longer night."[30]

Between the friends, there were plenty of quiet moments. One morning, Karl invited Victoire to the Ritz. "'I love having my breakfast at the Ritz,' Karl said to me, with the satisfied look of a cat that has finally found its place in the sun," Victoire remembered.

She raised the subject of Coco Chanel, mentioning that the great designer was living there in the Ritz. "Yes, but I don't know her personally," Karl replied. "At Balmain, they say that she has always been something of a monster. She has always been chic, with a real allure, but any kind of sexiness has never interested her at all. In fact, she must hate the word sexy!"

At the end of their breakfast, Karl presented Victoire with a gift on drawing paper that was rolled up like a scroll. When she unrolled it, she discovered an ink drawing that he had made, showing her in a series of the most important styles from the past century. "I was stunned," Victoire recalled. "There was an elegant figure from the Jockey Club, the courtesan from *Camille*, designs that went from the nineteenth century up until the little black dress by Chanel in 1925." The title he gave the illustration: *Victoire Throughout History*.[31]

Six decades later, in March 2020, Victoire Doutreleau was sitting in her Paris apartment on the rue de Verneuil, in the Faubourg Saint-Germain. Still beautiful at eighty-six years old, she was wearing a black

cashmere sweater, a trim pair of black pants, and high-heeled, black leather ankle boots.

She showed me around her apartment, pointing out several photos of her with Karl and the drawing that he had given her that morning at the Ritz. "Karl did not really distinguish between men and women," Victoire explained. "He did not have an enormous sexual appetite, which can happen—not for men or for women. But he did have for me—and that mattered. It caused some drama with Yves at the beginning but I was with Yves at Dior and I went with him when he started his own house. But it was a different kind of story."

I gave Victoire a print of the photo that Karl had given me, of the two of them on the beach at Deauville in 1956. It was an image that she had never seen. "Not bad, right," she said with a laugh as she studied her younger self. "Models were not usually made like me—they could wear clothes but they did not necessarily look like that in a swimsuit!" The scene brought back the tenderness that she felt she and Karl had enjoyed throughout their lives. "Karl really loved that woman," Victoire told me. "I can't speak of me, I mean that woman, there in that photo. He really loved her. Yves loved her because he could put his clothing on her. It was a relationship between a designer and a model. But Karl really loved that woman."[32]

In the years when they first became friends, Victoire saw how Karl's cultural interests were a part of his life. "He was curious about everything," she wrote in her memoir, "the latest jazz record, a new hit by Elvis Presley, his choice of the best version of an opera, an unusual object, or his collection of art books. He was discreet about his work but I had recently learned from Éric Mortensen, the right-hand man of Pierre Balmain, how much Karl was appreciated for his talent."[33]

Karl's work for Balmain, creating the Florilège line for the boutiques, advanced nicely. It was a chic, wearable collection, falling between haute

couture and what would become known as ready-to-wear. For Spring/ Summer 1958, Karl produced a look that was just right for its time. For day, he made a mauve and white suit, with a narrow skirt just below the knee, a trim short-sleeve top, and a matching light wool coat, or a schoolgirl shirtdress in tartan mousseline with white collar and cuffs, and a short-sleeve day dress, in black and white polka dot, with a full crinoline skirt below the knee. Florilège also contained such spectacular evening looks as a white bustier gown with a floor-sweeping skirt in ruched white tulle. The collection was also photographed, fully accessorized with gloves, hats, jewelry, and shoes, and displayed in settings that complemented the design, from a library with shelves filled with books to a garden with walls covered with ivy and ancestral portraits in oval frames.[34]

Karl felt that he had an easy working relationship at Balmain but, as he had sensed from the beginning, there were elements at the house that were less than ideal. "Behind the doors of the salon, it was quite horrible, quite sordid, people were quite mean," he later explained. "In those years, people in fashion had big social complexes. So, they wanted others who were under their orders to pay for their social complexes."[35]

He also felt like it was time for him to become a couturier. In October 1957, Christian Dior died suddenly of a heart attack, and Yves Saint Laurent, famously, became his successor, presenting his first collection in January 1958. By the spring of that year, Karl was ready to move on from Balmain. So, after three and a half years, on May 31, 1958, Karl left the rue François Premier. "I was a little sick of Balmain. It wasn't even about the money. I just didn't want to be there anymore. I had seen how miserable his secretary was—that was enough."[36]

For the 1958 Fall/Winter Haute Couture Collections, which premiered at the end of July, Karl Lagerfeld showed his first collection

for Jean Patou, considered one of the great couture houses, launched be-
tween the wars.[37] The twenty-five-year-old designer wore a very classic
dark suit, with a white shirt and a dark tie. He stood backstage as the
models swept through the couture salons, a series of rooms in succes-
sion, *en enfilade*, with high ceilings, parquet floors, white wood paneling
with gilded moldings, and white marble fireplaces topped by mirrors
that went up to the ceilings. The models walked in silence through the
perfectly proportioned rooms, holding numbers, as each outfit was an-
nounced, with a title of the ensemble and a full description. Clients and
select members of the press sat on gilded Napoleon III chairs. "It is a
nerve-racking day for Karl Lagerfeld as he shows his first collection,"
wrote *Paris Match*. "Le Tout Paris is at Patou."[38]

While the house of Jean Patou had opened in 1914, because of World
War I, it did not present its first collection until 1919. The eponymous
couturier was a dashing figure in early twentieth-century Paris, said to
have had affairs with the actress Louise Brooks and the champion tennis
player Suzanne Lenglen.[39] "Tall, thin, beardless, clenched teeth, burnt
chestnut hair slicked back, light eyes, and a tight silhouette, Monsieur
Jean Patou is impeccably bred," suggested one French magazine in 1924.[40]

Patou had died in 1936, only fifty-six years old. And the house was
continued by the designer's sister Madeleine and her husband, Raymond
Barbas, who had been running the business with Patou since 1922. For
decades, the house had been buoyed by its best-selling scents, while
Barbas hired outside designers to produce the collections. And it was
Patou's sister and brother-in-law who hired Karl just as he left Balmain.
"In 1958, some of Patou's past splendor remained," Karl recalled. "And
Raymond Barbas and his wife, who was Jean Patou's sister, were abso-
lutely adorable, like parents."[41]

Patou's headquarters was at 7, rue Saint-Florentin, an imposing
eighteenth-century building just off the Place de la Concorde. It was a
classic haute couture house, with salons, administrative offices, ateliers,
and fur ateliers. Patou, most importantly for Karl, was connected to the
great tradition of high fashion. "That is where I really learned how to

be a designer," he explained. "There were still *premières* in the ateliers who had worked in the '20s and '30s, who knew fabrics and everything. At the time, people did not retire at 60—there were still *premières d'atelier* who were 75 years old, and who were better than those who were young."[42]

Patou turned out to be good training for Karl. "I met people there who had mastered the techniques of the 1920s. Most workers in the big houses had been taught the techniques of Dior, after the War, with the somewhat stiff feel of the New Look, reminiscent of the corsets by Charles Worth from before World War I. At Patou, there was still Madame Alphonsine, who had known Patou and who taught me the technique and the silkiness of the bias cut. Monsieur Gabriel taught me everything about fabrics."[43]

Karl felt that the pace of the couture collections was not very demanding. "We didn't do much," he said decades later. "We had two collections per year, each with 60 designs. Today, I do three times as much in one month. So, I was a little bored there and it was the perfect time to learn. Also, they had kept everything: fabrics, samples, etc. So, I could study it all—those women really taught me a lot."[44]

When discussing his time at Patou in January 2000, Karl noted that Saint Laurent was the only other designer who had that connection with fashion history. And he explained why, even in the new millennium, it continued to be important for his work. "When someone in the atelier has a difficult time making one of my designs, even though I have never sewn, it is up to me to find the solution in three seconds. Otherwise, you completely lose respect in the eyes of the *première d'atelier*."[45] Learning the decades-old techniques at Patou allowed Karl to be more inventive in his designs and also gave him credibility in the eyes of his teams.

There was another amusing element of Karl's education at Patou: he began to learn the colorful language of the atelier seamstresses. Madame Alphonsine, the *première d'atelier* who had begun her career before World War I, spoke in very evocative ways that Karl used for the rest of his life. One expression was, "*Gentil n'a qu'un oeil,*" suggesting that people who are too nice are not to be trusted.[46] Another, which Karl

adored, came from the time before indoor plumbing was common and the contents of chamber pots were tossed out of windows into the gutter. When a piece of haute couture fabric was cut perfectly on the body, Madame Alphonsine would exclaim, "*Ça tombe comme une merde du sixième*," or, "That falls like a piece of shit from the top floor."[47]

"It wasn't all sweetness and light," Karl recalled with a laugh. "But that was the language of haute couture. And it was very funny."[48]

Moving from Balmain to Patou, becoming a couturier at twenty-five, was a major advance in Karl's career. His work was reviewed with all of the other couturiers. For that first collection, critics were mixed. The French daily *Le Figaro* noted, "There are important technical details that create this silhouette, secrets of a very knowledgeable cut."[49] Much of the international press was less convinced. "Pleasant but unprovocative presentation," was how the *Los Angeles Times* described Karl's debut.[50] Eugenia Sheppard in the *New York Herald* found what Karl had dubbed the "K Line" to be completely uninspiring. "As far as I'm concerned, the place for the alphabet is strictly in the soup."[51]

Some opposed Karl's work at Patou with Saint Laurent's "Trapeze Line," which he had introduced at Dior in his first collection in January. The headline of one daily was "Patou Introduces the Anti-Saint Laurent." Karl, however, disputed that take. "I am not at all the anti-Saint Laurent," he told the journalist. "We are still very close friends. It is true, though, that we don't ever talk fashion."[52] Karl had to correct another French journalist as well. "Saint-Laurent and I see each other a lot. We tell one another stories, which I hope are amusing, but we never chat about chiffon!"[53]

Karl's new job at Patou provided him a much larger salary and a better standard of living. He had spent only one year on the rue de

Tournon, next to the Luxembourg Gardens, before moving, in 1958, to 19, rue Jacob, still in the 6th arrondissement. It was another handsome eighteenth-century stone building, set back from the street.[54]

His parents also bought him a much more glamorous car: a Mercedes 190 SL convertible. The two-seater was low to the ground, with a sleek design: streamlined fenders at front and back, round headlights, and, in the center of the grille, a large Mercedes star in chrome. Karl's 190 SL was cream colored with a red leather interior. "There was only one of this type in all of Paris," he recalled. "It made me famous all over town, everyone knew who was coming."[55] With a flashier new car, and his body toned from working out, Karl was again taken for some kind of gigolo. "Many suggested that I must have been a kept man," he said decades later. "But not at all. Actually, I have the mentality of a gigolo and a sugar daddy at the same time."[56]

By 1959, his first full year at Patou, Karl moved into a new apartment at 7, Quai Voltaire, a spectacular eighteenth-century building overlooking the Seine, directly across from the Louvre. His apartment was in the back of the courtyard, in a small town house on the ground floor. Although Karl saw only the courtyard from his place, he loved the location of the building. "It was the most beautiful view in the world, for me, at the time, of the Seine and the Louvre."[57]

The German journalist Peter Bermbach visited him often there. The apartment had high ceilings and a stairway that went up to a sleeping loft that was lined with black-and-white fabric. Both levels were filled with books and hundreds of records, 33 rpm vinyl, mostly classical and opera. Feeling that he had little reason to leave, Karl referred to his new place as his "Oblomov Room," after the protagonist of a Russian novel, Ivan Goncharov's *Oblomov*, which satirizes the cloistered lives of the nineteenth-century Russian intelligentsia.[58]

Whenever Karl appeared in the little house in the courtyard, he made an impression. Also living there with her Anglo/French parents was an eleven-year-old girl, Colombe Pringle, who would go on to be a leading French journalist and editor in chief of French *Vogue* from 1987 to 1996.

She noticed what seemed like a parade of beautiful women to visit Karl. "There were these very, very tall girls, who arrived with these big port-folios, which I later understood were their look books," Colombe Pringle recalled. "And they would scream through the window, *'Karl!'* He would stick his head out, open the door, and let them in."[59]

Karl had a cordial relationship with her parents, who invited him over for a drink, occasions when the children were expected to say little more than *Bonsoir*. Her youthful impression was that he was charming but she also noticed that he was more outlandish than most. "My governess referred to him as *La danseuse*," Pringle recalled, using the term for a female ballet dancer, which can also imply a kept woman. "I was always looking out the window to see him dance," Pringle said. "I understood later that it was because of the way he walked and that he sometimes gestured in ways that seemed feminine."[60]

Five decades after Karl lived in that building, in 2008, he bought his own apartment at 17, Quai Voltaire. He went on to turn it into a futuristic atelier—all chrome, black and white, and mirrors—filled with the most important examples of French and European avant-garde design. His new apartment, with its walls of art books and tables covered with iPad charging stations, had spectacular views of the Seine and the Louvre. "When he bought that apartment, he called me and said, 'I'm going back to the Quai Voltaire,'" Pringle recalled with a laugh. "It was not the same building but he was thrilled to be back where it had started, like closing a loop. 'That's fantastic,' I said to him. 'And now you'll also have the view!'"[61]

In those early years of his career, Karl had one surprising encoun-ter that he remembered throughout his life. In 1956, when he was still at Balmain, he and Yves Saint Laurent had an outing to the 9th arrondissement of Paris.[62] "I went with Yves to see a psychic, Madame Zaroukian, who was very popular," Karl recalled in a 2015 interview

on French television. "She lived on the rue de Maubeuge, on a mez-zanine that was fake Louis XV. She was originally Turkish, with big turquoise eyes—an enormous woman, but fascinating. And everything that she told me would happen has happened. It's really incredible."[63]

Madame Zaroukian read tarot cards with what Karl felt was stunning accuracy. When she met with Saint Laurent, according to Karl, she told him, "It's all very good but it is going to end pretty soon."[64] It seems unlikely that a psychic would deliver such a verdict but that was Karl's version of the story.

When it was his turn, her comments, though cryptic, were more en-couraging. "She said, 'Your success is in the future. I see everything mul-tiplied by thousands.' In fashion, that means ready-to-wear but at that time, the term wasn't even invented. She said, 'I see books, and books, and books. I see images, and images, and images.'" Much later, Karl felt that it was clear that her observations predicted his move toward ready-to-wear, book publishing, and photography. "It didn't mean a lot to me at the time, but everything she predicted is everything that I do today, in a way that is so specific that it is almost frightening."[65]

Karl once suggested, in 1984, that Madame Zaroukian had even char-acterized the nature of his personality. "I play, work incessantly, do for the sake of doing, and have no family," was her assessment. "I am a kind of adventurer who wants to forget the past by reinventing themselves ev-ery day."[66]

Karl was open to the idea of psychics and astrology. He identified, when the subject came up, as a Virgo, with Sagittarius rising.[67] And he maintained contact with Madame Zaroukian throughout the 1990s. "The last time I spoke with her, I was in my car with my accountant and my chauffeur, so there are witnesses," he explained. "There were phones in the car then, not like cell phones today, and the phone rang. She said, 'You are on Avenue Paul Doumer, and you are going to see your lawyer on the Avenue Suffren.' That was true. 'You're going to sign a contract—it's not amazing but you can go ahead and sign. But on the 7th page, there is a mistake and it could do you harm.' I hung up and thought that was

absurd. But it turned out that there was a typo on the 7th page that was not to my advantage. When I tried to call her back to thank her, she was dead."[68]

On his first visit to Madame Zaroukian, what struck Karl the most was her conclusion. It, too, was a prediction that made little sense at the time. She told him, "For you, everything will really begin once it is ending for everyone else."[69]

9

CHLOÉ AND FENDI, ANDY AND ANTONIO

I invented a completely new profession: freelance designer.
It has allowed me to have a complete sense of freedom and
invulnerability.[1]

KARL SPENT FIVE YEARS at Jean Patou, producing beautiful, elegant haute couture. His second collection, for Spring/Summer 1959, introduced a bust in the form of a fan. A very young Carrie Donovan at the *New York Times* noted that the new season had earned wild applause. "Karl deserved it all," Donovan wrote in the *Times*.[2]

By the fall of 1960, Yves Saint Laurent was having a nervous breakdown in a military hospital after being forced to complete his military service, while Marc Bohan was named as his replacement at Dior (Saint Laurent, with Bergé, would start his own haute couture house in 1962).[3] The first years of the new decade witnessed great excitement coming out of newer houses such as Pierre Cardin, which had begun in 1950, and André Courrèges, begun in 1961. Leading Paris designers were hurtling toward the future, with Cardin doing a line of luxury ready-to-wear for the department store Printemps, starting in 1959, and unveiling a couture "Cosmonaut" collection for 1962, and Courrèges using a graphic, architectural approach to white miniskirts, white pants, and matching patent boots.[4]

Although Karl had built a loyal couture clientele at Patou, and was often doing thirty client fittings per day, he was not connected to the

new mood in Paris fashion and he was not feeling challenged in haute couture. "The atmosphere was too traditional," he remembered two decades later. "Tradition is a good thing, but it must remain alive. You have to inject some life into it or it just becomes a respectable habit, something negative."[5]

There were plenty of reasons for Karl to stay at Patou. He was just shy of his thirtieth birthday, he was the couturier for a major house, and he was living the life. "I had nice cars and lots of holidays," he later recalled. "I was a ballroom dancing champion. It was fun. But it was only two collections a year, of sixty dresses, and I was bored."[6]

After the Spring/Summer Haute Couture Collections shown in January 1963, Karl left Patou. He would not return to the rarefied world of haute couture for two decades.

Karl quickly became a prolific free agent, lending his design talents to a host of French, Italian, and Japanese firms. It was the year he turned thirty and, having worked at couture houses for the past seven years, he sensed that the world was changing. The great societal shifts of the 1960s were just around the corner.

Within a matter of months, Karl had joined a team of designers at the up-and-coming ready-to-wear house of Chloé, founded in 1952 by Gaby Aghion, who hailed from a cosmopolitan Jewish family in Alexandria, Egypt. She and her husband, Raymond Aghion, who became an art dealer, moved to Paris shortly after World War II, when both were still in their twenties. Gaby Aghion was bright eyed, very independent, and filled with energy. "When she arrived in Paris, it hit her forcibly that the young, healthy girls with light summer clothes she'd seen playing in Egyptian sports clubs looked much better than the drab, bourgeois women she saw in the streets of postwar Paris," wrote English fashion journalist Sarah Mower, who has studied the history of Chloé. "She saw her opportunity."[7]

Making the rounds of Paris haute couture houses, Aghion was underwhelmed. She appreciated the rigorous suits of Jacques Fath but was horrified by the froufrou and plunging necklines at Christian Dior.[8] She also realized that there was a huge gap between haute couture and the modest shops or dressmakers who copied patterns. Her friends had spotted her natural, casual style and encouraged her. "They were all saying, 'You must do something,'" Gaby Aghion recalled. "Suddenly, I did some cotton dresses for summer—very pretty, in poplin, a pale Oxford blue I like very much, midnight blue, berry pink, beige, black, and white. I only had one shape—six colors—but everybody loved them!"[9]

She borrowed the first name of one of her friends, Chloé Huysmans, hired seamstresses from the couture house of Lucien Lelong, which had just closed, and turned a maid's room in the couple's apartment into an atelier. Chloé became one of the first French lines of deluxe ready-to-wear.

Beginning in 1957, when Karl was at Balmain, Aghion showed her collections in morning presentations in Left Bank cafés: Café de Flore, Brasserie Lipp, and Closerie des Lilas. Instead of staid presentations in formal couture salons, these were little fashion happenings. "The press sits around at tables drinking café au lait and munching croissants while the models weave in and out of the tables," noted the *New York Times*.[10]

By 1958, Aghion realized that she needed to be working with designers in order to move Chloé forward. She hired a team of young creatives, including Gérard Pipart, who had been at Dior; Christiane Bailly, who had been a Balenciaga model; Graziella Fontana, an innovative Italian designer throughout the 1960s and 1970s; and Maxime de la Falaise, a chic English aristocrat and former Schiaparelli model (and mother of future Yves Saint Laurent collaborator Loulou de la Falaise).[11]

Karl joined the team at Chloé in 1964, quickly proving himself to be a talented designer and a hard worker. By the following year, Karl had done so well that the first credit, "Karl Lagerfeld pour Chloé," appeared in French *Vogue*.[12] By 1966, he eclipsed everyone else and became the

house's lead designer.[13] "Lagerfeld proved to be such a prolific collaborator that when Graziella Fontana and the other designers eventually departed, he was alone with Gaby Aghion in the studio," wrote Sarah Mower. "She encouraged him to invent, providing his creations were commercially relevant. His talent for blouses—beautiful things with poet sleeves and high, ruffled necklines that first surfaced in the pages of British *Vogue* in 1967—became a moneymaker for years."[14]

Aghion noticed how Karl kept his eyes open for ideas. One night, driving him back home after a long work session, she saw him observing the way students were dressing in the streets. As the Chloé founder explained, "He would take the students' ideas and then translate them into something beautiful."[15]

Karl's work for Chloé was certainly noticed. "At the house of Chloé, Lagerfeld invented the concept of *prêt-à-porter de luxe*, which put Paris ready-to-wear fashion on track," noted fashion critic Suzy Menkes.[16] In 1969, after Karl designed a Chloé collection inspired by the sensuous lines of Art Deco, *WWD* characterized him as the most original ready-to-wear designer in Paris.[17]

One meaningful encounter that Karl made at Chloé was Anita Briey, a seamstress who had begun her career as an apprentice at Chanel in 1955 at the age of sixteen. Briey's years in the suit atelier on the rue Cambon, though excellent training, were severe. Mademoiselle kept her distance from the staff, while, in the studios, all were required to work in complete silence. In 1966, when Briey joined Chloé, it was as though the world had gone from black and white to color. The offices by then were on the Right Bank, in the area known as the Faubourg Saint-Honoré, on the rue La Boétie across from the Church of Saint-Philippe-du-Roule. Karl would pull up in his convertible, wearing the latest '60s styles such as tight white jeans and printed shirts, or, by the mid-'70s, sporting a dark beard, a monocle, and a cape. "It was quite a show at the Place

Saint-Philippe-du-Roule," Briey remembered with a laugh. "For us, he was pretty eccentric, arriving in his convertible with a honk of a horn. He would stop by Dalloyau, an excellent bakery on the corner, to buy pastries for everyone in the atelier—there were about 10 of us. We had a plate for him next to ours and he would have a few bites and sit there and chat. We were mad about him."[18]

Karl, whose office was right next to the studio, made a point of coming in every day to talk with the seamstresses. Karl could speak so quickly that Briey often had difficulty keeping up. "Sometimes, I would turn to the atelier and say, 'I didn't fully understand what he said,'" Briey recalled with a laugh. "But looking at his drawings, you understood immediately. He was the king of detail. Drawings at the time were relatively simple, little dresses that slid over the body, sweet little minidresses. He would often draw next to us. And though he could toss off a basic sketch with lines that showed a shoulder or a sleeve, when he did more detailed drawings, they were just amazing, showing perfectly how the bust is cut, or any darts around the chest. Everything was just perfectly clear."[19]

That way of working was completely different from her training under Coco Chanel. "I can tell you that in my almost 11 years at Chanel, that I never saw one fashion drawing," Briey said. "Not one! I don't even know if Mademoiselle Chanel could draw. A manager would show up and announce, 'OK, we are going to make a suit in this fabric, with this kind of collar, and cuffs like this.' And here I arrive at Chloé and Karl comes into the studio with a bouncy '*Bonjour, mesdames!*' and a ton of beautiful drawings—I was in heaven!"[20]

It was also in these early years at Chloé that Briey saw her first fashion shows. Karl pushed Chloé in the direction of major productions, with music, raised runways, and dancing models. "For those of us who made the clothing, it was amazing to see it onstage, on a runway," Briey remembered. "It was something very different from seeing it in a couture salon, even the one at the rue Cambon. It was so impressive to see how everything came together: the hair, the makeup, the ambience. And to finish a collection in this way, with everyone applauding, it was amazing for us."[21]

By 1968, Anita Briey became the second in charge of the atelier and stayed at Chloé until 1984, after Karl had begun at Chanel, when she joined him in launching Karl Lagerfeld, becoming the head of the atelier. She worked with Karl for the rest of her career, spending forty years with him at Chloé and his own houses. "Talent, hard work, generosity, and kindness," Briey said. "Those are the four words I would use to sum up Karl."[22]

In 1965, Karl began his long collaboration with Fendi, the historic Roman luxury house. Founded in 1925 by Adele and Edoardo Fendi, on the Via del Plebiscito in Rome, Fendi started modestly as a shop in front of a workshop that produced beautifully crafted leather goods, umbrellas, and fur. For decades, Fendi remained a family-run firm, overseen by the daughters of the founders, the five Fendi sisters: Paola, Franca, Carla, Anna, and Alda.

The sisters had taken over the house in the '50s, after the death of their father. By 1964, they had opened a major new boutique on the elegant Via Borgognona. The following year, the sisters, all in their thirties, decided that they wanted Karl to be the creative director. It would be a fifty-four-year-long partnership that continued for the rest of his life. But it was a relationship that had a bumpy beginning.

He was still a young designer, just thirty-one years old, and his great success at Chloé was not yet clear. On the day that Karl was to sign his contract, Adele Fendi and her five daughters went to his apartment at 35, rue de l'Université. And there they waited. And waited.[23] "He was very young but he had this big opportunity," explained Silvia Venturini Fendi, the daughter of Anna, who has been the creative director for Fendi menswear and accessories since 1994. "I was not there—I was only four or five years old at the time. But my mother and her sisters told me that they had to wait for him for hours and hours."[24]

It was probably the most important professional appointment of his

life up to that point and Karl showed up several hours late. Silvia Venturini Fendi, who worked closely with Karl for decades, developed her personal theory about his lateness. "I think he wanted to see how much you actually wanted to be with him, how important it was for you," she says. "So, the fact that you were waiting for him was a sign of love and appreciation. I think he was late on purpose—it was a technique."[25]

After finally showing up and signing the contract with the Fendi sisters, Karl wasted no time in making a difference. Adele Fendi had asked Karl to make a small collection of fur that would be very "fashion" and very "fun."[26] He quickly sketched out a design, with an interlocking pair of F's, in black and tobacco, two colors that were signatures for the house. "Fun Fur" was what the pair of letters meant to Karl. The initial use was to be a jacquard lining for leather suitcases. But the interlocking F's were such a success that they were used as a monogram for bags and became the Fendi logo.[27] "The two F's together is my idea," Karl once pointed out. "You know, those initials are the basis of their fortune."[28]

Karl moved to forge a fashion image for the house, which concentrated, at that point, on leather bags and furs. He staged full fashion shows for Fendi, and, within a decade, introduced a line of ready-to-wear. Karl turned fur, which had long meant only the most classic designs, into a fashion fabric. From his first Fendi collection, he used mink, chinchilla, fox, and Persian lamb, in shades of gray or apricot, for floor-sweeping coatdresses, minidresses, or one jumpsuit that he dubbed "The Abominable Snow Woman."[29] In 1969, Karl designed an oversized blanket in Mongolian lamb, in beige and dark brown with fringe, that was meant to be worn like a poncho. The advertising campaign showed a model in her cloche hat, Fendi fur coat and bag, and bell-bottom pants, dragging along a male model, seemingly naked, wrapped only in the blanket. The piece was so striking that the Fendi sisters gave one to Karl, which, decades later, he returned for the house's archives.[30]

Karl began showing Fendi in Rome, at a time when the only other major international designer there was Valentino. As at Chloé, he wanted the shows to be dynamic, pairing the furs and bags with fashion and

putting male models on the runway. "The Fendi show was interesting because it was designed by Karl Lagerfeld, who is a force in French ready-to-wear and is said to anticipate Saint Laurent," wrote Bernadine Morris in the *New York Times* in the summer of 1971.[31]

Silvia Venturini Fendi witnessed the relationship between her mother and her aunts from the beginning. "They started working together when they were all very young, so they grew up together," she explained. "There was a lot of love and mutual respect. They were all full of energy and enthusiasm. And Karl was amazed that these women were all so committed to the creative part of the work. And, really, there was nothing that was not possible for them. They would work night and day preparing a collection at the beginning."[32]

Karl would often come up with new sketches in the days leading up to the show. So, everyone in the studios would work around the clock to make them happen. "And the shows were not like they are today," Venturini Fendi points out. "Today, we may do 40 or 50 looks on the runway. Then, there were 300 looks, presented twice a year."[33] As a young girl, she went to those early shows, finding a seat in the audience, when it was possible, or watching from backstage. "And I remember that Karl would often put on the final touches," Venturini Fendi recalled. "The girls would be in line to go out and he would be there in front of a table of accessories. He would put on a hat, a bow, a necklace—everything was done in the moment—he was using his creativity in a very immediate way."[34]

Karl and Fendi became known for intense innovations with furs and skins: brand-new colors, forms, techniques. His desire for experimentation found the perfect partners in the Fendi sisters. "A family motto was 'Nothing is impossible,'" recalled Silvia Venturini Fendi. "The sisters were prepared to invest in the creativity. There were no budget limits for the collections, and I think that is one of the reasons the relationship lasted so long. There was the research, the energy, and the passion, but also the budgets for the collections were enormous."[35] Karl was able to

ensure, first at Fendi and later at Chanel, that he had the means to produce the work that he wanted to produce.

By the 1990s, Fendi, having been family-run for over seventy years, felt the need to find a corporate partner. The sisters entered into a joint agreement with Prada and LVMH, with a final meeting in Paris with Karl, Prada's chairman Patrizio Bertelli, and LVMH chairman Bernard Arnault. "Karl and Monsieur Arnault became very good friends," Venturini Fendi said. "There was a lot of respect for one another."[36]

In November 2001, LVMH spent over $250 million to buy out Prada's shares in Fendi, becoming the majority owner of the house.[37] Arnault was purchasing the Roman firm, of course, which he felt was underdeveloped, but he was also acquiring Karl, the man behind his great Paris rival, Chanel.

By 2018, Fendi was estimated to have over $1.2 billion in annual sales.[38]

As Karl was accumulating fashion success in the 1960s, he also became known for his highly original way of living. In fact, the first major feature stories about him were on his interiors and lavish lifestyle. "I hate rich people who live below their means," Karl once said to explain his over-the-top lifestyle. "Money needs to circulate."[39]

In 1963, Karl moved from 7, Quai Voltaire to 35, rue de l'Université, also in the 7th arrondissement (not to be confused with his later, even grander apartments at 51, rue de l'Université). It was on the second floor of an eighteenth-century building, between a cobblestone courtyard and a garden behind. "Here I spent ten of the most carefree and happiest years of my life," Karl noted.[40]

His apartment was given a major feature in the French art magazine *L'Œil* in March 1968. "Karl Lagerfeld is one of those who set the tone today for fashion," *L'Œil* explained. "He designs dresses, coats, sweaters,

shoes, and accessories for leading ready-to-wear houses, manufacturers, and trendy boutiques. He is now styling himself, creating an apartment that is the perfect reflection of his personality."[41]

Built in the generous proportions of the eighteenth century, Karl's apartment had French doors, ceiling moldings, a fireplace in white carved marble, and the elaborate wooden floors known as *parquet Versailles*. But he did not intend to make it a museum of the *Siècle des Lumières*. Instead, he conceived of a highly original blend of the 1920s, modern art, and contemporary design. "In the historic volumes of the space, he mixed in furniture that he found at antique dealers, elements created for him by artists such as del Pezzo and François-Xavier Lalanne or designers such as Martine Dufour, and some work by the most avant-garde designers in Italy, South America, and Scandinavia, some that are still prototypes," *L'Œil* pointed out. "The use of colors that are precious or aggressive (wall coverings) as well as pastels (rugs) adds even more to the very unusual style of this apartment."[42]

Karl created a mix of furniture and objects that spanned the centuries. The center of the apartment was three rooms that flowed into one another: the living room, office, and bedroom. The salon had wood paneling, a carved marble fireplace mantel, a plum-colored Japanese wallpaper by Nobilis, and a rug in dusty pink, light blue, and white. His studio was dominated by a pair of armchairs, in white molded plastic and white leather, by the Italian industrial designer Joe Colombo. It had another marble fireplace, with a collage by Swiss artist Daniel Spoerri lit by a sleek black metal lamp by French modernist Serge Mouille. The bedroom had a third fireplace, silver Japanese wallpaper, a rug with a trellis design in dark brown and faded turquoise, and, floating in the center of the room, a custom-made, two meters by two meters platform bed with a stainless-steel base and bedding and pillows handmade by French textile designer Geneviève Dupeux.[43]

One of the most outstanding pieces in the interconnecting rooms was a one-of-a-kind drawing table that Karl had commissioned in 1964, by François-Xavier Lalanne. Completed in 1966, it was almost six feet in

height and six and a half feet wide. It had a swooping frame, legs, and supports in metal that had been painted red. The central surface was an adjustable drawing board in light wood. Rising up from the desktop was a red and patinated metal lamp and several containers in glass and patinated metal for brushes and pencils. Next to the drawing board was an oval surface, in opaline and dark brown leather, for preparing watercolors. Below was a large gilded, metal globe used for storage of supplies. In the mid-1970s, Lagerfeld sold the table to the noted decorator Jacques Grange (at Grange's Sotheby's sale, in May 2018, it was christened the "KL Unique Drawing Board" and sold for €753,000).[44]

The apartment also had a small terrace, 130 square feet, that overlooked the garden in back. There, Karl created an outdoor room with a dizzying array of styles. Over the black slate floor, he placed a geometric Art Deco rug and the iconic 1929 chaise longue by Le Corbusier and Charlotte Perriand, his in steel with black pony skin. A small round end table in black lacquer held a frosted crystal ice bucket by Lalique with a bottle of Coca-Cola, still his drink of choice. A low wall was topped with planters filled with the flowering plant fuchsia, while one white ceramic planter held a dwarf fig tree. There was also a bust of a Roman emperor, a plastic portable television, and an orange awning, "to give guests a good complexion," Karl suggested. For a 1969 story in *Elle*, he posed on the chaise longue, looking very 1960s: long dark hair swept back and prominent sideburns, a dark dress shirt with an oversized collar and bell sleeves, light, full pants, and square-toed, leather dress boots.[45]

It was into this original environment that Karl relocated his mother. Otto Lagerfeld died on July 4, 1967, in Baden-Baden. Obituaries appeared in German papers. "From the smallest of beginnings," read the obit in the *Frankfurter Allgemeine Zeitung*, "Otto Lagerfeld created one of the most important companies in the German dairy industry."[46] Karl suggested that Elisabeth Lagerfeld was so matter-of-fact about her husband's death that she did not mention it to her son for several weeks. German biographer Alfons Kaiser, however, found that Karl was in Hamburg for the funeral.[47] Regardless, Elisabeth Lagerfeld moved from

their retirement home in the German spa town into a room that Karl pre-
pared for her on the rue de l'Université.

Beginning in the late '60s, Karl made a new group of friends who
would be essential to his development as a designer. It was a world
that spun around fashion illustrator Antonio Lopez and art director/
photographer Juan Ramos. Lopez and Ramos, a unified, collaborative
team, also happened to be great fun.

From the time they were still students at New York's Fashion Institute
of Technology (FIT), in the early years of the decade, they seemed to
have sprung to life fully formed. Lopez did the drawings, while Ramos
focused on photography, collages, and art-directed Lopez (the two were
also lovers through the early '70s). In 1963, they began working for
WWD in New York and the *New York Times Magazine*, producing draw-
ings and collages that were spare, modern, and very sensual. They also
made several trips to Paris on assignment for *Elle*.[48] "They were taking
all the jobs that they could get in France and felt that that was a much
better place for their talents, that the United States, at that point, was
very limiting," remembered Paul Caranicas, an artist who met the pair in
Paris in 1971, became the lifelong partner of Juan Ramos, and has been
the administrator of the Antonio Archives.[49] Lopez and Ramos moved
to Paris in 1969, settling into a small apartment on the Avenue de Ver-
sailles, in the far reaches of the 16th arrondissement.

Lopez and Ramos had long felt that it was important to draw live
models rather than work from photographs. First in New York, then in
Paris, they assembled a posse of striking models who also became great
friends. Known as "Antonio's Girls," the group included Pat Cleveland,
Jane Forth, Donna Jordan, Jessica Lange, Jerry Hall, and Grace Jones.

Karl befriended Lopez and Ramos in Paris. By 1969, the group would
stage stylish tableaux in Karl's apartment. There was Lopez, wearing
high-waisted bell-bottoms and a silk printed shirt, dancing with Carol

LaBrie, one of the first famous African American models, in a striped silk short ensemble that Karl had designed for Chloé.[50] Or, in the Art Deco salon, there were Lopez and Karl, wearing a printed silk shirt, with Pat Cleveland posing for Ramos.[51] Or Karl, Lopez, and Ramos would head out to Café de Flore with Donna Jordan, Patti D'Arbanville, and Jay Johnson. They would position themselves on the red leather banquettes, smoking, laughing, and, of course, posing.[52]

Karl moved Lopez and Ramos into a much larger apartment at 134, Boulevard Saint-Germain. It had gray industrial carpeting, minimal furnishings, and a corner living room that functioned as a studio. The room had two drafting tables, a large mirror, and a splendid view of the Carrefour de l'Odéon.[53]

Someone else who entered the scene at that time was Corey Grant Tippin. In 1967, in New York, Tippin, then only seventeen, was introduced to Andy Warhol's Factory, surprisingly, because his mother saw an ad in the *Village Voice*. They were casting for young men, seventeen to twenty, who didn't want to be actors. His mother called the number and then urged Tippin to go, which is how he found himself at the original Factory on East Forty-Seventh Street. There he met the artist Fred Hughes, with whom he became very friendly. Tippin was also a student at Parsons School of Design. One day, Antonio Lopez and Juan Ramos were at Parsons to give a lecture. They were with Cathee Dahmen, considered the first Native American supermodel, who happened to be Tippin's favorite. Lopez, noticing the tall, blond Tippin in the crowd, asked him to come up onstage to pose with Dahmen. "All the kids were hanging out in the hallways and crowding the doorways," Tippin recalled. "Antonio was an immense fashion star, everyone was copying him—they all knew who he was, far more than Andy, at that point. He gave me his number and said to call. So, that all happened at once—I got involved with those two worlds simultaneously."[54]

Corey Tippin became something of a spark between the two groups. He hung out at the Factory, worked with Lopez and Ramos, spent time at Max's Kansas City, and discovered the models Jane Forth and Donna

Jordan, who was a student at the High School of Art and Design with Pat Cleveland. "I was like dressing them up, and they would model for Antonio," Tippin explained. "Fred introduced Donna and Jane to the Factory, and Andy, of course, loved them."[55]

In the fall of 1969, Tippin moved to Paris. He first stayed in Lopez and Ramos's old apartment on the Avenue Versailles. Then, Donna Jordan, who had been trying to model in London, without a lot of success, also arrived. Tippin and Jordan spent their first year in Paris hanging around in cheap hotels in Saint-Germain. Antonio Lopez encouraged Tippin to start doing makeup, a specialty that was not particularly well developed at that time.[56]

Soon enough, he was brought into Karl's orbit. As Tippin recalled, "Karl had been a friend of Antonio and Juan but I hadn't met him. I heard about him—they were always, 'Karl this' and 'Karl that,' 'Karl,' 'Karl,' 'Karl.' But they seemed kind of hesitant—they were like, 'When should we take you to meet him?'"[57]

When Tippin was finally introduced to Karl, it was at 35, rue de l'Université. And the thirty-seven-year-old designer certainly made an impression on the twenty-year-old makeup artist. "Once I met him, I would see him everywhere, at the Café de Flore, or running around and buying magazines," Tippin recalled. "He always had a little purse tucked under his arm. I had seen a lot of exaggerated queens in my life, but I had never seen anything like that! He was European, unapologetic, and very public. His movements and demeanor were kind of extraordinary."

When asked if he meant that he was unapologetically gay, Tippin replied emphatically, drawing out each syllable, *"Flam-boy-ant!"*[58]

Over the summers, Karl invited the whole crew down to his place in Saint-Tropez. He had a house in La Ponche, the historic neighborhood that had been the fishermen's port. It was a renovated, loftlike space that had plenty of room for guests, including his mother, who went down every summer. Karl also rented a furnished apartment in La

Ponche for more guests, including Tippin, Pat Cleveland, and Donna Jordan. Lopez and company would take mopeds out to the beach club, with Karl arriving for lunch by boat, one of those classic wooden crafts by Riva. "There was a driver that would take us waterskiing, if we wanted to try that," said Tippin.[59]

Karl would hit the beach with Lopez and Ramos, wearing a black wrestling singlet, beefed up from working out with his personal trainer. There was more posing in the surf, Karl in his singlet and the dashing Ramos in light blue Speedo and black and white bathing cap.[60] Or Karl, wearing a pair of tight jeans, a short-sleeve shirt, and dark aviator glasses, would make his way through the village of Saint-Tropez with Lopez and Donna Jordan.[61]

It was summer and everyone was on holiday, but Karl made time for work. "I went there for a couple of weeks once when Corey was there and Pat Cleveland," recalled Paul Caranicas. "Karl was working on his shoe collection for Mario Valentino. Corey gave him a Black Beauty and he stayed up all night. We woke up and there were like a thousand drawings."[62] Tippin had slipped Karl one of his mother's Dexedrine pills. "He was very appreciative but he never took anything like that," Tippin said of Karl. "He never smoked pot or drank. It was just Coca-Cola and frankfurters: and keep 'em coming."[63]

Karl was footing the bill for this entourage, paying for train tickets, places to stay in Saint-Tropez, activities, and apartments in Paris. But the relationships were mutually beneficial—those years were one of the most energetic, festive periods of Karl's life.

Whether he was in Paris or Rome, or on holiday with the band in Saint-Tropez, Karl continued to be on the lookout for what was happening. And he immediately got the appeal of Jordan, who, with her platinum hair, flat chest, and strong makeup, was a very unconventional beauty. "Around 1970, Donna Jordan invented a new kind of model," Karl later explained. "She turned herself into a parody of an asexual Marilyn Monroe."[64]

Karl's growing reputation, as a designer and as a collector of Art Deco, meant that others who were beginning to be interested in the period, such as Andy Warhol and his business manager, Fred Hughes, sought him out on visits to Paris. Which is how Sandy Brant, who was the publisher of Warhol's *Interview*, met Karl. Brant saw the connection between his fashion and how he lived. "Karl's designs for Chloé were simply sublime," Brant recalled. "It was when we were all madly collecting Art Deco and the fabrics and style of Chloé were very influenced by that. I still have all my old Chloé from that period and the designs are fantastic—filled with wit and humor."[65]

Brant, who, with her partner, the arts journalist Ingrid Sischy, would be one of Karl's best friends for decades, first came into contact with him through Warhol. In the fall of 1970, the artist was in Paris to shoot *L'Amour*. Directed by Paul Morrissey and produced by Warhol, the film stars Donna Jordan, Carol LaBrie, and Warhol Superstars Jane Forth and Patti D'Arbanville. Other roles were played by American actor Michael Sklar, French actor Max Delys, and Corey Tippin (who did the makeup for the film). Also present, playing a very fictionalized version of himself, was Karl Lagerfeld.

L'Amour, shot in Paris over a period of four months ending in November 1970 and inspired very loosely by *How to Marry a Millionaire*, uses Karl's apartment at 35, rue de l'Université as a location. In an opening scene, Patti D'Arbanville, who is supposed to be Karl's wife, soaks in the bathtub. She is chatting with Donna Jordan, Jane Forth, and Corey Tippin about how rich he is. "Much, much, much, much money," she says. All are taken with the environment. "This is the best house in all of Paris," Jordan says of Karl's place.

As an actor, Karl makes quite an impression. He appears in his Art Deco rooms in tight black trousers, with a flouncy, silk print shirt and a wide belt with a huge silver buckle. His hair is dark, just over the collar, and his sideburns are thick. After greeting everyone, he works out in his home gym. In one noteworthy scene, he makes out with D'Arbanville.

And it is not just a stage kiss: they have what looks like a proper make-out session, with lots of tongue.

"*L'Amour*, the newest chapter in the continuing series of Andy Warhol–Paul Morrissey soap opera put-ons, takes the Factory gang to Paris," sneered Vincent Canby in the *New York Times*. "Michael (Sklar), a rich American, represents his father's firm, the Watkins Bathroom Deodorant Company. Michael is head over heels in love with Max (Delys), a street hustler who looks like a French version of Joe Dallesandro. Michael, however, is also fond of Jane (Forth), a self-described American high school dropout who has come to Paris to model with her best friend Donna (Jordan), who would sort of like to marry Michael so they could legally adopt Max."[66]

Canby hated *L'Amour* but it certainly captures a moment and it is more cohesive than a lot of experimental cinema of that time. For many years after it was released, Karl had not seen the film and was pretty dismissive of the whole venture. In 2004, however, Sandy Brant arranged a surprise screening, through the Museum of Modern Art, at a New York party celebrating the publication of *Andy Warhol's Interview: The Crystal Ball of Pop Culture—The Best of the First Decade 1969–1979*, a special seven-volume book that Karl had published. He was pleasantly surprised to see how *L'Amour* held up, telling Brant that he was thrilled that she had screened it.

"I saw it again recently and I didn't recognize this creature with long eyelashes," Karl said, laughing about his younger self. "But I was just someone of my era and Warhol was the man of the moment. So, I had to try."[67]

The ending of *L'Amour* comes with a couple of surprises. One ongoing plot element is that Jordan would go with the sugar daddy if only he could get her the cover of *Vogue*. "And, in a case of life imitating art, at the end of filming, Donna got the cover of French *Vogue*," recalled

Corey Tippin.[68] The issue of the magazine shows Jordan, photographed from the side by Guy Bourdin, in a tight red top, leaning back erotically, with her platinum hair, heavy light blue eye shadow, and strong red lips.

The *Vogue* cover sets up the final scene of the film. Jordan sits in The Drugstore, a legendary pharmacy and café on the Boulevard Saint-Germain (which, in the '90s, was unceremoniously, and controversially, converted into the Paris flagship for Emporio Armani). She sits with her sugar daddy as they both admire her first big cover.

Karl and Delys are outside on the street, just in front of The Drugstore. Karl wears a long black military-style coat, a black shirt, and black pants with the big silver buckle. Delys smokes a cigarette and pouts, wearing a black turtleneck, black pants, and a safari jacket in beige suede. Inside the café, as Jordan continues to admire her magazine cover, her older companion wistfully watches the scene outside.

In the final scene of *L'Amour*, Karl puts his arm around the younger man's shoulder and they walk off together. Karl's long coat catches in the wind as they cross the Boulevard Saint-Germain, cutting through traffic, walking toward the Café de Flore, and off into the sunset, or, at least, the gray Paris dusk.

10

LOVE AND
OBSESSION

Jacques de Bascher, young, was the devil incarnate with the face
of Garbo. He had an elegance that was absolute. He dressed
like no one else, before everyone else. He was the person who
amused me more than anyone—he was my opposite. He was
also impossible, despicable—he was perfect. And he was the
cause of an appalling amount of jealousy.[1]

THE MAKING OF *L'AMOUR* was an important episode for Karl because
it reinforced his relationship with the Antonio Lopez band, brought him
into the Warhol orbit, and introduced him to new friends. "I had known
Yves Saint Laurent for probably a year but the first time I met Karl was
through *L'Amour*," remembered Paloma Picasso, the daughter of Pablo
Picasso and Françoise Gilot. "At that time, Yves and Pierre were very
good friends with Karl and we started seeing each other more and more.
That was also the beginning of my friendship with Fred and Andy, so all
of this was really quite fun and new."[2]

When asked to explain how Karl was seen in those years, Picasso was
clear. "Chloé was *very* important," she recalled, noting that she had been
buying there for several years by that point. "It was founded by Gaby
Aghion, and run by her and Monsieur Lenoir, but her husband had the
Galerie Saint-Germain on Boulevard Saint-Germain. So, there was this

whole art connection. Chloé at the time was the number one ready-to-wear house, the most prestigious, so Karl was right at the top."[3]

Picasso felt that there was a certain rivalry between Karl and Saint Laurent, though it was muted. "Karl was not doing couture at the time," she pointed out. "And Karl spent all his time insisting that, you know, they were friends from the beginning, because of the Woolmark Prize. They were not just two people doing the same kind of job—they were truly best friends."[4]

Another person who was part of this crowd was a beautiful twenty-one-year-old actor who Karl adored: Gérard Falconetti. He was the grandson of Renée Falconetti, the star of *La Passion de Jeanne d'Arc*, the landmark silent film by Carl Theodor Dreyer, a cinematic pedigree that had a special meaning for Karl. Falconetti was still studying acting in those years and had his first role in Éric Rohmer's *Claire's Knee*. "He was, at that time, let's say, the passion of Karl," Picasso explained. "I am not saying anything that Karl has not said many times but he never had a physical relationship with Jacques de Bascher and he did not have a physical relationship with Gérard Falconetti. It was his fantasy, at that time."[5] The actor would go on to have a brief career in film and theater, appearing in 1981 opposite Meryl Streep in *The French Lieutenant's Woman*. In 1984, Falconetti was diagnosed with AIDS and, in an act that is almost impossible to believe, threw himself off of the tallest building in Paris, the Tour Montparnasse.

It was also through Karl and Warhol that Paloma Picasso became friends with Antonio Lopez and Juan Ramos. They became closer when, in 1972, Lopez was hired to do a series of lingerie drawings for British *Vogue* and asked Picasso to model. "He wanted to have a girl who would not be a model, but a real person with flaws," Picasso recalled.[6] The sittings took place over several days in the Boulevard Saint-Germain apartment that Karl had provided for Lopez and Ramos, beginning in the early evening and stretching on until 3:00 or 4:00 a.m. "I had never posed for my father, so it was fascinating to do this with Antonio," Picasso said. "He was always working surrounded by millions of people.

There would be so many different models coming in, Jerry Hall and lots of other girls. And Juan would supervise the work, give him ideas about how to approach this new set of drawings, showing books of paintings and suggesting that there was maybe something there that he could transform into his own point of view."[7]

Paloma Picasso, when visiting Karl's apartment on the rue de l'Université, also had the chance to see Elisabeth Lagerfeld. "She looked fantastic but she was like a shadow passing through the apartment," she recalled. "You didn't want to move or anything as she was passing by. And Karl never mentioned her."[8]

The world of ready-to-wear seemed quite small in those years but that was about to change considerably. "It was about the time when fashion started becoming fashionable," Picasso said with a laugh. "It had not been before. I remember going to prêt-à-porter shows of Saint Laurent that were in their offices. And then people in fashion started making money—at first, it was not such a moneymaker. I was one of the only personalities to go to the shows. Today, actresses want to be seen in the front rows—earlier, it was strictly professional. Then it became a little more grand, let's say, and then grander and grander and grander."[9]

The shows that Karl was staging for Chloé were key to that development. They were getting larger and more lavish and more exciting. "Exactly," Picasso agreed. "That is why I say that he was at the top of his game. He was not at the top of his career, because, obviously, he did so much afterwards. But he was at the top of what was happening and he was pulling everyone else along."[10]

In the fall of 1971, Karl, thirty-nine years old, began the most meaningful relationship of his life, with Jacques de Bascher, a twenty-year-old French aristocrat.

"I remember the first time I saw Karl," de Bascher said several years later. "It was at La Coupole and he arrived. It was something like a

birthday party. There were about twenty people including Antonio, Juan, Donna Jordan, Jane Forth, Gérard Falconetti, Amina Warsuma, Pat Cleveland, Eija, and Kenzo. I can really tell you that when this group entered La Coupole, in the whole of La Coupole, there was a divine silence. The only noise was coming from this group winking through the tables to go to this huge table where they were seated. He was a fascinating man to look at—and he is still."[11]

It was a vivid memory, but there has also been the suggestion that de Bascher first saw Karl earlier, in the fall of 1971, at the nightclub Le Sept, when the designer was there with Donna Jordan, Jane Forth, and Pat Cleveland.[12] "That is a Swedish designer," de Bascher told a friend, pointing at Karl, a little confused about his nationality. "He is going to be the most important designer in the years to come and he is also going to be my boyfriend."[13]

As for the first time the two actually met, Karl placed it at Le Nuage, a tiny club at 5, rue Bernard Palissy in Saint-Germain-des-Prés, in the spring of 1972. Owned by Gerald Nanty, the nightlife impresario whom Karl had known since the 1950s, Le Nuage held no more than fifty clients. That night, de Bascher was wearing a Tyrolian getup, with long suede shorts held up with suspenders, a traditional white shirt, and, in the middle of his chest, a cameo carved from deer antler. As Karl remembered, de Bascher walked up to him and said, "I would like to know you." Then, they stayed at Le Nuage deep in conversation until 5:00 a.m.[14]

By all accounts, Jacques de Bascher was incredibly charming, seductive really, leaving in his wake legions of admirers, both men and women. "He amused me more than anyone else," Karl said in 2013. "I admired his complete irreverence and his total absence, in an almost cynical way, of any kind of professional ambition. 'I will die young so why wear myself out,' he used to say."[15]

De Bascher also had a strong, original sense of style. In the early '70s, he favored a thin mustache, groomed with "Hungarian pomade," giving him the look of a matinee idol from the 1930s.[16] He was known to wear high-waisted white flannel pants and silk crepe de chine dress shirts.[17]

There were also hints of the nineteenth-century dandy: beautifully tai-
lored tweed suits, a pale trench coat lined with fur, foppish scarves. But
he also had an insolence that was completely modern. Karl was con-
vinced that he was the most fashionable person in France.

Then, there were his looks: de Bascher was dark, thin, and alarmingly
handsome. He had a beauty mark on his lower right cheek and was always
impeccably groomed. That involved a daily regime of skin moisturizing,
weekly haircuts and mustache trims, and monthly facials at Carita. And
he worked out three days a week, still a rarity in mid-'70s Paris.[18] "More
than anything, he knew how to show off his God-given gifts," recalled
Diane de Beauvau-Craon, one of de Bascher's closest friends. "He was
not tall, probably 5 foot, 10 inches, very thin and angular. His eyes were
a khaki hazel, his nose was very narrow, and he had a thin mustache. He
looked like a beautiful, perfect engraving from the 19th century."[19]

De Bascher had another important part of his character: he pushed
things about as far as they could go. He drank, he did drugs, he had
sex—all to excess and all unapologetically. "To provoke, to shock the
bourgeois, that most abhorred brood," Christian Dumais-Lvowski, a
French author and editor, wrote of de Bascher. "To be as far away as
possible from a normal life and moral judgments. Live fast, with no lim-
its; party as much as possible; spare no effort—that was Jacques's life
motto."[20]

Once, when he was pulled over by a Paris police officer for riding a
motorcycle without a helmet, de Bascher slipped him his visiting card,
invited him over to drink some of his family's wine, and ended up bed-
ding the cop.[21] When de Bascher invited Patrick McCarthy, the Paris
bureau chief for *W* and *WWD*, over for drinks, the gathering turned out
to be a mix of Paris social figures and a slew of hard-drinking firemen,
in full uniform, from the local station.[22] By the time de Bascher was liv-
ing in a massive apartment on the Place Saint-Sulpice, he kept a brand-
new Harley-Davidson parked in the middle of the salon. Its mirrors were
pointed upward, transformed into handy working surfaces with razor
blades, straws, and piles of cocaine.[23] Although the Harley was a gift

from Karl, as was the apartment, Karl asked him not to drive it anymore, afraid that he would have an accident. "Now, it's the most expensive cocaine mirror in Paris," de Bascher said.[24]

His decadent behavior, he believed, required no justification. "'Cadent' comes from the Latin *cadare*, which means to fall," de Bascher once explained. "Decadent is something very different. It's the beautiful way to fall. It's a very slow movement which has lots of beauty—a kind of self-killing in a beautiful, tragic way. I don't find it an insult to be called decadent."[25]

The Princess Diane de Beauvau-Craon was a wild sixteen-year-old when she first encountered de Bascher at the Café de Flore, shortly after he met Karl. Having shaved her head in the past, she had, at that moment, a crew cut that she had died platinum (in October 1977, she would be tagged the Punk Princess and placed by Warhol on the cover of *Interview*). She and de Bascher became immediate best friends and partners in crime. "It was a case of two toddlers who were ready to engage in any and every kind of crazy bullshit—there is no better term for it—that was possible or even imaginable!"[26]

The Beauvau-Craon family was one of the oldest, grandest aristocratic clans in France, with a history that goes back to the fifteenth century. The family home, in the eastern region of Lorraine, is the extraordinary Château d'Haroué, built between 1720 and 1729. The massive, four-story house, which soars out of its formal French garden, has gray stone walls and a steep, dark gray slate roof. It is considered a "calendar house," with four bridges crossing the moat (representing the four seasons), twelve towers (months), fifty-two fireplaces (weeks), and 365 windows (days). Diane and her older sister, Mini, who now oversees the château, were raised there (though Diane divided her time between the family château and school in Paris).[27]

Her father, Marc de Beauvau-Craon, was the seventh and final prince

of the family. He was an active member of the French resistance, an industrialist, producing Vespa scooters in France, and an art collector and patron. His first wife, Albina Patiño y Borbon, was the daughter of Antenor Patiño and granddaughter of Simón Patiño, one of the richest men in the world, considered the king of the tin mining industry in Bolivia.

Very quickly after they met, Diane de Beauvau-Craon and de Bascher were dancing the night away at the nightclub Le Sept and she was virtually living with him in the rue du Dragon. Soon, surprisingly enough, Karl went to the trouble to track down her father's phone number in order to alert him to the existence of this unusual relationship. "He told him that his daughter was not behaving herself in a way that a 16-year-old from a good family should be behaving," de Beauvau-Craon recalled with a laugh. "And that I was a homewrecker! I really loved my father, and I really loved Karl, so it is a little delicate to tell you that my father ended the conversation in a way that was pretty brutal."[28] Marc de Beauvau-Craon cut Karl off by saying, "I am not in the habit of speaking with my daughter's dressmakers."

The comment illustrated the gulf that existed between grand French families and fashion designers, a division that is no longer particularly relevant. But the call itself—telling on someone to their parent—seemed uncharacteristic of Karl. "Jacques was pretty diabolical," Beauvau-Craon explained. "He could be perverse. So, God knows what he told Karl about me. Later, when Karl and I became good friends, he never mentioned what Jacques might have said to him. But I am sure that is why he called, that Jacques had exaggerated, in some way, our relationship."[29]

De Beauvau-Craon spent a big chunk of the 1970s living in New York, then married and moved to Tangiers. When she returned to Paris, in 1980, de Bascher introduced her to Karl. "And that is when we became something of a trio," she remembered. "We were together all of the time. And, by that point, Karl was thrilled that I was a friend of Jacques."[30] She was able to see the closeness of their relationship, and the importance de Bascher had in the life of Karl. "I remember very, very well that every

day, no matter what we were doing, at one point, Jacques would go find Karl and spend several hours with him, to tell him everything that was happening."[31]

Karl always maintained that one of the main reasons for his attraction to de Bascher was that they were opposites. And de Beauvau-Craon believed that to be true. "Jacques was exactly what Karl wasn't, meaning completely uninhibited," she said. "Karl had a lot of imagination and fantasy in his mind but he would never have allowed himself any room for error. And Jacques brought him all of that freedom. He lived vicariously through Jacques, experiencing everything that he would never have allowed himself."[32]

Jacques de Bascher, as the particle would suggest, hailed from an aristocratic family. His ancestor was ennobled in 1813, under Louis XVIII and the Bourbon restoration, a respectable, if not exactly glittering, heritage. Since 1800, the family home had been the Château de la Berrière, a historical monument that dates from the Middle Ages, located in the western region of the Loire Atlantique department, where the Loire River opens into the ocean. For generations, the property has produced its own wine, the Château de la Berrière, which de Bascher and Karl loved to serve guests.

The fourth of five children, he was born on July 8, 1951, in Saigon. He spent his early childhood in Vietnam, where his father was a colonial administrator. They moved back to France in 1955, when his father began working in communications for Shell Oil. He lived in the family apartments in Neuilly-sur-Seine, the posh suburb west of Paris, in a building across from the Bois de Boulogne. Summers were spent with his parents and siblings at La Berrière.

De Bascher did his compulsory military service in the French navy. Beginning in January 1972, he sailed on *L'Orage*, on a trip through the Panama Canal and around the world. De Bascher was in charge of the

library, writing articles for the navy journals, and hosting the ship's radio station. One day while taking a break in Tahiti, he stole the swimsuits of two fellow sailors, forcing them, in order to retrieve them, to run around naked on the beach. De Bascher was quickly shunted off of the ship. His prank earned him a month in the French Foreign Legion prison on Tahiti, and he was sent back to the mainland.[33] He moved back into his parents' place in Neuilly. Having begun to study law, de Bascher cut his education short in order to take a job as a steward at Air France, working short flights.[34]

In Paris, it was not surprising that a young de Bascher would plug himself into the most happening social scene. He quickly became a regular at Café de Flore and the more louche world that circulated around The Drugstore across the street. "The Flore was filled with fauna who, several hours later, would find one another in the bars and dance floors of the trendiest clubs," noted the writer Dumais-Lvowski. "Le Nuage, Le Sept, Chez Castel, or Régine's. The mix was always the same: head-splitting decibels, drugs, alcohol, and sex."[35]

There was a part of de Bascher's personality that was quite somber (his biography, by French journalist Marie Ottavi, was entitled *Dandy of the Shadows*). "Jacques lived in a way that was dangerous and dark," said Ines de la Fressange, the model and designer who was a close friend and collaborator of Karl's at Chanel. "Karl had partied some during his years with Antonio but nothing like what Jacques did, all the time. But Karl was fascinated. I think he represented a fantasy that Karl had about France."[36]

It was true that de Bascher embodied a certain idea of the French nobility, a world that had inspired Karl for decades. He was even known to exaggerate his background, borrowing a second particle from a distant relative, expanding his name to the unwieldy Jacques de Bascher de Beaumarchais. It was an affectation that Karl played along with, identifying some of his drawings of him with the initials, "JdeBdeB." The young man was clearly proud of his connection to the ancien régime, even having a fleur-de-lis, the aristocratic emblem, tattooed on his ass.

Karl quickly moved de Bascher into his own bachelor pad, a duplex apartment at 15, rue du Dragon, just across from the offices of *Cahiers d'art*, the famous art review, and just down the street from Brasserie Lipp and the Café de Flore, two spots that were part of de Bascher's daily routine. His place was on the fourth and fifth floors, in the back of the building. He had a view out onto the rue du Sabot and the rue Bernard Palissy, two of the neighborhood's charming narrow streets, steps away from Le Nuage, where he and Karl had met.[37] "Jacques was living at his mother's place in Neuilly and that was a little far," Karl told de Bascher's biographer. "I thought it was fun to arrange this apartment for him because I couldn't have him living with me. The coming and going of all of his friends was not going to work for me."[38]

Once he met Karl, de Bascher had a significant stylistic upgrade. Instead of dark jeans, white T-shirts, or thrift shop chic, he took to wearing made-to-measure suits from Caraceni in Milan, Cifonelli on the rue Marbeuf in Paris, or Renoma in the 16th arrondissement.[39] His shirts were custom made at Hilditch & Key, his pajamas came from Battistoni in Rome, and his shoes were John Lobb. Around the apartment, he kept his silk ties in a ribbon box that had belonged to Marie-Antoinette, and he used a gold Art Deco box by Cartier for his cocaine.[40]

Very quickly, de Bascher turned himself into that most Parisian of figures, *un personnage*. And Karl had a hand in making that happen, becoming something of a Pygmalion. "Karl really helped Jacques blossom," said Diane de Beauvau-Craon. "I think that Karl wanted Jacques to be someone who was completely unique. Jacques already had his own personality, his own identity, but Karl helped forge that into something even more powerful. What had already been innate with Jacques was completely resculpted and remodeled by Karl."[41]

By 1973, de Bascher was photographed in Karl's apartment for French *Vogue*, wearing a pair of lavender floral pajamas tied at the waist. He paired that with a pristine white pleated shirt with a wing collar and French cuffs, and an oversized black bow tie. In the summer of 1974,

de Bascher appeared in *Vogue Hommes* with his brother Xavier, model-
ing menswear designed by Karl. He wore a white flannel suit, with the
pants full and flared and a double-breasted jacket, with wide lapels, that
was belted. He carried an umbrella in one hand, also designed by Karl,
and a cigarette in another.[42]

There were certainly plenty of people around who did not fully get
Jacques de Bascher. Shortly after he met Karl, he was invited down to
Saint-Tropez. The Antonio Lopez band, realizing that the young man
was Karl's new favorite, was distinctly unimpressed. "He was horrible,"
said Paul Caranicas, who went that summer to Saint-Tropez, for the first
and last time. "He was snobbish and superficial and arrogant and talent-
less. He didn't have anything good going on—there just wasn't much
there."[43]

Corey Grant Tippin was also there that summer and had the same
take. "I didn't think he was sexy at all," he said of de Bascher. "He was
not sexy to me or to Antonio or to Juan, because everybody would have
been all over him. He was attractive but kind of college-y and nerdy. He
wasn't cool when I met him—eventually, he became sort of cool."[44]

Although de Bascher has often been portrayed as someone unseri-
ous, there was no doubt that he had substance. Like Karl, he, too, was
polyglot, comfortable expressing himself in his native French, English,
and German. At their first meeting, he and Karl discussed Homer's *The
Iliad*, not exactly a light conversation for a nightclub. When de Bascher
was selected to be in the first issue of *Vogue Hommes*, in the spring of
1973, he discussed his fascination with Robert de Montesquiou, a writer
and aesthete who inspired Proust's Baron de Charlus. "He wrote some
terrible poems that I adore," he said, amusingly, of de Montesquiou.[45]
But de Bascher knew his literature. One of his favorite authors was
J.-K. Huysmans, whose *Against Nature*, the 1884 novel about Jean des
Esseintes, takes dandyism to its greatest extreme—it could have been
almost an instruction manual for de Bascher.[46]

In 1973, David Hockney, who was living in Paris at the time, made a
pencil and watercolor drawing of a languid de Bascher. He leaned back in

a chair that was highlighted in light green, wearing a blue shirt with a wide white collar and a blue and white striped tie. In his lap, he held an open book, as though he had just taken a break from reading. His dark hair was parted in the middle and he had his thin, perfectly groomed mustache. The image was striking enough, and the subject was sufficiently significant, for Hockney to choose it as the poster for his exhibition of prints and drawings at the Galerie Claude Bernard on the rue des Beaux-Arts.

In the summer of 1973, de Bascher was down at Karl's place in Saint-Tropez when Paloma Picasso joined him. She had designed some jewelry that she was planning to show at the Hôtel Byblos and Karl suggested that, instead of going to the hotel, she stay at his place with Jacques and he would join them for the weekend. The year before, Picasso had met Helmut Newton, who wanted to photograph her. She had been in Saint-Tropez for about a week with Jacques, spending plenty of time going out and hitting the beach. "When Helmut saw me, he was furious," she recalled. "The last time he had seen me, I had long hair and pale skin. Now I had short hair and was tan." That night, Picasso and de Bascher went to a nightclub. "It was early in the summer, June or July, so there were no Parisians," she remembered. "We started dancing the way we danced at Club Sept, these very extravagant, complicated moves, and people started to get annoyed with us, pushing us around and misbehaving. The club realized what is happening and threw them out." Picasso and de Bascher continued their evening but when they left, an hour later, they found the group waiting for them outside. "And they start fighting with Jacques. I tried to protect him and some guy threw me like six feet. I thought, 'Helmut is already furious at me—imagine if I also have bruises all over my face!'" Picasso went back into the club to get help and then took de Bascher to the hospital, with his face banged up.[47]

Then, Picasso and de Bascher used Karl's Saint-Tropez apartment as a backdrop for the Helmut Newton photo, an image that became iconic. She was wearing a tight black dress that Karl had designed for Chloé, her wrists lined with silver bracelets and cuffs. "The dress was actually made of three pieces," Picasso explained. "There was a skirt that was

black, and a top that was made of two triangles, one in black and one in white. I had the black half on and while I was putting on the white part, Helmut said, 'Oh no, it looks better like that.'"[48] Newton's photograph captured Picasso, with her short hair and tan, her hand on her left hip, her left breast exposed, concealed partially behind a highball glass that she held in her right hand.

De Bascher, particularly once he was in Karl's world, had plenty of other interests besides sex, clothes, discos, and drugs. In addition to literature, he was very knowledgeable about cinema and music, stocking his apartment with the latest pop records from around the world. "I have read some books that only present one side of Jacques," said Silvia Venturini Fendi, who saw him often with Karl in Rome. "But he was also someone who was very cultured, sophisticated, and extremely nice. I loved Jacques so much."[49]

De Bascher became involved in Karl's professional life, discussing his drawings, working backstage with models, and doing the music for the shows. He often went to Chloé with Karl, turning up with him in his Mercedes 190 SL, his black Rolls-Royce, or his dark blue Bentley.[50] "Karl was becoming more famous and, at the same time, he seemed to become more and more free," recalled Anita Briey, who worked in the Chloé atelier. "And when he came for fittings, he was often with Jacques de Bascher. He was such a nice guy, charming, and very funny. Karl needed to be serious for work, while Jacques always had something amusing to say—he cracked everyone up."[51]

De Bascher knew enough about Karl's design that he could describe specific references. "He was inspired by antique china, such as those of Meissen and Nyon," de Bascher told fashion editor André Leon Talley, describing silk dresses in the Chloé 1975 Spring/Summer Collection. "And the hand-painted dresses were inspired from the Vienna Secession period. They had nothing to do with the original sketches, but were very much inspired by Art Nouveau and Art Deco in Vienna."[52]

Karl always maintained that their relationship was an emotional one rather than sexual. "That eliminates all jealousy and sense of competition,"

he once explained. "It sweeps away all of the heaviness that can happen in a normal relationship. It is a way to experience a love that is absolute, insouciant, and light, because it's not based on fucking."[53]

Diane de Beauvau-Craon, however, had long assumed that Karl and de Bascher did have a sexual relationship, at least at the beginning. "Of course, I don't know what may or may not have happened in the bedroom," she said with a laugh. "But I assume that it was sexual, at least in the first years of their relationship, and I might not even put the word 'years' in plural."[54]

A close friend of de Bascher, Philippe Heurtault, felt strongly that the relationship was sexual. Heurtault knew de Bascher from the time they were both in the French navy, becoming something of the official photographer for his friend: documenting him in his underwear at his family apartment, modeling suits in the Greco Roman sculpture galleries at the Louvre, or in the middle of wild parties he hosted at clubs and apartments around Paris. "I am absolutely certain that they had sex," Heurtault insisted. "And I feel that Karl's later story, about a love that was completely platonic, is a betrayal. It's completely made up."[55]

In 1984, de Bascher received what was the worst possible news in those years: he tested positive for HIV. On September 3, 1989, only thirty-nine years old, he died from complications with AIDS. Karl and de Bascher's relationship had lasted for just under two decades.

Heurtault insisted that the fear of HIV was a factor in how Karl spoke about the relationship. "I feel that is why Karl did not want to admit to his passion for Jacques," Heurtault suggested. "He was afraid that everyone in his little world, who knew that Jacques was sick and then died of AIDS, would wonder about him. So, he fabricated this story of a platonic love, to say, 'Look, I am seronegative.' That is why I say it is a betrayal—if Jacques were still alive, he would not have appreciated that kind of denial."[56]

De Beauvau-Craon, however, felt that it was always clear that the relationship was more of a sentimental one. "Karl was always very open about not being particularly interested in sex," she pointed out. "He considered Jacques more as his son. Karl would have loved to have adopted Jacques. Jacques is the only person that he would have ever adopted, but, unfortunately, he didn't have time to do it."[57]

It was clear that de Bascher had great respect and a real connection with Karl. One small note was telling. On one of his oversized calling cards, with his name beautifully engraved, de Bascher wrote, in English, "My heart belongs to K.L." His signature, using one of the many nicknames they had for one another, was "*Je t'aime*, Frichpo."[58]

And, throughout his life, Karl always spoke about the emotional link that they shared. In 2015, over twenty-five years after de Bascher's death, Karl appeared on a French talk show and discussed their time together. "In Proust, Swann lived with Odette, meaning that he had his great love with someone who was not at all his type," Karl explained. "That is my story. But our relationship allowed him to live his life as he wanted and for me to live mine. That did not, in any way, prevent an affection that was real, deep, and definitive."[59]

The host pressed him on their connection. Was it simply affection that he had felt for de Bascher or a love that was absolute? "The borders are difficult to discern," Karl replied. "A love that is absolute, insouciant, and light—let's put it that way. It sounds better—more literary."[60]

Over the years, Jacques de Bascher has become best known—notorious, really—for one small part of his life: an affair that he had with Yves Saint Laurent. It was a brief fling, lasting only a matter of months. It was an act, however, and this is not an exaggeration, that sent shock waves through the worlds of Paris fashion and society, causing ruptures that endured for decades.

Jacques Grange, considered one of the best interior designers in the

world, was very much in the inner circle of Saint Laurent, having played a major role in the designer's art collection and many of his interiors. In 1972, Grange designed his first project for Saint Laurent, a modernist bachelor pad on the Avenue de Breteuil (close to the town house he shared with Bergé on the rue de Babylone, also overseen by Grange, but far enough away that he could have some privacy). Over the decades, many of the great YSL interiors were conceived by Grange, including his château and a guesthouse in Normandy, a villa in Tangiers, as well as the couture house on the Avenue Marceau (and later its conversion into the Yves Saint Laurent Museum).[61]

Grange met de Bascher as soon as he appeared on the Paris scene. "I didn't know a Jacques de Bascher who was druggy, degenerate, with a motorcycle in his apartment, and having orgies day and night," Grange recalled. "I knew a Jacques who was completely charming, curious about everything, fun."[62]

As with many who crossed de Bascher's path, they, too, had a bit of a fling. "In fact, once, in Saint-Tropez, I was worried that Karl was going to throw me out," Grange said with a laugh. "But not at all—Karl could not have cared less!"[63]

Once they were back in Paris, de Bascher suggested that he and Grange have a rendezvous at his place on the rue du Dragon. "Jacques told me to meet him at the apartment, that he would leave the keys under the doormat on the landing," Grange explained. "It was to be somewhat secret, which was charming—a little game of seduction. So, I got the keys, went inside, and waited. The phone rang and I thought it was probably Jacques, calling me to tell me he was running late. I answer and hear, 'Hello, Jacques?'"

"I answered, 'Yes.'"

The call, though, was for Jacques de Bascher, not Jacques Grange.

"And then it dawned on me," Grange continued. "It's the voice of Yves Saint Laurent!"

Grange, staying silent, heard the designer say, "*Allô? Allô?*"

"I realized what was happening and quickly hung up," the decorator continued. "I put the key back on the landing and left."

Because of that phone call, Grange felt that he knew about the affair before anyone else. The possibility had the potential to be so explosive, he thought, so it was best to forget what had happened. "I never said anything to Karl or to Yves," Grange explained. "I thought to myself, 'Uh oh, this is something dangerous—let's just shut up about it!'"[64]

The affair between de Bascher and Saint Laurent lasted, at the most, six months.[65] "Yves' passion for Jacques was real but it was very short," explained Grange. "The legend around it has made it seem longer than it actually was." Several months after it began, friends of Saint Laurent suspected that he was having an affair but had no idea with whom.[66]

Their time together had plenty of vivid moments, both farcical and alarming. De Bascher's friend Philippe Heurtault remembered Saint Laurent filling de Bascher's apartment with deliveries of white lilies, massive arrangements from Lachaume, with notes that became more and more feverish.[67]

According to Heurtault, other elements of the relationship were more startling: Saint Laurent wanted the sex to be harder and harder. On one occasion, the designer asked to be locked in de Bascher's closet, so that he was forced to watch him while he had sex with another man. Once, outside de Bascher's apartment, he pleaded to be let inside, down on his hands and knees, calling up toward his windows, "My lieutenant." De Bascher told Heurtault that Saint Laurent had asked him to heat up his signet ring on the stove and then brand him with it. "One morning, I arrived at the apartment and the sheets were covered with blood," Heurtault recalled. "Jacques was stunned by what Saint Laurent wanted him to do."[68]

It was clear that de Bascher knew he was pushing things and that something noteworthy was happening. One afternoon, he asked to borrow Heurtault's camera. He hosted a gathering that night in his little bachelor pad: Karl, Yves Saint Laurent, Pierre Bergé, Clara Saint, Loulou de la Falaise, and Thadée Klossowski. "The situation was so incredible that Jacques wanted to get it on film to prove that it had actually happened."[69]

Diane de Beauvau-Craon was one of those who knew what was happening, as well. She saw how important it was to try to keep the affair a secret. "Jacques would have never left Karl for Yves," she once explained. "Whereas Yves was ready to leave Pierre for Jacques. A taste of something forbidden can heighten any romantic relationship and this wasn't a *ménage à deux*, or a *ménage à trois*, it was a *ménage à quatre!*"[70]

De Beauvau-Craon also felt that de Bascher used the affair to stir up some trouble. "My feeling is that Yves was, in fact, very much in love with Jacques but that, from his side, Jacques was interested primarily because he was Yves Saint Laurent and that that might have really pissed off Karl," she said. "I think the amount of scandal that came out of this affair was so out of line with the affair itself."[71]

In February 1974, Andy Warhol was the guest of honor at Yves Saint Laurent and Pierre Bergé's rue de Babylone town house. De Bascher's friend Heurtault was there to photograph the party. Karl and de Bascher were there together, looking relaxed in dark suits and ties. They chatted with Thadée Klossowski, Betty Catroux, and Loulou de la Falaise. Karl and Saint Laurent were photographed together, while de Bascher posed for a smiling photo with Pierre Bergé, his hand on Bergé's shoulder.

In one revealing moment, de Bascher was engaged in a smiling conversation with Nicky Weymouth, David Hockney, and Saint Laurent. While the rest of the group was clearly enjoying themselves, Saint Laurent stared at de Bascher, looking at the younger man with a plaintive, longing gaze. "Yves did not handle his drink well but that did not stop him from drinking," Heurtault recalled. "And he seemed to get out of control when he was drunk. He just stood there, fascinated by Jacques, and there was this fear that he might throw himself on him and confess his obsession in front of everyone."[72]

A certain tension hung in the air as Saint Laurent made his way out of the salon. Suddenly, there was a tremendous crashing sound from the next room. Saint Laurent had fallen down in the entrance of the house, taking with him as he tumbled one of a pair of giant narwhal tusks that stood in the entry. The artifacts, nineteenth-century Arctic relics

mounted on sculpted marble pedestals, were almost eight feet tall (when the pair were sold at Christie's, in 2009, for €217,000, it was noted that there were "minor chips and cracks to the bases").[73] As Heurtault remembered of the aftermath, "Lying on the floor, almost unconscious, he was carried by his friends to his bedroom. Jacques relaxed. The scandal was avoided, at least for that night."[74]

Word did eventually get out and the news, as Jacques Grange had suspected, was explosive. It happened to be the same year that the house of Saint Laurent was moving to its major new headquarters at 5, Avenue Marceau.[75] YSL was in a critical phase of its development and, strictly from a business point of view, there was a lot at stake.

Saint Laurent, however, dug in. There were stories of him calling de Bascher, pleading with him to continue the relationship, saying that he could do anything he wanted with him.[76] When Grange was in Marrakech, staying with the designer and Bergé, he saw one example of the designer's ongoing obsession. Bergé, furious, was railing about de Bascher. "I don't ever want to hear anything else about that piece of trash," he said.[77] As soon as Bergé left the room, Saint Laurent pulled a photo of Jacques de Bascher out from his chest pocket and rubbed it back and forth over his heart. "I'm just crazy about him," Saint Laurent insisted. *"Crazy about him!"*[78]

De Bascher's affair with Saint Laurent led to the breakup of the designer with Bergé, ending a romantic relationship that had lasted almost two decades. And, because of the outraged Bergé, it led to a major rupture between Saint Laurent and Karl, and many of their friends.

The shock waves were impressive. It was said that Bergé ran into de Bascher at the nightclub Le Sept and slapped him.[79] There was another scene at Le Sept when Bergé shouted at Karl, with some thinking it was going to come to blows. And there was a time when Bergé called de Bascher, threatening to have him killed, as was de Bascher's interpretation of the conversation, if he ever saw the designer again.[80]

Behind the scenes, Saint Laurent's partner did what he could to force a break. "Pierre Bergé was very direct and very clear," remembered

Pierre Passebon, the art dealer who has long been the partner of Jacques Grange. "It is your choice. Either you see Karl and we don't see one another again. Or you choose us. It was incredible. Jacques chose Saint Laurent because he worked for them and Karl understood—he was not angry or disappointed with Jacques Grange."[81]

Karl realized that the decorator remained close with Saint Laurent and he maintained a somewhat discreet friendship with Grange over the decades and also befriended Passebon—all three were also very tight with Princess Caroline. In fact, when it came to Grange, Karl seemed to play the long game. In 2016, when the interior designer was renovating the Mark Hotel in New York, he chose to use Karl's photographs in all the rooms. In 2017, Karl, bemused, noted that the coast was finally clear. "Well, Yves is dead, right?" Karl asked their mutual friend Françoise Dumas. "And Pierre Bergé is dead, right? So, now I can work with Jacques?"[82]

He then hired Grange to restore the apartment of Gabrielle Chanel and redesign the haute couture salons at 31, rue Cambon. Grange showed Karl archival photos of the salons, seeking to re-create a feeling closer to the original, modernist intentions of Coco Chanel. Completed in 2021, the salons have plush dark gray carpeting, walls of mirrors, oversized armchairs with white linen slipcovers, and black and gold lacquered Coromandel screens. "It feels like a nice homage to Karl, as well, because he asked for it, Chanel approved it, and we pulled it off," said Grange.[83]

Having worked with both Saint Laurent and Karl, Grange was well placed to observe the differences between the two designers. "Karl was much more tender than he appeared," Grange suggested. "He used his public persona to protect himself but, in reality, he was very sensitive, much more so than Yves. Yves pretended to be incredibly sensitive but, in reality, he didn't give a shit."

Many in Paris realized that, beginning in the mid-'70s, there was a distinct chill between the worlds of Karl and Saint Laurent. It is

not accurate to say that there was a complete rupture. Some, like Paloma Picasso, remained on friendly terms with both designers. And there were plenty of occasions when members of the two groups saw one another socially. But there was a definite break between the longtime friends and the split itself took on a life of its own.

More than a decade after the initial affair, Diane de Beauvau-Craon was at a dinner for Robert Mapplethorpe, held at Le Privilège, the club underneath the disco Le Palace. Everyone knew, at that point, how close she was with Jacques de Bascher. Pierre Bergé saw her, marched up to her, and, incredibly enough, assaulted her. "He slapped me twice and said, 'Oh, you're that slut of a princess!'"[84]

Much of Karl's anger about the rupture tended to focus on Bergé. "He really stirred up the shit with a group of people who had been really good friends," Karl said in the summer of 2018. "I was never mad at Yves. There was this famous fling with Jacques de Bascher but that didn't have anything to do with me. I never slept with Jacques—he could do whatever he wanted. Pierre said that I had orchestrated the whole thing to try to ruin the house of Saint Laurent. What an idiot!"[85]

Karl may not have blamed Saint Laurent for the separation but, after the 1980s, he rarely had anything positive to say about the designer. YSL officially retired in January 2002, presenting his final haute couture collection and becoming the subject of seemingly endless praise. The day before, Karl had staged his couture show for Chanel—a triumph—and then, on the evening of YSL's adieu, threw open the doors of his town house for a ball for *Harper's Bazaar*. As he said, "After a funeral, a ball seemed the right thing to do."[86]

Karl criticized the designer for months afterward. "Grotesque and depressing," he said of the outpouring of tributes to Saint Laurent, whose image of the solitary creator suffering for his art was abhorrent to Karl. "For Yves, it was torture, torture, torture," Karl said. "He went a little too far a little too quickly. And when people do that, they think they are above everyone and everything. Then, 20 years later, they have to pay the bill, and health bills are something that cannot be paid. And why tell

people that you suffered to make a taffeta dress, when you make the same dress as you did six months ago? *Please!* People buy your dresses to be happy, not to know about the dramas of a crying alcoholic."[87]

Some in Paris thought that Karl, with his continued attacks on Saint Laurent, had crossed a line. But Saint Laurent could be equally harsh about Karl. It was said that there was much snickering about his early work at Chanel, and particular pleasure was had in some of the early negative reviews.[88] Not long before the designer died, at a lunch at his apartment on the rue de Babylone with some of his closest friends, Saint Laurent issued something of an official statement. "You know, the problem with Karl," Saint Laurent said, "is that he has terrible taste."[89]

For his part, Karl at least had the courage to be direct.

Late in Saint Laurent's life, the two designers ran into each other on the street. They exchanged pleasantries, a reminder that they had been good friends for twenty years.

Saint Laurent suggested that they should see each other again.

Karl's reply: "What would be the point?"[90]

SEVENTIES PARIS
LES ANNÉES FOLLES

There was a time, in the 1970s, when I hated to be out of town
for more than 24 hours. There was the feeling that, wherever you
were in Europe, you did whatever you had to do to make it back
to Paris for drinks at the Café de Flore and dancing at Le Sept.[1]

MANY ASSUME THAT KARL Lagerfeld the star designer would emerge
only once he began at the rue Cambon in 1983. That was not true at
all. He had been doing excellent work for Fendi and Chloé throughout
the 1960s, while, by the 1970s, there was no doubt that he was a major
ready-to-wear designer and a social and cultural force in Paris. "Lager-
feld, who has had slow but steady recognition, has now made it to the
top," wrote fashion critic Hebe Dorsey in the *International Herald
Tribune* in the spring of 1974.[2]

Karl had been designing for a host of companies across Europe and
in Japan for the past decade. In addition to the two collections for Fendi
every year and the fifty designs he did for Chloé every season, he worked
for such entities as Mario Valentino, Timwear, Chavanoz, Trevir, and
the Wool Bureau. He designed fabrics for mills, some of which he then
used in his designs.

And he was becoming more of a public figure. One lively example
took place in 1971, when he and his band of Antonio Lopez creatives
took a one-day, three-city swing through Germany. It was something of a

high-style junket, showing off many of the lines he produced, and it was a master class of how to turn a television appearance into a performance.

By that point, everyone involved was on the upswing: Pat Cleveland was shimmying and spinning up and down runways in Paris, Milan, and New York; Donna Jordan was popping up on magazine covers across Europe; and Corey Tippin's crotch, as photographed by Andy Warhol, appeared on the cover of the Rolling Stones' *Sticky Fingers*. Lopez and Juan Ramos were an international fashion force. "Antonio's influence was growing in Paris and we were like family," Jordan recalled of those years in the early 1970s.[3]

So, Karl and his posse headed off for a day trip to Frankfurt, Berlin, and Düsseldorf. They had already done a similar routine at a trade event in Venice, at La Fenice, the opera house. Along for the German trip were Lopez, Ramos, Cleveland, Jordan, Nancy North (who would later be known as one of the "Halstonettes"), model Christine Melton, and Tippin.[4] Karl was sporting a three-piece, chocolate brown suit, a blousy white dress shirt, and a tie emblazoned with whimsical figures of golfers. His dark hair was swept back and gelled into place.

After an interview with Karl about his work, the show began with Lopez and the flame-haired Nancy North gliding onto the stage. He was in all black: pants, shirt, platform shoes, wide leather belt, felt hat, and cigarette holder. She was in high-waisted black pants and a pink and black top, and she had bright red lips with penciled-in eyebrows and bright blue eye shadow. They gave each other a quick smooch, spun around on a small, raised platform, then struck a pose. Next out was Corey Tippin in high-waisted, pleated white pants, a wide black cummerbund, and a white silk top. He was with Christine Melton, looking doll-like in a flouncy floral miniskirt and top, a striped sweater vest, pink hose, and short, spiky red hair. He bowed and spun his partner around a few times until they held their pose on their platform. And finally, out came Pat Cleveland and Donna Jordan, in full, long floral skirts, with striped sweaters, and wide-brimmed hats—forms and colors that had been inspired by the Bauhaus. They floated forward, taking baby steps, their

hands down at their sides but pointing outward, like avant-garde balle-rinas. Both then spun slowly on their platforms, fixing the camera with pensive, meaningful looks.

"That was a great day," recalled Corey Tippin. "We got up early and hit those three cities with Karl and a trunk load of clothes. There were cars to take us from the airports to the studios. I remember fooling around with Pat Cleveland while we were waiting for planes. She had the best walk, and I was like, 'Teach me your pivoting!' So, we practiced and that is what I was doing onstage: pivoting and pivoting, in those high heels."[5]

The team then made a second appearance in more casual clothes: Jordan in leggings and a tank top in sherbet green, Cleveland in white, horizontal-striped leggings and a matching knit top, and North in bright red pedal pushers with a flouncy red long-sleeved blouse. To a soundtrack of "Boogie Woogie," with a spirited piano solo and festive horns, they spun, danced, and kicked up their heels.

All were wearing head-to-toe designs by Karl, including Chloé, Tim-wear knits, and M. Valentino shoes and belts. Karl's designs and the en-ergy of Lopez and his friends produced quite an impression. "Through our own style, and Antonio's style, combined with Karl's style, it made for a shock," Tippin pointed out. The group finished their last show in Germany and rushed to fly back to Paris. Still dressed and in full makeup, they went straight to Café de Flore.

René Ricard, the New York poet and critic, happened to be at the Flore when they arrived. "And he just sat there, agog," Tippin recalled. "We were all on a high from our trip, from doing those shows. We were fresh off the set and hot to keep it going. I don't think we knew how excit-ing Paris was, at that point—it just felt like we *owned* it, like it was *ours*."[6]

By that time, Karl and his young companion, Jacques de Bascher, certainly knew what was happening on the scene in Paris. One of

their regular haunts was Club Sept, or Le Sept, opened in 1968, after the student riots of May 1968 that liberated, in many ways, French society. A tiny club, Le Sept had an oversized impact on Paris nightlife, like an earlier, smaller, Parisian version of Studio 54.

Le Sept was located at 7, rue Sainte-Anne, on the Right Bank, not far from the Palais-Royal. In the 1950s, the rue Sainte-Anne had a grand total of one gay bar, Le Fred and Carole. By the mid-'60s, the street was also home to a gay restaurant/club, Le Vagabond, and Pimm's, a tiny bar with a basement, owned by Fabrice Emaer, who had arrived in Paris after bartending at Crazy Boy, a popular gay bar in Cannes. "At Pimm's, Fabrice Emaer honed his public personality, of the theatrical host, a queeny socialite effortlessly tossing off compliments and cattiness," observed French writer Élisabeth Quin.[7]

In 1971, three years after the opening of Le Sept, Gerald Nanty crossed the Seine to start two spots on the street: the Bronx, a New York–style leather bar and sex club, and Le Colony, a much more sophisticated affair with an interior in black and gold designed by Jacques Grange.[8] Soon, the rue Sainte-Anne was lined with bars, discos, saunas, and street hustlers. "The idea of being politically correct, with all of its hypocritical compartmentalization, was yet to come," Karl later wrote about the era. "There was only Right Bank and Left Bank. And thanks to Fabrice Emaer, the night scene installed itself on the Right Bank, first with Le Sept on the rue Sainte-Anne and then, in 1978, with Le Palace on the rue du Faubourg-Montmartre."[9]

If the rue Sainte-Anne was seedy, Le Sept managed to transcend its setting. The entrance was through a nondescript black door, where a doorman—straight—would decide who made it in for the evening. There was no cover charge. The ground floor, with all four walls and the ceiling covered in mirrors, was a dining room, quite pricey. Andy Warhol and Fred Hughes, who had taken apartments in Paris, would be having pasta with caviar.[10] Downstairs was a dance floor, also with walls of mirrors, low chairs, tables, and banquettes. The ceiling was covered with strips of neon lights that pulsed with the music.

Le Sept attracted an impressive clientele: Bianca and Mick Jagger, David Bowie, Jerry Hall, Catherine Deneuve, Jeanne Moreau, Rudolf Nureyev, Françoise Sagan, Amanda Lear. "As soon as Hélène Rochas, Paloma Picasso, and Alexis de Redé started coming, Le Sept had this fabulous mix," explained Claude Aurensan, who managed the club. "When a few leaders from high society started getting in on the fun, the others followed."[11]

Karl and Jacques de Bascher stopped by Le Sept almost every night. "Thank God that Karl's group was there," said Guy Cuevas, the DJ at Le Sept. "He would come with those sublime girls: Donna Jordan, Jane Forth, Pat Cleveland."[12] Cuevas, a Cuban who had lived in New York, imported to Paris the sounds of the Caribbean along with American soul and disco. He spent long afternoons planning the sound for the evening. "Because it was before disco had started, I would mix African rhythms and other sounds along with the records to step up the energy," Cuevas explained. "I used bird whistles, sirens, foghorns, and slamming doors, cut back and forth between Marvin Gaye, Charles Trenet, Argentinian tango, Brazilian salsa, snippets of Vivaldi's *The Four Seasons*, and Marilyn Monroe singing 'Happy Birthday, Mr. President'—all done fairly tongue-in-cheek."[13] Cuevas did not even have a DJ booth—there were simply two turntables on a table at the edge of the dance floor. But the sound was innovative. "The music was completely new, like nothing we had ever heard before," Karl once recalled.[14]

Karl mostly talked with friends, picked up the bill, and kept an eye on the scene. In fact, he compared himself to Jean Rostand, a noted French biologist. "You know what Professor Rostand did with insects? He observed. Well, I did the same."[15] Jacques de Bascher had a much different approach. "Jacques was the king of Le Sept," said one habitué. "He used to dress beautifully, cover his eyes with whatever handkerchief he had, and dance outrageously. He was always with his cousin, Xavier de Castella—they were both beautiful like you can't imagine—so tall, slim, and elegant."[16]

Le Sept was also where Karl first adopted a signature accessory that

he used for decades. "Le Sept was really small, had poor ventilation, and people smoked like mad," Karl recalled. "So, because of all of the smoke and heat, I started carrying fans with me."[17]

It was also in the 1970s that Karl began to be associated with the cinema. He was friendly with Marlene Dietrich, collaborating with her on a special issue she guest edited for French *Vogue*, published in October 1971. He visited her at her apartment on the Avenue Montaigne, made clothes for her, and sent her thoughtful gifts. "My dream in the dark night," Dietrich wrote Karl in 1972. "You are so good with me and all of these gifts! What can I give you in return? Nothing that you would want! But I am going to try."[18]

Karl designed the costumes for actress Anouk Aimée in her 1978 drama *Mon Premier Amour*. For the release of the film, she was photographed by French *Vogue* lounging around Karl's apartment, wearing rubies and diamonds by Cartier and a series of elegant Chloé ensembles. "I either wear blue jeans or dresses designed by Karl Lagerfeld," Aimée announced.[19] The designer was equally enthusiastic about her. Karl remembered Aimée attending a press showing of Chloé, "on a Monday morning in October in a grey, unforgiving light." When she went backstage after the show, wearing little makeup and wrapped in an anonymous beige coat, Karl felt that she was more striking than all of the models. "She seemed somewhat vulnerable and fragile," Karl recounted. "As though she doubted herself, which only reinforced Anouk's power of seduction and sense of mystery."[20]

One of the longest, and most rewarding, screen collaborations for Karl was with actress Stéphane Audran. Though not well-known internationally, Audran was a highly esteemed actress in France, one of the best-known in the 1970s, and Karl worked with her for decades. Audran, who was statuesque with shoulder-length red hair, often played chilly, elegant women. Some of her most notable roles were in films made by her

husband, the great director Claude Chabrol (including *Les Biches*, 1968; *La Femme infidéle*, 1969; *Le Boucher*, 1970; *Violette Nozière*, 1978; *Poulet au vinaigre*; 1985; and *Betty*, 1992). Audran had long believed that costumes were the key to understanding fully her character. In the early '70s, she read an article about Karl in *Elle* and contacted him.

Karl and Audran ended up working together on over thirty films and television projects. Their first was Chabrol's *Just Before Nightfall* in 1971, where Audran plays the wife of a man who strangles his mistress during hardcore sex (a role for which Stéphane Audran won the BAFTA Award for Best Actress). She first appears in the woods around Versailles driving a motorcycle, with tight blue jeans, red leather boots, a black turtleneck, and a red motorcycle jacket with matching gloves. The following year, Karl designed Audran's costumes for Chabrol's *Wedding in Blood*. Playing an adulteress and murderer, Audran appears in deceptively conservative French designs such as a belted trench coat or high-waisted gray flannel slacks with a horizontal striped sweater. "I played a bourgeois wife, with a lover, who both decide to become murderers by killing their respective spouses," Audran once explained. "For one costume, Chabrol asked Karl for a touch of red that would symbolize sex and death. He designed a very classic dress, buttoned in front, that when I sat down, revealed that I was wearing a silk slip that was bright red. Another designer might have thought of something more obvious, like a scarf or a pair of gloves."[21]

Karl went on to design for Audran throughout her career, including her starring role as the French cook in *Babette's Feast* in 1987, which won the Oscar for Best Foreign Film. For the Danish drama, Audran uses all of her funds to prepare a feast for the isolated villagers who had taken her in as a refugee. Karl designed nineteenth-century bustle gowns and heavy traveling coats, and even lent Audran one of his own capes (now in the collection of Paris's Cinémathèque française).

Audran was struck by how Karl would conceive of the overall look for a character, not just the clothes. As did she, Karl wanted to use elements of style to convey overall character. "He would specify the jewelry, hats,

shoes, hair, makeup, undergarments," the actress explained. "Everything from head to toe."[22]

One powerful collaboration between Karl and Audran was for the great Surrealist film by Luis Buñuel, *The Discreet Charm of the Bourgeoisie* in 1973. It, too, won the Oscar for Best Foreign Film, while Audran picked up another BAFTA for Best Actress. The climax of the dreamlike story is a dinner party that is not quite like any other. It starts and stops and is constantly interrupted in alarming ways. Reading the script, Karl realized that, for most of the dinner, Audran would be filmed from behind. So he designed an elegant black evening gown that would highlight her back. It was a short-sleeve dress with skin-revealing cutouts in the back in the form of three triangles. The sexy design has an unforgettable presence in *The Discreet Charm of the Bourgeoisie* (and is also in the collection of the Cinémathèque française). "After we finished the film, I had to whisk the dress away," remembered Audran. "The wife of the producer had had her eye on it since the beginning of the shoot."[23]

Karl's reputation continued to grow, within France and internationally. "Fashion's King Karl" was the headline in the *Sunday Times* of London from April 1973. The article, written by the twenty-six-year-old Michael Roberts, who would go on to be a leading fashion editor in London and New York and style director of *Vanity Fair*, was published on the eve of the Paris collections. "I predict that the week will see a new fashion king emerging," Roberts wrote. "He will be the most influential designer of the Seventies."[24]

The story was accompanied by a photo, taken by Helmut Newton, of Karl sporting a dark beard, a monocle, a dark jacket, striped dress shirt, and a polka-dot tie. He stood with a model wearing an impeccably cut coatdress, said to have been inspired by Oskar Schlemmer, the painter, sculptor, and choreographer from the Bauhaus. The model wore a

simplified pale cloche hat with something of the form of a pith helmet. "Very World War I," Karl suggested.

From his previews of the Fall Chloé collection, Michael Roberts was impressed with the season's simplicity. "Mr. Lagerfeld seems to be the only designer at present to have grasped that most elementary of fashion fundamentals, 'Less means more,'" Roberts wrote. "That economy of line, cut, and color is the essence of classic design; that if fashion is not to choke on its own mediocrity, there has to be a New Mood."[25]

Roberts also reported that, the week before, Karl had turned down an offer to become the new designer of Chanel, at a salary of $250,000 per year, or over $1.5 million today. "Had he agreed, Prêt-à-Porter would have lost its greatest attraction," Roberts noted.[26]

The journalist suggested that the impeccable construction he saw in the collection was a result of Karl's early background in haute couture. "At 9:00 a.m. tomorrow, at the restaurant Laurent, Champs-Élysées, he will show his autumn collection for Chloé," Roberts concluded. "Having seen it in preparation last week, I would say that it is, quite simply, brilliant, a tour-de-force."[27]

By the mid-1970s, Karl also demonstrated his mastery of public relations. He was able to toss clever comments seemingly effortlessly. In describing a Chloé collection inspired by the lines of Art Deco, Karl said, "I really only like three materials: lacquer, chrome, and mirror." He clearly enjoyed the back-and-forth with journalists. When one asked if he was frivolous, Karl responded, "How could I not be? I sell wind, which is, for now, blowing in the right direction."[28]

In the fall of 1974, at the age of forty-one, he was profiled in the French men's magazine *Monsieur* as one of the fashionable men of Paris, along with thirty-year-old Jacques Grange and thirty-seven-year-old David Hockney (though Karl claimed his age was thirty-six). He was photographed lounging at home, a book open in front of him, with a dark jacket, light silk shirt, and a polka-dot bow tie. He had a perfectly groomed dark beard. The article enthused about his productivity. "For

20 years now, he has dressed women from head to toe," *Monsieur* noted. "He has had as much success in luxury as in less expensive lines, in fur or synthetics, in wool or cotton, in silk or rayon. He designs fabrics and shoes, coats and nightshirts, sweaters and evening dresses. He has just launched his first collection for men and he is just about to launch his first fragrance, with Chloé."[29]

After that litany of achievements, the magazine asked Karl if he was a workaholic. "Oh, let's not go too far," he replied. "What really matters is being open 24 hours a day. The world needs to be seen in terms of what can be made of it. Genius is knowing how to take ideas from everywhere, and I am the worst of vampires. I practice vampirism to the nth degree."[30]

He suggested that in the first two decades of his career he had learned, most of all, what not to do. "I have had the opportunity to learn my craft through on-the-job training," he pointed out, "all while being nicely paid."[31] While he admitted to being active socially, he said that he had mixed feelings about the subject. Karl explained that it was critical for his work to go out, to see what was happening in the world. "When you get right down to it, I am a voyeur," he said. "In fact, that's my job."[32]

A s the decade progressed, Karl's way of living became increasingly grand.

In 1974, Karl moved from 35, rue de l'Université to a sprawling apartment at 6, Place Saint-Sulpice in the 6th arrondissement. It was on the second floor, a 4,000-square-foot corner apartment with high ceilings and massive French doors that opened out onto the tree-filled square and the historic Église Saint-Sulpice. There was a wraparound balcony that extended along the square and the rue des Canettes. The eighteenth-century building was designed by Giovanni Niccolò Servandoni, the architect of Saint-Sulpice. Although he only rented the apartment, Karl spent hundreds of thousands of dollars renovating the space. The walls

were a pristine white and the floors were covered with plush black carpeting.

Karl's bedroom was a little masterpiece of 1920s elegance. On the black carpet, in front of the white walls and layers of sheer white curtains covering the windows, he placed an architectural table by Eugène Printz, a trio of lacquered vases by Dunand, crimson velvet armchairs by Paul Follot, and voluptuous white armchairs by Émile-Jacques Ruhlmann.

The spacious, high-ceilinged rooms were the perfect setting for Karl's increasing number of interviews and for fashion shoots. Soon, such innovative photographers as Helmut Newton and Guy Bourdin were using his place as a set. It was in that way that Karl first met Princess Caroline of Monaco, then a sixteen-year-old being photographed in his apartment for *Vogue* wearing Chloé. It was the beginning of a close friendship that would last for forty-five years.[33] Soon, Princess Caroline was caught by paparazzi out at Paris nightclubs, spilling out of a low-cut satin dress, in pearl gray, that Karl had designed for Chloé.[34]

While he was installing himself in Art Deco opulence on the Place Saint-Sulpice, within an eighteenth-century building, Karl made a definitive move toward the *Siècle des Lumières*. In 1974, he made his most important real estate purchase to that point: an eighteenth-century château in the Morbihan department of Brittany. Located in the village of Grand-Champ, the Château de Penhouët dated from 1756. Karl purchased the property at auction. It was a handsome, three-story structure in white stone with a steep gray slate roof. Additional buildings included a greenhouse, or *orangerie*, and a chapel, all positioned in a huge garden that was said to be by Louis XIV's landscape architect, André Le Nôtre.[35]

The property also happened to be only about ninety miles from de Bascher's family home, the Château de la Berrière. The house and the garden were in a state of abandon, so Karl set out on a massive restoration. He met a young man, Patrick Hourcade, who was an editor at French *Vogue* as well as an aficionado of the eighteenth century. "Karl, who had his dark beard and was wearing a monocle, told me that because

of Jacques de Bascher, he had just bought a château in Brittany," Hour-
cade recalled. "But he said that it doesn't look anything like a château
from Brittany. It looks like one of the townhouses you would find on the
rue de Varenne."

Hourcade suggested that it would be important to track down
eighteenth-century architectural treatises documenting the landscape
architecture, paneling, painting, etc. They spent three years studying
historical documents, acquiring art, furniture, and objects, rebuilding one
wing of the structure that had been burned during the French Revolution.
Karl had a model constructed of the house, to study its proportions.[36]

He would take the train from Paris's Gare Montparnasse to Grand-
Champ, spending one night to study the progress and then returning
the following afternoon. He made drawings and hired an architecture
firm to make major modifications to the house, the outbuildings, and the
grounds. "By 1977, the exterior renovations had resulted in new formal,
French gardens, fountains and terraces with waterspouts, and, at the en-
trance, a circular reflecting pool," noted a local newspaper. "He enclosed
the property with a high wall on its south side. Before, it had been visible
from the exterior—it was now concealed from view."[37]

And Karl took weekend trips with friends to Grand Champ, as the
château became known, continuing to perfect the interiors. "One of my
favorite places was the library," recalled Diane de Beauvau-Craon. "It
was in this building in front, as you came in the gate. It was a huge loft-
like space, with a ceiling of skylights, and high-tech shelves filled with
thousands of books. It was extraordinary."[38]

In the center of the room, which Karl designed with Andrée Put-
man, he also installed the latest workout equipment. On dark rubber
flooring, he had a large unit, in chrome and chocolate brown padded
vinyl, for bench presses, pull-downs, and an incline for sit-ups. Chrome
dumbbells were positioned on the floor. It became a space for indulging
the body and the mind. "The exuberance of the 18th century and the
stripped-down style of the end of the 20th century can coexist in the life
of the same person," Karl explained.[39]

Elisabeth Lagerfeld moved from her rooms in the back of the Place Saint-Sulpice to Grand Champ. Almost eighty years old, she was still well groomed, often wearing pants by Sonia Rykiel and crepe de chine tops designed by her son. A Spanish couple, Rafael and Pilar, oversaw the house and attended to her needs. She spent most of her time in her room, listening to classical records, primarily of violin and piano concertos.[40]

On September 14, 1978, having had a stroke, Elisabeth Lagerfeld, eighty-one years old, died at Grand Champ. Karl was in Germany, on a work trip for Chloé. He insisted that his mother told him not to see her after she died, that she wanted to be cremated, and not to have a ceremony. Alerted to the news, Karl continued his appointments and returned to Paris. There was no memorial. Illness and death were not subjects that friends chose to discuss with Karl.

One of his closest friends throughout the 1970s was the Italian fashion editor Anna Piaggi, who had one of the most singular, extravagant approaches to style. "The Italian journalist who startles everyone with her strange combination of clothes from the past and the present," was how she was characterized by the *New York Times*.[41] Marian McEvoy, who was the European fashion editor for *W* and *WWD* in the 1970s, and knew Piaggi quite well, said, "She was a performance artist."[42]

Piaggi was not tall but tended to make quite the impression. She wore an asymmetrical bob, cut by Vidal Sassoon in London, short on the neck, with one long, wavy lock of hair, often dyed purple, coming down over one eye. She had kind eyes and strong features, what the French call *jolie laide*. Karl, noting that he was paraphrasing a statement from a nineteenth-century French actress, Marie Dorval, said of his friend, "She's not beautiful—she's worse!"[43]

Jacques de Bascher photographed them sitting casually on a Paris park

bench, talking with Suzy Dyson, Karl wearing dark pants, high-heeled boots, and a seersucker jacket, while Piaggi was dressed as a "Belle Époque Amazon," with thigh-high leather boots, a nineteenth-century lace blouse, and a vintage black hat covered with feathers.[44] "In dressing herself, she is creating an image," Karl wrote of Piaggi, in a book containing some of the hundreds of his drawings of her. "An article of clothing she selects, and her way of wearing it, creates an overall mood. She is a great performer and yet she is also the author of the play."[45]

In 1975, Karl sketched Piaggi wearing a long Fendi coat in red and white squirrel, with a vintage cane made of segments of horn, probably from Africa, and a 1920s glove box in tortoise and leather used as a purse. Days later, she was sporting a 1925 black velvet coat by Jeanne Lanvin, a cotton T-shirt by Missoni, Turkish pants under a black silk kimono, and gray suede shoes, trimmed in mink, by Manolo Blahnik.[46]

Karl's drawings of Piaggi were snapshots of their everyday life together. He captured her lounging around in bed at Grand Champ, wearing a camisole and shorts in white cotton with floral embroidery, loungewear she had picked up at Senigalia, the Milan flea market.[47] In the summer of 1976, he sketched her in the kitchen at Saint-Sulpice, standing at the sink, washing lettuce in black pants and a colorful bustier designed by Sonia Delaunay for the Ballet Russes in 1909.[48]

For Karl, who was fascinated by fashion history, Piaggi was like a style encyclopedia brought to life. "There is no one else like Anna who can capture the visual language of clothing," he explained. "She ignores all banality. She never does what is expected and yet, once she has done it, it is always so obvious."[49]

In November 1975, Karl began to finalize his turn toward the French eighteenth century, selling much of his Art Deco collection in an auction at the Hôtel Drouot in Paris. "Karl Lagerfeld is giving up Art Deco

in order to plunge himself into the century of the great Royal cabinet-makers," noted *Le Monde* of the sale.[50]

The exhibition and the auction were packed, with French and international buyers, and it totaled 800,000 francs (approximately €600,000 today, or $650,000), a respectable result for a period of collecting that was still relatively new. Particularly successful were a pair of lacquered vases by Jean Dunand, two matching sconces by Émile-Jacques Ruhl-mann, and a pair of lacquered screens by Dunand.[51]

Karl organized the auction because he had found a new place in Paris. He was moving from the 6th arrondissement back to the 7th, and turning the huge apartment on the Place Saint-Sulpice over to Jacques de Bascher, then twenty-five years old.[52] Karl had taken a wing of the exquisite eighteenth-century town house at 51, rue de l'Université, just down from his first apartment on the same street, where he would live for the next three decades. The Hôtel Pozzo di Borgo, also known as the Hôtel des Maisons or the Hôtel de Soyecourt, is one of the most spectacular private homes in the Faubourg Saint-Germain.

Its construction began in 1706, by Pierre Cailleteau, known as Lassurance, who the Duc de Saint-Simon felt was the most accomplished architect at the court of Louis XIV. It was marked on the street by a high stone wall. In the center, a soaring set of double doors was flanked by a pair of Doric columns and surmounted by engravings of military helmets and laurel wreaths. "It is the most beautiful doorway on the rue de l'Université, designed in 1788 by Ledoux," Karl explained. "I love these great *portes cochères*. The great novels of French literature and countless scenes in French history take place behind doors like that."[53]

Past the entrance was a massive cobblestone courtyard, the *cour d'honneur*. The main house was straight ahead, a wide, two-story stone structure, with rows of large windows on both floors. The central entrance had double doors, Doric columns on both sides, and a tall, triangular pediment with Corinthian pilasters. Behind was a large lawn and garden, over 29,000 square feet, or two-thirds of an acre.[54]

Karl's first apartments at 51, rue de l'Université were in the wing on

the left, two stories with a grand staircase in marble and iron, with views onto the courtyard, the street, and the garden. Upstairs was a series of three salons, an office, and Karl's bedroom.

Liliane de Rothschild, a great expert on the eighteenth century, showed Karl miniatures that she had of interiors of the Duc de Choiseul, the Hôtel de Choiseul on the rue de Richelieu near the Palais-Royal, considered one of the most sumptuous eighteenth-century houses in Paris. The miniatures were painted by Van Blarenberghe in 1770 and Rothschild had large prints made for inspiration for Karl.[55]

"It was a great lesson in 18th century decoration," suggested Patrick Hourcade of their work on Karl's apartments. "The rooms were never finished, because we were so excited about new acquisitions that everything kept changing—a salon became a ceremonial bedroom, a dining room became an office, an office became a little salon."[56]

The constantly evolving interiors were based on Karl's ongoing research into the history, his purchases at galleries and auctions, and an ever-present desire to be modern. "The 18th century was very vigorous and healthy," Karl said at the time. "It is because of its energy that I love it, and because it has the proportions that best correspond to the way that a human being should live. But it is important to have some perspective, as well—I prefer to keep my windows wide open."[57]

In 1977, when he launched the line of ready-to-wear for Fendi, Karl hired de Bascher to direct a short film to mark the occasion. Entitled *Histoire d'Eau*, a play on the French word for water and *Histoire d'O*, the 1954 erotic novel that had been turned into an equally steamy film in 1975, *Histoire d'Eau* was written and directed by Jacques de Bascher. Fendi considers it the first short film by a fashion firm.

Histoire d'Eau stars American model Suzy Dyson, who was a major name in Europe in the '70s, posing for Helmut Newton and starring in the Chloé fragrance campaign. The film begins with the dark-haired

Dyson arriving at the Hotel de la Ville in Rome, on the Via Sistina, just off the top of the Spanish Steps. She pulls up in a white Mercedes sedan, wearing a white pantsuit with a gray-and-white fur poncho. The music is the instrumental of Barry White's "It's Ecstasy When You Lay Down Next to Me." She takes a couple of spins around the revolving door, before being shown to her room. As the disco music shifts to Chopin piano concertos, she goes onto the terrace with a panoramic view of Rome and writes a postcard to her mother back in New York. The sun is bright in Rome, but she tells her that she has just arrived in Baden-Baden, that the weather is terrible, and that her spa regime will be starting the next day.

She pours herself a glass of champagne and stares out over the Eternal City. She then takes a tour of Rome, in a variety of skimpy outfits, kicking off her shoes and playing in the city's fountains. Back at the Hotel de la Ville, she sits on her bed, in jean shorts and a sheer top, and writes another note home: "Dear Mum, The weather's getting worse. Wish I'd brought more furs. I'm freezing."

And, of course, de Bascher had to include a shout-out to Karl. Dyson lounges under the sun at the side of a Roman fountain, wearing a one-shouldered swimsuit in black. A wirehaired dachshund runs up and she cuddles with him. "Yesterday, I bought myself a lovely cat," she writes her mother. "I've named him Karl. Guess why?"

Back at her hotel, lounging on the terrace, a white-jacketed waiter brings Dyson a note on a silver platter. The stationery carries the Fendi logo. "Suzy darling: furs are ready, love, love, Paola, Anna, Franca, Carla, Alda."

What follows is a soft-focus fantasy sequence, six minutes that would absolutely horrify anyone who is even vaguely sympathetic to PETA. In a room with mirrored walls and steep stairs, she tries on a series of the most luxurious furs in the world. Often topless, she twirls around, holds her arms out, and looks at herself in the mirrors. The scene concludes with another note home: "Mommy, I'm broke—help!"

Back at the hotel, Dyson gets a call from Carla Fendi, inviting her for lunch. That leads to a scene at the Fendi headquarters, seeing the

ateliers, having lunch with the workers. She drinks red wine and chats with the atelier team and all of the Fendi sisters—a scene that drives home Karl's view of Fendi as a family affair and the importance that he always gave to the craftsmen working behind the scenes in fashion.

"It was beautiful, right?" Silvia Venturini Fendi asks about *Histoire d'Eau*. "Fendi gave him the best: the best director of photography, the best support, the crew was the one that used to work with Visconti."[58]

Karl was positive about the result. "It's a lovely film," he told de Bascher's biographer. "Apparently, the shoot was a nightmare but I wasn't there. Jacques would start working about 5:00 p.m. or 6:00 p.m. He slept during the day. Then he would stop working early in order to go out in Rome."[59]

P articularly for someone so focused on work, Karl was very much out on the scene in Paris. In October 1977, Jacques de Bascher hosted a party in his honor. Held after the Chloé 1978 Spring/Summer Show, it was entitled "Moratoire Noire," or Black Moratorium, and it was a particularly outrageous evening.

It took place at La Main Bleue, a massive nightclub that had opened on New Year's Eve 1976 in the working-class Paris suburb of Montreuil. Considered the largest disco in Europe, it catered primarily to incredibly styled African immigrants who were not always welcome at Paris clubs. Located under a shopping center, it was a cavernous space, almost 14,000 square feet, that had been built to house three movie theaters.

Its conversion into a nightclub was the work of Philippe Starck, a young designer working on the first major project of his career. It felt to many like something of a black hole, with a wide stairway, in dark blue concrete, that descended from the entrance, rough concrete walls, and a high-tech metal stage, like construction scaffolding, with columns for lights and fog machines.[60] La Main Bleue had the first laser light system ever installed in Paris. When the lasers were fired up, shooting around the dark space, the crowd broke into applause.[61]

For the party, de Bascher sent out engraved invitations, in an elegant script, using an intentionally florid French. "Xavier de Castella and Jacques de Bascher invite you to give them the pleasure and the joy of participating, for the entire night of the 24th through the 25th of October 1977, at a 'Moratoire Noire' party, in honor of Karl Lagerfeld," was how the invitation was phrased. "Tragic, black attire is absolutely obligatory."

"Moratoire Noire" attracted over four thousand guests for an evening that fused fashion and hard-core S&M. Attendees included actress Maria Schneider, Bianca Jagger, Paloma Picasso, designers such as Kenzo, and such stars of the Paris scene as Paquita Paquin and Edwige Belmore, a platinum-haired Punk. De Bascher and de Castella discarded the dress code, appearing in tight white fencing uniforms, replete with metal mesh masks, the only light colors in a sea of black. Karl went as something like a vampire, wearing a black cape, white makeup, with his hair black and worn loose. Staying for half an hour, or an hour tops, he was unclear about what exactly was happening. "Everything was black, and it was so dark that you couldn't see anything," Karl later recalled. "The photos in the following days made it look like a huge backroom and it caused such a scandal that the local mayor was fired."[62]

Karl missed most of the debauchery. As the night went on, the fashion crowd filtered out, and the mood became more and more hard-core. One guest arrived with a Roman breastplate, a leather motorcycle jacket, and a studded leather mask that covered his entire head. The cohost, Xavier de Castella, who was Kenzo's partner, used his fencing blade to whip one leather-clad guest. There were live sex acts, accompanied by "Amsterdam," a sailors' anthem by Jacques Brel, the floor was littered with broken bottles of poppers, and orgies began to take place around the club. One show involved a man in tight leather pants, no shirt, and a leather jacket humiliating his slave who was down on his hands and knees.[63]

Even the owner of the club was astounded. "I had never seen anything like that in my life," said Jean-Michel Moulhac. "It was total madness. There was that fist-fucking on stage, to the sounds of Jacques Brel, and after that, the party degenerated. People were fucking everywhere—even

my press officer was doing his thing in the locker room. I had completely lost control."[64]

The initial press was scathing. "Public orgies in the heart of Paris," was how one newspaper phrased it.[65] The owner of La Main Bleue was hassled by the city of Montreuil, while the deputy for the area took the issue all the way to the Assemblée Nationale, the French congress, demanding the closure of the club.

Eventually, however, the evening received glowing write-ups in French *Vogue*, *L'Uomo Vogue*, and newsweeklies *Le Point* and *Le Nouvel Observateur*. The investigations were wrapped up; the club became even more fashionable; the tide had turned. "Along with the wedding of Loulou de la Falaise," wrote French journalist Alain Pacadis, "I think it was one of the best parties of the year."[66]

The first party that Karl hosted in his new apartments at 51, rue de l'Université was a buffet dinner for nine hundred to mark the launch of his new men's fragrance, Lagerfeld. Karl had the salons lit by thousands of candles. The menu of foie gras and petits fours was prepared by pastry chef Gaston Lenôtre based on period engravings of eighteenth-century feasts.[67] Karl wanted the waiters to be in period costume, an idea that horrified the caterer. "But Monsieur Lagerfeld," Lenôtre said, "this is the 20th century!" It was an argument that Karl won, for the waiters, all two dozen of them, appeared in white wigs tied behind with black ribbon, ruffled white shirts, red breeches with a black belt, white hose, and black shoes with gold buckles.[68]

Karl, his hair back in a ponytail, wore a three-piece black suit, a white wing-collared shirt, and a black foulard. De Bascher, with a close-cropped beard, had a matching black suit with a crisp white shirt with a high officer's collar, and a narrow black tie. Guests included Paloma Picasso and her fiancé, Rafael Lopez-Sanchez, Anna Piaggi, Antonio

Lopez, actress Jean Seberg, Chloé's Gaby Aghion and Jacques Lenoir, Manolo Blahnik, and André Leon Talley.

"If you count the cost of replacing Lagerfeld's thick golden carpet, which was liberally sprinkled with cigarette butts and spilled drinks, it all obviously adds up to a lot more than the cost of one of his thousand-dollar dresses," the *New York Times* noted of the party.[69]

Just a few weeks later, in May 1978, Karl hosted the wedding dinner for Paloma Picasso and Rafael Lopez-Sanchez. "I had the civil ceremony at the town hall dressed in Saint Laurent," Picasso recalled. "The jacket was white, the shirt was red, the skirt was black, and the hat was white with some little red feathers. Karl had said that he would host the dinner, so, of course I wanted to be dressed by Chloé. It was a red dress that was supposed to be like a double heart."[70]

The dinner was held at the historical splendor of 51, rue de l'Université. "Karl decided to do what he said people would do in the 18th century," Picasso remembered. "So, he decided to have these big square tables, with 10 people on each side, seating 40 people. It was a huge table to be able to seat that many people." There were several of these large tables in two different rooms.[71] On white linen tablecloths Karl had arranged massive floral centerpieces that were in the form of an eight-pointed star from Andalusia, where Picasso's father, of course, had been born.[72]

Guests were greeted downstairs by Karl and de Bascher. And, four years after the affair that had so many repercussions, the entire Saint Laurent team went to Karl's dinner, including the designer, Pierre Bergé, Loulou de la Falaise, Madame Muñoz, and Clara Saint. "What is this love affair?" asked de la Falaise when she saw Karl and Bergé deep in conversation.[73] Others from the world of fashion were well represented, including Kenzo and Xavier de Castella, André Leon Talley, and Manolo Blahnik. The worlds of art and society were also at Karl's with Françoise Gilot—the mother of the bride—Claude Picasso, choreographer Serge Lifar, art dealer Alexandre Iolas, Fred Hughes, and Tina and Michael Chow.

Karl was often eager to throw open the doors of his new home. In the fall of 1979, he hosted another major evening at 51, rue de l'Université, this one a candlelight dinner for Mikhail Baryshnikov, then the star dancer of the New York City Ballet. For the party, which followed a gala performance by Baryshnikov at the Théâtre des Champs-Élysées, Karl worked with a designer behind the extravagant decors at the Hôtel Lambert receptions given by Marie-Hélène de Rothschild, the queen of Paris society. The grand staircase of Karl's place was strung with garlands of chrysanthemums, tuberoses, and ferns. In the first two salons, with their historic, ornate wood paneling, gilded chandeliers were wrapped with the same floral garlands mixed with ivy, its leaves lacquered in gold.[74]

A glittering crowd joined Karl and de Bascher: Marie-Hélène and Guy de Rothschild, Princess Caroline, Jacqueline de Ribes, Ira von Fürstenberg, Hélène Rochas, Sao Schlumberger, and Betty Catroux. A flutist and harpsichordist played Baroque chamber music, compositions by Antonio Vivaldi, François Couperin, and Jean-Philippe Rameau. Dinner, by Lenôtre, included a pyramid of duck foie gras, *poularde aux morilles* (chicken with morel mushrooms), a special confection of chocolate cake topped with leaves of chocolate, known as *entremet feuille d'automne*, and vodka sorbet. After dinner, Karl, Baryshnikov, and a pair of princesses—Caroline of Monaco and Ira von Fürstenberg—went dancing at Castel, finishing the evening at 3:00 a.m.[75]

Others certainly noticed Karl's increasing visibility. A trendy Paris magazine, *Façade*, did a ranking of the leading figures of Paris nightlife. One hundred were included, with headshots of each winner. The Bronze level consisted of several dozen, including Anna Piaggi, Betty Catroux, Andrée Putman, Claude Pompidou, Ira von Fürstenberg, Thierry Mugler, and Philippe Junot. The Silver level, more select, was led by Jacques de Bascher, Diane de Beauvau-Craon, Yves Saint Laurent, André Leon Talley, Marian McEvoy, Johnny Pigozzi, and Princess Caroline.

There were only five members who qualified for Gold, or "*Nightclubbers d'or*": Fabrice Emaer, Loulou de la Falaise, Paloma Picasso, Kenzo, and Alain Pacadis (the journalist).

At the top of the chart, the Platinum level, there was only one: "Karl Lagerfeld, *styliste de mode*."[76]

Le Palace, which had opened in April 1978, was a massive new club in a former theater that was Paris's answer to Studio 54. It had a spectacular interior, with gilded wood paneling, ceiling frescoes that had been restored, and acres of ruby red velvet. From the entrance, a wide hallway descended toward a foyer and then the main room, several stories tall, with a large balcony hanging over the scene. A huge dance floor was positioned in front of the stage; lights and lasers descended from above. The waiters wore strong-shouldered red jumpsuits designed by Thierry Mugler.[77]

De Bascher had been going to Le Palace practically every night and Fabrice Emaer suggested that Karl should host a party. So, in October 1978, six months after the club had opened and one year after "Moratoire Noire," Karl hosted his own costume party at Le Palace. It was a Venetian Ball.

The invitation to the party, timed to coincide with Paris Fashion Week, was a small booklet, with a line drawing of a historic street performance on Piazza San Marco. The title of the evening: "From the City of the Doges to the City of the Gods." On the back was a mask that could be used by guests. "The theme was imagined by Karl Lagerfeld and Fabrice Emaer, who thank you for having participated in this pretext for a party."[78]

The Venetian theme was Karl's idea, as was the design of the invite. "I thought people were less likely to lose the invitation if they wore the mask," Karl said at the time. He suggested the dress could be thought of as "Changing Venice."[79]

Karl worked with Emaer on the design of Le Palace. The area around the dance floor became a Doge's Palace, with obelisks and garlands of red carnations crisscrossing the ceiling. Onstage, as a backdrop for

singers and flamethrowers, was a painted backdrop of Venice. The club
entrance was lined with thousands of red roses, suspended from the ceil-
ing in netting.[80]

On the night of the event, as Parisians made their way to Le Palace,
they saw others throughout the city, in costume, headed in the same di-
rection. As they approached the club, they found the streets and bou-
levards were packed with cars, limousines, and revelers on foot. One
club employee said, "This has never been seen before, or if it has, it was
in another century."[81] There were some forty-five hundred guests at the
party, which turned out to be one of the biggest and most exciting yet in
Paris. "They came as curés and padres, courtesans and decadent Con-
tessas," noted a story on the evening in the *Washington Post*. "Some
had clearly raided the rental costumeries. Most were from the fashion
world or at least related to it—hairdressers, decorators, models. Their
costumes were trimmed and tasseled, sequined and feathered versions
of their fantasies."[82]

Karl wore a tricorn hat, a curled wig, and an eighteenth-century black
costume with lace, a look inspired by a Tiepolo painting. He carried a
rectangular fan on a long handle. De Bascher had a model of the Rialto
Bridge built across his shoulders, his arms extended out (a clever design
that became impractical because of the crowds). Paloma Picasso wore a
strapless black gown from the 1950s and had the salon Carita install cork
letters in her hair spelling out "Venise."

One of the most remarkable appearances that night was from Jenny
Bel'Air, a transgender woman who was part of a team that worked the
front door at Le Palace. Born and raised in Paris, to parents who were
from Guyana, Bel'Air had turned herself into one of the most original
figures on the scene, extravagant, funny, and often quite harsh. A book
about her life had a backhanded title, *Jenny Bel'Air: A Creature*.

For Karl's party, Bel'Air studied the photos of a Venetian ball from the
1950s, given by the extravagant art collector Charles de Beistegui, con-
sidered one of the most creative parties of the century. Inspired, Bel'Air
and a friend decided to build a gondola. And she made her triumphant

appearance to Le Palace perched in the gondola, carried into the club on the shoulders of a bunch of shirtless firemen. She wore a polka-dot princess dress, a tall blond-and-silver wig, and a push-up bra with fake cleavage. A hidden speaker played classical music. "I said very little but I waved in a way that would have made the Queen jealous," Bel'Air recalled. "I was totally imperial. I was no longer a tranny, a creature, but a woman—I had never felt more like a woman in my life."[83]

It took more than an hour for Bel'Air to be carried slowly down the corridor toward the main room. "Then some charming girlfriend of mine tripped one of the firemen, and the gondola came tumbling down," she recounted. "There I was, my legs up in the air, my Kidneys in Madeira sauce on full display, for all of those who were unaware that I had never had the big operation in Casablanca. Chica da Silva thought that she was going all Louis XV but instead ends up sprawled on the floor. I'm still laughing about it! Karl Lagerfeld had planned everything perfectly—but not that . . ."[84]

The conclusion of the Venetian Ball, for the thousands who were packed into the club, was suitably dramatic. "There was a Baroque set built for the evening, and we found a special kind of fireworks," Karl recalled. "When they went off, the set slowly burned away—it was very, very beautiful."[85]

These disco parties were a major form of escapism, of course, but they also included an intangible element so essential to the world of fashion: fantasy. And they were intended to be democratic. "Everyone loves to wear a costume, to have a different life for an evening," Fabrice Emaer told the *Washington Post* for its story on Karl's party. Loulou de la Falaise agreed. "It's pretty boring when everyone is in tuxedos and pretty dresses," she explained. "Costume parties are more fun for those with less money. Everyone loves to stick a feather in his head."[86]

Karl had just turned forty-five years old, and the Venetian Ball took place only weeks after his mother had died. For someone so hesitant to engage on subjects like loss or death, the escapism of a costume ball was a welcome distraction. But Karl also stressed the energy, and egalitarian

feeling, of what was happening in '70s Paris. "The standards of what is chic and not chic are not the same anymore," he told the *Post*. "Who cares if you are a rich banker's wife and put all your money into ugly jewelry. The rich trip on their money. They want to be entertained, but no one wants to entertain them. So why bother? They are not amusing—I don't know if we are either but we are alive."[87]

12

INTERNATIONAL
TRAVELS

My motto is "Open your eyes!" I go around the world, working
not only in Paris but also in Italy, America, Japan, and I pay
attention to everything. While doing so, I keep asking myself,
"How can I translate this into fashion?"[1]

IN THE SPRING OF 1979, Karl's international reputation hit a major
crescendo.

"In the past, there were designers like Dior, Chanel, and Balenciaga,
important not only for the clothes they made themselves but for the fact
that they seemed to be influencing everybody else who made clothes,"
wrote Bernadine Morris in the *New York Times*. "Today there is Karl
Lagerfeld."[2]

For Fall 1979, Karl staged two triumphant shows back-to-back, Fendi
in Milan and Chloé in Paris. "It was a tour de force, the range of col-
ors, shapes, and textures," noted the *New York Times* of Fendi. "And
it all happened in furs."[3] The show included fur sweaters with strong
shoulders, riding coats with satin jodhpurs, and leather coats lined with
brightly colored fur. There were common skins such as mole or squirrel
mixed with fox, mink, and chinchilla. "The collection left the packed
audience at the Palazzo della Permanente speechless. And you didn't
have to be mad for furs to be impressed."[4]

In April, Karl staged an equally spectacular Chloé show in Paris, in

a giant tent at the Forum des Halles, where the collections were being held—some felt that it was too spectacular. He opened with a loud opera overture, Scott Joplin's *Treemonisha*, a score from 1912 that had been discovered in the early '70s, but then switched to thumping disco music, because, he explained, it set the right mood for the models and the audience.[5] "His show for Chloé, staged in the largest tent in the Forum des Halles, was full of marvels," declared Bernadine Morris in the *Times*. "It also encapsulates what is wrong with the Paris showings. Runways the length of football fields and cavernous spaces make spectacular displays the norm. Any relation between the clothes shown and the styles women might wear to a small dinner party or to work is hard to grasp."[6]

Karl had been staging ambitious shows at Chloé for years, as had Kenzo, while younger Paris designers were doing the same, especially Claude Montana and Thierry Mugler. Many mainstream critics were horrified by the early work of this new generation, their hard-edged designs and their kind of showmanship. Fashion students and design groupies, however, practically rioted trying to get into their shows and Karl certainly appreciated the new energy. "It is true that the presentation of a collection sometimes gives an extreme idea of what the designer wants to express but I think that they are right to make a fuss and be excessive," Karl said of Montana and Mugler. "And excess is healthy—without it, there is no way to evolve. For example, those shoulders by Claude Montana that were too big? Well, they were useful for everyone else: the shape has now evolved."[7]

In the past year, Karl's style had also changed significantly. He moved from soft, feminine designs into styles that were much bolder, reflecting the mood of the late '70s and giving a hint of what would come in the '80s. "The times today are not poetic or romantic—they're tougher and women are tough in their own way," Karl explained. "They are imposing themselves. They no longer feel the need to be protected; they are protecting themselves. It's a question of survival, and what counts is to stay strong, healthy, and aggressive."[8]

Many were thrilled with Karl's new direction. "His work is like his

personality," suggested *WWD*'s Marian McEvoy, "filled with humor and never boring."[9] French *Vogue* chose to have Guy Bourdin photograph one of the standout ensembles of the collection, a long skirt and bell-sleeved top in dark blue silk taffeta, with a towering hat in blue velvet covered with white pearls, with the doll-like model splayed across a Louis XVI settee covered with bottle green silk. "It was one of the most ravishing collections possible," the magazine suggested of Chloé, "from the first to the last of the 200 models that were shown."[10]

Even some critics who were clear about Karl's significance felt the need to comment on his showmanship. "Karl believes in presenting his ideas at full blast," was how Carrie Donovan put it in the *New York Times Magazine*.[11] She also noted that another talent had a very different approach that season. "Yves Saint Laurent, for years the designer from whom it seemed all fashion ideas flowed, chose to present a beautifully-edited, classic rendition of many of his former ideas without adding, in the opinion of many, anything new," Donovan wrote. "Saint Laurent may have reached the point where he feels that he has made his basic contribution to fashion and that now, like Chanel kept on and on with her famous suit, he wants to reinforce his legend."[12]

Whipping up excitement was increasingly part of the fashion game, however, and Karl had proven himself to be very adept. His success with the Chloé fragrance, marking its fourth year of strong sales around the world, and his increasing fame as a designer, led to his first global tour, his most ambitious to date. "It was a trip that opened up mysterious doors to the future," Karl said of his three-week-long visit to the United States and Japan.[13]

Just a few weeks after the Chloé show, he flew from Paris to New York on the Air France Concorde, the supersonic flight that had begun regular service the year before. Karl noted that spare, aerodynamic lines of the plane had been predicted by Constantin Brâncuși's bronze sculpture

The Bird in Space (1941), a seminal piece in the collection of the Pompidou Center.[14] "It is the Concorde 50 years before the Concorde," he said of the Brâncuşi.

In New York, Karl and his team transferred to a Gulfstream II to fly down to Texas, for a Neiman Marcus event in Houston, where he received the most singular welcome of his career. Waiting on the tarmac was a fleet of white Cadillac limousines and a marching band, in burnt orange and white suits. Also standing in formation were the Wranglerettes, eighty champion pom-pom girls, in burnt orange minidresses with white fringe, wide white belts, white patent boots, white gloves, and white cowboy hats. Their hair, much like their smiles, tended to be big and plastered into place.[15] As André Leon Talley described it in French *Vogue*, "Their impeccable hair seemed like it had been lacquered under their cowboy hats by an invisible magician with a giant can of aerosol spray."[16]

Karl stepped off the plane and into the scorching sun of south Texas. He wore a dark burgundy jacket, a checked vest and pants, and a narrow wine-colored tie. He wore his sunglasses, which were necessary there, and his hair was back in a ponytail. He came down the stairs and onto a carpet that had been rolled out for his arrival, in royal purple. As he shook hands with a Neiman Marcus executive, the band struck up the theme from *Rocky*, "Gonna Fly Now." The Wranglerettes stood at attention holding giant red, white, and blue Texas flags that flapped in the wind. Karl was given a Stetson, which he immediately fixed on top of his head, a glass of champagne, and a bouquet of long-stemmed roses. He was shown to his car, a special gold and black stretch Cadillac with a pair of Longhorn antlers that had been mounted on top of the grille, extending the width of the hood. As Karl posed for photographers, the driver honked the horn, which played "The Eyes of Texas."

A motorcycle police escort accompanied Karl and his entourage, which included models and the presidents of Elizabeth Arden and Parfums Lagerfeld, into downtown Houston. Karl seemed to be delighted by his Texas-size welcome. "That was the funniest thing in the world,"

he said. "I saw it on TV. It was a big Hollywood production—so many people, and with the sunlight and the colors, I thought it looked divine. I didn't know how exactly to behave. I'm not the Queen of England, you know—I'm not used to that!"[17]

Neiman Marcus closed the store for a cocktail party and Chloé show. An elevated runway had been built for the occasion. The invited guests were served champagne and caviar. "We just flew down on a Lear Jet from Dallas for the evening," said one. "We might fly to New Orleans for dinner." Dozens of models who had been brought in for the show vamped down the runway, while the audience sipped from their champagne flutes. It was the height of the disco era and the sound system blared the Alicia Bridges anthem, "I Love the Nightlife." The models, spinning and moving to the music, showed off the bold lines, deep colors, and dramatic disc hats that had been shown in Paris just weeks before. At the end of the show, Karl ran down the runway to a big round of applause from the audience and hugs and kisses from the models. He even showed off his new cowboy hat.[18]

After the party, Karl joined a crowd of several thousand at a party given in his honor at Gilley's, the country western club where *Urban Cowboy* had been filmed, the Debra Winger–John Travolta romance/drama that would open the following year. There was a barbecue and a couple of thousand guests on the club's football field–size dance floor.[19]

Downtown Houston was a fast-growing place with spectacular new buildings, including the fifty-story One Shell Plaza, designed by Skidmore, Owings, and Merrill, and Pennzoil Place, two thirty-six-story towers nestled together like pieces of minimalist sculpture, designed by Philip Johnson. "The architecture here is like nothing else in other big cities," Karl noted. "There is no mix of old and new. Nothing that suggests past civilizations or other cultures. Houston is the city of the 21st century. Here, a cowboy standing in front of a skyscraper does not seem surreal. It is a tourist attraction as much as a painter in front of his easel in Montmartre."[20]

For his trip, Karl certainly did not travel lightly. He brought his collection of Goyard trunks filled with a full wardrobe, including dozens of shirts. He packed two per day for the three-week trip. "Because hotel laundries never do them properly," he explained.[21]

After Texas, Karl flew back to New York, taking over a suite at The Pierre, with a view looking out over Central Park and the Manhattan skyline. His sense of imagination was clearly fired by being back in the city. On a nighttime photo of the Empire State Building, Karl sketched in a design he called the Skyscraper Dress, with the grid of a building covering a towering female form and the Art Deco crown of the Chrysler Building used as the top of her bodice and as a collar.[22] "After Houston, New York was almost like old Europe," Karl pointed out. "New York is certainly the city of the 20th century but it also has a sense of history. To me, New York is what all major European cities should be, but aren't."[23]

Karl staged another Chloé runway show, this one with Saks Fifth Avenue, benefiting Memorial Sloan Kettering.[24] And he made the rounds of New York media, sitting down for a long talk with the *Times*' Bernadine Morris and appearing on a live talk show, interviewed by New York television personality Bill Boggs.

They sat in modern swivel chairs covered with bright red upholstery, on a neon-colored set with ferns placed around in the background. Karl wore a wine-colored sport coat, brown pants, a plaid shirt with a white collar, and a narrow red-and-white polka-dot tie with a pin. He carried a fan but dropped the sunglasses. The host asked if he had always been interested in fashion. Karl explained that he didn't remember a time when he wasn't interested in clothes. "I'm a born fashion queen," he said with a laugh, a little joke that did not land, with host or audience.[25]

Karl then brought out a few models wearing Chloé. The first wore a form-fitting dress, a belted tunic, and leggings, all in a winter white knit. There was also a large tubular necklace, in matching white knit, which Karl said reminded him of a hose on a vacuum cleaner. "I think there has to be humor in fashion," he explained. "Fashion without humor is a

bore." Out came another model, in a pair of black pants, a red coat, and a towering black hat, which Karl pointed out was inspired by the shape of the fan he held in his hand. When Pat Cleveland appeared in a tight black coatdress with a high collar, leggings, and a matching hat, the host asked if the dramatic design made it difficult to walk. "Nothing is hard for Pat Cleveland to walk in because she is the world's best show girl," Karl answered, earning her a round of applause. The final look was a double-breasted lavender coatdress with dark gray leggings. "This is a much easier coat," Karl pointed out. "It is important to show some exaggerated things and then show a slimmed-down version. It's not a natural shoulder, it is much larger than usual, but now you are used to it."[26]

After the mini-show, and hearty applause from the audience, the next guest was a young Diane von Fürstenberg. Her first comment, graciously enough, was to downplay expectations. "Looking at my clothes after Karl's clothes is a bit like looking at a Volkswagen after a Rolls-Royce," von Fürstenberg suggested. "But that's alright—you need both."[27]

After New York, Karl jetted off to Los Angeles. On the way, the Gulfstream flew over the Grand Canyon, flying low enough that Karl was able to take photos.

In Los Angeles, he moved into a bungalow at the Beverly Hills Hotel, explaining that he had stayed there with his parents on his first trip to America when he was a teenager. "The very particular shade of pink of this hotel was the color that symbolized all of Los Angeles for me when I was a child," Karl explained. "I went there with my parents in 1950. Everything has changed since then except the Beverly Hills Hotel and its bungalows."

While visiting the city, Karl was struck by how everything seemed to be so excessive. He was amazed at the sheer size of Tower Records, on Sunset Boulevard in West Hollywood, suggesting that it was like a supermarket for music. While there, he couldn't help noticing a massive

blowup of a disco group, Saint Tropez. Wearing a dark jacket and a rep tie, Karl posed in front of the singers, twice as big as he, huddling around a microphone and wearing lace bodysuits.[28]

Karl certainly socialized on his stay in L.A. He went to a party at the house of John Schlesinger, the English director who, in the years before, had made such films as *Midnight Cowboy*, *Sunday Bloody Sunday*, *The Day of the Locust*, and *Marathon Man*. The house was on Rising Glen Road, high in the Hollywood Hills. "From his house you can see all of Los Angeles," Karl said. "It is a panorama that gives the definitive sense of the city, like an immense, theatrical curtain, sparkling in perpetual motion."[29]

After Los Angeles, Karl flew to Tokyo, where he had already been for Chloé several years before. On the earlier trip, which was to promote Miss Chloé, a Japanese line that the house licensed, he traveled with the owners of the house, Gaby Aghion and Jacques Lenoir. Wearing loose pants and a foulard, and carrying a polka-dot fan, Karl visited the house's boutiques, made personal appearances, and made time to go to restaurants with Kenzo.[30] In 1979, as he had just done in Houston and New York, he staged a fashion show for Chloé. "In a trend-setting collection, Karl Lagerfeld shows big melon sleeves, nipped waists on peplum jackets, and enormous brooches or plaques of beaded embroidery, and narrow skirts," noted the *Japan Times*. "Models wear embroidered high spats wrapping their legs and large off-the-face hats, which they obviously adore."[31]

From Tokyo, Karl returned to Paris, concluding his first around-the-world tour. He sensed, accurately, that, moving forward, international travel would be part of his life. "Jetting from city to city is the dream for life in the future," Karl said. "To keep moving, to be everywhere and nowhere!"[32]

13

A VERY FASHIONABLE FRIEND

One of the great things about Karl is that he never had a drug problem. He never had a drinking problem. He never had those substance abuse problems that some designers have. He was German—he was disciplined about getting in that studio. He turned the music up loud and he would just sketch. And you were not going to interrupt! Don't you dare knock on his door! You did not knock on his door and say, "Karl, come have a Diet Coke." No, Diet Cokes were carried to him—you did *not* interrupt his work!
—*André Leon Talley*[1]

IN THE SPRING OF 1975, Karl flew to New York and Los Angeles to launch the first Chloé fragrance, a rollout that was organized with the American fragrance leader Elizabeth Arden. In New York, Karl took over a sprawling suite at the Plaza Hotel (Antonio Lopez suggested it was an entire floor).[2] Karl was traveling with Jacques de Bascher and José de Sarasola, a childhood friend of de Bascher who was acting as something of a business consultant for Karl. And they were certainly going in style. On the night table, Karl had the correspondence of eighteenth-century writer Madame de Staël, and his rooms were packed with trunks

and suitcases—the excess baggage charges amounted to $3,500 (over $18,000 today).[3]

Just three weeks after he had presented the Chloé 1975 Fall/Winter Collection in Paris, Karl staged the show again on a dramatic runway in the atrium of Avery Fisher Hall in Lincoln Center. The evening was a benefit for the Memorial Sloan Kettering Cancer Center. There were hundreds of guests: socialites, American clients of Chloé, and fellow designers in from Paris such as Sonia Rykiel. "It made everything else look old fashioned," one guest told the *New York Times* about Karl's show. Another said that it made her want to throw out her own clothes and start over.[4]

A highlight of the trip for Karl was meeting someone who would become one of his closest friends for several decades: André Leon Talley. The six-foot, seven-inch native of Durham, North Carolina, then twenty-seven years old, had a master's in French literature from Brown University and had interned with Diana Vreeland at the Costume Institute of the Metropolitan Museum. He was working for Andy Warhol's *Interview* magazine, on a special Paris issue guest edited by Antonio Lopez and Juan Ramos. "They had me do the big interview with Karl," Talley remembered. "We went up to his suite at the Plaza Hotel: Andy, Fred, Juan and Antonio. And we spent the whole afternoon with Karl."[5]

Lopez's illustration showed Talley in profile interviewing, with Karl on the sofa with sunglasses and a dark sweater, looking pensive. Instamatic photos captured the designer lying on the bed in his black sweater, sporting his rectangular dark glasses and dark beard, and talking on one of those oversized 1970s telephones. Another series showed Karl in the back seat of a car, wearing an open dress shirt and a striped ascot, sitting with de Bascher and Sarasola, and holding up a wad of cash. The title of the story was "Karl Lagerfeld: In a Cloud of Chloé."[6]

Talley was determined to make a good first impression. He wore khaki shorts, a striped dress shirt, penny loafers, knee socks, and aviator glasses by Halston.[7] As one of the first, and for many years the only, senior African American editors in fashion, Talley distinguished himself in

one very simple way: by knowing his stuff. "I always did my homework," he recalled of that first meeting. "I read everything I possibly could in those days. We did not have Google! We did not have the Internet! I did not want to sound stupid or vapid. I knew he loved the 18th century, not only for its fashion but for its way of living. I knew that he collected 18th century furniture, rugs from Versailles—all of that I had prepared myself for. So, when I sat down to interview him, I had something to say. We started with the French 18th century and then went on and on."[8]

Karl, of course, was a great interview, trotting out lines that he knew would be of interest. "I can't live without books," he announced. "I bought books here and in California. I came with half empty suitcases to have room for all of the books." And he was enthusiastic about the United States. "It's a technicolor country," he stated. Karl was thrilled to be in New York, his first time in the city since his American trip with his parents, twenty-five years before. "But I had the feeling that I was only here a week ago," he told Talley. "Everybody tells you about New York, you see so many pictures, so when you are finally here you are not surprised because it's exactly the way you suspected it would be."[9]

Karl and de Bascher did not hide their feelings for each other. "Seated next to him was his boyfriend, the handsome and debonair Jacques de Bascher," Talley later wrote in his memoir, *The Chiffon Trenches*.[10] Karl's puritanism was also on display. Asked if he fell in love every day, he insisted that he was really in love with his work.

Their conversation took place in the living room of the suite, with Warhol observing and Lopez sketching the scene. "We just seemed to hit it off," Talley remembered. "The chemistry was there."[11] It was clever, of course, for Talley to have focused on a subject that was so important to Karl: the French eighteenth century. "I did not know a lot about it until I prepared for that interview," Talley continued. "I asked him about the furniture he collected and about the period he cared about and that's how we became friends. I didn't just ask him stupid questions like 'What did you eat last night?' 'Where did you go?' I asked him things that he was interested in."[12]

After the interview, the group sat around having tea, until Karl made what sounded like an indecent proposal. "He said, 'Come into my room, dear, come into my bedroom.' And I thought, 'What is this? An invitation to what?' We went into his bedroom and I had an unexpected surprise. He was not there to hit on me but to throw me his toss offs from this beautiful trunk by Goyard. Karl gave me two *beautiful* crepe de chine shirts and matching mufflers that he had had made at Hilditch & Key in Paris. They were the perfect gift for me. I was skinny then. I was handsome. And I left that interview with two *beautiful* shirts: one was Kelly green, the other was pink peony."[13]

The pair of Hilditch & Key shirts immediately became staples for André Leon Talley's style. "That was my first, big, fabulous wardrobe," he explained. "These were personal shirts from Karl Lagerfeld. In August, I went to my interview at *Women's Wear Daily* with the pink one and I got the job. I interviewed on Friday and they said, 'Come to work on Monday.'"[14]

When Karl headed back to Paris, they continued their friendship, primarily through the mail. "We were instantly, constantly writing back and forth to one another. Karl loved letter writing, and he wrote the most extraordinary letters, long, copious letters, and so did I. There were no faxes. No email. We were constantly writing letters and I was constantly looking forward to getting the mail to get these *extraordinary* letters."[15]

In January 1978, André Leon Talley moved to Paris to work as the fashion editor for *Women's Wear Daily*. "Karl and I were already very close, by that point. And when I got off the plane that night in Paris, I went straight to a small hotel on the rue de l'Université, because that was actually the hotel chosen for me by *Women's Wear Daily* and not because that is the street where Karl lived. So, I went to the hotel, dropped off my luggage, Karl came and picked me up, and we went straight to La Coupole. I believe it was a Friday night and La Coupole was the place to go in those days. Karl had a long table with Jacques de Bascher, Anna Piaggi, Vern Lambert, etc. etc. And right across was a table with Loulou de la Falaise, Betty Catroux, François Catroux, Yves Saint Laurent, Éric

de Rothschild. So, there was the Lagerfeld group and the Saint Laurent group, the same night, the first night I arrived in Paris."[16]

One of his first shows was Yves Saint Laurent's 1978 Spring/Summer Haute Couture Collection, held in the ornate salons of the Hotel Intercontinental. Prior to the show, Talley previewed the collection for *WWD*, with the designer telling him, "I have simply transformed my classics through *Porgy and Bess*." What became known as the "Broadway Suit" collection was a clear success. "I was lucky to be there to witness its making," Talley noted, "as it was perhaps the last great collection Yves created in his life."[17]

Talley was another figure who, because of his role as a journalist, was able to glide between the worlds of Saint Laurent and Karl. But he became particularly close with Karl. They would speak in the morning, before Karl left for Chloé. Then they would often see each other for lunch, or dinner, or at a party. At night, they would speak together on the phone again for hours. "He loved socializing by telephone," Talley recalled of Karl. "It was like being with my best friend in college."[18]

Looking back on the world of Paris fashion in the 1970s, Talley stressed how small it was, compared with later decades. Fashion Week, which now takes place over nine or ten days with a dense schedule of shows from 10:00 a.m. to 8:00 p.m., was a much more easygoing affair. "You could go to maybe four shows a day—that was a full schedule. Now, it is 13 shows a day. I remember, we used to go to the Chloé show at around 11:00 a.m., then go to lunch at Café de Flore, then go and relax ourselves until the next big show, which was Kenzo at 10:00 p.m. I remember going to the shows with Paloma, and her husband Rafael, before they were married, in a Cadillac convertible. Paris was wonderful in those days."[19]

And once he began seeing Karl's shows for Chloé in person, he was very sensitive to his work. "I cried once on the front row of a show but only once," Talley wrote in his memoir. "Karl opened Chloé's 1978 Fall/Winter show with Pat Cleveland and Carol LaBrie, two extraordinary African American models. They were standing behind a grey grille, like they were in prison. Or was it a giant birdcage? It was magical."[20]

Talley was able to see the significance that Chloé had in Paris ready-to-wear. "The Chloé shows were way ahead of everything," he recalled. "They were the avant-garde, yet they were sophisticated and raffiné. I would go to the showroom and meet with the owner, Gaby Aghion—Karl had a great relationship with her. It was a small company but it was full of wonderful wonders—the clothes were just exquisite. The clothes were new and the way he showed the clothes was new. His runway shows were always exciting."[21]

Talley did experience an ugly side of Paris fashion: cattiness and racism. In 1978, Hubert de Givenchy staged a show with all Black models and Talley quickly wrote a story for *WWD*, raving about it. The Saint Laurent team was unhappy and accused him of stealing their drawings and passing them along to Givenchy. Then, one night at a party, Paloma Picasso pulled him aside and said, "I don't know how to say this but I think you should know: Clara Saint has been going all over Paris referring to you as 'Queen Kong.'"

Talley, of course, was mortified to know that a Saint Laurent publicist would say, or repeat, such an ugly comment. "What a ton of bricks. I felt my face flush, and, for a moment I thought I might cry. Here I was running around Paris, thinking I was successful, and these sophisticated, elegant people in the world of fashion were comparing me to an ape behind my back."

Picasso was reassuring. "There are many hypocrites in the world," she said, taking his hand and giving it a kiss. "You are loved."

Talley told no one else about the incident except for Karl, who had a snarky comment about those who would say such a thing. "But Karl was used to the viciousness of French fashion," Talley recalled. "It was just water off of his back. He had a steel will about that kind of stuff."[22]

Talley knew that there could be a dark side to Karl's friendships: when they were over, they were over. "He would burn his bridges," Talley pointed out, mentioning the clashes that Karl eventually had with Saint Laurent, Pierre Bergé, Anna Piaggi, Inès de la Fressange, Paloma Picasso, Laure de Beauvau-Craon, and many others. "He could be like

the little spoiled boy back in Germany, who has had everything he ever wanted. He would have a temper tantrum and just get rid of people. If you do things with Karl, you know the rules and you have to make sure you don't break them. Being a friend of Karl was like having another vocation—you had to make sure you minded your p's and q's."[23]

Talley himself had had a falling-out with Karl, which he detailed in *The Chiffon Trenches*. In December 2013, at a Chanel fashion show in Dallas, Talley was given pride of place. Karl had directed a film about Chanel's comeback in 1954 and a set was built to screen the short feature, with dozens of vintage convertibles lined up as though at a drive- in. Talley was seated in the front seat of a roadster once owned by Rita Hayworth, next to Geraldine Chaplin, who played Coco Chanel in the film; Anna Wintour and Karl were in the back seat.

The next day, Talley was at Karl's hotel to discuss a possible project. He hoped to curate an exhibition of the work of the photographer Deborah Turbeville. He presented the idea to Karl when they were in a small group, showing him some of Turbeville's work. and he later wondered if it was the idea of backing another photographer that bothered him. Regardless of the reason, Talley felt like he saw the exact moment when their friendship came to a close. "The guillotine dropped," was his description of the moment. "After decades of friendship, I had finally made the list of erased, deleted personal and professional friends who were no longer of any value to Karl."[24]

When we were in touch about an interview for this book, just weeks before he died, Talley seemed eager to approach the situation in a gentler way. "I want to celebrate Karl," he wrote in an email. "He was a very good friend and I know he loved me. Please let us speak and speak joyfully and candidly. So, call me anytime you want—I can fill in your holes in the dam."[25]

In 1980, André Leon Talley had an epic clash with Fairchild executive Michael Coady, who flew from New York to confront him. There had been concern about his closeness to some designers. "I emoted at their shows and people didn't like that," Talley later explained to the *New York Times*. "At *Women's Wear*, they told me, 'You've been to bed with every designer in Paris!'"[26]

Talley insisted that was untrue and felt that the charge was racist. He was leaving for a weekend in Normandy with Betty and François Catroux, great friends of Yves Saint Laurent. Without telling them what had happened, or asking anyone else's opinion, including Karl's, he decided over the weekend to quit his job. On Monday morning, he wrote a letter of resignation and stopped by the American embassy to make the document official.[27]

Mr. Fairchild later wrote that Talley accused him in the letter of running his newspaper like a plantation. Talley insisted that was not true. The truth was more poignant. "I went to the American Embassy to have my letter notarized because I didn't want them to say they fired me because I was stealing," Talley once explained. "That's what they say about black people, you know, when they want to bring us down. So, I handed in my letter of resignation."[28]

Talley went from the embassy to the Église de la Madeleine and said a prayer. Then he walked to the Fairchild offices on the rue Cambon to present his notarized letter. "And I got a call from Mr. Fairchild. 'André, you can stay in Paris and still write for us and do whatever you want.' I said, 'No, thank you!'"[29]

Talley later learned, through Oscar de la Renta, that Pierre Bergé had delivered an ultimatum, that either Talley be pushed out of the Paris office or Bergé would pull the YSL advertising in *W* and *WWD*. "Lagerfeld was the professional and personal nemesis of Saint Laurent, but I thought I could straddle the fence between both houses," Talley wrote in his memoir. "I was wrong. When I was applauding Givenchy for his all black *cabine*, I was also making an enemy out of Pierre Bergé."[30]

Talley's apartment lease was up for renewal, and he had organized it through Fairchild. "I didn't have a place to live," Talley remembered. "So, Karl said, 'Come and stay here. Come and stay in my guest room, as long as you want.' And that, to me, showed me that Karl really cared about me. He allowed me to stay in his apartment, in his beautiful red brocade guest bedroom suite. And I stayed there for three or four or five months."[31]

Karl's hospitality was not limited to room and board. "Not only did I stay there but I stayed there with cash," Talley recalled incredulously. "He would leave me 500 francs in an envelope, pocket money to go to a bookstore. He accepted me in his house and he trusted me. He would get up and go to work and I would get up at 12:00 or 1:00 p.m., take a shower, and walk to Café de Flore to get a coffee."[32] That amount of generosity was a positive reflection on Karl, who also paid for Talley's flight back to New York, yet it was also a reminder of the blurry ethics of fashion journalism.

Talley felt that the months he spent there were not without danger for the designer. "He was risking his career with *Women's Wear*," he pointed out. "Here he was housing André Leon Talley who had just resigned from the damn paper—that was a real professional risk for him."[33]

Talley also believed that there was a deeper significance to Karl's act. "He treated me like a friend," he said simply. "And, as a black person! Do you understand how important it was in 1980 to be allowed to stay in the house of Karl Lagerfeld in Paris, France? Remember, you're talking to a black man!"[34]

14

THE RUE CAMBON

Karl was absolutely determined not to take the easy way
out. He could have had even more success doing something
that was much easier, by repeating himself. That is what
Saint Laurent did for some time, using the same patterns and
sometimes even the same dresses—he would change the
colors, a pink paired with a violet, shown on these beautiful,
black models—it was breathtaking. But Karl never yielded to
that temptation. He no longer had anything to prove. It was as
though he wanted to keep working so hard just for himself, in
order to be able to look at himself in the mirror.
—*Ines de la Fressange*[1]

KARL BEGAN THE 1980S, a decade that would be so consequential for
him, in a way that was becoming familiar: creating an increasingly grand
lifestyle, taking design risks—some of which were successful, while some
were not—and constantly pushing forward. If it could all seem a little
frenetic, he was unapologetic. "I can't tell you how I am going to start or
finish the 1980s," Karl explained at the time. "I am a chameleon. I am
constantly going from one thing to another. I have very specific ideas
about what I like but I feel obligated to try everything, from time to
time."[2]

By that point, he had been known for his extravagant interiors for two
decades, and he continued to refine what he had already begun and to

add new places across Europe. "He is the darling of every auction house, the privileged interlocutor of the biggest collectors, and, in the village of Grand-Champ in Brittany, the obsession of the local gendarmerie who fly over his chateau by helicopter to ensure that all is safe behind the iron gates," suggested *Le Monde*. "He receives us in his Paris apartment, which makes the Trianon look like a college dorm."[3]

Karl was living in the left wing of the Hôtel Pozzo di Borgo (he would move to the larger, main part of the house in 1991). The collection that he assembled on the rue de l'Université, and his way of presenting furniture and objects, had become sharper, more intentionally historic. The bulk of the apartment was lit only by candles. "The softness of candlelight," as Karl phrased it.[4] He felt that it was, quite possibly, the most eighteenth-century house in existence. "Every single doorknob is pure 18th century and so is every piece of furniture," Karl explained. "The wood paneling is genuine; when you enter, it is exactly like a painting from the period, because I have decorated it as they did at the time, with the furniture along the walls, unlined curtains, and huge four-poster beds with feather mattresses. And not in the way that we imagine it in the 20th century."[5]

Grand Champ had become increasingly spectacular. A new circular reflecting pool was built, bordered by weathered old stones and surrounded by linden trees. Karl acquired so much new furniture and paneling that an inventory was required to keep track of it all.[6] By the end of the decade, in June 1990, having made the property into such a showcase, Karl received an official visit by the Queen Mother. He wore a classic black suit and dark tie to give Elizabeth Bowes-Lyon, in a green floral dress and extravagant green hat, a tour of the garden. A buffet was installed on the terrace, with towers of macaroons and floral arrangements six feet in height. The Grand-Champ town hall placed its official guest book at Karl's château, so that the Queen Mother could record her visit. "That day, the village was filled with Rolls-Royces," recalled a Grand-Champ official.[7]

In Rome, when he wasn't staying at the Hotel Hassler, Karl was living

in an apartment filled with design from the turn-of-the-century Vienna Secession. To help with the project, Karl hired Andrée Putman, his longtime friend and an interior designer who was a major advocate of modernist movements. The palette was black and white, a Putman specialty, with black floors, white walls, and graphic period furniture by Joseph Hoffmann, Kolo Moser, Otto Wagner, and Michael Thonet.[8]

Karl also bought a huge apartment on the twenty-first floor of a residential tower, Le Millefiori, in Monte Carlo, making himself, for the first time, a resident of the tax haven of Monaco. In 1981, he was in Milan and heard from Anna Piaggi about a new group of designers he should check out, Memphis, which turned out to be startling, Post-Modern work that Karl immediately adored. Although Memphis had attracted plenty of attention, the group had sold little or nothing. Karl bought the entire contents of the showroom and had them shipped to Monte Carlo, a purchase that made a huge difference in the fortunes of the design collective.[9] He filled his rooms—with their views out to the ocean and the searing Mediterranean light—with candy-colored shelving units inspired by Aztec forms (Ettore Sottsass), a bright green dressing table that looked like a New York skyscraper (Michael Graves), and a conversation pit in the form of a boxing ring (Masanori Umeda).[10] "Its founder, Ettore Sottsass, has created all the Olivetti designs since the beginning," Karl said of his fascination with Memphis. "The furniture resembles nothing else. It is very colorful, belongs to no particular context, and looks wonderful in Monte Carlo—just the right place for it."[11]

The sheer variety of houses and apartments demonstrated Karl's stylistic range as well as the increasingly immense scale of his life. There was also something of a frenetic feel to it, a kind of aesthetic ADHD. Karl, however, was convinced that there was a unity between these disparate interiors. "I can adapt myself perfectly to each of them," he explained. "They have no similarity, but, in fact, there is a certain correlation between them. I like the idea of changing places but at the same time feeling at home."[12]

A decade into his relationship with Jacques de Bascher, Karl decided to offer him the kind of gift that few ever receive: an engagement party with an actual princess.

Diane de Beauvau-Craon had returned to Paris and was spending more and more time with de Bascher. So, Karl thought their relationship should be made official. "When you unspool the film, it is really quite funny," remembered de Beauvau-Craon. "When I was not yet 17, Karl was horrified and calling my father to accuse me of being a homewrecker. And then, a few years later, he thought that Jacques and I should be married. He knew that we were crazy about one another, that we were inseparable, and he said, 'Look, you are both such a pain in the ass but you love one another.'"[13]

Karl decided that the engagement should take place in Rome. "The idea was to do something like the Romans but not the normal Romans, more like the Emperors," laughed Silvia Venturini Fendi, whose family was very involved in the planning. "I think it was also a way for Karl to organize something for Jacques that was not a marriage but was something less binding. So, he wanted to do an engagement but to make it a fantastic engagement."[14]

In January 1981, Karl organized several days for everyone in Rome. He booked rooms at the Hotel Hassler, the grandest in the city, at the top of the Spanish Steps. There were three suites, one for him, one for de Bascher, and one for de Beauvau-Craon. "I paid for everything, as usual," Karl later explained, "which didn't bother me at all."[15]

Venturini Fendi remembers the organization that went into all of the events. "Karl sketched all of the clothes—they were both dressed in Fendi. We prepared everything, organizing the flowers, and the food. It was like doing a movie in Rome. But for Karl, it was a *mise-en-scène* that was very important."[16]

The end result was impressive. The ceremony was to be held at the Chiesa della Santissima Trinità degli Spagnoli, an eighteenth-century

chapel on the Via dei Condotti, which Karl had filled with flowers. The ring had been blessed by the pope, John Paul II. "Karl had a gorgeous dress made for me at Fendi and a large shawl, in chinchilla, that he had made at Fendi," de Beauvau-Craon recalled. "All of that was just spectacular."[17]

Of course, the twenty-five-year-old princess and her twenty-nine-year-old fiancé, when provided with such a beautiful occasion, were not about to behave in any reasonable way. "Obviously," she explained, "the night before, Jacques and I decided to hit every nightclub in Rome! We made it back to the hotel about 5:00 a.m."[18]

Although they were able to get dressed and go to the church, the couple were so hungover that they had a hard time taking the communion wafer. "And Karl had managed to have a cardinal officiate," de Beauvau-Craon said, "to bless these two little devils."[19]

After the ceremony, Karl hosted a magnificent lunch on the seventh-floor terrace of the Hassler, with its panoramic views of the city of Rome. "All the family was there," recalled Silvia Venturini Fendi. "It was like a fairy tale—they were living in a fairy tale."[20]

That night, the party continued at Jackie O's, a glamorous Roman disco. "I didn't go," Karl later said. "Three days later, they were still out of it."[21]

By the end of 1981, with de Beauvau-Craon still officially married to Moroccan intellectual Ahmed Mohamadialal, the father of her son, Yunes,[22] and a close friend of the French philosopher Bernard-Henri Lévy,it was increasingly unlikely that there would ever be a wedding. "If I have not sent you a wedding announcement it is because Diane's divorce is not yet official and her former husband is engaged in the worst kind of blackmail," de Bascher wrote his friend Philippe Heurtault in September 1981.[23] The marriage would never take place.

It has been suggested that Karl might have pushed for this engagement as some sort of reflected glory, that if Jacques de Bascher were to be affiliated with such a grand family, it would heighten Karl's standing. Diane de Beauvau-Craon did not see it that way. "I don't think there was

any ulterior motive," she said. "More than anything, Karl found the idea funny, to organize the engagement of the boy that he loved."[24]

For a good dozen years, there was one question that drove many fashion conversations: What in the world is going to happen with the great old house of Chanel?

There was no doubt that Gabrielle "Coco" Chanel had had an outsize impact on fashion in the twentieth century. Karl had a succinct explanation of her significance. "Chanel left us more than fashion," he pointed out. "She left us a style. And that, as she said herself, never grows old."[25]

When Coco Chanel died in January 1971, at the age of eighty-seven, in her room at the Ritz, still at work on her next haute couture collection, it was major international news. "An intense woman with a scalding tongue, hair-trigger wit, unbounded immodesty, and ineffable charm, Gabrielle Chanel was, throughout her life, a free spirit who used fashion as her pulpit," wrote Enid Nemy in the *New York Times*. "Her message was carried to millions through the medium of the Paris haute couture, a world over which she reigned, with arrogant self-assurance, for long stretches of almost six decades."[26]

At the time of her death, her importance was accepted by all. "Chanel was probably the greatest fashion force who ever lived," wrote James Brady for the front-page obituary in *WWD*. "She influenced most of the best young designers in Paris and in the United States."[27]

Chanel, not unlike Karl, could be scathing about her colleagues. "I adore you," she once said to Christian Dior, "but you dress women like armchairs."[28] She could be equally biting about younger designers and the latest fashion trends. Chanel was horrified by the futurism of Courrèges and refused to design anything even approaching a miniskirt. "An exhibition of meat," was her dismissal of the body-conscious designs of the 1960s. "Saint Laurent has excellent taste," she once remarked. "The more he copies me, the better taste he displays."[29]

Coco Chanel—and she never denied it—could be difficult. Jean Coc-
teau once wrote, "She had the marvelous little head of a black swan."[30]
Colette Bracchi added: "And the heart of a little black bull."[31]

The intensity of her personality carried over into her way of working.
"The best time to be a Chanel-watcher was when she was actually mak-
ing a collection," wrote *WWD*'s Brady, who had observed her firsthand,
at work and at play. "Just when a suit or dress looked perfect to you,
Chanel ripped off a sleeve, chewed out her assistant tailors, reduced the
mannequin to tears, and started all over again. The slim young bodies
of the models sagged and tired as the fittings went on six and eight hours
without a break. But Chanel went on, seemingly impervious to fatigue."[32]

It was unclear if the house she founded had the same stamina. The day
after her death, it was announced that her last collection would be shown
posthumously, two weeks later. "Chanel Show Jan. 26," was the *WWD*
headline. "House's Future in Doubt."[33] Reviewing that final collection,
the *Times* opined, "Her workrooms carried on but how long could they
continue without 'the iron hand of Mademoiselle'?"[34]

That summer, John Fairchild, the fearsome owner of *WWD*, stopped
by Chanel to preview the fall haute couture collection. His assessment:
"The rue Cambon is like the Kremlin after the death of Stalin."[35]

Mr. Fairchild had been given a tour of Chanel by someone who would
be very important in Karl's career, Marie-Louise de Clermont-Tonnerre,
a young publicist who had joined the house just weeks after the death of
Coco Chanel. Born in Chile, the daughter of diplomats, she had moved
to Paris at the age of nine. Her grandmother had been a Balenciaga client,
and she wore haute couture, as well, including one early 1960s evening
gown that Karl had designed for Jean Patou. After marrying into the de
Clermont-Tonnerre family, with noble roots that go back to the Middle
Ages, Marie-Louise de Clermont-Tonnerre decided to enter the work-
force in order to be able to afford a nanny for her children. She began at
Pierre Cardin in 1966, before joining Chanel in 1971. Petite, rail thin, and
with a formidable personality, she retired only in 2021, having mapped out
the international communications strategy for the house for fifty years.[36]

After beginning her career at Pierre Cardin, during the designer's go-go years, de Clermont-Tonnerre discovered a much different mood at Chanel. "At Cardin, I had thigh-high leather boots, clothes plastered with logos, and his famous bubble dresses," she recalled. "When I joined Chanel, everyone was in three-piece suits; the women were wearing all black and had these very tight chignons. It was horrible—I felt like I was working in a Protestant bank!"[37]

Throughout the 1970s, the house was kept afloat primarily through its briskly selling fragrances, Chanel N°5, begun in 1921, and Chanel N°19, launched in 1970. In fact, two years after Coco Chanel's death, in 1973, the sales of Parfums Chanel doubled.[38] "Chanel N°5 was the number one selling fragrance in the world," explained Marie-Louise de Clermont-Tonnerre. "Before Karl, fragrance accounted for about 90 percent of Chanel's business."[39]

The Wertheimer family, which had owned Chanel for three generations, sensed that change was needed. As Marie-Louise de Clermont-Tonnerre recalled, "Alain Wertheimer, who really began running Chanel in the end of the 1970s, asked us to find a solution."[40]

Given Karl's burgeoning success in ready-to-wear in Paris and Milan, it was not surprising that he would be considered for Chanel. It was Clermont-Tonnerre who had initiated the approach ten years before, when he had declined. "For me, Karl was really the only one who could come here," she later explained. "Because we needed someone who could be respectful of the past but we also needed someone who could really kick this anthill. And the only one who was going to be able to give it a swift kick was Karl."[41]

Alain Wertheimer, whose grandfather Pierre, who cofounded the Societé des Parfums Chanel with Gabrielle Chanel in 1924, had become chairman of the house in 1974, when he was only twenty-five years old. He sought to modernize the operation. It was he who encouraged the

introduction, beginning in 1975, of Chanel ready-to-wear, designed by Philippe Guibourgé, who had been at Christian Dior.[42]

In 1979, Wertheimer hired Kitty D'Alessio, a New York executive who had worked for many years on advertising campaigns for Chanel, to be the president in the United States. She worked out of her new office at 9 West Fifty-Seventh Street, on the forty-fourth floor, with its un-obstructed views of Central Park. D'Alessio had been following Karl's career from the beginning and felt that he would be the perfect designer to lead Chanel forward. "Lagerfeld respected Chanel," D'Alessio explained at the time. "He never borrowed from her. He never, in any of his collections, used a single Chanel touch."[43]

In 1981, after discussing the idea with Alain Wertheimer, she set out to pursue him.[44] When D'Alessio met Karl, he told her that he was open to the possibility but that he did not see how he could give up what he was already doing at Chloé and Fendi. "Who asked you to give up anything?" D'Alessio replied.[45]

A discreet meeting was arranged at Alain Wertheimer's house in London, with Karl slipping in from Paris and D'Alessio flying over from New York. As soon as they spoke, Wertheimer agreed that Karl was the right person for Chanel.[46]

Karl had a contract with Chloé, through the end of 1983, that forbade him from designing for another ready-to-wear house in Paris. There was also the question of his relationship with Elizabeth Arden, which produced the Chloé and Lagerfeld fragrances and was a direct competitor of Chanel. So, as lawyers set about untangling all of the various contracts, the plan was that he would design only the haute couture for Chanel, at least in the beginning,

By January 1982, during the haute couture collections, there were rumors that Guibourgé would soon be out as ready-to-wear designer. In March, during ready-to-wear, his exit was confirmed.[47] And it was reported that Karl was being "heavily courted" for a design role at Chanel. When contacted, Karl admitted that the idea of designing couture for Chanel "intrigues him."[48]

In 1982, the idea of anyone reviving a fading house, no matter how important it was historically, was not an obvious one. The ongoing commercial strength of Chanel fragrances proved that there was still life around the rue Cambon. And there had been, of course, designers who had taken over established ventures, notably Yves Saint Laurent stepping in for Christian Dior in 1957, or Karl at Jean Patou. But no other house had the long history of Chanel, its importance to the history of fashion, and its significance to a certain idea of France.

"Karl, who always captured what was going on at that moment, sensed that there was a potential for Chanel," explained Ines de la Fressange, the model who would play a major role in Karl's early success at the house. "Remember, at that point, there was only one Chanel ready-to-wear boutique, on the rue Cambon. For a lot of people, it was incredibly unlikely that the house of Chanel could have a comeback. It was what my grandmother wore, or my mother—the image of Chanel was a lady of a certain age with a chignon. We didn't really understand how it could be something modern."[49]

There had been some early signs of potential rebirth. One of Kitty D'Alessio's first moves, in 1980, was to hire Frances Stein, a former fashion editor and stylist for Calvin Klein, to design a small collection of accessories. D'Alessio believed that Stein's line of jewelry and handbags was a fresh direction for the house. "I knew that she would be perfect for the job."[50]

Also, the ready-to-wear designer Guibourgé had made efforts to freshen up the image. "Philippe Guibourgé has been a little forgotten but he was really the first one who started to shake off the dust," explained de la Fressange. "He had a young assistant named Lucien Pellat-Finet, who knew everyone at Le Palace. He had lent Edwige, the queen of the Punks, a Chanel suit. And Karl, who was always so clever about knowing everything that was happening, saw that what began as somewhat of a joke, this Punk in Chanel, was actually something interesting."[51]

In September 1982, after months of rumors and legal busywork, the deal was made public. "The house of Chanel confirmed Wednesday what

everyone already knew: that Karl Lagerfeld will design the next Chanel couture collection," announced *WWD*. "In a terse announcement which loses none of its pomposity in translation, the house announced that, 'The life and imagination of Chanel's haute couture collection will be benefited by the artistic orientation of Karl Lagerfeld beginning in January 1983.'"[52]

Karl was going to become the artistic director of Chanel. The issue of the Lagerfeld Parfums, produced by Elizabeth Arden, a major source of income for Karl, had been resolved. "Arden previously had opposed the possibility of the Lagerfeld link with Chanel but Arden president Joseph Ronchetti now sees the move as benefiting his company, which will introduce the KL fragrance in Paris next month," reported *WWD*. "'It can only enhance his position as an international designer,' Ronchetti said. He added that the resultant publicity, 'has to be favorable' for Arden."[53]

Sources at Chanel suggested that Karl's annual salary there was $500,000 per collection, or $1 million per year (just under $3 million annually in 2022). It was also reported that he had an annual clothes budget for friends of $100,000.[54] *WWD* took to referring to Karl as "The Million Dollar Man."[55]

As for whether or not he would be designing all of Chanel's collections when his Chloé contract expired, Karl played it coy. His response: "Let's wait and see."[56]

I n October 1982, for the spring ready-to-wear collections that were presented in Paris, Karl's presence seemed to hover over the proceedings.

"The starring role for the season went to Karl Lagerfeld, the brilliant designer from Hamburg, though a Parisian since 1954," wrote *Le Monde*. "He managed a superb collection for Chloé, refined and perfectly original, while setting up a stable of young designers at Chanel."[57] The new Chanel ready-to-wear was overseen by Hervé Léger and Eva Campocasso, two former assistants of Karl's.

The news of Karl's involvement pushed Chanel into the spotlight in a way that it had not been for years. "Merely a whisper of a Karl Lagerfeld connection was enough to bring out the crowds and the tension," wrote Bernadine Morris in the *New York Times*. "The Lagerfeld touch seems apparent in the pearl earrings in the shape of the numbers 5 and 19, both names of Chanel perfumes. For the rest, no one is saying just how much he did. 'Consultant' is as far as his friends will go."[58]

There were concerns, however, that this first presentation by Karl's team was a little too much, accusations that would dog him throughout his career on the rue Cambon. American buyers grumbled about the new proportions, shorter jackets, and shorter skirts, suggesting that more conservative retail customers would not approve. "It's a good thing that Coco Chanel is dead," said Hebe Dorsey of the *International Herald Tribune*, "because she would not have understood."[59]

There was definitely blowback to the idea of Karl at Chanel. He had not been responsible for an haute couture collection for two decades, since he had been at Jean Patou. And as successful as he had been at Chloé and Fendi, they were very different from an institution like Chanel. There was also some chauvinism in the mix, with many in France horrified that such a uniquely Gallic house should be taken over by a German designer.

Even those who believed in Karl, like Ines de la Fressange, were cautious. "He was taking a big risk in accepting," she explained. "There was not any excitement around haute couture—that was not what fashion was about, at the time, not at all."[60]

In short, particularly around Paris, the knives were out. "One can be sure that Chanel fans and critics will be waiting," suggested the *New York Times Magazine*, "to judge whether the enormously talented designer has infused new blood or delivered a body blow."[61]

In the midst of all of the grumbling and second-guessing, Alain Wertheimer had no doubts about placing Karl at Chanel. "Everyone thought it was not the right decision to take," Wertheimer explained, "except the people who took it."[62]

15

A STORIED INSTITUTION, A JOLT OF ENERGY

Respect is not creative. Chanel is an institution, and you have to treat an institution like a whore—then you get something out of her. Now we begin![1]

STANDING IN THE FAMOUS atelier on the rue Cambon in the days before his first haute couture show, Karl, forty-nine years old, was lean, tanned, and a little nervous. He wore one of his classic dark suits, by the Milanese tailor Caraceni, a white shirt, and a dark tie. He had dropped twenty-two pounds, from dieting, the gym, and, some felt, working so intensely. In the weeks leading up to the collections, Karl was putting in sixteen-hour days.

The weight of the house's history, the ghost of Coco Chanel, was still quite present. It was at Karl's insistence that the sign on the door of the studio, "Mademoiselle Privé," had been left untouched.[2] "He works deep into the night, hoping to live up to the hallowed name while keeping aloft his own reputation," was how the final flurry of activity was described by *WWD*. "The rue Cambon is humming with excitement and tension that threatens to crack the smiling surface any second."[3]

It was suggested that there was a certain amount of friction between the people that Karl had brought into the house and the old guard, some

of whom had been there since Coco Chanel's comeback in 1954. Running the studio with Karl was a young designer, Gilles Dufour, who had worked with him since the early '70s. After Pierre Balmain died, the summer before, Karl hired Paquito Sala away from the house, a Spanish-born suit maker who Karl had had his eye on since he started working at Balmain, in 1955. Monsieur Paquito, as he was known, became the head of the Chanel suit atelier until he retired in the late '90s. "I'm working like the Communist Party," Karl said with a laugh, "bringing in my own people and placing them everywhere."[4]

Another key member that Karl had added to his team was the aristocratic French model Ines de la Fressange. She was twenty-five years old, tall—five feet eleven—with short, dark hair and bone structure for days. Ines Marie Lætitia Églantine Isabelle de Seignard de la Fressange, to use her full name, was almost achingly beautiful. Her father was a stockbroker, her mother an Argentinian model. She grew up outside Paris and studied art history at the Louvre. "Since I was 15, people told me I would be a model because I was tall and thin," de la Fressange once said. "But models are supposed to be stupid—it's not supposed to be an interesting job."[5]

Nevertheless, at nineteen years old, she began as a fit model and started doing runway work. But she was not about to tamp down her personality. "I'm a big bony green bean that talks too much," de la Fressange once pointed out, underscoring how opinionated she was about style.[6] "There was part of me that couldn't help being a bad model," she later explained. "I did what you are not supposed to do: give my opinion. I would say, 'I don't think it should be in this color—I wouldn't do it like this.' I loved doing all these things that models are not supposed to do."[7]

Karl had worked with de la Fressange at Chloé, so he knew all about her. In 1982, she was in New York, making plans with a high-powered agent to take her career to the next level. She was at the Mark, the hotel on East Seventy-Seventh Street, when she saw Karl walking by on Madison Avenue. She went outside, caught up with him, and they struck up a conversation about her plans.

"Look, I have an agent here now," she told Karl, "one who represents Björn Borg and the Pope! So, I'm looking to get a major contract, just like the kind of contract that Björn Borg has." De la Fressange explained that she had envisioned representing some kind of industrial concern, perhaps a multinational food company, or, really, any big company.

"You should try for coffee," Karl suggested: "Ines Café!"

"OK, not anything," she replied with a laugh. "But I can't be a model all of my life."

They said their goodbyes and she went back into the hotel. "Through the window, I saw Karl continue his walk with this small woman who he was with," she explained. "I later found out that it was Kitty D'Alessio. And during their walk, they said, 'What if, instead of her going to work with something like sausages or coffee, we made her the image of Chanel?'"[8]

Karl, fully supported by the house, offered de la Fressange an exclusive contract, considered a fashion first. It was reported that she was being paid $300,000 per year by Chanel (over $850,000 in 2022).[9] "I signed the contract of a crazy woman," de la Fressange later joked. "It was complete exclusivity. I no longer had the right to do any other shows. I could work only for Chanel, which is, actually, what I wanted."[10]

To freshen up the Chanel studio, Karl turned again to Andrée Putman, who was working at that time on the Morgans Hotel in New York, a project that would, when it opened in 1984, clinch her international reputation. For the rue Cambon, Putman designed a massive desk, in limed oak, with a large pedestal base and a semicircular top. Scattered about were black metal chairs by Robert Mallet-Stevens. Karl sat with his back to the windows, which had been covered with gray shades. A large black-and-white photo of Coco Chanel was propped against the wall.[11]

During working hours, the desk was piled with sketch pads, scissors, staplers, phones, bottles of water, and Karl's crystal goblet of Coke. No fewer than a half dozen Chanel workers were at the desk, standing or bunched around him, while he sat in his elegant suit, tossing off designs and directing the action.

Karl made a point of creating an atmosphere in the studio that was open and inventive. "One day, in the studio, I found this little piece of fabric lying around, folded it, and put it up to my head like a hat," remembered de la Fressange of those early days. "Karl was like, 'Oh, that's totally 1913,' and started sketching the silhouette of a woman with a hat like that."

De la Fressange then changed the way she was holding the scrap of fabric, and Karl said, "Oh, no, now that is completely 1930." He then produced another sketch that showed how that would have looked. Karl then raced through the history of fashion, tossing off drawings from Schiaparelli to Courrèges.

"So, immediately, in the studio, we saw that he knew the history of fashion by heart," de la Fressange continued. "Every drawing that he did was of a design that actually existed, not even something that he was making up to give an idea of the style. It was clear that he had this immense fashion culture."[12]

One of Karl's first tasks at Chanel was to step back and consider what it meant to revisit a historic house. "It's like doing a revival of an old play," he told Suzy Menkes of the *International Herald Tribune*. "You have to try to see with the eyes of the first audience but you should not have too much reverence. It's important for young people to touch her style—it must be fun."[13] In order to make that happen, Karl threw himself into research about the heritage of Chanel, spending months analyzing the history, filling scrapbooks with photographs, drawings, and notes.[14] "These days, I'm like a computer that's plugged into Chanel mode," he explained just before the first show.[15]

Karl made an effort to learn about the subject in a myriad of ways. He asked Anita Briey, then the second in charge of the studio at Chloé, about her experience at Chanel in the 1950s and early 1960s. "Karl, I was only sixteen when I started there," she told him. "But I gave him a sense of what my experience had been and that was that—he didn't say anything further."[16]

Karl's ideas about a new direction for the house came into focus. He

wanted to sweep away much of the more conventional designs of the de-
signer's later years and return primarily to her first great successes in the
1920s and 1930s. Karl explained his thinking on that first preview, for
WWD. "'A very static image has emerged based on Chanel's last years,'
he explains, hesitantly straightening five circles of faux pearls around a
swan-neck mannequin, 'So I've looked over her whole career and found
something much more interesting.'"[17]

The Chanel of the 1950s and 1960s, with boxy suits, often in pastels,
and hemlines that hit just below the knee and stayed there for the rest
of her career, was not where Karl wanted to begin. "She did hundreds
of different lengths," he explained, noting that he had lengthened many of
his suits to the top of the shin. Days before the show, Karl stood in the
studio, showing, for the first time, his new fitted jackets, longer, slender
skirts, and shell blouses in plush cotton ottoman. He said, "Even if she
never did it this way, it's very Chanel, *non?*"[18]

At the same moment, all around the world, the style set was chattering
about what was going to happen in Paris. At a Manhattan dinner party
given by Mercedes Kellogg for the Winter Antiques Show, conversation
centered on Karl's Chanel collection. "Indeed, it was impossible for the
fashion crowd to gather without mention of his name," noted John Duka
in the *New York Times*. "'Everyone in New York is going,' said Tina
Chow. Everyone, in this case, meant Tina Chow and the other fashion
obsessed. 'But I wonder what it's going to look like?'"[19]

On Tuesday, January 25, 1983, at 3:00 p.m., at 31, rue Cambon, the
atmosphere was electric.

As fashion presentations had gotten bigger and more theatrical, most,
including Karl's for Chloé and Fendi, were held in large auditoriums on
raised runways. For his debut at Chanel, Karl went in an entirely differ-
ent direction. He chose to show in the historic haute couture salons on
the rue Cambon, with their pale walls and plush beige carpeting, the

same rooms where Mademoiselle had worked her magic. And instead of a raised runway, the models were floor level, with passages made through the gilded chairs that were packed in tightly throughout the salons.

Karl's involvement that season had lured hundreds more journalists to the haute couture collections, many more couture clients, and a sense of energy that was usually felt only in ready-to-wear. There was so much interest in what might happen at Chanel, with crowds lining the street out front on the rue Cambon, that three shows had to be staged.[20]

The audience for the first presentation was suitably impressive: Claude Pompidou, Bernadette Chirac, Isabelle Adjani, Marie-Hélène de Rothschild, Hélène Rochas, Paloma Picasso, Andrée Putman, Carla Fendi, Gaby Aghion and Jacques Lenoir from Chloé, and every top fashion editor from around the world. Jacques de Bascher was seated in the second row, wearing a navy jacket with a tie and oversized, dark aviator glasses.

Backstage, however, remained very calm. "With Karl, during a show, there was never any panic or anxiety," recalled Ines de la Fressange. "There was no sense of hysteria backstage."[21]

Historically, Chanel collections had been shown in silence. Karl decided to add a soundtrack, kicking off the show with "Douce France," a 1940s anthem by Charles Trenet. It began slowly, with the tinkling of a piano and the first few lines spoken, then building into a bouncy orchestration with charming lyrics about the glories of French life, "Sweet France."[22]

The presentation began with the introduction of three models grouped at the entrance of the runway, each wearing Karl's interpretation of the braid-edged Chanel suit. The skirt lengths were below the knee, the tweed jackets were fitted, the shoulders were strong but not excessive. Hairstyles, by Parisian legend Alexandre, were very soigné and were topped by smart hats in a variety of forms.

First out, on the right, in a navy-blue jacket, white blouse, and navy skirt, was Diane de Witt, a blond Texan. She had a single gold belt, a long strand of pearls, and a white piqué camellia worn on her lapel (Karl

had a version of the flower, which Chanel had used since the beginning of her career, placed on every seat for the guests). His selection of the first model was not accidental. "When Coco Chanel relaunched her house in Paris after the war, Parisians were very negative," remembered de la Fressange. "And it was really thanks to the United States that she started to be successful again. So, right away, he began with an American model, who worked a lot in New York and was very appreciated by American editors, in order to say, 'This is something that is still very French but it is going to work for Americans, it's going to be international.'"[23]

Next out, on the left, was French model Anne Rohart, wearing a red suit, a red hat, and gold chains around her waist. De Witt stood on the right, in navy, while Rohart was on the left, in vivid red tweed, both posing elegantly, each with an arm resting on the wall. Only then were they joined, in the middle, by de la Fressange, in all white, holding a pair of white gloves and wearing a small white boater adorned with white ribbon. Together, the three created a striking tableau in *bleu, blanc, rouge,* the national colors of France.

It was subtle, but Karl made sure that his first Chanel collection began with a sense of emotion. Between the tricolor scene and the charming, nostalgic song by Charles Trenet, Marie-Louise de Clermont-Tonnerre, who had stuck it out at Chanel for the past dozen years, had tears in her eyes.[24]

Karl had assembled a diverse assortment of models, of many nationalities and ethnicities, and he also made the decision to slow down the pace of the show. "It was like the old way of modeling, where you took the time to show the lining of the garment," de la Fressange recalled. "He wanted to show the mastery of the technique, the idea that the Chanel lining is a personal pleasure for the client, that everything was refined, even if it was not visible."[25]

De la Fressange appeared in one striking homage to the house's founder. She wore a black tulle veil over her face and a long black jersey dress with long sleeves that was covered with trompe-l'oeil embroidered jewels by Lesage. She held a cigarette in an unusual way, positioned up,

between her thumb and index finger, exactly as Mademoiselle had, reclining in a chaise, in a famous 1937 portrait by Horst.[26]

The show ended with the traditional bride, the house model, wearing a long white skirt, veil, and white Chanel jacket. Karl came out to a healthy round of applause, walking over to the photographers, stopping to give a kiss to just one member of the audience, Hanae Mori, the only couturier from Japan.

"Lagerfeld Guides Chanel into the 80s," was the headline in the *New York Times*. "The day belonged to Karl Lagerfeld," wrote Bernadine Morris. "The German-born designer had dared to tackle the House of Chanel—a national monument with which one does not trifle. Mr. Lagerfeld didn't trifle."[27]

The French press was positive about Karl's debut. "Chanel Finds Its Maestro," was the headline in *Le Monde*.[28] That opinion was not unanimous. According to *WWD*, "Lagerfeld committed too many Chanel Dont's and not enough Do's." The paper criticized fabrics that were bulky and the piling on of accessories that it felt were tacky.[29]

Some Chanel couture clients objected to many of the changes and details. Marie-Hélène de Rothschild was guarded, suggesting only that it was a beginning.[30] She later expanded on her assessment. "No one could have done it on the first try," she said. "It will come."[31]

While he was throwing himself into his first collection at Chanel, Karl created a new bachelor pad for himself, and another one for Jacques de Bascher. He took two apartments at 202, rue de Rivoli, opposite the Tuileries Gardens, the only time he had a place on the Right Bank, not far from the rue Cambon.

Karl's new studio, as he termed it, was a four-room apartment on the third floor, while de Bascher was lodged on the fifth floor (bringing to an end his five years of living on the Place Saint-Sulpice). Karl's new apartment had a magnificent view looking out over the Tuileries, a sight that

took in the Louvre, the Seine, the Gare d'Orsay (in the midst of being turned into a museum), and the Place de la Concorde.

He asked Andrée Putman to work on the interiors, and they settled on high tech. They kept and restored the historical elements of the rooms, ornate white ceiling moldings and marble fireplaces. Within that framework, Putman installed steel bookcases on wheels, low upholstered sofas and tables, and stereos on top of every mantel.[32] Gray was the primary color of the apartment, a choice Karl made because of the setting. "It is all grey as it looks out on the skies of Paris," he said as he was working on the first Chanel show. "There is a magnificent view of Paris. But it is so nice that you cannot do a damn thing there. In fact, the only place where I work well and seriously is a little dark room on the ground floor of my house on the rue de l'Université."[33]

Karl also had a gym installed. It was a high-tech, stainless affair, with stations for bench presses, pull-downs, and leg extensions. Stainless steel dumbbells were stacked along the periphery. Karl, his hair held back in a ponytail, had quite the workout outfit: spiffy white trainers, white tube socks, short—and very snug—black shorts, and a tight white T-shirt. He may have been a grand Paris couturier but his workout clothes were a reminder that it was, after all, 1983.

With his second haute couture collection, for 1983 Fall/Winter, Karl silenced virtually every critic and swept aside any doubts.

In Milan, his most recent Fendi collection had been a tremendous success. "Karl Lagerfeld and the Fendi clan proved they were one of the most brilliant teams in contemporary fashion this morning," wrote the *Times'* fashion critic Bernadine Morris.[34]

Chloé, shown two weeks later in Paris, was equally successful. It included lean evening gowns and accessories inspired by workmen's tools and hardware. "Wrenches, hammers, and pliers set with jewels decorated collars and shoulders," noted the *Times*. "Faucets dripped pearls,

and shower heads sprayed rhinestone beads on evening dresses. It was all stylish fun."[35]

The following month, Karl jetted off to New York for the launch of his new men's fragrance, KL, and a spectacular show of that season's designs for Chloé, taking over no less a venue than Radio City Music Hall. The event, entitled "Fanfare," was a benefit for Memorial Sloan Kettering. There were some 450 guests, including Gaby Aghion and Jacques Lenoir, leading New York socialites, major retailers, and American fashion designers. Downstairs was a lounge with cocktail tables with arrangements of freesia and orchids, wall decorations of oversized fans, and a memento for every guest, a cardboard fan designed by Antonio Lopez. After drinks, guests filed upstairs to the Art Deco lobby, where tables were covered with peach moiré fabric and centerpieces of white lilacs that were reflected in mirrored trays. Models descended the grand staircase of Radio City. They carried those tongue-in-cheek accessories— wrenches, pliers, and hammers—and the finale was a series of evening dresses adorned with shower heads and streams of water made of jewels. After the show, Karl practically skipped down the Radio City staircase, while the audience and the models lining the stairs applauded. "That man is really good," said Pat Buckley. "He knows what he is about."[36]

By his second season of haute couture at Chanel, Karl had created so much interest in the house that the show had to leave the rue Cambon, where it had always been presented, for the École des Beaux-Arts, on the rue Bonaparte on the Left Bank. The show took place in the historic Palais des Études, a long, two-story rectangular room with marble statues displayed in arches along the second floor for students and topped by a steel-and-glass roof. It took place on a sweltering July day, in front of an audience of five hundred.

"Karl Lagerfeld takes that old black panther Coco by the tail and pulls her into Le Cirque, dressed to kill," exclaimed *WWD*. "The million-dollar man takes the Chanel chassis and adds a lot of chrome—fur trim, crown-shaped jewelry, Fabergé-like embroidery, dozens of chain necklaces and belts, and even his bride goes to the altar in an ermine

Chanel jacket. There is nothing subtle about this collection. It's for the New York super-rich. And the Chanel cosmetics machine, represented by Alain Wertheimer and his wife Brigitte, seated discreetly in the back row, should be delighted."[37]

In her haute couture story in the *New York Times Magazine*, Carrie Donovan raved about Karl's second collection for Chanel. "An unquestioned triumph of luxury, lavishness, and femininity, all poured over what is a well-liked fashion to begin with," Donovan wrote. "It is the kind of collection that makes every woman ooh and ahh, imagining herself wearing the clothes."[38]

Although they were a distinct minority, there were still some who did not get what Karl was doing. "You can't help but wonder whether the people at Chanel got the wrong man for the job," wrote Holly Brubach in the *Atlantic*. "After two collections, he still hasn't figured out how to make a mark on the Chanel style without defacing it."[39]

Most in the fashion world quickly approved of Karl's work at Chanel. John Fairchild had taken to referring to him as "Kaiser Karl." It was a term that Karl abhorred—it was meant to be a snide reference to his German origins—but there was also some truth to it. He had become an immensely forceful figure in fashion.

On the rue Cambon, Karl's achievements were immediately appreciated. "Make no mistake about it, the couture house was practically bankrupt," said Bruno Pavlovsky, who worked with Karl beginning in the 1990s and has been president of Chanel fashion since 2008. "When Karl took over the house, he gave it a new force by looking at the career of Mademoiselle Chanel and deciding what made the most sense stylistically, what was most relevant, and what could help build the brand. That we owe completely to Karl. Even during the last years of Mademoiselle Chanel, everything was dropping off dramatically and Karl was able to determine what was important and what made sense from what Chanel had done."[40]

The deep research that Karl had conducted and his increasing familiarity with the house allowed him to capture the essence of the designer,

to tease out the codes of her style. One key element, from the beginning, was a new sense of humor and irreverence.

He was even impertinent about the man who had hired him, Alain Wertheimer. As Karl once explained, "When I came to Chanel, I said to Mr. Wertheimer, 'Let's make a pact, like Faust with the devil.' But we don't know who is the devil and who is Faust."[41]

16

ONE VOICE

Fashion is a game with no rules. And, at the same time, you have
to know all the rules. You have to know about the structure, the
business, and then forget about it, and do it the right way, at the
right moment, your own way.[1]

IN HIS FIRST FEW years at Chanel, Karl burnished his international
reputation.

He was a regular at Paris's Orly Airport, an elegant figure boarding
the Concorde for New York. "He's there some ten times a month, one of
the commuters of the jet age, and familiar to the other regulars," noted
a mid-'80s journalist. "He wears a well-cut, conservative suit, and so,
with luck, do they. He sports no flamboyant accessories; he has no trail
of admirers and slaves. It is only the ponytail that gives them pause. It
suggests that he is, perhaps, not just another financier."[2]

Many fashion observers felt that, at soon as Karl began on the rue
Cambon, it was only a matter of time before he left Chloé. That oppor-
tunity came in the fall of 1983, after he was approached to start his own
label by the Bidermann Group, a textile, tailored clothing, and licensing
conglomerate based in New York.

The Chloé 1984 Spring/Summer Collection, presented in October,
was Karl's grand farewell to the house, a collaboration that had lasted
nineteen years. The silhouette was long and lean, often with a classical
Grecian feel, which was also an homage to the craft of making clothes.
Karl eulogized the tools of the trade, transforming spools of thread, bob-

bins, and thimbles into jeweled accessories. One striped dress and loose jacket had a belt fastened by large stainless scissors, while a bracelet was made from an oversized pincushion clipped to the wrist that was stuck with jeweled pins. "Though Mr. Lagerfeld designs clothes of great style, he feels that they should be relieved with some levity," noted the review in the *New York Times*. "The clothes have ease and grace and considerable charm. Plus, they make you smile. What more can you ask from a fashion show?"[3]

Before the show, Karl had told everyone that it would be his last collection under his old contract for Chloé. But there was a clue that it was a more permanent change. The set had oversized fit mannequins on either side of the runway, like columns, which underscored the theme of the show. On the backdrop was an illustration of a biplane flying through the sky, pulling a banner that read CHLOÉ. "The pilot, who had a scarf blowing in the wind, was wearing a ponytail," recalled Anita Briey, who had been working with Karl at Chloé since the 1960s. "We were like, 'What does that mean?' There had been lots of talk but we thought, 'No, Karl can't leave.' He knew what he was doing, though—it was his way of announcing his departure from Chloé, and, because the first backers were American, Bidermann, he was flying across the Atlantic."[4]

When the plans were still very hush-hush, a young English designer at Chloé, Alistair Blair, told Briey that Karl wanted to speak with her that evening. "That Karl Lagerfeld wants to speak with me at home, what on earth is he going to say?" Briey later recalled. "That night, his chauffeur, Brahim, whom I knew quite well, rang me at home and then put Karl on the phone."[5]

"Would you like to come and work with me," Karl asked, explaining that he was going to be starting his own house. Briey assumed that Karl wanted her to continue in the same role, being responsible primarily for cutting the patterns. Instead, he said that he felt she had the experience and the skill to run the studio.

"Well, I about fell down," Briey said of the offer. "It was so kind of him—it was like a bomb went off over my head!"[6]

By the beginning of 1984, Karl concluded his divorce from Chloé and launched his own label, Karl Lagerfeld. He made sure the offices were spectacular, taking over two floors at 144, avenue des Champs-Élysées, a 7,000-square-foot space with balconies overlooking the great sweep of the avenue and the Arc de Triomphe.[7]

Briey ran an atelier of around twenty regular workers that would swell to twice that number in preparation for the shows.[8] "We worked like crazy but in a really good atmosphere," Briey explained. "Karl would come into the atelier. When he saw that we were working in silence, he bought a stereo so that we could play music, in order to create some ambiance."[9]

And Karl set about assembling the rest of his team. While on a trip to New York, he met Eric Wright, a young African American designer who he had heard about from Anna Piaggi. Karl hired Wright and brought him over to Paris to be his right-hand man at the new house.[10]

Karl began every morning working from home. Most of the time was spent sketching, but he also had regular phone conversations with his teams at Fendi, Chanel, and Lagerfeld. Eric Wright would start off his mornings checking with Briey and the ateliers, making sure that everything that had been decided the day before was moving forward. Then he would head out to meet with all of the artisans around Paris who made embroideries, hats, and jewelry. "It was before cell phones, but Brahim always knew exactly where I was," Wright explained of Karl's driver. "He would call me and say that he was on the way with Karl and I would jump in a taxi to be back at Lagerfeld."[11]

Wright, who would become involved in much of Karl's professional life, also traveled with him to Rome and observed him with the Fendis. "He really saw the Fendis as family," Wright recalled. "They were like sisters to him. They would talk to him, and touch him, in ways that no one else did—no one! If Carla Fendi didn't like the way his hair looked, she would take her fingers and fix it herself. So, there was a real connection between them—you could see they had grown up together."[12]

Wright also got to know Jacques de Bascher, when he was in the offices on the Champs-Élysées. It was made clear to everyone that de Bascher

was Karl's partner. "A lot of people were afraid of him and I could never understand why," Wright said of de Bascher. "Working in a traditional way was not Jacques's thing. But he was so informed, so intelligent—he knew everything that was going on in the art scene, in music, in film, so the conversation was amazing. And with his good friend, Diane de Beauvau-Craon—they were two people who did not work but they were both intensely cultivated and it was wonderful to be around them."[13]

The first Lagerfeld show was in March 1984, for Fall/Winter. Karl held it in the largest of the three tents constructed for the Paris collections that season in the Tuileries Gardens. The audience included Catherine Deneuve, Texas socialite Lynn Wyatt, who flew to Paris just for the show, designers Sonia Rykiel and Marc Bohan, as well as several Fendi sisters. "The Lagerfeld collection failed to ignite," the *New York Times* suggested of the first half of the show, conceding that it came alive at the end, with long black dresses embroidered with gold.[14] The *Washington Post*, however, called it, "a virtuoso performance."[15]

Two months later, Karl presented that first Lagerfeld collection at Saks Fifth Avenue in New York for an audience in black tie and evening gowns. After the show, guests were shuttled to the Museum of Modern Art for dinner. The crowd included Andy Warhol, Fran Lebowitz, Dina Merrill, Nancy and William Zeckendorf, and Patricia Kennedy Lawford. Karl made sure that the flowers were white and the vases were black. The evening took place long before fashion designers became ubiquitous in art museums, for better or worse. The unusualness of the setting prompted Fran Lebowitz to ask, "Should painters start having openings in Seventh Avenue showrooms?"[16]

In October 1984, Karl began his second presentation of his eponymous line in Paris with a curtain that was raised to reveal groups of models chatting together at café tables, wearing brightly colored sweaters and jackets and whimsical hats. "Karl Lagerfeld lit the fire that ignited the spring and summer fashion openings here and briefly dispelled the doldrums that preceded his colorful, authoritative presentation," noted the *New York Times*.[17]

By the time his new house was up and running, Karl established a punishing work schedule for himself that he would maintain, with variations and even more shows, for the remainder of his life. Starting in the mid-'80s, every year, he showed two collections of ready-to-wear for Fendi, two collections for Karl Lagerfeld, and two haute couture and two ready-to-wear shows for Chanel (by the end of his life, he was designing eight collections per year just for Chanel, six of which were presented on the runway).[18] Designing simultaneously for those three houses meant that, starting in 1984, he unveiled eight major runway shows, in two fashion capitals, every twelve months.

Karl had become the most prolific man in fashion. There was no other designer, in Paris or anywhere else in the world, who was producing that amount of work.

It was at that time of unqualified triumph that Karl, starting in October 1985, initiated a very public dustup with the American management of Chanel and the Wertheimer family.

The conflict began over Chanel accessories and ready-to-wear that was being designed by Frances Stein, who had been hired by Kitty D'Alessio in 1980.[19] The issue became a spat between Karl and D'Alessio, the person who had, after all, put him forward for the job at Chanel. Just a few months before, Karl was still very positive about her, telling the *New York Times Magazine* of the importance of her role in his decision to join the house. "She had exactly my ideas and I had hers," he explained. "So it was easy."[20]

Karl was also aware of D'Alessio's increasingly visible role and the credit she was being given for the house's success. "Although Kitty D'Alessio, 56, only heads Chanel's American operation, she has, in almost six years as its president, made an impressive mark on the clothing, cosmetic, and fragrance company, updating the house for a new generation," wrote Michael Gross that July in the *New York Times Magazine*. "Much

of the new energy at Chanel comes from Miss D'Alessio, who last year received the Council of Fashion Designers Award for 'revitalizing Chanel's image in the United States.'"[21] It does not require a tremendous amount of imagination to consider how that kind of praise went down with Karl.

In July for the haute couture, Karl and D'Alessio were working together splendidly.[22] But by the time of the Paris ready-to-wear shows in October, after the article in the *Times Magazine*, a conflict erupted. "Chanel managed to steal the spotlight Monday with talk of the heated battle brewing at the house on rue Cambon between designer Karl Lagerfeld and Chanel, Inc. president Kitty D'Alessio," reported *Women's Wear Daily*. "Lagerfeld resents the idea that D'Alessio's cohort, Frances Stein, designs ready-to-wear separates in the Chanel Accessories collection, sold apart from his own ready-to-wear for the house."[23]

The *Washington Post* specified that the main issue was that jewelry designer Stein was also making knitwear for Chanel. "As long as there is a Stein for Chanel collection there will always be tension," suggested the *Post*. "Probably not for long, however, Lagerfeld doesn't lose many fights."[24]

Karl raised the stakes by threatening to quit the rue Cambon. "The will-he-won't-he-leave-Chanel upset may have teeny-weeny global significance," suggested the *Guardian* from London, "but in the fashion world, it is a controversy in the grand manner."[25]

Karl gave style journalists what they always seemed to enjoy: a cat-fight. He personalized the conflict, suggesting that he could no longer trust D'Alessio. He said that a fortune-teller told him that he would run into trouble with her. "I have the same fortune teller," D'Alessio shot back.[26] Karl was more conciliatory, however, about Alain Wertheimer. He described him as "Sympatico" and stated, "It's just like marriage. It has to be worked out. And Alain knows that."[27]

Karl's contract with Chanel was, reportedly, only an annual agreement.[28] Karl stressed that he was prepared to walk away. "I don't need Chanel," Karl said flatly, "but I would be sorry to leave this studio."[29]

The night before the show, the designer had meetings with Chanel ownership until 2:00 a.m.[30] For his part, Alain Wertheimer maintained his policy of saying little to the press. "No comment," was his response to *WWD*, before adding, which was more than usual, "All that counts is a good collection."[31]

The spat threatened to upstage the show. "The atmosphere was heavy at Chanel on Monday as people wondered if this was going to be Karl Lagerfeld's last collection, or just a tempest in a teapot," wrote Hebe Dorsey in the *International Herald Tribune*.[32] "Chanel Sizzles as Lagerfeld Burns," was a page 1 headline in *WWD*. As the newspaper noted, "Tension was in the air and even reared itself in the gyrations of Chanel image model Ines de la Fressange, who bumped and swished her way down the runway, scaring the other models and even ripping down one of the grillwork stage doors as she swung backstage."[33]

Karl's set for Chanel re-created the facade of the rue Cambon, with a pair of oversized shop windows on either side containing his oversized drawings of the classic quilted Chanel bag and the latest two-toned pump. The show included high-waisted, one-piece swimsuits—worn with gold belts, camellia broaches, and strands of pearls—the navy suit reduced to a bustier and skirt, and white shorts paired with a navy motorcycle jacket with gold buttons. For one exit, de la Fressange, smoking and carrying a pair of black leather gloves, took a languorous walk up and down the runway, solo, showing off a strong-shouldered black jacket, cinched with a wide gold belt and a matching, tight, knee-length skirt. "Lagerfeld delivered a perfectly lovely, lean and sexy collection that should raise his stock with the company even higher," suggested the *International Herald Tribune*.[34]

At the end of the show, however, Karl did not come out to take a bow on the runway or wait backstage to meet with buyers and editors. As *WWD* wrote, "Knowing full well that he had made the cash registers jingle yet again, Lagerfeld, in a defiant gesture to the management, pouted backstage at show's end, refusing to accept the thunderous applause."[35]

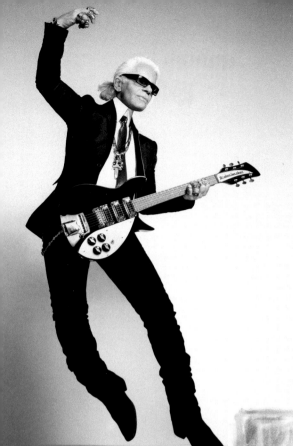

By his mid-seventies,
Karl Lagerfeld
went from being
fashion famous
to a **rock star.**

Jean-Baptiste Mondino

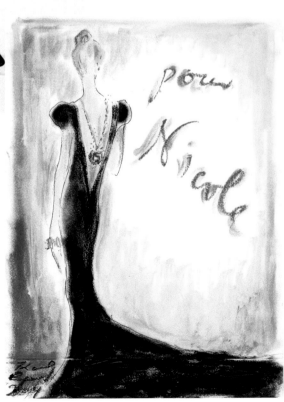

Karl's drawing for
Nicole Kidman of a
Chanel haute couture
evening gown for the
Chanel N° 5 commercial
directed by Baz Luhrmann
in 2004 (the actress's fitting
at the Dorchester Hotel in
London was one of the few
times that Karl ever showed
up on time).

Patrimoine de Chanel, Paris

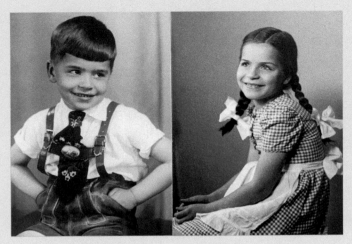

Four-year-old Karl with his six-year-old sister, Christiane, in 1937.

Courtesy Gordian Turk

The earliest known drawing by Karl, from 1942, the year he turned nine, a portrait of himself taking a nap in his room, his table crowded with books.

Patrimoine de Chanel, Paris

A fourteen-year-old Karl, very soigné, in the front row of his class photo from
Bad Bramstedt, outside Hamburg.

Courtesy Gordian Turk

Karl with his parents, Elisabeth and
Otto Lagerfeld, in the early 1960s.

Courtesy Gordian Turk

With a drawing by famed fashion illustrator René Gruau, the ads announcing the 1954 Woolmark Prize for young designers, which, at the age of twenty-one, Karl entered and won, igniting his career.

Author's collection

On the night of his victory in the Woolmark Prize, Karl was hired as an assistant by couturier Pierre Balmain.

Patrimoine de Chanel, Paris

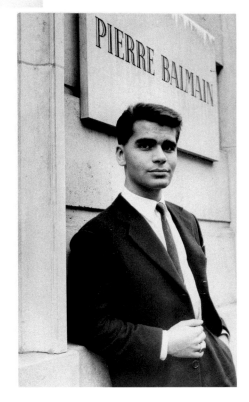

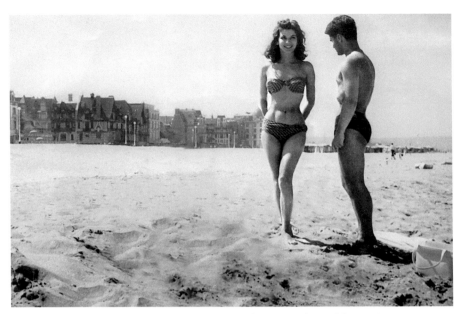

Karl at the beach in Deauville in the summer of 1956, with model Victoire
Doutreleau—in the original, sitting on the sand on the left, was a young Yves
Saint Laurent, whom Karl had banished from the photo.

Author's collection

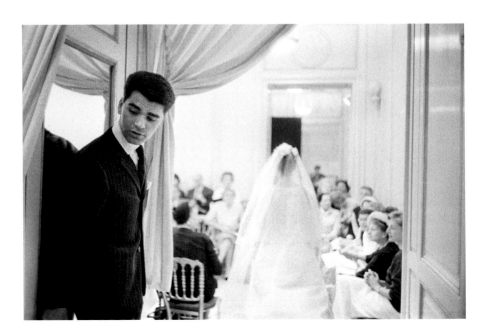

July 1958, Karl's debut collection as a couturier for Jean Patou.

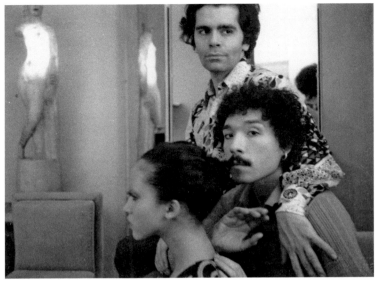

Model Pat Cleveland, fashion illustrator Antonio Lopez, and Karl, circa 1969, in his Art Deco apartment at 35, rue de l'Université.

Juan Ramos; © Antonio Lopez Archives

French aristocrat Jacques de Bascher, the great love of Karl's life.

© Philippe Heurtault—1973

Karl's drawing of the elegant line of Jacques de Bascher, 1975, in Grand Champ, Karl's château in Brittany.

Patrimoine de Chanel, Paris

At the Chloé studio, Karl watching Antonio Lopez sketch Finnish model Eija, with Juan Ramos and Jacques de Bascher in the background.

Max Scheler © SZ Photo/Max Scheler/Bridgeman Images

Karl takes the Chloé team out for dinner at La Coupole.

Max Scheler © SZ Photo/Max Scheler/Bridgeman Images

In January 1983, Karl is named artistic director of Chanel and is immortalized by Helmut Newton on the mirrored staircase at 31, rue Cambon where Gabrielle Chanel once perched.

Patrimoine de Chanel, Paris; © The Helmut Newton Foundation

Ines de la Fressange, reinterpreting the classic style of Gabrielle Chanel in Karl's January 198⟩ debut for Chanel, photographed by Dominiqu⟩ Issermann.

© Chanel/Photographer Dominique Issermann/Ines de la⟩ Fressange/1983 Spring/Summer Haute Couture Collectio⟩

Ines de la Fressange, 1986, wearing Chanel haute couture and the French crown jewels in the Galerie d'Apollon at the Louvre.

Patrimoine de Chanel, Paris © Réunion des Musées Nationaux, Paris, 1989

Claudia Schiffer, 1989,
photographed by Karl
for the first time, for
the Chanel advertising
campaign.

*© Chanel/Photographer Karl
Lagerfeld/Claudia Schiffer/
1990 Spring/Summer Ready-t
o-Wear Collection*

Stella Tennant, 1996,
photographed by
Karl at the Hôtel
Ritz, in Chanel haute
couture..

*© Chanel/Photographer
Karl Lagerfeld/Stella Ten-
nant/1996 Spring/Summer
Haute Couture Collection*

Karl with Anne-Marie Périer, editor in chief of French *Elle,* at home in his town house at 51, rue de l'Université.
© Jean-Marie Périer/Photo12

Karl and his Hummer, with André Leon Talley at Le Palais de l'Élysée, the French presidential palace.
© John Fairer

With Anna Wintour at the 2014 opening of the Fondation Louis Vuitton.
Pierre Suu/GC Images

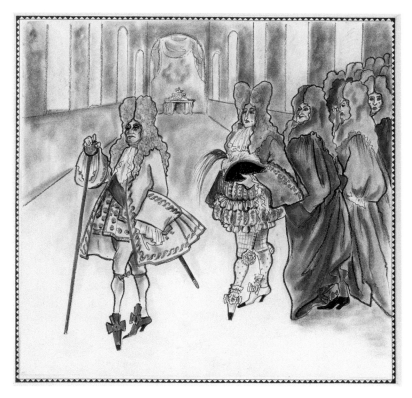

In Karl's reimagining of *The Emperor's New Clothes* by Hans Christian Andersen, the poor monarch is off to discover his imaginary clothes, accompanied by his false, fawning court.

Patrimoine de Chanel, Paris

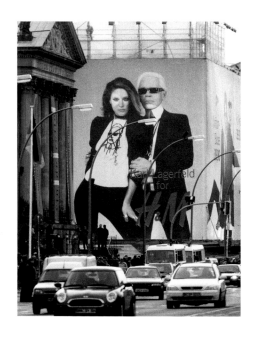

Towering over the Konzerthaus in central Berlin, in November 2004, more than sixteen thousand square feet of billboards announce Karl's collection for H&M, a collaboration that turned him into a household name around the world.

© *Sean Gallup/Getty Images*

The historic October 2007 Fendi show on the Great Wall of China.

For Chanel 2010/2011 Fall/Winter Ready-to-Wear, Karl had massive icebergs sculpted in the Grand Palais.

A volume published by Steidl of Karl's iPhone photographs of his beloved Choupette.

© L.S.D./Steidl, 2018

The Little Black Jacket, a portrait series, a style book, and a series of high-energy exhibitions across the globe.

© Steidl, 2012

In July 2011, at a royal wedding in Monaco, Karl with his bodyguard and *homme de confiance* Sébastien Jondeau.

© Sean Gallup/Getty Images

With Rihanna at the Chanel 2014/2015 Fall/Winter Ready-to-Wear show.

Michel Dufour/WireImage

Karl adored grand gestures with flowers, such as this Eiffel Tower he had crafted out of roses, by Paris florist Lachaume, for Brigitte and French president Emmanuel Macron on Bastille Day, July 14, 2018.

Caroline Cnocquaert for Lachaume

Chanel does Cuba: in May 2016, Karl brought the fashion
world to Havana for a joyful cruise collection.

© Olivier Saillant

In March 2017, a rocket appeared to lift off in one of Karl's
most jaw-dropping productions for Chanel in the Grand Palais.

© Olivier Saillant

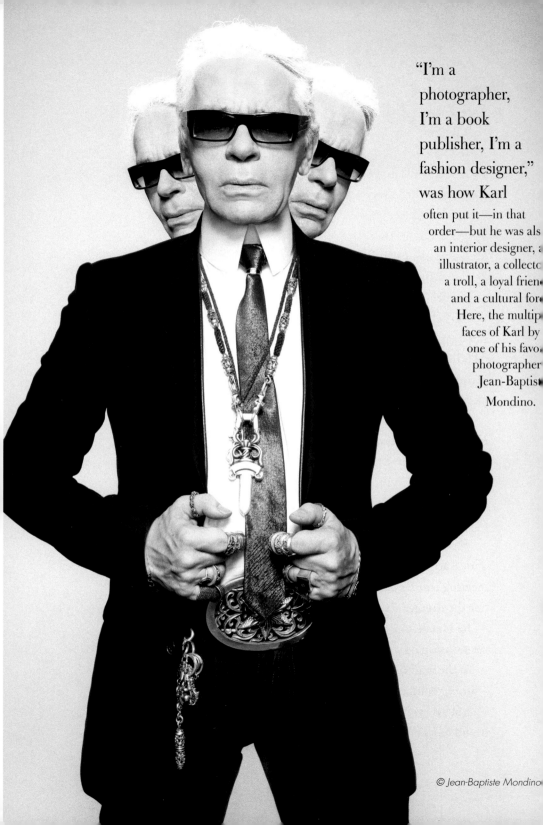

"I'm a photographer, I'm a book publisher, I'm a fashion designer," was how Karl often put it—in that order—but he was als an interior designer, a illustrator, a collecto a troll, a loyal frien and a cultural for Here, the multip faces of Karl by one of his favo photographer Jean-Baptis Mondino.

© Jean-Baptiste Mondino

"He had to go to a television studio," Jacques de Bascher told the *New York Times*. "That is the official explanation."[36]

The next day, Karl spoke frankly about the scandal on the evening news of Europe 1, a national French radio station. The journalist, Jean-Pierre Elkabbach, said that he had seen stories from around the world suggesting that Karl might leave Chanel. "But you are part of the French cultural heritage," Elkabbach said.

"You know, there are ups and down," Karl replied. "And there are some issues that can be resolved. We will know more within two weeks. I think things can be worked out but, what do you want—no one is perfect."

Karl clarified that his beef with Chanel management was that it was not keeping to the original agreement made when he joined the house. "And I am absolutely not about to deviate even one quarter of a milli-meter from what had been agreed upon at the beginning. If they want to deviate, then it will be without me."[37]

He had certainly picked his moment wisely. "Lagerfeld could not have chosen a more strategic time to threaten to leave Chanel," reported the *Guardian*. "Some have observed that with the fortunes of the house on a high, with a thriving cosmetics business and the launch of a new perfume this year, Mr. Lagerfeld will get power-proving, maximum publicity out of his resignation."[38]

That night, there were more meetings with Wertheimer and D'Alessio, with Karl "coolly arriving an hour late." The designer emerged from the meeting triumphant.[39] At 2:00 a.m., Chanel attempted to draw a line un-der the drama, sending letters and telegrams to retailers and journalists. "The House of Chanel and Karl Lagerfeld announce that their working relationship continues," the communiqué announced.

As Bernadine Morris wrote in the *Times*, "Many felt relieved that a winning combination was not being disbanded."[40]

Not everyone was so optimistic. "The battle is not over," suggested a friend of Karl's.[41]

Fashion critic Suzy Menkes, writing for the *Times* of London, was bemused by the whole affair. "Like any older woman attracting a younger man, the house is alternately willing to indulge his whims, terrified of losing him, and infuriated by his insouciance," Menkes suggested. "Karl, for his part, behaves like a toy boy, complaining of the attitude of the American management, of boredom, of lack of appreciation of his skills."[42]

Other fashion leaders did not object to Karl's way of stirring things up. "He's good for the whole business because excitement swirls around him," said Burt Tansky, the president of Bergdorf Goodman. "He loves to create controversy and he's catty."[43]

The spat, which continued to play out during Paris Fashion Week, then took an absurd turn. "The Chanel Saga: Does the Hairdresser Know for Sure?" was the headline in *WWD*. "In a dramatic change of heart, Karl Lagerfeld announced Wednesday that the happy agreement he had sewn up just the day before to go on working with Chanel has fallen through, as far as he's concerned. 'Back to point zero,' he said." Karl insisted that he needed guarantees that D'Alessio and Alain Wertheimer would keep their end of the bargain, giving him full design approval of everything produced by Chanel.[44]

Karl was doubtful of the house's sincerity when he heard of a conversation at a Parisian hair salon when Wertheimer's mother, Eliane Heilbronn, also a formidable attorney for Chanel, had a conversation with Geneviève Hebey, one of Karl's best friends and the wife of his equally impressive lawyer, Pierre Hebey. "Karl won't get anything from Chanel," Madame Heilbronn was to have said to Madame Hebey. "I'm furious," Karl said. "Can you imagine how seriously they are taking it if they are talking about it at the hairdressers?"[45]

WWD even tracked down Alain Wertheimer for his reaction to the latest development. "Wertheimer, contacted in Paris, responded to the coiffure caper by saying, 'We've had a great collection and you have the press announcement. I have no further comment.'"[46]

Although it took another couple of months of back-and-forth, the con-

flict ended in Karl's favor. He would not be leaving Chanel. Of course, he had a clever, bitchy observation about it all. "The good news is that Kitty D'Alessio has been made 'Director of Creative Projects,'" Karl said. "The bad news is that there *are* no Creative Projects."[47]

But the dispute was more meaningful than it might appear. Yes, it involved a collection of colorful personalities and oversized egos and, because of Karl's prodding, became the season's fashion scandal. But it was really about control.

By forcing the issue, Karl and his team in the studio on the rue Cambon solidified their responsibility for Chanel creativity. It was not a question of Kitty D'Alessio's abilities as a manager, nor Frances Stein's gifts as a designer. Both were eminently capable. But, as Karl saw it, he had been hired as the artistic director. The ascension of Chanel, like many great triumphs, was very much a team effort, but Karl felt that the creative direction of fashion and accessories had to be the result of only one point of view: his.

A sign was placed above the door to the Chanel studio: "Creation is not a democratic process." It was a quote from Alain Wertheimer that also nicely encapsulated Karl's philosophy. "Without a free hand, I wouldn't have done this," Karl explained in 2005, in the studio during a fitting. "I do everything myself—it doesn't interest me otherwise. A fitting of something that someone else has done would not be for me. I don't debate—I decide."[48]

It was a curt statement about how Karl saw his role, but his team at Chanel did not seem to mind. Pavlovsky, who worked with the designer for thirty years, was struck by how everyone adored Karl. The day after every collection, for example, there would be a reception for the staff. Karl called it a *Pot d'atelier* and made sure that all were included, as he characterized it, "from the seamstresses to the *premières*, the design studio, the press office, etc."[49] The gathering, which Karl always made sure to attend, was greatly appreciated. "All of the workers, the seamstresses, everyone who had worked day and night, and often on weekends, were always so excited to see him, to give him a round of applause, to

be photographed with him," Pavlovsky explained. "He was the first to acknowledge those sacrifices and to thank everyone for having done such great work."[50]

Those gatherings could go on for two or three hours, because Karl took the time to talk with everyone, to pose for photos, and to sign drawings. "That was also the case with our other partners, manufacturers, embroiderers, etc.," Pavlovsky continued. "He always knew exactly what each had contributed and had something to say to each one. He was very precise and if he felt that the work was not as good as the time before, he was capable of saying it very directly: *Pow*! But he always did it with a lot of respect for those who did the work. He was an excellent leader, in that sense, of making sure that his vision was implemented."[51]

Karl led a system of governance at Chanel that was something of a benign, chic dictatorship. He was convinced that it was the best way to empower the house. And, judging from the bottom line—going from nearly bankrupt to $11 billion in annual sales—Karl was right.

17

NEW VISIONS

I'm an intelligent opportunist. In fashion, you have to be.[1]

IT WAS A DIZZYING little moment, in the summer of 1986, when mid-1980s glamour collided with a few centuries of French culture. And the setting happened to be one of the most extraordinary galleries at the Louvre Museum.

Ines de la Fressange had an older friend, Axelle de Broglie, who wrote for a very well respected arts journal, *Connaissance des arts* (stories she signed using her maiden name, Axelle de Gaigneron). She was the kind of serious writer who, in the past, had weekly lunches with French culture minister André Malraux. Because she did not know the world of fashion, de la Fressange invited her to a Chanel show. She was impressed with the creativity of what she had seen on the runway. Afterward, backstage, de la Fressange introduced her to Karl, who immediately asked if she was the writer for *Connaissance des arts*. "She was very flattered," de la Fressange explained, "and she was amazed that a designer would read *Connaissance des arts* and that he knew it well enough to have recognized her byline."[2]

De la Fressange invited de Broglie to a dinner at Karl's, where they bonded over the eighteenth century. "Because of how much he had studied the subject, Karl was pretty unbeatable, by that time," de la Fressange recalled. Both Karl and the editor knew a curator at the Louvre, Daniel Alcouffe, who was hoping to mark the reopening of an important section of the museum that had been closed for renovation. And they

conceived of a photo session that would involve Karl, de la Fressange, and the French crown jewels.[3]

The idea was that the museum, for the first time in its history, would allow someone to wear the jewels. "I had already learned that this sort of thing is never allowed," de la Fressange said. "Once, I had a private visit to the Victoria & Albert Museum and I saw this Balenciaga coat. I was like, 'Oh, that's so beautiful, can I try it on?' And these curators, wearing their white gloves, just stared at me, wide-eyed. And I learned that under no circumstances could that be possible—for even suggesting it, I suddenly felt like the most vulgar person in the world!"[4]

In this case, though, the Louvre was making an exception. "These jewels had not been worn by anyone since Queen Hortense," de la Fressange explained of Hortense de Beauharnais, the stepdaughter of Emperor Napoleon who became, in 1806, the Queen of Holland. "All of these very special permissions had to be granted, which was done because it was going to be for a major story in *Connaissance des arts*, because it was Axelle, and because it was Karl."[5]

On a day that the museum was closed to visitors, the designer and muse made their way to the Louvre. Karl wore a perfectly tailored, dark pinstripe suit, with a striped dress shirt and paisley tie. For de la Fressange, Karl had designed a Chanel evening gown in black satin velvet, sleeveless, with a large bow at the bust. "It was a *robe à bijoux*," she recalled. "One that was not obvious so that it wouldn't distract from the jewelry."[6]

The photo session required a small team. "The hair was by Katia Mordacq, who had worked with Guy Bourdin and Helmut Newton, and was an exceptional woman who Karl really loved," de la Fressange remembered. "The makeup was by Heidi Morawetz, who did the makeup for Chanel—Austrian, very cultured, who had also worked for all of the best photographers in the world. So, there was this little fashion troupe, that had also worked for leading artists, thrilled to find themselves, at least in my case, stripped down to their panties in the Louvre."[7]

Karl and the team made their way to the Galerie d'Apollon, a particularly spectacular space in the museum. In the seventeenth century, Louis XIV, at the tender age of twenty-three, had decided that he was the Sun King. In 1661, he commissioned a gallery, considered the first royal gallery in France. It was dedicated to Apollo, the Olympian god of the sun and of the arts. The architecture was by Louis Le Vau; the painting and decoration was by Charles Le Brun (two decades later, they would do the Hall of Mirrors at Versailles). The Galerie d'Apollon, with its vaulted ceiling and gilded plasterwork, was a glowing golden masterpiece. Along the ceiling, Le Brun painted a series of frescoes depicting Apollo guiding his chariot across the skies. The gallery was not fully completed, however, until two centuries later when, in 1850, Eugène Delacroix finished the center painting, a forty-foot-wide panel, *Apollo Slaying the Serpent Python*. The walls were hung with twenty-eight Gobelins tapestries of all of the monarchs who had built the Louvre, as well as the palace's painters, sculptors, and architects.[8]

No less an aesthete than Henry James, when he first set eyes on the room, in 1856, was enthralled. "The wonderous Galerie d'Apollon," James wrote, "drawn out for me as a long but assured initiation and seeming to form, with its supreme coved ceiling and inordinately shining parquet, a prodigious tube or tunnel through which I inhaled, little by little, that is, again and again, a general sense of glory."[9]

For Karl and de la Fressange, museum curators brought out the priceless jewels, many in their historic cases, and arranged them on a table in a corner of the gallery. The pieces had managed to make it through the French Revolution intact, until, in the nineteenth century, they were sold by the French government and scattered. De la Fressange was presented with a set made up of hundreds of diamonds and thirty sapphires from Sri Lanka: a choker necklace, a pair of drop earrings, a stately diadem, and a large broach. The most recent addition to the collection was the diadem, having been acquired by the museum only the year before. Karl helped place the jewels on de la Fressange, positioning the broach in the

center of the dress's bow and carefully settling the crown on the top of her head. He also took the time to study the jewels closely, noticing that one of the loose sapphires had a mount from Marie-Étienne Nitot, the jeweler for Marie-Antoinette.

"One of the things that really struck me is that I had the impression that the stones were fake," de la Fressange recalled. "I didn't know anything about jewelry at the time and they were so beautiful that they didn't look real. Karl and I were laughing about how they were probably fake—just kind of giggling amongst ourselves."[10]

"Ines Enters the Louvre," was the *Connaissance des arts* headline. "It is a *coup de théâtre* at the Louvre, a first in the history of the museum, when the precious stones of Queen Hortense and Queen Marie-Amélie, with diamonds and sapphires that probably belonged to Marie-Antoinette, are worn by Ines de la Fressange, the star model of Chanel."[11]

She had a poetic view of the chance to wear these jewels that day, telling the reporter, "I feel like I am wearing history."[12] But not everything was so solemn. At one point, de la Fressange kept a grasp on the diadem with one hand, while the other held a camcorder that she pointed up to the spectacular ceiling. "I carried that thing with me everywhere I went," she explained. "It was heavy and made this loud sound when filming—you could even hear it when you played it back. Today, you would have the video in your phone and the whole thing would be in Instagram. But, then, it was only the readers of the magazine that saw us."

The Louvre did come up with a clever use for the images, making a postcard out of the photo session. "People would go to the Louvre and the only postcard with a living person was me," she recalled. "And I heard that for many years afterward, amazingly, it was the biggest selling postcard at the museum."[13]

The photo session certainly broke new ground. "I have never heard of the Louvre doing something else like this," de la Fressange added. "So, this was a one and only kind of thing. And it was the first time that this serious, academic publication had featured a fashion designer. I think the exceptional nature of it all really pleased Karl."[14]

Back in Hamburg, when he was still a teenager, Karl had his earliest experience with a camera. His mother gave him a Minox, the subminiature camera that was a must-have for luxury consumers and for spies. "A camera is the toy that all grown-up men should have," he explained decades later. "It is one of the few toys that grown-ups are allowed. My newest one is an 8x10 Sinar. But I have done nearly all my work with a Hasselblad. And I love the Leica 6. A camera is something very physical—I love the way it feels and the way it sounds."[15]

He had worked closely with fashion photographers Guy Bourdin, a friend, and Helmut Newton, a very close friend. And there were many photographers that he admired, including Peter Lindbergh, Bruce Weber, Steven Meisel, and Herb Ritts. "And Horst, for me, is the supreme fashion photographer," Karl once said.[16]

Éric Pfrunder, who was hired at Chanel in January 1983 to create the advertising campaigns for haute couture and ready-to-wear, first worked with Karl on a series of portraits by Helmut Newton to mark his arrival on the rue Cambon. Looking elegant in a high-waisted dark suit, a white dress shirt with no tie, and a white pocket scarf, Karl was immortalized in several meaningful places around the house. He stood on the famous curving staircase with its mirrored wall, leaning against the railing, his hands in his pockets. In front of three-way mirrors in the studio, he was shot from behind, a black ribbon holding back his ponytail. And he was captured outside the door to the studio, looking straight at the camera, the shadow of his ponytail falling over the words "Mademoiselle Privé."

By January 1987, while preparing the press kits for the Chanel Spring/Summer Haute Couture Collection, Pfrunder had a hard time producing photos that pleased Karl. For Chanel advertising campaigns, they worked with big names such as Newton, Albert Watson, and Arthur Elgort. Karl was always happy with those images. Newton had done some of the early press photography. But most major photographers were not interested in that kind of work—it was not prestigious enough, not creative enough, and did not pay enough.

That season, they had shot the collection three different times, with three different photographers. "And Karl wasn't happy," Éric Pfrunder recalled. "He kept saying, 'I don't like these. I don't like these.' So, finally, I said, 'You know, if you're going to be such a pain in the ass, we're going to do the pictures ourselves!'"

And Karl said, "OK, let's do it!"[17]

And that is how Karl, at fifty-three, embarked on a new, and important, phase of his career: photographer. They did the first photos for the Chanel press kit, with Ines de la Fressange, downstairs in the haute couture salon on the rue Cambon.[18] "Press kits are not fun, because they have to be black-and-white and handled in such a way that they can be used for daily papers," Karl explained to the photography magazine *Aperture*. "Press kits have to be made a week to ten days before the collection is finished. Very often, I photograph unfinished dresses, so I have to know how to make them look finished."[19]

Karl also quickly began doing the advertising campaigns for Chanel. The first was for the following season, 1987 Fall/Winter Haute Couture. It was a relatively simple affair, with de la Fressange in a studio, wearing several couture gowns with their exquisite Lesage embroidery, and a backdrop of huge swaths of taffeta in saffron and persimmon falling to the floor, not unlike the window coverings in Karl's apartment.[20]

"And it never stopped after that," Pfrunder continued. "It became a real passion for Karl. There were the press kits and the advertising for Chanel but also for Lagerfeld and Fendi and many other things. As soon as he had an idea, *bam*, we were off and doing it!"[21]

Soon, Karl was shooting fashion stories for magazines around the world, interior and architectural photography, and more personal art images. "For me, photography is a kind of late realization of a childhood dream," Karl once said. "Fashion—my real means of expression—is a pretext, a source of inspiration, and a logical link with photography. I build on those elements for most of my photos—they are images of an idealized reality."[22]

Karl's good friend Ingrid Sischy, who had been the editor in chief of

Artforum and the photography critic for the *New Yorker*, made an art world comparison to explain Karl's work as a photographer. She noted that the sculptor Constantin Brâncuşi had long been dissatisfied with photographs of his work. "Finally, Brancusi, out of frustration, started taking photographs of his own sculptures in his own studio," Sischy pointed out. "And when one looks at the photos of his own work, there is nothing like it."[23]

Pfrunder believed that what set Karl apart as a photographer, more than any technical skill, was his eye. Karl could take a cheap disposable camera and, just sitting in the back seat of a car, come up with a striking image. Karl conceded, however, that just having a visual sense was not enough. "We were able to take technically acceptable photographs from the outset," he explained. "Merely having ideas is not enough—I have always known what I wanted, but I did not know how to achieve it on my own."[24]

Pfrunder was able to find the highest-quality printers available in Paris, with innovative processes that fascinated Karl, and he tracked down the most exquisite papers for reproducing the photos.[25] "The paper that a photo is printed on is almost as important to me as the photo itself," Karl once explained. "Paper is my favorite material in the world, the starting point for all of my creativity. In the case of photography, it is the final result, the coronation."[26]

Karl would usually start shooting late in the evening, only after he had finished his other work, and go throughout the night and often into the next morning. "The gentle but steely organizational talents of Éric Pfrunder transform hard work into a kind of professional way of spending one's leisure time," Karl explained. "Our advertising campaigns are practically Hollywood productions. We work hours that are pretty near inhuman and have a destructive effect on family life. Nobody complains, and often I almost feel guilty."[27]

Karl and Pfrunder worked together for thirty-six years. "It was like a marriage, except without the sex," he recalled. "It was 24 hours a day. We might finish shooting at 6:00 a.m., catch some sleep, and then call

one another at 8:30 a.m. And it was like that right up to the end of his life."[28]

Karl stressed the importance of Pfrunder and the team they had assembled for his photography. "Often, we are 15 and 20 people—makeup artists, stylists, models, lighting people," Karl recalled. "I work with nearly all the people I started working with from the beginning. You can't spend nights and days with people you don't like or don't know. I don't want to—I don't have to."[29]

18

DEATH AND DISASTER

I would not do it without Ines de la Fressange. I ask her
everything. She tells me what she wants to wear and I design it.[1]

AS HE SETTLED INTO the rue Cambon, becoming more comfortable playing with the history of the house, Karl had been giving more thought to the house's founder. "As a human being, I think she was a nightmare, *non?*" he once pointed out. "The other designers were sweet grannies, great artists, but she couldn't care less about being sweet or about Greek beauty or dressing boring daughters or whatever it was. She wanted to look beautiful, modern, different, mean, and fun. And I like that."[2]

Insiders pointed to one key moment when Karl seemed to express with certainty where he was taking the house. The Chanel 1986 Fall/Winter Haute Couture Collection was held in the École des Beaux-Arts. For the season, Karl loosened up the Chanel jacket, eliminating the gold buttons and treating it more like a cardigan. For Véronique Perez, who was the communications director for Chanel for many years, the key exit was when Ines de la Fressange and Jerry Hall appeared on the runway together. Both were wearing classic red tweed suits, with the new cardigan jacket. But the Texan was wearing hers with a red silk blouse and was loaded up with long pearl necklaces, a gold choker, a few gold chains around her waist, and high-heeled two-tone pumps. The Parisian had a red tweed skirt and cardigan jacket with a T-shirt, one belt around her waist, and minimal jewelry. "They were completely different

but equally chic," Perez recalled.[3] "It was a little thing that really gave me the message about Chanel as seen by Karl."[4]

He was, as he had been doing since he began on the rue Cambon, making a point about how couture could be interpreted in a fresher way. "Karl Lagerfeld's triumphant success with the Chanel image has come precisely because the clothes no longer look proper and lady-like but young and sexy," suggested Suzy Menkes in the *Times* of London. "He has twisted and tweaked the gilded chains, hiked up hemlines, puffed out shoulders, and molded the jackets to the body."[5]

And the mood that Karl had created in the house's studio, still the same space that had been used by Gabrielle Chanel, was ebullient. "It was super fun," recalled Virginie Viard, who was part of the team beginning in 1987. "And it was a small group: Gilles ran the studio; Ines was there; someone would work on hats; Victoire was doing jewelry. Victoire was, and is, someone who is hilarious—just her way of being. She sat there all day playing with old stones, putting them together and taking them apart, wearing the latest things by Azzedine Alaïa—it was all just great."[6]

For the Chanel 1987 Fall/Winter Haute Couture Collection, staged again in the great hall of the École des Beaux-Arts, Karl looked to one of the favorite operas of Louis XIV, *Atys* by Jean-Baptiste Lully, which had been staged in the past year at the Château de Versailles.[7] The skirts were short, while the jackets were sumptuous and shapely. Ines de la Fressange appeared in a long black evening dress with a floor-length opera coat in persimmon taffeta. Season after season, de la Fressange was the biggest star on the runway and the biggest inspiration for Karl and his new take on Chanel.

In the front row, smiling and taking notes on their next purchases, were such leading couture clients as Nan Kempner and Lynn Wyatt, wearing a black-and-white Chanel jacket and minidress, with giant gold earrings, in the form of the number "5," swaying as she moved. "I thought it was a ravishing collection," Wyatt said after the show. The Texan had filled her notepad with more than a dozen ensembles that she

planned to check out. When asked how many she was going to buy, she laughed and said, "I'll never tell you—more than I can afford!"[8]

S ofia Coppola, though far from your average teenager, was raised primarily on a farm in the Napa Valley. She had long been interested in style. "Growing up in the country, in Napa, my only kind of connection to fashion and glamour was through magazines," Coppola recalled. "I would track down issues of French *Vogue*, which was hard to get at that time, pre-Internet. And it just seemed to me that Chanel was the epitome of excitement and Paris fashion."[9]

Coppola was sensitive to the history of the house. "I've always loved the classic codes from Coco Chanel," she explained. "Look at old photos of her and she still looks chic and modern today. And I love how Karl interpreted that, because that was my introduction to Chanel, through Karl's eyes. He reinterpreted her codes, bringing back the symbolism that she created, keeping it alive. I mean, what woman doesn't want to wear a Chanel jacket?"[10]

Luckily, her father, Francis Ford Coppola, had a good connection, the actress Carole Bouquet. And thanks to her, in the summer of 1986, the fifteen-year-old Sofia Coppola secured an internship in the Paris studio of Chanel. "I remember going for my first day and thinking that it was going to be kind of strict old ladies in Chanel suits. I didn't know what to expect. I was so surprised and relieved at how fun and relaxed the atmosphere was there."[11]

The studio was being run by Gilles Dufour, while Victoire de Castellane, his niece, played a big role in lifting the mood, as well. Coppola was surprised to see how interns were allowed to be in the studio and watch closely as the collections developed from Karl's sketches to the fittings and then onto the runway. "He loved the people around him and always seemed to be so amused by everything," she said of Karl. "And he was very open to input from younger people and seeing how they were

wearing things. It was just a very fun atmosphere, full of life and music—they were clearly enjoying themselves."[12]

Not that Coppola's time on the rue Cambon was completely free of tension. "Once, Karl was talking on the phone, and I tripped over the cord and disconnected his call," she remembered. "I was horrified. He thought it was funny but he was always so nice and not at all scary like you might think."[13]

Coppola interned at Chanel for two summers, 1986 and 1987. For the 1987 Fall/Winter Haute Couture show, she invited her father to attend. Backstage, Karl posed for photos with Sofia and Francis Ford Coppola.

"It was beautiful," the director said to Karl of the show. "I've never been to one before."

"It wasn't boring?" asked Karl.[14]

Although Sofia Coppola had grown up in an intensively creative environment, she was impressed by Karl's multidisciplinary output. "I was inspired by so many things he was doing. He is the first example, outside my family, of this kind of endless creativity: his sketches, the photography, publishing books. I had never seen anyone like that."[15]

In Monte Carlo, Karl took over a spectacular white villa perched on cliffs overlooking the Mediterranean. La Vigie, or The Vigil, held its commanding position as though watching out over the rugged coastline. The three-story, flat-roofed structure, built on rocks and bordered by tropical plants and pines twisted by the wind, was surrounded on three sides by the sea.[16]

La Vigie had been constructed in 1902 by Sir William Ingram, an Englishman who was said to have made his fortune on printing ink, a fortuitous connection for Karl.[17] It had been abandoned for almost forty years. Karl and his team, led by his close friend Patrick Hourcade, undertook two years of pharaonic reconstruction and interior design. The grand staircase, entirely reconstructed, was inspired by the one

used by Marie-Antoinette at the Château de Saint-Cloud. The project was so costly that Karl took to referring to it, instead of the Côte d'Azur, as the Côte d'Usure, or "Debtors Coast."[18]

The finished house, with a separate apartment built for Jacques de Bascher, was spectacular.[19] The German weekly *Stern* called it a "princely domain."[20] On the ground floor was a series of three connecting salons, with pale walls and light yellow curtains of draped taffeta, a monumental eighteenth-century terra-cotta sculpture, and some thirty Louis XVI chairs, armchairs, and sofas all embroidered with silk specially woven in Lyon.[21] In his suite, the breakfast room contained several paintings by Élisabeth Vigée Le Brun, the great portraitist favored by Marie-Antoinette.

Karl always made a point about how much he worked when he was at La Vigie. He also used the property for his photography, making it both a studio and a set. "It is all about the light," he said of shooting there. "It is like an open-air studio, with this light that is just sublime."[22]

One hot evening in the late summer, Karl organized a photo session on the terrace of La Vigie with Princess Caroline and her husband Stefano Casiraghi, to mark their five-year anniversary. Inspired by the sapphire ring that he had given her, she wore a sapphire blue taffeta gown by Marc Bohan for Christian Dior. She also had long diamond earrings and a diamond tiara. In one portrait, she was captured from behind, standing, holding on to her three young children, Andrea, Charlotte, and Pierre. Karl also took a portrait of the couple, with Casiraghi wearing white tie and tails. They stood in profile, leaning on the white stucco railings of the terrace, looking into each other's eyes, with the bright blue Mediterranean glimmering behind them.[23]

Karl and Caroline had been good friends for a decade by that point. "She is curious about everything, as am I," Karl said of their friendship. "She wants to know everything—she is interested by so much. We talk about books, music, architecture, houses—she loves houses."[24]

From her perspective, Princess Caroline, who was a close friend of Karl's for forty-five years, felt that he was like a member of her family. "I

was so young when we first met," she explained. "I had so much to learn. And he taught me not to be afraid to seek out new paths, to question everything all the time, and especially, not to take myself too seriously."[25]

Of course, Karl also socialized when he was in Monaco. Helmut Newton and his wife, June Springs, also an excellent photographer, were very close friends who lived in Monte Carlo, and he saw them quite a bit. In 1985, Newton took a portrait of Karl and Jacques de Bascher in nearby Èze, both wearing light tropical suits, leaning against a Range Rover, with Karl holding a white fan and de Bascher sporting a wide-brimmed light straw hat.

Another close friend in the area was Lynn Wyatt, who owned La Mauresque in Cap Ferrat, an estate that had been home to Somerset Maugham for four decades. Wyatt, who had bought her first Chanel suit in the early 1960s, when she met Coco Chanel, was a major fan of Karl's work on the rue Cambon. She and Karl would see each other often in Paris and during the summer when both were down in the south of France. Wyatt wanted her couture to be as timeless as possible, so she tended to buy black or white or a combination of the two. Karl took to referring to the colors as "Black and Wyatt."

One notable, and surprising, encounter that Karl had in Monaco was with an eleven-year-old girl, Amira Casar, who would go on to become a model and actress. Born in London, raised primarily in England, to a father who was Kurdish and a mother who was Russian, Casar would spend a couple of weeks every summer with her father in Monte Carlo. She was a regular at the Monaco Open Air Cinema, an outdoor movie theater surrounded on two sides by the ocean, with a huge screen and, rising up behind, the storybook skyline of Monte Carlo.

At the time, she had short dark hair, and, because she was a competitive rider in England, she had something of the tomboy about her.

Karl called her "*jeune homme*," or "young man," also suggesting that she looked like a Tissot painting.[26]

For her part, Amira Casar was certainly not shy with Karl. "I told him that I was a little fag in the body of a woman," she remembered with a laugh. "He was insolent, as well—he loved insolence. Not rudeness; not being poorly brought up; but insolence. He certainly needed that in order to succeed in fashion the way that he did."[27]

Soon enough, Casar was being photographed by Helmut Newton and in 1986, when she was fifteen, walking for Karl in a Chanel show. "I was a kind of Mini-Ines," she said. Karl insisted that she use the more familiar "*tu*" with him. "Karl and I bonded over theatre and cinema, of course, but what I also loved about him, which I felt was lacking in France, was how he could make fun of himself, his self-mockery. Of course, some people have that in France, individuals, but it is not a national trait. I noticed that Karl had it and I did too."[28]

The actress also met Jacques de Bascher and saw what the relationship meant to Karl. "I think that Jacques was not only a great love of Karl's but also a projection for him," she explained. "Karl was completely subjugated by Jacques—subjugated by his beauty, by his aristocratic impertinence, and by his sense of invention, because Jacques de Bascher invented himself." Casar mentioned Oscar Wilde's belief that the dandy was all about being who you wanted to be, and that Honoré de Balzac also explored the subject. "One of the great Balzac characters, Lucien de Rubempré, in *Illusions perdues* and *Splendeurs et misères des courtisanes*, is exactly Jacques de Bascher," she said. "From a minor aristocracy, he comes to Paris from the provinces, thanks to an older woman, he arrives in the neighborhood of the Tuileries, on the rue Cambon—that's in Balzac: *the rue Cambon!*"[29]

Casar went on to Chanel shows, sitting in the front row wearing Yohji Yamamoto and Comme des Garçons. She also built an impressive acting career, starring in mainstream French films such as *La Vérité si je mens!*, and art films like Catherine Breillat's erotic drama *Anatomy of Hell*,

where she was cast opposite porn star Rocco Siffredi. She played an eighteenth-century aristocrat in the television series *Versailles*, as well as Timothée Chalamet's hip, intellectual mother in *Call Me by Your Name*.

In 2004, Amira Casar was asked to present the best costume award for Les César, considered the French Oscars. The host, comedian Gad Elmaleh, knew that she was friendly with Karl and suggested they give a special award to him for costume design. Casar called Karl, at home on the rue de l'Université, to propose the idea. After a complicated series of transfers throughout the house, she reached the designer.

"Why are you calling me, you know I don't like the phone," Karl barked.

Casar explained the idea of honoring him at Les César. He checked his calendar and found that, unfortunately, he was going to be in Los Angeles when the ceremony would take place.

It had become widely known—though not by Karl—that Casar could imitate him. So, the host asked, if Karl could not make it, what she would think about doing her impersonation of him for the ceremony.

"I'm not a fearful person by nature but I thought, OK, I'm going to have to call Karl to ask," Casar explained. "How am I going to explain to him that I want to do his voice? That I want to . . . *be* . . . *him*? So, I call and, again, it is this long ritual to get through. 'Hold, please, for Monsieur.' It's like something from the 1930s. 'OK, I will pass you now to Monsieur.' He finally picks up the phone, and I'm sure that he's in the bathroom."

"Oh, it's you again! What do you want?"

"Listen, Karl, I spoke with the Academy and with Gad Elmaleh. Even though you can't be there, they would still like to celebrate you. But would you be open to having me, uh, do an impersonation of you?"

"Oh? You do an impersonation of me? Go ahead, go ahead: speak like me."

"I thought, OK, I like to improvise, so I'm just going to go for it." She then launched into an incredibly animated monologue, speaking French as quickly as possible, with a clipped German accent.

"You know, in the 19th century, all of these women that you saw, the Countess de Castiglione and all of that, it was all very, very dirty. There was all this dust, and everything was dragged through the mud. And it didn't smell very good, *huh*? There was an aroma to it that was just atrocious! But because the photos were in black and white, no one had any idea about the amount of dirt and the filth, *non*?"

Silence.

Had she gone too far? "I thought, 'Fuck, he's going to decapitate me,'" she remembered. "'It's going to be the guillotine set up on the Place Vendôme.'"

After milking the silence for a moment, Karl replied. "I am horrified to tell you," he said. "*Horrified!* That you do it better than I!"

"Anyone who has the humor," Casar said, "and ability to laugh at themselves, to say that—it's just extraordinary."

Amira Casar went on to do her Karl impersonation at the Césars, where Jean Paul Gaultier, in particular, was in stitches. She imitated Karl on the French radio, and on a joint appearance they made on a Paris talk show. "About 10 years ago, he said, 'No one has done me like Amira.' And it said a lot about him. It's seeing that he created something—that he created a kind of a monster. And I am interested in monsters—I love monsters!"[30]

As they continued to work together, Karl and Ines de la Fressange had developed a symbiotic relationship at Chanel. She was much more than a model for the house, or even a muse—they had become creative collaborators.

In the summer of 1986, just after the haute couture collections, Karl was given a prestigious French fashion award, the Dé d'or, for his work at Chanel. He was traveling and unable to attend the gala dinner, so de la Fressange accepted in his place. A French television host raised the issue and said, "It's true that today, you are the incarnation of the name Chanel."

"No, actually it was given to Karl Lagerfeld and he was in the United States," she replied, smiling. "He left that morning and had no idea that he would win. So, I had all of the attention, the glory, the photographers, but, in fact, I hadn't done anything. I just represent the image of Chanel."[31]

The following summer, Karl and de la Fressange appeared together on the French national news. "I am here with the two stars representing the house of Chanel," announced the host, Hervé Claude. Turning to Karl, he asked, "When we talk about Chanel now, we often talk about Ines de la Fressange, who has become the star of the house—that doesn't bother you?"

"Absolutely not—I am the one who chose her and who wanted to promote her as much as possible," Karl replied. "Chanel was women's fashion made by a woman. The woman who made this style no longer exists—I don't like to say that she is dead—so we needed someone who was alive, modern, and young, and I have not found anyone better in the world, and we looked a lot, as good as Ines."

"But it is usually the designer that is the star, isn't it?"

"You know, I don't have that problem—I am enough of a star elsewhere that I don't feel the need to take attention away from Ines. *Au contraire*! I am the one who pushes her to be seen instead of me. She is much more attractive!"

The year 1989 in France was a very significant one, the Bicentennial of the French Revolution. It would be celebrated on July 14, Bastille Day, in the most spectacular way, with a parade art directed by the photographer Jean-Paul Goude, culminating in Jessye Norman singing "La Marseillaise" in the center of the Place de la Concorde, draped in an enormous version of the French flag designed by Azzedine Alaïa.

In the midst of such patriotic fervor, France decided to select a new Marianne, the female symbol of the country since 1792. Versions of Marianne appeared as postage stamps and as statues placed in town halls throughout the country. In recent decades, the figure had been represented by major film stars including Brigitte Bardot and Catherine Deneuve.

So, on May 30, it was big news when it was announced that de la Fressange had been selected to be the new Marianne. She had been chosen by a jury of French and international journalists and editors organized by *Vogues Hommes*, and her victory was announced by placing her on the cover of the June issue (though de la Fressange was later told by French president François Mitterrand that she was chosen by the mayors of France).[32] She arrived for the official unveiling of her statue, at the Place du Palais Bourbon, looking resplendent in a strapless black Chanel minidress, with a single gold belt and gold and pearl earrings. She milled about with officials, in the midst of other plaster busts that had been created over the years.[33]

De la Fressange thought that the honor could not have been more perfect. She was the image of a great French couture house, representing it internationally, and now she was also going to be the image of France. Everyone at the rue Cambon, she felt, was equally enthusiastic. They saw how meaningful it could be for Chanel, what synergy. Everyone was incredibly enthusiastic, except for Karl. "Too boring, too pretentious, too bourgeois," he snapped.[34]

De la Fressange insisted that there were valid reasons for her to take the role of Marianne. "At a time of the rise of the far right in France, I thought I was a good reminder that the symbol of the nation was from the nobility but also had Jewish blood and was a product of immigration. I felt like it was a positive political statement."[35]

But Karl was clearly not happy about the portrayal—and came up with his own political gesture. For that summer's haute couture collection, instead of having de la Fressange make multiple appearances, as she had for the past six years, he wanted to use her sparingly to make a grand statement. "Karl wanted me to have just one passage, with a dress that was embroidered entirely with fleur-de-lys," de la Fressange remembered. "The symbol of the French aristocracy. And, I said, in front of Karl and everyone else who was there, that I did not find that funny at all and that I had no intention of wearing that dress. It was like a declaration of war."[36]

De la Fressange felt that Karl's behavior was a childish joke. She quickly called a high-powered lawyer, Georges Kiejman, to get her out of the remainder of her Chanel contract.[37]

Clearly, there were other reasons for the rift between the two friends. Whatever he might have said out loud, the public perception that de la Fressange was somehow Chanel must have started to grate. Often, she would be with Karl, walking on the street or sitting in the back seat of a car, when people would call out to her about how they loved what she did at that house. "And I would point to him and say, 'No, it's Karl who does it.'" Then there were all of the letters that were sent to her at the rue Cambon, flowers, even packages with gifts. "I didn't have an office at Chanel and when I started receiving all of these things they were stacked in the studio behind Karl's desk. There was an increasing notoriety and all of that bugged him a little."[38]

Once, on a trip to New York to promote the fragrance Coco, she made a personal appearance at Macy's. One customer rushed up to her. "It's Coco Chanel," she exclaimed. "Are you Coco Chanel?" It was something that would happen on the streets in Paris, as well. Ever loyal to Karl, she would reply: "'No, c'mon, I'm a little bit younger and less dead!'"[39]

Around that time, de la Fressange was approached with an impressive job offer: to become the designer of Hermès. "I was thrilled that they asked but it did not really make sense and I was very happy at Chanel," she said. "Then, like a child, I told Karl that they had made the offer but I that had refused, that I wanted to stay with him. It was really stupid on my part. I was 29 years old, had never been a designer, did not begin when I was a teenager like he had, and here I was given the chance to take over a house like Hermès. That must have really irritated Karl."[40]

Finally, de la Fressange had also met the man that she would marry, Luigi d'Urso, an elegant art historian and businessman. "So, here I am, in love with this art historian, who knows a lot more about art than Karl, who comes from an old family, and who was not at all in awe of Karl," she explained. "From his side, Karl didn't really like Luigi and

he started to feel abandoned, to have the impression that I was no longer going to be available—which wasn't true."[41]

Most people told de la Fressange that she was making a terrible mistake, that she would be quickly forgotten if she left Chanel. But she was convinced that it was time to move on (in 1991, she started her own house, for which she designed, and has not looked back). "He started saying horrible things in the press about Marianne, like an angry little boy," de la Fressange explained. "I was too young to understand the psychology of it. But he felt like he was being abandoned and reacted like a hurt child."[42]

At the same time, in those weeks and months during 1989, there was a grave issue in Karl's life, one that definitely impacted his frame of mind: Jacques de Bascher was dying.

Five years before, in 1984, de Bascher had found out that he was HIV positive (it was the same year that the actor Gérard Falconetti had the same news and jumped to his death). De Bascher shared the news only with Karl. Initially, they carried on as before.

Karl's relationship with de Bascher was not hidden—in the German newsweekly *Stern*, the magazine identified the Helmut Newton portrait of Karl and de Bascher as a photo of Karl and his partner.[43] De Bascher continued to spend time at his family château, staying in his childhood room. His mother, who learned that her son was sick in 1987, preferred not to say the term, calling it only "that nasty disease."[44] Although de Bascher was less social than before, not going out as much, not accepting as many dinner invitations, he did not hide himself away. He made the rounds to Chanel and Lagerfeld and was often at major events in Karl's life.

In 1987, he went to the grand fashion awards ceremony, meant to be like the fashion Oscars, held in the Paris Opéra. Wearing a sharply tailored

tuxedo, de Bascher was seated a few seats away from Karl, directly behind Audrey Hepburn and Hubert de Givenchy. Only thirty-five, he had aged considerably since his diagnosis.[45] In July, he was backstage at the Chanel haute couture show, wearing a striped suit and a jaunty straw boater. "It's in the *air du temps*," he said of the collection, inspired by the Lully opera. "It is about capriciousness, game playing, and, of course, Karl's great sense of humor."[46] Though his mustache was more substantial, de Bascher was noticeably thinner.

By 1988, he had that look that was becoming so familiar: where he had once been trim, he had become gaunt, with his cheekbones protruding and his eyes hollowing out. He was photographed seated at home, his legs crossed, his handsome face in profile with a determined smile. He was dressed elegantly in white pants and a black satin jacket, and he held a walking stick across his lap. All of the makeup—and he was wearing a lot—and a look of determination could not conceal the fact that he was sick. It was a portrait that Karl kept close to him.[47]

Karl made sure that de Bascher had access to excellent medical care. By 1988, he entered the Hôpital Bichat, or the Hôpital Raymond-Poincaré, in Garches, west of Paris. Karl arranged his schedule so that he was able to spend as much time as possible at the hospital.

Diane de Beauvau-Craon, who had a full life of her own, had seen less of Karl and de Bascher for some time. Like almost everyone else, she did not know that he was sick. One evening in Paris, she received a call from de Bascher's mother, Armelle de Bascher. "Listen, Diane, Jacques is asking for you—he is in the Bichat Hospital in Garches." The following day at 2:00 p.m., as soon as visiting hours began, de Beauvau-Craon was at the hospital. "Karl was there, of course, next to Jacques's bed," de Beauvau-Craon recalled. "And from that moment, Karl and I began a continuous relay, to make sure that one of us or both of us were always there with Jacques."[48]

In 1989, there was still a great deal of fear about AIDS and uncertainty about transmission. "When I first arrived at the hospital, they told

me that I had to put on a plastic cap, plastic over my shoes, gloves, and a mask," de Beauvau-Craon remembered. "They wanted me to be like a cosmonaut. I refused and had to sign like a dozen documents confirming that I would not hold the hospital legally responsible."[49]

For one holiday weekend, de Bascher wanted to have a break. Karl had to be out of Paris for work, so de Beauvau-Craon organized to take him back to the rue de Rivoli, with its exceptional view out over the Tuileries. His lungs were weak by that point, however, and, once they were there, he needed more oxygen. De Beauvau-Craon called a friend, Dr. Jacques Leibowitch, who was one of the world's leading AIDS researchers (he played a key role in identifying the virus in 1982, and would go on to be the first to develop tri-therapy treatments).[50] They arranged for an ambulance to take de Bascher back to the hospital in Garches, where, coincidentally, Leibowitch had his research lab and began to help oversee his treatment.[51]

By the spring of 1989, de Bascher's health was precarious. He had become skeletal. "If you gain back three kilos [seven pounds] by the end of the month, I'll get you an Aston Martin," Karl said, trying to buck up his spirits.[52]

For everyone around him, those months were difficult. "There were moments that were just excruciating for Jacques, with cries of pain, tears, and fits of rage," said de Beauvau-Craon. "It was incredibly painful. But, at the same time, there was something beautiful about it—to be with someone you know is dying and to be able to tell them that you love them, and to see the hope in their eyes, is one of the greatest gifts in the world."[53]

Karl and de Beauvau-Craon planned another outing for de Bascher, a three-day weekend at Le Mée-sur-Seine, Karl's latest country house, south of Paris. They discussed it with him for weeks, working with the hospital to secure the necessary authorizations. "We wanted it to be a weekend when Karl could be there the whole time," she recalled. "Karl made sure that it was organized beautifully. In the days leading up to the weekend, Jacques started to panic, worrying about what might happen."

De Bascher left the hospital in an ambulance, with Karl and de Beauvau-Craon and her young son, whom de Bascher wanted to meet, in the car behind. "It was a three-day weekend that ended up lasting only 24 hours. Jacques asked to be taken back to the hospital. He never left again."[54]

Karl spent the last few nights sleeping in de Bascher's room, on a military cot that the hospital had provided. "It was just atrocious," he later recalled. "I don't ever want to go through something like that again. But I did it for Jacques, to be there for him."[55]

On September 3, 1989, in the hospital in Garches, Jacques de Bascher died. It was not long after he had turned thirty-eight (and the week before Karl's fifty-sixth birthday). Karl, de Beauvau-Craon, and Armelle de Bascher were with him in his room. He died in Karl's arms.[56]

For Karl, always so reluctant to discuss death or illness, it was striking that he was so determined to be there for de Bascher. "Jacques was always very 'no future,' like you can be when you are 20 or 30 years old," Karl confided to de Bascher's biographer in 2017, with tears in his eyes. "He always thought that he would die early. But when it was time, he didn't want to. He would have preferred a more sophisticated way of dying—he practically decomposed alive, in front of our eyes. It was terrible—worse than terrible."[57]

De Bascher's ashes were divided, half for Jacques's mother, half for Karl.[58]

In the time afterward, Karl and de Beauvau-Craon stayed close. "Karl and I supported one another," she said. "I hope, at least, that I supported Karl because it was devastating for him. He was never the same after—never!"[59]

Sophie de Langlade worked closely with Karl for many years, first at Chanel, then at Karl Lagerfeld. "The death of Jacques was the worst thing in Karl's life," she recalled three decades later. "Even so, he remained completely composed. We had a fitting that day, and Karl was there at 5:00 p.m. It was upsetting for us, because we knew Jacques well, but Karl kept it together, as though nothing had happened."[60]

There was no letup in his work schedule, no pause in the relentless

rhythm of fashion. "If he did not show his emotions, it was not because he didn't have them," said Caroline Lebar, who also worked with Karl at Lagerfeld. "He just chose not to show them out of respect to others."[61]

There were times when Karl spoke about his sense of loss. "He was the only thing that gave a kind of sense to things," Karl explained three years after de Bascher had died. "He brought to my life a kind of sparkle nobody else ever will. Maybe there is one person in life for you and that's all."[62]

In the early part of the decade, Karl began to replace his perfectly tailored bankers' suits and conservative ties with baggy black ensembles by Japanese designers. His weight had often gone up and down, but by the early 1990s he started to gain weight and to keep it on. Many would not have known, and Karl certainly never put it this directly, but he was in mourning.

In 1991, when he was fifty-eight years old, Karl was asked by *Vanity Fair* writer Maureen Orth if he had reached the point in life when he was content. "Happiness, in my sense, doesn't say anything," he replied. "The only person I really cared for died, so—*poof*—I don't care."[63]

19

SHIFTING GEARS

Essentially, I am a Calvinist attracted to superficiality. My obsession is to survive.[1]

KARL NEVER FULLY RECOVERED from the loss of Jacques de Bascher. He would never have another important sentimental attachment—until Choupette—and even at the end of his life, he was still emotional when discussing the loss. Yet, in some key ways in the back-to-back episodes, the break with Ines de la Fressange and the death of Jacques de Bascher, Karl simply turned the page.

Several months after the rupture with de la Fressange, and just days after de Bascher died, he picked up a copy of British *Vogue*. On the cover was a young blond woman, photographed by Herb Ritts, shot from the side, with an ivory taffeta wrap, big jeweled earrings, and her long blond hair piled high with curls tumbling down. Inside was the magazine's haute couture story for fall. The model was shown lounging in Chanel in a suite at Le Meurice and being driven around Paris, dodging paparazzi, on the back of a Harley-Davidson in Christian Lacroix. "Very shortly afterward, I received a call from Karl Lagerfeld, asking me to meet him at Chanel's headquarters on the rue Cambon," recalled that model, Claudia Schiffer, who was eighteen years old at the time. "That's when my career for Chanel began."[2]

Karl immediately sensed that Schiffer had that little something extra that set her apart from other models. The image that he had been building for Chanel for seven years seemed to change overnight. De la

Fressange—with her dark-haired French aristocratic insouciance—was out and Schiffer—with her towering blond Teutonic youth—was very much in.

"Before I knew it, I was being fitted for his new collection and then, the next day, I found myself driving to Deauville to shoot my first Chanel campaign, photographed by Karl," Schiffer recalled. For the 1990 Spring/Summer Ready-to-Wear campaign, Karl shot her looking angelic in white, surrounded by television cameras, and standing on the beach of Deauville.[3] "I remember us bonding over the fact that we were the only two people full of energy at 3:00 a.m."[4]

The new relationship between designer and model went public in January 1990, for the Chanel Spring/Summer Haute Couture Collection. In the first runway appearance she had ever made, Schiffer wore a long white halter top with a lace minidress, long gloves in black and white polka dots, and a white straw boater hat wrapped with a black bow. Standing six feet tall, before heels, with long golden hair and a broad smile, she looked for all the world like a young Brigitte Bardot.

As a young model who had only ever been photographed, she was nervous about her first show. "Karl said to me, 'Don't think about it—just walk out like you always walk.'"[5] Compared with the otherworldly creatures who stalked the runway, Schiffer did appear a little rough. "Some people said that she didn't know how to walk but that was irrelevant," Karl pointed out. "When you have her face and her charisma, it doesn't matter how you walk—that can always be taught."[6]

Karl and Schiffer would go on to have one of the longest, most productive collaborations in fashion history. She walked innumerable runways for him, was photographed by him for a seemingly endless number of fashion stories, and starred in sixteen advertising campaigns, more than any other model. "Karl was my magic dust," Schiffer said. "He transformed me from a shy German girl into a supermodel."[7]

The pair did have some dustups. One year after her debut, in January 1991, at the start of the Gulf War, Schiffer felt that the conflict made it unsafe to travel to Paris. Karl lashed out. "She's from Düsseldorf and

she's afraid of terrorists?" he said. "There is no excuse for stupidity like that. All the other models came. It's a shame because she was a girl I liked very much." Mischievously, Karl went on to build up another top model, who had just dyed her hair blond. "The most famous of all— Linda Evangelista—was there."[8]

Their spat was soon forgotten, however—star power was more important to Karl than one missed season. By that fall, he was back to working with Schiffer and extolling her virtues. "When we were shooting in Monte Carlo, teenagers were waiting in the street for Claudia Schiffer's autograph. I asked them why and they said, 'Because she is the most beautiful girl in the world and we all want to look like her.' I never hear a girl tell me that she wants to look like Adjani or even Deneuve."[9]

Four years after they had met, in October 1994 at the end of Paris Fashion Week, Karl asked Schiffer to join him for a talk on creativity at the Sorbonne. The setting was the university's Grand Amphithéâtre, a massive, historic auditorium, under a dome, with wooden benches that seat an audience of one thousand.[10]

Karl wore a shapeless black suit, a white dress shirt, and a wide black tie. His fan was black with gold embellishments. The host was Guillaume Durand, a noted French television journalist. An hour before the talk was scheduled to begin, hundreds of Sorbonne students stormed the auditorium to protest a lack of classroom space.

"Professional provocateur that you are, you must be delighted," the host said to Karl.

"I don't see myself as a provocateur—that is not at all what I am about," Karl said. "It can often seem that way because what seems normal for me is not normal for others, so that can lead to a kind of tension. But these students are really great—we had a nice time together outside, talking and laughing. I understand their issues and hope that it works out for everyone."

Durand kicked off the presentation by bringing out a small painting, reminding the audience of Karl's fascination for the eighteenth century, and asking students for guesses about the canvas. After a few incorrect answers he turned to the designer. "My dear Karl, concentrate . . ."

"I saw it earlier, so I was able to study the iconography. It is the Virgin Mary, the marriage of the Virgin, I assume—is that an ironic allusion to my relationship with Chanel?"

"Perhaps," said the host.

"Well, it is a French painting, seventeenth century—I would say Corneille or something like that—possibly his nephew."

"Suspense," Durand said, as he had the identification brought to him. "I swear that I did not say anything to Karl, but it is the *Marriage of the Virgin* by Michel Corneille (1601–1664)."

Karl sat there in the auditorium, sipping his Coca-Cola, in front of a full house, having a wide-ranging conversation about fashion, art, and image. The interviewer brought out a pair of black rubber boots, like Wellies, with the Chanel logo stamped on the top. He asked about the contradiction between someone who knew everything about the French eighteenth century and something as common as a pair of rubber rain boots.

"You can't just live in a world that is super sophisticated and spiritual," Karl explained. "There has to be something more down-to-earth and I like the mix of the two."[11]

After showing a selection of footage from recent Chanel shows and asking for Karl's comments, the host began to introduce Schiffer. "We are going to welcome to the stage someone who is known by everyone in the world." He asked Karl about Schiffer's first runway appearance, and what role she was to have played.

"The same that she has played very well since. She had an aura and a personality that made it clear from the beginning that she was a natural star."

"And how has she changed in the past few years?"

"She has become more comfortable and she has become even more beautiful. And now she walks better than everyone else."

Schiffer then took to the stage, wearing a sexy black Chanel jumpsuit, sleeveless, with a single black and white camellia on her sternum. Her blond hair was long and loose. She was asked about Karl, "A genius,"

and about the incredible ascension she had since her first show, "I have worked a lot."

One student asked Karl if she had become so visible that she over-shadowed the house. "Do you go to a Chanel show to see the collection or to see Claudia Schiffer?"

"I think both," Karl replied. "Claudia does many other shows—she is not exclusive to Chanel. Claudia is Claudia. If people come for her, that's fine. But there are 35 other models and what I love is the mix of everything: the models, the clothes, the spirit, the music—it is all of it together."[12]

Music had been an essential part of Karl's life since he was a boy. And it was a key element of his work as a designer—he used it to provide a sense of adrenaline for his shows. For the past two decades, Jacques de Bascher had helped Karl know what was happening on the musical scene. De Bascher was gone, so, enter Paris DJ Michel Gaubert.

Karl had known Gaubert since the 1970s, when they would run into each other at Le Sept. By the end of that decade, Gaubert was managing Champs Disques, a legendary music store on the Champs-Élysées. It was the best place in Paris to track down the latest vinyl imports from London and the United States. Karl and de Bascher were big clients of Champs Disques, particularly once the Karl Lagerfeld headquarters were just up the street. Gaubert would recommend music to de Bascher and Karl, who would often send his driver, Brahim, to pick up the latest purchases (de Bascher would also slip in some cassettes of the latest porn films). "So, we got to know one another better," Michel Gaubert recalled. "And it was Jacques who had more or less taken care of the music for Karl's shows. He may not have done all of the technical work but he had a very artistic feel for music. In September 1989, after Jacques died, Eric Wright came to see me at Champs Disques and asked if I would do the music for the show."[13]

Gaubert's first major runway show was for Karl Lagerfeld in October 1989. Karl told him that he was inspired by Malcolm McLaren's *Waltz Darling*, an album that included Willi Ninja's "Deep in Vogue." Gaubert used that album as a starting-off point. He also did the music for the January 1990 Chanel Haute Couture, Claudia Schiffer's debut. For the March Ready-to-Wear, Gaubert worked again on the Lagerfeld show. Not having heard anything from Chanel, he assumed they had found someone else. "The night before the Chanel show, just by chance, I was walking along the rue Cambon and saw everyone upstairs working," he said. "I had finished my little week of fashion, so I go home, go to bed, and, because I really wanted to have a good night's sleep, take a sleeping pill."[14]

An hour later, the phone rang: it was Karl. "Listen, Michel, I'm here with Diane de Beauvau-Craon, we just heard the music they have planned for the show, and it's terrible," Karl told Gaubert. "You have to save my life and do the music—the show is tomorrow morning!"[15]

Gaubert downed loads of coffee and got to work. He took what he had come up with to Diane de Beauvau-Craon's apartment, arriving there about 4:00 a.m. "So, that was the beginning of my time with Chanel," Gaubert explained. "It's a story that says a lot about Karl. He knew exactly what people could bring him, what other people could do well, and he liked taking risks. He was a gambler, in that way—he wasn't afraid to take a chance."[16]

Michel Gaubert went on to do every major fashion show for Karl—Chanel, Lagerfeld, and Fendi—for the next thirty years. In the rarefied circle of fashion DJs, or sound designers, he has been one of the best and most original in the world. In addition to Karl, he has worked with such leading designers as Nicolas Ghesquière at Louis Vuitton, Raf Simons at Calvin Klein, and Phoebe Philo at Céline. The trendy London magazine *i-D* dubbed him "The Monarch of Music."[17]

In all of their time working together, Gaubert understood what mattered in Karl's relationship with music. "He always wanted to listen to the latest, not because it was good, necessarily, but because it was new.

When I said to Karl, 'This is something new,' it was, *bam*! He was immediately interested."[18]

Gaubert and Karl would go to concerts together, including French rocker Johnny Hallyday at the Stade de France, new folk singer Devendra Banhart at L'Olympia, and Prince in the great hall of the Grand Palais (which the singer chose to do after falling in love with the space when he was there for a Chanel show). Gaubert also loaded up iPods with all the latest music. "Michel makes me listen to everything," Karl said in 2006. "I have like 60 iPods and I love having them filled with every kind of unexpected music—I don't even know what is going to be on there and that's ideal."[19]

Gaubert quickly learned that Karl wanted the soundtrack to be exuberant. "He hated slow music for shows," Gaubert recalled. "He always said, 'I don't want runway glue!'" Although he employed snippets of catchy dialogue and a great variety of music, the defining quality of the sound for Karl was buoyancy. "Sometimes the music was extreme, sometimes it was ironic, but it was always joyful, up, and glam."[20]

By the start of the 1990s, Karl was responsible for some fifteen collections per year at Chanel, Fendi, and Lagerfeld. His fragrance business, a joint venture with Elizabeth Arden—for the scents Lagerfeld, KL, KL Homme, and Chloé—produced some $100 million in annual revenue. A new fragrance for 1992, Lagerfeld Photo, was expected to make $35 million in its first year. It was estimated that Karl's annual salary at that time was $5 million (or over $10 million today).[21]

In 1991, Karl moved into the main part of the Hôtel Pozzo di Borgo. It was the spectacular central wing of the town house, the first and second floor, including a massive walled garden behind. The entrance hall was double height, with a black-and-white floor and a large marble staircase with an ornate wrought iron banister and brass railing. The upstairs

rooms were lined up in a row, *en enfilade*, with views onto the courtyard or the back garden.

Karl filled the rue de l'Université with a museum-quality collection of paintings, sculpture, furniture, tapestries, and objects. "He was not necessarily looking for the most lavish or important pieces but for those that had the most character or were the most expressive," suggested Alexandre Pradère, a leading expert on the French eighteenth century. "It was a living lesson of style, from Rococo to Neoclassicism."[22]

It was also a place of work for Karl. He had his studio off his bedroom, where he would spend his mornings drawing. Off the kitchen was a dining room with a large round table, for meals and for work sessions, surrounded by floor-to-ceiling cases with books. And he turned one large salon that looked north onto the courtyard into a photo studio.

It was all impeccable, of course. "Karl had the great taste of the 18th century, in both furniture, paintings, and objects, right down to the china and the silverware," Diane de Beauvau-Craon recalled. "But it was a little like a museum. There were flowers everywhere—it was tremendously beautiful—but it felt to me that it was missing the magic of life. It was like a magnificent set."[23]

De Beauvau-Craon felt that Karl's private quarters were the best spaces in the house. "The most intimate place was certainly his bedroom," she explained. "Very few people were allowed to see it."[24] On the wall, Karl kept that painting of the round table by Adolph Menzel that had kick-started his interest in the eighteenth century. Tables and dressers had photos of de Bascher in gleaming silver frames.

In his new apartments, Karl worked on a project that incorporated so much of his life: his skill at illustration, his knowledge of historical fashion, and his fascination with the life of aristocracies. It was also a wry reflection on the reality of his daily existence, that he had, by that point,

swirling around him a cast of friends and coworkers and staff that could feel like a collection of courtiers vying for the favor of a king.

In 1992, Karl published his version of *The Emperor's New Clothes*, Hans Christian Andersen's tale of falseness and fashion.[25] Karl spent several years on the illustrations, beginning at his country house in Le Mée-sur-Seine, when Jacques de Bascher was still alive, and finishing in his own regal splendor on the rue de l'Université. The colorful drawings were executed in ink, felt pen, grease pencil, and makeup. The chance to tell the story of a ruler deceived by his own vanity clearly delighted Karl.

The book is housed in a case covered with details of the poor emperor's world: a jeweled crown, a golden hand mirror, tall wigs, ceremonial broaches, ribbons and bows, scissors, opera glasses, high-heeled shoes, and a red-and-white-striped hat box from Rose Bertin, the dressmaker for Marie-Antoinette. A bookmark is attached to the volume, a red ribbon with, at the end, a pair of gold scissors.

The opening drawings show the emperor in a variety of extravagant ensembles, on a walkabout with an embroidered waistcoat with frilly sleeves and a feathered fan while an obsequious attendant hovers over him with a parasol, appearing at the theater in fancy dress with his soaring wig covered with plumes, or strolling through a formal French garden in a floor-sweeping purple coat bordered with white fur, while a trio of subjects bow down in reverence. The drawing of the security guard the emperor had outside his dressing room positioned him in front of gilded white paneling, a large marble fireplace, and a massive mirror, a room that looked exactly like the salons of Karl's apartment.

Two swindlers arrive at the palace, weavers who promise to work with invisible thread, producing garments so exquisite that they cannot be seen by the human eye. Of course, the emperor orders a complete wardrobe, spending more and more money as the process is dragged out. Assured by his court that the result is particularly beautiful, he prepares to wear his new wardrobe for a procession. The designers arrive, pretending to hold up new garments. "'Will your Imperial Majesty be graciously pleased to take off your clothes,'

said the imposters, 'so that we may put on the new ones, along here before the great mirror.'"

Suitably unclothed, he leaves for the royal procession, with two chamberlains behind him, pretending to carry the train of his magnificent, invisible robe. Everyone acts as if the emperor is impeccable—his court, his attendants, and the public—until a child finally blurts out, "But he has got nothing on!" Karl captures the scene with, on the left page, a young boy pointing, and, on the right, the emperor standing on the red carpet with his crown, scepter, sash, and little else, surrounded by his duplicitous courtiers and with a huge crowd lined up behind him, staring.

The public, initially terrified by what the boy has said, begins to join in: "But he has nothing on!" The emperor realizes the truth but steels himself and continues on, with the chamberlains continuing to hold up the invisible train. A full-page drawing shows a satisfied public, in their moment of honesty.

Karl, though, came up with a sharp little kicker. The image on the final page is a small circular drawing showing the two tailors sneaking away from the palace, holding a bag of gold.[26]

GENTLEMEN CALLERS

For me, sex has never been particularly interesting. I always thought that it was something like a sporting activity for the young. I'm an authentic puritan.[1]

FOR SOMEONE SURROUNDED BY so much beauty, male and female, clothed and unclothed, Karl could be something of a prude. There were many in Paris fashion who were militant in terms of their sexuality: Jean Paul Gaultier, Thierry Mugler, and Alexander McQueen, for example. And Pierre Bergé was a committed AIDS activist. Karl was not the kind to bang the drum for a cause but he was, at the same time, a gay man who was certainly interested in attractive men.

In the mid-'90s, Karl made a trip to New York and went for a night out on the town with Patrick McCarthy, the influential successor to John Fairchild at Fairchild Publications. McCarthy would be named, in 1997, the chairman and editorial director of *W* and *WWD*.

McCarthy had begun his career in the 1970s in an unpromising way, with the Fairchild bureau in Washington, DC, then was promoted to London. An excellent reporter and outstanding editor, he quickly became Mr. Fairchild's dauphin. In 1980, he was named Paris bureau chief. If he was not as capricious as Mr. Fairchild, who embarked on legendary fashion feuds with designers from Geoffrey Beene to Azzedine Alaïa, he could be just as competitive about exclusives and equally relentless if denied. The title of a cover story in *New York* magazine on his ascension: "The McCarthy Era." As he told the journalist Michael

Gross, "No one else could get the story, and if anyone else got the story, someone had to pay!" pounding his hands on the table to punctuate each word. "You can't make the *New York Times* pay, so make the poor little designer pay—or the big rich designer. Mr. Fairchild instilled it in me. I'm like the abused child that is now abusing. I will kill for the story, and if I don't have it, I will get angry."[2]

Suffice it to say, Patrick McCarthy was a piece of work. He had known Karl since 1980, when he moved to Paris. "We bonded immediately," he said of the designer. The feeling was certainly mutual. McCarthy was one of the handful of editors with whom Karl maintained a close personal friendship. As he said of McCarthy, "He has wit, great talent, and is a marvelous friend."[3]

The editor was discreet about his sexuality, although he was not closeted. He favored bridge games with Upper East Side grandes dames to slumming it in nightclubs. In choosing where to take Karl on his trip to New York, however, McCarthy decided to be adventurous. They headed to the Gaiety, a notorious strip club, just off Times Square, at a time when the entire neighborhood was still very seedy.

The Gaiety was at 201 West Forty-Sixth Street, just west of Broadway. It was marked by a canopy on the side street, behind the Howard Johnson's, the orange-and-white restaurant that held the corner for decades. Three plate glass windows above the restaurant's flashing neon sign were blocked by huge photos of male dancers wearing black pants and vests and carrying top hats and canes. A sign read, "Gaiety: The Best in Male Burlesk [*sic*]." In 2005, when both Howard Johnson's and the Gaiety were closed, the headline in the *New York Times* was, "Quietly, a Bawdy Gay Beacon Goes Dark."[4]

The entrance to the club was marked by a few steps up off the street, then a steep staircase that went upstairs. The entrance kiosk was usually guarded by an older woman, who pushed open a slot to take the $17 admission fee, good for an all-day pass for the shows.[5] "This was a glorious smarm palace in the heart of Times Square that survived for decades, even after Madonna immortalized it in her saucy *Sex* book," was the

description of the Gaiety by New York nightlife writer Michael Musto. "The first time I went, I sat witness to the grinding of various 'male dancers' on a rinky-dink stage, only to find that the audience weirdly cleared out the second the show was over as if a bomb had dropped. I later found out that all of the old men had run backstage to negotiate 'dates' with the 'stars' right there on the spot. Ah, the old Times Square—how magical it was."[6]

Madonna's book *Sex* and her video *Erotica*, both from 1992, brought a certain amount of mainstream attention to the club—prints of some of the photos, by Steven Meisel, hung inside on the walls. Well-known visitors, besides Madonna, included Andy Warhol, John Waters, Divine, fashion insiders like Susanne Bartsch, and makeup artist François Nars.

The theater of the Gaiety had a stage with a proscenium arch, a red velvet curtain, and a runway that extended into the audience. Dancers appeared in skimpy costumes until, in most cases, stripping down to nothing and ending their performance with a demonstration of a full erection. To the left of the stage was a lounge, where bowls of chips were served and the dancers could mingle with customers. A couple of vending machines offered drinks and snacks. One regular at the Gaiety, when asked if it was true that some performers would leave with clients for money, said, "That was the whole point, dear!"[7]

There were other spots in Times Square that were raunchier. Both Stella's, on West Forty-Seventh Street, and Tricks, on West Forty-Ninth, attracted rougher crowds—performers and customers. The Gaiety, with its crews of rotating performers, which changed every Monday, many from Brazil or Montreal, seemed, in comparison, almost upscale. But it still had an edge. And for Karl, it was not a normal evening outing. It was bold of him to head out there with McCarthy—he certainly did not go to places like that in Paris.

When leaving, Karl and McCarthy made their way back down the stairs and onto Forty-Sixth Street. A driver had waited outside while they were in the club. As they made it onto the street, a young Black man happened to be walking by, "a fast-thinking New York queen," was

McCarthy's description. As soon as he saw Karl, he let out a theatrical gasp and shrieked, "*What would Coco say?*"[8]

In the mid-'90s, in the very specific world of French gay pornography, a new director, Jean-Noël René Clair, was making waves. Instead of sleek Hollywood productions with well-known porn stars, he went for low-budget videos, often starring amateur performers from Eastern Europe, France, or North Africa. Some of his hits included *Légionnaires 1* and *Légionnaires 2*—meant to be members of the French Foreign Legion—*Pompiers 1* and *Pompiers 2*—with French firemen—and, the self-explanatory, *U.S.S.R.*

In the realm of pornography, they were pretty mild. Often, the performers, presumably straight, were simply solo. In others, like for the legionnaire series, the sets—supposed to be a barracks—and costumes— uniforms and berets—did a lot of the work.

There were stories that Clair's next production, *Studio Beurs*, would focus on talent from Morocco, Algeria, and Tunisia. It was a project that, within a certain community, was highly anticipated.

André Leon Talley had taken to going to a little porn shop on the Place de Clichy to buy two copies of each of Clair's films. He would keep one for himself and pass along the other to Karl. When I mentioned this to a friend, he preferred not to hear any details. "I'm not getting involved in your Karl-André porn circle!"

In 1996, I mentioned to Talley an announcement I had seen that *Studio Beurs* was going to be released later that summer. His reply: "I am sorry but, right now, on the Place de Clichy, *Studio Beurs* is available for your viewing pleasure!"

Karl's reaction to the films was very much in character. Instead of focusing on the casting or the sex, he trotted out a reference to French cinema. He made a comparison between the porn director, Jean-Noël René Clair, and René Clair, an esteemed director of such sparkling 1930s

films as *Sous les toits de Paris*, *Le Million*, and *À Nous la liberté*. "Well," Karl said of the porn videos, "in terms of production values, they're not exactly René Clair, are they?"

In April 1996, I went with Karl and a few members of his team, including his partner in photography Éric Pfrunder, to the remarkable neoclassical house that he had bought in Hamburg. After spending years renovating and refurnishing the property, Karl christened it the Villa Jako, his nickname for Jacques de Bascher. So, the house became, in fact, a shrine to de Bascher.

It was also Karl's homecoming to Hamburg, in the same leafy neighborhood where he was born, Blankenese, with large houses on wooded properties overlooking the Elbe River. The Villa Jako was set in the middle of a large lawn with steps that went down to a reflecting pool. It was a two-story concrete cube with massive, fluted columns, oversized Palladian windows, and, on the four corners of the roof, sculptures of classical robed figures. The interior was built around a soaring central atrium lit by a skylight. Downstairs was a double-height living room and two additional rooms; upstairs were two bedrooms. Completed in 1922, it had been built for a shadowy owner, which appealed to Karl's love of mystery. "He lived there alone with six servants, so whether it was a party house, a place for a mistress, or an opium den, I don't know."[9]

The Villa Jako was a return to Germany after four decades but also to Karl's favorite period: the years of the Weimar Republic. The neoclassicism of the architecture came from the passion for ancient Greece and Rome held by some German intellectuals, including Walther Rathenau, the German Jewish industrialist and author that Karl and his mother had long appreciated. "All the people who built houses with this kind of mood don't exist anymore and there is not one private house like this left in Germany," Karl told me that day. "Walther Rathenau's house in Berlin

was just like this but he was killed by the Nazis. Because the family was Jewish, the Nazis sold all the furniture, so there was nothing left."[10]

In the salon, Karl had the walls reworked with gray faux marble, the marble pilasters outlined in gold, and in the center of the coffered ceiling, in shades of deep brown and blue, he placed a huge copper chandelier, Vienna Secession, that had originally been made for the lobby of a theater in Vienna. The walls of a library were covered in vertical stripes of gold and copper leaf, while the bathrooms were by Andrée Putman, sleek, modern spaces in white marble and stainless steel.

Karl furnished the house primarily with furniture and objects from the region where he had been born and raised. "For me, Northern Europe is the northern part of Germany—starting with Hamburg, Berlin in a way—Stockholm and Oslo," he explained. "It's all the same spirit."[11] At a Paris gallery, Éric Philippe, he found a grouping of 1920s bronze furniture and objects, known as Swedish Grace, and bought the entire exhibition. So many close friends of Karl, from Diane de Beauvau-Craon to Jacques Grange, felt that the Villa Jako was, of all of his houses, the most beautiful.

As soon as we had touched down in Hamburg, our group was met at the airport by three cars, two workmanlike vans and a big BMW sedan for Karl. We were whisked to the house, down a narrow drive, through a set of double gates, and to the front entrance. Parked in the courtyard was a big white moving van, filled with furniture and objects that Karl had acquired just for the house or had relocated from his various properties.

A team of three movers brought out pieces for Karl's approval: a clay statue of Neptune that had come from one of his places in Monaco, a monumental painting by eighteenth-century Swiss painter Henry Fuseli. The canvas was unloaded, hoisted on a series of straps, and carefully placed on top of a table. Karl decided it overwhelmed the room and had it sent back to the truck. "I love it," he said of the hive of activity. "This is my favorite thing to do in the world."[12]

As Karl was finishing the interior, I could not help but notice that one of the movers, a young man with dark hair and a tight body, looked to be particularly hot. He was straight, I assumed, but I had to tell Karl that I thought he was absurdly attractive. We gossiped about it a few times during the day—discreetly, I hope—and that was the end of that. I was flown back to Paris that night with a few members of Karl's team, while he spent the weekend in Hamburg to finish the house and to photograph it.

A few days later, at the office in Paris, I received a note from Karl. It was one of his beautiful cards, a rust-and-ivory envelope with a matching notecard. Inside on the left-hand side were three black-and-white photos: the mover. In one image, he wore a white sweater, in another he was shirtless, and in the third he sported only a pair of tight black-and-white underwear.

"The body was not too great," Karl wrote. "I have better bodies in other photos (I will show you). But some people may like this French boxer look."

Of course, Karl was being disingenuous. The whole thing was a flex on his part: we had discussed this guy and Karl was able to convince him to take off his clothes. It was not sexual—this was no #MeToo moment. Nor was it mean-spirited—and Karl's photo session produced beautiful prints that he gave to the mover. The whole episode was amusing, and the kind of troublemaking that Karl enjoyed.

It just so happened that, within three years, that young man, whose name was Sébastien Jondeau, would take on a tremendous importance in Karl's life. Jondeau, who was twenty-one years old at the time of the trip to the Villa Jako, was from a working-class neighborhood outside of Paris. He had been brought into Karl's orbit because his stepfather ran a moving company.

The first time Jondeau had been to 51, rue de l'Université, he was only fifteen years old. Like everyone, he was impressed. "It was like the Château de Versailles in the middle of Paris," Sébastien Jondeau said of that visit. "I was a kid from the suburbs, and, at that point, the only other building I knew that was like it was Versailles." Of course, also like

everyone, he had to be patient. "We waited for like four hours to do three things in like 10 minutes," Jondeau recalled. "But he spent time with us and he was super nice and then he gave us a huge tip, 500 francs (about $100). I had never seen that in my life."[13]

In 1994 and 1995, he did his compulsory French military service, then began working for Karl more regularly, often several times a week. Jondeau traveled between Karl's places in Paris, Le Mée, Monaco, and Hamburg. "We went wherever Karl wanted us to go. We would move furniture for a shoot or move things from one house to another."[14]

Jondeau and his stepfather's company also orchestrated the move to a new estate that Karl had bought in Biarritz, on La Côte Basque, in southwestern France, near the border with Spain. In November 1998, after a year of working on that move, the house, the Villa Elhorria, was finished. Jondeau and Karl were walking together on the property, heading back to the house, when he told Karl that he would like to work for him.

"Oh really? But you already work for your father's company."

"Yeah, but it's not my own thing."

"Oh, OK," Karl replied. "Why not?"

As a job interview, it was not the most substantial. But, one month later, Jondeau received a letter from Karl offering him a contract. There was already a driver, Monsieur Jouannet, who also acted as a bodyguard. In addition to being a furniture mover, Jondeau had been working security and doing a lot of boxing. "I think he wanted someone around him who was younger, dynamic," Jondeau said. "And he had seen me grow over the past few years. He knew that I could be fun, that I was a hard worker, that I knew how to keep my mouth shut, that I could be polite and discreet. I think he saw qualities that I didn't even know I had. He also liked people who were not afraid to be themselves but who weren't opportunists."[15]

Karl had bought a space at 7, rue de Lille, to open a bookstore, Librairie 7L, and, behind, a photo studio. "He stopped doing photography at rue de l'Université and started working in the studio on the rue de Lille. And it became my job to take care of the studio. When he was doing shoots in

the evening, Karl would say, 'Monsieur Jouannet, you can go ahead and go home—Sébastien will take me home.' So, that is how I started to become a driver, as well."[16]

Jondeau began taking on more responsibilities. "Karl would leave his place fairly late," he said of the daily routine in those years. "But when I arrived in the morning, there were all of these letters that he had written. I had a motorcycle, so I rode around town, left and right, delivering Karl's letters. I was to hand them to everyone personally—that was the ritual. Karl would have lunch at home alone, then we would leave at 3:00 p.m. or 4:00 p.m. to go to Karl Lagerfeld or Chanel. And then, if there was a photo session, we went to the rue de Lille, and stayed there until 2:00 or 3:00 a.m."[17]

Within a couple of years of their working together, Karl's life would take on immense proportions as he became one of the most famous people on the planet. And Sébastien Jondeau was very much a part of that ascension. Jondeau was with Karl at every public event. Backstage, after a show, he would be standing in a black suit, white shirt, and black tie, keeping an eye on Karl and the scrum of editors and well-wishers. His presence was certainly remarked on by the fashion crowd—impeccably dressed, gap-toothed French boxer bodyguards tend to be noticed.

Jondeau became Karl's driver, international traveling companion, and social secretary. He also modeled, appearing on runways for Chanel, Fendi, and Lagerfeld. In a very real way, he helped run Karl's life. He kept in close contact with all of the houses about his daily schedule, learned how to anticipate his needs, made sure that everything always went as smoothly as possible.

"Karl is the person I spent more time with than anyone else on earth," Jondeau said. "I spent more time with him than I did my own parents, with my mother, or with my own girlfriends. It is something that could seem strange but it's a reality."[18]

For two decades, the two had a beautiful, productive rapport. Though obviously different from the relationship with Jacques de Bascher, it was probably the most meaningful that Karl had had since. "It was an un-

usual situation because Karl wasn't my father, my brother, or my friend," Jondeau recalled. "And yet he was a friend, a brother, and a father. But he was also my boss, so we had a relationship that went beyond all of that, that encompassed so much."[19]

Karl's lawyer during those years, beginning in 2001, was Céline Degoulet. As the person who negotiated all of his contracts at the time when his career expanded exponentially, she was very much a part of Karl's inner circle. Maître Degoulet, therefore, was in a good position to know who was truly close with Karl and who might be the kind of person—so common around those who are famous—to suggest their relationship was more significant than it actually was.

"Karl could be completely relaxed with Sébastien," Céline Degoulet explained. "They had a relationship that was very intimate. You realize that Karl chose Sébastien to accompany him to his death, to be the only one who was with him as he was dying. Knowing Karl, he would not have done that with just anyone."[20]

21

HITS AND MISSES

I hate people in this business who stay stuck in a certain time
period and feel that the world has gone crazy. It's not that there
is something wrong with the world—it's just changing.[1]

THE MID- TO LATE 1990s were a time of unprecedented transformation
in Paris fashion. Massive luxury conglomerates were formed and then
jockeyed for position. Bernard Arnault's LVMH (or, to give its full, un-
wieldy name, LVMH Moët Hennessy Louis Vuitton), founded in 1987,
brought together a host of leading luxury brands: Louis Vuitton, Christian
Dior, Givenchy, Berluti, Kenzo, Guerlain, Céline, Loewe, Pucci, and by
the end of the decade, Fendi. The group founded by François Pinault,
Pinault-Printemps-Redoute, now Kering, went public in 1988 and, be-
ginning in the '90s, snapped up Gucci, Yves Saint Laurent, Balenciaga,
Bottega Veneta, and Alexander McQueen. Some did not cede to the ma-
nia for mergers and acquisitions: Chanel stayed private and independent.

But the presence of such powerful groups revolutionized the indus-
try. Flush with cash and marketing jargon, luxury groups brought in
international talent to try to revitalize houses in the way Karl had done
the decade before at Chanel. John Galliano was hired at Givenchy,
then switched to Christian Dior; Alexander McQueen was placed at
Givenchy, then funded to start his own house; Marc Jacobs was imported
from New York to launch a ready-to-wear line for Louis Vuitton; Nicolas
Ghesquière was placed at Balenciaga; and Michael Kors was brought to
Paris to design Céline.

Chloé had been acquired by the Swiss group Richemont (Cartier, Dunhill, Montblanc). After Martine Sitbon had spent four years designing Chloé, Karl returned to the house, from 1992 to 1997. When he left Chloé, he was replaced by twenty-five-year-old London designer Stella McCartney and her equally youthful assistant Phoebe Philo. "He's been abandoned by Chloé for a younger woman," was how it was put in the *New York Times*.[2]

This unprecedented game of musical chairs contributed to a new mood in design. John Galliano introduced an edgy kind of poetry into fashion and infused his presentations with theatricality. The English designer's 1994 Spring/Summer Ready-to-Wear Collection had slinky bias-cut dresses, impeccably cut pantsuits, and huge crinoline skirts as wide as the runway—they were Russian princesses fleeing the Revolution. In January 1996, Galliano staged his first haute couture show for Givenchy. "A seismic shift," declared the French daily *Libération*, "as though the Sex Pistols had given a concert on the lawn of Buckingham Palace."[3]

McQueen brought a London edge to Paris and a new kind of showmanship. When he unveiled his first show for Givenchy, in January 1997, it was in the same great hall of the École des Beaux-Arts that Karl had used for Chanel—except McQueen, for a collection inspired by mythology, sent out otherworldly creatures in gold and white with a soundtrack of hard-driving London club music mixed with arias by Maria Callas. He was one of the designers in Paris whose presentations achieved something like performance art.

Meanwhile, the Japanese avant-garde, led by Comme des Garçons and Yohji Yamamoto, along with a host of younger European designers, continued to push things forward. Martin Margiela was a force for mysterious, conceptual design; Ann Demeulemeester, with her rock 'n' roll chic, became the Patti Smith of fashion; while Helmut Lang introduced an edgy, intellectual minimalism.

In the midst of so much change, Karl was still very much a force, and incredibly prolific. For five years in the 1990s, he was responsible for

four distinct collections: Fendi, Chanel, Lagerfeld, and Chloé. That meant he was designing and staging at least ten major runway shows every year.

Facilitating matters somewhat, Karl's three Paris houses were clustered within a few blocks of each other: Lagerfeld had moved to the Place de la Madeleine, just down the street from the rue Cambon, while Chloé was on the rue du Faubourg Saint-Honoré. He would usually go to Lagerfeld after Chloé, meaning it could be midnight before he arrived. "And then we would have two hours of fittings," explained Caroline Lebar, who worked closely with him at Lagerfeld. "Many had been there since 9:30 a.m., and Karl appears with sausages and bites for all of us to share, and we're like a gang of teenagers, laughing, dancing. There were nights that were wild—that was a period that I really loved."[4]

But, because Karl was producing so much design, he was bound to have some disappointments. His work for Chloé was less inspiring than his first decades there, though he did create a new sense of excitement around the house (and he packed the runways with supermodels). Virginie Viard, whom Karl had brought with him from Chanel in 1992 to direct the studio at Chloé, felt the mood at all of Karl's houses in those years was exuberant. "The models were amazing: Christy (Turlington), Linda (Evangelista), Yasmin Le Bon, who would be with Duran Duran, Helena Christensen, and Michael Hutchence," Viard recalled. "When I was at Chloé, I remember going to a Chanel show, because we always went to all of his other shows, when Cindy Crawford was on the runway and Richard Gere was in the audience. It was electric, sparks flying everywhere, like something in a film."[5]

Viard also noticed in those years something else that many close friends of Karl realized: he could be awfully high-maintenance. "He required a *lot* of attention," Viard said with a laugh. "Before he was flying private, whenever we flew together, he managed to ruin entire trips because I always had to take care of him. 'What are you doing,' he would ask, 'are you sleeping?' Or, 'Oh, you're reclining your seat? I'm staying sitting up straight!' I mean, I took the Concorde with him and I don't

even remember it because it required so much work—like traveling with a little boy."[6]

At Karl's own label, along with management and ownership changes, there were bursts of creativity along with the occasional miss. In March 1994, at Lagerfeld, he unveiled what he called "Skin Dresses," sheer stretch tubes, usually in bright hues, that he used as a base for a variety of outfits. Unfortunately, they looked something like colorful condoms. "The idea is provocative but it needs work," suggested the *Times*.[7]

Of course, Karl was always capable of putting on a show. Chanel 1994 Spring/Summer Ready-to-Wear began with a rousing House version of "Dr. Love," a 1970s disco anthem by First Choice, and a veritable traffic jam of supermodels in vivid micro-miniskirts and matching jackets: Claudia Schiffer in pink, Helena Christensen in aqua, Nadja Auermann in lemon yellow, Carla Bruni in mint, Amber Valletta in peach, Cindy Crawford in black, Naomi Campbell in lavender. For the ending, a short snippet of a Carpenters song, "Sing," gave way to "Soul Finger" by the Bar-Kays, a blast of soul music. And out came one solid mass of top models in candy-colored short skirts and shorts with flouncy tops. "School is out and Chanel went to the top of the class," exclaimed Suzy Menkes in the *International Herald Tribune*. "A roar of joy from the photographers marked the effective end of a 12-day fashion marathon in Milan and Paris. Each season, you expect this to be Chanel's last stand, as its short suits finally get overtaken by the romantic fashion movement. But Lagerfeld manages to reinvent the style."[8]

In December 1993, a new model had appeared on the scene: Stella Tennant, a tall, pale, slightly androgynous English aristocrat. An art school graduate focusing on sculpture, Tennant had only reluctantly become a model, after being photographed by Steven Meisel for a series on cool London women in British *Vogue*. "I had done a few modeling jobs by that time and the agency sent me to see Karl in the studio with loads of

other girls," Stella Tennant recalled. "I was going around to see the whole of Paris in one week, like 30 different designers. And Karl booked me for that show. I had a nose ring—he was probably quite interested in that."[9]

Tennant had just pierced her navel and her septum, which had not been a standard look for high-fashion models. She also came from an impressive background: her grandfather was Andrew Cavendish, the Duke of Devonshire, and her grandmother was Deborah Cavendish, née Mitford, the youngest of the legendary Mitford sisters. Tennant was reluctant to focus too much on her lineage. "Everyone wants to write about me because my grandparents are titled, because I'm the granddaughter of the Duke and Duchess of Devonshire," she said at the time. "Sure, that's part of who I am—I mean, I love my family but that's not who I am. I grew up on a farm in Scotland." When the journalist David Colman of the *New York Times* asked what her family thought about her modeling, she answered, "Pass."[10]

Karl appreciated the fact that Tennant could bristle at too much talk about her heritage. "She's not glued to her background," he said of her appeal. "That's why she's great—she can be in the Gap or Chanel. Today, you have the Gap and couture. It's all the bourgeois mediocre stuff in between that's the problem."[11] He also understood how Tennant connected with the history of the house, given the founder's long association with Scotland, the English aristocracy, and British style (all those thick tweeds and luxurious cashmeres). "She is utterly modern and of the moment," Karl said of the model. "Yet she has an elegance and a style that is timeless, a little like Mademoiselle Chanel."[12]

Karl felt so strongly about Tennant that in 1996 he signed her to an exclusive contract for Chanel. Just as so many British designers were invading Paris fashion, Chanel, that quintessentially French house, was being represented by an English model. "It was very unusual to be under contract to them," Tennant recalled. "Suddenly I had a season of not being able to do any other shows because I was exclusively doing Chanel, which was kind of lovely. And then I continued to work closely with the house for the next 25 years."[13]

Over the decades, Tennant and Karl worked on a host of advertising campaigns, fashion shoots, and, of course, shows for all of his houses. Although they had a working relationship—designer and model, as well as photographer and model—they also developed a friendship. "I saw him through so many phases, from being rather overweight and a bit kind of frumpy to getting all skinny and being obsessed with Dior," she recalled with a laugh. Karl also became very friendly with her husband and her four children. "I think he rather admired that I was building quite a large family," she said of Karl. "One time, he said to me, 'If I had been a woman, I would have had six children!' And I thought, 'Really? It took you a long time to get a cat!'"[14]

Tennant also noticed a surprising aptitude that the designer had. "One thing about Karl which is quite spooky is that on three occasions, he noticed I was pregnant before I had told anybody," she said. "It is pretty weird because I was not showing at all—I knew I was pregnant but no one else did." When Tennant asked Karl how he could tell, he replied, "There is something that changes just around the eyes."

Tennant felt Karl's perceptiveness helped explain why he always wore sunglasses, that if he could read so much around people's eyes, he certainly did not want others doing the same. "And it was so surprising that he could be so in tune with nature," Tennant explained. "He was someone who was all about fashion and coming up with a good quip for the media—the PR machine that he was. But, actually, he had this incredible intuition."[15]

Not all of their interactions were so lofty. Tennant, like many who were close with him over the years, saw how much of a gossip Karl could be. "He was quite mischievous," she said. "He really liked to know all of the intrigues that might be happening."

Once, she happened to mention that Freja, a new Danish model he had started working with, was interesting.

"You know, she's a lesbian?" Karl said quickly.

"Oh, really? That's intriguing," Tennant replied.

"Yes! Would you like me to set you up?"[16]

In September 1996, I received a long letter from Karl about what was happening in his world at that moment. His energetic scrawl, in black ink, covered a full twelve pages. The scale of his life, at sixty-three years old, and the extent of his cross-cultural interests, was more substantial than ever. The stationery was ivory, with a border design Karl had drawn of black scalloped edges and little black dots. As for what he had been up to and what he had planned, it was *a lot*!

He had just returned, two days before, from a trip to Germany. In Cologne, he had received a major prize for his photography from the very serious—"too serious," Karl noted—German Society for Photography. "Irving Penn and Henri Cartier-Bresson had the prize before me, so some people were against it," Karl wrote. "In the end, I got it with 14 voices against one. After all, the winner of the Goncourt also never gets all the votes."[17]

His Cologne stay coincided with the opening of an exhibition of his photography, *Visionen*, at the Galerie Gmurzynska, a Zurich-based dealer of modern art. "They became famous 30 years ago for rediscovering the Russian Constructivist artists," Karl explained. The show consisted of twenty-one of his photographs, in spare frames in black or white, hung along the pristine white walls of the gallery, lit from above by skylights. The soft colors of the prints came from a special process developed by a nineteenth-century French chemist and photographer, Alphonse Poitevin. Karl felt that it was the most beautiful exhibition of his photography up to that point. "I was very happy because I fought more to be a decent photographer than to be a decent designer," Karl wrote. "And the fact of being a well-known designer was something that played against me as a photographer."[18]

He explained that he would be leaving the next day for Rome, to work with the Fendi family, then flying on to Tuscany, for the opening of the first Biennale of Florence, a citywide mix of art and fashion. At the Forte di Belvedere, in one of seven pavilions designed by Japanese architect Arata Isozaki, Karl was paired with the artist Tony Cragg, "a sculptor I

love," he explained. Karl also created a second installation for a section called *New Persona/New Universe*, held in the Stazione Leopolda, the historic Florence train station.[19] Also, over the summer, Karl had worked on illustrations for the various catalogs and books that would accompany the Biennale. "I have never worked so much in August," Karl wrote. "It was *divine!*"[20]

Karl's summer program, at a time when everyone else in France was on a monthlong holiday, had been packed. He had traveled to Deauville for a regular visit with Brigitte and Alain Wertheimer. He went to see his great friend Liliane de Rothschild, the collector and expert on the French eighteenth century, in her exceptional eighteenth-century château, L'abbaye de Royaumont, north of Paris. He did one hundred illustrations for a new edition of *The Allure of Chanel* by the French writer Paul Morand, a very personal look at the life of Mademoiselle, in her own words. "That was also great fun," Karl noted of his illustrations for the book. And he photographed Princess Caroline for *Harper's Bazaar*. "My 'client' *Vanity Fair* was not happy that *Bazaar* had Princess Caroline," Karl explained. "But it was her choice and I am a free person."[21]

Then, there was his work as a fashion designer—his day job, after all. He was getting ready for the spring shows that would take place in the next few weeks in Milan and Paris. "The rest of August and early September was spent with the preparation of the Lagerfeld, Chloé, Fendi and Chanel collections," Karl explained. An indication of how comfortable he had become on the rue Cambon: rather than spell out the name of Chanel, he just drew a pair of interlocking Cs.[22]

Two months later, on November 13, 1996, a relatively quiet Wednesday evening at the Paris office of Fairchild Publications, I received a fax that was practically shouting off of the page. The typeface was big, bold, and all caps. It was from André Leon Talley, who was back at his home in North Carolina. In order to make sure there would be

no questions about the significance of the missive, Talley's subject line read, URGENT, URGENT, URGENT, URGENT!

The message, in its entirety:

DEAR WILLIAM:

 PLEASE CALL ME AT ONCE.

 URGENT AND IMPORTANT NEWS.

 YOU SHOULD BE CALLING ME.

 THIS IS NEWS. GET ON THE BLOW!

ANDRÉ

That fall, the biggest topic of conversation in Paris was that John Galliano had been hired at Christian Dior and would be presenting his first collection for the house during the haute couture shows in January. Expectations were high. A question had arisen, however, about what was happening with one of Galliano's closest collaborators, The Right Honorable the Lady Harlech, to use her full title at that time.

Just a few weeks before, at the Chanel ready-to-wear show in October, Lady Harlech had been seated in the front row, wearing, conspicuously, a Chanel suit. After the show, Karl, surrounded by a big crowd, said loudly enough for all to hear, "If they don't give you what you want at Dior, I've got a great job for you."[23]

Harlech had been with Galliano since his 1984 graduate collection from Central Saint Martins. She was by his side in London, followed him to Paris, when they barely had the funds to keep the lights on, and then went with him to Givenchy, where, thanks to LVMH, it was practically raining money (certainly compared with the lean times that had come before). When the designer was hired by Dior, he was very well compensated, as were some members of his team. That did not seem to be the case with Harlech.

Talley was faxing that day to break the news that she had decided to leave Galliano in order to go work with Karl. So, he was right: in the world of high fashion, his news was a bombshell.

"Flight of a Muse" was the headline of the story I wrote for the next day's *WWD*. The rest of the piece was equally *dramatique*. "In what may be the biggest defection in Paris since Rudolf Nureyev leapt to freedom at Le Bourget airport, Lady Amanda Harlech is getting ready to move from John Galliano to Karl Lagerfeld," it announced. "Galliano's muse of a dozen years is close to taking a job in the design studio of Chanel."[24]

With her jet-black hair, porcelain skin, fine features, and light eyes that blazed with intelligence, Harlech was considered one of the best-dressed women in the world. She had been raised in London's Camden Town ("I was surrounded by writers, musicians, designers, journalists, poets, actors, directors, and just extraordinary, inspiring people").[25] She was a graduate of Oxford University, where she studied literature, with a particular interest in Henry James. In 1986, she married Francis Ormsby-Gore, the sixth Baron of Harlech. She divided her time between the Jacobean Hall in Harlech, North Wales, a romantic country house in Shropshire—where she raised her children, gardened, and rode horses—and the height of the fashion scenes in London and Paris.

The term *muse* is a nebulous one but Harlech and Galliano had been the closest of collaborators throughout the creative process, from the appearance of his first sketches to the way a set was styled. She had been a source of inspiration, proposing a theme or an idea to spark his creativity, and she often put his poetic intentions into words. "I see a captain, with lovers in two ports, one in Africa, the other in Spain," Harlech had said, to explain Galliano's fall 1995 show, combining influences from North Africa and Spain. "There will be some kind of tragedy, love letters will be discovered, and, as the collection progresses, their relationship will unravel."[26]

At the time she took the job with Karl, Harlech did not know him particularly well. They had first met a couple of years before, at 51, rue de l'Université. "I was with John, at one of those parties Karl gave at the end of Fashion Week," Amanda Harlech recalled. "It seemed that everyone was there: Tom Ford, Gianfranco Ferré, Valentino—and there was Shalom Harlow, Amber Valletta, Polly Mellen, Julien d'Ys—

photographers, makeup artists, everyone." It was the first time that Harlech had been in the same room with Karl and she was struck by his presence. "I had a feeling of fear, of awe," she recalled. "Because he radiated power and, always, the ability to see through everything. So, from that first meeting, my fear was, 'Do I live up to your expectations? What can you see in me?'"[27]

Once the news was public that Galliano was going to leave Dior, André Leon Talley told Karl that Harlech was not being looked out for. Her marriage was beginning to unravel—they would divorce in 1998—and she was responsible for raising their two young children. So, Karl invited Harlech to Paris, for a dinner he was giving at the rue de l'Université for Elton John. "This was something you had to get used to with Karl," she recalled. "Everything was wrapped up with filigree and gold. It was the most extraordinary invitation—he put me up at the Ritz. It was the whole thing—this idea that Karl could make fairy tales happen."[28]

She went to the dinner wearing a Galliano slip dress with large polka dots and a wig that she had borrowed from master hairstylist Odile Gilbert. "I hear you are having problems with Dior," Karl said to Harlech before dinner. "You know that I would love for you to work with me. But I absolutely respect your relationship with John and I would like to help you." He said that he would have a contract drawn up for Harlech to join Chanel, also suggesting that she could use that offer to show François Baufumé, the president of Christian Dior. "I did and there was a big explosion," Harlech said. "That kind of clinched it, really—Dior were absolutely furious. They thought there was a typing error!"[29]

It was a big decision, though, and Harlech hesitated. She discussed it with Anna Wintour, who did not mince words. "She said, 'Amanda, why don't you do something professional for the first time in your life? Look after yourself—go and work for Karl.'"[30]

The situation that Harlech found herself in could have seemed sexist—male designers who did such a good job of looking out for themselves did not seem to be so attentive to the women who had helped make them. When Alexander McQueen was hired by Givenchy, his

close collaborator, extravagant English aristocrat Isabella Blow, was also not brought aboard. ("Once the deals started happening, she fell by the wayside," said Blow's close friend Daphne Guinness. "Everybody else got contracts—she got a free dress.")[31] Harlech felt that the issue was more of a professional misunderstanding. "That role, what would now be termed a fashion consultant, or art director, was not clear at the time," she explained. "There was the designer, the head of the design studio, and that was it. Now, it is completely different—it is all about the creatives in the studio, offering ideas to the designer, who works much as artists worked in the past, where they would have other artists contributing to their work."[32]

Harlech began working in the Chanel studio, along with Gilles Dufour and Victoire de Castellane, making for a particularly high-voltage group. Karl and Harlech spent a lot of time together, at the Chanel studio, at public events, and in private. "He was excited that there was someone sitting waiting for him to have lunch at his house at 51, who's reading Rilke," she pointed out. "He was thrilled to have found somebody that wasn't only about clothes, but was also about a painting, a color, a poem, a novel, a moment in history. He showed me a photograph that he had taken of a lily with its throat filled with snow and I found that deeply moving, just like he did."[33]

Karl was clear that they connected on an intellectual level. "She has a modern approach coupled with a deep cultural background," he explained at the time, though he also could have been describing himself. "That combination is the only thing that can really last in fashion."[34]

When the 1997 Spring/Summer Haute Couture Collections were held, in January of that year, there was a greater sense of anticipation around high fashion than at any time in recent decades. It was Galliano's debut at Dior, McQueen's at Givenchy, as well as new couture collections from Thierry Mugler and Jean Paul Gaultier. "And Karl Lagerfeld, with Amanda Harlech as the latest high-profile player on Team Chanel, is always ready to rise to a challenge," noted *WWD*. "'You know, I prefer to show with this kind of excitement rather than with some old dusty houses

we won't mention,' Lagerfeld says of the new couture lineup. 'Whatever they may turn out to be, I think Paris needs changes like this.'"[35]

Galliano at Dior, which also marked the fiftieth anniversary of the house and the introduction of the New Look, was a triumph (*"Quel Succès Fou!"* screamed the front page of *WWD*). McQueen's debut at Givenchy, although greatly appreciated by the workers in the studio who actually made it, was panned. "A hostile collection from a gifted designer," wrote Amy Spindler in the *New York Times*.[36]

In a season with so much commotion, Karl quieted things down. He showed Chanel in a series of connecting suites at the Ritz, the legendary hotel where Gabrielle Chanel had lived and died. The show was set in the Windsor and Imperial Suites, which combined for over 4,000 square feet of space, with plush carpeting, pale walls, and pulse-racing views out over the Place Vendôme. That season's Chanel suit, cut close to the body in black tweed, was stripped down but elegant, and evening gowns, primarily in black, were long and sleek. Also, for the first time, Karl chose to show Chanel's collection of fine jewelry, which meant tiaras, necklaces, and bracelets that flashed in the lights. Model Kirsty Hume wore a platinum, white gold, and diamond choker in the form of a comet, a re-creation of a Coco Chanel design from 1932, a piece that the house considered priceless.[37]

Karl managed to produce a Chanel collection that was relevant and timeless. It was also, intentionally or not, a demonstration of the sheer power that was now radiating from the rue Cambon.

In the late 1950s, when Karl was the designer for Jean Patou, he was invited down to the Côte Basque, that idyllic region along the Atlantic coast of southern France and northern Spain. He stayed in Biarritz with Madeleine and Raymond Barbas, the owners of Patou. Their place there was the Villa Berriotz, the exceptional 1920s house that Jean Patou had built. On those trips, Karl saw another impressive estate, Elhorria, just

south of Biarritz. "It was designed by the Baron Robert de Gunzburg and was built by him between 1925 and 1927," Karl later explained.[38] It also had an interior by Jean-Michel Frank, the great modernist designer.

By the 1990s, Karl was spending more time in Biarritz. His lawyer at the time, Pierre Hebey, and his elegant wife, Geneviève, very close friends of Karl's, had a house there. There was also a history between the Basque country and Gabrielle Chanel: in 1915, during World War I, she opened a seasonal boutique and workshop in Biarritz. It was a connection that appealed to Karl, who by that time knew the life of Chanel forward and backward.

As he was in the area more often, he never forgot the Villa Elhorria. "One day I opened a magazine and it was for sale and I bought it like that," Karl explained.[39] Elhorria was a massive property, one hundred acres of rolling, wooded land. It had views from the Atlantic Ocean, just a few miles west of the estate, to the jagged peaks of the Pyrenees marking the border with Spain, some twenty miles to the south. The house was a rambling three-story structure, reflecting the Basque style of rustic architecture, with white stucco walls, courtyards, and a red tile roof.

Karl spent more than a year reworking Elhorria. He had a large photography studio constructed, so that he could shoot under ideal conditions while staying at the house, and a state-of-the-art library to hold one hundred thousand volumes. He also built a swimming pool—his first—and, adjacent, a high-tech pool house. The pool was a big, wide rectangle, with dark slate for the walls and bottom, and an underwater sound system. Karl insisted that it be heated to 81 degrees.

The interior of Elhorria was lush, with dark brown wooden beams and pillars, cream-colored walls, and oak paneling. The outdoor patios and walkways had dark red ceramic tiles, while, indoors, oak floors were covered with unadorned mats made from seagrass. The furniture was all in shades of white or chocolate brown leather while all of the simple modernist lamps were white. To take advantage of the mild climate, the house had no fewer than ten outdoor dining spaces and an

outside ballroom. For trips into town, he had a giant Humvee imported from the United States, which he had painted in that dark Basque red.[40]

Once he completed Elhorria, Karl made sure to surround himself with a revolving cast of houseguests. He invited his teams from Lagerfeld, Fendi, and Chanel and a large number of friends, including Princess Caroline and her husband, Ernst of Hanover, Ingrid Sischy and Sandy Brant, and Baz Luhrmann.

Anna Wintour and her two young children spent four or five days alone in Biarritz with Karl. "It was just the four of us," recalled the editor in chief of *Vogue*. "I'm not sure how interested he was in children but he was just so lovely to both of them—they still remember it." Karl came up with a full schedule of activities, including excursions to see Bilbao Guggenheim and to the beach in Biarritz. "He just arranged this incredible time for us," Wintour said. "There is an awful lot said about the public persona of Karl but there was a private side to him that was so gentle and kind and giving. It was a side of him that I think he was almost embarrassed about, that he didn't want to show because he was determined to be the king of the world. Actually, he was an extraordinary friend."[41]

Stella Tennant also stayed with Karl in Biarritz, shooting a Chanel advertising campaign. She was there with her husband, who was helping look after the two children they had at that point. "It was a huge house," Tennant recalled. "It could have been a hotel. It's not like you were all cozy having boiled eggs together in the kitchen." Tennant was also struck by that perfect, dark pool. "And it had to be a certain temperature, because if it was any colder, your body would put weight on, rather than lose it with the exercise. He was pretty specific about all of that."[42]

Karl also had Amanda Harlech and her two children down to Biarritz. They would spend a week or two with him every summer (an annual tradition that would continue up until the year before Karl died). Harlech would take down a suitcase to Elhorria packed with her vintage finds, which she would mix and match throughout the stay. She felt that she was expected to dress for lunch and dinner, and that, if she had seen Karl in the morning, she better come up with something new later in

the day. "Those were incredibly special, precious times because that was when you were really with Karl on his own," Harlech remembered. "There was a spirit and an ease to it—the number of books around and how you were encouraged to use your time in the way you wanted to, in my case, to paint or to read or to write."[43]

One summer, Karl insisted that André Leon Talley spend the entire month of August with him in Biarritz (although one insider suggested that Talley was actually invited to stay for a week and then refused to leave!). Karl arranged for a car, right after the summer couture shows, to take Talley down to Elhorria, a twelve-hour drive. "I told Karl that I was having caftans made for vacation, in Barbès, the African neighborhood in Paris, and he was just fascinated by that," Talley recalled. "So, when I got to Biarritz, I had all of these beautiful caftans—that is when I started wearing caftans and I never looked back."[44]

After initially staying in Paris to work, Karl joined his caftan-clad houseguest. "That was a blissful, blissful holiday," Talley said. At the same time, Karl invited other friends including Liliane de Rothschild and her husband, the Baron Élie de Rothschild. "Karl sent a private plane to pick them up in Paris, just for four days," Talley recalled. "And Karl had everything planned meticulously: every tablecloth was perfect, all of the silver was impeccable, every dinner was planned."[45]

Around the time that Karl acquired Elhorria, Françoise Dumas, the Paris publicist and event organizer, had also bought a place in Biarritz. Dumas had known Karl since the 1970s, though only professionally. She was already quite close with many in Karl's world, including Princess Caroline, Ira von Fürstenberg, Paloma Picasso, Jacques Grange, and Pierre Passebon. In Biarritz, Dumas and Karl got to know each other better and they quickly became the best of friends. "And we were always together from that point until the end," Dumas recalled.[46]

Karl appreciated the work ethic of Dumas, sending her, every May Day, huge arrangements of lily of the valley, with handwritten notes that said, "A little bouquet for the workers."[47] When he flew down to Biarritz, he would bring Dumas with him. She helped him entertain friends and

they would go around the Basque country looking for antique bed linens and pieces of pottery by Ciboure, a line of neoclassical and Art Deco designs that had been produced in the region before and after World War II. "We would hit all of the antique dealers and all of the linen shops in Saint-Jean-de-Luz," Dumas recalled. "Karl really loved everything that had to do with tableware, *les arts de la table*—he had an amazing collection that he always called his wedding trousseau."[48]

Dumas was at Elhorria when Karl organized a lunch for Bernard Arnault. The LVMH chairman had hopped on his jet to make a day trip to Bilbao to see the new Guggenheim, the spectacular museum designed by Frank Gehry (within months, Arnault hired Gehry to build the Vuitton Foundation in Paris).[49] Arnault, and Jean-Paul Claverie, his art adviser, stopped on the way back to Paris. "Bernard Arnault was still stunned by his visit to the Guggenheim," Dumas recalled. "And Karl was delighted to have them for lunch and to show them around."[50]

One lesser-known, though essential, figure in Karl's life throughout those years was Frédéric Gouby, his butler, or maître d'hôtel. Gouby started in 1985, a date he remembered easily because it was the year his son was born, meaning that he worked closely with Karl for thirty-four years. The only time that most people saw Gouby was backstage after a show, or at a public event, when he stood in the background with a silver platter, holding one of Karl's crystal goblets by Lalique filled with Diet Coke.

A consummate professional in a field where discretion is essential, Gouby had never before agreed to be interviewed. Prior to joining Karl's staff, he had worked at the French presidential palace, L'Élysée, at the National Assembly, and at the French Ministry of Foreign Affairs on the Quai d'Orsay. He had also been a private butler for such clients as Susan Gutfreund, who often invited Karl over to her town house on the rue de Grenelle (they had been friends since he designed her wedding dress, by Chloé, in 1981). "He was dieting at that time and he was a pretty difficult client for me," Gouby recalled. "But he felt that I was good with him, that I was attentive, so he asked Susan if he could have my number. She came

to Paris only a few months a year, so I began working with him the other times, then I became full-time."[51]

Gouby was astounded by the world he saw churning around Karl. "To be able to meet all the most interesting people from all over the globe; to be so close to a designer, seeing him think and create; seeing how images were gradually made; and to see how projects were conceived and then brought to life—all of that was just marvelous." He also noted Karl's intense schedule. "We would be down in Biarritz for two months and during that time, he would stop working for maybe two weeks," Gouby recalled.[52]

He remembered one key moment in Karl's life that took place at Biarritz in the summer of 1997, just after the death of Gianni Versace. Karl had known Versace for many years and was horrified by his murder. He had been to his funeral in Milan, seated with Princess Diana, Sting, and Elton John. That day at Elhorria, Karl had been given the local newspapers in the morning. He opened up to the fashion pages and saw a headline, "*Les derniers papys de la mode*," or "The Last Granddaddies of Fashion." Below was a photo of Karl with Valentino. "He looked at me, and the maître d'hôtel from Monaco, and said, 'Get me the number of Dr. Houdret.'" Although Karl would not begin his extreme diet with that Paris doctor, Jean-Claude Houdret, for several more years, the initial impulse came at Elhorria and the shock of a harsh photo and headline.[53]

Chanel executive Bruno Pavlovsky grew up just east of Biarritz, in Bayonne. In 1990, after earning a degree in management from the École supérieure de commerce de Bordeaux and an MBA from Harvard, he joined Chanel Fashion. And he quickly came into regular contact with Karl.[54] "My grandfather, André Pavlovsky, had been an architect around Biarritz, and Karl knew his work well," Bruno Pavlovsky explained. "And that was the trigger in our relationship. He realized that I did not really know my grandfather's work, so he taught me about him

and about Árt Deco in Southwestern France. This was when Karl had the house in Biarritz, so I began to know him in a way other than just through work."[55]

Karl initiated the young executive, who had previously worked in accounting at Deloitte, into the mysterious world of fashion. "He really helped me, someone very rational, enter into this world that is a little irrational," Pavlovsky said.[56] He quickly rose within the ranks of Chanel, becoming, in 1998, the managing director of fashion activities, and, in 2008, president of Chanel Fashion.[57]

Karl always made it clear that he did not participate in marketing meetings and had nothing to do with the management of the house. "Between you and me, that's not my wheelhouse," he told Pavlovsky. But he was interested in how clients responded to Chanel. After returning from a business trip, the executive would be grilled by Karl. "Every time that I came back from Japan, China, or the United States, he wanted a detailed debriefing. He wanted to know how the clients reacted, if the collection was well received, if they liked the designs, if the advertising and catalogues were well received."[58]

Anna Wintour, an outside observer, though a very well-placed one, had the sense that Karl always knew the sales figures for Chanel. "Oh, he wanted to know if the numbers were up," Wintour recalled. "He had all the numbers at his fingertips. I think that was a source of great pride to him—he always wanted to be the best."[59]

Pavlovsky noticed that Karl had a limited number of colleagues whom he depended upon for counsel. "He was someone who spoke with few people but those with whom he spoke, he spoke with a lot," he pointed out. Karl reserved two or three hours every weekday morning for phone calls at Chanel: Pavlovsky, Éric Pfrunder, Virginie Viard, and the communications team, including Marie-Louise de Clermont-Tonnerre and, beginning in 2004, Laurence Delamare. "He would make the rounds about all of the current subjects," Pavlovsky recalled. "He needed the contact. And he did not like it if people were not available for him. So, if

I was traveling or focusing on something else, it was always necessary to find time for our exchanges."[60]

When it came to new developments in fashion, there were occasions that Karl miscalculated. One notable example was the Chanel Spring/Summer 1999 Ready-to-Wear Collection, shown in October 1998, at the Opéra Bastille. A major influence at that moment was minimalism, led by Helmut Lang in Paris, Jil Sander and Giorgio Armani in Milan, and Calvin Klein in New York. Within a matter of months, Prada began assembling its own group, buying stakes in Jil Sander and Helmut Lang.[61] And it was suggested that LVMH was looking to acquire Giorgio Armani and Calvin Klein.[62] As Pavlovsky recalled, "It was at the time of this minimalist period, Italian and German, which was not the period that Karl preferred, obviously."[63]

The collection was, well, hideous. The colors were muted grays and beige, the proportions were loose and flowing, and almost all Chanel logos had been stripped away. A new bag design, in neoprene or leather, was shaped something like the headrest of an airline seat. "It was a nightmare," said Virginie Viard, who worked primarily at that time on embroideries. "A catastrophe! Karl, always interested in what was modern, was obsessed by neoprene. I love neoprene for scuba gear but that was terrible."[64]

"Romantic/Futuristic" was Karl's backstage description of the collection, an explanation that did little to help. "Galliano Soars While Chanel Is Spaced Out" was the headline in the *International Herald Tribune*, with Suzy Menkes calling it "a weird, futuristic collection."[65]

To make matters worse, there was a major production glitch. The show took place over several floors of the Opéra Bastille. A staging error meant that the models skipped one floor, which happened to be the level with the leading members of the American and international press. "After the show, it was a disaster," recalled Pavlovsky, who had just been promoted to managing director. "I was yelled at by everyone: by journalists, by the team at Chanel. It was really trial by fire."[66]

The designer, however, had a different take. "It's not that much of a problem," Karl said days after the show, when Pavlovsky told him about all of the blowback he had received. "The collection was not good, so, that way, they didn't see it—it's not that big of a deal."

Karl's bemused take on the incident was not his first reaction. "As it was happening, Karl did not think it was funny but, afterward, he did," Pavlovsky remembered. "'It's totally normal that they missed a floor—actually, we didn't want to show them the collection.' You have to have a pretty good sense of humor to see things that way, because everyone was furious."[67]

Retailers and editors were not enthused by the collection, either. One problematic show should not ruin the reputation of a designer or a house, but this one seemed to suggest a larger issue. "Lagerfeld is in a difficult position," wrote the *Herald Tribune*'s Menkes. "Having brought Chanel so brilliantly to life, the fashion cycle is again relegating the label to bourgeois bore. So now he has to do the Lazarus thing all over again."[68]

In the wake of that show, sixteen years into his tenure, there were rumors that Karl was going to be replaced at Chanel. At the very least, went the industry chitchat, another designer would have to be brought in to buck things up. It was the first time that that kind of gossip had been heard.

Karl and Chanel executives sat down with *WWD* for a major feature story on the house, published in January 1999. The piece, by *WWD* Paris bureau chief Sarah Raper Larenaudie, was a detailed analysis of all of the challenges facing the house, from a drop in sales in Asian markets to the muted reaction of American retailers to the most recent show.[69]

Karl made it clear that the situation at that moment was the most challenging he had faced since he began on the rue Cambon. "I have to redo with Chanel what I did when I started—change it," he said. "I need to hire new people and Chanel's look has to change. The store concept is

15 years old. It's time for a new one." Karl selected Peter Marino to start redesigning the house's retail locations around the world, a huge undertaking, and substantial investment, for eighty-one wholly owned boutiques and 121 corners in department and specialty stores.

As for the rumors that Karl might be replaced, Françoise Montenay, the president and CEO of Chanel, was unambiguous. "Karl has a contract for life," Montenay said. "As long as this amuses him, as long as he's happy evolving the house and trying different things."[70]

Not surprisingly, Karl had heard the gossip. When confronted, he began rattling off a list of the things that were going to have eighteenth-century to happen in order to move the house forward. Then, he did something uncharacteristic. It was only a brief moment, yet it suggested that someone who always seemed to so confident could, in fact, have doubts.

Karl stopped his rapid-fire recitation of changes that others were going to have to make and asked, very simply, "Do you think I'm the right person to design Chanel in the year 2000?"[71]

22

RADICAL CHANGE

I'm an intellectual opportunist and ready to kill if things and people don't move. This is the thing I hate most in life when people think, "Well, here we are now, let's wait quietly until retirement." This is something that gives me murder instincts.[1]

IT WAS THE CUSP of the new millennium and it seemed that Karl had reached something of a dead end. There was still some depression, though unacknowledged, about losing Jacques de Bascher a decade before. He was more overweight than he had ever been in his life. "He was eating like a pig," said Sébastien Jondeau.[2] And he was questioning himself as a designer.

When he wrote the *WWD* journalist Sarah Raper Larenaudie to congratulate her on her story, Karl restated his question: "So, you think I am the right designer for Chanel for 2000?" Reverting to form, he answered with a little bravado. "They seem to think so," Karl wrote. "And they have more to do to catch up than I."[3]

That spring, March 1999, Karl participated in a town hall discussion with Chanel employees titled "Moving Forward." Hundreds of senior staff from all over the world were brought together in Paris. Karl was questioned by journalists Hilary Alexander of the *Daily Telegraph* and Kate Betts of *Vogue*. "I have made many mistakes but I couldn't care less because you learn only from mistakes," Karl told the audience. "Nobody ever learned anything from success because then you think you did it. But from your mistakes, you learn a lot."[4]

January haute couture was another miss. "At Chanel, Karl Lagerfeld tried to straddle two worlds, producing a show filled with opposites, from cargo pants with fitted jackets through ball skirts with bare midriffs," wrote Suzy Menkes in the *International Herald Tribune.* "But a flat show proved that opposites don't always attract."[5] Even more damning was the verdict of Cathy Horyn in the *New York Times*: "Mr. Lagerfeld, bored or merely resting, needs to shake the dust off those bones."[6]

Which is precisely what Karl proceeded to do. The Fendi collection shown in early March in Milan was a great success. "A testament to Mr. Lagerfeld's far-flung brilliance," suggested Horyn.[7] The following week in Paris, Chanel was also well received. "Mr. Lagerfeld cannily blended the house's legacy and the future," wrote Constance C. R. White in the *Times.*[8]

A designer's reputation should not hinge on the failure of any one collection. After that momentary stumble, Karl would go on to design and stage over 150 major shows over the next two decades, some of the boldest, most critically acclaimed work of his long career.

But the back-to-back misfires, the rumors of his demise, and the moments of doubt led Karl to upend almost everything. They spurred him to make the most profound transformation of his life, setting the stage for his extraordinary last act.

One of his first steps was to clear the deck of a few longtime friends and colleagues.

Gilles Dufour had worked with Karl since the early '70s—their first job together was when he assisted Karl on the costumes for Stéphane Audran in the 1973 Claude Chabrol film *Les Noces Rouges.* By the late 1990s, Karl was grumbling, in private, about Dufour. He believed that Dufour was badmouthing him around Paris and was taking much of the credit for the success of Chanel. Karl was wondering about the best way to make him leave.[9] In the spring of 1998, Dufour accepted an offer to be

the designer for Pierre Balmain, where Karl had his start. Within a mat-
ter of months, Victoire de Castellane took an offer from Bernard Arnault
to design a new line of fine jewelry for Christian Dior.

Another longtime friend of Karl's was Laure de Beauvau-Craon, the
director of Sotheby's in France. Smart and sophisticated, she had mar-
ried into one of the oldest families in France (she was Diane de Beauvau-
Craon's stepmother). To celebrate one New Year's Day, Karl had asked
Laure de Beauvau-Craon to come around for a meal. After accepting his
invitation, she canceled, saying that her mother was not feeling well. Karl
quickly found out that she had, instead, been at another New Year's Day
gathering. That brought that friendship to a screeching halt.

Unfortunately, Karl had been working with Laure de Beauvau-Craon
and her Sotheby's team on the major sale of his eighteenth-century fur-
niture and objects. Because of the split, Karl, at a late date, switched the
auction from Sotheby's to Christie's.

That rushed decision contributed to another rupture: with Patrick
Hourcade, whom Karl had known since the mid-1970s, and who had
helped him build his remarkable eighteenth-century collection (and the
Art Deco pieces for the house in Biarritz). Even when they were close,
however, there were signs of friction. On buying trips to galleries and
auction houses, Karl felt that Hourcade exhibited a certain grandeur.
"Whenever I go shopping with Patrick," Karl told friends, "I have the
impression that he is the one with the money!"[10]

Karl and Hourcade had worked together closely on every aspect of
the eighteenth-century sale, which was held at Christie's in Monaco
at the end of April 2000. By most measures, it was a success, netting
$22 million. The sale of four great Gobelins tapestries that depicted
the story of Esther, which Karl had hung in the entrance of the rue de
l'Université, was preempted by the French government, deciding that
they were too significant to be allowed to leave France (they were returned
to their original location in the salon of the Château de La Roche-Guyon,
rising above the Seine, northwest of Paris).[11]

For those who really knew the market, however, the auction was not

viewed as a triumph. "A partial success" was how it was characterized in the *Art Newspaper*, noting that results represented the average presale estimate.[12] "The sale was a catastrophe," pointed out the Paris dealer Pierre Passebon, who had sold to Karl and Hourcade beginning in the mid-1980s. "One major error is that they did not indicate the provenance of the pieces, thinking that the name of Karl was enough, but that was not at all the case." Passebon, who also felt that the objects were priced too low, believed there was an aesthetic reason for the sale's moderate success. "They were very proud of having gone fully into the spirit of the 18th century, with really strong colors, turquoise, greens, and lots of gold," the dealer explained. "It was a side of the 18th century that was very flamboyant and I don't think people really got that—they were reconstituting a period but that was not how most people saw the 18th century."[13]

Two months after the sale, Hourcade forced the issue by returning Karl's mother's ashes—he had been keeping them for years. He accused Karl of being dishonest with himself, having mentioned that Hourcade had his mother's "possessions," when, in fact, it was his mother's remains. Karl, in response, seemed to be diplomatic but, in later years, he went to great efforts to avoid seeing him, preferring not to attend an art opening, for example, if he found out that he would be there. Hourcade had a pithy characterization of their friendship: "25 years of close collaboration; 20 years of divorce."[14]

Many in his orbit felt that these kinds of separations went with the territory. "Karl was always morphing into the next Karl," said Eric Wright, who worked with him for twenty-two years, on the design team at Lagerfeld and at Fendi. "And if you can morph along with him, then you continue. If not, it would end. It's not that all of a sudden you have done something wrong and you're fired. It's more like that period is just over."[15]

Wright experienced that himself. One day, he returned to Paris after a trip to Rome for Fendi. He was with Vincent Darré, a designer and decorator who had known Karl since the 1970s. When they arrived at the rue

de l'Université, where all of the eighteenth-century furniture had been replaced by elegant contemporary pieces by Christian Liaigre, Wright had a premonition. "In two years, you and I are not going to be here," Wright said to Darré. "I just had this vision, that Karl was changing. A year later, Vincent was no longer working with us. And a year and a half later, I was no longer there."[16]

Karl's rifts, even from the inside, could be startling. "Everyone saw how tough and caustic he could be, but I have never known anyone as kind and as generous as he," said Diane de Beauvau-Craon, who was a firsthand witness to his break with her stepmother. "But if you were to betray him, that's when the iron curtain came tumbling down. It wasn't a guillotine—it was a curtain made out of iron and it came crashing down."[17]

Sophie de Langlade worked closely with Karl for many years, first at Chanel, then as general manager and studio director at Lagerfeld for three decades. She wondered if some of the conflicts could be because some members of Team Karl were so completely absorbed by their engagement. "Some of us had other things—families, children—we were not 100% dependent on Karl," de Langlade pointed out. "And there were others, like Gilles Dufour or Eric Wright, for whom their entire life was him. Karl accepted that he did not always have complete control over others but when he did, I think he liked that and got used to it. As soon as Ines had a man in her life, who started taking more time, Karl was not happy."[18]

The fact of the matter is that Karl did enjoy long-lasting relationships, with many friends, journalists, and colleagues. The ruptures were what everyone always talked about, but there were a great number of friendships that lasted for decades, including German journalist Florentine Pabst, Princess Caroline, Liliane de Rothschild, French editor Colombe Pringle, Anna Wintour, Ingrid Sischy, Sandy Brant, Lynn Wyatt, Susan Gutfreund, and many others. There were also a great number of work relationships that endured. Those who stayed tended to be philosophical about Karl's breaks with others. "Like a lot of big personalities, there

were ruptures," pointed out Bruno Pavlovsky of Chanel. "I don't think he was that different from others in that sense. There were times that he changed, altering his circles of friends—it is not really surprising when you think of the force of his personality and his desire to continually evolve."[19]

There is one notable factor in the narrative about all of Karl's torpedoed relationships: it was a reputation that he burnished. "It's too easy to forgive," he once said. "I love revenge. I can forget by indifference but not forgive."[20] Karl knew that his public breakups, from Kitty D'Alessio to Pierre Bergé, made for good copy. They were also a way of keeping people on their toes—watch out, or you, too, might be frosted out. "I know that revenge is mean and horrible but, if someone has done something to me, I see no reason why I shouldn't return the favor," Karl once explained. "It can be once they have forgotten all about it that I pull out the chair—and it could be 10 years later."[21]

Stories of ruptures helped him craft an image that was even more formidable. They disguised, as effectively as the darkest pair of sunglasses, the softer, more sensitive side of Karl's personality. "The bit that we don't acknowledge is that he really wanted everybody to love him," believed Amanda Harlech. "Even though he would say he didn't care, he did. He often said that his fans were all ages and all over the world, and he was always touched in New York, when a kid, or a guy on a bike, would be like, 'Hi, Karl!' 'How are you, Karl?' That meant so much to him, in a loving, friendly way. So much of Karl just really wanted to be hugged, and embraced, and loved."[22]

That cleansing process—of friends and possessions—was a prelude to a physical and emotional transformation. "Before changing my look, I had to clean everything up that was around me," Karl explained. "I sold everything that was connected to my past, because you can't build a future if you are tied to your own past. It took me

three years to get rid of everything and then to be ready to get rid of my weight."[23]

In the past decade, in his sixties, Karl had been very overweight. He admitted to being 225 pounds, which for someone not quite five feet ten was obese. He had been wearing shapeless Japanese suits, which he said that he had loved, for ten years. "My black period," Karl termed it. "It was all a sort of camouflage, and I lived well in it, or behind it, I should say, because it was like a wall between me and the world."[24]

It was not true that he lived it well. Some colleagues were worried about how the excess weight was affecting Karl's health, noting that he was easily out of breath. "At one point, he was no longer able to go up the stairs," recalled Virginie Viard. "He fell one time and I was always afraid that that was going to happen again. It was a tough situation—he was not old."[25]

Karl had tried a few extreme diets without any results. He often confided, privately, that he was unhappy. Amanda Harlech remembered him making a visit to the office at Chanel that she shared with Viard and Pascal Brault. "He had had his hair crimped and it came across one side of his face—he looked like Colette!" Harlech recalled. "And he said, 'I've got to lose weight. But I can't stand this cabbage soup diet. Or that one when I just ate bananas. Maybe I should take up smoking!'"[26]

Karl bummed a cigarette from Viard and gave it a try. "And there he was, smoking one of Virginie's cigarettes with his hair like that—it was hilarious."[27]

Karl insisted that he did not need to lose weight for reasons of health or, even worse, for any dreams of romance. Instead, he felt that it was important for him professionally, to show that he was capable of self-transformation. "I said to myself, 'You work in fashion and fashion is about change—if you don't like your image, all you have to do is change it. And it is not about trying to be what you had been before.'"[28]

On November 1, 2000, Karl started a radical new diet, overseen by the Paris nutritionist Dr. Jean-Claude Houdret. The regime, initiated after a complete medical exam, was extreme and complicated, involving lean

protein such as fish, fresh vegetables, and lots of pills and protein powders. "For me, a diet without complex instructions isn't really a diet," Karl explained. "I need to be disciplined to take all of these little pills that I take at breakfast, lunch, and dinner—rituals are essential." Karl gave up sugar, creams, and rice, and was required to have his meals at precise times during the day. Drinking water was also important, three liters a day. One of his first dinners, on a Sunday, was nothing but green beans and a hard-boiled egg. For six months, his breakfast was one piece of a special kind of bread and a half grapefruit. After six months, he was allowed two slices of bread and some nonfat yogurt.[29]

Karl's friend Bethy Lagardère noticed that many who were close with him were expected to play along. "He put all of us on a diet," Lagardère said with a laugh. "But I told him that he had his German self-discipline and that not all of us did." When they went to Café de Flore, Karl, who had eaten more than a dozen sausages in the past, would have just one. "In Biarritz, you would open the door of your room in the morning, and there would be a 2 kg. package of those salty caramels that come from the area," Lagardère recalled. "Before you knew it, you had eaten the entire box. They are the most famous delicacy of Biarritz and they are put in front of your door at 8:30 a.m.—I mean, who could resist?"[30]

As his weight melted away, Karl was reinvigorated. He was delighted to show everyone the new purchases that he had made, slim-fitting jackets and suits from Dior Homme. Karl would try them on in front of the Chanel studio, proud that he was able to fit into this new wardrobe. "He was a completely different man," said Véronique Perez, the communications director for Chanel at the time. "He wanted to show himself. I remember a big dinner that he had at his place around that time, and he started dancing—everyone's jaws dropped!"[31]

Karl had a spring-loaded dance floor installed at the rue de l'Université, and he had the instructor from a dance school on the nearby rue de Varenne, Georges & Rosy, stop by for lessons. "He wanted us all to learn ballroom dancing," recalled Amanda Harlech. "And it was Princess Caroline, Hedi, Stephen Gan, Virginie, Sébastien, and me. These

teachers came, and Karl took time to dance with us, and we had to learn the Cha Cha."[32]

In July 2001, the Chanel Fall/Winter Haute Couture Collection was presented at a boys' school, the Lycée Buffon, on the Left Bank. At the end of the show, all the models assembled in the courtyard of the historic building, forming a pattern, intended by Virginie Viard to recall the performances of artist Vanessa Beecroft, with the audience looking down from the floor above. The designer suddenly appeared wearing a sharp black suit and a wing-collared starched white shirt, and weighing ninety pounds less than he had been the year before. "And Karl arrived in the middle, like a toreador," Perez recalled. "He was superb! Everyone was like, 'But he is incredible—how did he do that?'"[33]

His appearances at the end of the shows were longer—he was more at ease sharing the stage with some of the most stunning women and men in the world. In fact, he seemed to enjoy the rivalry. "He could be *quite* competitive about the size of his trousers," Stella Tennant recalled with a laugh. "His were a size smaller than mine, at one point—he had a 29-inch hip and mine was 30."[34]

One night at an event at Castel's, the Saint-Germain nightclub, Ines de la Fressange was surprised to run into the newly trim Karl. They had exchanged letters over the years but had not spoken in more than a decade.

"Wow," de la Fressange exclaimed. "Aren't you a skinny little thing?"

"Right, did you see that?" Karl asked. "Oh, what's your jean size?"

"Mine is twenty-five," she replied.

"Well, mine is twenty-four!"

"I'm not even sure that twenty-four exists," de la Fressange recalled, laughing. "Or it would be a children's size. But it was his way of saying, 'I'm thinner than you!' Like an infant!"[35]

In the fall of 2002, Karl published a book on his weight loss with Dr. Houdret. To promote its publication, he appeared on French television, wearing skintight Dior jeans, a black jacket, a white shirt, and a narrow black tie. He explained that he had lost the weight a year before but had wanted to wait to publish his account of the diet. "If you do a

book and then you puff back up again, it's not very honest, *non*?" Karl noted. "I wanted to make sure that I was like this for a full year—I haven't gained as much as one gram."

Fran Lebowitz had known Karl since the 1970s, when she was going to Paris regularly to see a girlfriend. And she would often see him when he was in New York. "He was intense," Lebowitz recalled, "and not just compared with other fashion designers—there were not other *people* who were like him." Lebowitz, too, was struck by the drama of Karl's rapid weight loss. "He lost all of that weight in like five seconds," she said. "And then, when he transformed himself, there was never any thought about what had come before—it was like it no longer existed."[36]

Karl's weight loss and new personal style—piling on the Dior Homme and the Chrome Hearts jewelry that he picked up at the trendy Paris boutique Colette—seemed to energize him in many areas of his life. In October 2001, he guest edited an issue of *Interview* magazine, overseen by his close friend Ingrid Sischy, on his view of Paris at that moment. His take on the French capital included leading contemporary artists—Sophie Calle, Annette Messager, Pierre Huyghe—actors and actresses—Marion Cotillard, Jalil Lespert, Charles Berling—film directors—Claire Denis, Catherine Breillat—and great contemporary design—the Bouroullec brothers. Karl featured all of the latest members of the pop movement known as "French Touch"—Cassius, Phoenix, Bob Sinclair, Alex Gopher, Rinôçérôse—as well as such legendary singers as Françoise Hardy.

There had been times in the 1990s when Paris felt morose, compared with London or New York or Berlin. But Karl felt a new energy. "Once again, one has the feeling that the lights are turned on again in Paris," he wrote. "Not thinking about Paris suddenly gives the impression we are missing something. Maybe we aren't but the idea is stimulating. Being in Paris suddenly gives the feeling that we are in the right place."[37]

Karl also began to amplify his international travel. In December 2002, he jetted off to Florida for Art Basel Miami, doing an exhibition with the Galerie Gmurzynska, the Zurich dealer of twentieth-century modern art that he had had a relationship with for years. "When we first did shows with Karl, we got killed for being opportunists who work with a star who is not an artist," recalled Galerie Gmurzynska director Mathias Rastorfer. "We were accused of doing this not for art but for publicity. When one knows the history of the gallery, it makes perfect sense because the Russian avant-garde, that Karl loved and we are famous for, did not make a separation between the fine arts and decorative arts. In Russia, in 1910–1920, female artists are absolutely equal to male artists, and theatre design and a scarf design and painting and drawing are absolutely equal." The first shows they did together had earned the gallery criticism from critics, clients, selection committees, and museums. "The more Karl established himself as a famous photographer, the more we got requests from, guess who, the top museums in the world," Rastorfer continued. "Everybody, at one point, wanted a Karl Lagerfeld show from us."[38]

By 2001, clearly, the art world was more open to some Lagerfeld excitement. Rastorfer was asked by the director of the art fair if he could bring Karl to South Beach for the first edition of Art Basel Miami. Rastorfer asked Karl what he would think about doing an exhibition in a shipping container that would be positioned outside the fair. Karl had the exterior of the long, narrow container covered with huge blowups of his black-and-white photos of Berlin. Inside were wall-sized black-and-white prints, in red lacquered frames, of Hollywood stars that Karl had photographed: Jack Nicholson, Nicole Kidman, Ryan Gosling, Meg Ryan, and Arnold Schwarzenegger.

To mark the occasion, Karl participated in an Art Basel Miami discussion about art and fashion with Ingrid Sischy. She wore loose black pants and an untucked blue Lacoste polo, while he appeared in tight white jeans, a sharply cut black jacket, a high-collared white dress shirt, and a skinny black tie with white diagonal stripes. His sunglasses were narrow,

angular. Karl was dismissive about designers who try to consider themselves artists. "One category should never compare itself with another one," he said. "Why would designers want to be called artists? They can be artisans. The world of art is another world. And it's not exactly the same deadline—every six months."[39]

Karl and Sischy had a wide-ranging discussion about Russian Constructivism, the design of the Bauhaus, and contemporary art. He pointed out that many fashion and textile designs of those early twentieth-century movements were not actually sophisticated, and that they were also far removed from all of the money that was now sloshing through the worlds of fashion and art. Karl suggested there was a certain tension between fine art and glamour. "Sophistication can take it away from the world of art," he pointed out. "I think Andy Warhol was the first to find a way in the middle of it—but not everyone is Andy Warhol!"[40]

A few weeks later, Karl was back in his apartment on rue de l'Université, taking a moment on New Year's Eve to write his friend Françoise Dumas. He told her how he missed being with her down in Biarritz. And he explained that he had declined an invitation to be at the house of Elton John near Nice with Sandy Brant and Ingrid Sischy. "Everyone else has left Paris, except for the team from couture and those we work with (Lesage, etc.)," he wrote Dumas. "I am, of course, thrilled because, in this day and age, it is a great privilege to do this kind of work. Chanel and Dior are the last two *maisons de couture*, in the true sense of the word, and I spend my life telling everyone I work with that they do not know how lucky they are. So, I am not at all bothered by being here alone."[41]

Karl also mentioned some events that he would like them to discuss after the holiday, for haute couture, for Hedi Slimane's show for Dior, and for a dinner he wanted to have at rue de l'Université for Elton John. "*Très privé*," Karl suggested.

Soon, Karl and Dumas came up with a clever entertaining idea: a dinner at rue de l'Université for their friends who were born under the sign of Pisces. The first was held on March 5, 2003. It was dubbed Dîner des

Poissons. "Actually, it was a birthday dinner for Bernard Arnault, because he was born on the fifth," Dumas explained. "So, he was Pisces, as was Ernst of Hanover, who was married to Princess Caroline, and Bethy Lagardère was, too. I am also Pisces, as were Ingrid Sischy and Pierre Passebon. So, Karl said that we should do a big dinner for everyone."[42]

They organized one big table in Karl's downstairs salon, spacious enough to seat twenty-eight guests. Karl came up with the idea for the decorations and worked with Dumas on the guest list and menu. The center of the table was given over to a large ring of flowers, at least six feet in diameter, surrounded by a dozen low candles, with, in the center, a tall bronze sculpture of a fish.

The guests that night underscored the range and internationalism of Karl's friendships. Bethy Lagardère was seated on Karl's right, while to his left was Claude Pompidou. Next to her were Bernard Arnault, Princess Caroline, Tom Ford, and Hélène Arnault. Ford's partner, Richard Buckley, sat next to Ingrid Sischy, Sandy Brant, and Françoise Dumas. Ernst of Hanover was paired with Amanda Harlech. And Eric Wright was between Delphine Arnault and Jacques Grange. The menu consisted of an artichoke-and-crawfish *tian*, a plump chicken with truffles and steamed vegetables, and a chocolate cake with mango.[43]

Karl's Dîner des Poissons was a tremendous success. "Bernard Arnault wrote me a note after, saying, 'You blew me away with that dinner,'" Dumas recalled with a laugh. "For Bernard Arnault to be blown away by something was quite a compliment!"[44]

By the time Karl had dropped the weight and reinvigorated himself creatively, he also developed a more expansive view of his vocation. "I have three professions," he often said, "photographer, book publisher, fashion designer."[45]

Karl's move into book publishing had begun in 1993, when he won a prestigious German design prize, the Lucky Strike Designer Award,

given by the Raymond Loewy Foundation. The prize came with a cash award, the equivalent of around $50,000, and the possibility of having a book published by the German house of Steidl Verlag, one of the best publishers of books on art and photography in the world. The idea was that the book would document the designer's historical work. Karl, of course, was horrified by that idea.

Gerhard Steidl wrote Karl a letter, congratulating him and suggesting that they could begin working on a monograph of his work. "And a letter came back immediately, handwritten, saying, 'The last thing I would want is a monograph of my work,'" Steidl recalled. "'So, forget about this. Karl Lagerfeld.' I was pissed because it was well paid at that time, roughly 100,000 Deutsche Marks, so I didn't want to let it go." Steidl also felt that the series for the prize had been impressive and that it was important to continue. So, he wrote back to Karl. "I understand that you do not want to publish a monograph but if you could dream about a book, what would it be?"[46]

Karl immediately wrote back explaining that he had had a book of his photography published that he was not thrilled about and that he would be interested in having a good one produced. Steidl responded that he did not know his photography work very well, that he had only seen some fashion images, so could he send some?

The press that Gerhard Steidl had built, in the out-of-the-way university town of Göttingen, was known for printing the work of leading contemporary artists and the best photographers in the world: William Eggleston, Robert Polidori, Mary Ellen Carroll, Martin Parr, Saul Leiter, Robert Frank, and Henri Cartier-Bresson. "A few days later the package arrived from Karl and I was really impressed," Steidl recalled. "It was landscape photography, abstractions in the Jardin du Luxembourg, streets in Paris, the rue de l'Université—places that I had seen before but not photographed in this way."[47]

Steidl did test prints of the photos, on a variety of paper stock. "I sent the test prints back to him, seriously labeled, specifying that this is a coated paper, 170 grams, and this is an uncoated paper, 150 grams, this

is an uncoated paper, high white, and this is an uncoated paper, very creamy."[48]

Karl was delighted. "I love your test printing," he immediately wrote back to Steidl. "We are both paper freaks—we will work very well together."

The first book they published, *Off the Record*, 1994, was a mix of Karl's landscapes, streetscapes, and some portraits—the cover was an edgy shot of Claudia Schiffer, with greasy hair and looking somewhat strung out. And they began regularly producing volumes of Karl's photography: *Villa de Noailles*, 1995 (the 1920s Robert Mallet-Stevens house in the south of France); *Villa Jako*, 1997 (his Hamburg property); *Casa Malaparte*, 1998 (the modernist villa perched on the cliffs above Capri); *Metamorphoses of an American*, 2008 (a four-volume set containing five years of photographs of the model Brad Kroenig); and *The Beauty of Violence*, 2010 (tough, erotic portraits of Baptiste Giabiconi). Over the next few decades, Karl and Steidl would go on to publish some fifty volumes of Karl's photography and dozens more books.

Karl also brought Steidl into his work as a designer. Soon he was printing all the invitations, press kits, and catalogs for Chanel and working with Éric Pfrunder on Karl's photography. Steidl, who had known nothing about the fashion world, began making weekly trips to Paris. Every season, he would print the invitations for the shows, the press kits that would be placed on every seat, and the catalog (Karl even made sure that the advertising catalogs, published every season from 1994 to 2019, were approached like books).

"Gerhard Steidl may have no detailed knowledge of dressmaking, but I also have no precise idea about the way he works," Karl wrote in 2009, a decade and a half into their collaboration. "His innovative methodology and technical vocabulary are notoriously obscure secrets for me. I know his aims, what he wants to accomplish, but don't ask me how he does it all. He wants people to love and understand everything about a perfect book, the inside and the outside."[49]

With Steidl, Karl founded Éditions 7L, his own publishing im-

print. Éditions 7L published such books such as *Grace: Thirty Years of Fashion at Vogue*, 2002, an oversized, extraordinarily beautiful volume of the work of stylist Grace Coddington. Published in limited quantities, it quickly sold out (and original editions have gone for up to $10,000).[50]

On one of his trips to Los Angeles, Karl often worked on the production of events and shoots with Victoria Brynner, the daughter of Doris and Yul Brynner. When she mentioned that she had some eight thousand photographs that her father had taken throughout his life, Karl suggested doing a book and immediately phoned Steidl. "I thought it was one of those things that people say, let's do a book, and didn't imagine that it would ever happen," Victoria Brynner said.[51] The work that came from that conversation, *Yul Brynner: A Photographic Journey*, 2010, was a four-volume boxed set, with a portrait of the actor holding a camera produced across the spine of the four books. Exquisite.

In 2010, Karl established another imprint with Steidl, for German literature and translations of English and French literature into German. Called L.S.D., abbreviated from Lagerfeld, Steidl, Druckerei (the German term for "printing plant"), it produced such beautiful volumes as Virginia Woolf's *A Letter to a Young Poet*, first published by Hogarth Press in 1932, and *The Art of Conversation*, an exploration of the use of wit in three historic salons by the French author Chantal Thomas.

Karl was closely involved in the preparation of the books that they produced together. He asked Fran Lebowitz if she would agree to have her two books, *Metropolitan Life* and *Social Studies*, republished in new volumes by Steidl. "I mean, who does that?" Lebowitz asked incredulously. They were published in 2003, in English and German versions, in a beautiful boxed edition with a saffron case (copies regularly go for over $2,000).[52]

Another book that Steidl and Karl published together was *Mademoiselle: Summer 62*, 2009, a series of photographs of Coco Chanel, taken over several weeks in 1962, by the American photographer Douglas

Kirkland. To submit the maquette for Karl's approval, Steidl flew from Frankfurt to Boston, then drove three hours north to Burlington, Vermont, and on to a house on the shore of Lake Champlain where Karl was shooting an advertising campaign for Chanel. Between shots, with the models Heidi Mount and Baptiste Giabiconi, Karl sat in the house's garage and drank a large glass of Pepsi Max. Steidl presented him with the maquette. Karl turned the pages with gloved hands, occasionally dropping his glasses to study the images. He approved the sequence of photos, chose a dark gray linen for the binding, and promised to write the captions and an introduction when he was back in Paris.[53]

The Éditions 7L imprint was connected to the Librairie 7L, the bookstore that Karl had opened at 7, rue de Lille, in front of his photography studio. The light-filled space contained a beautifully edited selection of books on art, photography, design, and fashion. Although Karl continued to be a dedicated customer of Galignani on the rue de Rivoli and Felix Jud in Hamburg, he now had his very own bookstore right around the corner from where he lived.

"Karl's shop was unusually stylish," recalled Fran Lebowitz. "Most book shops don't look like that. But to me, the fact that he had that bookstore and the fact that he had that publishing company was incredible. Truthfully, lots of designers could afford that but it wouldn't occur to them."[54]

REVOLUTIONS

I have never gone in reverse. I may have actually underexploited
myself, but everything that I have wanted to do, I have done. I
am neither Joan of Arc nor Don Quixote—I hate playing the role
of victim and I'm horrified of windmills. What matters the most is
survival.[1]

ON FRIDAY, NOVEMBER 12, 2004, in the middle of the night Paris
time, around 4:00 a.m., Karl called Donald Schneider, the art director
who had initiated the project with H&M. Schneider, who was in New
York on a shoot, received the call on his cell phone around 10:00 p.m.
He had been excited about the H&M project, but now he was nervous.
"What if nobody shows today?" Karl asked Schneider.

"He was worried that his career would be ruined," Schneider re-
called. "I calmed him down, telling him that, of course, it would be a
success, even if I had my doubts. We all had such adrenaline in those
last weeks—we thought we were onto something but we just were not
sure."[2]

Although Caroline Lebar, his longtime director of communications
and image at Lagerfeld, had initially been underwhelmed about the idea
of a collaboration with H&M, she worked closely on every aspect of the
project. On the morning of November 12, she was accompanying a
journalist from *Libération* to the H&M store on the rue de Rivoli. They
arrived at 7:30 a.m. Turning the corner, they saw people huddled to-
gether on the sidewalk, in sleeping bags. "We didn't understand what

was happening," Lebar recalled. "We assumed that they were homeless. Only after a moment did we realize that they were there camping out, waiting for the store to open. We said, 'Whatever is going to happen, it's going to be something that the world has never seen—that whatever is happening is something that's completely crazy.'"[3]

Lebar, the journalist, and the *Libération* photographer went into H&M to document the opening. From their first conversation, Lebar had told Karl that she thought the stores were a mess but he had a sensible response. "If you know that the stores are terrible," he told her, "all you have to do is specify in the contract that the place where your clothes will be shown has to be a place that is perfectly clean."[4]

As Lebar entered the H&M store, she understood what he had been saying. "The store was still a mess," she said with a laugh. "But we went down the escalator, and there, straight ahead, was this Karl Lagerfeld corner: impeccable, beautifully lit, clean, all in black and white—it was magnificent!" They took some photos of the space for the newspaper and then took their positions, waiting for the store to open. Lebar was going to take pictures for Karl. "We see the doors open, and then people start running down the stairs—it was a stampede! I couldn't take any pictures—we were literally run over by people. Five minutes later, everything in the corner was completely gone. I saw a guy get bitten. He was holding a cashmere coat, at like €80, and this lady wanted it back—she bit him—right in front of us!"[5]

Lebar left H&M feeling that she had witnessed the beginning of something significant. She called Karl to let him know what had happened. "He answered as though he had been waiting for my call," Lebar said. "We both said that it was fantastic and it seemed that he knew that something big was happening but he was also fairly calm. Perhaps, it was because I had been opposed to the project and he didn't want to take a victory lap." Years later, though, she heard from Karl how important that call, the first indication of the success of the project, was for him. "I will never forget where I was when I received that call," Karl said in an

interview in front of Lebar. "It is one of those moments I will remember all of my life."[6]

By the afternoon in Paris, the morning in New York, one thousand people rushed into the H&M on Fifth Avenue in the first hour that the store was open. "'He's an icon,' said Marni Low, a 24-year-old New Yorker, as she grabbed $49 skirts and tops."[7] The scene was repeated in big cities all over the world.

Many around Karl had doubts about H&M but it could not have been a bigger success. "He had already run it to the end of the film," Amanda Harlech said. "He probably understood that collaboration was the way that fashion was going to go. And what he was doing for H&M—great design, good quality, but at a good price point—was what he wanted to do for Lagerfeld, which was slightly stalled in comparison with where Chanel was going and where Fendi eventually went." Harlech pointed out that the H&M collaboration became a test-drive for where he would take his own label, which, within a year, would be acquired by Tommy Hilfiger, allowing it to expand greatly.

So much changed in the wake of Karl's collaboration with H&M. A few weeks after, he went off to Tokyo for Chanel, and then to New York. On the streets of Tokyo, he was mobbed. From Japan, with thirty-five pieces of luggage, he flew to New York. Then he went back to Paris, flying Air France, in an Airbus A380. "In the four seats in first class, were Jean Paul Gaultier, Karl, and me," recalled Sébastien Jondeau. "I felt like I was at the heart of international fashion. Karl hated the flight because of some equipment in the flight attendants' station that was beeping all night. I loved it all. It would be the last time that Karl took a commercial flight."[8]

His daily life in Paris also changed drastically. "I remember the date of November 12 so well," Caroline Lebar recalled of the day the H&M collection dropped. "A few days before, it was possible to walk with Karl on the street, to stand next to his car—no problem. Starting on the afternoon of the 12th, that was no longer possible. It was all over—he could never again walk alone on the street."[9]

For decades, Karl had been what might be called "fashion famous." Everyone in the world of style and luxury knew who he was. But suddenly, thanks to the international reach of H&M and the powerful fusion of high fashion and the mass market, he was known by every age group, every socioeconomic level, all over the world. His stature as a designer, and the scale of his life, were sent into the stratosphere.

Six weeks after H&M, an emboldened Karl had another idea. It was one that would move his work with Chanel onto the biggest possible stage. One morning in January 2005, he visited the Grand Palais, the monumental glass-roofed building that stood between the Champs-Élysées and the Seine. It was a Belle Époque fantasy of a structure, built for the 1900 World's Fair. One of its most impressive features was a barrel-vaulted iron, steel, and glass roof that created a massive central space, of almost 150,000 square feet, like the nave of a great cathedral. A French national historic monument, the Grand Palais had been built to celebrate the arts. It had housed, since 1965, a national gallery, and had been, over the decades, the site of important art exhibitions and salons.

One thing that the Grand Palais had never been before was a venue for fashion shows. Karl intended to change that.

"Couldn't we be the first to show there?" Karl wrote Marie-Louise de Clermont-Tonnerre, just after his visit to the Grand Palais. "I've about had it with our big auditoriums in the 'catacombs' of the Louvre—we've really worked that to death. Do you have a relationship with the Minister of Culture? I do, if I can be of help."[10]

By that October, Karl and his team had moved the Chanel shows into the Grand Palais. Many Paris designers had been doing big presentations, but his shows there were in an entirely different league. Their real message, though subliminal: Chanel was now a national monument and it deserved to be shown in a national monument.

Karl's shows at the Grand Palais pushed the boundaries of fashion, performance, and installation art. And they became much bigger than just the world of style—season in and season out, his productions were so bold that they made international news. They became a part of popular culture.

Karl's first show in the Grand Palais, held in October 2005, was Chanel 2006 Spring/Summer Ready-to-Wear. Under the soaring steel and glass canopy, the runway was as long, and almost as wide, as a football field. The backdrop was a wide, dusty pink wall that held an enormous version of an Apple iMac computer, a flat-screen monitor seventy feet wide. Below was a giant keyboard, while at the base of the screen, instead of an Apple logo, were the interlocking Cs.

The show began with the *rat-a-tat-tat* of a snare drum, a rhythmic version of typing on a keyboard, followed by the familiar chords of an Apple device springing to life. A computer-altered voice announced, "Welcome to the Chanel Summer 0-6 Collection." The audience was positioned on bleacher-style seating, more than a dozen rows on either side of the runway. At the opposite end was a big photographer's pen and a massive wall of lights. As the show began, the giant computer projected close-ups from the runway for all to see.

The starting point for Karl was an imaginary connection between James Dean and Coco Chanel. "Lagerfeld's now familiar system of send-it-all-out worked well in the big space," wrote Suzy Menkes in the *International Herald Tribune*. "But with as many themes as there are cable channels, it required multi-tasking. The result was visual and mental overload."[11] Yes, it certainly was—welcome to the modern world, Ms. Menkes.

The colossal new stage seemed to give Karl a new boost of creative power. Stefan Lubrina had worked with him to conceive and construct all of his sets since 1994. He saw what the new space meant to Karl. "Very quickly, he understood that it had to be big for the Grand Palais,"

Lubrina explained. "It is a space that is very beautiful but also very strong—it could easily overwhelm a set. So, my job was to learn how to play with the Grand Palais."[12]

The following presentation, Chanel 2006 Spring/Summer Haute Couture, was held in January. The set was round, with, in the center, a large circular structure like a column, five or six stories in height, in white with a grid of silver metal. As the models made their way around the set, they exited via a door at the base of the structure that slid open and closed behind them. At the conclusion of the show, the bride made her way around the set and then stood at the center of the stage. At that point, the outer wall of the column began to rise into the air, revealing that it was actually a sheath for a towering spiral staircase in white steel, with a model positioned on each level, going up five flights. Karl appeared and walked with the bride around the set as the models elegantly descended from the staircase.

"One of the things that Karl really wanted to do was take advantage of all of the space in the Grand Palais," Lubrina recalled. "There had been a series of art exhibitions there, *Monumenta*, that were overwhelmed by the scale of the building—they were actually not very monumental. Karl wanted it to be bigger than *Monumenta*—he always wanted it to be more and more."[13]

The shows at the Grand Palais showed Karl as showman but there was another side of him that was equally revealing. He had long cared deeply about the craft of haute couture, all of the highly skilled artisans who set Paris apart from other fashion capitals. And he knew that many of those small, independent firms were struggling. Some had survived for generations but there was serious concern about whether they would be around much longer. By the late 1990s and the early 2000s, many of the workrooms, scattered in old buildings around Paris, were dilapidated or overcrowded. And Karl wondered if Chanel should help.

"The most important point from the beginning is that Karl needed

these ateliers," explained Bruno Pavlovsky. "They allowed him the means of executing his vision."[14] Pavlovsky was taking on more responsibility on the fashion side of Chanel and he understood that, particularly as those who ran these firms retired, something was going to have to change. "For Karl it was obvious," Pavlovsky pointed out. "They needed to be purchased and they needed to have the means to do their work."[15]

So, Chanel began acquiring these little suppliers of haute couture magic. Lesage, since 1924, had created exquisite embroideries for everyone from Madeleine Vionnet to Christian Dior to Christian Lacroix. Lemarié, since the Belle Époque, had produced extraordinary creations with feathers and flowers made out of organza and silk mousseline. Desrues, since 1936, made costume jewelry and buttons, particularly for Coco Chanel. Goossens crafted handmade jewelry, working closely with Mademoiselle on her Byzantine- and Baroque-inspired pieces. Eventually, Chanel acquired Massaro, a bootmaker, the Maison Michel, a milliner, and Causse, a glovemaker.

But Chanel's acquisitions were not mercenary. The idea was that the ateliers would continue to work with all of the couture houses. Pavlovsky and Françoise Montenay went to Karl about what to do next. "Now that we have Lesage and Lemarié, what are we going to do to make sure that their work is better known, that other houses become interested in their savoir faire?"[16]

"The only thing I know how to do is a collection," Karl replied. "So, why don't we do a show?"[17] He decided that there was one moment in the calendar for a new event: early December, meaning that it slid in between the ready-to-wear shows in October and the haute couture in January. And that was the beginning of annual presentations that, to emphasize their connections with craftsmanship, would be called the Chanel Métiers d'Art Collections.

The first had been held in December 2002, in the haute couture salon of 31, rue Cambon. It was designed to show the embroidery work of Lesage, the feathers and camellias of Lemarié, the leather boots of Massaro (the house that had developed the two-toned slingback with

Coco Chanel), the buttons and costume jewelry by Desrues, and the hats made by the Maison Michel. The goal was to showcase craft on the runway and then produce the pieces in limited editions. "It's a bit of couture without being couture," Karl said of the collection.[18]

The Métiers d'Art shows became increasingly ambitious. In December 2004, Karl took some two hundred members of the Chanel team to Tokyo, to inaugurate the biggest Chanel boutique in the world, in a new ten-story building in Ginza designed by Peter Marino, and to stage the first Métiers d'Art Collection outside of Paris. It was also the first to celebrate the connection with another city, being christened *Paris-Tokyo*.

Soon came *Paris–New York*, 2005, in the newly reopened Fifty-Seventh Street Chanel boutique, *Paris–Monte Carlo*, 2006, in the ornate Opéra de Monte Carlo, and *Paris-Londres*, 2007, in the London offices of the Phillips de Pury auction house, blending influences ranging from Amy Winehouse to Brigitte Bardot. To mark the occasion, Chanel stamped London cabs with the Chanel logo and hosted a dinner for hundreds at Nobu. "It is a dream for Chanel to go to London but I don't come so often because I only go to cities where I work," Karl explained.

Thanks to Karl's encouragement, the house went on to acquire a total of twenty-five houses. That division was named Paraffection, or "Out of Affection." Since 2021, the group has been installed in a spectacular new complex of buildings, all concrete and steel and glass. Called 19M, in the 19th arrondissement in northeast Paris, the new structure affords six hundred artisans the opportunity to work in the best possible conditions.[19]

Karl's Métiers d'Art shows were made to highlight the technical skill of the artisans, yet they also turned into multimedia events for the house's clients and international press. They, too, transcended the world of fashion and became big news around the world.

In May 2005, Karl and Sébastien Jondeau, on the way to Rome for one of their regular trips for Fendi, made a quick stop in Saint-Tropez.

Images of Karl in the legendary resort, which would be beamed around the world in the last decades of his life, began with this little stopover.

Karl was there to visit La Réserve, a luxury hotel that was being built in the adjacent town of Ramatuelle. Not having been to Saint-Tropez in thirty years—since the heady days of Antonio Lopez and his gang—he was thrilled to be back. There was one villa at La Réserve, Number 10, that caught his eye. It was a Mediterranean-style house, stucco with a red tile roof, with six bedrooms, a swimming pool, and a pool house. It was positioned on a hill with spectacular views out over the bay and all the beaches of Saint-Tropez.

The following month, in order to see if it might make sense to spend summers there, Jondeau organized a day trip to Saint-Tropez for Karl and some friends. The group included Stephen Gan, a New York fashion editor, Brad Kroenig, a model, originally from Saint Louis, and Amanda Harlech. Jondeau booked a suite at the Hôtel Byblos so that Karl could change—even for a one-day outing, he brought plenty of luggage. Karl decided to dress in white and asked the rest of the group to do the same. He certainly played along: white jeans, white shirt and tie, short white jacket, and white leather boots.

The group hopped on a boat to go to the beach restaurant Club 55. After lunch, they went on a tour of the area, boating around the coast. They headed south from the beaches of Ramatuelle, past the lighthouse on the top of Cap Camarat, and toward another unspoiled cape, Cap Taillat, a grass-covered peak rising out of the clear blue waters of the Mediterranean. Jondeau and Kroenig did some Jet Skiing, which Karl photographed.[20]

That summer, he returned to Saint-Tropez. Jondeau organized everything about the stays, from the flights down, the staff on the planes, and the fleet of cars and cycles they had when they were at La Réserve. "He loved the times he spent in Saint-Tropez in the 1970s, and he loved the times he spent there later, as well," Jondeau recalled. "I think it was really a key time in his life."[21]

When asked, in 2007, about his favorite vacation spot, Karl cited

the new place. "For the moment, the Var in the south of France," he explained. "It was Biarritz before, but also Monte Carlo and Saint-Tropez in the past and different lives. Thought I hate the word vacation—it sounds like something empty."[22]

Karl would appear in the center of the port, perfectly composed in a white jacket, black jeans, a wide black tie, and driving gloves, fingerless in silver metallic leather. He tooled around in his black Bentley convertible, with Jondeau behind the wheel, and crowds on the sidewalk around taking pictures. One day, in the summer of 2009, he appeared in a black jacket and white jeans with a beautiful young model protégé, Baptiste Giabiconi, wearing a white sleeveless shirt and dark jeans. On the other side of the designer, Jondeau was sporting a white T-shirt that Karl had bought for him, with a slogan scrawled in black, "Karl who?"

Although Karl had had an international reputation for decades, his reach, after H&M and with all the dynamic shows that he was doing for Chanel, became increasingly global.

In 2006, Karl hired London-based, Iraqi-born architect Zaha Hadid to do a Mobile Art pavilion for Chanel that would travel the world. At the time, Hadid, though she had won the Pritzker Prize in 2004, had completed no more than a handful of major buildings. "Zaha is the first architect to find a way to part with the all-dominating post-Bauhaus aesthetic," Karl said. "The value of her designs is similar to that of great poetry. The potential of her imagination is enormous and people are only just beginning to realize how important her designs are."[23]

For Chanel, Hadid designed a swooping structure in steel and white PVC looking something like the world's most elegant spaceship. The 7,500-square-foot structure had polished black floors and vertiginous, angled white walls and was built around an open courtyard.[24] Shown for the first time as models at the 2007 Venice Biennale, Hadid's futuristic form had been loosely inspired by the shape of a classic Chanel bag.

Mobile Art traveled around the world—Hong Kong, Tokyo, New York—before settling in its permanent home, in front of the Institut du monde arabe on Paris's Left Bank. The exhibition included works by some twenty artists including the Japanese photographer Araki, French artist Sophie Calle, and Yoko Ono.[25]

"I could have kept it as a country house," Karl said of Hadid's structure for Chanel. "But I like to live in rectangular volumes—curved buildings are not really for me. Zaha Hadid is a genius but, on a day-to-day basis, genius is not always easy."[26]

In October 2007, not long after debuting the Hadid pavilion in Venice, Karl was off to Asia for a historic event, a Fendi show on the Great Wall of China. Held at sunset, it took place on a particularly scenic stretch of the ancient wall, the Juyongguan Pass, an hour north of Beijing. As it was characterized in *WWD*, "The models—44 of them Chinese, 44 of Western origins—planted their heels on that 2,000-year-old stone wonder, creating some of the most astonishing runway footage of all time."[27]

Karl had flown to Beijing ten days before the show, to finish the styling, cast the models, and discover China for the first time (an earlier trip having been canceled because of problems with a visa). One morning, Karl suggested that he and Silvia Venturini Fendi meet in the hotel lobby at 5:00 a.m. to go on a tour of Beijing. Assuming he would be late, she arrived at about 6:30 a.m. to find that he was already in the lobby, waiting. "I think it was the first time he arrived before the others because he was so excited," Venturini Fendi later said.[28] Karl made a point of visiting all of the great new buildings that were being constructed for the Beijing Olympics, to be held the following summer. He also made trips to local clubs, in order to sample the city's nightlife.

Then there was the show itself. On a platform above the Great Wall, a sloping white runway was constructed, 88 meters (289 feet) long, honoring what is considered a lucky number in China. Along both sides of the great stone wall, tall black columns held spotlights and the interlocking Fs of the Fendi logo. As the sun set and the night

grew darker, high-powered klieg lights projected spinning Fendi logos across the nearby mountains.[29]

The presentation began with a long dress, belted, in bright red, followed by another with circular motifs, a Chinese symbol of happiness. Michel Gaubert had crafted a rousing mix of music for the show: "Nsfas Groove" by Kjr Da Juniorx, an electronica star from South Africa; "That Sound Wiped" by Von Südenfed, a collaboration between the electronic duo Mouse on Mars and the lead vocalist of The Fall; and "Like an Eagle," a 1979 disco sizzler by Dennis Parker. The show ended with all of the models coming out in pairs, followed by Venturini Fendi and Karl walking together down the long runway to an enthusiastic ovation.

The afternoon before the Fendi show, Gaubert and Karl were on the wall doing a dress rehearsal. It was bitter cold but the mountains around them and the two-thousand-year-old wall running up and down the slopes were an unforgettable sight.

"Can you believe where we are, Michel?" Karl asked Gaubert. "Can you believe what we are doing? Can you believe that we get to do this?"[30]

24

STAR POWER

By the time I knew him well, he was very much talking about his childhood, his relationship with Germany. Later on in his life, he was definitely looking backward at where he came from.
—*Diane Kruger*[1]

THE WORLDS OF FASHION and celebrity had long been tied together. It was something of an arranged marriage but it worked out well for both. The actress, or the pop star, received a shot of style, while the house earned loads of free publicity. Many of the relationships, though, were only skin deep. Unlike most designers, Karl, over the many decades of his career, formed real friendships with many celebrities who were in his orbit, from Nicole Kidman to Isabelle Huppert, Kristen Stewart to Penélope Cruz. One such connection spanned two generations: Karl had been friendly with Vanessa Paradis since the early nineties, when she began modeling for Chanel; then, fifteen years later, he became even closer with her daughter, Lily-Rose Depp, whom he first met in 2006, when she was only seven years old. "I was up at the studio with my mom, who was having a fitting and had known Karl for some time," Lily-Rose Depp recalled. "Even at that age, I was aware that he was a genius, that he had such a presence, but I was taken back by how warm and kind and welcoming he was. For someone to be that way with a little kid is really rare in the fashion industry but also just in life."[2] They went on to work together, with Karl casting Depp in a Chanel show when she was seventeen, and became close enough for Karl to consider her one of

his "Choupettes," inspired by his beloved cream Birman cat Choupette. "When I got my own cat, a flat-faced Persian, we had a lot of conversations about being a cat parent," Depp explained. "He used to send me the cutest pictures of him and Choupette. When he called someone 'My Choupette,' it was just a really sweet term of endearment, someone he cared for a lot—I was always super flattered."[3]

Another illustration of how sincere and long-lasting Karl's celebrity relationships could be was his friendship with German actress Diane Kruger, whom he first met when she was a sixteen-year-old model just starting out in Paris. The blond-haired, blue-eyed Kruger had turned to modeling after a knee injury derailed her childhood dream of being a dancer. In 1992, shortly after she turned sixteen, she was sent to Karl's grand apartment on the rue de l'Université to be photographed with a few other well-known models. "It was a group of all of the new generation, of what he considered to be the next top models, and I was very young and very intimidated," Diane Kruger recalled. "And I remember from the get-go that he was extremely personable, that he was very, very nice to me. Obviously, we had that connection because we were both German and he spoke to me in German. On a photo shoot, when you are the youngest person there and it's full of adults and all of the other girls are more successful, that can make you feel much more confident."[4]

Kruger began working on Chanel beauty campaigns, modeling the house's makeup and becoming, in 1996, one of the faces of the fragrance Allure. By the early 2000s, she began going to drama school and took an apartment on the rue de Lille, near where Karl opened his bookstore, 7L, and his new photography studio. One day, she was walking down the rue de Lille when she heard Karl's voice. "He was in a big car, I think it was a Rolls-Royce, but an unusual car on the tiny Paris streets. And I remember this blacked-out window rolled down. And he was like, 'I'm so happy to see you—I've heard what you're doing—it's awesome—we have to do something together.'"

Kruger felt that Karl was picking up right where they had last had regular contact, almost ten years before. "We didn't really get to know

each other until then, when we ended up being neighbors in Paris," she recalled. "And it surprised me that he had followed my career, that he knew of my transition from modeling into acting, and that he was very encouraging."[5]

In 2004, Diane Kruger had her first major international starring role in *Troy*, a huge Hollywood production directed by Wolfgang Petersen, also starring Brad Pitt, Eric Bana, and Orlando Bloom. Based on Homer's *Iliad*, the film chronicles the decade-long war between the Greek and Trojan armies. Kruger played no less a figure than Helen of Troy, said to be the most beautiful woman in the world. She was the subject of that famous line from *Dr. Faustus* by seventeenth-century poet Christopher Marlowe, about the battle between the two armies to ensure her return: "The face that launch'd a thousand ships."

The premiere of *Troy* was to be held at the Cannes Film Festival, and the actress reached out to Chanel about the idea of borrowing a dress for the evening. She was told that Karl wanted to design an haute couture gown for her. "That, in itself, was unusual, because he doesn't do that very often," Kruger said. "He invited me to come to the studio at the rue Cambon and he asked, 'What do you want to wear? What colors do you want?' He designed it in front of me, and I still have that sketch."[6] Karl's design was a floor-length gown, sleeveless, in light blue chiffon with five tiers of powder blue feathers.

To produce the gown, Karl enlisted the *atelier flou*, which produced all of the Chanel haute couture evening wear. He introduced Kruger to Cécile Ouvrard, the head of the atelier, who was better known, as a sign of respect, as Madame Cécile. "I didn't know that one person pretty much made one dress each season, and how many hours it takes to do all of those things," Kruger recalled. "Obviously, I hadn't been exposed to that. And I loved seeing a man who was such an icon himself be so respectful to the people who got him there—I was struck by the close relationship he had with Madame Cécile, there was a mutual respect that I just loved."[7]

At the Cannes Film Festival, there was a great deal of excitement around the premiere of *Troy*, one of the most expensive films ever made

up to that point. Brad Pitt and Jennifer Aniston, in the last year of their marriage, were there. The paparazzi, of course, went wild. The group appeared together on the red carpet, and then mounted the stairs of the Palais des Festivals. The twenty-seven-year-old Kruger held her own with the big Hollywood stars, her presence bolstered by her spectacular Chanel gown. "It was a confection," Kruger explained. "It was truly, at the time, the dress of my dreams. I was so green and so young, and Karl made me feel like a princess."[8]

Diane Kruger's parents had divorced when she was quite young. And, as her friendship with Karl developed, she began to think of him as something of a father figure. "I didn't see him every day—it's not like I called him every day or we had dinner three times a week," she explained. "But we saw one another enough, and I always knew that he was someone who respected me, who thought I could do good, who believed in me. And I knew that if I felt like it, I could go by the studio at night, because he was always shooting then, and he would stop whatever he was doing and come and sit and talk with me."[9]

In March 2008, she was part of a small group that flew with Karl on a private jet to China for Chanel's Mobile Art exhibition, in the Zaha Hadid structure, that was being held in Shanghai.[10] While most of the others went to sleep, Kruger and Karl stayed up all night talking. "He traveled with this little pillow that was all faded and had hand-stitched words in German such as, 'Sleep tight.' I was like, 'What's this pillow?' He said that he had had it since he was a child, that his mother had made it for him."[11]

On the same long flight to Hong Kong, over twelve hours long, Kruger saw how bemused Karl could be about his life. "He loved presents," she explained. "I mean we all love presents but he truly *loved* them. And he was traveling with this huge Louis Vuitton case that had been custom-made and given to him by Bernard Arnault. When you opened it, it held just two crystal glasses that Karl used for drinking his Diet Coke. The extravagances of his life were not lost on him—he had to laugh at how excessive it was."[12]

As Kruger's career took off—in a mix of Hollywood films like Quentin Tarantino's *Inglourious Basterds* as well as French and German projects—she occasionally turned to Karl for professional advice. In 2012, she starred in the historical film *Farewell, My Queen*, directed by Benoît Jacquot, about Marie-Antoinette's final three days at Versailles. One of the first things she did to prepare for the role was to walk over to Karl's apartment to get his take on Marie-Antoinette.[13] "We talked about that at length—he helped me a lot to prep for that film," Kruger said. "I was scared. It was in French, and Old French. And it is one of those roles that you really can't mess up because there are so many great interpretations of Marie-Antoinette." Karl shared with her some of what he had learned of the eighteenth century, helping to ground her performance in fact. "He recommended lots of books and told me what she was like, in his opinion, and what life was like at court," Kruger recalled. "He was very much a part of that movie."[14]

The actress also spent time with Karl when he was on holiday. "In those days, he would go to Saint-Tropez all summer and he just loved the whole thing," she recalled. "And to see him in Saint-Tropez was always amusing because he was always so pulled together. In Saint-Tropez, everybody's in shorts and flip-flops and he's in a starched shirt with perfectly powdered and coiffed hair. It's not like he ever blended into a crowd."[15]

One of Kruger's most vivid memories of Karl also involves the world of cinema. In 2007, she was back at the Cannes Film Festival. She was the mistress of ceremonies for the Closing Ceremony, which is always televised live in France. Also on the final night was the screening of her latest film, *Days of Darkness* by Denys Arcand, which would be nominated in 2008 for an Oscar for Best Foreign Film. Karl, who had designed her costumes for that film, was also in Cannes, shooting a series of portraits. "At that point, Karl had never been to the Cannes Film Festival," Kruger recalled. "So, I asked him if he wanted to be my date, going up the steps on the night of the closing ceremony. He was so giddy—like a little kid. It was a different world for him and he was really into it."[16]

For the evening, she wore another beautiful Chanel gown, a floor-length, off-the-shoulder evening dress, in dark blue silk. She felt that Karl looked very handsome that night, in a tuxedo, with a high-collared white shirt, a skinny black tie, and metallic silver motorcycle gloves. On the drive to the Palais des Festivals, they sat together in the back seat of a limousine.

"I was very stressed out because I had to host," Kruger remembered. "I went kind of quiet because I was trying to concentrate. And he just grabbed my hand, held it, and said, in German, 'Look at how far you've come—I'm so proud of you.' He said it in such a sweet manner—obviously he was trying to encourage me. And then he said, 'And look at us: two little nobodies from Germany and here going to the Cannes Film Festival—isn't it amazing?'"[17]

25

LARGER THAN LIFE

The character that you see in the media is a marionette. But I am
the one who is pulling the strings.[1]

BY 2010, SIX YEARS after the H&M collaboration took his image to
new heights, Karl staged a series of shows that illustrated that he was
fully in command of his talent. As a fashion designer, as a showman, as a
cultural figure, he was setting himself apart from everyone else.

Fendi had been a hit in Milan in late February. Then, two weeks later
in Paris, he produced an astounding Chanel collection in the Grand Pa-
lais.[2] The audience took their seats facing a large white rectangle, like
a scrim, several stories in height. The music began, an ethereal instru-
mental with the sounds of howling winds, and the white rectangle began
to rise, revealing a rectangular runway covered with a series of massive
windswept glaciers. Applause!

The ice had been sculpted into forms that went up toward the sky-
lights. One had a large arch carved out of it, through which the mod-
els passed. Many wearing fake fur jackets, coats, and boots, the models
made their way through and around the masses of ice. The stage became
something of a reflecting pool, catching the water from the glaciers as
they melted.

"Karl said that he wanted an iceberg," Stefan Lubrina recalled. "At
first, he must have imagined a set that looked like an iceberg. I was
thinking of those ice sculptures you see at parties. And I thought maybe

that is what we should be doing. And I said to Karl, 'So, we should do it with real ice?' And he said, 'Yes, real ice.'"[3]

To make that happen, Lubrina and his team went to Sweden, 125 miles north of the Artic Circle, to visit the Icehotel, a complex of structures built out of ice and snow.[4] "We wanted to meet the people who do the Icehotel because they do monumental sculptures out of ice and we wanted to see how we could work together," Lubrina explained. "So, the sculptors came from there and we brought the ice from there—it was really packed snow that was brought to Paris in huge cubes and then sculpted."[5]

Fifteen truckloads of snow and chunks of ice were trucked from Sweden to Paris and taken to the Grand Palais.[6] The structure was created around the ice to keep the temperature close to freezing. Lubrina had to think about what forms would look good from three sides, for the audience and the photographers. He and his team constructed wooden structures in the shapes they needed, then packed the ice on top.

The presentations of Resort, or Cruise, Collections had always been in a minor register. Initially meant to hit retail around the time for winter holidays, Cruise was usually shown to editors and buyers on house models in showrooms. The season became more important, however, as population centers grew in warm climates and as temperatures climbed. In May 2000, Karl had decided to produce a full-scale runway show for Chanel 2000/2001 Cruise. The 1970s disco on the Champs-Élysées, Chez Régine, was the setting for the first show.

In 2004, Karl staged Chanel Cruise on an actual cruise, on one of those *Bateaux Mouches* that circle the Seine. By 2006, he decided to take the show on the road, as he had been doing with Métiers d'Art, producing Chanel 2006/2007 Cruise in New York's Grand Central Terminal. The following year, Karl pulled off a bold show at the Santa Monica airport. Giant boards indicated Arrivals and Departures, while the audience, in a massive hangar, was seated in a boarding lounge facing the runway. Two Bombardier Challenger 601 jets, each with a fuselage stamped with the Chanel logo, taxied up, and out came models wearing the latest cruise collection.

By May 2010, Karl was back on European soil, staging a Chanel Cruise show that was both dramatic and personally significant: he took over the old port of Saint-Tropez. "I have spent years of my life here," he noted. "I know Saint-Tropez as well as Paris."[7]

The collection was entitled "Riviera Bohemian." The audience was seated in the Café Sénéquier, a legendary spot with red awnings covering a huge terrace that looked out onto the port. Yachts pulled up to the pier and the models stepped off. The road between the café terrace and the dock became the runway.

"That show was a huge thing for Saint-Tropez," recalled Diane Kruger. "It was so extravagant but it was so fun. That is when the shows really started to become events, with people flown in just for the occasion. It would be like a three-day weekend with people being driven around in cars and playing *boules* on the beach."[8]

The show ended with Sébastien Jondeau roaring out onto the main square of Saint-Tropez on a 2010 Harley-Davidson CVO Ultra Limited, a totally black version of the chopper, of which only 999 were produced.[9] He swung around in front of Café Sénéquier and Georgia May Jagger, the daughter of Jerry Hall and Mick Jagger, jumped on the seat behind him. Jondeau throttled the engine as they made a turn around the square to the sounds of her father's "Let's Spend the Night Together"![10]

Two months later, in July, Karl was back in the Grand Palais for Chanel 2010/2011 Fall/Winter Haute Couture. Under the grand central skylight, a larger space than the earlier shows, he constructed an enormous sculpture of a golden lion, forty feet in height. The astrological sign of Gabrielle Chanel was Leo, so she was long fascinated by the animal. Karl had fully absorbed Mademoiselle's perfectly preserved apartment on the rue Cambon, three rooms that, decades after her death, remained charged with the designer's energy. He had seen, on a coffee table in the salon, a small bronze lion, in a regal stance, its powerful left front paw balanced on top of a ball. Karl had the small bronze blown up to the scale of the Grand Palais.

The enormous lion was positioned in the center of a large white

stage. Its ferocious front paw rested on a ball that looked like a pearl. The models stepped out of a door in the back of that orb, striding around the stage to the driving sounds of "Knight Moves" by Chilly Gonzales.

The next show at the Grand Palais was truly a jaw-dropper. Instead of being in a side wing or the central nave, the 2011 Spring/Summer Ready-to-Wear Collection spread out over the entire building. An audience of twenty-eight hundred were seated on low black risers looking onto a set that looked like a formal French garden that extended the entire length of the Grand Palais. In the center, there was a round fountain with water spraying up into the air. At the end of the central allée was a ninety-piece orchestra.

The space was inspired by *Last Year at Marienbad*, the 1961 film by Alain Resnais and Alain Robbe-Grillet, in which actress Delphine Seyrig was dressed by Coco Chanel. "The soft splash of fountains, bittersweet orchestral music, and an abstract black-and-white set echoing the dreamlike, enigmatic 1961 movie *Last Year at Marienbad* provided the background of one of the most beautiful and perfectly judged collections that Karl Lagerfeld has ever done for Chanel," wrote critic Suzy Menkes. "It was rich in imagination but ultra-light in detail, with feathers wafting across anything from a wisp of chiffon top over elegantly shredded jeans to a light tweed dress in celestial blue."[11]

It was the first runway appearance of model Brad Kroenig and his two-year-old son Hudson, who was Karl's godson. Also appearing were Stella Tennant, forty, and Ines de la Fressange, fifty-three. There was a statement there about diversity and inclusivity. At the end of the show, Karl appeared in a three-piece black suit, walking around the cavernous space with de la Fressange as the orchestra struck up the Verve's "Bitter Sweet Symphony." "It's this year in Marienbad," Karl said after the show.[12]

The couture show with the lion, in the central hall of the Grand Palais, had given Karl the idea of spreading out over the entire building. "So, we did that French garden across the 140,000 square feet of the Grand Palais," explained Stefan Lubrina. "It was so grandiose that some people

asked me if it was Karl's last show—like it was a retrospective. I was like, 'No, that is just one show—we're already working on the next one.'"[13]

In September 2010, Karl flew to New York to accept an award and to celebrate the reopening of the Chanel boutique on Spring Street in Soho. The Thursday night opening was a high-energy affair that brought out celebrities, the New York fashion crowd, and friends of Karl: Blake Lively, Sarah Jessica Parker, Diane Kruger, Sofia Coppola, Claire Danes, Russell Simmons, Liv Tyler, Peter Marino, Lynn Wyatt, and Cindy Sherman.

On Friday, Karl was at Avery Fisher Hall in Lincoln Center for a benefit luncheon for the Museum at the Fashion Institute of Technology. The museum awarded him the Couture Council Fashion Visionary Award. Karl wore a three-piece suit in dove gray with a matching shirt and wide tie with dark gray leather driving gloves, fingerless with little silver studs. Seated to his right were Anna Wintour and Amanda Harlech; to his left were Sandy Brant and Ingrid Sischy. The award was given to him by Diane Kruger. "Almost every woman in the world, from Kansas City to Kyoto, owns a piece of your design," Kruger said, "and those who don't, want to."[14]

On that trip, as he always did in those years, Karl stayed at the Mercer Hotel in Soho. Saturday evening, he left for the airport with Ingrid Sischy, in one of the black minivans that he preferred to use in New York. There had been a huge crowd gathered outside the Mercer, hundreds of people, perhaps as many as a thousand. Sischy said the scene reminded her of the crush of fans that greeted the Beatles on *The Ed Sullivan Show*. "All of these people waiting for a fashion designer, to get his autograph or to take a photo," Sischy said to Karl. "What's that like?"

"Well, it's getting better and better, or worse and worse, depending on how you look at it," Karl replied. "I am easy to spot—the white hair, the look. I am different from others—surely it's that."

They discussed when this began, with Karl noting that he had been stopped on the street before but also mentioning the H&M collaboration. "I think there is a connection with new technology," he suggested. "Phones with cameras didn't exist before. The whole system of communication has changed—my visibility increased with all of these new technologies."

"You are the perfect symbol of our technological era," Sischy pointed out.

"I'm not involved in any sexual scandal—I don't sing—I'm not an actor. For me, this public fascination is a little strange. But I have become something like a virtual character—I'm an avatar."

"How do you see your fans?" Sischy asked.

"They are not limited to any one generation or any specific age. One thing that I think is interesting, and flattering, is that many of those who shout, who stop me in the street, are young."

"What's that like?" Sischy asked.

"It makes me feel that I was right not to live in the past, not to look backward."

"I would like to look backward, however," Sischy said, turning to Sébastien Jondeau. "What happened last night, Sébastien, outside the Mercer?"

"When Karl left the hotel, there was practically a riot," Jondeau explained.

"How many people?"

"More than a thousand. They were pushing to get closer, trying to touch him, to get a lock of his hair, as though he were God."

"What do you think of all of that, Karl, what does it mean to you?"

"I'm not God," Karl replied, "but I am Good." After a laugh, he said, "Sorry, Ingrid, but I'm the king of this kind of game."[15]

Karl had left the rue de l'Université for his sparkling apartment on the Quai Voltaire, overlooking the Seine and the Louvre. He spent

two years turning the historic spaces into a futuristic cube, all steel, aluminum, and glass. It was filled only with great modern design: a chrome armchair by Marc Newson, metal tabourets by Jasper Morrison, a sweeping gray leather sofa by Amanda Levete, and sofas, cases, and installations by Erwan and Ronan Bouroullec. "I am a total fan," Karl said of the Bouroullec brothers.

One of the contemporary designers who Karl collected the most was Martin Szekely. The Quai Voltaire apartment had huge tables in Corian that Karl used for desks, a round table in aluminum and inox in the dining room, a metal console table in the bathroom, and dressers for the dressing room. "It is the search for perfection, in the form and in the material," Karl said of Szekely's work. "Particularly with materials that had not existed before. And it is the highest level of quality that could exist in this field."

In October 2011, Karl was given a private tour of a major Szekely exhibition at the Pompidou Center. He walked around the galleries with a journalist from French station TV5, Caroline Lebar, and Sébastien Jondeau. And he was not shy on superlatives. "I love this bookcase," he said. "This is perfect!" "Oh, this is beautiful!"

Szekely was also collected by François Pinault and Azzedine Alaïa, but Karl was a real connoisseur. "He's my favorite designer," Karl explained. "No one knows his work as well as I."

Szekely, unlike Karl, kept a very low profile. "Karl and I have a dialogue that takes place through pieces of furniture," he once said of their relationship. "Years ago, he ordered a bed from me, in fact, he ordered several examples. I think the thing that interests him about my work is its apparent simplicity combined with its technicality."[16]

As he toured the Pompidou show, Karl mused about what made Szekely so special. "The thing that I love about the designs of Martin is that it all seems so obvious," he said. "You have to ask yourself why no one had ever thought about it before." Karl stopped to admire a white pedestal table in Corian and resin, with four cylinders for the base and, between the layers of the top, aluminum honeycomb. He noted that he

had two in his Quai Voltaire apartment, one for drawing and one for correspondence (one of Karl's Szekely tables, in the 2021 auction of his estate at Sotheby's, sold for €264,000, or approximately $250,000).[17]

"So, we have seen it all?" Karl asked. "I don't think there is enough."

"Do you have more at your place?" the journalist asked.

"Oh, yes," Karl exclaimed. "Yes. Yes. Yes. A lot more. I have practically everything he has ever done, often in three or four examples of each."[18]

Karl was standing in the middle of his photography studio on the rue de Lille, with its big skylight and two-story-tall walls of books, camera in hand. He was with the stylist Carine Roitfeld, hair and makeup artists, and a phalanx of assistants. "The Chanel jacket is a men's jacket that became an article of clothing that is completely feminine," Karl explained. "It crossed that boundary and I love that. It has become the definitive symbol of a certain relaxed, and timeless, feminine elegance."[19]

Karl was there to shoot *The Little Black Jacket: Chanel's Classic Revisited*, a large-format book that he was publishing with Steidl, focusing on the tweed jacket that Gabrielle Chanel had launched in the 1950s. The idea was simple: black-and-white photographs, against a dark background, of a vast range of personalities, women and men, all wearing, in some way, a black Chanel jacket. Printed on matte paper, the volume gave a two-page spread to each of the 113 models, actors, and musicians. The full-page portraits were on the right; on the left was a blank page, black matte, except, near the bottom, small white lettering spelling out the subject's name and occupation.

Dubbed *LBJ* by insiders, the book opened with the project's stylist Carine Roitfeld done up as Coco Chanel. On her fingers were a pair of scissors, as though she were just about to start on some poor mannequin. The last image was Anna Wintour, shot from behind, wearing a light Chanel dress with the black jacket, and showing only the back of her perfectly coiffed bob.

In between was a remarkable collection of personalities. Carole Bouquet sat cross-legged, wearing her own clothes and jewels. The actress Maggie Cheung paired her jacket with Wolford tights, her own bra, and Miu Miu stilettos. Claudia Schiffer stood pulling her hair back and wearing, over her Chanel suit, a maid's apron. Uma Thurman was impossibly glamorous with a white organza blouse under her jacket and looking directly at the camera. Sarah Jessica Parker had on a crop top, a crown, and her hair blowing in the wind, while Jane Birkin posed laughing, the contents spilling out of her own Hermès Birkin bag. Actors included Gaspard Ulliel, in a black Chanel jacket and army fatigues, Tahar Rahim, in jeans and a white T-shirt, and Edgar Ramìrez, busting out of a Chanel jacket with his own Prada jeans.

Kanye West wore his own clothes—Acne jeans, Balmain belt, and Alexander Wang T-shirt. Carla Bruni had a guitar strapped on her back, while musical virtuoso Charlie Siem furrowed his brow and concentrated on playing his 1735 violin. Kirsten Dunst slung a Chanel jacket over one shoulder, with a Rodarte skirt, while Georgia May Jagger looked like a young Bardot with her hands up in the air, her long blond hair spilling down, and sporting a sexy black bra by Cadolle.

Producing a coffee table book is one thing, but Karl, starting six months before publication, had the whole thing taken on the road. In March 2012, a series of portrait exhibitions began a world tour. First was Tokyo, with Karl attending the opening along with Vanessa Paradis, Sarah Jessica Parker, Stella Tennant, Saskia de Brauw, and Alice Dellal. By June, *The Little Black Jacket* hit New York, at the Swiss Institute in Soho. At the opening party, Karl hung out with Lisa Bonet, Pharrell Williams, Linda Evangelista, and Lily Collins. The Manhattan stop coincided with the launch of a dedicated website, containing videos of the shoots, short films on subjects such as the complete process of making a Chanel jacket, and content on the exhibits as they spread out over the globe.

The Little Black Jacket went on to Taipei, Hong Kong, London, Moscow, Sydney, and Paris—of course, at the Grand Palais. "*The Little Black*

Jacket touched down in Berlin Tuesday night, where it has literally gone underground," reported *WWD*. "The roving Chanel exhibition has been installed in a former subway tunnel below Potsdamer Platz." Karl swept into the Berlin opening, for one thousand guests, with Laetitia Casta on his arm.[20] The project then went on to Seoul, Milan, Dubai, Beijing, Shanghai, São Paulo, and Singapore. As it unrolled, back in his Paris studio, Karl photographed twenty-one more celebrities and published an expanded edition of the book in 2013.

The Little Black Jacket revealed so much about how Karl worked: take the history of Chanel and make it modern, involve leading figures from throughout pop culture, harness the power of celebrity, manufacture buzz, and think globally. *LBJ* also represented his ease behind the camera—the portraits were uniformly excellent—and his skill as a book publisher—as an object, it was impeccable.

The entire project was another example of Karl's cross-disciplinary creativity.

It was well known by many in fashion, and certainly by Karl, that Coco Chanel had a long history with Scotland. In the 1920s, she spent several summers there with the Duke of Westminster, her dashing, immensely rich lover, hunting, riding, and salmon fishing.[21] In 1926, she even designed the interior of the Duke's estate in the Scottish Highlands, Rosehall.[22] She borrowed his clothing, sourced fabrics from local tweed mills, and made Scottish staples such as cardigan sweaters a part of the house's style for decades.[23]

"If Coco Chanel, in the fashion world, 'owns' the tweed jacket, the soul of the woven woolen fabric can be found beside the River Tweed, where the mix of soft water and skillful hands creates material that has been a staple of Chanel since the 1920s," pointed out Suzy Menkes in the *International Herald Tribune*. Because of the financial struggles of its parent company, Barrie Knitwear, one of the leading sources for the

house's cashmere sweaters and stockings, was faced with closure or a buyout by Chinese factories wanting to secure its specialized equipment. So, in 2012, Chanel acquired Barrie.[24]

In the spring of that year, Stella Tennant, who lived in the Scottish Borders, was in Paris for a Chanel show. Backstage, she heard from Amanda Harlech that Karl planned to do a Métiers d'Art show in Scotland that December. "My first thought was, 'Oh my God, that's crazy—the weather is going to be appalling,'" Tennant recalled. "Scotland in December can just be so grim—it's grey and wet and horrible and dark at 3:30 p.m."[25]

Tennant was introduced that day to Kim Young-Seong, the South Korean–born fabric director of Chanel (whom British *Vogue* called "Karl Lagerfeld's secret weapon").[26] "One thing about modeling is that there's so much you don't know about what's going on, because you turn up for the finished product," Tennant explained. "You walk in a show and you're there with hair and makeup people—you don't see the mechanics of how shows are put together."[27]

Tennant welcomed Kim Young-Seong and a member of her team on a research trip to Scotland. She gave them a tour of the Borders, going to a sheep farm to see the animals being sheared, visiting the semi-ruins of Hermitage Castle. "Kim was taking pictures of the stones in the rivers, the castle walls, the landscapes," Tennant explained. "It was fascinating to see what she was being inspired by, and to see how all of that could translate into fabrics that she would then present to Karl."[28] The scale of the work that went into preparing a show, particularly for Métiers d'Art, which were inspired by their locations, was revelatory for Tennant.

The show took place on December 4, 2012, a freezing winter evening, just outside of Edinburgh, at Linlithgow Palace. Dating from the fifteenth century, the castle was, in 1542, the birthplace of Mary Queen of Scots. Linlithgow sat on low hill, next to a small inland loch. It was a five- and six-story stone structure, roofless and in ruins.[29]

The presentation, entitled *Paris-Edinburgh*, took place outdoors, on a set built in the courtyard. A covered wooden runway formed a square.

It was built around a three-tiered fountain, over sixteen feet tall, that dated from the sixteenth century.[30] Barrels were placed throughout the courtyard, with fires for warmth, their sparks flying upward into the frigid, northern night.

"Visually, it was magical," said Stefan Lubrina, who designed the decor. "Karl had wanted a Scottish castle but everyone kept proposing these perfect places, restored, enclosed, heated and everything. Karl said, 'That's not what I want—I want a Scottish castle on a hill.' This was just perfect—the grounds were beautiful, the castle was insane, and it was such a risk to do an outdoor show in Scotland in the middle of the winter."[31]

Guests were offered hot toddies, while, at each seat, they found their very own Chanel cashmere blanket. Just before the show began, a light snow started to fall. "I think most people would say that was one of the best Chanel Métiers d'Art because the place was so atmospheric," Tennant recalled. "It was deep and rich in history and you can't imitate that. And, of course, Karl had even spun his magic on the weather, with that flurry of snow as people arrived." Tennant was struck by how effectively the decor amplified the setting. "The set was very subtle, with a wooden roof around the whole interior of the grange and then the place was lit up so you could see the ruins, empty windows. And then the music started, this beat—you could have dropped a pin in there. The anticipation and the pent-up excitement—it felt historic."[32]

The sound of drums filled the arena and out came Tennant, looking regal in a long dark coat trimmed with tartan plaid, and gray cashmere sweater and scarf. "Guests were whisked away on a highland fling that saw tweeds and tartan, Fair Isle knitwear, sporran-inspired bags, and argyle tights," noted design magazine *Wallpaper*. "It was a collection that was also in part dedicated to Mary Stuart herself—one couldn't miss the oversized feather ruffs and the regal white gowns."[33]

The presentation ended with Tennant and Karl walking arm in arm around the covered runway, with the light snow still falling. "And lots of people who came to the show were people who had never been to a

fashion show, as well," Tennant recalled. "I don't quite know how they do it—it's almost like Chanel has their own Lord-lieutenant in each county, and they know what dignitaries to invite wherever they go. So, that added to the excitement. I was very honored to open that show."[34]

Afterward, hundreds of guests made their way down the hillside, with paths lit by torches, and bare trees illuminated by up lights. On the top of a rising, backlit, a half dozen musicians, in full Scottish regalia, with pleated tartan kilts, horsehair sporrans, and tall black feathered bonnets, played drums and bagpipes. Dinner was served in a glass-roofed hall with octagonal tables and centerpieces with greenery, fresh fruit, and ivory candles.

For the *Paris-Edinburgh* advertising campaign, Karl turned to another great representative of Scotland, Tilda Swinton, the actress who lived in the Highlands. Swinton had not been able to attend the show, it was just after her mother had died, but she flew to France to be photographed by Karl. The setting was the Château d'Écouen, the National Museum of the Renaissance, north of Paris, in front of somber wall tapestries that had a distinctly northern feel.[35] "I will never forget him arriving four hours late at the chateau where we were shooting and complaining how dark everything was from behind the thickest black sunglasses," Swinton recalled. "We had, as ever, light and quick fun. He was relaxed and happy and full of fabulous stories of Dietrich that day."[36]

Swinton, no slouch when it comes to the intellectual, was struck by the quickness of Karl's thinking. "I remember a small debate about whether an artist was German or Austrian and he ended the question with, 'All the same thing, according to the Anschluss,'" Swinton recounted. "Sometimes, in terms of the span and thrust of it all, it felt like one was conversing with someone from the 18th century."[37]

The following fall, November 2013, the actress was in New York for an evening in her honor given by the film program at the Museum of Modern Art. It was a benefit for the museum and Karl was a cochair. He had just flown into New York after a trip to Brazil for the latest extravaganza for *The Little Black Jacket*. "I remember the somewhat emblematic moment when

we first met that evening, downstairs in MoMA, surrounded by reporters and photographers," Swinton recalled. "Karl had just returned from São Paulo and he greeted me with loud—and enthusiastically repetitive—protestations about how *dirty* everything there had been. I remember trying to divert and shout over him, drown out the subject and siphon him away from the scrum." But she also noticed that Karl did not seem to be bothered by all of the attention. "It occurred to me that the kerfuffle gave him a certain special twinkle, like he was enjoying the frisson and was playing with us all."[38]

In February 2013, Mathias Rastorfer, of the Galerie Gmurzynska, pulled off another exhibition of Karl's photography. Entitled *Karl Lagerfeld: Fire Etchings*, it was held in the St. Moritz branch of the gallery, on the slopes of the Alps. The show was a grouping of Karl's large-scale photographs that had been etched into glass. "It was St. Moritz at its peak, just after Christmas, with only top, top VIP's there," Rastorfer remembered. Karl had wanted the event to include a meal, so the opening was scheduled at 12:00 p.m., with lunch, for fifty leading collectors, to begin at 1:00 p.m. Karl was flying private from Paris, yet, by 2:00 p.m., there was still no Karl. Rastorfer called Paris to see if anyone knew when he might arrive. Then, it was 3:00 p.m. and Karl had still not shown. As the time stretched on, no fewer than ten guests left the lunch, furious that the designer had not shown up. The dealer was increasingly distraught. He eventually turned up at 4:00 p.m. As Rastorfer recalled, "I said, 'Karl, glad you're finally here.'"

He had a comeback that defused the tension. "It was totally disarming," the dealer recalled. "You couldn't be angry with him. And what is interesting is that the 40 people who were still there ended up having a very personal time with Karl. Later, those 10 who missed it said, 'Shit, I shouldn't have left!'"[39]

Karl's response when the dealer snapped at him about turning up so late? "*Ende gut, alles gut*," or, "All's well that ends well."

26

A KEPT WOMAN

Choupette is the center of this household. Everything revolves around Choupette.[1]

ON AUGUST 15, 2011, a Birman kitten, also known as the Sacred Cat of Burma, was born. Her given name was Choupette. At several months old, she was given to Baptiste Giabiconi, the model and muse for Karl. Over Christmas, Giabiconi asked if Karl would mind taking care of Choupette.

Karl had never had a close connection with a pet. When he had a Jack Russell, Lord Ashton, it was really Jacques de Bascher's responsibility. After de Bascher died, Lord Ashton receded into the background. Karl had no photos of him and he was parked in Monte Carlo at La Vigie. "The dog is in Monaco," Karl explained when Lord Ashton was seven years old. "He doesn't travel—he hates that."[2]

He was not particularly open to cats, either. Once, when Sandy Brant and Ingrid Sischy were staying in Biarritz, their cat, Cassidy, went missing and the house had to be turned upside down (the cat was eventually found). "My best friend, Sandy Brant, had a cat, and I thought it was too much, all the fuss about the cat," Karl later explained. "Then a friend of mine came with Choupette and said, 'I'm leaving for two weeks, can you keep the cat?' When he came back, I told him that the cat was not returning to his house, and I kept it, this kind of genius creature."[3]

Choupette was a particularly beautiful Birman. She had long pale fur, slightly darker around the face and ears, and large, expressive eyes

in sapphire blue. Karl, suggesting that the shade was celadon blue, said her eyes were the color of jewelry by Suzanne Belperron, a Paris jewelry designer that he collected.[4] Karl quickly became besotted with his new pet. "I don't have any boss," he once explained, "other than myself and Choupette."[5]

Françoise Caçote was a good friend of Sébastien Jondeau's—her husband was one of his childhood friends. Jondeau was looking to hire another maid for Karl and he thought she might be right. "When Sébastien first told me that he was looking for someone, it made me a little nervous," Caçote recalled. "He has such a big personality and when you don't know him, he could seem a little cold." She went to the rue de l'Université just as Karl was moving out, in order to meet him and have a sense of what he was looking for. "He arrived with Sébastien, who introduced us, and, right away, he was adorable. He was not at all how you might think."[6]

Caçote began working in September 2008, by the time he had moved into his last two Parisian addresses, 17, Quai Voltaire and around the corner at 8, rue des Saints-Pères. The Quai Voltaire was used more as his atelier and a place to sleep, while the rue des Saints-Pères, an eighteenth-century building, was where he would receive guests and have lunch. She was responsible for taking care of the apartments, having the laundry done, and doing grocery shopping.

Caçote alternated weeks with another maid, so she was not there on the day that Giabiconi brought Choupette. Once she returned, she was surprised that Karl would be so enthusiastic about a cat. "I didn't think he was capable of being attached like that but then I immediately understood why," Caçote explained. "He lived alone and he quickly became used to seeing this bundle of fur around the house. He would talk to her, for example. And after two weeks of having this presence, this personality, I understood why he was upset about not having Choupette around anymore."[7]

Once Karl was able to pry the cat away from Giabiconi, he noticed that Françoise Caçote had a good rapport with her. "It was Monsieur

who told me, 'Françoise, when you're not here, Choupette is not the same," Caçote explained. "On the weeks that I was off, he would send me texts from Choupette, 'I can't wait for you to come back.' 'I miss you!' It was really cute."[8]

Caçote began to deal more and more with Choupette and she saw the increasing importance she had in Karl's life. "Absolutely," she replied when asked if it was clear that Karl planned to give her such a luxurious life. "For him, she was a princess. She carried herself, and she still does, like a princess. And Monsieur wanted to make Choupette a cat that was not like any other."[9]

Karl decided that Françoise Caçote should focus on Choupette (which she has continued to do since Karl died). "I became Choupette's nanny," she said with a laugh. Karl wanted Caçote to take care of her during the day and to travel with them. Their first big trip was to New York. "It was the first time I had been, so that was already grandiose," Caçote said. "And, on the flight, Choupette did not stay in her case—she had the run of the plane. She really liked to travel—she was totally at home, walking around, going into the cockpit to see the pilot. The only thing that she didn't like was when she had to be put back in her case for takeoff and landing."[10]

At the Mercer, Choupette stayed in Karl's suite. If he went out, Françoise Caçote stayed with her in Karl's rooms. When it was time for Karl's place to be cleaned, she would take her back to her room. "Choupette really loved the Mercer," Caçote explained. "Each time we arrived, she went crazy. She would run around the room. Monsieur told me that the first night, she was always out of control: jumping on the bed, then jumping down and running around the room. She really had fun."[11]

Choupette was equally comfortable at the Hassler Hotel in Rome, where Karl had been staying since the 1960s. "One time, though, we stayed in a hotel in Rome owned by the Fendis and we saw right away that Choupette was not happy," Caçote explained. "She went to hide in little corners, out of the way places—behavior suggesting that something was wrong. But at the Mercer and the Hassler, she was totally at home."[12]

As Choupette's nanny, Caçote was astounded at how grand her own life became, flying private around the world, staying in the best hotels. "I would have never imagined that," she said. "Monsieur was so adorable with me. I would take Choupette down to Saint-Tropez, where another governess would take over, and he told me that I should take the jet back to Paris, on my own. Those are things that I could never have thought might happen, that I would be so well taken care of."[13]

On the Quai Voltaire, Choupette was allowed to slip between the Richelieu embroidered bed linens that Karl kept, an old-world elegance that contrasted with the futuristic architecture and design.[14] When they stayed together in Saint-Tropez, Choupette took full advantage of the big garden of the villa at La Réserve. As Karl described her, "Choupette is such a kept woman!"[15]

She quickly became an international star. Karl photographed Choupette constantly—at one point he thought he had ten thousand photos of her. He worked her into fashion shoots, with Laetitia Casta or Linda Evangelista. She was soon on the cover of *Harper's Bazaar* with Karl, German *Vogue* in the arms of Evangelista, and Brazilian *Vogue* with Gisele. Soon, Choupette was earning big bucks doing advertising campaigns, for Chanel, the German carmaker Opel, and cosmetics brand Shu Uemura. "I didn't want her to work but she had an offer from the Japanese and it was a massive success," Karl said. "In one trashy French paper they asked the reader, 'Are you shocked that a cat can make so much money?' Eighty-two percent were shocked, so I sent the editor a letter saying I was sorry to find that 82 percent of their readers were envious people. What can I say? She is the Garbo of cats."[16]

Choupette and her over-the-top lifestyle could seem silly, even offensive. "He was so extreme in every single thing he did," noted Fran Lebowitz. "So, if he's going to have a cat, he's going to have a cat that has a diamond necklace. That cat had a better life than about 90% of the human beings on planet earth."[17]

Karl often compared Choupette to the famous painting by Diego

Velázquez, *Las Meninas*, 1656, that hangs in the Prado Museum in Madrid. It depicts the Infanta Margaret Theresa, the five-year-old daughter of King Philip IV of Spain, surrounded by an entourage of staff and two *meninas*, or ladies-in-waiting, one kneeling before her and the other giving her a curtsy. In the foreground was a slumbering mastiff. Karl was once asked if, by referencing the Velázquez canvas, he saw himself in the long line of royals and their pets. "No, because in the case of Choupette, I am the *menina*, the lady-in-waiting. She is the Infanta!"[18]

The relationship for Karl, as comical as it could be, was deeper than it might first appear. "I think Choupette made me a better person," he once explained, "less selfish.[19] To have an emotional connection with another being, having not had anything like that since Jacques de Bascher had died over twenty years before, was something new for Karl. He was anxious about Choupette's well-being, making sure that she was taken to the vet every ten days.[20] "I never thought that I would fall in love like this with a cat," he said simply.[21]

People around Karl saw how his behavior changed once Choupette came into his life. "He would send me texts with a photo saying, 'Choupette says hello,'" recalled Silvia Venturini Fendi. "'Choupette says goodnight.' It was not Choupette—it was Karl. He was reserved about showing his feelings and this was a way for him to show that he was thinking of you, that you are part of his little family."[22]

Amanda Harlech also observed that Choupette softened Karl. "Ninety percent of the time with a cat, it will come and sit on your legs or jump up and sit on your lap," Harlech pointed out. "Or it will sleep on your head—which she did with Karl—he took a really good picture of that—or sit on his work when he's trying to concentrate. It's that thing of contact and I think Karl felt that acutely."[23]

Harlech also made an amusing observation to Karl. With her beauty, her knowing eyes, her pampered existence, and her feline ability to be withholding, Choupette, Harlech suggested to Karl, was really his mother. "Exactly!"

Karl also had fun with Choupette, realizing that the whole thing was quite camp. He provided her carriers from Louis Vuitton and custom-made travel kits from Goyard. And he got a kick out of how demanding she could be. "Thursday morning, she woke me up at 6:00 a.m.," Karl once explained. "She went to her bowl, came back, sat on my chest, and stared at me. She wanted her breakfast, but it had to be fresh. So, I served *mademoiselle*. She is very couture, Choupette."[24]

27

YOUNG FRIENDS

Meeting Karl changed so many things in my life.
—*Anne Berest*[1]

AS KARL'S RENOWN GREW, there was no shortage of people who clamored to be close to him. Many in his inner circle, in fact, felt the need to shield him from those who might have had bad intentions. And some did. One fashion editor had a partner who worked for Karl and overbilled him in a shocking way—that relationship was wound down. "People didn't take advantage of Karl," pointed out Éric Pfrunder. "He was generous, he gave gifts, but he always knew what he was doing—he was the one who was in control."[2]

But there were many new acquaintances that Karl made that were immensely rewarding, though he was in his eighties and many of the people he met were a fraction of his age. Two very different encounters in those years, one with a French literary figure, the other with a Silicon Valley social media tycoon, gave a sense of the breadth of the appeal that Karl had late in his life.

Anne Berest was one of those figures that only the French intellectual world seems to produce: young, attractive, charming, and terribly stylish. In 2014, the thirty-five-year-old author published *Sagan 1954*, marking the tenth anniversary of the death of French writer Françoise Sagan and the sixtieth anniversary of her debut novel, *Bonjour Tristesse*. Published in 1954, when Sagan was only nineteen years old, *Bonjour Tristesse* was a literary sensation. Karl, touched by Berest's text about

the novel, a book that blended essay, biography, and memoir, sat down and wrote her a fan letter. "I met him in my mailbox," Anne Berest explained of her introduction to Karl. "It was astonishing. I would have never thought that one of my books could have led me to meet someone so impressive."[3]

Berest, the great-granddaughter of Surrealist artist Francis Picabia, already had a notable career. She had founded and was the editor in chief of *Les Carnets du Rond-Point*, a quarterly publication for the renowned Théâtre du Rond-Point; had authored a play based on the memoir *Pedigree* by Patrick Modiano, who, in 2014, won the Nobel Prize in Literature; and had published two well-received novels exploring families and contemporary French society, *Her Father's Daughter* and *The Patriarchs*. She had been approached by Françoise Sagan's son, Denis Westhoff, to write a text about the making of Sagan's debut novel. Berest studied the time between the teenage Sagan's submission of her novel and its publication, which made her a star, and her close friendship with Florence Malraux, the daughter of French author and culture minister André Malraux. "The first two novels of Anne Berest were beautiful stories haunted by the issue of paternity," wrote *Le Monde*. "*Sagan 1954* is a forceful, racy text about friendship and sisterhood."[4]

Karl's letter to her, handwritten, of course, covered five pages. "You can imagine why the year 1954 would have attracted his attention," Berest explained of the year Karl won the Woolmark Prize. "And he loved Françoise Sagan. So, it was a long letter explaining how much he loved the book. I wrote back to tell him how touched I was that he would write, and that is how we eventually met."[5]

Karl invited her to come to a shoot he was doing at Castel, the legendary club in Saint-Germain. Berest recalled being a little intimidated. But one of the first things she said to Karl certainly grabbed his attention: "You know, I sleep every night with Jacques de Bascher?"[6]

Berest went on to explain that she had a poster of the David Hockney portrait of de Bascher on the wall in her room, opposite her bed. "That made him laugh and we started talking."[7]

One of their first topics of conversation: the eighteenth-century writer Princess Palatine, whom Karl knew so well. "She is one of my favorites," Berest explained. "She was hideously ugly, and enormous, and she wrote a lot about her hideousness and her body, all with such wit. She had an extraordinary way of expressing herself, and her correspondence, which is like a thousand pages, is a joy to read. When Karl brought up the Princess Palatine, he saw that I knew her well and I think he liked that."[8]

Karl and Berest struck up a friendship that was intellectual and literary. She would go to shows in Paris or to some of those that were held internationally. And there would often be a moment that she and Karl would find to have a chat. "In Salzburg, I remember, backstage after the show, we spoke about the Austrian novelist Hugo von Hofmannsthal," Berest recalled of the Métiers d'Art show held in Austria in December 2014. "I speak German and really like German literature, so we had that in common. Backstage, he would see me, and for five minutes, we would talk about literature, or just have a laugh. In the middle of the crowd, all of that madness backstage, it was like we were in this little bubble."[9]

Berest was taken up by Chanel and began to do some writing for the house. For the 2014/2015 Fall/Winter Haute Couture Collection, Karl closed the show with a sculptural white gown of neoprene, worn by New Zealand model Ashleigh Good, with a long train embroidered with gold. "The bride steps with sandals across the immaculate ground of the Grand Palais, as if entering a church," Berest wrote. "The golden slippers are flat but the dress is huge and its train is endless. Ashleigh Good advances like a virgin clad in white. Suddenly, before the startled eyes of the spectators, a spectacular roundness is revealed: the bride is pregnant! Her belly, full as a moon, is sublimated by the movements of the white fabric, the dress of an empress in neoprene."[10]

To close the show with a pregnant woman in a virginal gown was obviously a strong statement. "Instead of being a provocation, it is more the idea of provoking something: surprise, reflection, emotion," Berest wrote. "What does it say to us? That life is surprising, with the unexpected springing up around every corner. And, most importantly, that

a woman's forms cannot be fully erased, that it takes curves to give life. On the arm of the designer, the bride was transformed into a metaphor of creation, that of an impending birth."[11]

Berest was struck not just by the design but by what it said about Karl as a designer. "He was someone who always, at some point, knew how to create a surprise," she recalled. "His shows always created a moment, a shock—and that wedding gown was one of them. It was really something that set Karl apart as a designer, his ability to create a surprise."[12]

The author was often impressed by Karl's knowledge and attention to detail. In that first letter he had written to her, he cited a few factual errors that were in her book *Sagan 1954*. "It had to be written quickly, to be published on a specific date, and there were some points that were not accurate," Berest remembered. "He said that this boutique was not at this address but at another, for example. He always wanted things to be precise—he was crazy about historical accuracy."[13]

Asked how she would describe his character, she insisted on his vast range of knowledge and interests. "He was, in just one man, a connection between the 17th and the 22nd centuries." Berest cited his great timidity, which would seem to be surprising for someone who was so in the public eye, and his insistence on elegance in all areas, sartorial, of course, but also in terms of thoughtfulness and manners.

She recalled doing an interview with Amanda Harlech for a Chanel podcast. They spoke in Coco Chanel's apartment at 31, rue Cambon, looking at the founder's library, discussing her design of the famous 2.55 quilted bag.[14] "And Amanda told Karl how much she enjoyed the time that we had spent together and that she liked what I had to say," Berest recalled. "The next day, I received a bouquet of roses that was so big that I could barely hold them. I didn't even have a vase that was big enough. And he did to thank me because Amanda had been so touched by our exchange."[15]

When considering Karl's character there was one aspect that Berest found particularly fascinating. "I was struck by his mix of seriousness and humor," she pointed out. "Those are difficult qualities to reconcile

in only one person. But he was the most serious man that there was and he could also be the funniest. When the two are pushed to such an extreme, that makes for someone really exceptional."[16]

The relationship with Chanel came at an important time in the author's life. "I had been having some financial difficulties and being able to write for Chanel made a major difference," she said. "In a way, it felt like it was in the tradition of Gabrielle Chanel, who helped writers quite a bit, helped them to live. She was happy that this money that came from fashion could also help people that were far from that world. I think there was a little of that, a kind of patronage that was not really a patronage—it was something quieter and more intimate."[17]

After her encounter with Karl, Berest went on to have even more success as a writer. She was the coauthor of a 2014 best seller in the United States, *How to Be a Parisian Wherever You Are*. In 2017, with her sister, she cowrote a highly acclaimed book, *Gabriële*, about her great-grandmother, the wife of the artist Picabia. Berest was the screenwriter and cocreator of a 2019 French television series, *Mytho*, while her most recent novel, *La Carte Postale*, 2021, was short-listed for the Prix Goncourt (and in May 2022, she was awarded the first American version of the prize, the Choix Goncourt United States).[18]

Anne Berest had her second daughter in 2016. For some time, first when she was pregnant and later when she had a newborn, she had not gone to any fashion events. "Then I went to a Chanel show at the Grand Palais," Berest remembered. "Backstage afterward, it was as packed as usual—just crazy. I saw Karl and thought that I didn't want to bother him, because I had not been around for so long. He saw me, though, and he said, 'There she is, the young mother!'"[19]

Berest was astounded that, in the midst of a media scrum, Karl would notice her and immediately have a personal comment to make. "I said to myself, 'How can he remember, in that moment, in the middle of the madness?' And it made me realize that this incredible attention that he had for others was not just for me, that it was something that he had for everyone."[20]

The opening days of the 2015 Fall/Winter Ready-to-Wear Paris Fashion Week, at the beginning of March, attracted a very different kind of visitor: Kevin Systrom, the thirty-one-year-old cofounder of Instagram. "It is said that the Eiffel Tower is the most photographed monument on Instagram," observed *Le Monde*. "For two days in Paris, it was actually Kevin Systrom."[21]

Launched in 2010, the photo-sharing social media platform had been acquired two years later by Facebook for a cool $1 billion. Young, good-looking, and a multimillionaire, Systrom impressed Parisians as a different kind of Silicon Valley mogul. He had short dark hair and designer stubble, and wore trim dark suits with snappy white shirts. "I'm not the stereotypical founder of a startup wearing tennis shoes," Systrom explained. "Perhaps because I grew up near Boston, in a preppy school, in a preppy city."[22] Born and raised in Concord, Massachusetts, and a graduate of Stanford, he had long been passionate about photography and image, hence his idea of starting Instagram.[23]

The app was certainly known in France, having over three hundred million users worldwide at that point, but it was not as ubiquitous as it would become in later years. In order to raise its profile and create some glamorous international content, Systrom and his team decided on a trip to Paris. He was given a grand insider's tour of the city organized by Hugo Borensztein, a senior executive with Instagram and Facebook in France. And, of course, every stage of Systrom's trip was documented on social media.

At the Hôtel Plaza Athénée on the Avenue Montaigne, a lunch was prepared by Alain Ducasse, one of the most accomplished chefs in France. In the restaurant's kitchen, Systrom used his iPhone to shoot Ducasse as he grated truffles onto toast. "One more photo and then we eat," the chef announced.[24] On the spot, the silver-haired Ducasse was inspired to join Instagram (he now has five hundred thousand followers). After lunch, a wall of photographers shot Systrom as he took selfies with Ducasse. The Instagram founder also toured the offices of advertising

giant Publicis, at the top of the Champs-Élysées. On the building's spectacular rooftop terrace, he and his team posed for photos in front of the Arc de Triomphe. The 2014 FIFA World Cup, which had taken place the summer before in Brazil, had been a key event for Instagram's international growth. So, Systrom made a trip to Le Parc des Princes to see Paris Saint-Germain play Monaco, where they posed for pics with some of the team's star players.

Of course, an official Instagram stay in Paris had to include fashion. So, Systrom was able to visit the Chanel offices on the rue Cambon, where they were given a tour of the private apartments of Mademoiselle. Systrom did some selfies in front of Coco Chanel's lacquered Coromandel screens. He sat for interviews with leading journalists—including French *Vogue*, *Elle*, *Paris Match*, and *Le Monde*—and spent time with Louis Vuitton designer Nicolas Ghesquière and LVMH's Delphine Arnault.

Another fashion highlight was a dinner in Systrom's honor hosted by Jean Paul Gaultier. Held in the main hall of Gaultier's studio, on the rue Saint-Martin in the 3rd arrondissement, the dinner was organized by Karl's great friend Françoise Dumas. In the kitchen, Instagram's Borensztein told Dumas that she couldn't do a dinner without actually having an account. So they downloaded the app for her, to get her started. "And now I'm obsessed, of course," Dumas said.

The dinner featured one long table for fifty guests, a glittering group that included French stars such as Catherine Deneuve, Arielle Dombasle, Laeticia Hallyday, and Antoine de Caunes, along with models including Karlie Kloss and Gigi Hadid (both already had several million Instagram followers). Systrom wore a sharp black suit by Brioni, a white dress shirt, and a black Charvet tie. "Every entrepreneur has a little something that sets them apart from the others," he explained of his more formal look that night.[25]

As impressive as the schedule was, Systrom told his team that there was something else that he would really love to do: meet Karl Lagerfeld. Hugo Borensztein, also in his early thirties, shared that enthusiasm. "I grew up in the suburbs of Paris and, for us, Karl had always

been an icon," Borensztein explained. "He was someone who had been at the top of his game for decades. I remember that as soon as smartphones came out, so many used an image of Karl as their screensaver or for their case."[26] There were also professional reasons. Of course, photography and image were at Karl's core, but there was a larger idea. "At Facebook and Instagram, we were always looking for the next big thing," Borensztein said. "But we approached that systematically, almost intellectually: always trying to analyze what might be next on the horizon. Whereas Karl just seemed to know instinctively: what's next?"[27]

The Chanel show was happening in one week and Dumas knew that Karl was incredibly busy. But the night before the Gaultier dinner, she texted him to see if he might be available to meet Systrom.[28] Karl texted back the day of the dinner saying that he would make time. That night, he was shooting the Chanel press kit at his studio at 7, rue de Lille. Because Karl was working, the group had to be limited to no more than four: Dumas, Borensztein, Systrom, and his fiancée, Nicole Schuetz (the couple would marry that fall in Napa Valley).

It was late in the evening at the Gaultier dinner and Systrom had started making himself comfortable, taking off his tie and opening up his dress shirt. Around 11:30 p.m., the four made their way to the car for the trip to the Left Bank. On the way over, Systrom seemed somewhat nervous, putting his tie back on and buttoning up his shirt. "I think we were all a little nervous," Dumas said. "You had to be careful about disturbing Karl when he was working. And this was pretty surreal—an encounter between two people who were mythical."[29]

They arrived at the rue de Lille, where the bookstore was closed and the lights were off. They rang the buzzer and waited. There was always music playing during a shoot and it took awhile for anyone in the studio to hear their ringing. They stood there in the dark for a few minutes, making everyone feel a little more stressed.

The group was ushered into 7L and introduced to Karl and his team: Éric Pfrunder, Sébastien Jondeau, assistants, stylists, and models. Karl was wearing black jeans, a three-quarter-length black jacket, a white high-

collared shirt, his black glasses, and black leather gloves. Everyone in the studio knew about Instagram and were thrilled to meet the founder. Karl and Systrom had a friendly chat. Then it was time for a photo. A light beige backdrop was rolled out for the shot. Systrom was positioned in the foreground, sitting on a chrome stool, his hands folded on his lap. Karl stood behind, with his gloved hand on Systrom's shoulder.

After the first attempt, Karl asked how it looked. "It's fine," he was told.

"Fine isn't good enough," Karl answered. And they took another pic.

It was after midnight by the time the Instagram group left the studio. Normally, there was a procedure in place for Systrom to post to his account, a corporate process. Yet, on this occasion, as soon as he was back in the car, instead of running the image by anyone else, he posted the photo of him and Karl, the thirty-one-year-old Silicon Valley whiz kid and the eighty-one-year-old fashion designer.

"OK, one last one," Systrom wrote for the caption. "Life goals: unlocked!"

28

A FIERCE DETERMINATION, SOME MISSTEPS, AND THE FINAL BOUQUETS

He didn't want to declare weakness or doubt. Ever.
—*Amanda Harlech*[1]

IN MAY 2015, KARL jetted off to Seoul to present the Chanel Cruise Collection, then to the Cannes Film Festival, where he was launching a book, *Fendi by Karl Lagerfeld*, to be published that summer by Steidl. By June, he was at his villa at La Réserve in Saint-Tropez. One afternoon, he called Sébastien Jondeau, who was at the beach, to tell him that he was having a problem. "I am sorry for bringing this up," Karl told him, "and I don't know how it has happened, but I am not able to piss."[2]

Jondeau had noticed that Karl seemed to be a little swollen, and he had complained recently that he seemed to be gaining weight. By that point, 2015, Jondeau had been with Karl virtually around the clock for the better part of two decades. "He was never sick, so, this kind of issue had never come up," Jondeau recalled.[3] He immediately swung into action and called doctors in Paris, who arranged to have blood work

done by a nurse in Saint-Tropez. To avoid any press leaks, Jondeau put the medical tests in his name.

At 4:00 a.m., he received a call telling him that the tests showed elevated levels of creatinine and prostate-specific antigen, or PSA. The results were shared with the doctors and, in two days, Karl was back in Paris, seeing a surgical urologist. Another specialist wanted him to have an MRI as soon as possible. The following morning, on doctors' orders, he checked into the American Hospital in Neuilly-sur-Seine. "Karl's body is full of liquid," Jondeau recalled in his memoir (*Ça va, cher Karl?*, or, *How are you, Dear Karl?*, the phrase he texted him every morning). "Nine liters are withdrawn. Kidney function levels have exploded—we are deep in the red zone."[4]

Jondeau alerted Éric Pfrunder, who joined them for the appointments. From the hospital, Jondeau also called Bruno Pavlovsky and Virginie Viard at Chanel to tell them that Karl was having problems with his kidneys. He also told Amanda Harlech, who was at Karl's new country house in Louveciennes, west of Paris, to have dinner with him, Anna Wintour, and Annette de la Renta.

At the American Hospital, the patient was conscious but exhausted. He sent selfies to friends like Virginie Viard, suggesting that all was fine. The reality was considerably darker. "There is the fear that Karl will have to have dialysis for the rest of his life if his kidneys do not start functioning again," Jondeau recalled. "The doctors have probably used the word cancer with Karl but not in front of us."[5]

He was in the hospital for ten days, where his kidney function resumed. But it was determined that Karl had prostate cancer.

When he was discharged from the American Hospital, he went straight to the rue Cambon to work.[6] "We were in the middle of preparing haute couture," recalled Virginie Viard. "He told me that, at the hospital, they had decided not to operate. My father was a surgeon,

so I knew that when a decision is made not to operate, it is not always good."[7]

Viard knew much more than almost anyone else about Karl's condition. "As soon as we understood what the issue was, Karl wanted to make sure that no one else knew about it," Jondeau explained. "I am sure there are some who wondered but it was never said directly."[8] For the next five years, Jondeau would be the only member of Karl's entourage who knew the full extent of what was happening with his health.

"He never spoke with anyone about it," recalled Éric Pfrunder. "He never once complained. He didn't want to bother anyone—he just kept going straight ahead—he didn't flinch. What courage!"[9]

Karl's lawyer, Céline Degoulet, saw that Karl avoided any mention of his health. "He always said that it was not to be a burden to others and that he did not want it to become a subject of discussion," she explained. "I think it also allowed him to keep working without feeling that everyone around him was talking about it. When it's known that someone is sick, there is the temptation, consciously or not, to have pity for them. And that is the absolute last thing that he would have wanted."[10]

That was certainly one way to approach a fatal disease, and many who were close to Karl have lauded his desire to shield others. There were, of course, other strategies. He could have chosen to open up to some of his closest friends, to let them know, discreetly, what he was going through. That, too, would have required courage, to face the disease and to demonstrate vulnerability. But Karl, who could be so sensitive to the conditions of others, was, when it came to himself, very much a stoic. So, any talk of his cancer, his treatment, and his condition were all verboten.

Françoise Caçote, another of the very small handful of people who were with Karl on a day-to-day basis, never discussed his health, with Karl or with anyone else. "Even if I heard other people mention things, little pieces of gossip, I didn't think it was possible," she remembered. "I did not think that someone who was sick could work as much as he did. Just not possible."[11]

When Caçote found out much later that Karl had first been diagnosed

in 2015, she saw a conversation that they had at that time in a different light. Karl was planning to take a trip to the south, to Marseille and possibly to Corsica, and he mentioned to her that there was always some danger.

"If something were to happen to me, could you take care of Choupette?" he asked Caçote.

"But nothing is going to happen to you," she replied. "You'll be back tonight."

"Yes, but there are bombings down there, terrorist attacks—you never know," Karl replied, not wanting to let the issue drop. "I need to know: Would you be able to take care of Choupette?"

"Only later, when Sébastien explained that Monsieur had been sick since 2015 did I make the connection," Caçote explained. "He wanted to know that if something happened to him, Choupette was going to be OK."[12]

Earlier that year, when Karl knew that he was ailing but before he sought treatment, he had an unusually contentious moment involving nostalgia.

Amanda Harlech was curating a retrospective of Karl's work for a German museum, the Bundeskunsthalle, in the capital city of Bonn. The exhibition, entitled *Modemethode*, looked at six decades of Karl's designs for every major house he had worked for, including drawings, fashion, and accessories. It opened with an installation of his desk, covered with drawing pencils and notepads, and included the re-creation of the coatdress that earned him the Woolmark Prize in 1954. "When we were planning that, Karl was 100% enthusiastic," remembered Gerhard Steidl. "The title was his and he gave us many ideas and a lot of input. When I was in Paris, I showed him floor plans, installation design, wall texts, etc. And then, when the exhibition was to open, Amanda and I asked him if he was going to come and he got furious!"[13]

It was that issue of Karl not wanting to focus on his past work, in order to keep fully engaged in the present. But, in this case, he became incensed. "He was screaming and yelling, 'For months, you have held me up in my work with this old shit! And now you are asking me if I am coming? I know everything—I did these things—why should I come to see things I did before?'"[14]

While other designers loved nothing more than having their past enshrined in an exhibition, the idea had always horrified Karl. Particularly at a time when he was being reminded of his own mortality, the thought of a retrospective was ominous. "I don't think Madame Vionnet kept all her old dresses," he once pointed out. "Coco Chanel never kept one dress—when I arrived at Chanel there were no archives. Fashion is something that other people can keep. But a designer who builds his own archives is like he is building something funereal for himself. I think it's a frightening idea. It's against life and fashion is about life."[15]

In July 2015, just weeks after his hospitalization, Karl was finishing a short movie with Kristen Stewart and Geraldine Chaplin that would be premiered at that December's Métiers d'Art show in Rome. He was in his trailer, waiting for the last scene to be filmed, when he was told that Ingrid Sischy was calling from New York. He said that he would call her back—it was getting late—but Sébastien Jondeau suggested that it seemed that it was important that they speak.

"I am calling you today because I have to leave in two days and I wanted to thank you for all of your friendship and love for the over 20 years that we have known each other," Sischy told Karl.

"You may come back," Karl replied.

"I may be gone within two days—there is very little hope."

Karl had last seen Sischy in May, at the Cannes Film Festival. He noticed that she was very thin, and his first thought was that she was

dieting. The look on Sandy Brant's face, however, suggested that it was more serious.

Although the rest of their phone call was unclear in Karl's memory, he realized that she was in too much pain, that speaking was difficult. He could hear Brant next to Sischy, crying. Two days after their conversation, on July 25, 2015, Ingrid Sischy, sixty-three years old, died of breast cancer at Memorial Sloan Kettering Cancer Center.

"Karl just adored Ingrid," said Éric Pfrunder, who was often with them for the photo sessions they did around the world. "It was interesting because she was someone who could respond to Karl intellectually and he loved that. She had a remarkable knowledge of culture and art. And to see them together was exciting because they were two cultural giants who, instead of clashing, had a dialogue."[16]

At the beginning of November, only five months after his own cancer diagnosis, a memorial was held for Sischy at the Museum of Modern Art in New York. Some three hundred guests attended, including Sandy Brant, Anna Wintour, Miuccia Prada, Donatella Versace, Ralph Lauren, Brice Marden, Francesco Clemente, Julian Schnabel, Chuck Close, and Graydon Carter. There were performances by Elton John, Laurie Anderson, and K. D. Lang singing an emotional version of "Hallelujah."

Wearing a black suit, white shirt, and wide black tie, Karl gave a eulogy for his friend. "I never do speeches—I only answer questions," he began. "So, I had to write Ingrid a letter. For me, Ingrid is not dead—I never pronounce that word—she just left before us, is all."

Karl stressed that he had been friends with Sischy for twenty-five years, and with Brant for forty-five years. He spoke of how they would have phone calls, usually on a Sunday, the three of them on the same line. "Hello, my angel," was how Sischy would begin the conversation. "Certainly not the way most people see me, *huh*?" Karl said, to laughs.

As he described their last phone call, lifting up his glasses so that he could read the text, Karl choked up and starting crying. "That was the only time I ever saw Karl weep," said Amanda Harlech. "Agony."[17]

Karl barely remembered how that last phone call with Sischy finished. After they hung up, he took some time to return to the set and the film they were shooting. "I had to get my face back together to face the crew and the actors for this little comedy," he continued. "It was a scene when everyone was laughing and drinking champagne. We finished and I left quickly. Sébastien drove me back to Paris and the Quai Voltaire, where Choupette was waiting for me—I wanted to be alone, with only her silent but strong presence."[18]

One of the most extraordinary shows that Karl staged in his later years took place in May 2016, when he decided to take the Chanel Cruise Collection to Cuba. He later said that he had only been joking about the idea, that he thought it was so improbable that it could not actually happen. But Cuba was a place that had long fascinated him. From the time he was very young, he had loved Latin music. Growing up in Hamburg, in the years before and after World War II, he had seen sailors leaving for South America and the Caribbean. Those ships sailing to and from the distant tropics had fired his early imagination.[19]

Particularly in recent years, however, Karl's shows for Chanel had become big, flashy, capitalist juggernauts. To stage that kind of a production, the first international fashion show in Cuba since the 1959 revolution, in a communist country could be problematic.

There had been signs of a thaw. Nine months earlier, the American embassy had reopened; two months before, Barack Obama had visited Cuba to meet with Raúl Castro, while the very week that Chanel landed on the island, on May 2, the first American cruise ship in forty years docked in Havana.[20] "Going to Cuba was a gamble and Karl loved that kind of thing," explained Michel Gaubert. "He had always adored Latin music and was always talking about how he knew how to dance the Cha Cha. So, going there was a dream. He said, 'Michel, there won't be any decor—the decor will be the music.'"[21]

Gaubert went to Havana in January 2016 to begin scouting out the musical scene. "I saw, I don't know how many groups," he recalled. "I didn't want to choose the ones that were like a picture postcard of Havana. It shouldn't be like Chanel does Cuba—it needed to be more thought out than that."[22]

Chanel flew in seven hundred people to the island: clients, journalists, and staff from around the world. The house brought in forty-five international models, hiring two more in Cuba. Karl called the collection "Coco Cuba," creating a connection where none had existed. "It's all a bit of a crazy fever dream," wrote Amy Larocca in *New York* magazine. "High capitalism in Havana? Giddy consumption and luxury lust?"[23]

The main headquarters was the Hotel Nacional de Cuba, a towering edifice on a hill overlooking the city and the Caribbean. The fittings were done in a neoclassical nineteenth-century theater, the Teatro Martí, which had just been restored. Karl, surrounded by his Chanel team, sat at a card table piled high with colorful jewelry and accessories such as a clutch shaped like a cigar box. "It's a stupid idea," Karl said with a smile, "but it's an idea." As the Chanel team and the models worked, from an upper balcony came the soft sounds of a trio—bass player, maracas, and a singer.[24] "Instead of playing music on a stereo, we had bands come and play every afternoon, while Karl was doing fittings. Again, he was like a child—just delighted to be there."[25]

There was one member of Karl's entourage that did not make the trip to Cuba. He had planned to take Choupette, until he found out that there would have to be a quarantine. "Can you imagine?" he asked Françoise Caçote. "Choupette trapped in a quarantine?" Instead, she stayed in Paris, well cared for by her nanny.[26]

To see the island, Chanel arranged to have a fleet of cars and vans shuttling guests around. They visited Ernest Hemingway's house on the edge of the city, the Museo de la Revolución, and Old Havana, the historic section, founded in the sixteenth century. They were shuttled to the Factoria Habana to see an exhibition of two hundred of Karl's photographs, *Obra en Proceso/Work in Progress*, part of a

monthlong festival of French culture.[27] There was also a night on the town at El Tropicana, a famous 1930s nightclub with a spectacular floor show consisting of a full orchestra and a huge chorus of singers and dancers, men in tight pants and tiny vests and women in long ruffled dresses, bare midriffs, and sky-high headdresses. "It's all a mad blur of activity and heat and cultural overload," suggested *New York*'s Larocca.[28]

On the night of the show, some two hundred brightly colored convertibles, tops down, filled the circular drive of the Hotel Nacional. Guests jumped in and the caravan made its way along the Malecón, the majestic drive along the seawall. The show was being held on the Paseo del Prado, a wide pedestrian walkway, dating from the eighteenth century, that was paved with marble and lined on both sides by shade trees.

The audience was seated on park benches, along the runway that was 984 feet long. Guests included Vanessa Paradis, Tilda Swinton, Gisele Bündchen, Alice Dellal, Gaspard Ulliel, and Vin Diesel, who happened to be filming *Fast & Furious 8* in Cuba. The buildings lining the Paseo were filled with city residents, on balconies, on rooftops, leaning out of windows, taking in the spectacle. A band, positioned at the end of the runway, began to play and the audience and the onlookers went quiet. First out was the vocalist duo Ibeyi, twenty-one-year-old twin sisters Lisa-Kaindé and Naomi Díaz, who had just been featured on several tracks of Beyoncé's *Lemonade*.

The twins continued singing as they walked down the runway, the band played a medley of vigorous Cuban music, and out came Stella Tennant, wearing white pinstripe trousers, a black jacket, and a Panama hat. As the dusk faded, runway lighting took over and the historic buildings on both sides of the Paseo del Prado became the backdrop for clothes that were colorful, laid-back, and chic. "What made it work, in essence, was the easy styling, with T-shirts and flats, a casual attitude that the models clearly felt happy in," suggested *Vogue*. "So happy that the end of the show broke out into an anarchic kind of carnival where the girls and the audience and the local band all got mixed up together, dancing."[29]

For the finale, Karl, with his godson Hudson Kroenig, came out in black jeans, black boots, and a rainbow-colored sequined jacket that Hedi Slimane had designed for Saint Laurent. Closely behind was a marching group of musicians. "For the end of the show, I chose this group of percussionists, very tribal, almost like voodoo," explained Michel Gaubert. "There were about 30, all dressed in white. They came out with all of the models and everyone—celebrity or not—stood up to dance along with them. I had never seen that before—everyone dancing—it was fantastic."[30]

Then came the after-party. The guests hopped back into the convertibles and were transported to the Plaza de la Catedral, a large, historic square in front of the main cathedral. They downed mojitos and danced to more Cuban bands. Sandy Brant, wearing a simple black sleeveless dress, spun around the dance floor with Karl, still sporting his fabulous sequined jacket. "He just loved to dance," Brant recalled. "It was so sweet."[31]

Karl was taking serious medication for his prostate cancer, an oral chemotherapy.[32] Yet, that night, he did the mambo, the rhumba, and the cha-cha. He danced with Vanessa Paradis, French actress Cécile Cassel, his godson, and many others in the teeming crowd.

For an eighty-two-year-old with cancer, he certainly seemed to be up for it. "He spun all of us around the dance floor with ageless élan," remembered Tilda Swinton.

Once Karl and his Chanel team had taken over the entire Grand Palais, in October 2010, the shows had become increasingly ambitious.

In October 2012, for the 2013 Spring/Summer Ready-to-Wear, Karl had a long runway made of dark blue and silver solar panels and topped by two rows of a half dozen massive wind turbines in white steel. Large solar panels were also used for walls near the runway entrance, while the sleek

white windmills turned, creating a pleasant breeze throughout the Grand Palais. A writer at the *Atlantic* specializing in renewable energy felt the show made a serious statement about the future of alternate forms of fuel.[33]

A year later, for 2014 Spring/Summer Ready-to-Wear, Karl turned the Grand Palais into one big art gallery. He drew some seventy-five works of art and had them produced to hang on the walls of the gallery. The audience was seated on risers opposite a long art-filled white wall, while the runway was the kind of concrete floor seen in galleries and museums around the world. The music: "Picasso Baby" by Jay-Z. The following season, Karl turned the Grand Palais into a supermarket, with shelves stacked with more than one hundred thousand items made just for the show: Coco Chanel Coco Pops, Confiture de Gabrielle, Eau de Chanel mineral water. "Plus 30%, Right Now!" read one sign.

After the supermarket, Karl decided to take to the streets, making a statement about feminism and the French penchant for protest. For 2015 Spring/Summer Ready-to-Wear, he created a full-scale reproduction of a Paris streetscape, with a square of Haussmannian buildings, four facades, that were seven stories tall. The buildings had balconies, storefronts, and, in one case, scaffolding around the ground floor for a renovation. The wide street in the center, a boulevard, had actual curbs, sidewalks, and grates. The photographers' pen at the end of the runway was separated by the kind of metal fencing used for crowd control in Paris. The audience sat on either side of the street, on industrial metal risers. The end of the presentation turned into a noisy protest, with English model Cara Delevingne shouting feminist slogans into a megaphone. The soundtrack was Chaka Khan's "I'm Every Woman." The other models behind her, in their chic Chanel pantsuits and day dresses, shouted along, holding signs and banners that proclaimed, "HISTORY IS HER STORY," "LADIES FIRST," or "WITHOUT WOMEN THERE WOULD BE NO MEN!" Karl, wearing a three-quarter-length black coat and carrying an iPhone, marched along the long boulevard with the throng of models.

But one of the most astonishing shows Karl staged in the Grand Palais took place in March 2017, for 2017/2018 Fall/Winter Ready-to-Wear. "I

would like to have a rocket," Karl said to the set designer Stefan Lubrina. "And I started thinking about the story. If there is a rocket, there needs to be a launchpad. Where is it going? There needed to be some kind of story around it."[34]

For Karl, it was essential that the set and the fashion work together. "The colors and materials of the set are often inspired by the choice of fabrics in the collection," Lubrina explained. "Karl often told me that he dreamed of an idea for a set. I think that, more than anything, he dreamed of the collection that was going to be presented within that set."[35]

The two thousand members of the audience arrived at the Grand Palais to find, standing in the center, a glossy white rocket that was 35 meters tall, approximately 115 feet, or over ten stories. It had black interlocking Cs on each side and metal bracing on either side at the base. The runway, white, elevated on a metal structure, snaked around the massive nave. The entrance to the show was through a two-story white and steel structure with, spelled out in letters on the top, "Centre de Lancement, N° 5." It was an official launching center.

The soundtrack began with a remix of Kraftwerk's "Radioactivity," a futuristic bit of 1970s electronica. The models stomped out with go-go boots, metallic headbands encrusted with pearls, and gravity-defying *Barbarella* hair. "There's going to be space clothes but not silly like the 60s," Karl said before the show.[36]

"The starship Chanel crew will be wearing glittery lunar boots with co-respondent black tips, tweed tunics with standaway collars, Bermuda shorts, 'insulated' silver leather suits, and metallic padded space stoles," reported Sarah Mower of *Vogue*. "When the craft navigates to the dark side of the moon (perhaps), eveningwear will consist of black and white chiffon 'space person' prints and garments embroidered in constellations of Chanel pearls. Satellite bags will be carried."[37]

As the show wound down, a Daft Punk track, "Contact," buzzed and twitched. A group of models assembled on a circular section of the runway, standing at attention at the base of the rocket. Karl walked out, again with his godson, Hudson Kroenig. They went over to a small white

stand, pressed a red button, and a countdown began. The metal sup-
ports slowly shifted away from the rocket. "...3...2...1...*Liftoff!*"
And in a cloud of smoke and pyrotechnics, the rocket appeared to move
up toward the top of the Grand Palais. Cue Elton John's "Rocket Man."

One front-row section of Anna Wintour, Kristen Stewart, Pharrell,
Sofia Coppola, and Vanessa Paradis sat there applauding, smiling, their
mouths open wide. "It was a vintage piece of theatre from fashion's great
showman," suggested the *Financial Times*. "A pure spectacle with no
expense spared."[38]

Karl spent some six months working on every set with Stefan Lubrina
and his team. After Karl's initial idea of a rocket, Lubrina mulled it over
and said to Karl, "Wouldn't it be great if the rocket lifts off?"

Karl's response: "Of course, it should lift off!"[39]

Lubrina laughed about his comment but their collaboration was a se-
rious, involved process. After Karl's initial idea, Lubrina would design
the set and conceive how the audience would be placed, in order to vary
the seating each season. He would produce plans, elevations, and 3D
modeling, also involving additional specialists: light, sound, seating con-
tractors, and security. During the research-and-design phase, Lubrina
led a team of ten or twelve, while construction would require a workforce
of fifty, sixty, or seventy. And all of this for a fashion show that lasted no
more than a quarter of an hour.

Karl and Lubrina had developed a way of approaching these produc-
tions that was a real creative partnership. "He came up with an idea that
was crazy and I did what I could do to make it even crazier," Lubrina
said. "Every idea was a new challenge. Of course, there were budgetary
concerns, but that was between Karl and Chanel. We always started from
the position, both of us, that nothing was impossible."[40]

That summer, August 2017, just a few months after the Chanel rocket
lifted off, was the unveiling of an interior that Karl designed at the

Hôtel de Crillon, on the Place de la Concorde. "That was a real dream for him," said Caroline Lebar. "If you asked him what outside project he loved the most, it would probably be the Crillon."[41]

In 2013, Paris architect Aline Asmar d'Amman had been selected to be the artistic director for a complete restoration and renovation of the legendary hotel. It was an ambitious project, a full five years of work, with some eight hundred workers and a budget of €150 million (although some said that it was closer to €400 million).

Commissioned by Louis XV and completed in 1758, the Crillon was designed in the purest eighteenth-century neoclassical style. The architect was Ange-Jacques Gabriel, who had built the Petit Trianon and the Opera at the Château de Versailles. Gabriel was also hired by Louis XV to create the Place de la Concorde, the largest square in Paris, and the series of colonnaded limestone buildings that mark the end of the space, opposite the Seine, including the Crillon.

The hotel had been purchased in 2010 by a Saudi prince, Mutaib bin Abdullah bin Abdelaziz Al Saud, who had already hired Amman to design his houses in Beirut and Riyadh. "I had a great relationship with him and his wife, who dresses a lot in haute couture and is fascinated by fashion," explained Amman. "And I thought that the Orientalism that she represents matched perfectly with the idea of Karl Lagerfeld, who had just done, in 2011, this Byzantine collection for Chanel, inspired by the painter John Frederick Lewis." Some of Amman's images for inspiration came from the Chanel 2010/2011 *Paris-Byzance* Métiers d'Art.[42]

Although she had never met Karl, she wanted to approach him about the idea of designing suites for the hotel. She had founded her firm, Culture in Architecture, only that year and did not know anyone who knew him. She had long been an avid reader and was a regular customer of Karl's bookstore, the Librairie 7L. So, in March 2013, she decided to sit down and write a letter and ask a member of the staff if they would have the letter delivered to him. The 7L employee was not encouraging.

Amman, who is nothing if not ebullient, wrote her letter on beautiful stationery, with an embossed family crest at the top. She wrote:

March 29, 2013

Cher Monsieur Lagerfeld,

The Hôtel de Crillon is closing its doors for a renovation.

Because this renovation is being done in the spirit of audacity and savoir faire;

Because there is not, anywhere in the world, a suite in a great hotel that has been designed by Karl Lagerfeld;

Because this suite will be the perfect Parisian pied-à-terre that will be a symphony of design, art, fashion, and photography, and French decorative arts;

Because there is so much to be done and you are the only one who can do it;

I would be very honored to meet you, if possible, at your convenience, to discuss.

Cordially,
Aline d'Amman
Art Director of the Hôtel de Crillon.[43]

The next morning, at 11:00 a.m., she received a message on her cell phone. "Hello, this is Karl Lagerfeld," said the unmistakable voice. "I received your letter. I really liked it—no one writes letters anymore. I will call you back in 30 minutes to discuss. Here's my number—talk to you soon." When she listened to the message, she was panicked. "Has it already been 30 minutes?" she asked herself. "It's a miracle—Karl Lagerfeld is calling my cell. I can't believe it!"[44]

Amman stayed right next to her phone, and, within a few minutes, Karl called back. He told her, once again, how much he liked the letter and made an appointment for the next day at 8:00 p.m. in his studio be-

hind 7L. "In 24 hours, it is not like you can really prepare for a meeting with Karl Lagerfeld," she said with a laugh.

Amman met with Karl and they immediately had a good rapport. He agreed to design suites for the hotel, and, because he was going to need a trained architect for the project, asked her to be his architect (in addition to her duties as art director for the overall project). Karl had given the original eighteenth-century architect's model of the Crillon to Stefan Lubrina. He asked him to bring it over to his studio so that Amman and her team could study it. "If he was agreeing to do this, at 80 years old, it meant that it was an important decision for him," Amman explained. "It also meant that by doing this, he was choosing not to do many other projects. So, it was important that everything go as well as possible."[45]

Two months after their first meeting, Amman and Karl toured the Crillon, which had been stripped of all of its furnishings, making it nothing but a construction site. "At the entrance on the Place de la Concorde, Karl arrived in his sumptuous Rolls-Royce, with his jewelry, his allure, his incredible aura," Amman recalled with wonder. "We were alone, the sun was beginning to set, and we went into the hotel, completely empty, with dust hanging in the air. And Karl says, 'Those are real mirrors. That is fake. Oh, wow, they added that there?' I soaked it all up, all of this vivacity, almost a mysticism—I was learning more from him than I ever could with a book."[46]

They did not visit the entire hotel. Karl knew that he wanted to see spaces on the fourth floor, looking out over the Place de la Concorde and, in the distance, the Grand Palais. "And we will call them *Les grands appartements*, because that is what they are called in Versailles," Karl said.[47]

One of the most impressive things about the experience for Amman is how everyone—fabric houses, contractors, tool manufacturers—wanted to do whatever they could to make the project a success because it was for Karl. "Everyone totally played along," she explained. "Just by the power of his name, the Manufacture Royale Bonvallet produced from

its archives the same roller that had been used for the marriage of Marie-Antoinette and the dauphin, which Karl then used to emboss a grey velvet that was almost the color of concrete. He was a major influence on the entire project."[48]

Karl wanted the two interconnecting suites, a total of over 3,200 square feet, to represent the height of French classicism, to reflect the gray of the skies of Paris, and to include elements of modern French design. The sofas were pale gray, the window coverings were ivory, and the bathrooms were gray and white Carrara marble. Enormous photographs of Versailles taken by Karl covered the wall and the rooms were filled with a curated selection of books. "A must-see in a lifetime," suggested *Forbes*. Of course, at €30,000 (around $30,000) a night, not many people will actually be able to see the suites.[49]

"It was an extraordinary encounter," Amman said of her work with Karl. "But nothing in life happens by chance—you have to work for something like this and you have to be sincere. With Karl, you couldn't lie. You couldn't try to be one person with him and someone else in real life. He knew—he scanned everything."[50]

And, in December 2017, when Karl was eighty-four years old, two and a half years into his battle with cancer, he returned to Hamburg to stage one of his most poignant, and impressive, shows. The Chanel 2017/2018 Métiers d'Art *Paris-Hamburg* included some personal nostalgia, of course, but, in keeping with his spirit, it was also resolutely modern.

Françoise Caçote and Choupette went with Karl on his flight back to Hamburg. On the way to their hotel, he had them driven through Blankenese, the neighborhood where he had been born, with its wooded estates and views out over the Elbe River. "I saw that this trip was very important for him," Caçote recalled. "And he absolutely wanted Choupette there with him."[51]

Those who worked closely with Karl continued to be in the dark

about his condition. "Sébastien said that I was like a rottweiler, asking questions at dinners at the rue des Saints-Pères," said Amanda Harlech. "I was like, 'What are those pills for?' 'And what's this?' I asked Sébastien, 'What's really going on with Karl?'" It was obvious to Harlech that there was a serious medical issue and that it was getting worse. "I could tell by his eyes that were no longer brown but black—and staring at you as though you were a vast distance away, when you're just a foot away from him in the lift leaving Chanel."[52]

If Karl had wanted to stage a triumphant German homecoming, he could have done that at any point in his career. His desire to stage a major show then was certainly connected to his condition. "His decision to do Hamburg, I think, was because he knew that this was going to be tough, that he wasn't going to beat this cancer," Harlech said. "I know retrospectively that he was told at the beginning that they could deal with this with a pill form of chemo, when he really should have just done the operation. He had been very optimistic and then the numbers went up."[53]

One insider saw a barometer of Karl's health in the way he took photographs. At first, he had always stood and moved with the camera, up or down, to get the best shot. Then, he would stand still, limiting his movement. Next, he began sitting down, stationary, and shooting, until, finally, he would stay seated and direct assistants who actually took the photo.

In planning for *Paris-Hamburg*, he chose to delegate some of the photography. "He asked me to go to do photographs of Hamburg for a book that would be given to guests," Amanda Harlech explained. "I said, 'Why don't you want to photograph Hamburg? I mean, this is the song of your soul?'"

Karl deflected: "I've got too much to do."[54]

So, in November 2017, Harlech went to Hamburg with Gerhard Steidl, producing moody black-and-white images of boats in the harbor, factories enveloped in fog, massive container ships. "Steidl got hypothermia, trying to photograph Hamburg on a boat," Harlech recalled. "But I knew that the sense of Hamburg that Karl wanted was this misty, foggy, looming,

beautiful place."[55] The goal was also to document the rehabilitation of Hamburg's waterfront. *Die Renaissance einer Stadt*, or *The Renaissance of a City*, with its impeccably reproduced black-and-white photographs and a linen cover in gray, traditionally a shade of half-mourning, was given to all of the guests in Hamburg.

Karl, though he was beginning a new treatment protocol, participated in everything leading up to the show.[56] Choupette was even brought along for previews of the collection with top editors.[57]

The night before the show, a dinner was held at a traditional German restaurant in Blankenese, where Karl was seated next to Lily-Rose Depp. "He was telling us about how he loved going to this restaurant growing up, about the things that he would eat there, about his mother," she recalled. "That, for me, was a really, really special moment."[58]

Other guests that night were equally touched. "It was lovely that he wanted all of us in this place that had been so important for him," remembered the writer Anne Berest. "He never showed his emotions but you could tell that he was moved." Karl stayed at the dinner longer than was necessary, talking with friends and coworkers. "He had returned back to where he began and he was there with all of the people that he loved," Berest continued. "Because the people he worked with were his family. I found that really moving."[59]

While it was clear that Karl was stirred by being back in Hamburg, and that he was inspired by the city where he had been born and raised, he swept away the very idea. "But not at all," he said about the suggestion that he was nostalgic. "I am here for the new building."[60]

Karl's Métiers d'Art show was taking place in the recently completed symphony hall, the Elbphilharmonie, by the star architects Herzog & de Meuron. The hall, towering over the Elbe River, the tallest building in Hamburg, had been built on top of a 1960s warehouse. "Rising more than 100 meters above Hamburg's harbor like a great glass galleon marooned atop an old brick warehouse, the Elbphilharmonie concert hall looks as unreal as its computer renderings, first published 13 years ago to gasps of incredulity," noted the *Guardian* of London. "The gargantuan

glass tent rises to a roofline of frothing peaks, inscribing a silhouette of waves across the city's low-rise skyline, like a chunk of the sea that's been frozen, chiseled out of the water and craned into place. The building is already a landmark, visible from far down the river—evoking a ship in full sail."[61]

The interior of the twenty-one-hundred-seat hall was as impressive as the exterior. A multilevel amphitheater arranged around a central stage, it featured one thousand handblown glass lamps, ten thousand uniquely carved acoustic panels, and walkways and loges suspended in the air.[62] "I must say, it's stunning," Karl enthused about the interior.

The show began with a full orchestra onstage, led by Oliver Coates, an English cellist best known for his collaborations with Radiohead, playing variations of "La Paloma," a nineteenth-century song written by a Spaniard, and very popular on the docks of Hamburg, a moody, meaningful song that had been chosen by Karl. The strings began and the models, one by one, began appearing from the highest point in the hall. From the sailors' caps to the heavy knit sweaters to the smoky eyes, the collection was Karl's very specific vision of Hamburg. "Tonight, its most lauded, world-famous son returned with a slam-dunk of a Chanel Métiers d'Art show, a collection anchored in the seafaring character of the town of the River Elbe," wrote Sarah Mower in *Vogue*. "You saw the essence of his inspiration in a flash: sailors in peaked caps on leave, girls in thigh-high boots and leather, the people who mill around docks and nightclubs. The clothes evoked '60s beatniks, countercultural girls in sweaterdresses, smartly dressed officers in uniform, and naval ratings in sailor pants—looks that ran up and down the register of the cook, the hip, and the immaculately classic."[63]

Karl appeared at the end of the show wearing black jeans, a black jacket, a white shirt, a wide black tie, and black leather gloves. Members of the audience were visibly moved by the collection, by Karl's fragility, and by the valedictory feel of the show.

Colombe Pringle ran backstage afterward to congratulate Karl, noticing, fully for the first time, that he was ill. "Karl was not good at all,"

Pringle said. "You could see that he was physically ill at ease. And he was starting to put some distance between himself and others, except for those who were very, very close."

She saw him during the after-party, in a corner with Vanessa Paradis and a few others, and was planning to go say hello. "During the dinner, Marie-Louise de Clermont-Tonnerre came back from seeing Karl and she was crying," Pringle recalled. "She said, 'It's just too sad.'"[64]

In private, Karl had long been adept at the cutting comment. In the early '90s, he had the artist Jeff Koons and his then wife, La Cicciolina, the former porn star and member of the Italian parliament, over to his house on rue de l'Université. After they left, Karl remarked, "Of the two, the biggest prostitute is not the one that you might think."[65]

For those who really knew Karl, or for the fashion world that understood his significance as a designer, those kinds of observations were amusing. He had become very good at going right up to the limits of propriety while staying within an acceptable discourse. But as Karl became increasingly well known and the mainstream and tabloid press were ever more keen for scandal, his more outlandish takes were picked up and broadcast around the globe. For many, those catty comments were all they had ever heard about Karl.

If he had usually been able to handle the press perfectly, Karl seriously miscalculated in the spring of 2018, just weeks after the triumphant return to Hamburg, when he sat down for an interview for French fashion magazine *Numéro*. "Last year, I lost two of my best enemies," Karl said, about the deaths of Azzedine Alaïa and Pierre Bergé. Of Bergé, he added, "For his funeral, my florist asked, 'Do you want us to send a cactus?'"

The contempt between Karl and Alaïa was mutual—they were at opposite ends of the designer spectrum. The Tunisian-born Alaïa was very much an artist, working at his own pace, ignoring the commercial constraints of the industry and surrounding himself with a group of models

and editors and stylists who adored him and the meticulousness of his designs.

"I don't criticize him," Karl said disingenuously, "even if, at the end of his life, he did little more than make ballerina costumes for menopausal fashion victims." Ouch. Karl also claimed that Alaïa blamed him personally for the excessive pace of fashion, when, in fact, he was only following the rhythm of the industry. His rival designer had made those criticisms, Karl went on to say, "before he busted his face on the stairs." Just a few months before, Alaïa had died falling down the stairway at his house in the Marais.[66]

Karl did not reserve his ire that day for old rivals. He was asked which of the three young designers he would rather be stranded with on a desert island: Virgil Abloh, Jacquemus, or Jonathan Anderson. His reply: "I'd kill myself first."

None of those comments covered Karl in glory—they were ugly—but it was his discussion of #MeToo that was particularly problematic. It was only a matter of months after the Harvey Weinstein story had been broken in the *New York Times* and the *New Yorker*. Although Karl made it clear that he despised Harvey Weinstein, he seemed unsympathetic to the realities of sexual harassment. "What I find shocking is all of these starlets who have taken twenty years to remember what happened," Karl said. "Then there is the fact that there are no witnesses." He also suggested that new sensitivities in the wake of #MeToo could harm his creative freedom, as though that were more important than the right not to be sexually assaulted. As for accusations that had been made against one fashion editor, Karl Templer of *Interview*, Karl said that he did not believe one word. "One girl complained that he had grabbed her panties and he is immediately excommunicated from a profession that had worshipped him? Unbelievable! If you don't want to have your panties grabbed, then don't become a model. You should try a convent—there will always be a place there—they're even recruiting."

Although he congratulated Hedi Slimane on becoming the new designer at Céline, Karl also slagged off men's fashion. "Having to put up

with all of those stupid models, no, thanks. Not to mention the fact that with all of their accusations of harassment they have become quite toxic. No, no, no—don't leave me alone with one of those sordid creatures."[67]

The story was picked up all over the world and caused quite a stir. "Every Unbelievable Thing Karl Lagerfeld Said in his Latest Interview, Translated from the French," was the headline in *W.* Vanessa Friedman, the fashion critic for the *New York Times*, called Karl "Fashion's Shock Jock." She made a comparison between him and Donald Trump. "As with the president and his tweets, Mr. Lagerfeld has been saying outrageous things so regularly for so long and with such gumption, that everyone is numb to the substance," Friedman wrote. "It's almost expected. He's positioned himself as a provocateur: it's part of his brand."[68]

One of Karl's first controversies had come in the fall of 1984, with the program notes for a Fendi show. It was a body-conscious collection, at a time when the fitness craze was taking off, and Karl coined the phrase, "Shaped to be raped." Serious outrage. "It is a terrible misunderstanding," said Carla Fendi, representing a house that was led, after all, by five sisters. "To think that we, of all people, would want to insult women." Karl had the idea from a line in French, *formée pour être désirée*, or "shaped to be desired." As Carla Fendi explained, "Then he said, 'Shaped to be raped,' and it rhymed so well in English that we all laughed. He likes to shock a little but he really didn't mean to offend anyone."[69]

In the spring of 1997, when Stella McCartney was named designer at Chloé, taking over after Karl left, he greeted the news with a dig. Privately, he referred to her, a daughter of Paul McCartney, as the "Baby Beatle." Publicly, he said of Chloé's decision, "I thought they would choose a big name. They did, but in music, not fashion." It was a line that stung enough that McCartney was still mentioning it decades later.

In 2012, Karl commented on Adele's weight, suggesting that she had a beautiful face and divine voice but that he found her "a little fat." He soon backpedaled, claiming that his statement was taken out of context. "I would like to say to Adele that I am her biggest admirer," Karl said, reminding all that he had struggled with his weight. "I know what it is

like when the press is harsh about your physical appearance. Adele is a beautiful woman. She is the best and I look forward to hearing her next album."[70] Later, in an interview on CNN, Karl was less apologetic. "I only said that she was a little roundish," he explained. "A little roundish is not fat. But, after, she lost eight kilos, so I think the message was not that bad."[71]

In February 2017, just before the Academy Awards, Karl picked a fight with Meryl Streep. He told *WWD* that the actress had requested a dress from Chanel for the Oscars but backed out when she found another label that offered to pay her to wear its dress. "A genius actress but cheapness also, *non*?"

One of the problems with Karl's comment: it was not true. His first instinct was not to back down. But when he learned that he had been given wrong information, and that the spat was endangering the relationship between Chanel and Hollywood, Karl apologized. "After an informal conversation, I misunderstood that Ms. Streep may have chosen another designer due to remuneration, which Ms. Streep has confirmed is not the case. I regret this controversy and wish Ms. Streep well with her 20th Academy Award nomination."

It was an apology that was *not* accepted. "I do not take this lightly, and Mr. Lagerfeld's generic statement of regret for this 'controversy' was not an apology," Streep fired back. "He lied, they printed the lie, and I am still waiting."[72] Karl's initial comment, which the publication should have run by the actress before it was printed, was, rather than a lie, simply based on bad information.

But Karl's comments the following year to *Numéro* were not accidental. After publication, there was no statement of regret, generic or otherwise. It was as though someone who had been so adept at walking the line, of being just controversial enough, was unsure of where the limits were. He was also eighty-four years old at the time and he had been battling cancer for more than three years. Those factors do not excuse the ugliness of some of his remarks but they can explain why he would have been off his game.

The journalist who conducted the *Numéro* interview, Philip Utz, did not think it was any more controversial than other talks they had had over the years, suggesting that each had required some cleaning up afterward. "I did fifteen interviews of Karl, covering everything from the allegedly homosexual pope to Karl's experiences with pedophiles," Utz explained. "Chanel was always furious."[73]

J ust after the Hamburg show, Karl started growing his beard, which was as white as his powdered hair. "With this beard, I am really starting to look like Choupette," he stated. "We are like an old couple. She even takes care of the beard—we sleep on the same pillow and she spends her time licking it."[74]

It was becoming harder to deny that Karl was dying. "He always said that he was something like the Phoenix, rising from the ashes," said Véronique Perez from Chanel. "It was clear that he was tired, that he was slowing down. But when I saw that he had grown a beard, I thought that maybe, once again, he was going to be like the Phoenix. But no . . ."[75]

Karl was making a quick trip and decided not to take Choupette with him. Normally, Françoise Caçote would stay with Choupette on the Quai Voltaire. But, that time, he asked her if she would take Choupette to her place, a house northwest of Paris. Caçote said that she was happy to stay, as usual, at Karl's but he insisted. On that stay, Choupette was able to familiarize herself with Caçote's house and meet her family. She felt that it was Karl's way of making sure that Choupette would be happy where she was living after he died. "I think that Monsieur liked to do things correctly, without spelling them out," she explained.[76]

Even though Karl was ailing, he continued his run of impressive shows at the Grand Palais. In October 2018, for the Chanel 2019 Spring/ Summer Ready-to-Wear Show, he had a seashore created. There was a beach made of light sand and a backdrop, one giant screen, tall and wide, filled with an image of an ocean on the horizon and a bright blue sky. The

floor was covered with actual water, with small waves lapping over the sand. The audience was seated on and around the beach, while the models, barefoot, walked down wooden steps, past the lifeguards in their tall white chairs, around the beach, and along a boardwalk. At the end of the show, as the dozens of models frolicked in the water, Karl came out onto a wooden dock, appearing with Virginie Viard, acknowledging the applause. He moved slowly and his white beard could not hide the swelling, likely from steroids.

Ines de la Fressange had reignited her friendship with Karl years before, shortly after he had lost all that weight. They were soon appearing on French television together, laughing about old times and teasing each other about their separation. "I was never aggressive toward him and I still had that ability to laugh with him and to understand and appreciate his humor, because he was not just there to make jokes for a public audience," de la Fressange explained.[77]

Backstage at the Grand Palais, because Karl's movement was limited, a small loge had been arranged for him, a corner where he could sit and receive journalists.[78] "There was a place for people to have a bite to eat and then there was a separate area that had been made just for Karl," de la Fressange recalled. "I went to congratulate him—he was seated in his chair."

"Sit down, sit down," Karl said to her.

There were camera crews that came to interview Karl, journalists, celebrities who had been to the show. De la Fressange prepared to leave but Karl asked her to stay. "He had never been very physical, or tender, but he took my hand and held on to it," she remembered. "It was impossible to leave. So, I stayed there with him, for more than an hour or two hours. I was like *The Last of the Mohicans*—one of the only ones around who had known him for so long."[79]

Chanel's Marie-Louise de Clermont-Tonnerre witnessed the interaction that day between Karl and de la Fressange. "He held on to her and wouldn't let go," she recalled.[80]

"There were all of these people who came, celebrities who had known

him for like five minutes," de la Fressange continued. "And I realized later that I was someone who understands where he came from, what he was talking about, even if he didn't want to be turned toward the past. Everyone admired him, thought he was brilliant and funny, but I felt like I was the only one who actually had some tenderness for him."[81]

It was the last time that de la Fressange saw Karl.

The following month, Karl made his final public appearance in Paris. It was to join the mayor, Anne Hidalgo, to illuminate the Christmas lights on the Champs-Élysées.

Karl had known Hidalgo since before she was the mayor of Paris. In 2017, after a Chanel show at the Grand Palais, she awarded him the city's highest honor, the Medal of the City of Paris. "He loved politics and strong women," Hidalgo explained. "He put me in the same category as Martine Aubry and Brigitte Macron—an honor—I really loved him."[82]

Marie-Louise de Clermont-Tonnerre was there with Karl on the Champs-Élysées. "He was quite sick but he was so affable with everyone who was there," she recalled. "He pressed the button to turn on the lights of Paris—it was great."

Karl stood with Anne Hidalgo and a small group of children. The tall *allées* of trees on either side of the boulevard lit up with bright red lights. "We're here to talk with the evening's godfather," said a television journalist. "Flamboyant, *non*?"

"The term 'flamboyant' is bit of an exaggeration," Karl replied. "I think they're very elegant and discreet—not at all flashy. They give a great sense of the holidays, and not something vulgar, aggressive, and commercial."

"We are so thrilled that Karl could be here with us," said Mayor Hidalgo, interrupting Karl. "He is a great designer, who carries forward the reputation of an important house and also of France and of Paris."

The journalist wondered if Paris was, even more that night, the City

of Light. "Yes, but it shouldn't be a cliché, *huh*?" Karl answered. "Paris is unique in the world but an effort still needs to be made. We should never think that anything is fully accomplished—now is the time to start thinking about how it is going to be lit next year."[83]

Just a few weeks later, Karl left for New York and the Métiers d'Art show, *Paris–New York*, held at the Metropolitan Museum of Art's Temple of Dendur. "That one was really sad," recalled Anna Wintour. "We all knew that he was so sick—that one just didn't feel right at all to me."[84]

Both the collection and the party after seemed to be off. Karl made a brief stop by the after-party. "He would never talk about his illness like in a straightforward way," Anna Wintour continued. "But he would refer to it obliquely and it was just so evident by that time. We had all seen him get weaker and weaker. But I was amazed that he came and I spent quite a bit of time with him in those few days. I was amazed that he could even come out at the end of the show. So, that's not a good memory."[85]

"That show in New York was really tough," remembered Virginie Viard. "The theme, the setting, the whole thing—it was like a sarcophagus."[86]

Karl returned to Paris and continued to work. The following week, he had a dinner at his apartment on the rue des Saints-Pères with Princess Caroline and Françoise Dumas. It was an annual affair to plan the Bal de la Rose, the big fundraiser held very spring in Monaco. Already, the year before, after *Paris-Hamburg*, Karl had been very tired. In the past, he had always made drawings for the dinner meeting, illustrating the theme, the sets, and the invitations. But that time, he handed Princess Caroline and Dumas scissors and had them cut out images from magazines and books. "He directed us to make our own mood boards," Dumas recalled. "We knew that he was exhausted but that was such a clever way to get us to do the work under his direction." By December 2018, however, Dumas saw that Karl was in bad shape and that he really just wanted the dinner to be over.[87]

Karl also went to Stefan Lubrina's studio, to review his work on sets for the fall ready-to-wear shows, which would take place in March, on a decor that re-created a village high in the Alps. "He was there so I

could show him the model of the set with the mountain chalet," Lubrina recalled. "He loved snow, Karl. Whenever there was snow in Paris, he went out to take photos. So, it was that model that I showed him, with the snow and the mountains."[88]

By January, Sébastien Jondeau had informed Chanel's Bruno Pavlovsky of Karl's worsening condition.[89] The Chanel 2019 Spring/Summer Haute Couture Collection was being shown at the Grand Palais on Tuesday, January 22. On the Sunday night before the show, Karl was at the rue Cambon, reviewing the music with Michel Gaubert.

The set was an Italian villa and garden, with real cypress trees and a large reflecting pool, and the decision had been made to have two shows, each with around fifteen hundred guests. The morning of the show, Karl was not feeling well enough to make it to the Grand Palais. Missing a show was going to be big news in the world of fashion, and it was important that everything be done correctly. It was decided that the news would be delivered at the end of the show by Michel Gaubert. "We were writing the text backstage and I practiced it like 50 times, in English and in French," Gaubert recalled. "I made two different announcements. For the first, I said that Karl would be coming for the later show, because that is what Karl had said. For the second, I announced that Monsieur Lagerfeld would not be there because he needed to relax." For Gaubert, there was the stress around Karl's health and the tension around the message he had to deliver. "It was hard because I wanted to make sure that there was no emotion in my voice," he said. "I didn't stutter once, making it all the way through, both times. And I said to myself, 'I hope that he would be pleased—that he would be proud of me.'"[90]

The news immediately ricocheted around social media and the international press. "Karl Lagerfeld was absent from Chanel's haute couture shows in Paris, fueling speculation over the 85-year-old designer's health," reported the *Guardian*. "Chanel has two upcoming catwalk shows, the ready-to-wear collections in early March and another on May 3. All eyes will be on who takes the end bow."[91]

Paparazzi began stationing themselves outside Karl's apartment on

the Quai Voltaire. Jondeau and Pavlovsky decided to increase the security around Karl's houses.

Days after the couture show, Karl had an appointment in his studio on the rue de Lille with Silvia Venturini Fendi. The meeting was to finalize the accessories for the upcoming show in Paris. Normally, it would take place in Milan, but the Fendi team flew to Paris to meet with Karl. "He was suffering a lot in that appointment," Silvia Venturini Fendi recalled, beginning to cry at the memory. "He couldn't walk—he was in a wheelchair. But he said, 'I'm only in a wheelchair because I have a problem with my ankle.'"[92]

Karl's butler Frédéric Gouby was there for the Fendi meeting, as well. "It was terrible," Gouby said. "After the appointment, I went with him out to his car. Even with Sébastien, he was not able to get up from the wheelchair. I took his hand to help steady him."[93]

By the second week in February, Karl was back in the American Hospital. The first afternoon, he asked Françoise Caçote to bring Choupette out to Neuilly and sneak her into the hospital. Once she was in his room, Karl wanted to take her out of her case. Caçote verified that the doors were closed. But, while she was doing something else, they suddenly realized that Choupette had gone missing. "It was such a panic," Caçote recalled. "A nurse had come in at one point, and we thought that Choupette might have slipped out. With Sébastien, we went out into the halls, looking into other rooms, under patients' beds. But, finally, we found her in the bathroom, completely hidden behind the sink, with only a little bit of her tail that could be seen." They realized that Choupette was not going to be able to stay at the hospital with Karl. "I was afraid that I was going to have to tell Monsieur that we had lost Choupette—that would have been a disaster!"[94]

While he was in the hospital, Karl's condition went downhill. "On Thursday, February 14, I called the doctors because I felt like he really had a hard time breathing, worse than normal," wrote Sébastien Jondeau in his memoir. "I moved into the hospital with him and had a security guard stationed outside the door of his suite."[95]

"Sébastien was amazing," said Françoise Dumas. "He stayed with him up until the end and he made sure that no one else knew, which is what Karl wanted. Everything was done in such a dignified way."[96]

One of Karl's first memories in life, "I will never know how or why," he once explained, was a grouping of flowers planted under a big pine tree on the side of Bissenmoor, his family house outside Hamburg. He was also struck by two columns at the front entrance that held big arrangements of flowers.[97]

Karl had long enjoyed sending flowers in Paris, at least since the day in the fall of 1954 when he had a bouquet from Lachaume dispatched to the fashion director of the Wool Bureau to thank her for the prize that had first brought him into the public eye. For many years, Karl used Moulié Savart on the Place du Palais-Bourbon—the massive arrangements for Paloma Picasso's wedding, for example, were from Moulié. But by the 1990s, Karl focused exclusively on the other great Paris florist, Lachaume. Installed since 1889 on the rue Royale, the florist had been a fashion favorite for decades (in 2012, it moved a few blocks away to the rue du Faubourg Saint-Honoré).

Karl sent several bouquets from Lachaume every day, roughly one thousand every year. At the start of every Paris Fashion Week, he had some thirty arrangements sent to top magazine editors. And many were quite extravagant. Each of Karl's bouquets cost between €500 and €2,000, meaning his annual floral budget at Lachaume was in the area of €1.5 million.[98]

For Caroline Cnockaert and Stéphanie Primet, the sisters who own Lachaume, there were layers of meaning to Karl's act of sending flowers. The most obvious was to make the recipient happy, to brighten someone's day, but it was also a way to begin a dialogue. Karl had his driver rush over handwritten notes to Lachaume, on a variety of beautiful cards, to be delivered with the arrangements. And the communication was often

in multiple directions. "We always tried to send a particularly elegant bouquet for Anna Wintour, and one time she sent a note to Monsieur," remembered Stéphanie Primet. "She wrote, 'They are simply artists.' He then sent us the note, saying, 'This was addressed incorrectly—it was meant for you.'"[99]

Karl used these superb arrangements in the way that others might use a text message or a tweet. "Karl communicated with flowers," explained Françoise Dumas. "He always sent a bouquet for May Day, for birthdays, for New Year's, and always with a beautiful, handwritten note. I have never seen someone who communicated so much with others through the act of sending a bouquet."[100]

Chanel's Marie-Louise de Clermont-Tonnerre felt that sending flowers was proof of Karl's attention to those who were in his world. "He always thought of everything," she explained. "Lilies of the valley for May Day. Bouquets for Mother's Day. And it was all very sincere, done with heart."[101]

"When you received flowers from Karl you had to make sure that the vase came with it," recalled Colombe Pringle, the editor in chief of French *Vogue* and of *Point de Vue*. "He always sent the most gorgeous bouquets and they came with the most beautifully written notes."[102]

Karl had been photographed by Jean-Baptiste Mondino several times; in fact, he suggested that they were his favorite photos of himself since Helmut Newton in the 1970s and early 1980s. The photographer's wife, Friquette Thévenet, was a well-known fashion editor in Paris, and Mondino saw the number of bouquets arriving from Karl. "A lot of big companies send flowers but that is not what this was," Mondino explained. "It was a way to thank people, of course, but it was more than that—he liked making people happy. And you said to yourself, 'Wow, I am the one who should be sending you flowers.' Everyone needed Karl. He was such a force in this business and everywhere else."

When Vanessa Paradis gave a concert at the Château de Versailles, Karl had Lachaume send her a huge grouping of white orchids. She was so delighted that she texted him a photo of herself with the flowers, her face lit up with a smile. Karl had the photo printed and messengered

over to Lachaume. "*Merci pour tout*," was Karl's note. "It was funny for him to thank us, to congratulate us on the bouquet, but that was Karl," explained Cnockaert.

His floral extravagance was not in any way diminished by his declining health. For some time, Karl had been friendly with Brigitte Macron, since meeting her and Emmanuel Macron at a dinner at Bernard Arnault's, long before Macron was known by the general public. That night, Karl had a fascinating discussion about literature with Madame Macron, who had taught French. They were soon texting each other and chatting on the phone. Although she usually wore Louis Vuitton, she and Karl were quite friendly.[103]

Emmanuel Macron was elected president of France in May 2017. "He has only been president for a month but France is already seen differently," Karl exclaimed. "That kind of fresh breeze is priceless." He was equally enthused about Brigitte Macron. He vaunted her international reputation, adding, "She has the best legs in Paris."[104]

The following year, for Bastille Day, Karl had Lachaume craft a particularly impressive arrangement for the president and the first lady (he had also sent flowers for July 14 to President Sarkozy and President Chirac). It was an Eiffel Tower, over five feet tall, with a base of red roses, a middle section of white roses, a top of dried gypsophila in vivid blue, and, flying above it all, a French flag. The tower sat on a base of green moss, with red, white, and blue bunting around the edges. Karl had it delivered to Le Palais de l'Élysée, the presidential palace, to be used for the big receptions that took place after the parade on the Champs-Élysées.[105]

In the last two years of his life, the sisters, who had worked so closely with Karl for over two decades, saw that he was slowing down. The pace of their work for him did not diminish, however.

On Thursday, February 14, 2019—Valentine's Day—Karl sent a text to Caroline Cnockaert, then called her. He said, "Look, I am going to send you a list, as usual, and they absolutely have to be sent today."

Karl's handwritten correspondence was an important part of the experience of receiving flowers. They were often rushed over to Lachaume,

as soon as the order had been placed, so that the bouquets could be delivered as quickly as possible. When he was not able to get a note to Lachaume—if he was out of town, for example—he would give them a short text and ask them to write it.

She did not know that Karl was in the American Hospital but she sensed that he was not doing well. His voice was very hoarse and he sounded hesitant.

"Will you be sending over notes?" she asked.

"No," Karl replied. "No messages."

"He said it in such a way that I understood," Cnockaert explained. "So that was really, really hard."[106]

The four beautiful bouquets from Lachaume were sent to five of Karl's closest friends in Paris: Princess Caroline, Françoise Dumas, Virginie Viard, and Hélène and Bernard Arnault. They were particularly lovely groupings of large apricot-colored roses, probably two dozen, plump hydrangeas in a pale pink, and vivid green guelder roses, known as *Boules de neige* or Snowballs. The arrangements were sent with a Lachaume card that said, "From Karl Lagerfeld."

"Françoise called, saying that there was no note with her bouquet," recalled Lachaume's Cnockaert. "I told her that, unfortunately, there wouldn't be one."

Just after calling Lachaume, Dumas had a phone call from Hélène Arnault. "Françoise, what do you think this means?" she asked.

Dumas took a photo of the bouquet and texted it to Karl—she knew that he loved to see how the flowers looked once they had been received. And she wrote him a note to thank him.[107]

As Lachaume's Caroline Cnockaert said simply, "Those were the last bouquets."[108]

That weekend, Françoise Dumas was busy working on a series of events for the opening of a major exhibition at the Fondation Louis

Vuitton. *The Courtauld Collection*, which would open to the public on Wednesday, February 20, was an exhibit of 110 masterful Impressionist paintings assembled by English collector Samuel Courtauld: Cézanne, Van Gogh, Manet, Seurat, Gauguin. Many of the works belonged to the Courtauld Gallery, but others came from museums and collectors around the world.[109]

Prior to the official opening, Dumas was organizing dinners and receptions for LVMH, so she was able to see the collection. "On Saturday, I called Sébastien to see how Karl was doing and to ask if I could send him some photos of the exhibition," Dumas recalled. "Sébastien said, 'Yes, but don't send them to his phone—send them to mine and I'll show Karl.'" Jondeau showed the texts and photos to Karl, who was immediately intrigued. "On Sunday, he was asking me all of these questions: 'Now, tell me again who Courtauld was?' 'And this painting was done in what year?' It was incredible—he was totally sharp and alert."[110]

On Monday, February 18, Karl spoke with Virginie Viard for the last time. "Françoise, Choupette's mother, handed the phone to Karl so that we could talk," Viard remembered. "'Everything is going to be fine,' he said to me, 'don't worry.'" Viard, choked up at the memory, added, "So, yeah, that was really sad."[111]

The Fendi show was to take place in Milan on Thursday, February 21. Silvia Venturini Fendi knew that Karl was in the hospital but they all prepared for him to make the trip to Italy. "We had organized to have a doctor in the show venue," Fendi explained. "Karl had asked us if we could sleep there—he didn't want to go to the hotel because he didn't want people to see that he was in a wheelchair. I said, 'Don't worry, I will give you my studio—we will organize everything. There is another entrance where you can go inside and nobody will see you. We can make it—you will be with us.'"[112]

The last meeting in Paris had been so difficult but Fendi put on a brave face, speaking with Karl by telephone on Monday evening, February 18. "I tried to pretend that I didn't know but it was difficult not to know," she continued. "Until the last day I tried to—I played the game with him.

It was around seven o'clock, and then two hours later he started being very, very bad."

"You know, Silvia, I can't come to Milan," Karl said. "They won't allow me—they think that it's better if I stay in the hospital."

"Oh, OK," she replied. "Don't worry, Karl. We will work with the iPad. Sébastien will show you all the fittings on the iPad, and it will be exactly as if you were here."

Fendi felt that, under the circumstances, Karl sounded fairly good. "I don't know if he was still pretending to be fine, or if he was thinking that he was kind of invincible," she explained.[113] That was Karl's final phone call.

On Tuesday, February 19, 2019, at 10:00 a.m., at the American Hospital in the Paris suburb of Neuilly-sur-Seine, Karl Otto Lagerfeld, eighty-five years old, died.

THE ASTRAL PLANE

My own grave? *Quelle horreur!* Burnt—tossed—done! I hate the
idea of burdening people with remains. *Mais quelle horreur!* Just
get out of town—disappear. I admire these animals that just go
off into virgin forest—when it's over, it's over.[1]

THE NEWS OF KARL'S death spread immediately around the world.
"Haute couture, fashion, and French and European taste has lost one
of its greatest talents and its most celebrated ambassador," said French
president Emmanuel Macron.[2]

"He was an immense artist and a friend with a rare sensitivity who,
throughout his life, accompanied women in their freedom and their self-
affirmation," noted Paris mayor Anne Hidalgo. Later, she added, "Not
only was he the incarnation of Paris—he *was* Paris."[3]

Chanel rushed out an official statement titled, "Thank You, Karl La-
gerfeld." It included a rare comment from Alain Wertheimer, the CEO of
Chanel. "Thanks to his creative genius, generosity, and exceptional in-
tuition, Karl Lagerfeld was ahead of his time, which widely contributed
to the House of Chanel's success throughout the world," Wertheimer
said. "Today, not only have I lost a friend, but we have all lost an extraor-
dinary creative mind."[4]

The same statement confirmed that Virginie Viard would be Karl's
successor. "So that the legacy of Gabrielle Chanel and Karl Lagerfeld
can live on," the house suggested. Although it had long been assumed
that she would be taking over and they had appeared together at the

end of the ready-to-wear show the season before, Karl and Viard had never discussed the subject.

On the morning of February 19, she went to the American Hospital in Neuilly to see Karl one last time. But she arrived too late; he had just died. It was at that moment that Viard learned she would be the new creative director. "Bruno told me that morning at the American Hospital," Viard recalled. "I said, 'OK, we will do the ready-to-wear and then we will see what happens—if it doesn't work, I will stop.'"[5]

Viard, who had worked closely with Karl for three decades, felt that it was important to continue his legacy at the house. "I still use Karl's drawings as a place to begin," Viard pointed out. "They are the starting point and then things can evolve. We're not going to erase what he did— why would we?"[6]

Two days after Karl's death, in Milan, the Fendi show was held, concluding with a short video of Karl sketching himself on his first day at Fendi in 1965. Michel Gaubert crafted a soundtrack that was biographical: from "Small Town" by Lou Reed and John Cale to "Heroes" by David Bowie. When Silvia Venturini Fendi came out at the end of the show, alone, she was given a standing ovation. "He used to call me *la petite fille triste*," she said backstage after the show, "but today is not the day to be sad."[7]

In Paris, Sébastien Jondeau was left to handle the formalities of Karl's death. "I organized all of the paperwork that needed to be done afterward," he explained. "There needed to be someone to sign all of the papers around his death, which is pretty complicated in France."[8]

Although Karl had always dismissed the thought of having any sort of memorial or service, there were too many people who wanted to honor him. And, the following day, in the Paris suburb of Nanterre, at the Mont-Valérien Crematorium, a ceremony was held. There were some two hundred invited guests, close friends of Karl—Princess Caroline, Anna Wintour, Ines de la Fressange, Susan Gutfreund—the team from Chanel—Alain and Gérard Wertheimer, Bruno Pavlovsky, Éric Pfrunder—and so many close associates of Karl's—Hélène and Bernard

Arnault, Silvia Venturini Fendi, Sébastien Jondeau, Caroline Lebar, Nicole and Brad Kroenig with their sons, Hudson and Jameson, Baptiste Giabiconi, Carine Roitfeld, and Florentine Pabst.

Karl's body arrived in a shiny black coffin. Anna Wintour said a few words, while Princess Caroline read a poem by Catherine Pozzi, one of Karl's favorite writers. "Karl was someone very nice," said Alain Wertheimer, "but he didn't want anyone to know it." Inside was an open coffin, so that those who were closest could say their farewells.

"I was not involved in organizing that," Jondeau explained. "I have said that the day that I arrive up there, I am going to run into Karl and he's going to really chew me out. He would say something like, 'I knew you to be much more of an authoritarian,' because I could be tough with him, when I needed to be."[9]

Shortly after that service, Chanel organized a memorial for those who had worked closest with Karl. It was held at the Théâtre Edouard VII, an old theater not far from rue Cambon. The house organized a few speakers and some videos to illustrate what Karl had done for Chanel. Bruno Pavlovsky and Virginie Viard gave talks; Marie-Louise de Clermont-Tonnerre told stories about his early days at the house. Five or six hundred attended. "It was for people who really worked closely with him, people within Chanel and suppliers," explained Bruno Pavlovsky. "We needed a moment of contemplation, something very simple. When you have lived with someone for 30 years, someone with the moral authority of Karl, the teams needed to be able to honor him and to process his death—it was powerful."[10]

"People were super happy about that memorial," recalled Virginie Viard. "Even for those who were not close with Karl personally, it was a big shock."[11]

Right after Karl died, Françoise Caçote took Choupette back to her house. "I can tell that she is doing well, that she is happy," Caçote explained. "And I tell myself that if Monsieur sees us from above, that he can be happy because this is just what he wanted for Choupette."[12]

When Françoise Dumas and Princess Caroline had had their fi-

nal dinner with Karl, in December 2018, he was very upset about the after-party that had just taken place at the Métiers d'Art in New York. "He said, 'Why didn't they ask you to do that?'" Françoise Dumas recalled. "And he said that he had told them that I would be doing the one the following year. I didn't do the next one—instead, I did his memorial."[13]

In June 2019, four months after Karl died, Françoise Dumas, working with Chanel, Fendi, and Karl Lagerfeld, organized a massive memorial for Karl at the Grand Palais. Called *Karl Forever*, it was staged by Robert Carsen, a noted opera director. Over twenty-five hundred guests attended. Hung around the massive hall were fifty-six enormous black-and-white portraits of Karl from every stage of his life. Ines de la Fressange, when she entered the massive nave, took in the scene, kneeled, and crossed herself. "We're here in the Church of Karl," she said, showing that she still had the kind of irreverence that he had always loved about her.

The memorial involved performances by Tilda Swinton, Helen Mirren, Cara Delevingne, and Fanny Ardant. Violinist Charlie Siem played Paganini, an Argentinian troupe of dancers performed the tango, the pianist Lang Lang played Chopin, and Pharrell Williams ended the show with an uplifting performance of his 2014 "Gust of Wind," one of his collaborations with Daft Punk, and a final shout of "Love you, Karl!"

The live performances were interspersed with a host of video testimonials. "He hoped to disappear," said Anna Wintour. "Well, that cannot happen."

LVMH chairman Bernard Arnault was effusive. "He was, without a doubt, the most fascinating and exceptional fashion designer of our time," he said. "And he was recognized as such by his peers. He was like Picasso, managing to create new styles, new movements, in each period of his life."[14]

In the time after Karl's death, he has continued to be memorialized in ways large and small. After he joined Chanel, Karl encouraged

the house to build an archive of the work of Gabrielle Chanel. Over the decades, that impulse has grown to become Patrimoine de Chanel, or Chanel Heritage, a large department housed in a campus in Pantin, northeast of Paris, along the gentle waters of the Canal de l'Ourcq. It is responsible for documenting the three divisions of the house: fashion, fragrance, and beauty, as well as watches and jewelry. The department is now expanding its focus, recording the history of the house's two major designers, Coco Chanel and Karl Lagerfeld. Chanel Heritage now possesses some six thousand articles of clothing designed by Karl and more than twenty-one thousand accessories.[15] It is also gathering research, materials and objects that enrich the understanding of Karl's life and work. As the house states of its expanding objectives, "The mission of the Heritage Department is to value the history and cultural heritage of the house of Chanel."[16]

Those who were close to Karl, meanwhile, continue to have vivid memories of him. Anne-Marie Périer, the editor in chief of French *Elle* from 1984 until 2001, mentions a moment from the fall of 1999. She was marrying Michel Sardou, a famous French actor and singer. They held an engagement dinner at the 16th arrondissement apartment of Geneviève and Pierre Hebey, Karl's lawyer at the time. It was a small group; only Karl, the two hosts, and the two celebrants. When Périer opened the engagement gift from Karl, she was stunned: an antique platinum-and-diamond brooch in the form of an elongated star. Because she was marrying a star, Karl suggested, it was important that she have one of her own. As Anne-Marie Périer recalls, "It is still the most extraordinary gift that I have ever received."[17]

The president of Karl Lagerfeld, Pier Paolo Righi, also has a special memory of an evening event. In 2014, Karl flew up to Amsterdam for a dinner in the brand's corporate offices. He was, of course, late. When he finally arrived, instead of heading straight into the dinner, he went back to the kitchen. When Righi asked why he had to do that, Karl replied, "Because I wanted to thank everyone who had made the meal. And if I had waited until after dinner, they would have already left."[18]

Some of Anna Wintour's best memories of Karl are of the private dinners they had every Sunday night before Paris Fashion Week. There would be only three or four guests, often among them Amanda Harlech, Hamish Bowles, or Andrew Bolton, the director of the Costume Institute of the Metropolitan Museum. The evenings took place at Karl's house on the rue de l'Université, at Caviar Kaspia on the Place de la Madeleine, or at the Ritz. "It was a wonderful ritual that I always looked forward to," Wintour explains. "We never talked about fashion. Occasionally, he might show me a picture of the sets, but mostly we just talked about . . . the . . . world."[19]

Jean-Baptiste Mondino, for his part, focuses on Karl's strength of character. "People might think, judging from his appearance, that he could be a little uptight, a little precious, but the exact opposite was true," Mondino explains. "He was like a guardian—he represented the resistance. You didn't need to see him all the time or go on vacation with him—you just needed to know that he was there, that he existed."[20]

Well before all of the personal memories and tributes, the memorials and archives, Karl had long been effective at shaping his own narrative.

"He created his own mythology, which is incredibly rare," points out Colombe Pringle, the former French *Vogue* editor in chief, who had known Karl since the 1950s. "Most people would confide in others, have moments of weakness—did you ever see a moment of weakness in the life of Karl? Never! He certainly had them—disappointment in love, the death of his mother—but he never showed anything."[21]

In fact, Karl had already come up with his own epitaph, years before. It was a poetic observation that he made several times in the last dozen years of his life.

In 2007, he sat down for a long conversation with Carla Bruni, the Franco/Italian top model—this was after she had turned herself into a successful pop singer but before she married Nicolas Sarkozy and became the first lady of France. Their talk took place in the dining room of his apartments at 51, rue de l'Université, with contemporary furniture by Christian Liaigre, Karl's collection of early twentieth-century German

posters, and the view out to the magnificent garden. He was wearing a black suit, one of his high-collared white shirts, and a black tie with a jeweled pin like an arrow. She was in skinny faded jeans, a white tank top, and a black leather jacket. Although they had known each other for fifteen years, Bruni was nervous when they began.

"Are there things in your past that you regret?" she asked.

"Nothing! If you start regretting the past, it's all over—it diminishes the present."

They discussed Karl's childhood and, of course, his mother. "She had something that no one else had, she was arrogant and amusing at the same time, odious but charming," he explained. "I never heard her say 'Thank you' to anyone and yet we all fought to make her happy." Bruni told Karl that her mother was now very close to her young son, her grandson, but that she had not been that way with her own children. "Your mother belongs to a generation and social milieu that didn't dote on children—and that's a good thing."

Karl also made it clear that he adored strong women. "I believe in the matriarchy," he said. "My mother, *her again*, said, 'It is possible to have a child with any man, so let's not exaggerate their importance.' Those kinds of things were not said at the time."

Bruni spoke about her older brother, Virginio Bruni Tedeschi, who had died of AIDS two years before. "We have to live with the dead as much as with those who are alive," Karl replied. "It's important to keep up an imaginary communication with those who are gone."

"There is one question that I have wanted to ask you for so long," Bruni said to Karl. "Have you ever experienced heartbreak?"

"The worst heartbreak is when death is involved," Karl said, meaning Jacques de Bascher. "But, other than that, no."[22]

Seven years later, in the fall of 2014, just after he had turned eighty-one and only a matter of months before he would be diagnosed with cancer, Karl discussed a range of issues with the art publication *Technikart*. He spoke with Fabrice de Rohan Chabot, the magazine's founder, and Laurence Rémila, the editor in chief. Their exchange took place in Karl's

photography studio on the rue de Lille, surrounded by those four great walls of floor-to-ceiling books.

"You have often played with cultural codes, not distinguishing between high and low culture," it was pointed out to Karl.

"Today, there is a way to do it that did not exist before and that is awesome," he replied. "Plus, low becomes higher later—what you call low culture can go on to influence high culture. As soon as something is happening, it is important to keep an eye on it. In the past, new ideas came only from above—now that's not the case."

"Do you consider yourself an artist?"

"I do not give myself the label of artist," Karl replied. "It would be up to others to use that term. I am lucky enough to do what I want to do in life. And it is all completely improvised—but a professional improvisation."

"Do you ever stop talking?" the editors asked (rather impertinently, considering they were there to interview him).

"I can go a full day without saying a word," Karl answered. "I am happy to be with people but I am also thrilled to be alone. I am delighted to be able to spend two days home alone, without watching the clock, reading, or just messing around—a dream!"[23]

And, finally, one late afternoon in May 2018, in what would be the last spring of his life, Karl was interviewed by Christophe Ono-dit-Biot, the cultural editor of French newsweekly *Le Point* and a noted novelist. They sat at Karl's desk in his studio on the rue Cambon. It was just several days before he would present the latest Chanel cruise collection at the Grand Palais, when he would unveil a massive ocean liner, built at full scale, with black walls, white trim, and red funnels that produced steam. Christened *La Pausa*, after Coco Chanel's estate in the south of France, it had working foghorns and thick ropes that tied it to a dock, which became the runway.

"What are you reading right now?" Karl was asked.

"Several books at a time," he explained. "I have a wall of books around my bed in order to give the impression that I am intelligent. I am rereading Johann Gottlieb Fichte and the journals of Paul Léautaud, who loved

cats, and his famous *Panthère*. I never stop reading the diaries of Harry Kessler, whom Julien Green called 'a German of the past, courteous and well educated .'"

"Is fashion still interesting to you?"

"It reflects the moment and should not be expected to be any more than that," Karl replied. "The drama of some young designers that they want to be artists, with exhibitions and retrospectives right away. I'm against that—Chanel and Balenciaga never had any exhibitions during their lives. Our role is to make a consumer product that is just right for a specific moment—if that is not enough for you, you should find another job."

When asked why he had grown a beard, Karl suggested that it was laziness.

"You? Lazy? That's a scoop!"

"I spend my time thinking that I could be doing better," Karl replied. "That is what keeps me moving forward—perpetual, personal dissatisfaction. And I consider boredom a crime."[24]

In all three conversations, Karl was given the opportunity for a final word, asked if he had any regrets or how he would summarize his life at that moment. And, in all three discussions, over a decade apart, each exploring very different subjects, he chose the same, very specific line.

It was from a great Swiss German painter and a former instructor at the Bauhaus, that brief but deeply influential school in Weimar Germany that Karl had always adored.

"You know that observation from Paul Klee?" he asked. "'I have been everything, loved everything, tasted everything, and now I am an icy star.'"[25]

Acknowledgments

IT HAS BEEN A tremendous privilege to spend three and a half years thinking about, and working to arrange into a coherent narrative, the life of Karl Lagerfeld. Assembling a biography is both a solitary act and one that would be impossible without the help of a vast community.

Jonathan Burnham, the president and publisher of the Harper division of HarperCollins, and Sara Nelson, my editor at Harper, immediately got the idea of a cultural biography of Karl, one that would look at his life while also exploring his deep engagement with the culture of his time. Sara offered two pieces of advice that drove this book forward. Early on in the research, she said, "We want to feel like we are in the same room with Karl." If this biography captures him as he actually was, rather than just the public image, it is because of that deceptively simple suggestion. Sara also told me to try to explain clearly what distinguishes Karl from other designers. It was another essential piece of direction.

I am incredibly grateful to have interviewed, and been in close communication with, a great number of people who had daily contact with Karl. They include Anna Wintour, the editor in chief of American *Vogue*; Sandy Brant, the publisher of *Interview* and an art collector, whose late partner, Ingrid Sischy, was also one of Karl's best friends; Virginie Viard, who worked closely with Karl since the 1980s, replaced him as the creative director of Chanel, and generously agreed to give her first interview about Karl; Bruno Pavlovsky, the president of Chanel Fashion; Marie-Louise de Clermont-Tonnerre, the communications director of Chanel from 1971 until 2021; Amanda Harlech, who was one of Karl's closest creative collaborators at Chanel and Fendi; Laurence Delamare, the international director of press and communications for Chanel Fashion in the last two decades of Karl's life; Michel Gaubert, who did the hard-driving music for every Karl show since 1989; Stefan Lubrina, responsible for the remarkable decors of Karl's shows; Caroline

Lebar, the director of communications and image at Karl Lagerfeld; Pier Paolo Righi, the president of Karl Lagerfeld; Silvia Venturini Fendi, the creative director of Fendi; Françoise Dumas, Karl's secret weapon in the highest reaches of Paris society; Sébastien Jondeau, his bodyguard and one of his closest confidants; Céline Degoulet, Karl's lawyer for two decades; Françoise Caçote, the governess for Chopette; Fréderic Gouby, Karl's trusted butler; Caroline Cnockaert and Stéphanie Primet, the sisters who run the Paris florist Lachaume; and Gerhard Steidl, who published books with Karl for three decades and was, as much as anyone in the world, a witness to his dizzying creative output.

I am also indebted to many who knew Karl well at different points in his life, such as Victoire Doutreleau, Florentine Pabst, Éric Pfrunder, Ines de la Fressange, Diane de Beauvau-Craon, Colombe Pringle, Anne-Marie Périer, Tilda Swinton, Diane Kruger, Sofia Coppola, Lily-Rose Depp, Claudia Schiffer, André Leon Talley, Stella Tennant, Amira Casar, Anne Berest, Jean-Baptiste Mondino, Paloma Picasso, Susan Gutfreund, Jacques Grange, Pierre Passebon, Aline Asmar d'Amman, Patrick Hourcade, Donald Schneider, Mathias Rastorfer, Peter Bermbach, Bethy Lagardère, Amir Hosseinpour, Charles Siem, and Fran Lebowitz.

Mondino remembered photographing Karl one day in his studio at 7, rue de Lille, when the designer wanted to take a break to check his hair and makeup. "I'll be right back," he said jauntily. "Time to go freshen up the marionette!" The only way to go beyond the puppet that Karl created is through the memories of those who knew him best—they are the heroes of this whole endeavor.

The house of Chanel does a masterly job of documenting and preserving its history, which stretches back to the years before World War I. The team at Patrimoine de Chanel, or Chanel Heritage, has played a crucial role in providing access to research materials and in ensuring the accuracy of the text. Laurence Delamare, in her generous, precise way, facilitated the contact with Chanel Heritage. The team there included Hélène Fulgence, heritage director; Laura Draghici-Foulon, director of cultural production; Laurène Flinois, iconographer; Cécile Goddet-

Dirles, arbitrage; Patrick Doucet, director of documentation; Mehdi Boukhras, documentarian; and Madeleine Meissirel, research manager, who very patiently guided the archival research and fact-checking. Their collective knowledge of the history of Chanel and of Karl's engagement with the house has been critical.

So many others on the rue Cambon were helpful in providing access to interview subjects and in filling me in on Karl's career at Chanel. Those include Véronique Perez, director of press and communications in the 1980s and 1990s; Elsa Heizmann, the international director of celebrity relations; Emmanuelle Walle, the international director of press and communications for Chanel Fashion since 2021; as well as Angélique Rivière; Adriano Rossi; Estelle Aveline; and Myriam Netter.

At Fendi, in addition to Silvia Venturini Fendi, I would like to thank Cristiana Monfardini, the chief communications officer; Maria Sole Henny, worldwide director of public relations; Maria Elena Cima, director of Fendi Heritage; and Nicoletta Vaccarella, supervisor of Fendi Heritage. At Chloé, I am indebted to Geraldine-Julie Sommier, the director of Chloé Patrimoine; Catherine Lebrun, manager; and Camille Kovalevsky, researcher. The incredibly helpful team at Karl Lagerfeld, in addition to Caroline Lebar, included Anita Briey, Eric Wright, Sophie de Langlade, Florian Saint-Aimé, and Daniela Meli.

I am not a fashion critic, so I need to thank all of those who did cover Karl's design over the decades, including Bernadine Morris, Carrie Donovan, John Fairchild, Patrick McCarthy, Hebe Dorsey, Suzy Menkes, Michael Roberts, Hamish Bowles, Nathalie Mont-Servan, Janie Samet, François Baudot, Laurence Benaïm, Amy Spindler, Bridget Foley, Cathy Horyn, Sarah Mower, Loïc Prigent, Marie Ottavi, and Vanessa Friedman. Their reviews and fashion coverage were key to understanding how Karl's work was seen in the moment. And Jerry Stafford, the ultimate Paris insider, provided the lay of the land in photography, cinema, and fashion, while also bringing to the project the master photographer Sølve Sundsbø, who graciously agreed to do the author's portrait.

I would also like to acknowledge a host of friends who have kindly

read chapter drafts and endured years of my droning on about Karl Lagerfeld. That includes Lois de Menil, Lynn Wyatt, Dennis Freedman, Lesley Blume, Wendy Goodman, Marion Wilcox, Paul Johnson, Devon Fredericks, Malika Noui, Nick Hooker, Susan Hootstein, Max Heisig, Rose Romain, Ben Thomson, Mike Carragher, and Nick Wooster. George Hodgman, who, tragically, did not live to see the book completed, was instrumental in pushing me to tackle the subject.

In 2021, I was awarded a residency at the Dora Maar House in Ménerbes in the south of France. To be able to spend a month focusing completely on writing, in a room with spectacular views looking out over the Luberon, was a great gift. Thanks go to the director, Gwen Strauss, fellow residents Francesca Fuchs, Joanna Fiduccia, and Yasmin Spiro, as well as the patron, Nancy Negley, who bought Maar's house and turned it into a singular residency for artists and writers from around the world.

The team at Harper has been a dream: Joanne O'Neill, who designed a spectacular cover; David Koral, the production editor; Muriel Jorgensen, the copy editor; Katherine Beitner, the director of publicity; Becca Putman, the marketing director; Beth Silfin, the deputy general counsel; and Edie Astley, the very capable assistant to Sara Nelson.

And, finally, I owe a huge debt of gratitude to my agent at ICM Partners, Amanda Urban. She immediately understood the potential of this project, reached out to leading editors, and in a matter of days had a deal. Others at ICM/CAA who have played major roles in making this happen include John B. De Laney, Anne Giacobone, Ron Bernstein, Courtny Catzel, and John Ingold. Helen Manders and Peppa Mignone, who handle foreign rights for CAA in London, have done a terrific job of taking this book out to the world.

Biography, by its very nature, is fragmentary. That is particularly the case when writing about a life that was as long, and a career that was as protean, as Karl Lagerfeld's. It requires making some hard choices. Any errors of emphasis or interpretation, of course, are entirely the responsibility of the author.

NOTES

Epigraph

1. Karl Lagerfeld, interview with Augustin Trapenard, *Boomerang*, France Inter, Sept. 22, 2014.

Prologue: Superstar!

1. Karl Lagerfeld in Jean-Christophe Napias and Patrick Mauriès, *Le Monde selon Karl* (Paris: Flammarion, 2013), 46.

2. "Resultats financières de Chanel Limited," Chanel.com, June 17, 2019, https://services.chanel.com/media/files/resultats_financiers_de_chanel_limited_exercice_clos_au_31_decembre_2018.pdf.

3. Alain Toucas, interview with the author, April 20, 2021.

4. Stella Tennant, interview with the author, Dec. 9, 2020.

5. Frédéric Gouby, interview with the author, June 23, 2021.

6. Karl Lagerfeld in "A la recherche de la vingt-cinquième heure," *L'Express Style*, May 1988, 37.

7. Karl Lagerfeld, "20h10 pétantes," Canal+, Sept. 12, 2003.

8. Bethy Lagardère, interview with the author, April 19, 2021.

9. Bethy Lagardère, interview with the author, April 19, 2021.

10. Bethy Lagardère, interview with the author, April 19, 2021.

11. Françoise Dumas, email to the author, June 1, 2021.

12. Bethy Lagardère, interview with the author, April 19, 2021.

13. Françoise Dumas, interview with the author, Dec. 15, 2020.

14. Hedi Slimane in Emanuele Scorcelletti, "Master and Commander," *Telegraph Magazine*, Oct. 9, 2004, 35.

15. Veronique Hyland, "Halston's Penney's Serenade," *WWD*, May 12, 2010, https://wwd.com/fashion-news/fashion-features/halston-j-c-penney-3068848/.

16. Karl Lagerfeld in Marie-Pierre Lannelongue, "Karl Lagerfeld et H&M: Chronique d'un carton assuré," *Elle*, Aug. 23, 2004, 14.

17. Donald Schneider, interview with the author, Dec. 18, 2020.

18. Caroline Lebar, interview with the author, Dec. 14, 2020.

19. Miles Socha, "H&M Goes Designer with Karl," *WWD*, Sept. 17, 2004, 6.

20. Donald Schneider, interview with the author, Dec. 18, 2020.

21. Anna Wintour, interview with the author, May 25, 2021.

22. Tom Ford, interview, Associated Press, May 2, 2005.

23. Stefan Lubrina, interview with the author, March 12, 2022.

24. Cathy Horyn, "The Rootin' Teuton," *T*, Feb. 2005, 198.

25. Éric Pfrunder, interview with the author, April 26, 2021.

26. Archival video, Oct. 8, 2004, PdeC.

27. Archival video, Oct. 8, 2004, PdeC.

28. Michel Gaubert, interview with the author, May 13, 2021.

29. Hamish Bowles, interview with the author, May 25, 2021.

30. Estelle Colin, *20 heures le journal*, France 2, Oct. 8, 2004.

31. Michel Gaubert, interview with the author, May 13, 2021.

32. Stefan Lubrina, interview with the author, March 12, 2022.

33. Frédérique Verley, "Mythe Movie," *Vogue Paris*, Nov. 2004, n.p.

34. Amanda Harlech, interview with the author, June 18, 2021.

35. Virginie Viard, interview with the author, July 6, 2022.

36. Karl Lagerfeld in Verley, "Mythe Movie."

37. Colin, *20 heures le journal*.

Chapter 1: Blurred Origins

1. Karl Lagerfeld in Anne-Cécile Beaudoin and Elisabeth Lazaroo, "Karl Lagerfeld: L'étoffe d'une star," *Paris Match*, April 25, 2013, 76–77.

2. Edmonde Charles-Roux, *L'Irrégulière: L'Itinéraire de Coco Chanel* (Paris: Grasset, 1974), 77.

3. Louise de Vilmorin, *Mémoires de Coco*, ed. Patrick Mauriès (Paris: Éditions Gallimard, 1999), 10–13.

4. Karl Lagerfeld in Beaudoin and Lazaroo, "Karl Lagerfeld: L'étoffe d'une star," 74.

5. Alfons Kaiser, *Karl Lagerfeld: Ein Deutscher in Paris* (Munich: Verlag C.H. Beck oHG, 2020), 18.

6. Priscilla Long, "Carnation Condensed Milk First Manufactured in Kent on September 6, 1899," https://historylink.org/File/1608.

7. Karl Lagerfeld in Beaudoin and Lazaroo, "Karl Lagerfeld: L'étoffe d'une star," 75.

8. Karl Lagerfeld in "Lagerfeld: Hamburg ist mir familiar und fremd," *Bild am Sonntag*, Feb. 14, 2015.

9. Kaiser, *Karl Lagerfeld: Ein Deutscher in Paris*, 19–22.

10. Karl Lagerfeld in Beaudoin and Lazaroo, "Karl Lagerfeld: L'étoffe d'une star," 74.

11. Kaiser, *Karl Lagerfeld: Ein Deutscher in Paris*, 36.

12. Karl Lagerfeld in Andrew O'Hagan, "The Maddening and Brilliant Karl Lagerfeld," *T*, Oct. 12, 2015, n.p.

13. Karl Lagerfeld in Jacques Bertoin, "Karl Lagerfeld, marginal de luxe," *Le Monde*, April 28, 1980, n.p.

14. Karl Lagerfeld in Beaudoin and Lazaroo, "Karl Lagerfeld: L'étoffe d'une star," 75.

15. William Shirer, *The Rise and Fall of the Third Reich* (New York: Simon & Schuster, 1959), 200.

16. Shirer, *The Rise and Fall of the Third Reich*, 201.

17. Shirer, *The Rise and Fall of the Third Reich*, 220–26.

18. Karl Lagerfeld in William Middleton, "Heavenly Hamburg," *W*, Sept. 1996, 333–34.

19. Gerhard Steidl, interview with the author, Oct. 24, 2021.

20. Gerhard Steidl, interview with the author, Oct. 24, 2021.

21. Gerhard Steidl, interview with the author, Oct. 24, 2021.

Chapter 2: The Weight of German History

1. Karl Lagerfeld in *The Story of Fashion*, vol. 3, *The Age of Dissent*, dir. Eila Hershon and Robert Guerra (VHS; London: RM Arts, 1987), FA.

2. Karl Lagerfeld in William Middleton, "Heavenly Hamburg," *W*, Sept. 1996, 328.

3. Karl Lagerfeld in Loïc Prigent, dir., *Karl Lagerfeld se dessine*, Arte, 2013.

4. Karl Lagerfeld, "20h10 pétantes," Canal+, Sept. 12, 2003.

5. Karl Lagerfeld in Prigent, *Karl Lagerfeld se dessine*.

6. Karl Lagerfeld in Prigent, *Karl Lagerfeld se dessine*.

7. Karl Lagerfeld in "Lagerfeld: Hamburg ist mir familiar und fremd," *Bild am Sonntag*, Feb. 14, 2015.

8. Karl Lagerfeld in Prigent, *Karl Lagerfeld se dessine*.

9. Karl Lagerfeld, *Un Roi Seul*, TV5, 2008.

10. Karl Lagerfeld in "Karl Lagerfeld rencontrait Fabrice Luchini: Délire d'égos et joute verbal," *Télérama*, Feb. 19, 2019, 2.

11. Karl Lagerfeld in Anne-Cécile Beaudoin and Elisabeth Lazaroo, "Karl Lagerfeld: L'étoffe d'une star," *Paris Match*, April 25, 2013, 74.

12. Monte Packham, email to the author, Aug. 26, 2021.

13. Karl Lagerfeld, interview with Augustin Trapenard, *Boomerang*, France Inter, Sept. 22, 2014.

14. Karl Lagerfeld, interview by Jacques Braunstein, in "Watteau, What a Shock," *Technikart Mademoiselle*, Oct. 2004, 149.

15. Kennedy Fraser, "Imperial Splendors," *Vogue*, Sept. 2004, 824.

16. Karl Lagerfeld in Leila Farrah, "Of Shoes and Candle Wax," *Sunday Times*, May 13, 1990, n.p.

17. Karl Lagerfeld in Bayon, "Lagerfeld, entre les lignes de Keyserling," *Libération Next*, Nov. 6, 2010, 44.

18. Karl Lagerfeld in Hans Ulrich Obrist, "My Job Is Not to Dwell on the Past," *System*, vol. 3, 2014.

19. Laird M. Easton, ed., *Journey to the Abyss: The Diaries of Count Harry Kessler, 1880–1918* (New York: Alfred A. Knopf, 2011), 882.

20. W. H. Auden in Easton, ed., *Journey to the Abyss*, xii.

21. Karl Lagerfeld in Bayon, "Lagerfeld, entre les lignes de Keyserling," 44.

22. Gerhard Steidl, interview with the author, Oct. 24, 2021.

23. Gerhard Steidl, interview with the author, Oct. 24, 2021.

24. Easton, ed., *Journey to the Abyss*, xii.

25. Ian Buruma, introduction, Harry Kessler, *Berlin in Lights: The Diaries of Count Harry Kessler (1918–1937)*, trans. Charles Kessler (New York: Grove Press, 1999), ix.

26. Harry Kessler in Easton, ed., *Journey to the Abyss*, 516–17.

27. *Hamlet*, published by the Cranach-Presse, British Library, https://www.bl.uk /collection-items/hamlet-published-by-the-cranach-presse.

28. Gerhard Steidl, interview with the author, Oct. 24, 2021.

29. Karl Lagerfeld in Obrist, "My Job Is Not to Dwell on the Past."

30. Gerhard Steidl, interview with the author, Oct. 24, 2021.

31. Karl Lagerfeld in Obrist, "My Job Is Not to Dwell on the Past."

32. Karl Lagerfeld in Olivier Wicker, "Interview/Obsession," *Le Nouvel observateur*, Aug. 23, 2012, 8.

33. Karl Lagerfeld in Wicker, "Interview/Obsession," 8.

34. Jennifer M. Kapczynski, "Raising Cain? The Logic of Breeding in Michael Haneke's 'Das Weiße Band,'" *Colloquia Germanica* 43, no. 3 (2010): 153–73, www.jstor.org /stable/23982076.

35. Karl Lagerfeld in Wicker, "Interview/Obsession," 8.

36. Karl Lagerfeld in Andrew O'Hagan, "The Maddening and Brilliant Karl Lagerfeld," *T*, Oct. 12, 2015.

37. Karl Lagerfeld in Beaudoin and Lazaroo, "Karl Lagerfeld: L'étoffe d'une star," 76.

38. Karl Lagerfeld in Prigent, *Karl Lagerfeld se dessine*.

39. Alfons Kaiser, *Karl Lagerfeld: Ein Deutscher in Paris* (Munich: Verlag C.H. Beck oHG, 2020), 79.

40. Karl Lagerfeld, "Talk Asia," CNN, 2009.

41. Karl Lagerfeld in "Karl's Reign at Chanel," *WWD*, Jan. 22, 2003, 10.

42. Karl Lagerfeld in Monique Davidson, "Karl Lagerfeld Talks to Monique Davidson," *Clout*, Feb. 1983, 15.

43. Karl Lagerfeld in "Lagerfeld: Hamburg ist mir familiar und fremd.

44. Karl Lagerfeld, *Un Roi Seul*.

45. Karl Lagerfeld in Obrist, "My Job Is Not to Dwell on the Past."

46. Karl Lagerfeld, interview by Braunstein, in "Watteau, What a Shock," 148.

47. Karl Lagerfeld in *Reklame*, eds. Karl Lagerfeld and René Grohnert (Göttingen: Steidl, 2013), 6.

48. Ursula Scheube in Kaiser, *Karl Lagerfeld: Ein Deutscher in Paris*, 75.

49. Karl Lagerfeld, interview by Braunstein, in "Watteau, What a Shock," 148.

50. Karl Lagerfeld in Obrist, "My Job Is Not to Dwell on the Past."

51. Karl Lagerfeld in Dora Stern, "Itinéraire d'un enfant gâté," *Dépêche Mode*, May 1992, 33.

52. Karl Lagerfeld in Jacques Bertoin, "Karl Lagerfeld, marginal de luxe," *Le Monde*, April 28, 1980, n.p.

53. Gerhard Steidl, interview with the author, Oct. 24, 2021.

54. Karl Lagerfeld in Prigent, *Karl Lagerfeld se dessine*.

55. Karl Lagerfeld, *Un Roi Seul*.

56. Karl Lagerfeld in Beaudoin and Lazaroo, "Karl Lagerfeld: L'étoffe d'une star," 74.

57. Karl Lagerfeld in Nancy Collins, "Scent of a Man," *Mirabella*, Nov. 1994, 90.

58. Karl Lagerfeld in Stern, "Itinéraire d'un enfant gâté," 33.

59. Karl Lagerfeld in O'Hagan, "The Maddening and Brilliant Karl Lagerfeld."

60. Karl Lagerfeld in O'Hagan, "The Maddening and Brilliant Karl Lagerfeld."

61. Karl Lagerfeld in Beaudoin and Lazaroo, "Karl Lagerfeld: L'étoffe d'une star," 74.

62. Karl Lagerfeld in Collins, "Scent of a Man," 90.

63. Kaiser, *Karl Lagerfeld: Ein Deutscher in Paris*, 73.

64. Karl Lagerfeld in Beaudoin and Lazaroo, "Karl Lagerfeld: L'étoffe d'une star," 74.

65. Kaiser, *Karl Lagerfeld: Ein Deutscher in Paris*, 66.

66. Kaiser, *Karl Lagerfeld: Ein Deutscher in Paris*, 67–68.

67. Kaiser, *Karl Lagerfeld: Ein Deutscher in Paris*, 68–71.

68. Alfons Kaiser, *Karl Lagerfeld: A Life in Fashion* (New York: Abrams, 2022), 57–58.

69. Florentine Pabst, email to the author, May 29, 2021.

70. Silvia Venturini Fendi, interview with the author, July 14, 2021.

71. Diane de Beauvau-Craon, interview with the author, June 20, 2021.

72. Karl Lagerfeld in Beaudoin and Lazaroo, "Karl Lagerfeld, L'étoffe d'une star," 72.

73. Kaiser, *Karl Lagerfeld: Ein Deutscher in Paris*, 72.

74. Karl Lagerfeld, *Un Roi Seul*.

75. Karl Lagerfeld in Beaudoin and Lazaroo, "Karl Lagerfeld: L'étoffe d'une star," 75.

76. Karl Lagerfeld, interview with Marc Olivier Fogiel, *Le Divan*, France 3, Feb. 24, 2015.

77. Karl Lagerfeld in Prigent, *Karl Lagerfeld se dessine*.

78. Karl Lagerfeld, *Un Roi Seul*.

79. Karl Lagerfeld in Obrist, "My Job Is Not to Dwell on the Past."

80. Elisabeth Lagerfeld in Jean-Christophe Napias and Patrick Mauriès, *Le Monde selon Karl* (Paris: Flammarion, 2013), 151.

Chapter 3: The Age of Enlightenment

1. Karl Lagerfeld, *Un Roi Seul*, TV5, 2008.

2. Dr. Joachim Döbler, "Life Beneath the Facades of Bombed-Out Streets," *Indian Architect & Builder*, Nov. 1995, 102.

3. "Biggest RAF-U.S. Raids on Reich Blast Hamburg, Hit Baltic Cities," *New York Times*, July 26, 1943, 1.

4. Karl Lagerfeld in Raphaëlle Bacqué, "Karl Lagerfeld, une enfance allemande," *Le Monde*, Aug. 19, 2018, 16.

5. Alfons Kaiser, *Karl Lagerfeld: Ein Deutscher in Paris* (Munich: Verlag C.H. Beck oHG, 2020), 62.

6. Julien Green, *Journal, 1950–1954* (Paris: Plon, 1955), 174–75.

7. Karl Lagerfeld, interview by Bertrand du Vignaud, in *Collection Lagerfeld* (Monaco: Christie's, 2000), 17.

8. Kim Geonhee, Nationalgalerie, Berlin, email to the author, Aug. 3, 2021.

9. Karl Lagerfeld, "Karl Lagerfeld file Saint-Simon dans le Grand Siècle," *Le Figaro*, Aug. 5, 2004, 14.

10. Karl Lagerfeld, interview by Bertrand du Vignaud, in *Collection Lagerfeld* (Monaco: Christie's, 2000), 17.

11. Karl Lagerfeld, interview with Marc Olivier Fogiel, *Le Divan*, France 3, Feb. 24, 2015.

12. Karl Lagerfeld, interview by Jacques Braunstein, in "Watteau, What a Shock," *Technikart Mademoiselle*, Oct. 2004, 148.

13. Lytton Strachey, "Voltaire and Frederick the Great," in *Books and Characters, French and English* (New York: Harcourt Brace and Company, 1922).

14. Karl Lagerfeld, "Karl Lagerfeld file Saint-Simon dans le Grand Siècle," 13.

15. Karl Lagerfeld, "Karl Lagerfeld file Saint-Simon dans le Grand Siècle," 14.

16. Saint-Simon, *Mémoires suivi de Additions au Journal de Dangeau*, Tome VI, ed. Yves Coirault (Paris: Bibliothèque de la Pléiade, 1986), 142.

17. Saint-Simon, *Mémoires*, Vol. I, ed. Yves Coirault (Paris: Éditions Gallimard, 1990), 41–42.

18. Charles Augustin Saint-Beuve, quoted in Pierre Gascar and Olivier Amiel, eds., *Lettres de Madame, Duchesse d'Orléans, née Princesse Palatine* (Paris: Mercure de France, 1981), 32.

19. Karl Lagerfeld, "Karl Lagerfeld file Saint-Simon dans le Grand Siècle," 14.

20. Karl Lagerfeld, "Karl Lagerfeld file Saint-Simon dans le Grand Siècle," 14.

21. Karl Lagerfeld in "Karl Lagerfeld rencontrait Fabrice Luchini: Délire d'égos et joute verbal," *Télérama*, Feb. 19, 2019, 2.

22. Karl Lagerfeld, "Karl Lagerfeld file Saint-Simon dans le Grand Siècle," 14.

23. Gascar and Amiel, eds., *Lettres de Madame, Duchesse d'Orléans, née Princesse Palatine*, 182.

24. Bernadine Morris, "Karl Lagerfeld: The Designer Setting Fashion's Tempo," *New York Times*, May 21, 1979, B6.

25. Karl Lagerfeld in Jean-Jacques Lafaye, "Karl Lagerfeld: Modes et lumières," *Connaissance des Arts*, June 1992, 35.

26. Karl Lagerfeld, interview with Marc Olivier Fogiel.

27. Karl Lagerfeld, interview with Marc Olivier Fogiel.

28. Karl Lagerfeld in Leila Farrah, "Of Shoes and Candle Wax," *Sunday Times*, May 13, 1990, n.p.

29. Marie-Louise de Clermont-Tonnerre, interview with the author, Jan. 8, 2021.

30. Karl Lagerfeld, *Un Roi Seul*.

31. Karl Lagerfeld, *Un Roi Seul*.

Chapter 4: French Lessons

1. Karl Lagerfeld, *Un Roi Seul*, TV5, 2008.

2. Karl Lagerfeld in Alfons Kaiser, *Karl Lagerfeld: Ein Deutscher in Paris* (Munich: Verlag C.H. Beck oHG, 2020), 95.

3. Karl Lagerfeld in "Lagerfeld: Hamburg ist mir familiar und fremd," *Bild am Sonntag*, Feb. 14, 2015.

4. Karl Lagerfeld, "Weimar, Berlin, Potsdam," *Zoom*, May–June 1991, 24.

5. Karl Lagerfeld, "Weimar, Berlin, Potsdam."

6. Karl Lagerfeld, "Weimar, Berlin, Potsdam."

7. Karl Lagerfeld, interview by Elisabeth Lazaroo in "Roulez Jeunesse!" *Paris Match*, July 5, 2018, 25.

8. Bernadine Morris, "Can Couture Turn Heads If It Keeps Looking Back?" *New York Times*, Feb. 4, 1992, A19.

9. Karl Lagerfeld, letter to Janet Froelich, *New York Times Magazine*, Nov. 19, 1998, PdeC.

10. Adelheid Rasche with Christina Thomson, ed., *Christian Dior and Germany 1947–1957* (Stuttgart: Arnoldsche, 2007), 210.

11. Karl Lagerfeld in Christiane von Arp and Christoph Amend, "Ich bin im Grunde harmlos. Ich sehe nur nicht so aus. Karl Lagerfeld: Das Interview," German *Vogue*, Jan. 2018.

12. Kaiser, *Karl Lagerfeld: Ein Deutscher in Paris*, 96.

13. Kaiser, *Karl Lagerfeld: Ein Deutscher in Paris*, 96.

14. Kaiser, *Karl Lagerfeld: Ein Deutscher in Paris*, 96.

15. Karl Lagerfeld in von Arp and Amend, "Ich bin im Grunde harmlos."

16. Karl Lagerfeld in Adelia Sabatini, "The House That Dreams Built," *glass*, Summer 2010, 70.

17. Kaiser, *Karl Lagerfeld: Ein Deutscher in Paris*, 98.

18. Rasche with Thomson, ed., *Christian Dior and Germany*, 211–12.

19. Rasche with Thomson, ed., *Christian Dior and Germany*, 214.

20. Karl Lagerfeld in Sabatini, "The House That Dreams Built," 70.

21. Karl Lagerfeld in *Masters of Beauty: Karl Lagerfeld*, https://www.youtube.com/watch?v=sVTxm237SM8&list=PLw9qK_JhHsvPXx1v3goZnVNe7Z0_n76gg&index=10.

22. Karl Lagerfeld, "*Femme à sa fenêtre*, 1949," Lot 424, Sotheby's KARL, Karl Lagerfeld Estate, https://www.sothebys.com/en/buy/auction/2021/karl-karl-lagerfelds-estate/femme-a-sa-fenetre-ink-and-watercolor-on.

23. Karl Lagerfeld, "*Woman with a Bouquet of Flowers and Salomé*, 1950," Lot 425, Sotheby's KARL, Karl Lagerfeld Estate, https://www.sothebys.com/en/buy/auction/2021/karl-karl-lagerfelds-estate/woman-with-a-bouquet-of-flowers-andsalome.

24. Karl Lagerfeld, "Animated scenes in 18th century interiors and troubadours, set of three drawings," Lot 426, Sotheby's KARL, Karl Lagerfeld Estate, https://www.sothebys.com/en/buy/auction/2021/karl-karl-lagerfelds-estate/animated-scenes-in-18th-century-interiors-and.

25. Karl Lagerfeld, "Gallant scene and Woman at a patient's bedside, lot of two drawings, pastel on monogrammed paper, dated 1950," Lot 2040, Sotheby's KARL, Karl Lagerfeld Estate, https://www.sothebys.com/en/buy/auction/2021/karl-karl-lagerfelds-estate-3/gallant-scene-and-woman-at-a-patients-bedside-lot.

26. Kaiser, *Karl Lagerfeld: Ein Deutscher in Paris*, 99.

27. Karl Lagerfeld in Dora Stern, "Itinéraire d'un enfant gâté," *Dépêche Mode*, May 1992, 34.

28. Bernadine Morris, "Karl Lagerfeld: The Designer Setting Fashion's Tempo," *New York Times*, May 21, 1979, B6.

29. Karl Lagerfeld in Stern, "Itinéraire d'un enfant gâté," 35.

30. Karl Lagerfeld in "La Bicentenaire du frou-frou," *Madame Figaro*, June 17, 1989.

31. Karl Lagerfeld in Olivia de Lamberterie, "Karl Lagerfeld: Sa dernière interview à *Elle*," *Elle*, Aug. 2016, https://www.elle.fr/Loisirs/Livres/Dossiers/Karl-Lagerfeld -Je-sais-dessiner-lire-et-c-est-tout-2603318.

Chapter 5: Under the Paris Sky

1. Karl Lagerfeld in *The Story of Fashion*, vol. 3, *The Age of Dissent*, dir. Eila Hershon and Robert Guerra (VHS; London: RM Arts, 1987), FA.

2. Karl Lagerfeld, "Le film d'un film," *Vogue Paris*, March 1978, 276.

3. Karl Lagerfeld in *Masters of Beauty: Karl Lagerfeld*, March 12, 2014, https://www .youtube.com/watch?v=sVTxm237SM8.

4. Karl Lagerfeld, letter to Elisabeth Lagerfeld, Dec. 10, 1954, in Karl Lagerfeld, "Two Work Binders," Lot 423, Sotheby's KARL, Karl Lagerfeld Estate.

5. Karl Lagerfeld in Charlotte Cowles, "Karl Lagerfeld on Diets, Sobriety, and Becoming a 'Nicer Person,'" *New York*, Nov. 7, 2013.

6. Alfons Kaiser, *Karl Lagerfeld: Ein Deutscher in Paris* (Munich: Verlag C.H. Beck oHG, 2020), 68.

7. André Leon Talley, "Karl Lagerfeld: In a Cloud of Chloé," *Interview*, June 1975, 28.

8. Karl Lagerfeld in André Leon Talley, "Perspective 80," *Vogue Paris*, Nov. 1979, 215.

9. Karl Lagerfeld in Jacques Bertoin, "Karl Lagerfeld, marginal de luxe," *Le Monde*, April 28, 1980, n.p.

10. Karl Lagerfeld in Anne-Cécile Beaudoin and Elisabeth Lazaroo, "Karl Lagerfeld: L'étoffe d'une star," *Paris Match*, April 25, 2013, 74.

11. Karl Lagerfeld, *Off the Record* (Göttingen: Steidl, 1994), n.p.

12. Karl Lagerfeld, *Off the Record*.

13. Karl Lagerfeld, *Off the Record*.

14. Karl Lagerfeld in Loïc Prigent, dir., *Karl Lagerfeld se dessine*, Arte, 2013.

15. Karl Lagerfeld in Prigent, *Karl Lagerfeld se dessine*.

16. Karl Lagerfeld, *Off the Record*.

17. Karl Lagerfeld in Thierry Billiard and David Slama, "Karl Kapital," *Paris Capitale*, March 2008, 54.

18. Karl Lagerfeld, *Off the Record*.

19. Lettres Sorbonne Université, Histoire de la Faculté, https://lettres.sorbonne -universite.fr/faculte-des-lettres/histoire-de-la-faculte.

20. Laurent Allen-Caron, *Le mystère Lagerfeld* (Paris: Fayard, 2018), 50.

21. Karl Lagerfeld in Beaudoin and Lazaroo, "Karl Lagerfeld: L'étoffe d'une star," 74.

22. Honoré de Balzac, *Physiologie du mariage*, in Eric Hazan, *L'invention de Paris* (Paris: Éditions de Seuil, 2002), 411.

23. Adam Gopnik, "Saving the Balzar," *New Yorker*, Aug. 3, 1998, 39–42.

24. Jean-Michel Frodon and Dina Iordanova, dir., *Cinémas de Paris* (Paris: CNRS Éditions, 2017), 232.

25. Karl Lagerfeld in Beaudoin and Lazaroo, "Karl Lagerfeld: L'étoffe d'une star," 74.

26. Karl Lagerfeld in "Monsieur K. veut changer de ligne," 1958, n.p., https://www.sothebys.com/en/buy/auction/2021/karl-karl-lagerfelds-estate/deux-work-binders-dated.

27. Karl Lagerfeld in Violaine de Montclos, "Lagerfeld, portrait volé," *Le Point*, Oct. 4, 2007, 84.

28. Karl Lagerfeld in Dora Stern, "Itinéraire d'un enfant gâté," *Dépêche Mode*, May 1992, 34.

29. Voltaire in Marc Fumaroli, "Le genie de la langue française," in Pierre Nora, ed., *Les Lieux de mémoire*, Vol. 3 (Paris: Gallimard, 1997), 4623–24.

30. Stanley Karnow, *Paris in the Fifties* (New York: Random House, 1997), 240.

31. *France-Dimanche* in Élisabeth Quin, *Bel de nuit: Gerald Nanty* (Paris: Grasset, 2007), 41.

32. Quin, *Bel de nuit: Gerald Nanty*, 43.

33. Simone de Beauvoir, *La force des choses*, Vol. I (Paris: Gallimard, 1963), 61.

34. Gérard Letailleur, *Histoires insolite des cafés parisiens* (Paris: Perrin, 2011), 290.

35. Karl Lagerfeld, *Café de Flore*, Lot 571, Sotheby's KARL, Karl Lagerfeld Estate.

36. Gerald Nanty in Quin, *Bel de nuit: Gerald Nanty*, 46.

37. Karl Lagerfeld in Sylvia Jorif and Marion Ruggieri, "Karl Lagerfeld: L'homme sans passé," *Elle*, Sept. 2008, 94.

38. Karl Lagerfeld in *The Story of Fashion*, vol. 3, FA.

39. Karl Lagerfeld in Odile Benyahia-Koulder, "'Kaiser Karl,' un cas," *Challenges*, March 22, 2007, 90.

40. Jean-Marc Théolleyre, "Quatorze accusés presents ont entendu pendant plus de trois heures le récit du trois cents tortures," *Le Monde*, Nov. 21, 1952, n.p.

41. Janet Flanner, *Paris Journal: 1944–1955* (New York: Harcourt, Brace, 1965), 283.

42. Simone de Beauvoir, *Les Mandarins* (Paris: Gallimard, 1954), 27.

43. Flanner, *Paris Journal*, 123.

44. Flanner, *Paris Journal*, 123–24.

45. Ginette Sainderichin, "Les chaises dorées de la mode," *Les années 50* (Paris: Éditions Centre Pompidou, 1988), 521–22.

46. Karnow, *Paris in the Fifties*, 263.

47. Ykje Wildenborg, "Ordering a Dress," in Olivier Saillard and Anne Zazzo, eds., *Paris Haute Couture* (Paris: Flammarion, 2013), 224.

48. Sainderichin, "Les chaises dorées de la mode," 521.

49. *Dictionnaire de la Mode au XXe Siècle* (Paris: Éditions du Regard, 1994), 272.

50. *Dictionnaire de la Mode au XXe Siècle*, 53.

51. Karl Lagerfeld, "Le film d'un film," 276.

Chapter 6: Center Stage

1. Karl Lagerfeld, letter to Elisabeth Lagerfeld, Dec. 10, 1954, in Karl Lagerfeld, "Two Work Binders," Lot 423, Sotheby's KARL, Karl Lagerfeld Estate.

2. Eric Guillot, interview with the author, Dec. 5, 2021.

3. Eric Guillot, interview with the author, Dec. 5, 2021.

4. Marie-Pierre Ribere, email to the author, Dec. 16, 2021.

5. Sylvie Roy, email to the author, Dec. 15, 2021.

6. Eric Guillot, interview with the author, Dec. 5, 2021.

7. Karl Lagerfeld in Thierry Billiard and David Slama, "Karl Kapital," *Paris Capitale*, March 2008, 54.

8. Eric Guillot, interview with the author, Dec. 5, 2021.

9. Blaise Cendrars, "Le Mystère de la Création," *Le Jardin des Modes*, Oct. 1952, 25–28, in Karl Lagerfeld, "Two Work Binders," Lot 423.

10. Karl Lagerfeld, "Two Work Binders," Lot 423.

11. Karl Lagerfeld in Elisabeth Lazaroo, "Roulez Jeunesse!" *Paris Match*, July 5, 2018, 25.

12. Karl Lagerfeld, "Two Work Binders," Lot 423.

13. Karl Lagerfeld, note to Catherine Castro, *Beaux Arts*, Oct. 3, 1996, PdeC.

14. Karl Lagerfeld, "Two Work Binders," Lot 423.

15. Karl Lagerfeld, *Two Bathers*, Lot 576, Sotheby's KARL, Karl Lagerfeld Estate.

16. Karl Lagerfeld, *The Art of Accommodating Leftover Fur*, Lot 421, Sotheby's KARL, Karl Lagerfeld Estate.

17. Karl Lagerfeld, *Élégantes*, Lot 1099, Sotheby's KARL, Karl Lagerfeld Estate.

18. Éric Guillot, interview with the author, Dec. 5, 2021.

19. Éric Guillot, interview with the author, Jan. 10, 2022.

20. Éric Guillot, email to the author, Dec. 16, 2021.

21. Amanda Harlech, text to the author, Dec. 12, 2021.

22. "The Divine History of the International Woolmark Prize," woolmarkprize.com.

23. Karl Lagerfeld in *Masters of Beauty: Karl Lagerfeld*, March 12, 2014, https://www.youtube.com/watch?v=sVTxm237SM8.

24. Karl Lagerfeld in *Masters of Beauty: Karl Lagerfeld*.

25. Karl Lagerfeld, "Two Work Binders," Lot 423.

26. *L'Aurore*, Nov. 25, 1954, n.p.

27. Press release, International Wool Secretariat, Dec. 10, 1954, in Karl Lagerfeld, "Two Work Binders," Lot 423.

28. Thelma Sweetinburgh to Karl Lagerfeld, Nov. 25, 1954, in Karl Lagerfeld, "Two Work Binders," Lot 423.

29. Karl Lagerfeld, telegram to Elisabeth Lagerfeld, Nov. 25, 1954, in Karl Lagerfeld, "Two Work Binders," Lot 423.

30. Karl Lagerfeld in Loïc Prigent, dir., *Karl Lagerfeld se dessine*, Arte, 2013.

31. "Le secretariat international de la laine a choisi parmi six mille dessins ses trois lauréats," *Le Figaro*, Nov. 25, 1954.

32. Karl Lagerfeld, letter to Elisabeth Lagerfeld, Dec. 10, 1954, in Karl Lagerfeld, "Two Work Binders," Lot 423.

33. Karl Lagerfeld in Prigent, *Karl Lagerfeld se dessine*.

34. Thelma Sweetinburgh to Karl Lagerfeld, Nov. 29, 1954, in Karl Lagerfeld, "Two Work Binders," Lot 423.

35. Press release, International Wool Secretariat, Dec. 10, 1954, in Karl Lagerfeld, "Two Work Binders," Lot 423.

36. M. Maufroy, "Les salaires en France en 1954," *Journal de la société statistique de Paris*, tome 96, 1955, 113.

37. Karl Lagerfeld in Charlotte Cowles, "Karl Lagerfeld on Diets, Sobriety, and Becoming a 'Nicer Person,'" *New York*, Nov. 7, 2013.

38. Press release, International Wool Secretariat, Dec. 10, 1954, in Karl Lagerfeld, "Two Work Binders," Lot 423.

39. Press release, International Wool Secretariat, Dec. 10, 1954, in Karl Lagerfeld, "Two Work Binders," Lot 423.

40. Press release, International Wool Secretariat, Dec. 10, 1954, in Karl Lagerfeld, "Two Work Binders," Lot 423.

41. Press release, International Wool Secretariat, Dec. 10, 1954, in Karl Lagerfeld, "Two Work Binders," Lot 423.

42. Karl Lagerfeld in Prigent, *Karl Lagerfeld se dessine*.

43. Karl Lagerfeld, letter to Elisabeth Lagerfeld, Dec. 10, 1954, in Karl Lagerfeld, "Two Work Binders," Lot 423.

44. Karl Lagerfeld, letter to Elisabeth Lagerfeld, Dec. 10, 1954, in Karl Lagerfeld, "Two Work Binders," Lot 423.

45. Karl Lagerfeld, letter to Elisabeth Lagerfeld, Dec. 10, 1954, in Karl Lagerfeld, "Two Work Binders," Lot 423.

46. Karl Lagerfeld, letter to Elisabeth Lagerfeld, Dec. 10, 1954, in Karl Lagerfeld, "Two Work Binders," Lot 423.

47. Karl Lagerfeld, letter to Elisabeth Lagerfeld, Dec. 10, 1954, in Karl Lagerfeld, "Two Work Binders," Lot 423.

48. Kaley Roshitsh, "Woolmark Spins a New Yarn in Tribute to Karl Lagerfeld," *WWD*, Feb. 4, 2020.

49. Karl Lagerfeld, letter to Elisabeth Lagerfeld, Dec. 10, 1954, in Karl Lagerfeld, "Two Work Binders," Lot 423.

50. Amanda Harlech, text to the author, Dec. 12, 2021.

51. Karl Lagerfeld, letter to Elisabeth Lagerfeld, Dec. 10, 1954, in Karl Lagerfeld, "Two Work Binders," Lot 423.

52. Karl Lagerfeld, letter to Elisabeth Lagerfeld, Dec. 10, 1954, in Karl Lagerfeld, "Two Work Binders," Lot 423.

53. Karl Lagerfeld, letter to Elisabeth Lagerfeld, Dec. 10, 1954, in Karl Lagerfeld, "Two Work Binders," Lot 423.

54. Karl Lagerfeld, letter to Elisabeth Lagerfeld, Dec. 10, 1954, in Karl Lagerfeld, "Two Work Binders," Lot 423.

55. "Ein Hamburger gewann: Sensation in Paris," *Berliner Morgenpost*, Dec. 10, 1954, n.p.

56. Marion, "Paris war begeistert," *Bildzeitung Weihnachten*, 1954, n.p.

57. Karl Lagerfeld, letter to Elisabeth Lagerfeld, Dec. 10, 1954, in Karl Lagerfeld, "Two Work Binders," Lot 423.

58. Karl Lagerfeld in Monique Davidson, "Karl Lagerfeld Talks to Monique Davidson," *Clout*, Feb. 1983, 15.

Chapter 7: Public Relations

1. Karl Lagerfeld in Odile Benyahia-Koulder, "'Kaiser Karl,' un cas," *Challenges*, March 22, 2007, 90.

2. Karl Lagerfeld, note to Jean-Claude Zana, *Paris Match*, July 1, 1994, PdeC.

3. "Taking a Powder," *WWD*, January 16, 1995, 1.

4. Karl Lagerfeld in William Middleton, "Monte Karl," *W*, July 1995, 118.

5. William Middleton, "Heavenly Hamburg," *W*, Sept. 1996, 334.

6. William Middleton, "The Prêt Pack," *W*, Nov. 1996, n.p.

7. Victoire Doutreleau, interview with the author, March 13, 2020.

Chapter 8: High Fashion, Entry Level

1. Karl Lagerfeld in Monique Davidson, "Karl Lagerfeld Talks to Monique Davidson," *Clout*, Feb. 1983, 15.

2. Karl Lagerfeld in Davidson, "Karl Lagerfeld Talks to Monique Davidson," 15.

3. Cecil Beaton, *The Glass of Fashion* (New York: Rizzoli, 2014), 302.

4. Pierre Balmain, "Des rapports de l'architecture avec la couture," Nov. 24, 1950, in Émilie Hammen and Benjamin Simmenauer, *Les Grands textes de la mode* (Paris: Regard, 2017), 74–75.

5. Karl Lagerfeld in "King Karl," *WWD*, Nov. 20, 1991, n.p.

6. Karl Lagerfeld in Loïc Prigent, dir., *Karl Lagerfeld se dessine*, Arte, 2013.

7. Karl Lagerfeld in Prigent, *Karl Lagerfeld se dessine*.

8. Peter Bermbach, interview with the author, Dec. 8, 2021.

9. Peter Bermbach, interview with the author, Dec. 8, 2021.

10. Karl Lagerfeld in Prigent, *Karl Lagerfeld se dessine*.

11. Karl Lagerfeld, *Off the Record* (Göttingen: Steidl, 1994), n.p.

12. Karl Lagerfeld in Prigent, *Karl Lagerfeld se dessine*.

13. Karl Lagerfeld in Prigent, *Karl Lagerfeld se dessine*.

14. Peter Stanford, "Bronwen, Lady Astor Obituary," *Guardian*, Jan. 1, 2018, https://www.theguardian.com/uk-news/2018/jan/01/bronwen-lady-astor-obituary.

15. Bronwen Astor in Peter Stanford, *Bronwen Astor: Her Life and Times* (London: HarperCollins, 2000), 119.

16. Zsa Zsa Gabor, interview with Pierre Guénin, July 1955, in Karl Lagerfeld, "Two Work Binders," Lot 423, Sotheby's KARL, Karl Lagerfeld Estate.

17. Yseult Williams, letter to Charles Mathieu Saint Laurent, Feb. 16, 1955, in Yseult Williams, *La Splendeur des Brunhoff* (Paris: Fayard, 2018), 381.

18. Victoire Doutreleau, *Et Dior créa Victoire* (Paris: Robert Laffont, 1997), 20.

19. Doutreleau, *Et Dior créa Victoire*, 247–48.

20. Doutreleau, *Et Dior créa Victoire*, 251.

21. Karl Lagerfeld in Prigent, *Karl Lagerfeld se dessine*.

22. Roland d'Anna, email to the author, Jan. 17, 2022.

23. Karl Lagerfeld in Anne-Cécile Beaudoin and Elisabeth Lazaroo, "Karl Lagerfeld: L'étoffe d'une star," *Paris Match*, April 25, 2013, 74–75.

24. Doutreleau, *Et Dior créa Victoire*, 253.

25. Doutreleau, *Et Dior créa Victoire*, 261.

26. Karl Lagerfeld, interview with Reinhold Beckmann, ARD, July 5, 2004, in Alfons Kaiser, *Karl Lagerfeld: Ein Deutscher in Paris* (Munich: Verlag C.H. Beck oHG, 2020), 124.

27. Raphaëlle Bacqué, "Catherine Deneuve et son double," *Le Monde*, Aug. 24, 2020, https://www.lemonde.fr/series-d-ete/article/2020/08/24/catherine-deneuve-et-son -double_6049813_3451060.html.

28. Doutreleau, *Et Dior créa Victoire*, 262–66.

29. Karl Lagerfeld, *Off the Record*.

30. Doutreleau, *Et Dior créa Victoire*, 293–97.

31. Doutreleau, *Et Dior créa Victoire*, 268–71.

32. Victoire Doutreleau, interview with the author, March 13, 2020.

33. Doutreleau, *Et Dior créa Victoire*, 293.

34. *Collection 'Florilege' de Pierre Balmain, Paris, printemps-été 1958*, in Karl Lagerfeld, "Two Work Binders," Lot 423.

35. Karl Lagerfeld in *Masters of Beauty: Karl Lagerfeld*, https://www.youtube.com/watch ?v=sVTxm237SM8&list=PLw9qK_JhHsvPXx1v3goZnVNe7Z0_n76gg &index=10.

36. Karl Lagerfeld in Prigent, *Karl Lagerfeld se dessine*.

37. *Dictionnaire de la Mode au XXe Siècle* (Paris: Éditions du Regard, 1994), 287.

38. *Paris Match*, Aug. 9, 1958, n.p., in Karl Lagerfeld, "Two Work Binders," Lot 423.

39. Emmanuelle Polle, *Jean Patou: Une vie sur mesure* (Paris: Flammarion, 2013), 36.

40. *Fantasio*, July 15, 1924, n.p., in Polle, *Jean Patou: Une vie sur mesure*, 62.

41. Karl Lagerfeld in Davidson, "Karl Lagerfeld Talks to Monique Davidson," 15.

42. Karl Lagerfeld in Prigent, *Karl Lagerfeld se dessine*.

43. Karl Lagerfeld in Caroline Tossan, "Ma collection? Zen-baroque," *Le Journal du dimanche*, Jan. 16, 2000, n.p.

44. Karl Lagerfeld in Prigent, *Karl Lagerfeld se dessine*.

45. Karl Lagerfeld in Tossan, "Ma collection? Zen-baroque."

46. Karl Lagerfeld in Richard Gianorio, "L'odeur de sainteté je n'y tiens pas," *Madame Figaro*, May 20, 2013, https://madame.lefigaro.fr/style/karl-lagerfeld-lodeur-de -saintete-ny-tiens-pas-200513-382922.

47. Karl Lagerfeld in Prigent, *Karl Lagerfeld se dessine*.

48. Karl Lagerfeld in Prigent, *Karl Lagerfeld se dessine*.

49. "Départ de la mode d'hiver," *Le Figaro*, July 29, 1958, n.p., in Karl Lagerfeld, "Two Work Binders," Lot 423.

50. Fay Hammond, "Paris Opening Launch," *Los Angeles Times*, July 31, 1958, n.p., in Karl Lagerfeld, "Two Work Binders," Lot 423.

51. Eugenia Sheppard, "New Dresses in Paris, Simple, High-Waisted," *New York Herald*, July 29, 1958, n.p., in Karl Lagerfeld, "Two Work Binders," Lot 423.

52. "Paris Cancane: Patou sort l'anti-Saint Laurent," p. 2, in Karl Lagerfeld, "Two Work Binders," Lot 423.

53. "Monsieur K veut changer de ligne," p. 21, in Karl Lagerfeld, "Two Work Binders," Lot 423.

54. Karl Lagerfeld, *Off the Record*.

55. Karl Lagerfeld in Kaiser, *Karl Lagerfeld: Ein Deutscher in Paris*, 124.

56. Karl Lagerfeld in Sylvia Jorif and Marion Ruggieri, "Karl Lagerfeld: L'homme sans passé," *Elle*, Sept. 2008, 94.

57. Karl Lagerfeld, *Off the Record*.

58. Peter Bermbach, "Mein Karl," *Frankfurter Allgemeine*, July 26, 2011, n.p.

59. Colombe Pringle, interview with the author, June 7, 2021.

60. Colombe Pringle, interview with the author, June 7, 2021.

61. Colombe Pringle, interview with the author, June 7, 2021.

62. Karl Lagerfeld in Raphaëlle Bacqué, "Karl Lagerfeld, La sensation Warhol," *Le Monde*, Aug. 20, 2018, 12.

63. Karl Lagerfeld, interview with Marc Olivier Fogiel, *Le Divan*, France 3, Feb. 24, 2015.

64. Karl Lagerfeld in Bacqué, "Karl Lagerfeld, La sensation Warhol," 12.

65. Karl Lagerfeld, interview with Marc Olivier Fogiel.

66. Jean-François Bizot, "Lagerfeld veut regner sur la mode," *Actuel*, March 1984, 137.

67. Karl Lagerfeld in Davidson, "Karl Lagerfeld Talks to Monique Davidson," 16.

68. Karl Lagerfeld, interview with Marc Olivier Fogiel.

69. Karl Lagerfeld in Lydia Bacrie and Charlotte Brunel, "Karl Lagerfeld: 'Beaucoup des collègues me reprochent d'avoir tué le métier,'" *L'Express*, Dec. 16, 2015.

Chapter 9: Chloé and Fendi, Andy and Antonio

1. Karl Lagerfeld in Bertrand Fraysse, "Iconique," *Challenges*, Feb. 14, 2008, 63.

2. Carrie Donovan, "Fashion Trends Abroad," *New York Times*, Jan. 27, 1959, 28.

3. "Marc Bohan Appointed Dior's New Designer," *New York Times*, Sept. 29, 1960, 38.

4. Yves Saint Laurent in Caroline Rousseau, "André Courrèges était un visionaire," *Le Monde*, Jan. 8, 2016, https://www.lemonde.fr/m-mode/article/2016/01/09/andre-courreges-ou-la-jeunesse-eternelle_4844288_4497335.html.

5. Karl Lagerfeld in Monique Davidson, "Karl Lagerfeld Talks to Monique Davidson," *Clout*, Feb. 1983, 15.

6. Karl Lagerfeld in Charlotte Cowles, "Karl Lagerfeld on Diets, Sobriety, and Becoming a 'Nicer Person,'" *New York*, Nov. 7, 2013.

7. Sarah Mower, *Chloé: Attitudes* (New York: Rizzoli, 2013), 26.

8. Mower, *Chloé: Attitudes*, 26.

9. Gaby Aghion in Mower, *Chloé: Attitudes*, 15.

10. Gill Goldsmith, "Paris Designer Longs to Return to High Fashion," *New York Times*, Dec. 7, 1960, 59.

11. Mower, *Chloé: Attitudes*, 27.

12. Mower, *Chloé: Attitudes*, 38.

13. Karl Lagerfeld in Davidson, "Karl Lagerfeld Talks to Monique Davidson," 15.

14. Mower, *Chloé: Attitudes*, 38.

15. Gaby Aghion in Mower, *Chloé: Attitudes*, 38.

16. Suzy Menkes, "Chanel's Toy Boy," *Times* (London), April 15, 1986, 15.

17. Layla Ilchi, "Karl Lagerfeld: A Look Back at His Iconic Career in Fashion," *WWD*, Feb. 19, 2019.

18. Anita Briey, interview with the author, Dec. 2, 2020.

19. Anita Briey in *Karl Lagerfeld: Être et paraître*, "Un Jour, un destin," April 10, 2017.

20. Briey, in *Karl Lagerfeld: Être et paraître*, "Un Jour, un destin."

21. Briey, in *Karl Lagerfeld: Être et paraître*, "Un Jour, un destin."

22. Briey, in *Karl Lagerfeld: Être et paraître*, "Un Jour, un destin."

23. Silvia Venturini Fendi, interview in *Karl For Ever*, June 20, 2019, PdeC.

24. Silvia Venturini Fendi, interview with the author, July 14, 2021.

25. Silvia Venturini Fendi, interview with the author, July 14, 2021.

26. Elisabeth Lazaroo, "Fendi & Karl fêtent leurs noces d'or," *Paris Match*, July 9, 2015, https://www.parismatch.com/Vivre/Mode/Fendi-Karl-fetent-leurs-noces-d-or-796990.

27. "The Double F Logo," n.d., FA.

28. Karl Lagerfeld in Davidson, "Karl Lagerfeld Talks to Monique Davidson," 15.

29. "Fendi Autumn–Winter 1966–1967 Collection," n.d., FA.

30. "One of the most beautiful pieces of the Fendi fur archives is a blanket?" Oct. 30, 2020, FA.

31. Bernadine Morris, "Valentino—Quiet but Beguiling, Tailored but Feminine," *New York Times*, July 23, 1971, 38.

32. Silvia Venturini Fendi, interview with the author, July 14, 2021.

33. Silvia Venturini Fendi, interview with the author, July 14, 2021.

34. Silvia Venturini Fendi, interview with the author, July 14, 2021.

35. Silvia Venturini Fendi, interview with the author, July 14, 2021.

36. Silvia Venturini Fendi, interview with the author, July 14, 2021.

37. "LVMH to Buy Prada's Fendi Stake," *Los Angeles Times*, Nov. 26, 2001, https://www.latimes.com/archives/la-xpm-2001-nov-26-fi-8394-story.html.

38. "LVMH Taps Dior's Brunschwig to Lead Luxury Brand Fendi," Reuters, https://www.reuters.com/article/lvmh-fendi/lvmh-taps-diors-brunschwig-to-lead-luxury-brand-fendi-idINKCN1G41G5.

39. Karl Lagerfeld in Colombe Pringle, "Je déteste les riches qui vivent au-dessous de leurs moyens," *L'Express*, Nov. 11, 1999, 30.

40. Karl Lagerfeld, *Off the Record* (Göttingen: Steidl, 1994), n.p.

41. "Appartement d'un styliste," *L'Œil*, March 1968, 51.

42. "Appartement d'un styliste."

43. "Un styliste d'aujourd'hui aux sources du design," *L'Œil*, Oct. 1969, no. 178, 52–58.

44. "KL Unique Drawing Board, 1964–1966," Design, May 3, 2018, Sothebys.com, http://www.sothebys.com/en/auctions/ecatalogue/2018/design-pf1804/lot.156 .html.

45. Régine Vivier, "Ils ont choisi les vacances à domicile," *Elle*, July 14, 1969, 41.

46. Alfons Kaiser, *Karl Lagerfeld: Ein Deutscher in Paris* (Munich: Verlag C.H. Beck oHG, 2020), 26.

47. Kaiser, *Karl Lagerfeld: Ein Deutscher in Paris*, 26.

48. Paul Caranicas, *Antonio's People* (New York: Thames & Hudson, 2004), 8.

49. Paul Caranicas, interview with the author, Dec. 17, 2021.

50. "1969 (c), Paris, Karl Lagerfeld's apartment, Carol LaBrie and Antonio Lopez _PH38_067.jpg," AA.

51. "1969 (c), Paris, Karl Lagerfeld's apartment, Pat Cleveland and Antonio Lopez _PH37C_20.jpeg," AA.

52. "1970 (c), Paris, Cafe de Flore, Donna Jordan, Jay Johnson, Sergio Arena, Patti D'Arbanville, Karl Lagerfeld and Antonio Lopez_PH38_073.jpg," AA.

53. Caranicas, *Antonio's People*, 10.

54. Corey Grant Tippin, interview with the author, Dec. 19, 2021.

55. Corey Grant Tippin, interview with the author, Dec. 19, 2021.

56. Corey Grant Tippin, interview with the author, Dec. 19, 2021.

57. Corey Grant Tippin, interview with the author, Dec. 19, 2021.

58. Corey Grant Tippin, interview with the author, Dec. 19, 2021.

59. Corey Grant Tippin, interview with the author, Dec. 19, 2021.

60. "1970 (c), St Tropez, Juan Ramos and Karl Lagerfeld_PH38_246.jpg," AA.

61. "1970, St Tropez, Antonio Lopez, Donna Jordan, Chris Poracchia, Karl Lagerfeld _PH38_267.jpg," AA.

62. Paul Caranicas, interview with the author, Dec. 17, 2021.

63. Corey Grant Tippin, interview with the author, Dec. 19, 2021.

64. Minouflet de Vermenou, "Silence! On tourne . . . les pages," *Vogue Paris*, March 1979, 415.

65. Sandy Brant, email to the author, Oct. 2, 2021.

66. Vincent Canby, "The Screen: L'Amour," *New York Times*, May 11, 1973, 26.

67. Karl Lagerfeld in Sylvia Jorif and Marion Ruggieri, "Karl Lagerfeld: L'homme sans passé," *Elle*, Sept. 2008, 95.

68. Corey Tippin, interview with the author, Dec. 19, 2021.

Chapter 10: Love and Obsession

1. Karl Lagerfeld in Sylvia Jorif and Marion Ruggieri, "Karl Lagerfeld: L'homme sans passé," *Elle*, Sept. 2008, 95.

2. Paloma Picasso, interview with the author, March 21, 2021.

3. Paloma Picasso, interview with the author, March 21, 2021.

4. Paloma Picasso, interview with the author, March 21, 2021.

5. Paloma Picasso, interview with the author, March 21, 2021.

6. Paloma Picasso, interview with the author, March 21, 2021.

7. Paloma Picasso, interview with the author, March 21, 2021.

8. Paloma Picasso, interview with the author, March 21, 2021.

9. Paloma Picasso, interview with the author, March 21, 2021.

10. Paloma Picasso, interview with the author, March 21, 2021.

11. Jacques de Bascher in "Karl Lagerfeld: In a Cloud of Chloé," *Interview*, June 1975, 30.

12. Philippe Heurtault, email to the author, March 20, 2022.

13. Philippe Heurtault in Marie Ottavi, *Jacques de Bascher: Dandy de l'ombre* (Paris: Séguier, 2017), 61.

14. Karl Lagerfeld in Ottavi, *Jacques de Bascher: Dandy de l'ombre*, 70.

15. Karl Lagerfeld in Anne-Cécile Beaudoin and Elisabeth Lazaroo, "Karl Lagerfeld: L'étoffe d'une star," *Paris Match*, April 25, 2013, 76.

16. Jacques Quoirez, "Pourquoi la Barbe," *Vogue Hommes*, March 1973, 135.

17. Jacques de Bascher in André Leon Talley, "Karl Lagerfeld: In a Cloud of Chloé," *Interview*, June 1975, 30.

18. Quoirez, "Pourquoi la Barbe," 135.

19. Diane de Beauvau-Craon in Simon Liberati, "Cet obscure objet du désir," *Vogue Hommes*, Sept. 2014, n.p.

20. Christian Dumais-Lvowski in Philippe Heurtault and Christian Dumais-Lvowski, *Jacques de Bascher* (Paris: Michel de Maule, 2017), 11.

21. Philippe Heurtault, interview with the author, March 23, 2022.

22. Patrick McCarthy in Alicia Drake, *The Beautiful Fall* (New York: Little, Brown, 2006), 221.

23. Jérémy Patiner, "Jacques de Bascher: Le grand amour de Karl Lagerfeld et Saint-Laurent," *Têtu*, Nov. 7, 2017, https://tetu.com/2017/07/11/jacques-de-bascher-grand-amour-de-karl-lagerfeld-saint-laurent/.

24. Jacques de Bascher in Heurtault and Dumais-Lvowski, *Jacques de Bascher*, 189.

25. Jacques de Bascher in Talley, "Karl Lagerfeld: In a Cloud of Chloé," 30.

26. Diane de Beauvau-Craon, interview with the author, June 20, 2021.

27. Diane de Beauvau-Craon, email to the author, Jan. 3, 2022.

28. Diane de Beauvau-Craon, interview with the author, June 20, 2021.

29. Diane de Beauvau-Craon, interview with the author, June 20, 2021.

30. Diane de Beauvau-Craon, interview with the author, June 20, 2021.

31. Diane de Beauvau-Craon, interview with the author, June 20, 2021.

32. Diane de Beauvau-Craon, interview with the author, June 20, 2021.

33. Heurtault and Dumais-Lvowski, *Jacques de Bascher*, 13–17.

34. Philippe Heurtault, email to the author, March 20, 2022.

35. Christian Dumais-Lvowski in Heurtault and Dumais-Lvowski, *Jacques de Bascher*, 8–9.

36. Inès de la Fressange, interview with the author, March 16, 2021.

37. Philippe Heurtault, email to the author, March 23, 2022.

38. Karl Lagerfeld in Ottavi, *Jacques de Bascher: Dandy de l'ombre*, 76.

39. Karl Lagerfeld in Ottavi, *Jacques de Bascher: Dandy de l'ombre*, 87.

40. Christian Dumais-Lvowski in Heurtault and Dumais-Lvowski, *Jacques de Bascher*, 10–11.

41. Diane de Beauvau-Craon, interview with the author, June 20, 2021.

42. "Avec K.L., Classicisme K.O.," *Vogue Hommes*, Summer 1974, n.p.

43. Paul Caranicas, interview with the author, Dec. 17, 2021.

44. Corey Tippin, interview with the author, Dec. 19, 2021.

45. Jacques de Bascher in Quoirez, "Pourquoi la Barbe," 135.

46. Christian Dumais-Lvowski in Heurtault and Dumais-Lvowski, *Jacques de Bascher*, 9.

47. Paloma Picasso, interview with the author, March 21, 2021.

48. Paloma Picasso, interview with the author, March 21, 2021.

49. Silvia Venturini Fendi, interview with the author, July 14, 2021.

50. Ottavi, *Jacques de Bascher: Dandy de l'ombre*, 91.

51. Anita Briey, in *Karl Lagerfeld: Être et paraître*, "Un Jour, un destin," April 10, 2017.

52. Jacques de Bascher in Talley, "Karl Lagerfeld: In a Cloud of Chloé," 30.

53. Karl Lagerfeld in Ottavi, *Jacques de Bascher: Dandy de l'ombre*, 75.

54. Diane de Beauvau-Craon, interview with the author, June 20, 2021.

55. Philippe Heurtault, interview with the author, March 23, 2022.

56. Philippe Heurtault, interview with the author, March 23, 2022.

57. Diane de Beauvau-Craon, interview with the author, June 20, 2021.

58. Jacques de Bascher, note to Karl Lagerfeld, Oct. 17, 1983, private collection.

59. Karl Lagerfeld, interview with Marc Olivier Fogiel, *Le Divan*, France 3, Feb. 24, 2015.

60. Karl Lagerfeld, interview with Marc Olivier Fogiel.

61. Jacques Grange in Véronique Lorelle, "Jacques Grange, le décorateur des stars, vend une partie de sa collection art et design," *Le Monde*, Nov. 17, 2017, https://www.lemonde.fr/m-design-deco/article/2017/11/15/le-decorateur-des-stars-fait-le-vide-chez-lui_5215279_4497702.html.

62. Jacques Grange, interview with the author, Feb. 25, 2021.

63. Jacques Grange, interview with the author, Feb. 25, 2021.

64. Jacques Grange, interview with the author, Feb. 25, 2021.

65. Gilles Dufour in Liberati, "Cet obscure objet du désir."

66. Thadée Klossowski de Rola in Ottavi, *Jacques de Bascher: Dandy de l'ombre*, 125.

67. Philippe Heurtault, interview with the author, March 23, 2022.

68. Philippe Heurtault, interview with the author, March 23, 2022.

69. Heurtault and Dumais-Lvowski, *Jacques de Bascher*, 49–50.

70. Diane de Beauvau-Craon in Ottavi, *Jacques de Bascher: Dandy de l'ombre*, 91.

71. Diane de Beauvau-Craon, interview with the author, June 20, 2021.

72. Heurtault and Dumais-Lvowski, *Jacques de Bascher*, 51.

73. *Deux Dents de Narval*, "Collection Yves Saint Laurent et Pierre Bergé," Feb. 25, 2009, https://www.christies.com/en/lot/lot-5171506.

74. Heurtault and Dumais-Lvowski, *Jacques de Bascher*, 51.

75. "1974: Installation au 5 avenue Marceau," Musée YSL Paris, https://museeyslparis .com/biographie/installation-au-5-avenue-marceau.

76. Ottavi, *Jacques de Bascher: Dandy de l'ombre*, 136.

77. Patrick Hourcade, interview with the author, Feb. 22, 2021.

78. Jacques Grange, interview with the author, Feb. 25, 2021.

79. Ottavi, *Jacques de Bascher: Dandy de l'ombre*, 136.

80. Philippe Heurtault, interview with the author, March 23, 2022.

81. Pierre Passebon, interview with the author, Feb. 18, 2021.

82. Jacques Grange, interview with the author, Feb. 25, 2021.

83. Jacques Grange, interview with the author, Feb. 25, 2021.

84. Diane de Beauvau-Craon, interview with the author, June 20, 2021.

85. Karl Lagerfeld in Elisabeth Lazaroo, "Karl Lagerfeld: Roulez Jeunesse!" *Paris Match*, July 5, 2018, 24.

86. Karl Lagerfeld in Godfrey Deeny, "Karl Lagerfeld's Eternal Youth," *Fashion Wire Daily*, April 8, 2002, PdeC.

87. Karl Lagerfeld in Deeny, "Karl Lagerfeld's Eternal Youth."

88. Jean-François Bizot, "Lagerfeld veut regner sur la mode," *Actuel*, March 1984, 162.

89. Jacques Grange, interview with the author, Feb. 25, 2021.

90. Pierre Passebon, interview with the author, Feb. 18, 2021.

Chapter 11: Seventies Paris

1. Karl Lagerfeld in Natasha Fraser and William Middleton, "Paris: The Party Years," *W*, April 1996, 377

2. Hebe Dorsey, "50,000 Buyers Flood Paris," *International Herald Tribune*, April 3, 1974.

3. Donna Jordan in "Utopia," *CR Fashion Book*, Sept. 2013, n.p.

4. Corey Tippin, email to the author, March 14, 2022.

5. Corey Tippin, interview with the author, Dec. 19, 2021.

6. Corey Tippin, interview with the author, Dec. 19, 2021.

7. Élisabeth Quin, *Bel de nuit: Gerald Nanty* (Paris: Grasset, 2007), 224.

8. Quin, *Bel de nuit: Gerald Nanty*, 228–29.

9. Karl Lagerfeld in Philippe Morillon, *Une dernière danse?* (Paris: Edition 7L, 2009), n.p.

10. Alicia Drake, *The Beautiful Fall* (New York: Little, Brown, 2006), 121.

11. Claude Aurensan in Fraser and Middleton, "Paris: The Party Years," 378.

12. Guy Cuevas in Marie Ottavi, *Jacques de Bascher: Dandy de l'ombre* (Paris: Séguier, 2017), 61.

13. Guy Cuevas in Fraser and Middleton, "Paris: The Party Years," 380.

14. Karl Lagerfeld in Fraser and Middleton, "Paris: The Party Years," 380.

15. Karl Lagerfeld in Laurence Rémila and Fabrice de Rohan Chabot, "Karl Lagerfeld, La grande interview," *Technikart*, Oct. 2014, n.p.

16. John Crawley in Fraser and Middleton, "Paris: The Party Years," 380.

17. Karl Lagerfeld in Fraser and Middleton, "Paris: The Party Years," 379.

18. Marlene Dietrich to Karl Lagerfeld, "An autograph letter and a telegram sent to Karl Lagerfeld," KARL, Karl Lagerfeld's Estate, Sotheby's Part I, Lot 45, https://www .sothebys.com/en/buy/auction/2021/karl-karl-lagerfelds-estate/an-autograph -letter-and-a-telegram-sent-to-karl.

19. "Le Premier amour d'Anouk Aimée," *Vogue Paris*, April 1978, 171–75.

20. Karl Lagerfeld in "Le Premier amour d'Anouk Aimée," 172–74.

21. Stéphane Audran in Adrien Gombeaud, "Quand Karl Lagerfeld habillait Stéphane Audran," *Vogue Paris*, March 27, 2018, n.p, https://www.vogue.fr/culture/a-voir /story/quand-karl-lagerfeld-habillait-stephane-audran-dessins-films-cinema/1649.

22. Stéphane Audran in Gombeaud, "Quand Karl Lagerfeld habillait Stéphane Audran."

23. Stéphane Audran in Gombeaud, "Quand Karl Lagerfeld habillait Stéphane Audran."

24. Michael Roberts, "Fashion's King Karl," *Sunday Times* (London), April 1, 1973, n.p.

25. Roberts, "Fashion's King Karl."

26. Roberts, "Fashion's King Karl."

27. Roberts, "Fashion's King Karl."

28. Gérard Benoit, "Une éminence grise pour des robes (très) colorées," *Sud Ouest*, July 5, 1972, n.p.

29. Jean-Claude de Luca, "Des hommes à la mode," *Mr.*, no. 6, 1974, 83.

30. De Luca, "Des hommes à la mode," 83.

31. De Luca, "Des hommes à la mode," 83.

32. De Luca, "Des hommes à la mode," 83.

33. Stéphane Bern, "Caroline de Hanovre: Karl Lagerfeld était comme un membre de ma famille," *Point de Vue*, April 3, 2019, 21.

34. "La métamorphose de Caroline," *Paris Match*, April 5, 1975, n.p.

35. Jérôme Enez-Vriad, "Karl Lagerfeld Chatelain Morbihannais de Penhoët," *Bretagne Actuelle*, March 4, 2019, https://www.bretagne-actuelle.com/karl-lagerfeld -chatelain-morbihannais-de-penhoet/accueil-top.

36. Patrick Hourcade, *Une si longue complicité* (Paris: Flammarion, 2021), 92.

37. Hourcade, *Une si longue complicité*, 92.

38. Diane de Beauvau-Craon, interview with the author, June 20, 2021.

39. Karl Lagerfeld in "Mens Sane in Corpore Sano," *Maison et Jardin*, Dec. 1986, 126, 127.

40. Hourcade, *Une si longue complicité*, 73–74.

41. Bernadine Morris, "Karl Lagerfeld: The Designer Setting Fashion's Tempo," *New York Times*, May 21, 1979, B6.

42. Marian McEvoy, interview with the author, April 6, 2022.

43. Karl Lagerfeld, *Karl Lagerfeld: Journal de Mode* (Paris: Éditions Vilo, 1986), 7.

44. Lagerfeld, *Karl Lagerfeld: Journal de Mode*, 8.

45. Lagerfeld, *Karl Lagerfeld: Journal de Mode*, 7.

46. Lagerfeld, *Karl Lagerfeld: Journal de Mode*, 9.

47. Lagerfeld, *Karl Lagerfeld: Journal de Mode*, 32–33.

48. Lagerfeld, *Karl Lagerfeld: Journal de Mode*, 66.

49. Lagerfeld, *Karl Lagerfeld: Journal de Mode*, 7.

50. G.V., "Premières enchères à l`Hôtel Drouot," *Le Monde*, Nov. 21, 1975, n.p.

51. "50 300 F Paire de Vases de Jean Dunand," *Le Monde*, Dec. 1, 1975, n.p.

52. Karl Lagerfeld, *Off the Record* (Göttingen: Steidl, 1994), n.p.

53. Lagerfeld, *Off the Record*.

54. "L'hôtel de Maison ou hôtel Pozzo di Borgo," Paris-promeneurs, https://paris-promeneurs.com/l-hotel-de-maisons-ou-hotel-pozzo/.

55. Hourcade, *Une si longue complicité*, 70.

56. Hourcade, *Une si longue complicité*, 70–71.

57. Karl Lagerfeld in Jacques Bertoin, "Karl Lagerfeld, marginal de luxe," *Le Monde*, April 28, 1980, n.p.

58. Silvia Venturini Fendi, interview with the author, July 14, 2021.

59. Karl Lagerfeld in Ottavi, *Jacques de Bascher: Dandy de l'ombre*, 173.

60. Alice Augustin, "Quand le Tout-Paris des années 70 dansait à La Main bleue," *Vanity Fair*, June 22, 2016, https://www.vanityfair.fr/culture/people/articles/la-main-bleue-discotheque-legendaire-des-annees-1970/43430.

61. Alexis Bernier and François Buot, *Alain Pacadis: Itinéraire d'un Dandy Punk* (Paris: Le Mot et le Reste, 2018), 204.

62. Karl Lagerfeld in Fraser and Middleton, "Paris: The Party Years," 382.

63. Alain Pacadis, "Les collections d'un jeune homme chic," *Libération*, Nov. 4, 1977, n.p., in Bernier and Buot, *Alain Pacadis: Itinéraire d'un Dandy Punk*, 204–5.

64. Jean-Michel Moulhac in Augustin, "Quand le Tout-Paris des années 70 dansait à La Main bleue."

65. Paquita Paquin in Augustin, "Quand le Tout-Paris des années 70 dansait à La Main bleue."

66. Pacadis, "Les collections d'un jeune homme chic."

67. "L'Oeil de Vogue," *Vogue Paris*, July 1978, 13.

68. Philippe Heurtault and Christian Dumais-Lvowski, *Jacques de Bascher* (Paris: Michel de Maule, 2017), 141.

69. Marian McEvoy, "French Designers Show a Talent for Partying, Too," *New York Times*, April 14, 1978, 16.

70. Paloma Picasso, interview with the author, March 21, 2021.

71. Paloma Picasso, interview with the author, March 21, 2021.

72. Heurtault and Dumais-Lvowski, *Jacques de Bascher*, 177.

73. Loulou de la Falaise in Vanessa Lau, "May 10, 1978: La Vie en Rouge," *WWD*, Nov. 29, 2010, https://wwd.com/fashion-news/fashion-features/may-10-1978-la -vie-en-rouge-3391294/.

74. André Leon Talley, "Souper aux chandelles," *Vogue Paris*, Nov. 1979, n.p.

75. Talley, "Souper aux chandelles."

76. *Façade*, n.d., n.p.

77. Bernier and Buot, *Alain Pacadis: Itinéraire d'un Dandy Punk*, 218.

78. Heurtault and Dumais-Lvowski, *Jacques de Bascher*, 184–87.

79. Karl Lagerfeld in Nina S. Hyde, "Donning Masks, Dodging Boredom," *Washington Post*, Oct. 29, 1978, https://www.washingtonpost.com/archive/lifestyle/1978/10/29 /donning-masks-dodging-boredom/f8a39c48-b907-427f-ad38-1cba53ec4f77/.

80. Heurtault and Dumais-Lvowski, *Jacques de Bascher*, 186.

81. Dominque Segall in Heurtault and Dumais-Lvowski, *Jacques de Bascher*, 186.

82. Nina S. Hyde, "Donning Masks, Dodging Boredom," *Washington Post*, Oct. 29, 1978, https://www.washingtonpost.com/archive/lifestyle/1978/10/29/donning-masks -dodging-boredom/f8a39c48-b907-427f-ad38-1cba53ec4f77/.

83. François Jonquet, *Jenny Bel'Air: Une créature* (Paris: Points, 2021), 273.

84. Jonquet, *Jenny Bel'Air: Une créature*, 274.

85. Karl Lagerfeld in Fraser and Middleton, "Paris: The Party Years," 385.

86. Hyde, "Donning Masks, Dodging Boredom."

87. Karl Lagerfeld in Hyde, "Donning Masks, Dodging Boredom."

Chapter 12: International Travels

1. Karl Lagerfeld in Liselotte Millauer, "Interview mit Karl Lagerfeld," *Petra*, Jan. 1984, 76.

2. Bernadine Morris, "Karl Lagerfeld: The Designer Setting Fashion's Tempo," *New York Times*, May 21, 1979, B6.

3. Bernadine Morris, "Fendi Furs Dazzle Milan," *New York Times*, March 29, 1979, C1.

4. Morris, "Fendi Furs Dazzle Milan."

5. Nina Hyde, "Mickey and Minnie on the Paris Runway," *Washington Post*, April 10, 1979.

6. Bernadine Morris, "Impressarios of Fashion Preside at Les Halles," *New York Times*, April 10, 1979, C12.

7. Karl Lagerfeld, "Plaidoyer pour les créateurs," *GAP*, Dec. 1980, 133.

8. Karl Lagerfeld in Carrie Donovan, "Why the Big Change Now," *New York Times Magazine*, Nov. 12, 1978, 103.

9. Marian McEvoy in Joël Stratte McClure, "Un week-end avec Karl Lagerfeld," *Le Matin de Paris*, March 21, 1980, n.p.

10. *Vogue Paris*, "Chloé par Karl Lagerfeld," Aug. 1979, 286–87.

11. Donovan, "Why the Big Change Now," 104.

12. Carrie Donovan, "American Designers Come of Age," *New York Times Magazine*, May 6, 1979, 254.

13. Karl Lagerfeld in André Leon Talley, "Perspective 80," *Vogue Paris*, Nov. 1979, 213.

14. Constantin Brâncuși, *L'Oiseau dans l'espace*, 1941, https://www.centrepompidou.fr/fr/ressources/oeuvre/cbLy4oX.

15. Susan and Alan Raymond, dir., *The Third Coast*, 1981, Texas Archive of the Moving Image, https://texasarchive.org/2018_04589.

16. Talley, "Perspective 80," 213.

17. Raymond and Raymond, dir., *The Third Coast*.

18. Raymond and Raymond, dir., *The Third Coast*.

19. Talley, "Perspective 80," 213.

20. Karl Lagerfeld in Talley, "Perspective 80," 215.

21. Morris, "Karl Lagerfeld: The Designer Setting Fashion's Tempo," B6.

22. Karl Lagerfeld in Talley, "Perspective 80," 217.

23. Karl Lagerfeld in Talley, "Perspective 80," 215.

24. Morris, "Karl Lagerfeld: The Designer Setting Fashion's Tempo," B6.

25. Karl Lagerfeld with John Weitz, Diane von Furstenberg, Betsey Johnson Fashion Show with Bill Boggs, https://www.youtube.com/watch?v=ueHc63OAMNM.

26. Karl Lagerfeld with Weitz, von Furstenberg, Johnson Fashion Show with Bill Boggs.

27. Karl Lagerfeld with Weitz, von Furstenberg, Johnson Fashion Show with Bill Boggs.

28. Karl Lagerfeld in Talley, "Perspective 80," 216.

29. Karl Lagerfeld in Talley, "Perspective 80," 217.

30. Camille Kovalevsky, email to the author, Nov. 30, 2021.

31. *Japan Times*, June 7, 1979, n.p.

32. Karl Lagerfeld in Talley, "Perspective 80," 217.

Chapter 13: A Very Fashionable Friend

1. André Leon Talley, interview with the author, Oct. 10, 2021.

2. Antonio Lopez in André Leon Talley, "Karl Lagerfeld: In a Cloud of Chloé," *Interview*, June 1975, 29.

3. Talley, "Karl Lagerfeld: In a Cloud of Chloé," 28.

4. Bernadine Morris, "A Day of Fashions, Photos and Faces," *New York Times*, April 24, 1975, 59.

5. André Leon Talley, interview with the author, Oct. 10, 2021.

6. Karl Lagerfeld in Talley, "Karl Lagerfeld: In a Cloud of Chloé," 28.

7. André Leon Talley, *The Chiffon Trenches* (New York: Ballantine Books, 2020), 25.

8. André Leon Talley, interview with the author, Oct. 10, 2021.

9. Karl Lagerfeld in Talley, *The Chiffon Trenches*, 25.

10. Karl Lagerfeld in Talley, *The Chiffon Trenches*, 24.

11. André Leon Talley, interview with the author, Oct. 10, 2021.

12. André Leon Talley, interview with the author, Oct. 10, 2021.

13. André Leon Talley, interview with the author, Oct. 10, 2021.

14. André Leon Talley, interview with the author, Oct. 10, 2021.

15. André Leon Talley, interview with the author, Oct. 10, 2021.

16. André Leon Talley, interview with the author, Oct. 10, 2021.

17. Talley, *The Chiffon Trenches*, 48–49.

18. Talley, *The Chiffon Trenches*, 52.

19. André Leon Talley, interview with the author, Oct. 10, 2021.

20. Talley, *The Chiffon Trenches*, 93.

21. André Leon Talley, interview with the author, Oct. 10, 2021.

22. Talley, *The Chiffon Trenches*, 65–67.

23. André Leon Talley, interview with the author, Oct. 10, 2021.

24. Talley, *The Chiffon Trenches*, 188–92.

25. André Leon Talley, email to the author, Oct. 7, 2021.

26. Ruth La Ferla, "Over the Top, as He Wants to Be," *New York Times*, April 13, 2003, Sec. 9, 1.

27. André Leon Talley, interview with the author, Oct. 10, 2021.

28. André Leon Talley in "The Disruptor," *Metal*, https://metalmagazine.eu/en/post /interview/andre-leon-talley-the-disruptor.

29. André Leon Talley, interview with the author, Oct. 10, 2021.

30. Talley, *The Chiffon Trenches*, 70.

31. André Leon Talley, interview with the author, Oct. 10, 2021.

32. André Leon Talley, interview with the author, Oct. 10, 2021.

33. André Leon Talley, interview with the author, Oct. 10, 2021.

34. André Leon Talley, interview with the author, Oct. 10, 2021.

Chapter 14: The Rue Cambon

1. Inès de la Fressange, interview with the author, March 16, 2021.

2. Karl Lagerfeld in Joël Stratte McClure, "Un week-end avec Karl Lagerfeld," *Le Matin de Paris*, March 21, 1980, n.p.

3. Jacques Bertoin, "Karl Lagerfeld, marginal de luxe," *Le Monde*, April 28, 1980, n.p.

4. Karl Lagerfeld in McClure, "Un week-end avec Karl Lagerfeld."

5. Karl Lagerfeld in Monique Davidson, "Karl Lagerfeld Talks to Monique Davidson," *Clout*, Feb. 1983, 16.

6. Patrick Hourcade, *Une si longue complicité* (Paris: Flammarion, 2021), 76–77.

7. Yvonne Moël in "Quand Karl Lagerfeld recevait la Reine mère d'Angleterre dans son château de Penhoët," FranceInfo, https://www.francetvinfo.fr/culture/mode /quand-karl-lagerfeld-recevait-la-reine-mere-d-039-angleterre-dans-son-chateau -de-penhoet_3384411.html.

8. Karl Lagerfeld in "Chez Karl Lagerfeld à Rome: Tous les chemins mènent à Vienne," *Maison Française*, July 1983, 76–81.

9. Alfons Kaiser, *Karl Lagerfeld: A Life in Fashion* (New York: Abrams, 2022), 180–81.

10. A.S. "Le mobilier 'BD' de Karl Lagerfeld," *Le Figaro*, Oct. 11, 1991, n.p.

11. Karl Lagerfeld in Davidson, "Karl Lagerfeld Talks to Monique Davidson," 16.

12. Karl Lagerfeld in Davidson, "Karl Lagerfeld Talks to Monique Davidson," 16.

13. Diane de Beauvau-Craon, interview with the author, June 20, 2021.

14. Silvia Venturini Fendi, interview with the author, July 14, 2021.

15. Karl Lagerfeld in Marie Ottavi, *Jacques de Bascher: Dandy de l'ombre* (Paris: Séguier, 2017), 220.

16. Silvia Venturini Fendi, interview with the author, July 14, 2021.

17. Diane de Beauvau-Craon, interview with the author, June 20, 2021.

18. Diane de Beauvau-Craon, interview with the author, June 20, 2021.

19. Diane de Beauvau-Craon, interview with the author, June 20, 2021.

20. Silvia Venturini Fendi, interview with the author, July 14, 2021.

21. Karl Lagerfeld in Ottavi, *Jacques de Bascher: Dandy de l'ombre*, 221.

22. Olivier Zahm, "Bernard Henri Lévy," *Purple*, Spring/Summer 2009, https://purple.fr/magazine/ss-2009-issue-11/bernard-henri-levy/.

23. Philippe Heurtault, email to the author, April 14, 2022.

24. Diane de Beauvau-Craon, interview with the author, June 20, 2021.

25. Karl Lagerfeld in Patrick Mauriès, *Chanel: Catwalk* (London: Thames & Hudson, 2016), 15.

26. Enid Nemy, "Fashion Was Her Pulpit," *New York Times*, Jan. 11, 1971, 35.

27. James Brady, "Chanel Dead in Paris at 87," *WWD*, Jan. 11, 1971, 1.

28. Gabrielle Chanel in Nemy, "Fashion Was Her Pulpit," 35.

29. Gabrielle Chanel in Brady, "Chanel Dead in Paris at 87," 1.

30. Jean Cocteau, "Le retour de Mademoiselle Chanel," *Fémina*, March 1954, n.p.

31. Nemy, "Fashion Was Her Pulpit," 35.

32. Brady, "Chanel Dead in Paris at 87," 1.

33. "Chanel Show Jan. 26; House's Future in Doubt," *WWD*, Jan. 12, 1971, 1.

34. "Coco Is Missed," *New York Times*, Jan. 27, 1971, 42.

35. Marie-Louise de Clermont-Tonnerre, interview with the author, Jan. 8, 2021.

36. Miles Socha, "Marie-Louise de Clermont-Tonnerre Looks Back on an Illustrious PR Career," *WWD*, Feb. 19, 2022, https://wwd.com/eye/people/chanel-history-before-karl-lagerfeld-clermont-1235057786/.

37. Marie-Louise de Clermont-Tonnerre, interview with the author, Jan. 8, 2021.

38. Patricia McColl, "Parfums Chanel: Good Results from Number 19," *WWD*, Jan. 12, 1973, n.p.

39. Marie-Louise de Clermont-Tonnerre, interview with the author, Jan. 8, 2021.

40. Marie-Louise de Clermont-Tonnerre, interview with the author, Jan. 8, 2021.

41. Marie-Louise de Clermont-Tonnerre, interview with the author, Jan. 8, 2021.

42. Michael Gross, "Chanel Today," *New York Times Magazine*, July 28, 1985, Sec. 6, 47.

43. Kitty D'Alessio in Bettijane Levine, "Luxury and Discipline Reborn in Name of

Legendary Chanel," *Los Angeles Times*, Feb. 22, 1985, https://www.latimes.com /archives/la-xpm-1985-02-22-vw-763-story.html.

44. Gross, "Chanel Today."

45. Gross, "Chanel Today."

46. Alain Wertheimer in Gross, "Chanel Today," 47.

47. John Duka, "Notes on Fashion," *New York Times*, March 2, 1982, A16.

48. "Say Chanel Couture Woos Lagerfeld," *WWD*, March 8, 1982, 36.

49. Inès de la Fressange in Loïc Prigent, "Chanel: Inès de la Fressange at Karl Lagerfeld's First Show," https://www.youtube.com/watch?v=4zd3zrQ3isU.

50. Kitty D'Alessio in Levine, "Luxury and Discipline Reborn in Name of Legendary Chanel."

51. Inès de la Fressange, interview with the author, March 16, 2021.

52. Patrick McCarthy, "It's Official—Lagerfeld to Design for Chanel," *WWD*, Sept. 16, 1982, n.p.

53. McCarthy, "It's Official—Lagerfeld to Design for Chanel."

54. Prigent, "Chanel: Inès de la Fressange at Karl Lagerfeld's First Show."

55. McCarthy, "It's Official—Lagerfeld to Design for Chanel."

56. McCarthy, "It's Official—Lagerfeld to Design for Chanel."

57. Nathalie Mont-Servan, "Au printemps prochain," *Le Monde*, Oct. 21, 1982, n.p.

58. Bernadine Morris, "Givenchy and Chanel Excite Paris," *New York Times*, Oct. 19, 1982, C8.

59. Carrie Donovan, Hebe Dorsey in "Reshaping the Classics at the House of Chanel," *New York Times Magazine*, Dec. 12, 1982, Sec. 6, 116.

60. Inès de la Fressange, interview with the author, March 16, 2021.

61. "Reshaping the Classics at the House of Chanel."

62. Alain Wertheimer in Gross, "Chanel Today."

Chapter 15: A Storied Institution, a Jolt of Energy

1. Karl Lagerfeld in Jane Kramer, "The Chanel Obsession," *Vogue*, Sept. 1991, 515.

2. Christopher Petkanas, "Lagerfeld Tackles Couture," *WWD*, Jan. 19, 1983, 1.

3. Petkanas, "Lagerfeld Tackles Couture," 4.

4. Karl Lagerfeld in Petkanas, "Lagerfeld Tackles Couture," 4.

5. Inès de la Fressange in Steven Greenhouse, "After Bastille Day: Liberty, Equality and Royalty," *New York Times*, Aug. 1989, A4.

6. Inès de la Fressange in Greenhouse, "After Bastille Day: Liberty, Equality and Royalty," A4.

7. Inès de la Fressange, interview with the author, March 16, 2021.

8. Inès de la Fressange, interview with the author, March 16, 2021.

9. Greenhouse, "After Bastille Day: Liberty, Equality and Royalty," A4.

10. Inès de la Fressange in Loïc Prigent, "Chanel: Inès de la Fressange at Karl Lagerfeld's First Show," https://www.youtube.com/watch?v=4zd3zrQ3isU.

11. "Karl Lagerfeld, sur son 31," *Maison Française*, July 1983, 74.

12. Inès de la Fressange, interview with the author, March 16, 2021.

13. Karl Lagerfeld to Suzy Menkes, in *Chanel: Catwalk* (London: Thames & Hudson, 2016), 20.

14. Kitty D'Alessio in Bettijane Levine, "Luxury and Discipline Reborn in Name of Legendary Chanel," *Los Angeles Times*, Feb. 22, 1985, https://www.latimes.com /archives/la-xpm-1985-02-22-vw-763-story.html.

15. Karl Lagerfeld in Christopher Petkanas, "Lagerfeld Tackles Couture," *WWD*, Jan. 19, 1983, 5.

16. Anita Briey, in *Karl Lagerfeld: Être et paraître*, "Un Jour, un destin," April 10, 2017.

17. Karl Lagerfeld in Petkanas, "Lagerfeld Tackles Couture," 4.

18. Karl Lagerfeld in Petkanas, "Lagerfeld Tackles Couture," 4.

19. John Duka, "Notes on Fashion," *New York Times*, Jan. 18, 1983, C9.

20. Karine Porret, "Le jour où . . . Karl Lagerfeld présente sa première collection pour Chanel," *L'Express*, https://www.lexpress.fr/styles/mode/saga-4-10-le-jour-ou-karl -lagerfeld-presente-sa-premiere-collection-pour-chanel_2123572.html.

21. Inès de la Fressange in Prigent, "Chanel: Inès de la Fressange at Karl Lagerfeld's First Show."

22. "Des égéries aux défilés spectaculaires, comment Karl Lagerfeld a révolutionné la maison Chanel," France Television, Feb. 20, 2019.

23. Inès de la Fressange in Prigent, "Chanel: Inès de la Fressange at Karl Lagerfeld's First Show."

24. Marie-Louise de Clermont-Tonnerre, interview with the author, Jan. 8, 2021.

25. Inès de la Fressange in Prigent, "Chanel: Inès de la Fressange at Karl Lagerfeld's First Show."

26. Inès de la Fressange in Prigent, "Chanel: Inès de la Fressange at Karl Lagerfeld's First Show."

27. Bernadine Morris, "Lagerfeld Guides Chanel into the 80s," *New York Times*, C1.

28. Nathalie Mont-Servan, "Chanel trouve son maître," *Le Monde*, Jan. 21, 1983, n.p.

29. Kali Hays, "When Karl Came to Chanel," *WWD*, Dec. 20, 2017, https://wwd .com/fashion-news/designer-luxury/when-karl-lagerfeld-came-to-chanel-1983-couture -collection-11077517/.

30. Morris, "Lagerfeld Guides Chanel into the 80s," C 1.

31. Hays, "When Karl Came to Chanel."

32. Marilyn Bethany, "Be It Ever So Functional, There Is No Place Like Home," *New York Times*, Oct. 31, 1982, Sec. 6, 74.

33. Karl Lagerfeld in Monique Davidson, "Karl Lagerfeld Talks to Monique Davidson," *Clout*, Feb. 1983, 16.

34. Bernadine Morris, "Fendi and Lagerfeld Triumph in Milan," *New York Times*, March 10, 1983, C1.

35. Bernadine Morris, "The Japanese Challenge to French Fashion," *New York Times*, March 21, 1983, B7.

36. Bernadine Morris, "A Fanfare for (and by) Karl Lagerfeld," *New York Times*, April 20, 1983, C10.

37. "Karl Lagerfeld: Anything but Subtle," *WWD*, July 27, 1983, 8–10.

38. Carrie Donovan, "From Paris Couture: The Influential Two," *New York Times Magazine*, Sept. 11, 1983, Sec. 6, 132.

39. Holly Brubach in Rone Tempest, "Does Karl Lagerfeld Ever Sit Still?" *Los Angeles Times Magazine*, April 14, 1991, 44.

40. Bruno Pavlovsky, interview with the author, Jan. 4, 2021.

41. Karl Lagerfeld in Jane Kramer, "The Chanel Obsession," *Vogue*, Sept. 1991, 514.

Chapter 16: One Voice

1. Karl Lagerfeld in "Lagerfeld," *WWD*, Oct. 8, 1985, 35.

2. Jackie Moore, "Lagerfeld," *City and Country Home Fashion*, Sept. 1985, 110.

3. Bernadine Morris, "Applause in Paris for Lagerfeld and Miyake," *New York Times*, Oct. 17, 1983, A18.

4. Anita Briey in *Karl Lagerfeld: être et paraître*, "Un Jour, un destin," April 10, 2017.

5. Anita Briey in *Karl Lagerfeld: être et paraître*, "Un Jour, un destin."

6. Anita Briey in *Karl Lagerfeld: être et paraître*, "Un Jour, un destin."

7. Caroline Lebar, interview with the author, Dec. 14, 2020.

8. Caroline Lebar, interview with the author, Dec. 14, 2020.

9. Anita Briey, interview with the author, June 24, 2021.

10. Eric Wright, interview with the author, Nov. 21, 2020.

11. Eric Wright, interview with the author, Nov. 21, 2020.

12. Eric Wright, interview with the author, Nov. 21, 2020.

13. Eric Wright, interview with the author, Nov. 21, 2020.

14. Bernadine Morris, "Lagerfeld: Slow Start, Big Finish," *New York Times*, March 28, 1984, C14.

15. Nina Hyde, "Lagerfeld's New Look," *Washington Post*, March 28, 1984, n.p.

16. Ron Alexander, "The Evening Hour," *New York Times*, May 25, 1984, A20.

17. Bernadine Morris, "Lagerfeld Lifts Spirits in Paris," *New York Times*, Oct. 22, 1984, C14.

18. Patrick Mauriès, *Chanel: Catwalk* (London: Thames & Hudson, 2016), 18.

19. Michael Gross, "Chanel Today," *New York Times Magazine*, July 28, 1985, Sec. 6, 47.

20. Gross, "Chanel Today."

21. Gross, "Chanel Today."

22. Gross, "Chanel Today."

23. "Chanel Sizzles as Lagerfeld Burns," *WWD*, Oct. 22, 1985, 1, 19.

24. "Lagerfeld & Chanel: Friction in Fashionland," *Washington Post*, Oct. 27, 1985, n.p.

25. *Guardian*, Nov. 21, 1985, n.p.

26. "Chanel Sizzles as Lagerfeld Burns," 19.

27. "Chanel Sizzles as Lagerfeld Burns," 19.

28. Hebe Dorsey, "Alaïa's Body-Hugging Contours Shape the Scene," *International Herald Tribune*, Oct. 22, 1985, 7.

29. "Chanel Sizzles as Lagerfeld Burns," 1, 19.

30. Dorsey, "Alaïa's Body-Hugging Contours Shape the Scene," 7.

31. "Chanel Sizzles as Lagerfeld Burns," 19.

32. Dorsey, "Alaïa's Body-Hugging Contours Shape the Scene," 7.

33. Bernadine Morris, "Word from Paris: Body-Hugging Designs," *New York Times*, Oct. 22, 1985, A28.

34. Dorsey, "Alaïa's Body-Hugging Contours Shape the Scene," 7.

35. "Chanel Sizzles as Lagerfeld Burns," 19.

36. Morris, "Word from Paris: Body-Hugging Designs," A28.

37. Karl Lagerfeld, interview by Jean-Pierre Elkabbach, "Découvertes," Europe 1, Oct. 23, 1985.

38. *Guardian*, Nov. 21, 1985, n.p.

39. "De Ribes's 1001 Nights; Laroche's Denim Days," *WWD*, Oct. 23, 1985, 24.

40. Bernadine Morris, "Saint Laurent's Buoyant Skirts, Spare Boleros," *New York Times*, Oct. 24, 1985, C10.

41. Dorsey, "Alaïa's Body-Hugging Contours Shape the Scene," 7.

42. Suzy Menkes, "Chanel's Toy Boy," *Times* (London), April 15, 1986, 15.

43. Burt Tansky in Maureen Orth, "Kaiser Karl: Behind the Mask," *Vanity Fair*, Feb. 1992, 112.

44. "The Chanel Saga: Does the Hairdresser Know for Sure?" *WWD*, Oct. 24, 1985, 17.

45. "The Chanel Saga: Does the Hairdresser Know for Sure?" 17.

46. "The Chanel Saga: Does the Hairdresser Know for Sure?" 17.

47. Karl Lagerfeld in Orth, "Kaiser Karl: Behind the Mask," 111.

48. Karl Lagerfeld in Cecilie Rohwedder, "Freedom Without Democracy Is Lagerfeld's Design at Chanel," *Wall Street Journal*, Oct. 10, 2005, n.p.

49. Karl Lagerfeld, note to *Vogue*, April 20, 1998, PdeC.

50. Bruno Pavlovsky, interview with the author, Jan. 4, 2001.

51. Bruno Pavlovsky, interview with the author, Jan. 4, 2001.

Chapter 17: New Visions

1. Karl Lagerfeld in Maureen Orth, "Kaiser Karl: Behind the Mask," *Vanity Fair*, Feb. 1992, 72–73.

2. Inès de la Fressange, interview with the author, April 25, 2022.

3. Inès de la Fressange, interview with the author, April 25, 2022.

4. Inès de la Fressange, interview with the author, April 25, 2022.

5. Inès de la Fressange, interview with the author, April 25, 2022.

6. Inès de la Fressange, interview with the author, April 25, 2022.

7. "Henry James at the Louvre," Museum of Dreams, https://www.museumofdreams.org/henry-james-at-the-louvre.

8. "Galerie d'Apollon: Soleil, or et diamants," Musée du Louvre, https://www.louvre.fr/decouvrir/le-palais/soleil-or-et-diamants.

9. "Henry James at the Louvre," Museum of Dreams.

10. "Henry James at the Louvre," Museum of Dreams.

11. Axelle de Gaigneron, "Inès entre au Louvre," *Connaissance des arts*, Dec. 1986, 101.

12. de Gaigneron, "Inès entre au Louvre," 102.

13. "Henry James at the Louvre," Museum of Dreams.

14. "Henry James at the Louvre," Museum of Dreams.

15. Karl Lagerfeld in Andrew Wilkes, "A Conversation with Karl Lagerfeld," *Aperture*, Winter 1991, 112.

16. Karl Lagerfeld to *Diario 16*, Dec. 6, 1991, PdeC.

17. Éric Pfrunder, interview with the author, April 26, 2021.

18. Éric Pfrunder, interview with the author, April 26, 2021.

19. Karl Lagerfeld in Wilkes, "A Conversation with Karl Lagerfeld," 108.

20. Patrick Mauriès, *Chanel: The Karl Lagerfeld Campaigns* (London: Thames & Hudson, 2018), 16–18.

21. Éric Pfrunder, interview with the author, April 26, 2021.

22. Karl Lagerfeld in *Karl Lagerfeld* (Cologne: Benedikt Taschen, 1990), 8.

23. Karl Lagerfeld, interview by Ingrid Sischy, "Galerie Gmurzynska at Art Basel Miami Beach 2002," Dec. 5, 2002, https://vimeo.com/253969217.

24. Karl Lagerfeld in *Karl Lagerfeld*, 11.

25. Éric Pfrunder, interview with the author, April 26, 2021.

26. Karl Lagerfeld in *Karl Lagerfeld*, 10.

27. Karl Lagerfeld in *Karl Lagerfeld*, 15.

28. Éric Pfrunder, interview with the author, April 26, 2021.

29. Karl Lagerfeld in Wilkes, "A Conversation with Karl Lagerfeld," 108.

Chapter 18: Death and Disaster

1. Karl Lagerfeld in Suzy Menkes, "Chanel's Toy Boy," *Times* (London), April 15, 1986, 15.

2. Jane Kramer, "The Chanel Obsession," *Vogue*, Sept. 1991, 518.

3. Kramer, "The Chanel Obsession," 518.

4. Véronique Perez, interview with the author, May 21, 2021.

5. Menkes, "Chanel's Toy Boy," *Times* (London), 15.

6. Virginie Viard, interview with the author, July 6, 2022.

7. Bernadine Morris, "Paris: Irreverent Chanel and Seductive Ungaro," *New York Times*, July 29, 1987, C10.

8. Chanel Haute Couture Fall/Winter 1987—Ambient Sound, A. Saleszy, https://www.youtube.com/watch?v=mK2pv60JhEk.

9. Sofia Coppola, interview with the author, Oct. 11, 2020.

10. Sofia Coppola, interview with the author, Oct. 11, 2020.

11. Sofia Coppola, interview with the author, Oct. 11, 2020.

12. Sofia Coppola, interview with the author, Oct. 11, 2020.

13. Sofia Coppola, interview with the author, Oct. 11, 2020.

14. Chanel Haute Couture Fall/Winter 1987—Ambient Sound; Woody Hochswender, "Amid the Rustle of Finery, Fashion Celebrates Its Own," *New York Times*, Jan. 10, 1989, Sec. B9.

15. Sofia Coppola, interview with the author, Oct. 11, 2020.

16. François Baudot, "Chez Lagerfeld, Le Magnifique," *Elle Décoration*, Nov. 1988, 95.

17. Patrick Hourcade, *Une si longue complicité* (Paris: Flammarion, 2021), 81–82.

18. Baudot, "Chez Lagerfeld, Le Magnifique," 95.

19. Rone Tempest, "Does Karl Lagerfeld Ever Sit Still?" *Los Angeles Times Magazine*, April 14, 1991, 22.

20. Ursula Harbrecht, "Fürstliche Domizile," *Stern*, Sept. 22, 1988, 171.

21. Baudot, "Chez Lagerfeld, Le Magnifique," 92–93.

22. Karl Lagerfeld, "Caroline le bonheur," *Paris Match*, Dec. 29, 1988, 54.

23. Karl Lagerfeld, "Caroline le bonheur," 54.

24. Karl Lagerfeld, "Caroline le bonheur," 56.

25. Caroline de Hanovre in Stéphane Bern, "Karl Lagerfeld était comme un membre de ma famille," *Point de Vue*, April 3, 2019, 22.

26. Amira Casar, interview with the author, Dec. 18, 2020.

27. Amira Casar, interview with the author, Dec. 18, 2020.

28. Amira Casar, interview with the author, Dec. 18, 2020.

29. Amira Casar, interview with the author, Dec. 18, 2020.

30. Amira Casar, interview with the author, Dec. 18, 2020.

31. Inès de la Fressange, interview by Marie Laure Augry, *Journal Treize heures*, TF1, Aug. 1, 1986.

32. Inès de la Fressange, interview with the author, April 25, 2022.

33. *Journal Treize heures*, TF1, May 31, 1989.

34. Karl Lagerfeld in Kramer, "The Chanel Obsession," 516.

35. Inès de la Fressange, interview with the author, April 25, 2022.

36. Inès de la Fressange, interview with the author, April 25, 2022.

37. Inès de la Fressange, interview with the author, April 25, 2022.

38. Inès de la Fressange, interview with the author, March 16, 2021.

39. Michael Gross, "An Irreverent Model Shapes Chanel's New Image," *New York Times*, Dec. 13, 1986, Sec. 1, 36.

40. Inès de la Fressange, interview with the author, March 16, 2021.

41. Inès de la Fressange, interview with the author, March 16, 2021.

42. Inès de la Fressange, interview with the author, March 16, 2021.

43. Harbrecht, "Fürstliche Domizile," 182.

44. Marie Ottavi, *Jacques de Bascher: Dandy de l'ombre* (Paris: Séguier, 2017), 263.

45. Oscars de la Mode 1986, Tim Sav, https://www.youtube.com/watch?v=Q_iYi52E uRc&t=277s.

46. Chanel Haute Couture Fall/Winter 1987—Ambient Sound.

47. Ottavi, *Jacques de Bascher: Dandy de l'ombre*, 265.

48. Diane de Beauvau-Craon, interview with the author, June 20, 2021.

49. Diane de Beauvau-Craon, interview with the author, June 20, 2021.

50. "Archives de Jacques Leibowitch," L'École normale supérieure, http://www.calames .abes.fr/pub/#details?id=FileId-2776.

51. Diane de Beauvau-Craon, email to the author, May 1, 2022.

52. Karl Lagerfeld in Ottavi, *Jacques de Bascher: Dandy de l'ombre*, 267.

53. Diane de Beauvau-Craon, interview with the author, June 20, 2021.

54. Diane de Beauvau-Craon, interview with the author, June 20, 2021.

55. Karl Lagerfeld in Ottavi, *Jacques de Bascher: Dandy de l'ombre*, 268.

56. Diane de Beauvau-Craon, interview with the author, June 20, 2021.

57. Karl Lagerfeld in Ottavi, *Jacques de Bascher: Dandy de l'ombre*, 269.

58. Diane de Beauvau-Craon, interview with the author, June 20, 2021.

59. Diane de Beauvau-Craon, interview with the author, June 20, 2021.

60. Sophie de Langlade, interview with the author, Dec. 7, 2020.

61. Caroline Lebar in Alfons Kaiser, *Karl Lagerfeld: A Life in Fashion* (New York: Abrams, 2022), 165.

62. Karl Lagerfeld in Maureen Orth, "Kaiser Karl: Behind the Mask," *Vanity Fair*, Feb. 1992, 112.

63. Karl Lagerfeld in Orth, "Kaiser Karl: Behind the Mask," 112.

Chapter 19: Shifting Gears

1. Karl Lagerfeld in Olivier Wicker, "Interview/Obsession," *Le Nouvel observateur*, Aug. 23, 2012, 9.

2. Claudia Schiffer in Hayley Maitland, "When Claudia Schiffer Rode Through Paris on a Motorcycle While Wearing Haute Couture," *Vogue* U.K., May 17, 2020, https:// www.vogue.co.uk/arts-and-lifestyle/article/claudia-schiffer-paris-couture-vogue.

3. Patrick Mauriès, *Chanel: The Karl Lagerfeld Campaigns* (London: Thames & Hudson, 2018), 72–73.

4. Claudia Schiffer, interview with the author, Dec. 15, 2020.

5. Claudia Schiffer in Isabella Burley, "Claudia Schiffer on Model Life in 1993," *Dazed & Confused*, July 23, 2013.

6. "Conference de Karl Lagerfeld à la Sorbonne," Oct. 18, 1994, 1–12, CP.

7. Claudia Schiffer, interview with the author, Dec. 15, 2020.

8. Karl Lagerfeld in Rone Tempest, "Does Karl Lagerfeld Ever Sit Still?" *Los Angeles Times Magazine*, April 14, 1991, 22.

9. Karl Lagerfeld in "King Karl," *WWD*, Nov. 20, 1991, 7–9.

10. "Grand Amphithéâtre," La Sorbonne, https://www.sorbonne.fr/la-sorbonne/location -espaces/grand-amphitheatre/.

11. "Conference de Karl Lagerfeld à la Sorbonne."

12. "Conference de Karl Lagerfeld à la Sorbonne."

13. Michel Gaubert, interview with the author, May 13, 2021.

14. Michel Gaubert, interview with the author, May 13, 2021.

15. Michel Gaubert, interview with the author, May 13, 2021.

16. Michel Gaubert, interview with the author, May 13, 2021.

17. Anders Christian Madsen, "Michel Gaubert Is Fashion Week's Monarch of Music," *i-D*, March 9, 2015.

18. Michel Gaubert, interview with the author, May 13, 2021.

19. Karl Lagerfeld in Églantine Aubry, "Les bonnes notes de Karl," *Mixte*, Aug. 2006, 122.

20. Michel Gaubert, interview with the author, May 13, 2021.

21. Tempest, "Does Karl Lagerfeld Ever Sit Still?" 22.

22. Carole Blumenfeld, "Karl Lagerfeld, la couleur du XVIII siècle," Feb. 28, 2019, *La Gazette Drouot*, https://www.gazette-drouot.com/article/karl-lagerfeld-la-couleur -du-xviiie%25C2%25A0siecle/5844.

23. Diane de Beauvau-Craon, interview with the author, June 20, 2021.

24. Diane de Beauvau-Craon, interview with the author, June 20, 2021.

25. Hans Christian Andersen, *The Emperor's New Clothes*, illus. Karl Lagerfeld (New York: Atlantic Monthly Press, 1992).

26. Andersen, *The Emperor's New Clothes*.

Chapter 20: Gentlemen Callers

1. Karl Lagerfeld in Anne-Cécile Beaudoin and Elisabeth Lazaroo, "Karl Lagerfeld: L'étoffe d'une star," *Paris Match*, April 25, 2013, 76.

2. Michael Gross, "The McCarthy Era," *New York*, Aug. 4, 1997, n.p.

3. Gross, "The McCarthy Era," n.p.

4. Kathryn Belgiorno, "Quietly, a Bawdy Gay Beacon Goes Dark," *New York Times*, April 24, 2005, Sec. 14, 5.

5. "The Gaiety Theater," Jeremiah's Vanishing New York, Oct. 11, 2007, http:// vanishingnewyork.blogspot.com/2007/10/gaiety-theater.html.

6. Michael Musto, "8 Forgotten Hangouts That Made NYC Special," *Paper*, Feb. 18, 2005, https://www.papermag.com/8-forgotten-hangouts-that-made-nyc-special -1427513337.html.

7. Robert Forrest, interview with the author, Sept. 27, 2021.

8. Patrick McCarthy, conversation with the author, 1996.

9. Karl Lagerfeld in William Middleton, "Heavenly Hamburg," *W*, September 1996, 333.

10. Karl Lagerfeld in Middleton, "Heavenly Hamburg," 333.

11. Karl Lagerfeld in Middleton, "Heavenly Hamburg," 334–39.

12. Karl Lagerfeld in Middleton, "Heavenly Hamburg," 334.

13. Sébastien Jondeau, interview with the author, Dec. 12, 2020.

14. Sébastien Jondeau, interview with the author, Dec. 12, 2020.

15. Sébastien Jondeau, interview with the author, Dec. 12, 2020.

16. Sébastien Jondeau, interview with the author, Dec. 12, 2020.

17. Sébastien Jondeau, interview with the author, Dec. 12, 2020.

18. Sébastien Jondeau, interview with the author, Dec. 12, 2020.

19. Sébastien Jondeau, interview with the author, Dec. 12, 2020.

20. Céline Degoulet, interview with the author, March 12, 2022.

Chapter 21: Hits and Misses

1. Karl Lagerfeld in Dora Stern, "Itinéraire d'un enfant gâté," *Dépêche Mode*, May 1992, 34.

2. Constance C. R. White, "Lagerfeld's Lesson for Younger Designers: Stay Relevant," *New York Times*, March 16, 1999, B11.

3. Daniel Licht, "John Galliano enivre la maison Givenchy," *Libération*, Jan. 22, 1996.

4. Caroline Lebar, interview with the author, Dec. 14, 2020.

5. Virginie Viard, interview with the author, July 6, 2022.

6. Virginie Viard, interview with the author, July 6, 2022.

7. Bernadine Morris, "Paris Flash or Milan Style," *New York Times*, March 15, 1994, B9.

8. Suzy Menkes, "In Paris Shows, He's Top of the Class," *International Herald Tribune*, Oct. 15, 1993.

9. Stella Tennant, interview with the author, Dec. 9, 2020.

10. Stella Tennant in David Colman, "Chanel's Upper Class Face," *New York Times*, June 16, 1996, Sec. 1, 42.

11. Karl Lagerfeld in Colman, "Chanel's Upper Class Face," Sec. 1, p. 42.

12. Karl Lagerfeld, note to Catherine Busuttil, April 17, 1996, PdeC.

13. Stella Tennant, interview with the author, Dec. 9, 2020.

14. Stella Tennant, interview with the author, Dec. 9, 2020.

15. Stella Tennant, interview with the author, Dec. 9, 2020.

16. Stella Tennant, interview with the author, Dec. 9, 2020.

17. Karl Lagerfeld, letter to the author, Sept. 19, 1996.

18. Karl Lagerfeld, letter to the author, Sept. 19, 1996.

19. "Biennial of Florence," MaMe, June 4, 2015, https://fashion.mam-e.it/biennial-of -florence/.

20. Karl Lagerfeld, letter to the author, Sept. 19, 1996.

21. Karl Lagerfeld, letter to the author, Sept. 19, 1996.

22. Karl Lagerfeld, letter to the author, Sept. 19, 1996.

23. "Flight of a Muse," *WWD*, Nov. 14, 1996, 1.

24. "Flight of a Muse," 1.

25. Amanda Harlech, email to the author, May 19, 2022.

26. Amanda Harlech in William Middleton, "Having It All," *WWD*, March 15, 1995, 10.

27. Amanda Harlech, interview with the author, June 18, 2021.

28. Amanda Harlech, interview with the author, June 18, 2021.

29. Amanda Harlech, interview with the author, June 18, 2021.

30. Amanda Harlech, interview with the author, June 18, 2021.

31. Daphne Guinness in Cathy Horyn, "The Woman No Hat Could Tame," *New York Times*, May 10, 2007, https://www.nytimes.com/2007/05/10/fashion/10BLOW.html?ref=fashion.

32. Amanda Harlech, interview with the author, June 18, 2021.

33. Amanda Harlech, interview with the author, June 18, 2021.

34. Karl Lagerfeld in Amy Spindler, "Giving More Weight to Lightness," *New York Times*, Jan. 24, 1997, Sec. 1, 24.

35. Karl Lagerfeld in William Middleton, "Paris Couture: Will It Sizzle?" *WWD*, Jan. 16, 1997, 6.

36. Amy M. Spindler, "Among Couture Debuts, Galliano's Is the Standout," *New York Times*, Jan. 21, 1997, B7.

37. Patrick Mauriès, *Chanel: Catwalk* (London: Thames & Hudson, 2016), 234.

38. Karl Lagerfeld in Vicky Woods, "Basquing in the Sun," *Vogue*, April 2002, 338.

39. Karl Lagerfeld in Cathy Horyn, "Profile in Style: Karl Lagerfeld," *T Magazine*; *New York Times*, Dec. 4, 2008, n.p.

40. Woods, "Basquing in the Sun," 338.

41. Anna Wintour, interview with the author, May 25, 2021.

42. Stella Tennant, interview with the author, Dec. 9, 2020.

43. Amanda Harlech, interview with the author, June 18, 2021.

44. André Leon Talley, interview with the author, Oct. 10, 2021.

45. André Leon Talley, interview with the author, Oct. 10, 2021.

46. Françoise Dumas, interview with the author, Dec. 15, 2020.

47. Karl Lagerfeld, note to Françoise Dumas, n.d.

48. Françoise Dumas, interview with the author, Dec. 15, 2020.

49. Bernard Arnault in Philippe Dagen, "Je ne crois pas au nationalisme artistique," *Le Monde*, Sept. 30, 2014, https://www.lemonde.fr/arts/article/2014/10/07/bernard-arnault-je-ne-crois-pas-au-nationalisme-artistique_4502164_1655012.html.

50. Françoise Dumas, interview with the author, Dec. 15, 2020.

51. Frédéric Gouby, interview with the author, June 23, 2021.

52. Frédéric Gouby, interview with the author, June 23, 2021.

53. Frédéric Gouby, interview with the author, June 23, 2021.

54. Laurence Delamare, email to the author, Jan. 3, 2001.

55. Bruno Pavlovsky, interview with the author, Jan. 4, 2021.

56. Bruno Pavlovsky, interview with the author, Jan. 4, 2021.

57. Laurence Delamare, email to the author, Jan. 3, 2001.

58. Bruno Pavlovsky, interview with the author, Jan. 4, 2021.

59. Anna Wintour, interview with the author, May 25, 2021.

60. Bruno Pavlovsky, interview with the author, Jan. 4, 2021.

61. Leslie Kaufman, "Five Questions for Bernard Arnault," *New York Times*, Oct. 17, 1999, Sec. 3, 7.

62. Pascal Galinier, "En s'emparant la griffe romaine Fendi, LVMH prend sa revanche en Italie," *Le Monde*, Oct. 14, 1999, n.p.

63. Bruno Pavlovsky, interview with the author, Jan. 4, 2021.

64. Virginie Viard, interview with the author, July 6, 2022.

65. Suzy Menkes, "Galliano Soars While Chanel Is Spaced Out," *International Herald Tribune*, Oct. 17, 1998, n.p.

66. Bruno Pavlovsky, interview with the author, Jan. 4, 2021.

67. Bruno Pavlovsky, interview with the author, Jan. 4, 2021.

68. Menkes, "Galliano Soars While Chanel Is Spaced Out."

69. Sarah Raper, "Evolution of a Classic: Lagerfeld Sees a Need for Changes at Chanel," *WWD*, Jan. 25, 1999, n.p.

70. Françoise Montenay in Raper, "Evolution of a Classic: Lagerfeld Sees a Need for Changes at Chanel."

71. Karl Lagerfeld in Raper, "Evolution of a Classic: Lagerfeld Sees a Need for Changes at Chanel."

Chapter 22: Radical Change

1. Karl Lagerfeld in "Moving Forward," March 13, 1999, CP.

2. Sébastien Jondeau, interview with the author, Dec. 12, 2020.

3. Karl Lagerfeld, note to Sarah Raper, Feb. 5, 1999.

4. Karl Lagerfeld in "Moving Forward," March 13, 1999, CP.

5. Suzy Menkes, "At Chanel Show, Opposites Fail to Attract," *International Herald Tribune*, Jan. 20, 1999, n.p.

6. Cathy Horyn, "Couture, the Game for Pure Players," *New York Times*, Jan. 24, 1999, Sec. 9, 1.

7. Cathy Horyn, "In Praise of Short Memories," *New York Times*, March 9, 1999, B7.

8. Constance C. R. White, "Lagerfeld's Lesson for Younger Designers: Stay Relevant," *New York Times*, March 16, 1999, B11.

9. Karl Lagerfeld, letter to the author, n.d.

10. Pierre Passebon, interview with the author, Feb. 18, 2021.

11. Souren Melikian, "Karl Lagerfeld Steps Off an 18th-Century Stage," *International Herald Tribune*, May 2, 2000, n.p.

12. Eric Tarient, "The Lagerfeld Collection: We All Have to Live in Our Times," *Art Newspaper*, June 1, 2000, https://www.theartnewspaper.com/2000/06/01/the-lagerfeld-collection-we-all-have-to-live-in-our-own-times.

13. Pierre Passebon, interview with the author, Feb. 18, 2021.

14. Patrick Hourcade, *Une si longue complicité* (Paris: Flammarion, 2021), 11.

15. Eric Wright, interview with the author, Nov. 21, 2020.

16. Eric Wright, interview with the author, Nov. 21, 2020.

17. Diane de Beauvau-Craon, interview with the author, June 20, 2021.

18. Sophie de Langlade, interview with the author, Dec. 7, 2020.

19. Bruno Pavlovsky, interview with the author, Jan. 4, 2021.

20. Karl Lagerfeld in "Fashion Genius," *Elle*, Sept. 2007, 204.

21. Karl Lagerfeld in Jean-Christophe Napias and Patrick Mauriès, *Le Monde selon Karl* (Paris: Flammarion, 2013), 16.

22. Amanda Harlech, interview with the author, June 18, 2021.

23. Karl Lagerfeld in Jean-Claude Houdret, *Le Meilleur des régimes* (Paris: Robert Laffont, 2002), 24.

24. Karl Lagerfeld in Houdret, *Le Meilleur des régimes*, 16–17.

25. Virginie Viard, interview with the author, July 6, 2021.

26. Amanda Harlech, interview with the author, June 18, 2021.

27. Amanda Harlech, interview with the author, June 18, 2021.

28. Karl Lagerfeld in Houdret, *Le Meilleur des régimes*, 16.

29. Karl Lagerfeld in Houdret, *Le Meilleur des régimes*, 25–29.

30. Bethy Lagardère, interview with the author, April 19, 2021.

31. Véronique Perez, interview with the author, May 21, 2021.

32. Amanda Harlech, interview with the author, June 18, 2021.

33. Véronique Perez, interview with the author, May 21, 2021.

34. Stella Tennant, interview with the author, Dec. 9, 2020.

35. Ines de la Fressange, interview with the author, March 16, 2021.

36. Fran Lebowitz, interview with the author, Feb. 5, 2022.

37. Karl Lagerfeld, "Inside Paris Fashion," *Interview*, Oct. 2001, 64.

38. Mathias Rastorfer, interview with the author, April 23, 2021.

39. Karl Lagerfeld, interview by Ingrid Sischy, "Galerie Gmurzynska at Art Basel Miami Beach 2002," Dec. 5, 2002, https://vimeo.com/253969217.

40. Karl Lagerfeld, interview by Sischy, "Galerie Gmurzynska at Art Basel Miami Beach 2002."

41. Karl Lagerfeld, letter to Françoise Dumas, Dec. 31, 2002.

42. Françoise Dumas, interview with the author, Dec. 15, 2020.

43. Photographs, menu, and seating plan from Françoise Dumas.

44. Françoise Dumas, interview with the author, Dec. 15, 2020.

45. Gerhard Steidl, interview with the author, Oct. 24, 2021.

46. Gerhard Steidl, interview with the author, Oct. 24, 2021.

47. Gerhard Steidl, interview with the author, Oct. 24, 2021.

48. Gerhard Steidl, interview with the author, Oct. 24, 2021.

49. Karl Lagerfeld in Monte Packham, *Concentric Circles* (Göttingen: Steidl, 2010), 52.

50. Hamish Bowles, "Grace Coddington Fans, Rejoice," *Vogue*, Aug. 26, 2015, https://www.vogue.com/article/grace-coddington-book-thirty-years-of-fashion-reprint.

51. Victoria Brynner, interview with the author, Feb. 26, 2021.

52. Fran Lebowitz, interview with the author, March 22, 2022.

53. Packham, *Concentric Circles*, 48–50.

54. Fran Lebowitz, interview with the author, March 22, 2022.

Chapter 23: Revolutions

1. Karl Lagerfeld in Colombe Pringle, "Je déteste les riches qui vivent au-dessous de leurs moyens," *L'Express*, Nov. 11, 1999, 30.

2. Donald Schneider, email to the author, May 17, 2002.

3. Caroline Lebar, interview with the author, Dec. 14, 2022.

4. Caroline Lebar, interview with the author, Dec. 14, 2022.

5. Caroline Lebar, interview with the author, Dec. 14, 2022.

6. Caroline Lebar, interview with the author, Dec. 14, 2022.

7. Cathy Horyn, "The Rootin' Teuton," *T*, Feb. 2005, 198.

8. Sébastien Jondeau, *Ça va, cher Karl?* (Paris: Flammarion, 2021), 153.

9. Caroline Lebar, interview with the author, Dec. 14, 2022.

10. Karl Lagerfeld, note to Marie-Louise de Clermont-Tonnerre, Jan. 2005, PdeC.

11. Suzy Menkes, "Zapping at Chanel; Lacroix Is Pretty Calm," *International Herald Tribune*, Oct. 8, 2005, n.p.

12. Stefan Lubrina, interview with the author, March 12, 2022.

13. Stefan Lubrina, interview with the author, March 12, 2022.

14. Bruno Pavlovsky, interview with the author, Jan. 4, 2021.

15. Bruno Pavlovsky, interview with the author, Jan. 4, 2021.

16. Bruno Pavlovsky, interview with the author, Jan. 4, 2021.

17. Bruno Pavlovsky, interview with the author, Jan. 4, 2021.

18. Karl Lagerfeld in Miles Socha, "The Full Monte," *W*, Feb. 2007, 98.

19. Godfrey Deeny, "Chanel dévoile 19M, le nouveau quartier general de ses métiers d'art," FashionNetwork.com, Oct. 10, 2019, https://fr.fashionnetwork.com/news/Chanel -devoile-19m-le-nouveau-quartier-general-de-ses-metiers-d-art,1145954.html.

20. Jondeau, *Ça va, cher Karl?*, 11–15.

21. Sébastien Jondeau, interview with the author, Dec. 3, 2020.

22. Karl Lagerfeld in "Fashion Genius," *Elle*, Sept. 2007, 204.

23. Karl Lagerfeld in "Power Couples: Day 10," *Wallpaper*, Sept. 26, 2006, n.p.

24. "Chanel Mobile Art Pavilion/Zaha Hadid Architects," *Arch Daily*, https://www .archdaily.com/144378/chanel-mobile-art-pavilion-zaha-hadid-architects.

25. "Chanel's 'UFO Exhibit' Lands in Hong Kong," *International Herald Tribune*, Dec. 6, 2008, n.p.

26. Cédric Moriset, Karl Lagerfeld in "Karl Lagerfeld, le déco, le design, et quelques mises au point," *AD* France, September 2011, 66.

27. Miles Socha, "Seminal Moments: When Fendi Conquered the Great Wall of China," *WWD*, Sept. 24, 2020, https://wwd.com/fashion-news/designer-luxury /when-karl-and-fendi-conquered-the-great-wall-of-china-1203671195/.

28. Silvia Venturini Fendi in Socha, "Seminal Moments: When Fendi Conquered the Great Wall of China."

29. Socha, "Seminal Moments: When Fendi Conquered the Great Wall of China."

30. Michel Gaubert, interview with the author, May 13, 2021.

Chapter 24: Star Power

1. Diane Kruger, interview with the author, Nov. 1, 2020.

2. Lily-Rose Depp, interview with the author, Jan. 5, 2021.

3. Lily-Rose Depp, interview with the author, Jan. 5, 2021.

4. Diane Kruger, interview with the author, Dec. 11, 2020.

5. Diane Kruger, interview with the author, Dec. 11, 2020.

6. Diane Kruger, interview with the author, Dec. 11, 2020.

7. Diane Kruger, interview with the author, Dec. 11, 2020.

8. Diane Kruger, interview with the author, Dec. 11, 2020.

9. Diane Kruger, interview with the author, Dec. 11, 2020.

10. Elsa Heizmann, email to the author, Nov. 8, 2021.

11. Diane Kruger, interview with the author, Dec. 11, 2020.

12. Diane Kruger, interview with the author, Dec. 11, 2020.

13. "Twenty Odd Questions: Diane Kruger," *WSJ*, July 20, 2012, https://www.wsj.com/articles/SB10001424052702303343404577518712094268998.

14. Diane Kruger, interview with the author, Dec. 11, 2020.

15. Diane Kruger, interview with the author, Dec. 11, 2020.

16. Diane Kruger, interview with the author, Dec. 11, 2020.

17. Diane Kruger, interview with the author, Dec. 11, 2020.

Chapter 25: Larger than Life

1. Karl Lagerfeld in Jean-Christophe Napias and Patrick Mauriès, *Le Monde selon Karl* (Paris: Flammarion, 2013), 21.

2. Suzy Menkes, "A Walk on the Wise Side," *International Herald Tribune*, Feb. 25, 2010, n.p.

3. Stefan Lubrina, interview with the author, March 12, 2022.

4. Icehotel.com, https://www.icehotel.com/day-visit-icehotel.

5. Stefan Lubrina, interview with the author, March 12, 2022.

6. Suzy Menkes, "Chanel Leads the Ice Pack," *International Herald Tribune*, March 9, 2010, n.p.

7. Patrick Mauriès, *Chanel: Défilés* (Paris: Éditions de La Martinière, 2020), 474.

8. Diane Kruger, interview with the author, Dec. 11, 2020.

9. Basem Wasef, "2010 Harley-Davidson Photo Gallery and Buyer's Guide," https://www.liveabout.com/2010-harley-davidson-photo-gallery-4122609.

10. Mauriès, *Chanel: Défilés*, 474.

11. Suzy Menkes, "Chanel's Year in Marienbad," *International Herald Tribune*, Oct. 5, 2010, n.p.

12. Karl Lagerfeld in Menkes, "Chanel's Year in Marienbad."

13. Stefan Lubrina, interview with the author, March 12, 2022.

14. "2010 Couture Council Fashion Visionary Award: Karl Lagerfeld," Museum at FIT, https://www.fitnyc.edu/museum/couture-council/_hide/karl-lagerfeld.php.

15. Karl Lagerfeld in Ingrid Sischy, "Je ne suis pas Dieu," *Madame Figaro*, Sept. 25, 2010, 86–87.

16. Martin Szekely in "Les talents de Karl," *AD* France, May 2012, 93.

17. Martin Szekely, *Table Blanche*, 2007, Lot 552, Sotheby's KARL, Karl Lagerfeld Estate, https://www.sothebys.com/en/buy/auction/2021/karl-karl-lagerfelds-estate-2/blanche-table-2007.

18. Karl Lagerfeld in "Entrée libre," France 5, Oct. 24, 2011.

19. Chanel: The Little Black Jacket Shoot with Karl Lagerfeld and Carine Roitfeld, https://www.youtube.com/watch?v=7gzK77xdpyI.

20. Melissa Drier, "Chanel Fetes Little Black Jacket in Berlin," November 21, 2012, https://wwd.com/fashion-news/fashion-scoops/chanel-fetes-little-black-jacket-in-berlin-6499080/.

21. Justine Picardie, *Coco Chanel: The Legend and the Life* (London: HarperCollins, 2017), 147.

22. Picardie, *Coco Chanel: The Legend and the Life*, 166.

23. Picardie, *Coco Chanel: The Legend and the Life*, 171.

24. Suzy Menkes, "Chanel's Scottish Touch Warms Up the Scottish Highlands," *International Herald Tribune*, Dec. 10, 2012, n.p.

25. Stella Tennant, interview with the author, Dec. 9, 2020.

26. Suzy Menkes, *Vogue* U.K., https://www.vogue.co.uk/article/cnilux-suzy-meets-kim-young-seong-chanel.

27. Stella Tennant, interview with the author, Dec. 9, 2020.

28. Stella Tennant, interview with the author, Dec. 9, 2020.

29. "Linlithgow Palace," Historic Environment Scotland, https://www.historicenvironment.scot/visit-a-place/places/linlithgow-palace/history/.

30. "In a Nutshell, the Linlithgow Palace Fountain," The Hazeltree, https://thehazeltree.co.uk/2014/05/14/in-a-nutshell-the-linlithgow-palace-fountain/.

31. Stefan Lubrina, interview with the author, March 12, 2022.

32. Stella Tennant, interview with the author, Dec. 9, 2020.

33. Apphia Michael, "Chanel Unveils Its Métiers d'Art 2013 Collection at Linlithgow Palace, Scotland," *Wallpaper*, Dec. 4, 2012, https://www.wallpaper.com/fashion/chanel-unveils-its-mtiers-dart-2013-collection-at-linlithgow-palace-scotland.

34. Stella Tennant, interview with the author, Dec. 9, 2020.

35. Patrick Mauriès, *Chanel: The Karl Lagerfeld Campaigns* (London: Thames & Hudson, 2018), 466–67.

36. Tilda Swinton, email to the author, Jan. 25, 2022.

37. Tilda Swinton, email to the author, Jan. 25, 2022.

38. Tilda Swinton, email to the author, Jan. 25, 2022.

39. Mathias Rastorfer, interview with the author, April 23, 2021.

Chapter 26: A Kept Woman

1. Karl Lagerfeld in Françoise Caçote, interview with the author, June 15, 2021.
2. Karl Lagerfeld, note to Barbara Schwarm, *L'Officiel*, March 9, 1994, CP.
3. Karl Lagerfeld in Carl Swanson, "Karl Lagerfeld's House of Provocation," *New York*, Dec. 9, 2018, n.p.
4. Karl Lagerfeld in Loïc Prigent, dir., *Karl Lagerfeld se dessine*, Arte, 2013.
5. Karl Lagerfeld in Florent Vairet, "Je n'ai pas de patron, à part moi et Choupette!" *Les Echos Business*, July 2, 2018, 19.
6. Karl Lagerfeld in Vairet, "Je n'ai pas de patron, à part moi et Choupette!" 19.
7. Françoise Caçote, interview with the author, June 15, 2021.
8. Françoise Caçote, interview with the author, June 15, 2021.
9. Françoise Caçote, interview with the author, June 15, 2021.
10. Françoise Caçote, interview with the author, June 15, 2021.
11. Françoise Caçote, interview with the author, June 15, 2021.
12. Françoise Caçote, interview with the author, June 15, 2021.
13. Françoise Caçote, interview with the author, June 15, 2021.
14. Cédric Moriset, "Le Vaisseau amiral de Karl Lagerfeld," *AD France*, May 2012, 136, 137.
15. Karl Lagerfeld in Patrick Mauriès, *La vie enchanté d'un chat fashion* (Paris: Serendip, 2014), 213.
16. Karl Lagerfeld in Andrew O'Hagan, "The Maddening and Brilliant Karl Lagerfeld," *T*, Oct. 12, 2015, n.p.
17. Fran Lebowitz, interview with the author, March 22, 2022.
18. Karl Lagerfeld in Christophe Ono-Dit-Biot, "Karl Lagerfeld: Les Zadistes sont un peu sales," *Le Point*, May 9, 2018, n.p.
19. Karl Lagerfeld in O'Hagan, "The Maddening and Brilliant Karl Lagerfeld."
20. Karl Lagerfeld in Anne-Cécile Beaudoin and Elisabeth Lazaroo, "Karl Lagerfeld: L'étoffe d'une star," *Paris Match*, April 25, 2013, 76.
21. Karl Lagerfeld in Patrick Mauriès, *Choupette: The Private Life of a High-Flying Fashion Cat* (New York: Flammarion, 2014), b.c.
22. Silvia Venturini Fendi, interview with the author, July 14, 2021.
23. Amanda Harlech, interview with the author, June 18, 2021.
24. Karl Lagerfeld in Elisabeth Lazaroo, "Roulez Jeunesse!" *Paris Match*, July 5, 2018, 24.

Chapter 27: Young Friends

1. Anne Berest, interview with the author, Dec. 18, 2020.
2. Éric Pfrunder, interview with the author, April 26, 2021.
3. Anne Berest, interview with the author, Dec. 18, 2020.
4. Raphaëlle Leyris, "Sagan nostalgie," *Le Monde*, May 20, 2014, n.p.
5. Anne Berest, interview with the author, Dec. 18, 2020.

6. Anne Berest, interview with the author, Dec. 18, 2020.

7. Anne Berest, interview with the author, Dec. 18, 2020.

8. Anne Berest, interview with the author, Dec. 18, 2020.

9. Anne Berest, interview with the author, Dec. 18, 2020.

10. Anne Berest, "Haute Couture Automne–Hiver 2014/15," Chanel News, https:// www.chanel.com/be-fr/mode/news/2014/07/fall-winter-2014-15-haute-couture-by -anne-berest.html.

11. Berest, "Haute Couture Automne–Hiver 2014/2015."

12. Anne Berest, interview with the author, Dec. 18, 2020.

13. Anne Berest, interview with the author, Dec. 18, 2020.

14. "3.55 Handbag Stories, Podcast avec Anne Berest," Chanel News, https://www .chanel.com/fr_CA/mode/news/2018/04/355-handbag-stories-podcast-with-anne -berest.html.

15. Anne Berest, interview with the author, Dec. 18, 2020.

16. Anne Berest, interview with the author, Dec. 18, 2020.

17. Anne Berest, interview with the author, Dec. 18, 2020.

18. "*La carte postale* by Anne Berest Wins First Ever Choix Goncourt United States," Villa Albertine, April 30, 2022, https://villa-albertine.org/the-villa/la-carte-postale -anne-berest-wins-first-ever-choix-goncourt-united-states.

19. Anne Berest, interview with the author, Dec. 18, 2020.

20. Anne Berest, interview with the author, Dec. 18, 2020.

21. Guillemette Faure, "Le marathon de Paris de M. Instagram," *Le Monde*, March 11, 2015.

22. Kevin Systrom in Faure, "Le marathon de Paris de M. Instagram."

23. Daniel Roberts, "How Kevin Systrom Got Started," *Fortune*, Oct. 10, 2014, n.p.

24. Alain Ducasse in Faure, "Le marathon de Paris de M. Instagram."

25. Kevin Systrom in Faure, "Le marathon de Paris de M. Instagram."

26. Hugo Borensztein, interview with the author, Nov. 5, 2021.

27. Hugo Borensztein, interview with the author, Nov. 5, 2021.

28. Françoise Dumas, interview with the author, March 5, 2022.

29. Françoise Dumas, interview with the author, March 5, 2022.

Chapter 28: A Fierce Determination, Some Missteps, and the Final Bouquets

1. Amanda Harlech, email to the author, May 29, 2022.

2. Sébastien Jondeau, *Ça va, cher Karl?* (Paris: Flammarion, 2021), 42–48.

3. Sébastien Jondeau, interview with the author, Dec. 3, 2020.

4. Jondeau, *Ça va, cher Karl?*, 42–48.

5. Jondeau, *Ça va, cher Karl?*, 49.

6. Jondeau, *Ça va, cher Karl?*, 50.

7. Virginie Viard, interview with the author, July 6, 2022.

8. Sébastien Jondeau, interview with the author, Dec. 3, 2020.

9. Éric Pfrunder, interview with the author, April 26, 2021.

10. Céline Degoulet, interview with the author, March 2, 2022.

11. Françoise Caçote, interview with the author, June 15, 2021.

12. Françoise Caçote, interview with the author, June 15, 2021.

13. Gerhard Steidl, interview with the author, Oct. 24, 2021.

14. Gerhard Steidl, interview with the author, Oct. 24, 2021.

15. Karl Lagerfeld, interview by Ingrid Sischy, "Galerie Gmurzynska at Art Basel Miami Beach 2002," Dec. 5, 2002, https://vimeo.com/253969217.

16. Éric Pfrunder, interview with the author, April 26, 2021.

17. Amanda Harlech, email to the author, May 28, 2022.

18. Karl Lagerfeld in "Ingrid Sischy Memorial," Nov. 1, 2015; Rachna Shah, email to the author, April 15, 2022.

19. Michel Gaubert, interview with the author, May 13, 2021.

20. "First U.S. Cruise in Decades Arrives in Cuba," *Wall Street Journal*, May 2, 2016, https://www.wsj.com/articles/first-u-s-cruise-in-decades-arrives-in-cuba-1462 202835.

21. Michel Gaubert, interview with the author, May 13, 2021.

22. Michel Gaubert, interview with the author, May 13, 2021.

23. Amy Larocca, "Viva la Fashion," *New York*, May 2016, https://www.thecut.com/2016/05/chanel-resort-show-cuba-c-v-r.html.

24. Larocca, "Viva la Fashion."

25. Michel Gaubert, interview with the author, May 13, 2021.

26. Françoise Caçote, interview with the author, June 15, 2021.

27. "'Work in Progress': Karl Lagerfeld to Show His Photos in Cuba," *Vogue Paris*, May 2, 2016, https://www.vogue.fr/fashion/fashion-news/articles/work-in-progress-karl-lagerfeld-to-show-his-photos-in-cuba/37607.

28. Larocca, "Viva la Fashion."

29. Sarah Mower, "Chanel Resort 2017," Vogue.com, https://www.vogue.com/fashion-shows/resort-2017/chanel.

30. Michel Gaubert, interview with the author, May 13, 2021.

31. Sandra Brant, email to the author, July 24, 2021.

32. Jondeau, *Ça va, cher Karl?*, 158.

33. Alexis C. Madrigal, "Chanel's Renewable-Energy-Themed Fashion Show," *Atlantic*, Oct. 4, 2012, https://www.theatlantic.com/technology/archive/2012/10/chanels-renewable-energy-themed-fashion-show/263242/.

34. Stefan Lubrina, interview with the author, March 12, 2022.

35. Stefan Lubrina in Angèle Châtenet, "Rencontre avec Stefan Lubrina, scénographe pour la maison Chanel," *Le Monde*, Feb. 3, 2014, n.p.

36. Karl Lagerfeld in Bridget Foley, "Chanel RTW Fall 2017," *WWD*, March 7, 2017, 1.

37. Sarah Mower, "Chanel," *Vogue*, March 7, 2017, https://www.vogue.com/fashion-shows/fall-2017-ready-to-wear/chanel.

38. Jo Ellison, "Chanel no. 5, 4, 3, 2, 1," *Financial Times*, March 7, 2017, https://www.ft.com/content/4fd74dde-0334-11e7-ace0-1ce02ef0def9.

39. Stefan Lubrina, interview with the author, March 12, 2022.

40. Stefan Lubrina, interview with the author, March 12, 2022.

41. Caroline Lebar, interview with the author, Dec. 14, 2022.

42. Aline Asmar d'Amman, interview with the author, Jan. 17, 2022.

43. Aline Asmar d'Amman, email to the author, Jan. 22, 2022.

44. Aline Asmar d'Amman, interview with the author, Jan. 17, 2022.

45. Aline Asmar d'Amman, interview with the author, Jan. 17, 2022.

46. Aline Asmar d'Amman, interview with the author, Jan. 17, 2022.

47. Aline Asmar d'Amman, interview with the author, Jan. 17, 2022.

48. Aline Asmar d'Amman, interview with the author, Jan. 17, 2022.

49. Cécilia Pellous, "Explore Hotel de Crillon and 'Les Grands Appartements' by Karl Lagerfeld," *Forbes*, Dec. 30, 2020, https://www.forbes.com/sites/ceciliapelloux/2021/12/30/explore-hotel-de-crillon-and-les-grands-appartements-by-karl-lagerfeld/?sh=781979c6703f.

50. Aline Asmar d'Amman, interview with the author, Jan. 17, 2022.

51. Françoise Caçote, interview with the author, June 15, 2021.

52. Amanda Harlech, interview with the author, June 18, 2021.

53. Amanda Harlech, interview with the author, June 18, 2021.

54. Amanda Harlech, interview with the author, June 18, 2021.

55. Amanda Harlech, interview with the author, June 18, 2021.

56. Jondeau, *Ça va, cher Karl?*, 159.

57. Marie-Caroline Bougère, "Le défilé métiers d'art Paris-Hamburg en neuf détails," *Le Figaro Madame*, Dec. 6, 2017, n.p.

58. Lily-Rose Depp, interview with the author, Jan. 5, 2021.

59. Anne Berest, interview with the author, Dec. 18, 2020.

60. Sylvia Jorif, "À bon port," *Elle*, Dec. 12, 2017, 29.

61. Corinna da Fonseca-Wollheim, "Finally, a Debut for the Elbphilharmonie Hall in Hamburg," *New York Times*, Jan. 10, 2017, https://www.nytimes.com/2017/01/10/arts/music/elbphilharmonie-an-architectural-gift-to-gritty-hamburg-germany.html?_r=0; Oliver Wainwright, " 'We Thought It Was Going to Destroy Us,' . . . Herzog and De Meuron's Hamburg Miracle," *Guardian*, Nov. 4, 2016, https://www.theguardian.com/artanddesign/2016/nov/04/hamburg-elbphilhamonie-herzog-de-meuron-a-cathedral-for-our-time.

62. Wainwright, "'We Thought It Was Going to Destroy Us,' . . . Herzog and De Meuron's Hamburg Miracle."

63. Mower, "Chanel."

64. Colombe Pringle, interview with the author, June 7, 2021.

65. Patrick Hourcade, interview with the author, Feb. 22, 2021.

66. Karl Lagerfeld in Philip Utz, "Karl Forever," *Numéro*, April 2018, 14.

67. Karl Lagerfeld in Utz, "Karl Forever."

68. Vanessa Friedman, "Karl Lagerfeld, Fashion's Shock Jock," *New York Times,* May 17,

2018, https://www.nytimes.com/2018/05/17/fashion/karl-lagerfeld-renounce-german -citizenship.html .

69. Carla Fendi in Peggy Polk, "Joke About Rape Is Trouble for Fashion House," UPI, Oct. 10, 1984.

70. Clémentine Rebillat, "Karl Lagerfeld vs. Adele: Un conflit de poids," *Paris Match*, Feb. 9, 2012.

71. Bianca Britton, "Karl Lagerfeld's Most Controversial Quotes," CNN.com, Feb. 20, 2019, https://edition.cnn.com/style/article/karl-lagerfeld-controversial-quotes-intl /index.html.

72. Devon Ivie, "'Defamed' Meryl Streep Slams Karl Lagerfeld Over Oscars Dress Controversy; Lagerfeld Issues Apology," *New York*, https://www.vulture.com /2017/02/meryl-steep-criticizes-karl-lagerfeld-over-dress-controversy.html.

73. Philip Utz, email to the author, Nov. 8, 2021.

74. Karl Lagerfeld in Utz, "Karl Forever."

75. Véronique Perez, interview with the author, May 21, 2021.

76. Françoise Caçote, interview with the author, June 15, 2021.

77. Inès de la Fressange, interview with the author, March 16, 2021.

78. Marie-Louise de Clermont-Tonnerre, interview with the author, May 19, 2022.

79. Inès de la Fressange, interview with the author, March 16, 2021.

80. Marie-Louise de Clermont-Tonnerre, interview with the author, May 19, 2022.

81. Inès de la Fressange, interview with the author, March 16, 2021.

82. Anne Hidalgo in Elisabeth Quin, "On entre dans un monde qui misera sur la coconstruction, le partage, le recyclage, le localisme, la vie, quoi!" *Madame Figaro*, June 29, 2020, n.p.

83. France3, Ile de France, "Une des derniers fois Karl Lagerfeld est apparu en public," https://www.youtube.com/watch?v=yVpML_WIFsM.

84. Anna Wintour, interview with the author, May 25, 2021.

85. Anna Wintour, interview with the author, May 25, 2021.

86. Virginie Viard, interview with the author, July 6, 2022.

87. Françoise Dumas, interview with the author, Dec. 15, 2020.

88. Stefan Lubrina, interview with the author, March 12, 2022.

89. Jondeau, *Ça va, cher Karl?*, 228.

90. Michel Gaubert, interview with the author, May 13, 2021.

91. Jess Cartner-Morley, "Karl Lagerfeld Misses Chanel Haute Couture Shows in Paris," *Guardian*, Jan. 22, 2019, https://www.theguardian.com/fashion/2019 /jan/22/karl-lagerfeld-misses-chanel-haute-couture-shows-in-paris.

92. Silvia Venturini Fendi, interview with the author, July 14, 2021.

93. Frédéric Gouby, interview with the author, June 23, 2021.

94. Françoise Caçote, interview with the author, June 15, 2021.

95. Jondeau, *Ça va, cher Karl?*, 118–19.

96. Françoise Dumas, interview with the author, Dec. 15, 2020.

97. Karl Lagerfeld in Loïc Prigent, dir., *Karl Lagerfeld se dessine*, Arte, 2013.

98. Caroline Cnockaert, interview with the author, March 11, 2021.

99. Caroline Cnockaert, interview with the author, March 11, 2021.

100. Françoise Dumas, interview with the author, Dec. 15, 2020.

101. Marie-Louise de Clermont-Tonnerre, interview with the author, Jan. 8, 2021.

102. Colombe Pringle, interview with the author, June 7, 2021.

103. Françoise Dumas, interview with the author, May 30, 2022.

104. Karl Lagerfeld in Elise Poiret, "Karl Lagerfeld sur Brigitte Macron: 'Les plus belles jambes de Paris!'" *Madame Figaro*, July 21, 2017, https://madame.lefigaro .fr/celebrites/karl-lagerfeld-sur-le-physique-de-brigitte-macron-les-plus-belles -jambes-de-paris-210717-133365.

105. Caroline Cnockaert, interview with the author, May 30, 2022.

106. Caroline Cnockaert, interview with the author, May 30, 2022.

107. Françoise Dumas, interview with the author, May 30, 2022.

108. Caroline Cnockaert, interview with the author, May 30, 2022.

109. "La Collection Courtauld. Le parti de l'Impressionnisme," Fondation Louis Vuitton, https://www.fondationlouisvuitton.fr/en/events/la-collection-courtauld-le -parti-de-l-impressionnisme.

110. Françoise Dumas, interview with the author, Dec. 15, 2020.

111. Virginie Viard, interview with the author, July 6, 2022.

112. Silvia Venturini Fendi, interview with the author, July 14, 2021.

113. Silvia Venturini Fendi, interview with the author, July 14, 2021.

Chapter 29: The Astral Plane

1. Karl Lagerfeld in Loïc Prigent, dir., *Karl Lagerfeld se dessine*, Arte, 2013.

2. "Hommage à Karl Lagerfeld," elysee.fr, Feb. 19, 2019, https://www.elysee.fr/ emmanuel-macron/2019/02/19/hommage-a-karl-lagerfeld.

3. Anne Hidalgo, Twitter, Feb. 19, 2019, https://twitter.com/Anne_Hidalgo/status /1097836423577849856?ref_src=twsrc%5Etfw%7Ctwcamp%5Etweetembed %7Ctwterm%5E1097836423577849856%7Ctwgr%5E%7Ctwcon%5Es1_&ref _url=https%3A%2F%2Fwww.bfmtv.com%2Fpeople%2Fmode%2Fmort-de-karl -lagerfeld-plus-qu-une-incarnation-de-paris-il-etait-paris-salue-anne-hidalgo_AN -201902190084.html.

4. Alain Wertheimer in "Thank You Karl Lagerfeld," Feb. 19, 2019, https://www .chanel.com/us/fashion/news/2019/02/chn-thank-you-karl-lagerfeld-alias.html.

5. Virginie Viard, interview with the author, July 6, 2022.

6. Virginie Viard, interview with the author, July 6, 2022.

7. Silvia Venturini Fendi in Hamish Bowles, "Fendi," *Vogue*, Feb. 21, 2019, https:// www.vogue.com/fashion-shows/fall-2019-ready-to-wear/fendi.

8. Sébastien Jondeau, interview with the author, Dec. 3, 2020.

9. Sébastien Jondeau, interview with the author, Dec. 3, 2020.

10. Bruno Pavlovsky, interview with the author, Jan. 4, 2022.

11. Virginie Viard, interview with the author, July 6, 2022.

12. Françoise Caçote, interview with the author, June 15, 2021.

13. Françoise Dumas, interview with the author, Dec. 15, 2020.

14. Bernard Arnault, interview in *Karl For Ever*, June 20, 2019, P21.

15. Madeleine Meissirel, email to the author, Oct. 3, 2022.

16. Madeleine Meissirel, email to the author, Sept. 28, 2022.

17. Anne-Marie Périer Sardou, interview with the author, June 8, 2021.

18. Pier Paolo Righi, interview with the author, Nov. 30, 2020.

19. Anna Wintour, interview with the author, May 25, 2021.

20. Jean-Baptiste Mondino, interview with the author, April 15, 2021.

21. Colombe Pringle, interview with the author, June 7, 2022.

22. Karl Lagerfeld in Carla Bruni, "La vulnérabilité m'est étrangère," *Madame Figaro*, Oct. 6, 2007, 143–46.

23. Karl Lagerfeld, interviewed by Laurence Rémila and Fabrice de Rohan Chabot in "Karl Lagerfeld, Le grand interview!" *Technikart*, Oct. 2014, n.24.

24. Karl Lagerfeld in Christophe Ono-Dit-Biot, "Karl Lagerfeld: Les Zadistes sont un peu sales," *Le Point*, May 9, 2018, n.25.

25. Karl Lagerfeld, interviewed by Laurence Rémila and Fabrice de Rohan Chabot in "Karl Lagerfeld, Le grand interview!"

Bibliography

The Antonio Archives (AA)

Patrimoine de Chanel (PdeC)

"Chanel Prèt-a-porter printemps-été 2005." Video.

Conference de Karl Lagerfeld à la Sorbonne." Transcript, Oct. 18, 1994.

"Costumes de scène KL." Listing of costumes and decors for fifteen opera, theater, and ballet productions from 1978 until 2018.

Deeny, Godfrey. "Karl Lagerfdeld's Eternal Youth," Fashion Wire Daily. April 8, 2002.

Karl For Ever. Video of memorial at Grand Palais, June 20, 2019.

Lagerfeld, Karl. Interview transcript. Elsa Klensch, CNN, Oct. 21, 2000.

———. Interview transcript. Europe 1, Oct. 23, 1985.

———. Interview transcript. Maria Shriver, The Today Show, June 15, 2001.

———. Interview transcript. RTL, July 29, 1986.

———. Note to Alexandra Shulman, British Vogue, Oct. 4, 1999.

———. Note to Catherine Busuttil, April 17, 1996.

———. Note to Catherine Castro, Beaux Arts, Oct. 3, 1996.

———. Note to Diario 16, Dec. 6, 1991.

———. Note to Estela Estrada, Biba España, May 22, 1991.

———. Note to Galerie Boulakia, July 16, 1992.

———. Note to Gilles Brochard, Le Figaro Magazine, Feb. 15, 1991.

———. Note to Janet Froelich, New York Times Magazine, Nov. 11, 1998.

———. Note to Jean-Claude Zana, Paris Match, July 1, 1994.

———. Note to Lisa Armstrong, Independent, June 11, 1992.

———. Note to Lucinda Alford, Observer, Feb. 15, 1991.

———. Note to Marie-Louise de Clermont-Tonnerre, Jan. 2005.

———. Note to Nadine Frey, Harper's Bazaar, Jan. 3, 1991.

———. Note to Richard Buckley, Mirabella, Feb. 28, 1991.

———. Note to Roger Thérond, Paris Match, July 19, 1991.

———. Note to Sarah Mower, British Vogue, July 12, 1991.

———. Note to Vogue, April 20, 1998.

"Moving Forward." Transcript. March 13, 1999.

"Préfaces/Textes de Karl Lagerfeld." Listing of thirty-nine texts authored from 1986 to 2019.

Chloé Archives (CA)

Fendi Archives (FA)

"1966/1967 Fall/Winter Press Release."

"1968/1969 Fall/Winter Press Release."

"Did You Know That Karl Lagerfeld Created the Double F Logo in 1965?" Newsletter 106, Sept. 21, 2015.

"Fendi Autumn-Winter 1966-1967 Collection."

Histoire d'Eau. Film directed by Jacques de Bascher for the first Fendi women's wear collection, 1978.

"In Fendi's Archives in Rome There Are More than 45.000 Sketches Made by Karl Lagerfeld?" Newsletter 47, April 22, 2014.

"One of the Most Beautiful Pieces of the Fendi Fur Archives Is a Blanket?" Newsletter 305, Oct. 30, 2020.

Books, Catalogs, Other Published Material

Allen-Caron, Laurent. *Le mystère Lagerfeld*. Paris: Fayard, 2018.

Amiel, Olivier, and Pierre Gascar, eds. *Lettres de Madame, Duchesse d'Orléans, née Princesse Palatine*. Paris: Mercure de France, 1981.

Andersen, Hans Christian. Illustrated by Karl Lagerfeld. *The Emperor's New Clothes*. New York: Atlantic Monthly Press, 1992.

Beaton, Cecil. *The Glass of Fashion*. New York: Rizzoli, 2014.

Beauvoir, Simone de. *La force des choses*, vol. 1. Paris: Gallimard, 1963.

———. *Les Mandarins*. Paris: Gallimard, 1954.

Bernier, Alexis, and François Buot. *Alain Pacadis: Itinéraire d'un Dandy Punk*. Paris: Le Mot et le Reste, 2018.

Charles-Roux, Edmonde. *L'Irrégulière: L'Itinéraire de Coco Chanel*. Paris: Grasset, 1974.

Collection Lagerfeld. Monaco: Christie's, 2000.

Dictionnaire de la Mode au XXe Siècle. Paris: Éditions du Regard, 1994.

Doutreleau, Victoire. *Et Dior créa Victoire*. Paris: Robert Laffont, 1997.

Drake, Alicia. *The Beautiful Fall*. New York: Little,Brown, 2006.

Flanner, Janet. *Paris Journal: 1944–1955*. New York: Harcourt, Brace, 1965.

Frodon, Jean-Michel, and Dina Iordanova. *Cinémas de Paris*. Paris: CNRS Éditions, 2017.

Green, Julien . *Journal, 1950–1954*. Paris: Plon, 1955.

Grohnert, René, and Karl Lagerfeld, eds. *Reklame*. Göttingen: Steidl, 2013.

Hammen, Émilie, and Benjamin Simmenauer. *Les Grands textes de la mode*. Paris: Regard, 2017.

Hazan, Éric. *L'invention de Paris*, Paris: Éditions de Seuil, 2002.

Heurtault, Philippe, and Christian Dumais-Lvowski. *Jacques de Bascher*. Paris: Michel de Maule, 2017.

Houdret, Jean-Claude. *Le Meilleur des régimes*. Paris: Robert Laffont, 2002.

Hourcade, Patrick. *Une si longue complicité*. Paris: Flammarion, 2021.

Jondeau, Sébastien. *Ça va, cher Karl?* Paris: Flammarion, 2021.

Jonquet, François. *Jenny Bel'Air: Une créature*. Paris: Points, 2021.

Kaiser, Alfons. *Karl Lagerfeld: A Life in* Fashion. New York: Abrams, 2022.

———. *Karl Lagerfeld: Ein Deutscher in Paris*. Munich: Verlag C.H. Beck oHG, 2020.

Karl: Succession Karl Lagerfeld. Partie I. Monaco: Sotheby's, 2021.

Karl: Succession Karl Lagerfeld. Partie II. Paris: Sotheby's, 2021.

Karnow, Stanley. *Paris in the Fifties*. New York: Random House, 1997.

Kessler, Harry. *Berlin in Lights: The Diaries of Count Harry Kessler (1918–1937)*. Translation by Charles Kessler. New York: Grove, 1999.

———. *Journey to the Abyss: The Diaries of Count Harry Kessler 1880–1918*. Edited by Laird Easton. New York: Alfred A. Knopf, 2011.

Lagerfeld, Karl. *Karl Lagerfeld: Journal de Mode*. Paris: Éditions Vilo, 1986.

———. *Off the Record*. Göttingen: Steidl, 1994.

Les années 50. Paris: Éditions Centre Pompidou, 1988.

Letailleur, Gérard. *Histoires insolites des cafés parisiens*. Paris: Perrin, 2011.

Mauriès, Patrick. *Chanel: Catwalk*. London: Thames & Hudson, 2016.

——. *Chanel: Défilés*. Paris: Éditions de La Martinière, 2020.

——. *Chanel: The Karl Lagerfeld Campaigns*. London: Thames & Hudson, 2018.

——. *Choupette: The Private Life of a High-Flying Fashion Cat*. New York: Flammarion, 2014.

——. *La vie enchantée d'un chat fashion*. Paris: Serendip, 2014.

Morillon, Philippe. *Une dernière danse?* Paris: Edition 7L, 2009.

Mower, Sarah. *Chloé: Attitudes*. New York: Rizzoli, 2013.

Napias, Jean-Christophe, and Patrick Mauriès. *Le Monde selon Karl*. Paris: Flammarion, 2013.

Ottavi, Marie. *Jacques de Bascher: Dandy de l'ombre*. Paris: Séguier, 2017.

Packham, Monte. *Concentric Circles*. Göttingen: Steidl, 2010.

Picardie, Justine. *Coco Chanel: The Legend and the Life*. London: HarperCollins, 2017.

Polle, Emmanuelle. *Jean Patou: Une vie sur mesure*. Paris: Flammarion, 2013.

Quin, Élisabeth. *Bel de nuit: Gerald Nanty*. Paris: Grasset, 2007.

Rasche, Adelheid, and Christina Thomson, eds. *Christian Dior and Germany*. Stuttgart: Arnoldsche, 2007.

Saillard, Olivier, and Anne Zazzo, eds. *Paris Haute Couture*. Paris: Flammarion, 2013.

Shirer, William. *The Rise and Fall of the Third Reich*. New York: Simon & Schuster, 1959.

Saint Simon. *Mémoires suivi de Additions au Journal de Dangeau*. Vol. 6. Edited by Yves Coirault. Paris: Bibliothèque de la Pléiade, 1986.

Strachey, Lytton. *Books and Characters, French and English*. New York: Harcourt, Brace, 1922.

Talley, André Leon. *The Chiffon Trenches*. New York: Ballantine Books, 2020.

Vilmorin, Louise de, and Patrick Mauriès, eds. *Mémoires de Coco*. Paris: Éditions Gallimard, 1999.

Williams, Yseult. *La Splendeur des Brunhoff*. Paris: Fayard, 2018.

Newspaper, Journal, and Magazine Articles

AD. "Les talents de Karl." France, May 2012, 92–101.

Alexander, Ron. "The Evening Hour." *New York Times*, May 25, 1984, A20.

Arp, Christiane von, and Christoph Amend. "Ich bin im Grunde harmlos. Ich sehe nur nicht so aus. Karl Lagerfeld: Das Interview." German *Vogue*, January 2018.

Aubry, Églantine. "Les bonnes notes de Karl." *Mixte*, Aug. 2006, 120–23.

Bacqué, Raphaëlle. "Karl Lagerfeld, une enfance allemande." *Le Monde*, Aug. 19, 2018, 16–17.

——. "Karl Lagerfeld, La sensation Warhol." *Le Monde*, Aug. 20, 2018, 16–17.

Bacrie, Lydia, and Charlotte Brunel. "Karl Lagerfeld: 'Beaucoup des collègues me reprochent d'avoir tué le métier." *L'Express*, Dec. 16, 2015, n.p.

Baudot, François. "Bons baisers de Monte-Karl." *Elle*, Feb. 15, 1993, 40–51.

——. "Chez Lagerfeld, Le Magnifique." *Elle Décoration*, Nov. 1988, 92–98, 178.

Bayon. "Lagerfeld, entre les lignes de Keyserling." *Libération Next*, Nov. 6. 2010, 40–45.

Beaudoin, Anne-Cécile, and Elisabeth Lazaroo. "Karl Lagerfeld: L'étoffe d'une star." *Paris Match*, April 25, 2013, 68–77.

Belgiorno, Kathryn. "Quietly, a Bawdy Gay Beacon Goes Dark." *New York Times*, April 24, 2005, Sec. 14, 5.

Benoit, Gérard. "Une éminence grise pour des robes (très) colorées." *Sud Ouest*, July 5, 1972, n.p.

Benyahia-Koulder, Odile. "'Kaiser Karl,' un cas." *Challenges*, Mar. 22, 2007, 89–90.

Berliner Morgenpost. "Ein Hamburger gewann: Sensation in Paris." Dec. 10, 1954, n.p.

Bermbach, Peter. "Mein Karl." *Frankfurter Allgemeine*, July 26, 2011, n.p.

Bern, Stéphane. "Caroline de Hanovre: Karl Lagerfeld était comme un membre de ma famille." *Point de Vue*, April 3, 2019, 20–23.

Bertoin, Jacques. "Karl Lagerfeld, marginal de luxe." *Le Monde*, April 28, 1980, n.p.

Bethany, Marilyn. "Be It Ever So Functional, There Is No Place Like Home." *New York Times*, Oct. 31, 1982, Sec. 6, 74.

Billiard, Thierry, and David Slama. "Karl Kapital." *Paris Capitale*, March 2008, 54–59.

Bizot, Jean-François. "Lagerfeld veut régner sur la mode." *Actuel*, Mar. 1984, 136–68.

Bougère, Marie-Caroline. "Le défilé métiers d'art Paris-Hamburg en neuf détails." *Le Figaro Madame*, Dec. 6, 2017, n.p.

Boulay, Anne. "Self-Mode Man." *Libération*, March 24, 1999, n.p.

Brady, James. "Chanel Dead in Paris at 87." *WWD*, Jan. 11, 1971, 1.

Braunstein, Jacques. "Watteau, What a Shock." *Technikart Mademoiselle*, Oct. 2004, 148–49.

Bruni, Carla. "La vulnérabilité m'est étrangère." *Madame Figaro*, Oct. 6, 2007, 140–46.

Canby, Vincent. "The Screen: L'Amour." *New York Times*, May 11, 1973, 26.

Châtenet, Angèle. "Rencontre avec Stefan Lubrina, scénographe pour la maison Chanel." *Le Monde*, Feb. 3, 2014, n.p.

Cocteau, Jean. "Le retour de Mademoiselle Chanel." *Fémina*, March 1954, n.p.

Collins, Amy Fine. "Haute Coco." *Vanity Fair*, June 1994, 106–11, 133–41.

Collins, Nancy. "Scent of a Man." *Mirabella*, Nov. 1994, 88–92.

Colman, David. "Chanel's Upper Class Face." *New York Times*, June 16, 1996, Sec. 1, 42.

———. "The Gem, in a Modern, Sleek Crown." *New York Times*, May 11, 2003, Sec. 9, 8.

Davidson, Monique. "Karl Lagerfeld Talks to Monique Davidson." *Clout*, Feb. 1983, 14–16.

Döbler, Dr. Joachim. "Life Beneath the Facades of Bombed-Out Streets." *Indian Architect & Builder*, Nov. 1995, 102–7.

Donovan, Carrie. "American Designers Come of Age." *New York Times Magazine*, May 6, 1979, 254.

———. "From Paris Couture: The Influential Two." *New York Times Magazine*, Sept. 11, 1983, Sec. 6, 132–35.

———. "Reshaping the Classics at the House of Chanel." *New York Times Magazine*, Dec. 12, 1982, Sec. 6, 116, 133.

———. "Why the Big Change Now." *New York Times Magazine*, Nov. 12, 1978, 103, 104.

Dorsey, Hebe. "Alaïa's Body-Hugging Contours Shape the Scene." *International Herald Tribune*, Oct. 22, 1985, 7.

———. "50,000 Buyers Flood Paris." *International Herald Tribune*, April 3, 1974, n.p.

Duka, John. "Notes on Fashion." *New York Times*, March 2, 1982, A16.

———.. "Notes on Fashion." *New York Times*, Jan. 18, 1983, C9.

Elle. "Fashion Genius." Sept. 2007, 202–4.

Farrah, Leila. "Of Shoes and Candle Wax." *Sunday Times*, May 13, 1990, n.p.

Faure, Guillemette. "Le marathon de Paris de M. Instagram." *Le Monde*, March 11, 2015.

Foley, Bridget. "Chanel RTW Fall 2017." *WWD*, March 7, 2017, 1.

Fraysse, Bertrand. "Iconique." *Challenges*, Feb. 14, 2008, 57–63.

Fraser, Kennedy. "Imperial Splendors." *Vogue*, Sep. 2004, 709–15, 824.

Fraser, Natasha, and William Middleton. "Paris: The Party Years." *W*, April 1996, 377–82, 410–12.

Gaigneron, Axelle de. "Inès entre au Louvre." *Connaissance des arts*, Dec. 1986, 100–105.

———. "Jack Lang vu par Karl Lagerfeld." *Connaissance des arts*, Dec. 1988, 78–79.

Galinier, Pascal. "En s'emparant la griffe romaine Fendi, LVMH prend sa revanche en Italie." *Le Monde*, Oct. 14, 1999, n.p.

Goldsmith, Gill. "Paris Designer Longs to Return to High Fashion." *New York Times*, Dec. 7, 1960, 59.

Gopnik, Adam. "Saving the Balzar." *New Yorker*, Aug. 3, 1998, 39–42.

Greenhouse, Steven. "After Bastille Day: Liberty, Equality and Royalty." *New York Times*, Aug. 1989, A4.

Gross, Michael. "Chanel Today." *New York Times Magazine*, July 28, 1985, Sec. 6, 47, 55, 56.

———. "An Irreverent Model Shapes Chanel's New Image." *New York Times*, Dec. 13, 1986, Sec. 1, 36.

———. "The McCarthy Era." *New York*, Aug. 4, 1997, n.p.

Harbrecht, Ursula. "Fürstliche Domizile." *Stern*, Sept. 22, 1988, 171–86.

Hautclere, Viviane. "Chanel La légende." *L'Express*, Feb. 4, 1993, 18–27.

Hochswender, Woody. "Amid the Rustle of Finery, Fashion Celebrates Its Own." *New York Times*, Jan. 10, 1989, B9.

Horyn, Cathy. "Couture, the Game for Pure Players." *New York Times*, Jan. 24, 1999, Sec. 9, 1.

———. "In Praise of Short Memories." *New York Times*, March 9, 1999, B7.

———. "Profile in Style: Karl Lagerfeld." *T*, Dec. 4, 2008, n.p.

———. "The Rootin' Teuton." *T*, Feb. 2005. 198.

Hyde, Nina. "Lagerfeld's New Look." *Washington Post*, March 28, 1984, n.p.

———. "Mickey and Minnie on the Paris Runway." *Washington Post*, April 10, 1979, n.p.

Ilchi, Layla. "Karl Lagerfeld: A Look Back at His Iconic Career in Fashion." *WWD*, Feb. 19, 2019, n.p.

International Herald Tribune. "Chanel's 'UFO Exhibit' Lands in Hong Kong." Dec. 6, 2008, n.p.

Jorif, Sylvia. "À bon port." *Elle*, Dec. 12, 2017, 28, 29.

Jorif, Sylvia, and Marion Ruggieri. "Karl Lagerfeld: L'homme sans passé." *Elle*, Sept. 2008, 10–13.

Kapczynski, Jennifer M. "Raising Cain? The Logic of Breeding in Michael Haneke's 'Das Weiße Band.'" *Colloquia Germanica* 43, no. 3 (2010): 153–73.

Kaufman, Leslie. "Five Questions for Bernard Arnault." *New York Times*, Oct. 17, 1999, Sec. 3, 7.

Kramer, Jane. "The Chanel Obsession." *Vogue*, Sept. 1991, 512–19, 608–10.

La Ferla, Ruth. "Over the Top, as He Wants to Be." *New York Times*, April 13, 2003, Sec. 9, 1.

Lagerfeld, Karl. "Caroline le bonheur." *Paris Match*, Dec. 29, 1988, 50–57.

———. "Inside Paris Fashion." *Interview*, Oct. 2001, 64.

——. "Le film d'un film." *Vogue Paris*, March 1978, 276–78.

——. "Plaidoyer pour les créateurs." *GAP*, Dec. 1980, 132, 133.

——. "Weimar, Berlin, Potsdam." *Zoom*, May–June 1991, 16–24.

Lagerfeld, Karl (as Minouflet de Vermenou). "Nancy Cunard ou la réalité d'un mythe." *Vogue Paris*, Sept. 1979, 120–27.

——. "Silence! On tourne . . . les pages." *Vogue Paris*, March 1979, 414–19.

Lafaye, Jean-Jacques. "Karl Lagerfeld: Modes et lumières." *Connaissance des arts*, June 1992, 34–43.

Lannelongue, Marie-Pierre. "Karl Lagerfeld et H&M: Chronique d'un carton assuré." *Elle*, Aug. 23, 2004, 12–15.

Lazaroo, Elisabeth. "Roulez Jeunesse!" *Paris Match*, July 5, 2018, 22–25.

Le Figaro. "Karl Lagerfeld file Saint-Simon dans le Grand Siècle." Aug. 5, 2004, 13–14.

——. "Le secretariat international de la laine a choisi parmi six mille dessins ses trois lauréats." Nov. 25, 1954.

L'Express Style. "Le Pied-a-terre Romain de Karl Lagerfeld." May 1988, 30–37.

Leyris, Raphaëlle. "Sagan nostalgie." *Le Monde*, May 20, 2014, n.p.

Liberati, Simon. "Cet obscur objet du désir." *Vogue Hommes*, Sept. 2014, n.p.

Luca, Jean-Claude de. "Des hommes à la mode." *Mr. 6* (1974), 82–83.

Madame Figaro. "La Bicentenaire du frou-frou." June 17, 1989, n.p.

Madsen, Anders Christian. "Michel Gaubert Is Fashion Week's Monarch of Music." *i-D*, March 9, 2015, n.p.

Maison et Jardin. "Mens sane in corpore sano." Dec. 1986, 126, 127.

Maison Française. "Chez Karl Lagerfeld à Rome: Tous les chemins mènent à Vienne." July 1983, 76–81.

——. "Karl Lagerfeld, sur son 31." July 1983, 74, 75.

McCarthy, Patrick. "It's Official—Lagerfeld to Design for Chanel." *WWD*, Sept. 16, 1982, n.p.

McClure, Joël Stratte. "Un week-end avec Karl Lagerfeld." *Le Matin de Paris*, Mar. 21, 1980, n.p.

McColl, Patricia. "Parfums Chanel: Good Results from Number 19." *WWD*, Jan. 12, 1973, n.p.

McEvoy, Marian. "French Designers Show a Talent for Partying, Too." *New York Times*, April 14, 1978, 16.

Melikian, Souren. "Karl Lagerfeld Steps Off an 18th-Century Stage." *International Herald Tribune*, May 2, 2000, n.p.

Menkes, Suzy. "At Chanel Show, Opposites Fail to Attract." *International Herald Tribune*, Jan. 20, 1999, n.p.

——. "A Walk on the Wise Side." *International Herald Tribune*, Feb. 25, 2010, n.p.

——. "Chanel Leads the Ice Pack." *International Herald Tribune*, March 9, 2010, n.p.

——. "Chanel's Scottish Touch Warms Up the Scottish Highlands." *International Herald Tribune*, Dec. 10, 2012, n.p.

——. "Chanel's Toy Boy." *Times* (London), April 15, 1986, 14–15.

——. "Chanel's Year in Marienbad." *International Herald Tribune*, Oct. 5, 2010, n.p.

——. "Galliano Soars While Chanel Is Spaced Out." *International Herald Tribune*, Oct. 17, 1998, n.p.

——. "In Paris Shows, He's Top of the Class." *International Herald Tribune*, Oct. 15, 1993.

——. "Zapping at Chanel; Lacroix Is Pretty Calm." *International Herald Tribune*, Oct. 8, 2005, n.p.

Middleton, William. "Heavenly Hamburg." *W*, September 1996, 330–40.

——. "Monte Karl." *W*, July 1995, 117–21.

——. "The Prêt Pack." *W*, Nov. 1996, n.p.

Millauer, Liselotte. "Interview mit Karl Lagerfeld." *Petra*, Jan. 1984, 76–77.

Mont-Servan, Nathalie. "Au printemps prochain." *Le Monde*, Oct. 21, 1982, n.p.

——. "Chanel trouve son maître." *Le Monde*, Jan. 21, 1983, n.p.

Montclos, Violaine de. "Lagerfeld, portrait volé." *Le Point*, Oct. 4, 2007, 82–84.

Moonan, Wendy. "A Designer Bids Adieu to Art Deco." *New York Times*, May, 11, 2003, E42.

Moore, Jackie. "Lagerfeld." *City and Country Home Fashion*, Sept. 1985, 102–16.

Moriset, Cédric. "Karl Lagerfeld, le déco, le design, et quelques mises au point." *AD France*, September 2011, 64–66.

——. "Le Vaisseau amiral de Karl Lagerfeld." *AD France*, May 2012, 128–37.

Morris, Bernadine. "A Day of Fashions, Photos and Faces." *New York Times*, April 24, 1975, 59.

——. "A Fanfare for (and by) Karl Lagerfeld." *New York Times*, April 20, 1983, C10.

——. "Applause in Paris for Lagerfeld and Miyake." *New York Times*, Oct. 17, 1983, A18.

——. "Can Couture Turn Heads If It Keeps Looking Back?" *New York Times*, Feb. 4, 1992, A19.

——. "Fendi and Lagerfeld Triumph in Milan." *New York Times*, March 10, 1983, C1.

——. "Fendi Furs Dazzle Milan." *New York Times*, Mar. 29, 1979, C1.

——. "Givenchy and Chanel Excite Paris." *New York Times*, Oct. 19, 1982, C8.

——. "Impressarios of Fashion Preside at Les Halles." *New York Times*, April 10, 1979, C12.

——. "The Japanese Challenge to French Fashion." *New York Times*, March 21, 1983, B7.

——. "Karl Lagerfeld: The Designer Setting Fashion's Tempo." *New York Times*, May 21, 1979, B6.

——. "Lagerfeld Guides Chanel into the 80s." *New York Times*, C1.

——. "Lagerfeld Lifts Spirits in Paris." *New York Times*, Oct. 22, 1984, C14.

——. "Lagerfeld: Slow Start, Big Finish." *New York Times*, March 28, 1984, C14.

——. "Paris Flash or Milan Style." *New York Times*, March 15, 1994, B9.

——. "Paris: Irreverent Chanel and Seductive Ungaro." *New York Times*, July 29, 1987, C10.

——. "Saint Laurent's Buoyant Skirts, Spare Boleros." *New York Times*, Oct. 24, 1985, C10.

——. "Valentino—Quiet but Beguiling, Tailored but Feminine." *New York Times*, July 23, 1971, 38.

——. "Word from Paris: Body-Hugging Designs." *New York Times*, Oct. 22, 1985, A28.

Mower, Sarah. "Keeping Up with Karl." *Harper's Bazaar*, Jan. 1993, 80–89.

Nemy, Enid. "Fashion Was Her Pulpit." *New York Times*, Jan. 11, 1971, 35.

New York Times. "Biggest RAF-U.S. Raids on Reich Blast Hamburg, Hit Baltic Cities." July 26, 1943, 1–7.

Obrist, Hans Ulrich. "My Job Is Not to Dwell on the Past." *System 3* (2014).

O'Hagan, Andrew. "The Maddening and Brilliant Karl Lagerfeld." *T*, Oct. 12, 2015, n.p.

Ono-Dit-Biot, Christophe. "Karl Lagerfeld: Les Zadistes sont un peu sales." *Le Point*, May 9, 2018, n.p.

Orth, Maureen. "Kaiser Karl: Behind the Mask." *Vanity Fair*, Feb. 1992, 68–73, 109–14.

Paris Match. "La métamorphose de Caroline." April 5, 1975, n.p.

Petkanas, Christopher. "Lagerfeld Tackles Couture." *WWD*, Jan. 19, 1983, 1, 4, 5.

Petronio, Ezra. "Wanted." *Self-Service*, Oct. 1999, 71–75.

Polk, Peggy. "Joke About Rape Is Trouble for Fashion House." UPI, Oct. 10, 1984.

Pringle, Colombe. "Je déteste les riches qui vivent au-dessous de leurs moyens." *L'Express*, Nov. 11, 1999, 26–30.

Quoirez, Jacques. "Pourquoi la Barbe." *Vogue Hommes*, March 1973, 135.

Raper, Sarah. "Evolution of a Classic: Lagerfeld Sees a Need for Changes at Chanel." *WWD*, Jan. 25, 1999, 1, 8–10.

Rance, Christiane. "Coco Toujours." *Le Figaro Magazine*, Jan. 19, 1991, 52–59.

Rebillat, Clémentine. "Karl Lagerfeld vs. Adele: Un conflit de poids." *Paris Match*, Feb. 9, 2012.

Rémila, Laurence, and Fabrice de Rohan Chabot. "La Grande Interview." *Technikart*, Oct. 2014, n.p.

Roberts, Daniel. "How Kevin Systrom Got Started." *Fortune*, Oct. 10, 2014, n.p.

Roberts, Michael. "Fashion's King Karl." *Sunday Times* (London), April 1, 1973, n.p.

Rohwedder, Cecilie. "Freedom Without Democracy Is Lagerfeld's Design at Chanel." *Wall Street Journal*, Oct. 10, 2005, n.p.

S., A. "Le mobilier 'BD' de Karl Lagerfeld." *Le Figaro*, Oct. 11, 1991, n.p.

Sabatini, Adelia. "The House That Dreams Built." *glass*, Summer 2010, 66–71.

Scorcelletti, Emanuele. "Master and Commander." *Telegraph Magazine*, Oct. 9, 2004, 30–37.

Sischy, Ingrid. "Je ne suis pas Dieu." *Madame Figaro*, Sept. 25, 2010, 86–90.

Socha, Miles. "The Full Monte." *W*, Feb. 2007, 96–98.

———. "H&M Goes Designer with Karl." *WWD*, Sept. 17, 2004, 1, 6.

Sheppard, Eugenia. "New Dresses in Paris, Simple, High-Waisted." *New York Herald*, July 29, 1958, n.p.

Spindler, Amy M. "Among Couture Debuts, Galliano's Is the Standout." *New York Times*, Jan. 21, 1997, B7.

Stern, Dora. "Itinéraire d'un enfant gâté." *Dépêche Mode*, May 1992, 32–35.

Swanson, Carl. "Karl Lagerfeld's House of Provocation." *New York*, Dec. 9, 2018, n.p.

Talley, André Leon. "Karl Lagerfeld: In a Cloud of Chloé." *Interview*, June 1975, 28–31.

———. "Perspective 80." *Vogue Paris*, Nov. 1979, 213–15.

———. "Souper aux chandelles." *Vogue Paris*, Nov. 1979, n.p.

Télérama. "Quand Karl Lagerfeld rencontrait Fabrice Luchini: Délire d'égos et joute verbal." Feb. 19, 2019, n.p.

Tempest, Rone. "Does Karl Lagerfeld Ever Sit Still?" *Los Angeles Times Magazine*, April 14, 1991, 21–23, 44–46.

Théolleyre, Jean-Marc. "Quatorze accusés presents ont entendu pendant plus de trois heures le récit du trois cents tortures." *Le Monde*, Nov. 21, 1952, n.p.

Tossan, Caroline. "Ma collection? Zen-baroque." *Le Journal du dimanche*, Jan. 16, 2000, n.p.

Tredre, Roger. "Kaiser Karl." *Life: The Observer Magazine*, Aug. 7, 1994, 26–29.

Utz, Philip. "Karl Forever." *Numéro*, April 2018, 46–52.

———. "Lagerfeld Lets His Hair Down." *Talk*, Nov. 2000, 119–21, 158, 159.

Vairet, Florent. "Je n'ai pas de patron, à part moi et Choupette!" *Les Echos Business*, July 2, 2018, 18–20.

Verley, Frédérique. "Mythe Movie." *Vogue Paris*, Nov. 2004, n.p.

Vivier, Régine. "Ils ont choisi les vacances à domicile." *Elle*, July 14, 1969, 40–41.

Vogue Hommes. "Avec K.L., Classicisme K.O." Summer 1974, n.p.

Vogue Paris. "Chloé par Karl Lagerfeld." Aug. 1979, 286–87.

———. "Le Premier amour d'Anouk Aimée." April 1978, 170–75.

W. "Chantilly Caper." Oct. 18, 1985, 10.

White, Constance C. R. "Lagerfeld's Lesson for Younger Designers: Stay Relevant." *New York Times*, March 16, 1999, B11.

Wicker, Olivier. "Interview/Obsession." *Le Nouvel observateur*, Aug. 23, 2012, 4–9.

Wilkes, Andrew. "A Conversation with Karl Lagerfeld." *Aperture*, Winter 1991, 102–12.

Woods, Vicky. "Basquing in the Sun." *Vogue*, April 2002, 337–42.

WWD. "Chanel Sizzles as Lagerfeld Burns." Oct. 22, 1985, 1, 19.

———. "De Ribe's 1001 Nights; Laroche's Denim Days." Oct. 23, 1985, 24.

———. "Flight of a Muse." Nov. 14, 1996, 1.

———. "Karl Lagerfeld: Anything but Subtle." July 27, 1983, 8–10.

———. "Karl's Reign at Chanel." Jan. 22, 2003, 9–10.

———. "King Karl." Nov. 20, 1991, n.p.

———. "Lagerfeld." Oct. 8, 1985, 35.

———. "Say Chanel Couture Woos Lagerfeld." Mar. 8, 1982, 36.

———. "The Chanel Saga: Does the Hairdresser Know for Sure?" Oct. 24, 1985, 17.

Websites

Arch Daily. "Chanel Mobile Art Pavilion/Zaha Hadid Architects." https://www.archdaily .com/144378/chanel-mobile-art-pavilion-zaha-hadid-architects.

Augustin, Alice. "Quand le Tout-Paris des années 70 dansait à La Main bleue." *Vanity Fair*, June 22, 2016, https://www.vanityfair.fr/culture/people/articles/la-main-bleue -discotheque-legendaire-des-annees-1970/43430.

Bacqué, Raphaëlle. "Catherine Deneuve et son double." *Le Monde*, Aug. 24, 2020, https://www.lemonde.fr/series-d-ete/article/2020/08/24/catherine-deneuve-et-son -double_6049813_3451060.html.

"Biennial of Florence." MaMe, June 4, 2015, https://fashion.mam-e.it/biennial-of-florence/.

Blumenfeld, Carole. "Karl Lagerfeld, la couleur du XVIII siècle." *La Gazette Drouot*, Feb. 28, 2019, https://www.gazette-drouot.com/article/karl-lagerfeld-la-couleur-du -xviiie%25C2%25A0siecle/5844.

Bowles, Hamish. "Fendi." *Vogue*, Feb. 21, 2019, https://www.vogue.com/fashion -shows/fall-2019-ready-to-wear/fendi.

———. "Grace Coddington Fans, Rejoice." *Vogue*, Aug. 26, 2015, https://www .vogue.com/article/grace-coddington-book-thirty-years-of-fashion-reprint.

Britton, Bianca. "Karl Lagerfeld's Most Controversial Quotes." CNN.com, Feb. 20, 2019, https://edition.cnn.com/style/article/karl-lagerfeld-controversial-quotes-intl/index .html.

Cartner-Morley, Jess. "Karl Lagerfeld Misses Chanel Haute Couture Shows in Paris."

Guardian, Jan. 22, 2019, https://www.theguardian.com/fashion/2019/jan/22/karl
-lagerfeld-misses-chanel-haute-couture-shows-in-paris.

Chanel.com. "Thank You Karl Lagerfeld." Feb. 19, 2019, https://www.chanel.com/sg
/fashion/news/2019/02/thank-you-karl-lagerfeld.html.

"Constantin Brancusi, *L'Oiseau dans l'espace*, 1941." https://www.centrepompidou.fr/fr
/ressources/oeuvre/cbLy4oX.

Cowles, Charlotte. "Karl Lagerfeld on Diets, Sobriety, and Becoming a 'Nicer Person.'"
New York, Nov. 7, 2013, https://www.thecut.com/2013/11/lagerfeld-on-diets-and
-becoming-a.html.

Dagen, Philippe. "Je ne crois pas au nationalisme artistique." *Le Monde*, Sept. 30, 2014,
https://www.lemonde.fr/arts/article/2014/10/07/bernard-arnault-je-ne-crois-pas-au
-nationalisme-artistique_4502164_1655012.html.

Deeny, Godfrey. "Chanel dévoile 19M, le nouveau quartier general de ses métiers d'art."
FashionNetwork.com, Oct. 10, 2019, https://fr.fashionnetwork.com/news/Chanel-
devoile-19m-le-nouveau-quartier-general-de-ses-metiers-d-art,1145954.html.

Deux Dents de Narval. "Collection Yves Saint Laurent et Pierre Bergé." Feb. 25, 2009,
https://www.christies.com/en/lot/lot-5171506.

"The Disruptor." *Metal*, https://metalmagazine.eu/en/post/interview/andre-leon-talley
-the-disruptor.

"The Divine History of the Woolmark Prize." *International Woolmark Prize*, https://
www.woolmarkprize.com/news/history-international-woolmark-prize/.

Drier, Melissa. "Chanel Fetes Little Black Jacket in Berlin." Nov. 21, 2012, https://wwd
.com/fashion-news/fashion-scoops/chanel-fetes-little-black-jacket-in-berlin-6499080/.

Ellison, Jo. "Chanel no. 5, 4, 3, 2, 1." *Financial Times*, March 7, 2017, https://www
.ft.com/content/4fd74dde-0334-11e7-ace0-1ce02ef0def9.

Enez-Vriad, Jérôme. "Karl Lagerfeld Chatelain Morbihannais de Penhoët." *Bretagne
Actuelle,* March 4, 2019, https://www.bretagne-actuelle.com/karl-lagerfeld-chatelain
-morbihannais-de-penhoet/accueil-top/.

Fondation Louis Vuitton. "La Collection Courtauld. Le parti de l'Impressionnisme."
https://www.fondationlouisvuitton.fr/en/events/la-collection-courtauld-le-parti-de-l
-impressionnisme.

Fonseca-Wollheim, Corinna da. "Finally, a Debut for the Elbphilharmonie Hall in
Hamburg." *New York Times*, Jan. 10, 2017, https://www.nytimes.com/2017/01/10
/arts/music/elbphilharmonie-an-architectural-gift-to-gritty-hamburg-germany
.html?_r=0.

FranceInfo. "Quand Karl Lagerfeld recevait la Reine mère d'Angleterre dans son
château de Penhoët." Feb. 20, 2019, https://www.francetvinfo.fr/culture/mode
/quand-karl-lagerfeld-recevait-la-reine-mere-d-039-angleterre-dans-son-chateau-de
-penhoet_3384411.html.

Friedman, Vanessa. "Karl Lagerfeld, Fashion's Shock Jock." *New York Times*, May 17,
2018, https://www.nytimes.com/2018/05/17/fashion/karl-lagerfeld-renounce-german
-citizenship.html.

Gianorio, Richard. "L'odeur de sainteté je n'y tiens pas." *Madame Figaro*, May 20, 2013,
https://madame.lefigaro.fr/style/karl-lagerfeld-lodeur-de-saintete-ny-tiens-pas-200513
-382922.

Gombeaud, Adrien. "Quand Karl Lagerfeld habillait Stéphane Audran." *Vogue Paris*,

March 27, 2018, https://www.vogue.fr/culture/a-voir/story/quand-karl-lagerfeld
-habillait-stephane-audran-dessins-films-cinema/1649.

Hays, Kali. "When Karl Came to Chanel." *WWD*, Dec. 20, 2017, https://wwd.com
/fashion-news/designer-luxury/when-karl-lagerfeld-came-to-chanel-1983-couture
-collection-11077517/.

The Hazeltree. "In a Nutshell, the Linlithgow Palace Fountain." https://thehazeltree
.co.uk/2014/05/14/in-a-nutshell-the-linlithgow-palace-fountain/.

Hidalgo, Anne. Twitter, https://twitter.com/Anne_Hidalgo/status/1097836423577849856?ref_
src=twsrc%5Etfw%7Ctwcamp%5Etweetembed%7Ctwterm%5E10978364235778
49856%7Ctwgr%5E%7Ctwcon%5Es1_&ref_url=https%3A%2F%2Fwww.bfmtv
.com%2Fpeople%2Fmode%2Fmort-de-karl-lagerfeld-plus-qu-une-incarnation-de-paris-il
-etait-paris-salue-anne-hidalgo_AN-201902190084.html.

Historic Environment Scotland. "Linlithgow Palace." https://www.historicenvironment
.scot/visit-a-place/places/linlithgow-palace/history/.

"Hommage à Karl Lagerfeld." Elysee.fr, https://www.elysee.fr/emmanuel-macron
/2019/02/19/hommage-a-karl-lagerfeld.

Horyn, Cathy. "The Woman No Hat Could Tame." *New York Times*, May 10, 2007,
https://www.nytimes.com/2007/05/10/fashion/10BLOW.html?ref=fashion.

Hyde, Nina S. "Donning Masks, Dodging Boredom." *Washington Post*, Oct. 29, 1978,
https://www.washingtonpost.com/archive/lifestyle/1978/10/29/donning-masks
-dodging-boredom/f8a39c48-b907-427f-ad38-1cba53ec4f77/.

Hyland, Veronique. "Penney's Serenade." *WWD*, May 12, 2010, https://wwd.com
/fashion-news/fashion-features/halston-j-c-penney-3068848/.

Icehotel.com. https://www.icehotel.com/day-visit-icehotel.

Ivie, Devon. "'Defamed' Meryl Streep Slams Karl Lagerfeld over Oscars Dress Controversy;
Lagerfeld Issues Apology." *New York*, Feb. 26, 2017, https://www.vulture.com/2017/02
/meryl-steep-criticizes-karl-lagerfeld-over-dress-controversy.html

Jeremiah's Vanishing New York. "The Gaiety Theater." Oct. 11, 2007, http://
vanishingnewyork.blogspot.com/2007/10/gaiety-theater.html.

Larocca, Amy. "Viva la Fashion." *New York*, https://www.thecut.com/2016/05/chanel
-resort-show-cuba-c-v-r.html.

Lau, Vanessa. "May 10, 1978, La Vie en Rouge." *WWD*, Nov. 29, 2010, https://wwd
.com/fashion-news/fashion-features/may-10-1978-la-vie-en-rouge-3391294/.

Lazaroo, Elisabeth. "Fendi & Karl fêtent leurs noces d'or." *Paris Match*, July 9, 2015,
https://www.parismatch.com/Vivre/Mode/Fendi-Karl-fetent-leurs-noces-d-or
-796990.

L'École normale supérieure. "Archives de Jacques Leibowitch." http://www.calames
.abes.fr/pub/#details?id=FileId-2776.

Lettres Sorbonne Université. "Histoire de la Faculté." https://lettres.sorbonne-universite
.fr/faculte-des-lettres/histoire-de-la-faculte.

Levine, Bettijane. "Luxury and Discipline Reborn in Name of Legendary Chanel." *Los
Angeles Times*, Feb. 22, 1985, https://www.latimes.com/archives/la-xpm-1985-02-22
-vw-763-story.html.

Long, Priscilla. "Carnation Condensed Milk First Manufactured in Kent on September
6, 1899." https://historylink.org/File/1608.

Lorelle, Véronique. "Jacques Grange, le décorateur des stars, vend une partie de

sa collection art et design." *Le Monde*, Nov. 17, 2017, https://www.lemonde.fr
/m-design-deco/article/2017/11/15/le-decorateur-des-stars-fait-le-vide-chez-lui
_5215279_4497702.html.

Los Angeles Times. "LVMH to Buy Prada's Fendi Stake." Nov. 26, 2001, https://www
.latimes.com/archives/la-xpm-2001-nov-26-fi-8394-story.html.

Madrigal, Alexis C. "Chanel's Renewable-Energy-Themed Fashion Show." *Atlantic*,
Oct. 4, 2012, https://www.theatlantic.com/technology/archive/2012/10/chanels
renewable-energy-themed-fashion-show/263242/.

Maitland, Hayley. "Claudia Schiffer Rode Through Paris on a Motorcycle While
Wearing Haute Couture." *Vogue* U.K., May 17, 2020, https://www.vogue.co.uk/arts
-and-lifestyle/article/claudia-schiffer-paris-couture-vogue.

Menkes, Suzy. *Vogue* U.K., https://www.vogue.co.uk/article/cnilux-suzy-meets-kim
-young-seong-chanel.

Michael, Apphia. "Chanel Unveils Its Métiers d'art 2013 Collection at Linlighgow
Palace, Scotland." *Wallpaper*, Dec. 4, 2012, https://www.wallpaper.com/fashion
/chanel-unveils-its-mtiers-dart-2013-collection-at-linlithgow-palace-scotland.

Mower, Sarah. "Chanel." *Vogue*, March 7, 2017, https://www.vogue.com/fashion-shows
/fall-2017-ready-to-wear/chanel.

———. "Chanel Resort 2017." Vogue.com, https://www.vogue.com/fashion-shows
/resort-2017/chanel.

Musée du Louvre. "Galerie d'Apollon: Soleil, or et diamants." https://www.louvre.fr
/decouvrir/le-palais/soleil-or-et-diamants.

Musée YSL Paris. "1974: Installation au 5 avenue Marceau." https://museeyslparis.com
/biographie/installation-au-5-avenue-marceau.

Museum at FIT. "2010 Couture Council Fashion Visionary Award: Karl Lagerfeld."
https://www.fitnyc.edu/museum/couture-council/_hide/karl-lagerfeld.php

Museum of Dreams. "Henry James at the Louvre." Nov. 2017, https://www
.museumofdreams.org/henry-james-at-the-louvre.

Musto, Michael. "8 Forgotten Hangouts That Made NYC Special." *Paper*, Feb. 18, 2005,
https://www.papermag.com/8-forgotten-hangouts-that-made-nyc-special-1427513337
.html.

Paris-promeneurs. "L'hôtel de Maison ou hôtel Pozzo di Borgo." https://paris-promeneurs
.com/l-hotel-de-maisons-ou-hotel-pozzo/.

Patiner, Jérémy. "Jacques de Bascher: Le grand amour de Karl Lagerfeld et Saint Laurent."
Têtu, Nov. 7, 2017, https://tetu.com/2017/07/11/jacques-de-bascher-grand-amour-de
-karl-lagerfeld-saint-laurent/.

Pellous, Cécilia. "Explore Hotel de Crillon and Les Grands Appartements by Karl
Lagerfeld." *Forbes*, Dec. 30, 2020, https://www.forbes.com/sites/ceciliapelloux
/2021/12/30/explore-hotel-de-crillon-and-les-grands-appartements-by-karl-lagerfeld
/?sh=781979c6703f.

Poiret, Elise. "Karl Lagerfeld sur Brigitte Macron: 'Les plus belles jambes de Paris!'"
Madame Figaro, July 21, 2017, https://madame.lefigaro.fr/celebrites/karl-lagerfeld-
sur-le-physique-de-brigitte-macron-les-plus-belles-jambes-de-paris-210717-133365.

Porret, Karine. "Le jour où Karl Lagerfeld présente sa première collection pour Chanel."
L'Express, April 15, 2020, https://www.lexpress.fr/styles/mode/saga-4-10-le-jour-
ou-karl-lagerfeld-presente-sa-premiere-collection-pour-chanel_2123572.html.

Reuters. "LVMH taps Dior's Brunschwig to lead luxury brand Fendi." https://www
.reuters.com/article/lvmh-fendi/lvmh-taps-diors-brunschwig-to-lead-luxury-brand
-fendi-idINKCN1G41G5.

Socha, Miles. "Marie Louise de Clermont-Tonnerre Looks Back on an Illustrious PR
Career." *WWD*, Feb. 19, 2022, https://wwd.com/eye/people/chanel-history-before
-karl-lagerfeld-clermont-1235057786/.

———. "Seminal Moments: When Fendi Conquered the Great Wall of China." *WWD*,
Sept. 24, 2020, https://wwd.com/fashion-news/designer-luxury/when-karl-and-fendi
-conquered-the-great-wall-of-china-1203671195/.

Stanford, Peter. "Bronwen, Lady Astor Obituary." *Guardian*, Jan. 1, 2018, https://www
.theguardian.com/uk-news/2018/jan/01/bronwen-lady-astor-obituary.

Tarient, Eric. "The Lagerfeld Collection: We All Have to Live in Our Times." *Art
Newspaper*, June 1, 2000, https://www.theartnewspaper.com/2000/06/01/the
-lagerfeld-collection-we-all-have-to-live-in-our-own-times.

Villa Albertine. "*La carte postale* by Anne Berest Wins First Ever Choix Goncourt
United States." April 30, 2022, https://villa-albertine.org/the-villa/la-carte-postale
-anne-berest-wins-first-ever-choix-goncourt-united-states.

Vogue Paris. "'*Work in Progress*': Karl Lagerfeld to Show His Photos in Cuba." May 2, 2016,
https://www.vogue.fr/fashion/fashion-news/articles/work-in-progress-karl-lagerfeld
-to-show-his-photos-in-cuba/37607.

Wainwright, Oliver. "'We Thought It Was Going to Destroy Us,' . . . Herzog and De
Meuron's Hamburg Miracle." *Guardian*, Nov. 4, 2016, https://www.theguardian
.com/artanddesign/2016/nov/04/hamburg-elbphilhamonie-herzog-de-meuron-a
-cathedral-for-our-time.

Wall Street Journal. "First U.S. Cruise in Decades Arrives in Cuba." May 2, 2016, https://
www.wsj.com/articles/first-u-s-cruise-in-decades-arrives-in-cuba-1462202835.

———. "Twenty Odd Questions: Diane Kruger." July 20, 2012, https://www.wsj.com
/articles/SB10001424052702303343404577518712094268998.

Wasef, Basem. "2010 Harley-Davidson Photo Gallery and Buyer's Guide." https://www
.liveabout.com/2010-harley-davidson-photo-gallery-4122609.

Zahm, Olivier. "Bernard Henri Lévy." *Purple*, Spring/Summer 2009, https://purple.fr
/magazine/ss-2009-issue-11/bernard-henri-levy/.

Index

About the Author

WILLIAM MIDDLETON is a Paris-based cultural writer. He has been the fashion features director for *Harper's Bazaar* and the Paris bureau chief for Fairchild Publications, overseeing *W* and *Women's Wear Daily*. He is also the author of *Double Vision*, the first biography of Franco-American art patrons and collectors Dominique and John de Menil. *ARTnews* named the de Menil biography one of the best art books of the decade.